WASHINGTON *at Home*

Edited by KATHRYN SCHNEIDER SMITH

JANE FREUNDEL LEVEY, *Consulting Editor*

ANNE W. ROLLINS, *Assistant Editor and Senior Photo Researcher*

RICHARD T. BUSCH, *Editorial Assistant*

MARILYN NEWTON, *Photo Research*

THE JOHNS HOPKINS UNIVERSITY PRESS Baltimore

Washington AT HOME

AN ILLUSTRATED HISTORY

OF NEIGHBORHOODS IN THE

NATION'S CAPITAL

SECOND EDITION

This book has been brought to

publication by generous support

from Cultural Tourism DC and

made possible through major grants

from Long & Foster Real Estate,

the Meyer Foundation, and B. F. Saul

Company, and the generous gifts of

the Lois and Richard England Family

Foundation and Mark G. Griffin.

The Johns Hopkins University Press
2715 North Charles Street
Baltimore, Maryland 21218-4363
www.press.jhu.edu

Library of Congress Cataloging-in-Publication Data
Washington at home : an illustrated history of neighborhoods in the
nation's capital / edited by Kathryn Schneider Smith. — 2nd ed.
 p. cm.
Includes bibliographical references and index.
ISBN-13: 978-0-8018-9353-7 (hardcover : acid-free paper)
ISBN-10: 0-8018-9353-4 (hardcover : acid-free paper)
1. Washington (D.C.) — History. 2. Washington (D.C.) — Description
and travel. 3. Washington (D.C.) — Social life and customs. 4. Neighborhoods —
Washington (D.C.) I. Smith, Kathryn Schneider.
F194.W34 2009
975.3 — dc22 2009020232

A catalog record for this book is available from the British Library.

Title page illustration: Congress Heights, 1910. Courtesy Library of Congress

Special discounts are available for bulk purchases of this book. For more information,
please contact Special Sales at 410-516-6936 or specialsales@press.jhu.edu.

The Johns Hopkins University Press uses environmentally friendly book materials,
including recycled text paper that is composed of at least 30 percent post-consumer
waste, whenever possible. All of our book papers are acid-free, and our jackets and
covers are printed on paper with recycled content.

Contents

Color illustrations follow page 156.

Preface

This is a book about community, written by a community.

Here are authors who share a fascination with small urban places and understand their value, supported by librarians, archivists, and neighborhood residents eager to share pictures and tell stories about the neighborhoods they and their families have called home. We have in common a love of the city and a deep appreciation for those who keep its history. Seen from my perspective as editor, this is an extraordinary network of individuals doing important work for Washington, D.C.

While a version of *Washington at Home* was published in 1988, this is a new book. There are new chapters: Barry Farm / Hillsdale, Columbia Heights, Congress Heights, Kenilworth, the Palisades, and Wesley Heights / Spring Valley. There is also a new chapter under a revived historical name, East Washington Heights, that includes Fort Dupont, Hillcrest, Penn Branch, and Randle Highlands. Other chapters have been updated and revised, most by the original authors. Sadly, Ruth Ann Overbeck and Marvin Caplan, two of the original authors, have passed away. We miss them greatly and are dedicating this volume to their memories. Their work remains, however, updated by others. Another innovation is the addition of reference notes, making the new edition a better tool for researchers as well as a good read for the layperson. Finally, most of the illustrations are new, with a special emphasis on maps that place the stories in space as well as in time.

Thanks first and foremost go to all to the authors, who, in the midst of busy lives, made time for this project. I have learned from all of them, have been thankful for their patience with seemingly endless questions, and have been grateful for the care they have taken to get it right.

Orchestrating this effort would not have been possible without a team of other extraordinary people who volunteered their time. Thanks to Jane Levey, my consulting editor, who has been my colleague in Washington history for decades on many projects, and whose depth of knowledge of the city and sensitivity to its nuances make her advice and thoughtful editing invaluable. Anne Rollins signed on as a photo researcher and copy editor and became my sidekick and solace; she never gave up trying to correct an obscure reference or to find a picture we knew was there — somewhere. Thanks also to Larry Bowring for his expertise and his patience in producing the sometimes challenging contemporary maps, and to Rick Reinhard who went back again and again until satisfied he had captured the essence of a place in his photographs. Rick Busch and Marilyn Newton chased down information, looked for photos, and were always ready to take a call. While this team is key to the success of this book, I take responsibility for any mistakes that remain despite all our careful work.

This edition of *Washington at Home* is sponsored by Cultural Tourism DC. The coalition of more than two hundred District cultural and neighborhood organizations was formed in 1999 to help residents and visitors find and experience the historical and cultural attractions that lie not only on the National Mall but also throughout the neighborhoods of our residential city. Its work, particularly on the development of marked neighborhood heritage trails and walking tours, has also inspired and encouraged interest in neighborhood historical research on the part of residents and scholars alike. The staff of Cultural Tourism DC was also always ready to help, especially Mara Cherkasky and Erinn Roos.

I speak for all the authors in expressing our deep gratitude to those who keep the city's historical records. Their gracious help with our requests often came with inspired suggestions that led to treasures we never would have found otherwise. Staff and volunteers at the Historical Society of Washington, D.C., have been particularly helpful, including Kiplinger Library director Yvonne Carignan, special collections librarian Colleen McKnight, reference librarian Lida Churchville, and volunteers Elizabeth Ratigan and Jack Brewer. We offer a very special tribute to the late Richard F. "Dick" Evans, the full-time HSW volunteer who had just finished his brilliant and dedicated help with photographs for this book when illness took him too suddenly from us in the summer of 2008. Everyone who knew him feels that loss deeply. Readers of the notes will see how much our authors have drawn on the scholarship published in the *Records of the Columbia Historical Society* (the society's former name) and its successor, *Washington History*.

We are all equally indebted to the staff in the Washingtoniana Division of the DC Public Library, led by Karen Blackman-Mills — another gold mine of information on Washington and its communities. Faye Haskins time and again helped track down photographs from its huge collections; Jerry McCoy and Mark Greek were always helpful. Thanks go also to Joellen ElBashir and Donna Wells of the Moorland-Spingarn Research Center at Howard University, and Clifford L. Muse, university archivist. David Haberstich and Kay Peterson assisted us in using the outstanding collection of photographs by the Scurlock Studio in the Archives Center at the Smithsonian Institution's National Museum of American History. David Anderson, author of the Foggy Bottom chapter and, at that time, head of the Special Collections Division of the Gelman Library at George Washington University, helped with images from that collection. The staff of the Prints and Photographs Division of the Library of Congress is always a tremendous resource for Washington historians.

Thanks go also to Evelyn Gerson of the Chevy Chase Historical Society, Patricia Anderson of the Montgomery County Historical Society, Sabrina Baron of Historic Takoma, Inc., Susan McElrath of the American University Archives, Hayden Wetzel and Nancye Suggs of the Sumner School Museum and Archives, Wendy Turman of the Jewish Historical Society of Greater Washington, and Frank Aucella of the Woodrow Wilson House.

The D.C. Office of Historic Preservation has sponsored extensive research on Wash-

ington's historic districts that has enriched the work of many of the authors. Steve Call-cott of that office was always ready to help, as were others, in particular Amanda Molson.

Individuals throughout the city have searched for photographs for us in their personal or institutional collections, often sharing our excitement when just the right image appeared. Our thanks go to Lavinia Wohlfarth of the Brookland Community Development Corporation; Ian Richardson at the Chevy Chase Presbyterian Church; Lynn Turner of the Diplomatic Reception Rooms at the State Department; Christian Minter at the Fort Dupont Ice Arena; Liz Whisnant of Horace Mann Elementary School; Heather Riggins of the Kiplinger Washington Collection; Carter Bowman and Janet Ricks of Mount Zion United Methodist Church; Ron Harvey, Debbie Kirkley, Stephen W. Syphax, and Sam Tamburro of the National Park Service; Tom Jacobus and Patricia Gamby at the Washington Aqueduct; Liza Lorenz of the Shakespeare Theatre Company; James Goode, curator of the Albert H. Small Collection; Rabbi Ethan Seidel, Marcia Goldman, and Carl Bergman of Tifereth Israel Congregation; Sherman Fleek of the U.S. Army; and Bill Rice, who did photo research for the first edition of this book.

We are also grateful to all the individuals who have provided photographs from their private collections; they are noted in the picture credits. We particularly want to pay tribute to Robert A. Truax, who generously shared his photo collection with so many of us over the years. We mourn his passing at the age of 93 in spring 2009 — he was a pioneer in our field. Austin H. Kiplinger and Albert H. Small have been devoted collectors of Washingtoniana for decades; I join the community of Washington historians in thanking them for the treasures they have preserved and so generously make available. My personal thanks also go to friends and colleagues who helped in ways too many to detail — Sally Berk, Nicky Cymrot, Patsy Fletcher, Joan Habib, Don Hawkins, Jim Kise, Nola Klamberg, Carole Kolker, Brian Kraft, Terri Robinson, Julie Rogers, Anne Satterthwaite, and Barbara Wolfson — and my thanks and apologies to others who, in this long project, may have helped me along and whose name I have not recalled.

The new *Washington at Home* would not exist without those who funded this ambitious undertaking. We are enormously grateful to the Meyer Foundation, the B.F. Saul Company, Long & Foster Real Estate, and the Lois and Richard England Family Foundation. Mark Griffin was instrumental in making the first edition of this book happen, for which I continue to be thankful, and he contributed again to this volume.

Close readers of the contributors' brief biographies may note the number of degrees in American studies from George Washington University. That department has been a catalyst for scholarship on the history of Washington and is owed thanks from all of us who have, like the city, been the beneficiaries. Historian Howard Gillette, formerly of that department, and a mentor to so many including myself, is due particular acclaim, as are Roderick S. French, who did so much to turn the attention of the university to the city through the Department of Experimental Studies in the 1970s, and the late Letitia Woods Brown who did the same. I owe my own thanks to another mentor at George

Washington University, James Oliver Horton, who introduced me to social and African American history. The department's involvement in Washington history also includes the work of Richard Longstreth in architectural history and historic preservation, and Bernard Mergen who taught us all the value of material culture.

My husband, Sam, has been my soulmate in this sail through the history of Washington, his hometown. An extraordinary writer and student of this city, his knowledge, patience, technical prowess, and never-ending sense of humor have kept me afloat. My love and appreciation go also to my sons Nathaniel and Benjamin, who have lived with us on Capitol Hill and in Cleveland Park, who have endured endless talk about the history of their hometown.

My love of neighborhoods began in my childhood world on 54th Street and Washington Boulevard in Milwaukee, Wisconsin, where my church, school and playground, park, drugstore soda fountain, and neighbors with open doors were all within roller-skate reach. As suburban Tysons Corner and Rockville Pike prepare to reorganize around small, new, distinct communities, it feels to me that it might not just be sentimentality that suggests this way of life is regaining its appeal.

Some Major Events Affecting Washington Neighborhoods

1790	Congress chooses a Potomac River location for the nation's capital.
1791	George Washington announces the specific site for the Federal City. Andrew Ellicott and Benjamin Banneker survey the boundaries of the District of Columbia; Peter Charles L'Enfant designs the Federal City.
1800	The federal government moves from Philadelphia to Washington City.
1802	Washington City receives a charter from the federal government, providing an elected council and presidentially appointed mayor. Georgetown and Alexandria elect their own local governments; Washington and Alexandria counties governed by justices of the peace.
1804	Public schools established for white children.
1807	First known private school for African American children opens.
1812	The Washington City charter is amended to allow an elected board of aldermen, from which body a council and a mayor are chosen.
1820	The mayor begins to be elected directly by the people.
1846	The Virginia section of the District is retroceded to the state of Virginia.
1861–65	Washington is command central for the Union cause in the Civil War.
1862	Horse-drawn streetcars begin regular service for the general public. Slavery is abolished in Washington, D.C. First public schools for African Americans established on a segregated basis.
1864–74	Local ordinances protect rights of African Americans to public education and access to public accommodations, including seating on public streetcars.
1871	The City of Washington, Georgetown, and Washington County are combined under a new territorial government, with a governor and governor's council appointed by the president of the United States, and an elected House of Delegates.
1871–74	The territorial government modernizes the city — grading and paving streets, laying sewer and water mains, and planting trees, thus inspiring a real estate boom.
1874	Congress replaces the territorial government with three commissioners appointed by the president of the United States. District residents lose all voting rights.
1878	The Organic Act makes the commissioner system permanent for the entire District of Columbia and eliminates the governmental distinctions between Washington City, Georgetown, and Washington County.

1888 The first electric streetcar in the city runs on the Eckington & Soldier's Home Railway line.

1890 Boundary Street, once the northern edge of Washington City, becomes Florida Avenue, symbolically erasing the distinction between the L'Enfant city and the rest of the District.

1891 The Chevy Chase Land Company builds the first major bridge across the Rock Creek chasm at today's Calvert Street, opening new opportunities for suburban developments west of the creek.

1893 Congress authorizes the extension of the L'Enfant Plan, with its diagonal avenues superimposed on a grid system, to the entire District.
 A national economic panic slows the development of new subdivisions in the District.

1896 *Plessy v. Ferguson* establishes separate but equal doctrine that increases discrimination affecting Washington's large African American population and encourages residential segregation.

1898 A revised highway act exempts previously planned developments from the extension of the L'Enfant street plan.

1899 Congress passes legislation establishing the city's first building height limit, which will create the city's unique low-scale profile.

1901 Laws protecting the rights of African Americans passed during Reconstruction are quietly dropped from the D.C. Code.

1901–2 The McMillan Commission Plan lays out a vision for today's National Mall and a citywide park system.

1917–18 Population surges as Washington gears up for World War I.

1920 The city enacts its first zoning regulations.

1920s The automobile becomes affordable for the middle class, opening up land far from the streetcar lines for suburban development.

1929–37 Federal Triangle rises between Pennsylvania and Constitution avenues, separating downtown from the National Mall.

1933–41 The New Deal of President Franklin D. Roosevelt brings population growth, and neighborhoods expand despite the Great Depression.

1941–45 World War II brings thousands of newcomers to the city, causing severe crowding. War-related demands for materials shut down the private housing industry, but the government builds housing for war workers in the District.

1945–50 A postwar building boom begins to fill the District's open spaces. Suburban developments grow outside the boundaries of the District as it becomes the heart of a thriving metropolitan area.

1948 The Supreme Court in *Hurd v. Hodge* declares discriminatory housing covenants unenforceable.

1950 Population reaches its highest level to date at 802,178.

1953 The Supreme Court rules in the restaurant case *District of Columbia v. John R. Thompson Co.* that public accommodations must be open to all in the District of Columbia, affirming laws passed in the 1870s that had been left out of the D.C. Code in 1901.

1954 In *Brown v. Board of Education*, and a companion District case, *Bolling v. Sharpe*, the Supreme Court desegregates the nation's public schools.

1954–60 Most of Southwest Washington is leveled by urban renewal.

1957 White flight and population shifts create an African American majority population in Washington.

1966 Griffith baseball stadium closes.

1967 President Lyndon Johnson creates a new system of government for the District of Columbia by executive order, with a presidentially appointed mayor/commissioner and council.

1968 Civil disturbances following the assassination of the Reverend Dr. Martin Luther King Jr. engulf many neighborhoods of the city. Burned-out areas would remain in a state of disrepair for forty years in some places.

1974 The Home Rule Act of 1973 returns an elected local government to the District of Columbia, but Congress keeps final control over the city budget, local legislation, and judicial appointments. Walter Washington is elected mayor; Sterling Tucker is elected D.C. Council chairman. The legislation creates a system of Advisory Neighborhood Commissions.

1976 First Metrorail stations open; the system begins to encourage commercial and high-density residential development around neighborhood subway stops.

1978 Marion Barry is elected mayor for the first of four, often troubled and controversial, terms he would serve over the next twenty years.
 The D.C. Council passes a strong historic preservation ordinance, creating the Joint Committee on Landmarks.

1980s A financial upturn fuels new building projects throughout the city.
 The Historic Preservation Review Board replaces the Joint Committee on Landmarks.

1995–2001 A financial control board created by Congress takes responsibility for many city functions until the city can recover from a crisis of finances and congressional confidence.

1997 Opening of MCI (now Verizon) Center marks beginning of a downtown renaissance.

1998 Anthony A. Williams is elected mayor. Increased financial stability coinciding with a strengthened national economy restores confidence that will lead to an end of the financial control board in 2001.

late 1990s Home prices begin dramatic rise as the nation experiences an economic boom at the same time as an interest in urban neighborhoods grows; revitalization is accompanied by demographic changes as gentrification affects many communities.

2001 Original Metrorail system is complete.

Terrorists crash plane into the Pentagon on September 11, killing 189 people, as part of the same event that destroyed the World Trade Center in New York. The event would increase security measures and physical barriers across the city, particularly downtown and in federal buildings and monumental areas in the central city.

2003 The new Washington Convention Center opens between 7th and 9th streets on Mount Vernon Square, impacting both the revitalizing historic downtown to the south and the gentrifying Shaw neighborhood to the north.

2005 The Washington Nationals baseball team brings Major League Baseball back to Washington; the team plays its first season at RFK Stadium on the eastern edge of Capitol Hill.

2006 Adrian M. Fenty is elected mayor at the age of 35, winning all voting precincts in the city.

2007 D.C. Voting Rights Act, which would give the District one vote in the U.S. House of Representatives, passes the House but fails in the Senate. Citizen activism on this issue continues, led by the nonprofit organization DC VOTE.

2008 The Washington Nationals move to the new Nationals Park on the Anacostia River at South Capitol Street, spurring dramatic new developments at the eastern edge of the Southwest neighborhood and at the southern edge of the Capitol Hill neighborhood along M Street, SE. National economic downturn slows new construction and challenges rising home prices.

2009 The D.C. Council creates a committee to renew the drive for statehood for the District, which would provide full voting representation in Congress and complete control over the city's budget and judicial system.

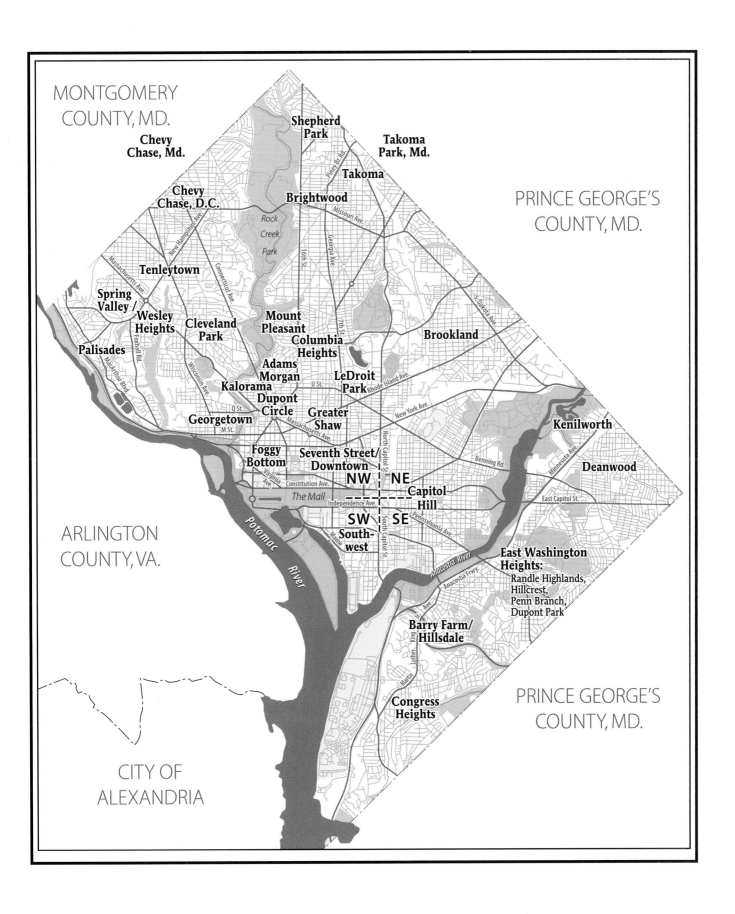

MONTGOMERY
COUNTY, MD.

Chevy
Chase, Md.

Chevy
Chase, D.C.

Shepherd
Park

Takoma
Park, Md.

Takoma

Brightwood

PRINCE GEORGE'S
COUNTY, MD.

Rock
Creek
Park

Tenleytown

Spring
Valley /

Wesley
Heights

Cleveland
Park

Mount
Pleasant

Columbia
Heights

Brookland

Palisades

Adams
Morgan

Kalorama

Dupont
Circle

LeDroit
Park

Kenilworth

Georgetown

Greater
Shaw

Deanwood

Foggy
Bottom

Seventh Street/
Downtown

NW | NE

Capitol
Hill

The Mall

SW | SE

ARLINGTON
COUNTY, VA.

Southwest

East Washington
Heights:
Randle Highlands,
Hillcrest,
Penn Branch,
Dupont Park

Potomac River

Anacostia River

Barry Farm/
Hillsdale

PRINCE GEORGE'S
COUNTY, MD.

Congress
Heights

CITY OF
ALEXANDRIA

WASHINGTON *at Home*

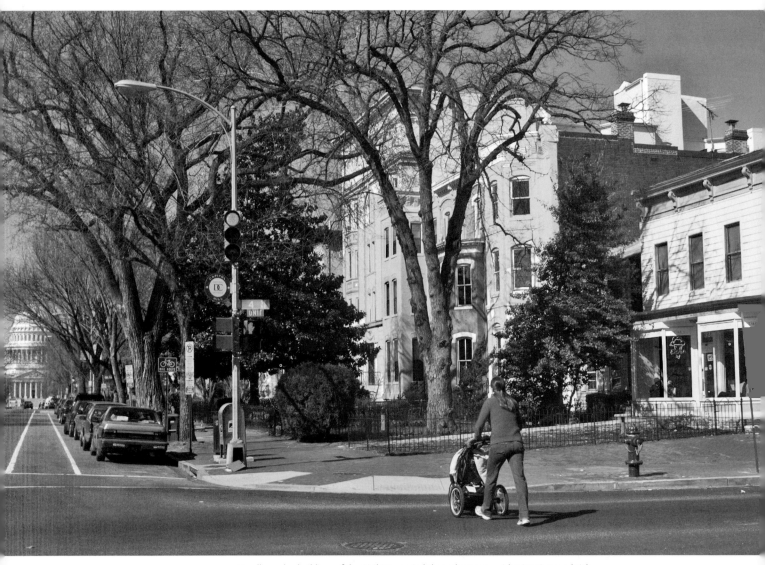

Small wooden buildings of the Civil War period share the streets with Victorian-era brick row houses and twentieth-century apartments in the Capitol Hill neighborhood, where a stroll with the baby can mean a walk by the Capitol itself. In Washington, neighborhoods and monuments, the local and the federal, keep daily company. Photo by Kathryn S. Smith

Introduction

WASHINGTON AT HOME

KATHRYN SCHNEIDER SMITH

Seen around the nation and the globe as a city of politics and marble monuments, Washington, D.C., is one of the best-known and least understood cities in the world. It is a place that can be hard to pin down. It is the federal capital as well as the hometown of almost six hundred thousand people. Situated on the edge of the North and the South, it is both and neither. In a nation where many of the nation's central cities are defined by varied ethnic neighborhoods, Washington has been seen mostly as simply black and white for much of its history. While other American cities suffered during times of war and depression, the capital often prospered and grew, stoked by the energies of thousands who came to fight these and other threats. The capital of the world's greatest democracy, it has no vote in Congress and limited control over its own local affairs.

This complexity can be invisible to outsiders, obscured in the minds of most by the image of national memorials and museums on the Mall and the talking heads in front of the Capitol and the White House on the evening news. Yet within a small area of only sixty-eight square miles lies a residential city of diversity, beauty, and charm.

Washingtonians live in an array of distinct communities that, though sometimes only a few blocks apart, have unique histories and cultures revealed in the style of their architecture and the feel of their streets. The D.C. Office of Planning lists 131 of them; residents have names for many more. The essays in this book on twenty-six of these communities reveal Washington's fascinating variety. The neighborhoods have been chosen because they either reflect a unique piece of the city's story or because they have a strong local identity that begs for inclusion. Taken together, they represent all four quadrants of the city.

Neighborhoods are organic, not official, and their boundaries and even their names change over time. The differing boundaries of civic and citizens associations, advisory commissions, school districts, and census tracts can be confusing. Some neighborhoods, such as LeDroit Park, have identities that go back to their emergence as suburban developments and still have basically the same boundaries. But that is the rare exception. The place known as Shaw expanded in the 1960s, but the smaller communities it absorbed are coming into their own again. Similarly, the intersection of the Columbia Heights and Pleasant Plains neighborhoods has changed over time; in the 1960s they were enveloped by the name Cardozo, only to have their original names reappear in common use again in the 1980s. Across town, the historical name Tenleytown disappeared for much

of the twentieth century but came back on a new Metrorail station in the 1980s. Sometimes real estate agents create new names, as in North Cleveland Park. Sometimes it is city officials, as in Shaw. Sometimes it is the residents themselves, as in Adams Morgan.

Yet the first question people ask about a neighborhood is almost always, "Where is it?" And it is hard to say where a place is without trying to define both its center and its edges. Therefore we have been bold and have included maps with edges, based on what seem to be the most commonly accepted boundaries. In almost every case, exceptions are noted in the captions. While we all feel this is a somewhat risky path, we hope the lines are helpful and that any discussion they might provoke will only underscore the importance Washingtonians put on the places they call their own.

These essays are written by authors as diverse as the communities they describe. As revealed in the authors' biographical notes at the end of the book, there is a folklorist, an anthropologist, an archivist, a librarian, a Realtor, and a journalist. There are architectural historians and social historians, some by training, some by avocation. Many, in addition to their special neighborhood knowledge, have a personal attachment that shapes their chapters. All were aware they could only scratch the surface of the stories that could be told. There has been no attempt to homogenize these essays, because the voices in which they are written, as much as the subject matter the authors have chosen to include, are revealing in their variety and representative of the complexity of the city itself.

Yet in focusing on the city through these various lenses, pivotal events in the history of the city and its neighborhoods emerge by their very repetition. It becomes clear, for example, that the Civil War had a seismic impact. So did the street paving and other physical improvements brought about by Alexander R. "Boss" Shepherd in the 1870s, which literally laid the groundwork for new neighborhoods. The world wars of the twentieth century brought population growth and housing pressures. The riots following the assassination of the Reverend Dr. Martin Luther King Jr. in 1968 violently changed the course of development and community life in neighborhoods across the city. These and other key events that had an impact on the growth and character of Washington's residential communities are listed on the timeline beginning on page xiii. The reader may discover others, as well as connections between the neighborhoods too numerous to make explicit without encumbering the narrative. We hope their discovery will be one of the pleasures of this book.

Not only pivotal events but unifying themes emerge as these separate narratives unfold. First, it becomes clear that many Washington neighborhoods were shaped by some of the same forces that created distinctive communities in other large American cities. Foremost were transportation innovations — the public horse-drawn car lines beginning in the 1860s and the electric streetcars and steam railroads beginning in the 1880s and 1890s that offered residents the option, for the first time, of living farther away from their employment than they could conveniently walk. Once people took this opportunity, the old pedestrian city — where people of all races, ethnic backgrounds, and

economic levels had lived closely intermixed — began to separate into a city of different incomes and purposes. Many people of means left the increasingly crowded and relatively unhealthy central cities for new suburban developments along the streetcar and railroad lines.

Many Washington neighborhoods have their roots in this common nineteenth-century transportation phenomenon. Mount Pleasant and LeDroit Park began as horsecar suburbs; Chevy Chase and Cleveland Park began as electric streetcar suburbs; Takoma Park and Brookland started as early beneficiaries of commuter railroads. The automobile, available to the middle class by the 1920s, opened new development opportunities beyond and between the streetcar lines, such as Wesley Heights and Spring Valley. The effect of the Metrorail system begun in the 1970s is still being felt, as nineteenth-century District neighborhoods with subway stops, such as Columbia Heights, become the focus for twenty-first-century economic development. The Metro also connects the downtown and the neighborhoods of Washington with a vast metropolitan area of more than five million people. These transportation innovations inspired the organizing scheme that underlies the sections of this book.

While the patterns of expansion experienced in Washington often replicated those in other cities, the neighborhoods of Washington were affected by the peculiar origin and unique role of the city as the nation's capital. The visionary and large-scale plan drawn for Washington City by Peter Charles L'Enfant (recent research by Kenneth R. Bowling shows he preferred Peter to Pierre) fostered the emergence of separate communities in great open spaces. When the federal government moved to the banks of the Potomac River in 1800, the Capitol and the President's House rose about a mile and a half apart, amid orchards, woods, and open, rolling fields. The Capitol Hill neighborhood grew up around the legislative branch, Foggy Bottom became the city's first industrial area, and Southwest its port. To reach the independent town of Georgetown required a one-mile trek from the President's House. Thus each place began its own unique story within the city.

Physical distances also separated the streetcar suburbs of the post–Civil War era, as developers selected parcels scattered around the rural parts of the District of Columbia beyond L'Enfant's planned Washington City, which was bounded by the Potomac and Anacostia rivers on the southwest and southeast, by Rock Creek on the west, and by today's Florida Avenue and Bladensburg Road on the north. The residents of 1890s Takoma Park straddling the District boundary in the far northern part of the District felt like pioneers. As late as the 1920s, maps showed undeveloped land between such

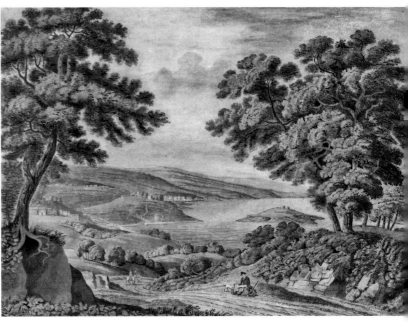

Little clusters of buildings mark the scattered settlements of early Washington, the beginning of today's neighborhoods, in this romantic 1800 engraving by J. Cartwright after a painting by George Beck. As one looks southeast down the Potomac River, Georgetown rests on the first hill at the left, with the entrance to Rock Creek at its base and Foggy Bottom on the opposite rise. The farthest cluster of buildings represents the center of Washington City, today's downtown. The man and his dog in the foreground stop to rest about where MacArthur Boulevard enters today's Palisades neighborhood. Courtesy The Historical Society of Washington, D.C.

places as Cleveland Park and Tenleytown and between Brightwood and Takoma Park. These distances reinforced neighborhood identities.

The city's topography also shaped the way Washington's neighborhoods evolved. Washington has the configuration of a bowl, the product of an ancient river that created a series of rising terraces on the west side of the Anacostia River and a steep rise to the heights on the east. The city's first prosperous residents built their mansions and summer residences on the heights to escape the heat and the threat of disease in the central city. Those mansions sometimes became centerpieces of the neighborhoods that developed around them, such as President Grover Cleveland's summer home in Cleveland Park, Amzi Barber's Belmont in Columbia Heights, and John Van Hook's (later Frederick Douglass's) Cedar Hill in Old Anacostia.

The chasm of Rock Creek effectively stopped development in the District north of Kalorama and west of the creek until Senator Francis Newlands built the first major bridge to traverse it along today's Calvert Street in 1891. The park created around the creek the year before continues to divide the Northwest quadrant of the city in perception and reality. And one cannot read the chapters about Barry Farm / Hillsdale, Congress Heights, Deanwood, East Washington Heights, and Kenilworth without appreciating the defining quality of their separation from the rest of the city by the Anacostia River. Their distance is so complete that people living across the river from them have most commonly referred to the entire area east of the river as Anacostia, even though the name is applied properly only to the oldest of thirty-seven communities on that side of the river listed by the D.C. Office of Planning. More recently these distinct communities have been lumped together as "East of the River," a phrase that also suggests a place apart. It is a separateness that, on the positive side, has encouraged successful self-reliance, as seen most clearly in the Deanwood chapter, and a village quality, as emphasized by the author of Barry Farm / Hillsdale. On the negative side, an "out of sight, out of mind" mentality, combined with institutional racism and classism as the area became increasingly African American and low income beginning in the 1950s, encouraged the neglect of city services, the building of crowded substandard housing, and the use of open space for civic nuisances such as the city dump in Kenilworth.

The physical character of Washington's neighborhoods has been shaped to a great extent by planners, a city tradition since L'Enfant laid out his grand design. The L'Enfant Plan, however, existed more on paper than on the ground until after the Civil War when Alexander Shepherd, the most powerful member of the Board of Public Works and then governor of the short-lived Territory of the District of Columbia from 1871 to 1874, graded and paved many of L'Enfant's streets, avenues, and circles. His hasty and controversial yet effective actions modernized the city seemingly overnight and paralleled the city's rise in importance as a true national capital for the first time. The rush to buy and build of 1875–1900 gave us the brick row house architecture that dominates the neighborhoods that ring the central city today — Capitol Hill, Shaw, Dupont Circle, and upper Georgetown, mostly built up between those years. In the 1890s, as the city spread

beyond the boundaries of Washington City, the L'Enfant Plan was extended throughout the District, although many exceptions were subsequently made. The irregular streets of neighborhoods laid out before the 1890s, such as LeDroit Park, Tenleytown, early Mount Pleasant, Kalorama, and parts of Adams Morgan, still stand out on today's maps in contrast to L'Enfant's extended grid.

Washington neighborhoods have also been affected, some profoundly, by the actions of planners who used Washington as the nation's capital to test approaches to urban problems. It was an easy place to do so because they could work directly with Congress, which had ultimate control over the city. Some of these experiments were beneficial, such as the Senate's McMillan Commission Plan of 1901–2 in which the principles and visions of the City Beautiful movement were first applied to an American city. While the design of the National Mall was its focus, the plan also suggested the city's extensive system of parks that now provide many Washington neighborhoods with natural boundaries and convenient sylvan retreats, as in the communities of Fort Dupont, Mount Pleasant, and Wesley Heights. Some of the experiments were less positive, especially the wholesale urban renewal that leveled almost all the 150-year-old Southwest neighborhood in the late 1950s. The impact on those so abruptly torn from their community, however rundown it might have been, and on the places to which they fled — such as Barry Farm / Hillsdale, Congress Heights, and Kenilworth — was dramatic. The lessons learned can be seen in Adams Morgan, where a highly organized community rejected that avenue to urban revitalization, as did community leaders in Greater Shaw.

The work of social reformers and housing activists, looking for ways to provide places to live for those with the fewest resources, played out in many Washington neighborhoods. The inhabited alleys inside the city's large blocks in such central city neighborhoods as Foggy Bottom, Southwest, and Capitol Hill were crowded and unsanitary and attracted decades-long efforts of housing reform carried out with national figures in a national spotlight, including tours of alleys by Eleanor Roosevelt and other dignitaries. The federal government first provided funds for affordable public housing in the National Housing Act of 1937 and again in the 1949 National Housing Act. But, as seen in Barry Farm / Hillsdale, Congress Heights, and Kenilworth, the public housing policies that made such dwellings a place to get a foothold later changed in ways that helped make them places of last resort and a detriment to the community. In the 1980s residents of Kenilworth Courts organized and became a national model for a federal government initiative encouraging improvements through tenant management and even tenant ownership. By the 1990s and into the next century, however, public housing was being demolished for mixed-income developments, as in Congress Heights and on Capitol Hill. Deanwood stands out as a place where modest homes, built by local craftsmen beginning in the 1920s, continue to provide affordable opportunities for homeownership even as public housing developments have come and gone.

The essays in this book also reveal the enormous influence of de facto planning by private developers. In some cases their visions still define and identify the places they

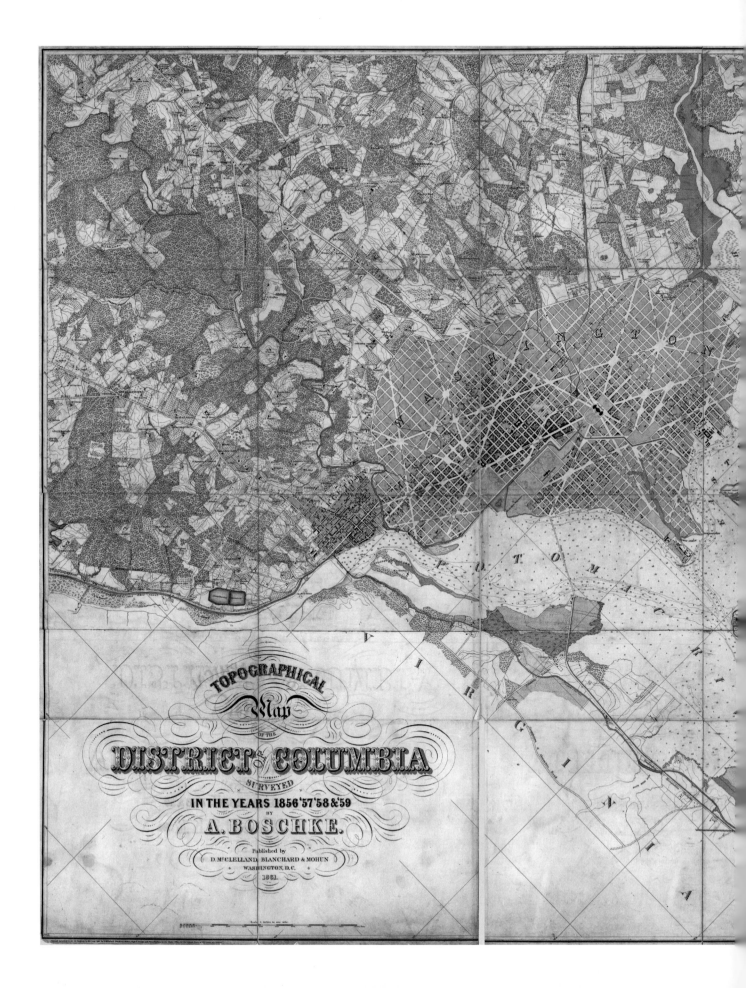

TOPOGRAPHICAL
Map
OF THE
DISTRICT OF COLUMBIA
SURVEYED
IN THE YEARS 1856 '57 '58 & '59
BY
A. BOSCHKE.
Published by
D. McCLELLAND, BLANCHARD & MOHUN
WASHINGTON, D.C.
1861.

created. The street layout and distinctive cottage-style romantic architecture of LeDroit Park retain the qualities Amzi Barber and Andrew Langdon intended in the 1870s. Chevy Chase remains the predominantly residential suburb that Francis Newlands envisioned; his huge financial resources enabled him to control his creation for decades before realizing any financial gain. The founders of the Cleveland Park Company put high value on a variety of architectural designs by accomplished architects, and their success in this area continues to define the neighborhood in the public mind. Arthur Randle saw the potential of the highlands ascending Pennsylvania Avenue east of the Anacostia River for middle-class homes, and despite changed racial demographics, his vision persists. Other real estate entrepreneurs, such as Benjamin Gilbert in Takoma Park, Stilson Hutchins in the Palisades, and John Sherman in Columbia Heights, did not control development long enough to leave distinctive physical places, but their initiatives laid the groundwork for neighborhoods still identified with the names they gave them.

It is also interesting to see how the goals of these businessmen expanded from just laying out the streets for a suburban neighborhood as in Columbia Heights, to the addition of physical and social amenities as in Cleveland Park, to creating an organized and controlled social as well as physical setting as in Wesley Heights and Spring Valley. In telling these development stories, chapter authors frequently cite the cost of new houses in the late nineteenth and early twentieth centuries, which varied widely from $1,000 to $15,000. While these prices may seem low to us today, it is instructive to note that $1,600 a year was seen as a handsome government salary in 1900 and $2,000 a year allowed a lifestyle of considerable social standing.

Because the city was also the nation's capital, the developers were working within the context of a place unusual in its economy and its mix of people. Washington's neighborhoods, for example, are defined more by their physical and historical qualities than by a dominant ethnicity, as has been the case in cities such as Boston or Chicago. Washington, a city of government, did not have the factory jobs that drew thousands of European immigrants to large industrialized cities. Washington's smaller ethnic communities were scattered throughout

(opposite)
The black squares in the gray area labeled Washington on this map by A. Boschke show how little of the city designed by Peter Charles L'Enfant was occupied at the time of the Civil War. The rest of the District is still a patchwork of woods and farm fields. A building boom beginning in the 1870s would create new neighborhoods in L'Enfant's city and begin to fill the open spaces beyond with suburban developments. Courtesy Library of Congress

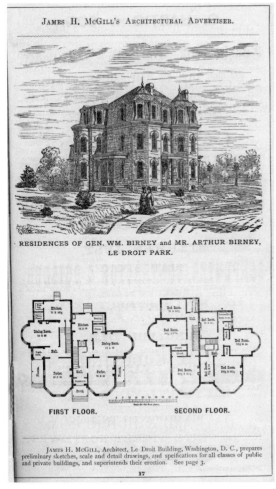

JAMES H. McGILL'S ARCHITECTURAL ADVERTISER.

RESIDENCES OF GEN. WM. BIRNEY and MR. ARTHUR BIRNEY,
LE DROIT PARK.

FIRST FLOOR. SECOND FLOOR.

JAMES H. McGILL, Architect, Le Droit Building, Washington, D. C., prepares
preliminary sketches, scale and detail drawings, and specifications for all classes of public
and private buildings, and superintends their erection. See page 3.

17

Private developers such as Amzi Barber and Andrew Langdon, creators of LeDroit Park, often left a unique stamp on the communities they started. Barber and Langdon did so by hiring architect James H. McGill to design more than sixty houses, such as this one, in picturesque styles popular in the 1870s for their new neighborhood. This double house, a mixture of Italianate and Second Empire styles, still stands on Anna Cooper Circle at the heart of the community at 3rd and T streets, as do other McGill houses nearby. Courtesy The Historical Society of Washington, D.C.

the city and affected the culture of the places they settled, but except perhaps for a small Chinatown, did not totally define them. As the essay on Seventh Street / Downtown explains, Germans both Christian and Jewish, Greeks, Italians, and Chinese clustered around the commercial opportunities offered by the Center Market and the needs of workers in the nearby local and federal government offices. The port and light industrial activities of the Potomac River waterfront in Southwest, Foggy Bottom, and Georgetown drew migrants not only from Europe but from rural Maryland and Virginia. Most recently, beginning in the 1970s, people fleeing difficult conditions in South and Central America found new homes in Adams Morgan and Mount Pleasant, giving a Latino flavor to neighborhoods that came to be known as the city's most racially and ethnically diverse.

There are instances where culture and religion created a distinct ambience. Brookland grew up around the Catholic University of America and over the years attracted the Basilica of the National Shrine of the Immaculate Conception, the Franciscan Monastery, and scores of Catholic religious orders that rival their numbers in Rome. The presence of these institutions attracted Italians and people of other nationalities with strong Catholic traditions to the neighborhood. At the same time Jewish people were drawn downtown and to Southwest where there were small business opportunities. As they prospered, they tended to move north along 7th Street and Georgia Avenue and up 14th and 16th streets into Brightwood and Shepherd Park and then into Montgomery County, Maryland, taking their businesses and synagogues with them — one of the city's most notable group migrations. Latinos were following a similar migration route north from Adams Morgan and Columbia Heights as this book was being written.

The most dominant cultural thread in the city's history, however, has been African American, as is evident in many of these essays. People of color made up one-quarter to one-third of the city's population from 1800 until 1957, when Washington became the nation's first large city to have an African American majority. This large African American presence has been a defining factor in the city's social and political history, and the movements of people by race in the city have had profound effects on the changing character of its historic neighborhoods. In the distinct communities of pre–Civil War Washington City, such as Southwest, Downtown, Capitol Hill, and Foggy Bottom, and in the town of Georgetown, whites and enslaved and free blacks lived together, although often clustered in small patterns by block or side of the street. In rural areas, such as the crossroads community of early Brightwood, free black landowners were

interspersed with white. Washington's black population was distinguished at this time by the number who were free, a majority by 1830, and by the number and strength of its own separate social, religious, and educational institutions long before the Emancipation Proclamation.

By the late nineteenth century, there were two predominantly black neighborhoods, both east of the Anacostia River. The author of the Barry Farm / Hillsdale chapter, whose family lived in the area for four generations, describes a close-knit network of personal relationships that began in a freedmen's village in 1867 and became the nucleus of a black Anacostia that included the existing communities of Garfield and Stantontown. Deanwood, north of Barry Farm at the northeastern tip of the District, though predominantly African American, developed in a semirural atmosphere that fostered some collaboration between white and black, particularly in the construction trades. Small black communities also emerged within white neighborhoods after the Civil War around the remains of military forts and camps, where those fleeing slavery had clustered for protection and the possibility of work. This was true at Fort Reno in Tenleytown, around Battery Kemble in the Palisades, around Camp Barker at 13th and R streets in Shaw, and near an encampment on Meridian Hill in what would become Columbia Heights. Such clustering was no doubt also the reason for the selection of the farm of James Barry for the Barry Farm freedmen's village, close to Fort Stanton and Fort Carroll and the enormous cavalry depot at Giesboro Point.

Although many new residents began to arrive in Washington from the North and the West after the Civil War, Washington remained a Southern town in culture and practice. As early as 1854 in Uniontown/Anacostia, where blacks and Irish could not buy land or houses, developers of suburbs outside of old Washington City began putting racially restrictive covenants in their deeds. Although time-consuming deed research is needed to fully describe the extent and type of such restrictions in Washington neighborhoods, the practice was common. In the twentieth century it expanded in some neighborhoods to include not only African Americans but also, as some deeds read, "Armenians, Jews, Hebrews, Persians, and Syrians." The impact of restrictive covenants is noted particularly in the chapters on Brookland, Columbia Heights, and East Washington Heights and is most fully described in the chapters on Shepherd Park and Wesley Heights / Spring Valley.

Given such restrictions, it was mostly whites who were able to take advantage of the electric streetcars that, beginning in 1888, made it possible to live in a semirural suburb and commute to work downtown. At the same time, Jim Crow practices tightened in the city following the 1896 *Plessy v. Ferguson* ruling that gave separate but equal the imprimatur of the Supreme Court. Early civil rights laws that required public accommodations be open to all regardless of race, passed by the Reconstruction-era territorial government in the District in the early 1870s, were quietly dropped from the city's legal code in 1901 and were not rediscovered until the late 1940s.

As African Americans were forced out of places in the center city by the increas-

Members of the Dozen, a social group founded by a group of twelve African American men new to Washington, enjoy a formal dinner at the True Reformers Hall at 12th and U streets about 1917. The newcomers became part of a large black community in Washington, with roots in the early nineteenth century, whose presence would continue to be central to the city's cultural identity. Courtesy The Historical Society of Washington, D.C.

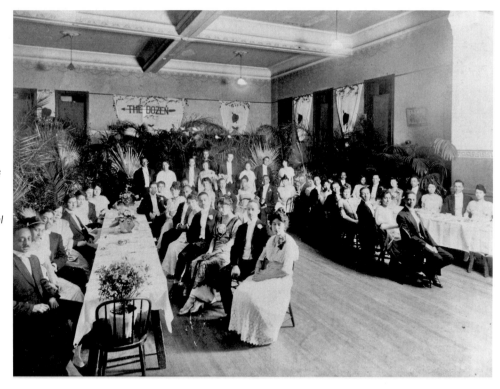

ingly discriminatory practices of the turn of the twentieth century, they were drawn to the area north of the center city near Howard University. Founded by the Freedmen's Bureau in 1867 expressly to serve all regardless of race, the university had become a magnet for blacks seeking the best higher education. Nearby U Street became the boulevard of an increasingly African American neighborhood that would later come to be called Shaw. By the early twentieth century, it was the commercial, professional, and entertainment heart of the black community in Washington. The adjacent LeDroit Park neighborhood, along with the streets just south of U Street, became home to the community's leaders in education, science, the arts, medicine, law, and the military. At the same time, smaller black communities continued in Southwest, Foggy Bottom, and Georgetown.

When Supreme Court cases of the late 1940s and early 1950s declared restrictive housing covenants unenforceable (*Hurd v. Hodge*, 1948) and discrimination in public accommodations (*District of Columbia v. John R. Thompson Co., Inc.,* 1953) and schools (*Brown v. Board of Education*, 1954) unconstitutional, Washington as the federal city was the first to move toward compliance, made easier by the fact that the president of the United States appointed its local government. One day after the *Brown v. Board of Education* decision desegregating the public schools in 1954, President Dwight D. Eisenhower ordered the District commissioners to move swiftly to develop a plan to integrate the D.C. public schools that would make the capital city a "model for the nation."

Massive demographic shifts followed, as many whites fled to the suburbs and more African Americans gained access to fine neighborhoods formerly closed to them.

Takoma (as many now call the part of Takoma Park that is in the District of Columbia), for example, changed from about 18 percent to about 63 percent African American in just ten years between 1960 and 1970. Shepherd Park counted only ninety-three African Americans among its residents in 1960, and by 1970 African Americans made up 48 percent of its population. East of the Anacostia River, new zoning laws that encouraged rental apartments over single-family homes, the construction of large public housing developments, and an influx of refugees from urban renewal in Southwest changed the social make-up of neighborhoods there. The population of Far Southeast (east of the Anacostia River and south of East Capitol Street), which was historically white, changed from about 82 percent white to about 86 percent black between 1950 and 1970. In historically African American Barry Farm / Hillsdale, the change was not a racial one but rather a loss of social cohesion and shared community values. The Shepherd Park essay takes as its theme the efforts of that community and neighboring Manor Park and Takoma to stand against the racial fears fanned by blockbusters and to find ways to build and take pride in a multiracial and multicultural community. Residents of Hillcrest and Penn Branch in East Washington Heights organized a similar effort, taking Shepherd Park as a model.

The civil disturbances following King's assassination in April of 1968 increased the challenges that faced those working for integrated neighborhoods in Washington. The riot's pivotal nature in the history of late twentieth-century Washington becomes clear with the number of references the individual authors have made to it in this book. Perhaps the more important theme, however, is the way in which individuals in Washington — on the frontlines in the struggle for equal rights because of the city's large black majority and because the spotlight often shines on the nation's capital — have had the courage to enter the fray and seek solutions. The young men who created the New Negro Alliance to protest employment discrimination in the 1930s in today's Greater Shaw set the stage for a Supreme Court decision that presaged and supported the civil rights movement of the 1950s and 1960s. The principals of the white Adams Elementary School and black Morgan Elementary School worked with residents in a variety of local organizations to create an entirely new multiracial community along 18th Street, NW, even renaming the neighborhood Adams Morgan. Sometimes it was just an individual — like the Hanafi Muslim man who was the first to minister to the Jewish victim of a car accident in Shepherd Park — who did something that moved human relationships in the city a step forward.

Indeed, when one asks, in the end, why Washington has so many unique neighborhoods, it is only partly because some have clear boundaries and names that go back to the nineteenth century or because some have architecture that sets them apart. The neighborhoods have strong identities also because they have provided the framework for civic activism. This is particularly true in Washington, a city in which the leaders of neighborhood organizations effectively took the place of locally elected officials for the one hundred years between 1874 and 1974 when the District was governed by three com-

missioners appointed by the president of the United States and where the U.S. Congress has had the final word. The first civic (a name chosen mostly by African Americans) and citizens (a name usually chosen by whites) associations began to appear in the new suburban developments after the Civil War, as residents realized they had to organize to demand the services they needed from public and private sources — such as street paving, fire protection, lighting, schools, libraries, and efficient streetcar service.

The Mount Pleasant and Brightwood chapters provide early examples. There were no elected officials to hold responsible for the delivery of city services, and contacts had to be made with the commissioners and sometimes directly with members of Congress someone happened to know. The neighborhood associations organized residents and lobbied those in power, and their presence in the public dialogue helped perpetuate the neighborhood names and identities they represented. In 1973, when the city won limited home rule with an elected mayor and council, an unusual system of elected advisory neighborhood commissions was included in the legislation, recognizing the century-old tradition of community advocacy. Since the late 1990s, Main Street programs involved in community revitalization and historic preservation along neighborhood commercial corridors and neighborhood Business Improvement Districts that promote safety and clean streets and sometimes provide social activities are keeping neighborhood names and unique identities alive.

In some cases, neighborhoods have provided the launching pads for citywide activism. Takoma Park and Brookland residents spearheaded the anti-freeway movement in the 1960s and won a powerful victory over the forces about to cut through these and other neighborhoods in the city with ribbons of multilane highways. (Highways did, however, change the face of the riverside neighborhoods of Southwest, Foggy Bottom, Georgetown, Kenilworth, and Barry Farm.) Latino immigrant residents of Adams Morgan and Mount Pleasant used meager resources to start an annual parade to call attention to their presence in the city and win city services.

The work that neighborhood residents have done to strengthen and maintain the qualities they value in their communities also reflects the importance these small places have in the minds of Washingtonians. While focusing on different themes, many of the writers in this book comment on the village or small-town quality of life in what they describe and the efforts of neighbors to maintain that ambience. Georgetown residents worked to preserve their historic buildings. Cleveland Park successfully fought intensive housing development on the historic estates that help define the community. In some cases the village quality is expressed in places people shared — U Street in Shaw, 4½ Street in Southwest, and the park surrounding the fountain in Dupont Circle. In other cases an individual represents the quality of life in the community that people value — Herbie Carter, the bus driver in Spring Valley, and Bernie Chapman, who drove the shuttle in Deanwood; Carlos Rosario, the political leader in Adams Morgan and Mount Pleasant; Page "Deacon" Maccubbin, the organizer and bookstore owner

so important to the gay community in Dupont Circle; and Florence Matthews, the recreation director and mentor for children in Barry Farm / Hillsdale.

The District's strong historic preservation program has been an asset for Washingtonians seeking to preserve the physical fabric of their neighborhoods — the buildings and familiar streetscapes that define their unique character and provide touchstones for memories commonly shared. Georgetown was one of the first neighborhoods in the nation to be granted official historic district status, in legislation passed by the U.S. Congress in 1950. The District of Columbia created a Joint Committee on Landmarks in the early 1960s, before the 1966 National Historic Preservation Act established the first nationwide program to identify

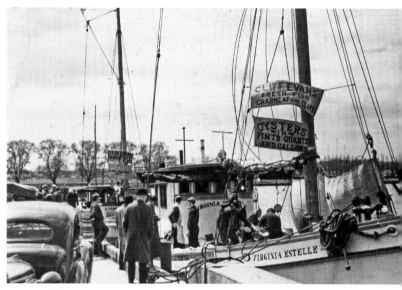

Fishermen, shoppers, and spectators congregate on a pier on the Southwest waterfront in 1937, an experience that continues to be uniquely associated with this riverside neighborhood. It is one of many distinct communities that exist side by side in the District of Columbia. Courtesy The Historical Society of Washington, D.C.

and protect the nation's historic resources and created the National Register of Historic Places. In 1978 citizen lobbying persuaded the D.C. Council to pass a comprehensive historic preservation ordinance that offers some of the strongest protection in the nation for valued cultural resources. In 1982 the Joint Committee on Landmarks was replaced by the Historic Preservation Review Board and the professional staff of the Historic Preservation Office of the D.C. Office of Planning. Many of the neighborhoods in this book have saved local landmarks through this program, and a majority are all or in part locally designated historic districts listed on the National Register of Historic Places. Information on historic district boundaries is available at the Historic Preservation Office.

As this book was being written, there was a swell of new interest in the kinds of places these historic districts preserve and in the character of daily life they provide. Appreciation for urban neighborhood living has reached flood tide in Washington and nationwide, fueled at least in part by suburban residents tired of long and stressful commutes and the blandness of highway-oriented landscapes. As the conclusions of a number of the chapters in this book suggest, the new value being put on Washington's urban communities is bringing new challenges along with its benefits. Prices rose dramatically in many neighborhoods around the turn of the twenty-first century. The nationwide economic crisis that began in earnest in 2008 slowed sales and lowered or steadied home values across the city. But even in these circumstances, buying a home in certain neighborhoods is out of reach for many. As values rise, owners of rental properties often evict tenants to cash out on their investments or dramatically increase rents. Homeowners who occupy their properties may be forced out by rising taxes. In some places, residents want suburban-sized mansions on small city lots, and the "teardowns" that result are changing the neighborhood ambience, for example in the Palisades, Wesley Heights,

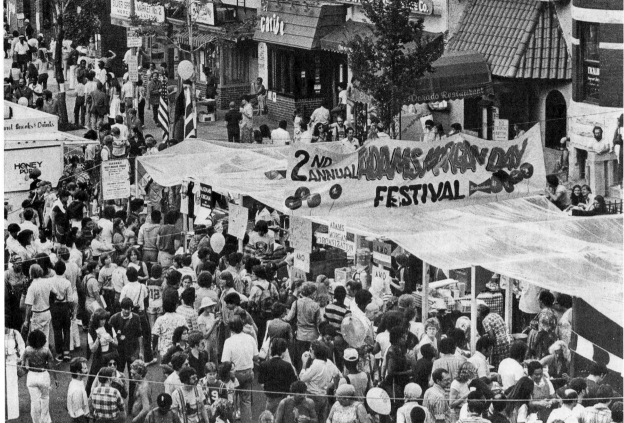

Crowds fill 18th Street, NW, for the second annual Adams Morgan Day festival in 1979. Among the many neighborhoods with strong identities in the nation's capital, Adams Morgan stood out at the time as the most racially and culturally diverse. Courtesy Star Collection, DC Public Library. © Washington Post

and Spring Valley. In other places, upscale businesses and chain stores, desired by many, threaten small businesses with long ties to the community. Newcomers, in some cases, unconsciously threaten to alter the very character that drew them in the first place. Dramatic change is in the air; in fact, cycles of change are the subtext of this book.

Amid the talk of the conveniences and cultural amenities that beckon newcomers to small places in the city, there is perhaps a new passion that is hard to quantify. Underneath the trend there seems to be a yearning for the sense of place and community that urban neighborhoods with unique character provide. Washingtonians are identifying with and advocating for their neighborhoods with renewed vigor, and they value and preserve their histories with increasing enthusiasm. The very controversies around the changes taking place in Washington's neighborhoods reflect the increasing importance being placed on them. For many, these urban villages are more than physical settings. They are communities where personal encounters enrich daily life. Here are the buildings, streets, shops, spiritual centers, and local gathering places that ground those human connections in a place that is comfortable because it is familiar. It belongs to us. It is a place where we can make a difference. As we increasingly live in a global community where most feel they can have little influence, places with meaning — with stories that become our own — are comforting, and beyond that, a human necessity.

Washington City & Georgetown

After intense congressional debate about the best location for a federal capital, one that would not give unfair advantage to any state, northern and southern members of Congress hammered out a compromise. In 1790 Congress agreed on a Potomac River location and in 1791 created the ten-mile-square District of Columbia, carving it out of the states of Virginia and Maryland. The site was geographically at the center of the new nation, which was then spread north to south along the Atlantic coast. It was also considered advantageous for trade with the trans-Appalachian West because the Potomac River and its tributaries reached far inland toward the Ohio River Valley.

President George Washington hired Peter Charles L'Enfant, as Pierre L'Enfant preferred to be called, to design a new Federal City within the District, called Washington City. Its boundaries were the Potomac River and its Eastern Branch (today the Anacostia River) on the southwest and southeast and Rock Creek on the west. The northern boundary followed the route of today's Florida Avenue and Benning Road. Two other towns already existed within the District—Georgetown and Alexandria—towns with roots in the tobacco trade, with their own local governments. The areas beyond the three towns were called Washington County and Alexandria County.

A tiny federal government, including 138 members of Congress in 1800, shared an undeveloped, semirural landscape with a population that grew to only seventy-five thousand by the time of the Civil War. While the expansive plan of L'Enfant existed on paper, it would be more than seventy years before its grandeur would become a reality on the ground. Uninterested in and even

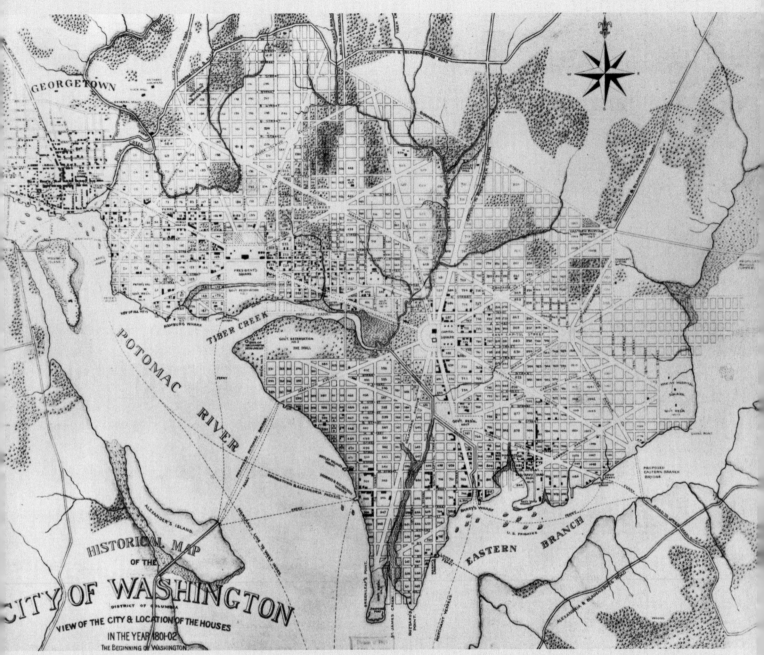

The first Washingtonians clustered in different parts of the open spaces in L'Enfant's grand plan for Washington City, creating separate communities within the city from the start. The tiny black squares on this map indicate the houses in the city in 1801, one year after Congress moved to the site. The most settled areas are between the President's House and the Capitol, today's downtown; just east of the Capitol and near the Navy Yard (the bay in the Eastern Branch of the Potomac, now called the Anacostia River), today's Capitol Hill; and west of the President's House, today's Foggy Bottom. Georgetown was an established community, already about fifty years old. The map was drawn by Artemus Harmon in 1931. Courtesy Library of Congress

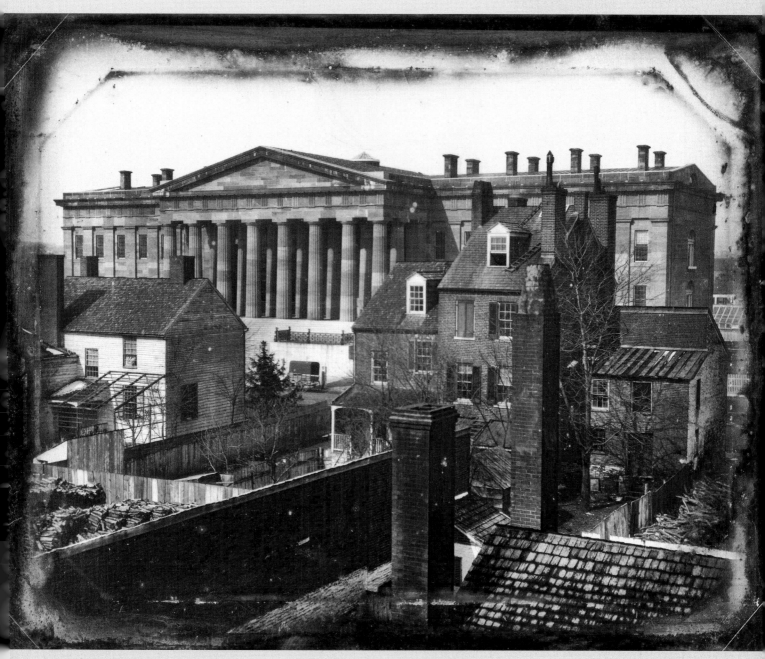

One of the earliest photographs of Washington, taken about 1846, provides a rare glimpse into the back yards of homes in the 700 block of F Street, NW. The Patent Office across the street was built between 1836 and 1840 and was an important source of federal employment in what is today's downtown. The building, later enlarged, is currently the home of the Smithsonian's National Portrait Gallery and American Art Museum. Courtesy Library of Congress

suspicious of a strong federal government, Congress invested little in physical improvements in the capital. Hopes that the city would become a center for commerce and trade with the frontier to the west were dashed when the Chesapeake and Ohio Canal, its avenue to the trade of the Ohio River Valley, didn't make it over the mountains and was soon superseded by the railroad out of Baltimore.

The new District of Columbia, situated on land taken from the two largest slave states in the Union, had a major black population, between one-quarter and one-third of the total throughout the antebellum period, a majority of whom had achieved freedom by 1830. Black Washingtonians created a uniquely strong and self-sufficient community of their own. At the same time, immigrants from England, Ireland, and Germany came to seek employment and new lives in the fledgling capital. Until 1871 Washington City had a locally elected mayor and city council, which struggled with a tiny tax base to maintain streets and care for the less fortunate.

Between 1800 and 1860, residents settled in clusters within the grand spaces of L'Enfant's Washington City, initiating distinct communities we know as neighborhoods today—among them Capitol Hill, Southwest, Foggy Bottom, and an area between the White House and the Capitol that would develop as a residential and commercial downtown. Others chose Georgetown just across Rock Creek from Washington City, its shops and social assemblies making it the most sophisticated place in the new District. Alexandria, isolated and suffering economically across the Potomac River, retroceded to Virginia in 1846. By 1860 the population still did not come close to occupying the boundaries of Washington City, and the rest of the District remained totally rural.

Georgetown

WASHINGTON'S OLDEST NEIGHBORHOOD

KATHRYN SCHNEIDER SMITH

In Georgetown, red-brick houses huddle along tree-shaded sidewalks. Visitors know they are entering a distinctive place from any approach. It is a scene known nationwide, for its old houses and charming streetscapes have been home to many of the nation's social and political elite, its historic physical fabric saved by one of the country's most publicized preservation efforts. Its character is so clearly defined in the public mind that its varied history — as a port, as an industrial center, and as a small town where black and white, rich and poor lived side by side — is seldom recognized.

Georgetown is Washington's oldest neighborhood, a once-independent town that predates the federal capital itself by more than fifty years. Until 1871 it had its own elected government and stood socially and economically apart from the rest of the District of Columbia. Even after its separate legal identity was officially ended by an act of Congress in 1895, Georgetown's mixture of grand and modest homes, housing all races and classes side by side, gave it the flavor of a Southern small town, a character that lasted well into the twentieth century. Its waterfront served shipping and then industrial purposes until the 1960s. Its large African American population, about one-third of the

total, made its own mark on the community's history until it began to decrease in the face of rising real estate values in the 1930s and 1940s. The neighborhood's leading role in the historic preservation movement in the 1950s and the arrival of such luminaries as John F. Kennedy about the same time brought the community national attention.

In some ways Georgetown is still thought of as a place apart. With clear boundaries on three sides — the Potomac River on the south, Rock Creek on the east, and Glover-Archbold Park on the west — it remains a distinctive destination, with lively streets lined with shops and restaurants that attract tourists and Washingtonians alike. For locals, it is a place that is truly their own, in a city where federal buildings and activities most often claim center stage.

This story begins in the middle of the eighteenth cen-

Georgetown's commonly accepted boundaries coincide with those of the Georgetown Historic District, designated by Congress in 1950. That area is shown here, with the addition of Georgetown University, Oak Hill Cemetery, and Montrose and Dumbarton Oaks parks, all thought of as part of the neighborhood. Map by Larry A. Bowring

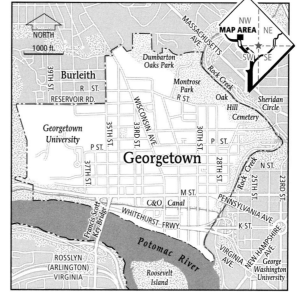

tury. Georgetown was one of a number of Maryland and Virginia tidewater towns created to provide inspection stations and shipment facilities for tobacco, the area's major cash crop. Long before, Native Americans had discovered it as a good place for trade. Situated just below the Little Falls and the Great Falls of the Potomac, Georgetown had the advantage of being at the head of navigation on the Potomac River — as far inland as one could go by water. Its location was crucial for the first European traders also. By 1740 tobacco merchants from Glasgow, Scotland, and Whitehaven in northwestern England had focused on the future site of Georgetown. When a 1745 Maryland law required the official inspection of tobacco, the warehouse of Scottish merchant George Gordon, southwest of the present-day intersection of Wisconsin Avenue and M Street, NW, was designated for that purpose. By 1751 a small cluster of buildings had sprung up around the warehouse, and a group of merchants decided to petition the Maryland General Assembly for permission to lay out a town. The sixty acres included in the original site were bounded approximately by the Potomac River on the south, today's N Street on the north, Jefferson Street on the east, and 34th Street on the west.[1]

While trade in wheat would shortly surpass tobacco as a commercial staple, it was the tobacco merchants who dominated Georgetown in the eighteenth century, fueling its economy, creating a social elite, and initially running the town with appointed commissioners. Robert Peter was among the most prominent, a Glasgow native who had come to America as a representative of John Glassford and Company, that town's biggest tobacco importer. In 1789, when the town was granted a charter by the Maryland legislature, Peter was elected the first mayor. His son would marry a step-granddaughter of George Washington and live in elegance at Tudor Place, 1644 31st Street, as would six generations of that family until the 1980s.[2]

Benjamin Stoddert also dominated the political and social scene from his Halcyon House at 3400 Prospect Street, one of the grand Georgian homes of the eighteenth century that still stand in that street's 3400 and 3500 blocks. From these houses he and others could watch the activity on the riverbanks. Although archaeologists have uncovered the remains of warehouses, wharves, and cobblestone paths to the river beneath today's landscape, the only buildings associated with the early shipping trade in Georgetown that remain are the warehouses and offices of Francis and A. H. Dodge at the foot of Wisconsin Avenue.[3]

Colonial leaders held high hopes for this area in the eighteenth century. The Potomac River reached farther west than any other river on the eastern seaboard; its headwaters were only about seventeen miles from tributaries to the Ohio River. A plan by the Ohio Company sponsored by George Mason as early as 1749 would have made the Georgetown site the entrepôt for trade with the entire trans-Appalachian West by improving navigation on the Potomac. Mason's plan was never carried out, but in 1785 the idea was revived by the Patowmack Company, with George Washington himself as president. Although the river improvements and short canals the company completed on

(opposite)
Traffic and pedestrians crowd the corner of Wisconsin Avenue and M Street at the heart of commercial Georgetown. The golden dome atop the bank and the Federal and Victorian-era buildings stretching up the avenue define a setting everywhere recognized as one of Washington's most distinctive neighborhoods. Photo by Rick Reinhard

the Virginia side of the river by 1802 were eventually abandoned, hopes remained that a way across the mountains to the Ohio River Valley could still be developed. It is thus not surprising that the area around Georgetown should have been considered a leading contender for the federal capital, a site that was intended to become a commercial as well as a political center. When Andrew Ellicott and Benjamin Banneker surveyed the site of the District of Columbia in 1791, Georgetown and its competitor in the tobacco and wheat trade across the Potomac, Alexandria, were enclosed within its boundaries.[4]

Washington City, the new town designed by Peter Charles L'Enfant, was in its infancy in 1800, its approximately three thousand residents scattered across a semirural landscape with few social or commercial amenities. Georgetown, also with about three thousand people, and Alexandria with about five thousand, were not much bigger but had the shops and societies of more settled communities. Alexandria, however, was inconvenient to residents of Washington, separated from Washington City by the Potomac River. It was Georgetown that provided the daily necessities for the new capital. Abigail Adams, for example, sent someone daily from the President's House to Georgetown to do the marketing. The highly regarded Dr. Stephen Bloomer Balch of Georgetown welcomed people of all denominations from Washington City and Georgetown to his Bridge Street Presbyterian Church (long since demolished). Georgetown College, founded in 1789 as the nation's first Catholic institution of higher education, was the new capital's only center of intellectual life and the anchor for an important Catholic community.

Initially Georgetown benefited from its new status; the population jumped to more than eight thousand by 1830. It had already begun to suffer from competition with Washington City, however, as well as with Alexandria. Washington City was growing faster, up to more than eighteen thousand in 1830. The construction of the Long Bridge from Virginia into the Federal City in 1809, located where the 14th Street Bridge is today, had been hotly contested by Georgetowners who favored a bridge at the Three Sisters site just above their town. As predicted, the Long Bridge carried most Virginia business to Washington City rather than to Georgetown, and its low construction caused silt from upstream to fill in the shipping channel to Georgetown, a problem that would persist throughout the century.[5]

Concurrently the tobacco trade sputtered and died. Soil exhaustion, damage to crops in the War of 1812, and navigation problems all contributed to its demise. The trade had peaked in 1792 and 1793 but was effectively finished with the death of the last of the large merchants, John Laird, in 1833. Though coastal shipping of wheat and other commodities continued, by the 1820s most of the international trade had been lost to Alexandria, with its more favorable position below the Long Bridge. Between 1830 and 1840 Georgetown's population dropped to about seven thousand, and the town submitted a petition for retrocession to Maryland, hoping affiliation with that state would help its economic position.[6]

The local economy was saved, however, by a revival of the old dream of an improved waterway to the West. In 1828 the Chesapeake and Ohio Canal Company took over the nearly bankrupt Patowmack Company with the goal of building a single canal parallel to the river on the Maryland side all the way to the Ohio River Valley. Unlike the Patowmack Company's improvements, which allowed boats to move between the river and the canal, the C&O would offer a single canal where mule-drawn barges would never touch the river. On July 4, 1828, the first spade of dirt for the C&O Canal was turned by President John Quincy Adams, with Georgetown as its terminus. Unfortunately that very same day Baltimore drove the first spike for its Baltimore and Ohio Railroad. The railroad was the technology of the future, and Baltimore would capture the regional trade with the trans-Appalachian West, effectively ending hopes that the capital would be a center of commerce as well as a center of government. The C&O Canal would never make it over the mountains, reaching its western terminus in Cumberland, Maryland, in 1850 for lack of funds to continue. The canal would nevertheless make Georgetown a local and regional transshipment center for wheat, coal, lumber, and other commodities as cargo brought down the canal was loaded onto sailing ships for the Atlantic coastal trade. By the 1850s coal dominated the trade; wooden trestles were constructed at the west end of the waterfront to carry the cargo from canal boat to sailing ship. The Pickrell, Libbey, and Wheatley families all developed significant lumber businesses on the riverbanks to the east. The water power created by the approximately thirty-foot drop from canal to river combined with the influx of wheat to bolster the milling industry. By 1860 Georgetown counted twenty-two flour dealers and seven millers.[7]

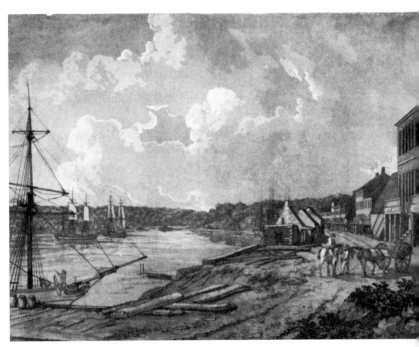

The approximate equivalent of K Street today, this riverside road carried the business of the port of Georgetown in 1800, just as the federal capital moved to its new location across Rock Creek. Courtesy Library of Congress

Until 1871 Georgetown existed for the most part politically and economically independent of the District of Columbia, of which it was a physical component. The town elected its own mayor and council. Unlike the new and more transient residents of Washington City, Georgetowners could claim some old families and social traditions that dated back to the eighteenth century. The fashionable Georgetown Assembly, founded about 1810, regularly attracted the cream of society to dances in the Pompean Hall of the Union Hotel, while the old families occasionally welcomed congressmen and other officials to their homes. In 1848 prominent local businessman and philanthropist William Wilson Corcoran donated land on the hillside above Rock Creek north of town for Oak Hill Cemetery, one of the nation's first burial grounds laid out in the fashionable picturesque style. It served as a public park as well as a burial place. On Bridge (now

M) Street residents could do their banking; have their shoes made and fixed; shop for food and clothing, harnesses, and feed; and hoist a pint. There were more than eighty such businesses listed in the 1850 census.[8]

This tidewater town was Southern in its population and social patterns. In 1810, the first year for which figures by race are available for Georgetown, 35 percent of the population was African American, with about two-thirds held in slavery. By 1860 the percentage of African Americans had dropped to 22, and only about one-third were in bondage. Many of Georgetown's enslaved people served in the town homes of Chesapeake area planters, who moved them between town and country as the seasons changed. Some slave owners manumitted those they held in bondage before the Civil War, for reasons that probably included the fact that slaveholding was not as advantageous in an urban setting. Some of those enslaved also were able to purchase their own freedom and that of their relatives by working for wages on the side or by raising and selling produce. Members of the free black community found Georgetown hospitable, with its opportunities for domestic service and manufacturing work. Despite legal and social restrictions, some managed to move from service and labor to craft, commercial, and professional occupations and to property ownership. One of the most successful was Alfred Lee, a feed dealer at 29th and M streets, who left his two sons a fortune in real estate on his death in 1868.[9]

The black community formed its own strong institutions, such as Mt. Zion United Methodist Church at 1334 29th Street. Founded in 1816, it is the oldest black congregation in the District. Its church register notations suggest the trials of the community: "sold off . . . lost . . . taken away . . . escaped." Mount Zion was most likely a stop on the Underground Railroad as well as an education center in the years before Congress first funded black public education in 1862. The black population, enslaved and free, was interspersed residentially with the white population before the Civil War in a pattern typical of Southern towns. In the late nineteenth century many African Americans would settle in larger enclaves centered on 28th and P streets, an area that came to be called Herring Hill, and on the other side of Wisconsin Avenue west of 33rd Street. As the Georgetown waterfront became more industrial, a working-class community developed south of M Street that became largely black by 1910.[10]

The coming of the Civil War brought severe strains to Georgetown, as it did to the entire District of Columbia. Military activities disrupted shipping on the Potomac, and Confederate guerrillas vandalized the Maryland and northern Virginia stretches of the canal. Miss Lydia English's Georgetown Female Seminary, Georgetown College, the Union Hotel, and three Georgetown churches were commandeered for hospital space. The largely Southern population of the town engendered sharply divided loyalties, and in some cases families were torn by the war. The son of William A. Gordon, the chief clerk of the U.S. Quartermaster Corps, for example, fought in the Confederate army.[11]

The end of Georgetown's governmental autonomy had roots in the Civil War. It soon became clear after the war that the three governments in the District of Colum-

bia — Georgetown, Washington City, and Washington County — could not deal efficiently or effectively with the vast social and physical problems of the postwar capital. In 1871 Congress created one territorial government for the District of Columbia, ending the separate town governments of Georgetown and Washington City. Although the idea at first met with vociferous objections from Georgetowners who valued their independence, the actual transition took place with surprisingly little turmoil. While the territorial form of government lasted only until 1874, it was succeeded by a single District government run by three presidentially appointed commissioners. Georgetown never regained its separate political identity, although its independent status was not officially ended until an act titled Changing the Name of Georgetown passed Congress in 1895.[12]

The loss of its own government notwithstanding, Georgetown continued for approximately the next two decades to cling to its own social identity and customs and to maintain its own local economy. The town had a rich social life, regularly reported in the *Evening Star,* which ran the town's news under the name "Affairs in West Washington" in the 1880s but later beat a retreat and restored the older "Affairs in Georgetown" heading. Neighborhood residents joined clubs and societies devoted to literary pursuits, music, sports, civic betterment, bicycling, and any other interest one might pursue. The dances of the Georgetown Assembly and the Ladies German Club entertained the cream of society; five dancing academies were open to those of lesser social prominence. An array of Masonic orders attracted as many as two hundred people to regular events. There were excursions and picnics up and down the river, sporting events on Analostan (now Roosevelt) Island, and rowing competitions out of the waterfront boat clubs.[13]

The C&O Canal had its most successful years in the 1870s. About five hundred canal boats pulled by mules brought coal, limestone, flour, and other raw materials to the many waterfront industries in Georgetown. The cluster of mills, cooperages, iron foundries, lime kilns, fertilizer manufacturers, carriage builders, and blacksmiths made the Georgetown waterfront one of the District's few centers of manufacturing. A Northeast coast trade in coal and ice beginning in the 1880s added new business to the waterfront. Sailing schooners brought ice from Maine rivers and returned with Cumberland, Maryland, coal that had traveled down the canal.[14]

Meanwhile the number and variety of businesses along M Street grew. Many were run by European immigrants such as the Nordlinger brothers, Wolf and Isaac, who owned clothing and shoe stores across the street from each other in the 3100 block of M Street amid a cluster of other Jewish merchants from Germany and France. Irish families ran saloons and grocery stores. In 1888 the Aqueduct Bridge, a privately owned toll bridge that had carried both canal boats and carriage traffic across the Potomac near the site of today's Key Bridge since the 1830s, reopened as a public thoroughfare. Led by M Street businessmen, Georgetown celebrated the end of the tolls that had hindered trade with Virginia with a massive parade featuring displays of fifty-eight trades on four hundred wagons pulled by eight hundred horses.[15]

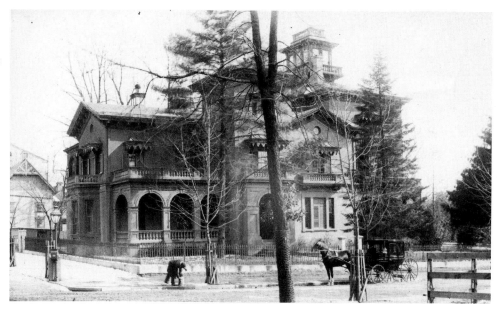

This fanciful Italianate house, designed in 1850 by Andrew Jackson Downing and Calvert Vaux, reflects the affluence of its first owner, successful Georgetown merchant Francis Dodge. It still stands at 30th and Q streets. Courtesy The Historical Society of Washington, D.C.

The prosperity of the old town was reflected in the number of new houses erected late in the century — as many as four hundred in the last decade — adding a fine array of Victorian structures to the Federal, Greek Revival, and modest vernacular homes of the earlier period, particularly north of P Street. The opening of the Curtis Public School on O Street between Wisconsin Avenue and 33rd Street in 1876 was a matter of great community pride; it also housed the town's first library, a gift of George Peabody, and the Linthicum Institute for the schooling of young workers.[16]

It was the 1890s that saw Georgetown begin to shift in character from a small town to an urban neighborhood. Its local economy, based on the transshipment of goods by canal boat and sailing ship and on the products of mills powered largely by waterwheels, had become outmoded in an age of railroads and steam. Many attempts by town leaders to get a rail line to the waterfront had been frustrated by Congress and the District commissioners who seemed to discourage improvements that would help Georgetown compete with Washington City. The dredging of the Washington Channel in Southwest Washington in the 1880s further hindered Georgetown's competitiveness. The project created a protected harbor behind Hains Point. The Georgetown harbor, more exposed to damaging floods and ice floes, was now clearly inferior.[17]

When Georgetown was hit with a massive flood in 1889, the vulnerability of its outdated economy became clear. The raging waters smashed boats and broke through the walls of the C&O Canal, putting hundreds of canal boatmen and waterfront craftsmen and laborers out of work. The canal company went bankrupt, and control of the canal passed to none other than its major rival, the Baltimore and Ohio Railroad, which had little interest in seeing the canal reopened with dispatch. It was two years before the canal was fully operational again, and it never returned to profitable operations. Some

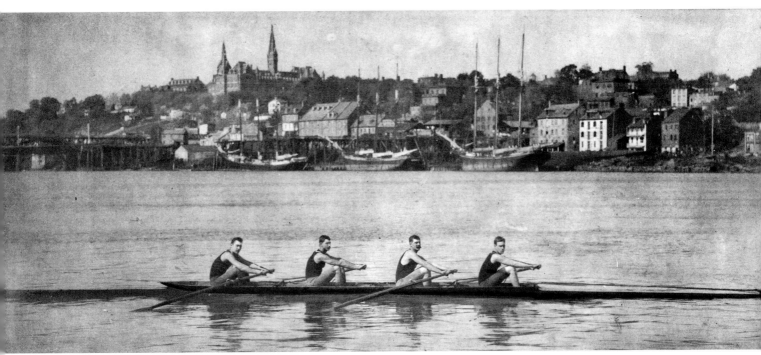

The three-masted schooners that carried ice and coal between Maine and Georgetown line up at the wharves along K Street in the background as these scullers enjoy a row, about 1886. Courtesy Historical Society of Washington, D.C.

businesses such as the Borden Coal Company closed immediately after the flood. Several flour mills changed hands and then closed one by one. By 1913 only one flour mill and one paper mill remained.

After these changes to its economy, the Georgetown waterfront played a very different role in the city. This shift was part of a larger pattern that emerged as the city grew to fill the District of Columbia boundaries; different sections came to serve different urban functions. The center of old Washington City became the commercial downtown; the new suburban developments along the streetcar lines became the most desirable residential areas; the Southwest harbor became the District's major port; and the railroad yards in Northeast Washington emerged as the transportation hub for coal, lumber, produce, and other commodities once partially handled by Georgetown. By default, the waterfront of politically powerless Georgetown was given over to some of the city's least desirable functions: power production, meat rendering, cement mixing, and the storage of stone and other construction materials. A spur of the B&O Railroad finally came to K Street in 1911 to bring coal to the Capital Traction power plant at the foot of Wisconsin Avenue, but it was too little and too late to save the old town's role as transportation center. Smokestacks had replaced ship's masts on the skyline. In 1920 the city's first zoning ordinance labeled the Georgetown waterfront "industrial."

At the same time, the old houses of Georgetown, the most modest of which had no indoor plumbing or central heating, came to be considered out of style and uncomfortable, the neighborhood dowdy and unfashionable, a backwater in the suburban-style

growth all around it. Georgetown was the hub of a network of electric streetcars, with four lines running out of town in all directions in the 1890s. Many Georgetowners went looking for more modern living arrangements in the suburbs of Virginia across the Aqueduct Bridge and elsewhere in the District of Columbia. M Street, like the waterfront, began to serve more citywide and regional functions. The streetcar lines made it accessible as a regional marketplace for residents of rural and suburban areas of Maryland, Virginia, and the District who did not yet have local services. Spurred by the arrival of the automobile in the first decade of the twentieth century, some new suburbs developed their own shopping streets, but through the 1920s, workaday Washingtonians and residents of Ballston, Cherrydale, Clarendon, Falls Church, Rosslyn, and Vienna in Virginia came to Georgetown to shop.

Those who lived in Georgetown in the 1920s and 1930s remembered it as unfashionable but appealing, with a mixture of people, nearby shops and services, and an intimate style. A number of prominent old families remained, often in the near-mansions up on the heights, farthest from the waterfront. While suburban growth and new transportation patterns were encouraging the segregation of people by race and by class elsewhere in the city, Georgetown retained the mixed character of Southern towns. The grand houses of the wealthy and elite often stood side by side with the row houses of the middle class and the little wooden houses of the poor, occupied by both races. Black and white were physical neighbors, but their relationships were proscribed by social conventions. The black population did not increase, remaining between 20 and 30 percent as it had since 1830. However, the mixed nature of the population, both racial and economic, must have added to the sense that the place was out of date, as the separation of white from black, middle class from poor, and residential from commercial was becoming the modern ideal.[18]

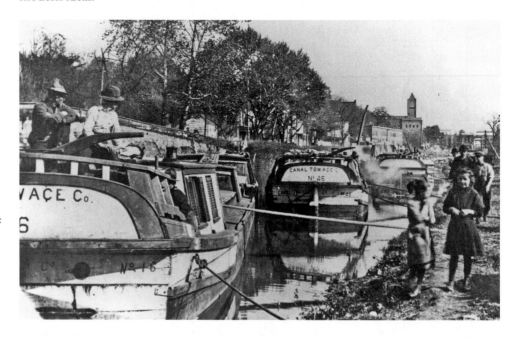

Canal boats wait to enter Georgetown with their cargo about 1910, with the tower of the Capital Traction streetcar company at 36th Street in the distance. Though traffic was much less than in the canal's heyday in the 1870s, boats continued to operate on the waterway until 1924. Courtesy The Historical Society of Washington, D.C.

But it was not long before newcomers to Washington rediscovered the charm of Georgetown's buildings and small-town character, not to mention its close-in location. The roots of the preservation movement in Georgetown go back as far as the early 1920s with the restoration of two mansions on the Georgetown heights: Dumbarton Oaks by Robert Woods Bliss, and Evermay by Ferdinand Lammot Belin. In that same decade a group of homeowners, concerned about apartment and possible high-rise development near the new Q Street Bridge linking Georgetown to Dupont Circle, took the first citizen action to protect the town's ambience. The move was led by Bernard Wyckoff and John Ihlder, new residents and employees of the national Chamber of Commerce who were familiar with the new tool of zoning. It took only a month for a small group of new residents — and the old families they organized — to push through a zoning amendment prohibiting construction over forty feet high in Georgetown. Ihlder would later head the city's low-income housing efforts as director of the Alley Dwelling Authority.[19]

It was the New Deal, however, that spurred interest in the historic character of the old town. Highly educated, idealistic newcomers, attracted by Georgetown's low prices and charm and consciously unconcerned about its social status, bought houses there in the 1930s. Two key members of President Franklin D. Roosevelt's brain trust, Benjamin Cohen and Thomas Corcoran, lived at 3238 R Street, where they and their colleagues met to fashion the social legislation that would revolutionize the federal government's role in American life. Among the newcomers were middle-level government employees as well as the socially elite; 117 Georgetown residents made the social register in 1919; by 1932 the number had risen to 688.

By the late 1930s an organized approach to the preservation of the area's historic character began to take shape. Led by the Progressive Citizens' Association, an organization founded by women in 1926 and led by Etta Taggart and others, the Georgetown community began to look for legal methods to protect the neighborhood's historic architecture. The Second World War interrupted the movement, but in 1948 Eva Hinton and Harriet Hubbard spearheaded a successful rezoning that promoted residential uses in Georgetown. In 1949 Dorothea De Schweinitz led citizen efforts to make Georgetown a historic district; a year later the Old Georgetown Act was passed by Congress. The law required that all exterior changes, demolitions, and new construction be reviewed by a panel of architects, known as the Old Georgetown Board, to be selected by the U.S. Commission of Fine Arts. The historic district would be listed on the National Register of Historic Places in 1967. As one of the first officially designated historic districts in the nation, it became an icon of the growing historic preservation movement across the country and remains today as a remarkable example of the preservation of an entire nineteenth-century town. Leaders in society and politics would be increasingly drawn to its historic streetscapes, including John F. Kennedy, who left his home at 3307 N Street to be inaugurated as U.S. president in 1961.[20]

At the time of the passage of the Old Georgetown Act, and as the neighborhood's prestige began to grow, the community remained a mix of black and white, rich and

poor, with a waterfront still dominated by semi-industrial uses. Many of the humblest houses still did not have the most basic modern conveniences; according to the 1950 census, 14 percent of the dwellings in Georgetown did not have indoor bathrooms and 8 percent had no running water. One resident, Bobbie Leigus Habercom, remembered that during her childhood in a rented home in the early 1950s at Wisconsin Avenue and Q Street, the family lived mostly in the kitchen, warmed by a coal stove and lit by a kerosene lamp.[21]

As the neighborhood's desirability grew and home prices and rents rose, the African American community was hurt most dramatically. While some black homeowners benefited from the rise in values, others could not afford the taxes, and renters could not afford the rents. The Georgetown Act put further pressure on those with few means, with accompanying zoning restrictions outlawing boarding houses. The black population of Georgetown, which had been about 30 percent in 1930, dropped to 9 percent in the 1960 census, with the most dramatic decreases beginning in the 1940s. The African American churches that remain on the east end of Georgetown in the vicinity of P Street, to which parishioners return on Sundays, are among many reminders of the rich black community life in Georgetown.[22]

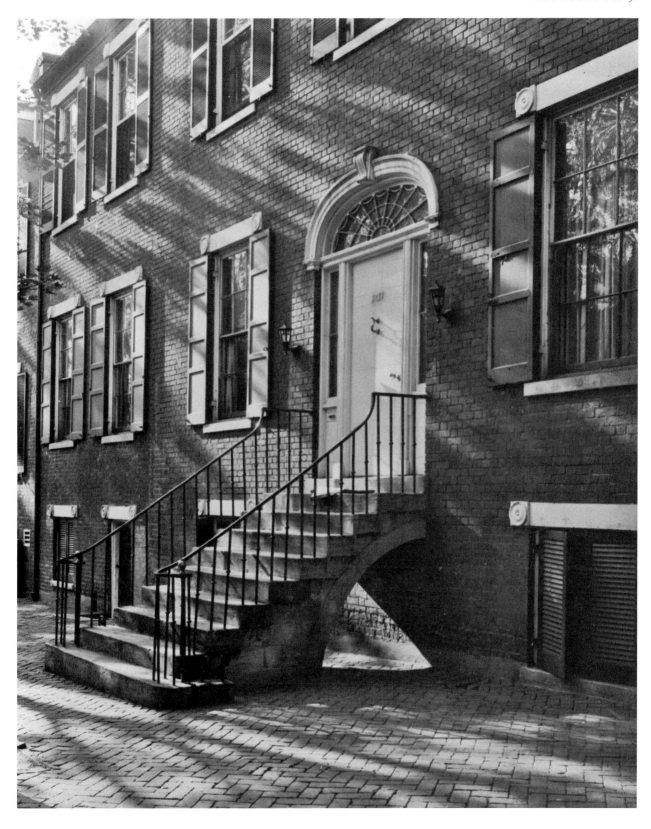

While the Old Georgetown Act preserved the physical character of the town above M Street, protracted citizen battles over the future of the waterfront to the south ended with a court decision in 1977 that allowed the city to rezone the area for high-rise, mixed commercial and residential buildings on the streets leading to the riverbank. The character of the riverfront had already been invaded in 1949 by the construction of the elevated Whitehurst Freeway over K Street, its bulk slicing through the waterfront and cutting off views of the river from the streets above. After the late 1970s, modern construction came to dominate the waterfront. Some industrial buildings, including a former paper mill, flour mill, and city incinerator, were adapted for new uses, but only pockets of the waterfront's nineteenth-century ambience remain along Jefferson Street and the adjacent C&O Canal and on the grounds of the 1867 Grace Episcopal Church.[23]

Meanwhile, on Wisconsin Avenue and M Street, the commercial scene changed as well. Beginning in the 1950s, old family businesses, some having operated for two and three generations, began to be replaced with antique shops and clothing boutiques as new, more affluent people moved in. Students at Georgetown University, on the western edge of the neighborhood, were an increasing presence, some renting houses near the campus. The neighborhood also became a magnet for the hippies of the 1960s and 1970s, as well as young professionals attracted by the community's history and charm. As the young, single population of Georgetown increased, so did the number of restaurants, bars, and trendy shops. A vibrant street scene reminiscent of New York's Greenwich Village developed as shoppers mixed with Georgetown University students, vendors, crew-cut young military men serving at Fort Myer across the Potomac, street musicians on M Street and Wisconsin Avenue, and those just passing the time. By the 1980s Georgetown had become a social center, especially for the young of the city and the region. Suburban-style chain retailers took up positions along Wisconsin Avenue and M Street. Some boutiques remained, while others went underground inside the Georgetown Park shopping mall, an adaptation of a group of early nineteenth-century buildings on the southeast corner of Wisconsin and M. The last vestiges of the industrial waterfront disappeared in 1985 as the postmodern, mixed-use Washington Harbour replaced a cement factory with upscale condominiums, offices, restaurants, and a riverside boardwalk.

These buildings at 30th and M streets were saved by Historic Georgetown, Inc., a citizen group formed for this purpose in 1952, just after the passage of the Old Georgetown Act. Built between 1810 and 1812, they were threatened with demolition for a parking lot. Photograph by William Barrett. Courtesy the Kiplinger Washington Collection

The sun bathes the small shops along M Street in late afternoon light in this 1948 view looking west toward Key Bridge. In the 1950s and 1960s this small town, main street scene began to change as family businesses gave way to trendy shops and restaurants. *Courtesy National Archives*

Georgetown's popularity as a shopping and entertainment mecca brought traffic problems. Some blamed the congestion on Georgetown's lack of a subway stop. While many continue to believe this omission was the result of active community opposition, and there was some, the Washington Area Metropolitan Transit Authority never proposed a stop at this location. Georgetown did not have the commuter traffic that the subway was first and foremost designed to serve. Furthermore, the engineering of a stop so close to the river would have necessitated a new bridge over the river and tunneling under private property. While some Georgetown residents were opposed, as were residents in other neighborhoods scheduled for a station, a stop in Georgetown was never on the drawing board in the 1970s.[24]

Sunday school teacher Ann Ricks Underwood presides over a class at Mt. Zion United Methodist Church at 29th and O streets in Georgetown about 1960. Once part of a strong black community in Georgetown, its members have now moved away, but they return to Georgetown from around the region for services and activities. Courtesy Mount Zion United Methodist Church Archives

Georgetowners have been known, however, for strong opinions, and civic activism continues in many forms. A decades-long push led by local residents for a park along the Potomac River finally met success in 2006 with the first phase of a landscaped green space planned to stretch from Washington Harbour to the Key Bridge. Managed by the National Park Service, the park features a dramatic set of steps to the river where increasingly popular sculling races end. Young families, though in the minority, became more involved in supporting local schools and improving local parks. The Georgetown Business Improvement District, formed by business and property owners in the 1990s, enlivened commercial streetscapes along M Street and Wisconsin Avenue. The Georgetown Citizens Association, founded in 1878, continued to work to maintain the historic character and quality of life in the neighborhood. Traffic congestion and lack of adequate parking along the narrow streets continued to be issues for the both the residential and business communities, sometimes creating tensions between them. The 2000 U.S. Census revealed a community still predominantly white, but that, according to its categories, was about 5 percent African American, 4 percent Asian, and 4 percent Latino east of Wisconsin Avenue. Statistics were the same west of Wisconsin Avenue, however, the African American population there stood at a little more than 1 percent.[25]

Despite the characteristics that set Georgetown apart, it retains a quality that is uniquely identified with local Washington. It is a special place for shopping or a night

out and for celebrations of local triumphs, such as the success of Georgetown University's winning basketball team, the Hoyas. Its uninterrupted nineteenth-century streetscapes take one back to a time before the federal presence claimed center stage in much of the central city. For many visitors to Washington, it is the one easily recognizable neighborhood in the federal capital. For Washingtonians, it is a place that is truly local, truly their own.

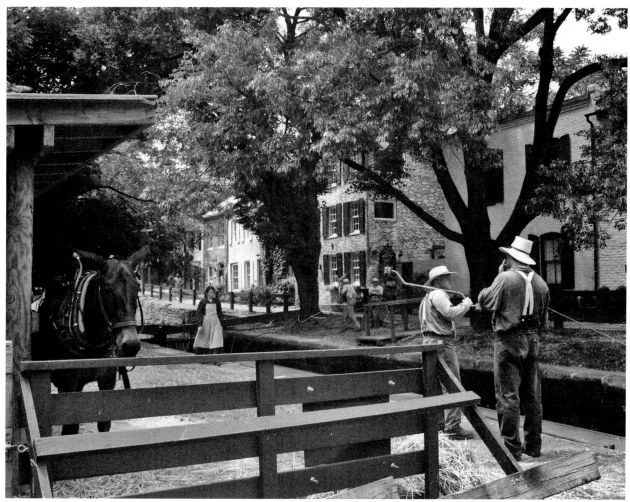

National Park Service guides in nineteenth-century costume wait while a canal boat designed for tourists makes its way (unseen below) through the lock at Thomas Jefferson Street. The mule has been released from its pulling duties along the towpath. The Federal-style brick buildings along the canal preserve some of the ambience of pre–Civil War Georgetown. Photo by Kathryn S. Smith

Capitol Hill

THE CAPITOL IS JUST UP THE STREET

RUTH ANN OVERBECK AND NANCY METZGER

The Capitol Hill neighborhood has expanded from its earliest settlements around the Navy Yard and the Capitol to an area that in the minds of many stretches from the seat of Congress to the Anacostia River. Residents identify with a number of smaller communities within it, including Stanton Park, North Lincoln Park, Hill East, Rosedale, Kingman Park, and Barney Circle. A major portion of the neighborhood has been designated as the Capitol Hill Historic District, the largest such designation in Washington. Map by Larry A. Bowring

Capitol Hill. The very words conjure up a lofty seat of government. In Washington, D.C., however, the words mean not only the heights crowned by the nation's legislature but also the adjoining neighborhood that occupies the broad expanse east of the halls of Congress. Two hundred years ago, some Capitol Hill residents helped build the Capitol while others built the foundations of the nation's laws and institutions. Those early nineteenth-century residents also started schools, a lending library, a volunteer fire company, and lobbied for a market near the Navy Yard. Current residents continue in the same spirit of civic activism, assisting the public schools, establishing sports leagues, mentoring youth, and many other activities created by a dense network of local organizations unmatched in any part of the city.[1]

Today's backdrop for mingling is Eastern Market at 7th and C streets, SE, the city's last operating nineteenth-century food market. Recently restored and reopened after a fire destroyed the roof and gutted the interior in April 2007, its merchants are surrounded on the weekends by farm trucks, a huge flea market, and sellers of crafts, art, and antiques that draw a diverse collection of customers from across the city. Residents meet to shop for staples on weekdays, having developed personal relationships with the vendors in the mostly family-owned stalls. Eastern Market has been the hub of the neighborhood since 1872 but never more so than at the present time.

Some say the Hill's boundaries have always included only the three or four blocks nearest the Capitol where the earliest residents clustered. However, the little village that started near the Navy Yard (established 1799) was, from the beginning, known as Navy Yard Hill. These two villages grew until they met and became one. Even today the boundaries of the Capitol Hill neighborhood keep stretching from those two historic points. Although the historic district added to the National Register of Historic Places in 1976 is recognized as the heart of the neighborhood, areas to the north, south, and east are also commonly referred to as Capitol Hill. For the purposes of this chapter, the neigh-

Eighth Street, SE, just south of Pennsylvania Avenue, draws pedestrians and alfresco diners on a Friday evening in July. An active Main Street program christened the street Barracks Row, in honor of the Marine Barracks located there, and brought new shops and restaurants as well as streetscape improvements to the area. Photo by Rick Reinhard

borhood extends from a southern boundary at the Navy Yard and M Street, SE, and follows the arc of the Anacostia River to the east to a northern boundary at H Street, NE. The Capitol and its related buildings form the western boundary. Included in this area are the smaller neighborhoods of Stanton Park, North Lincoln Park, Capitol Hill East, Rosedale, Barney Circle, and Kingman Park.[2]

The area was farmland when it was selected as the location of the Capitol in 1791. Descendants of the Rozier-Young-Carroll family, a prosperous Maryland clan whose original land grant came from Lord Baltimore, had farmed much of the land using slave labor. Daniel Carroll "of Duddington," as he was known to distinguish him from his cousin Daniel Carroll of Rock Creek, stood to profit most from the arrival of the federal government. The first federal city designer, Peter Charles L'Enfant, noting a sharp rise on Carroll's land, called it "a pedestal awaiting a monument" and reserved it for the Capitol. His plan faced the Capitol eastward, toward the pedestal's broad top. Consequently land speculators such as George Walker, a Scottish merchant who lived in Philadelphia, and Thomas Law, an aristocratic Englishman who married George Washington's step-granddaughter, Eliza Parke Custis, assumed that much of the city's development would occur on the hilltop and to the east, and invested accordingly.[3]

As it turned out, the Capitol was slow to rise, and the community around it lagged as well, while settlement gravitated westward toward the President's House and Georgetown. Little money was available for building, and too few skilled craftsmen and laborers to build the Capitol, much less a whole city. At the Capitol, native and foreign-born whites and free and enslaved blacks worked side by side. Some of these builders, with or without their families, joined the old rural population to constitute the Hill's first community. Most lived within walking distance of their work; some lived right on

the Capitol grounds in wooden barracks. The houses of master craftsmen, supervisors, and surveyors usually were more solid, most often two-story frame buildings with steep gable roofs. Whether frame or brick, the houses looked very similar, with multipaned windows flanked by shutters, rectangular paneled wooden doors, and shingled roofs. A few houses from this period can still be found; the earliest ones, built in 1802, are at 423 and 421½ 6th Street, SE. (A porch and tower were added to no. 423 in 1899.)[4]

Scattered across the Hill were some large, grand houses set on extensive grounds. At 2nd Street and Maryland Avenue, NE, Robert Sewall built a substantial brick house that he leased to Albert Gallatin, secretary of the treasury under presidents Jefferson and Madison. It was from this house that Gallatin worked with Jefferson on the Lewis and Clark expedition and drafted the Louisiana Purchase. Daniel Carroll built Duddington, a Georgian style brick mansion, in the square at 2nd and F streets, SE. His first attempt at building a house was reduced to a pile of bricks after L'Enfant discovered that it projected onto the street line of the proposed New Jersey Avenue. The relocated Duddington stood within that same square until 1886, when — over protests from the community — it was torn down to construct housing for Navy Yard workers. Carroll's home became a gathering place for a fledgling Washington society, as did the Maples, the nearby home of William Mayne Duncanson, which still stands, much altered, at 619 D Street, SE. Duncanson, an Englishman who had amassed a fortune in the East India trade, dressed his servants in full livery and had a wine cellar that reputedly rivaled that of his friend Thomas Jefferson. By 1800, however, Duncanson's ill-fated real estate investments led to bankruptcy.[5]

A little farther to the southeast, Capitol Hill had gained a second nucleus: the Navy Yard. George Washington in 1792 had personally approved its site on the west bank of the Eastern Branch (today's Anacostia River), almost two miles above the river's confluence with the Potomac, and it was reaffirmed by President John Adams in 1798. Sheltered from the view of ships coming up the Potomac, the site was presumed to provide U.S. warships the element of surprise necessary to defend the Federal City against invasion by sea. The yard's other purpose was to build those warships, and it quickly earned the reputation as one of the town's most reliable employers. Because it hired whoever had the needed skills, many free black and European immigrant craftsmen and laborers achieved financial independence working there. The yard also hired enslaved African Americans, allowed by their owners to work and usually expected to pay them a percentage of their earnings.[6]

The original owner of the Navy Yard site was William Prout, an Englishman who immigrated to America in 1790 in search of business opportunities and who expected to make a fortune on his investment in the newly established Washington. He didn't, but he proved to be an indefatigable community builder and managed to stay solvent by starting a series of modest income-producing ventures. He helped establish an early tavern, set up a fishery and a dry goods store, sold hay and bricks, and petitioned for and helped build the Eastern Branch market near the Navy Yard. He was a charter member

of the Anacostia Bridge Company that built a span across the Eastern Branch in 1819 at the site of today's 11th Street Bridge. In 1806 Prout gave land at 620 G Street, SE, for Christ Episcopal Church, the oldest church building in the original L'Enfant-planned city, which still is an active congregation. A few years later the city's first Methodist congregation built its church on Prout land at 514 4th Street, SE. (Mount Joy Baptist Church stands on this site today.) While Prout sold relatively few lots, he did generate income by renting them. In 1804 he leased a lot with an option to buy to Moses Liverpool, a newly emancipated cooper and carpenter. In 1806 Liverpool purchased the lot, becoming one of the earliest African Americans to acquire real estate in the Federal City. A year later Liverpool and two other freedmen, George Bell and Nicholas Franklin, opened a school for black children, and the area around 4th and D streets became a center of African American life in Southeast Washington.[7]

When the federal government moved to the District of Columbia in 1800, only the north wing of the Capitol was finished. Nonetheless a Connecticut congressman described it as a "shining object" in contrast to its surroundings. Vice President Thomas Jefferson and the 138 congressmen took rooms at the few boardinghouses and taverns scattered in the blocks nearest the Capitol. The following year President-elect Jefferson sited the U.S. Marine Barracks on 8th Street near the Navy Yard and then added to the Hill's ethnic diversity by sending to Italy for musicians to be members of the U.S. Marine Band. By 1810 gable-roofed houses, shops, smithies, a farmer's market, the Masons' Naval Lodge, churches, and schools were flourishing on the Hill. They dotted a swath of development that swept generally southeast from the Capitol to the Navy Yard and Marine Barracks. The heaviest concentration of buildings surrounded the Navy Yard because of its year-round employment opportunities. Congress's cyclical sitting, after fall harvest and before spring planting, punctuated time for the Hill.[8]

In August 1814, near the end of the War of 1812, the British army almost ended those cycles. When troops surprised Washington with an invasion by land instead of by sea, British soldiers neatly defeated the American forces at nearby Bladensburg, Maryland, and then marched in triumph onto Capitol Hill. Legend has it that the only shots fired in defense of the Hill came from the Sewall house at 2nd Street and Maryland Avenue, NE, where an American sniper shot the British general's horse as he led the column toward the Capitol. Quick retaliation by British troops led to the burning of the Sewall house, where statesman Albert Gallatin had lived for many years. At the time, Gallatin was in Ghent, Belgium, attempting to negotiate a peace settlement with Britain. The commandant of the Navy Yard, acting on orders to prevent the yard, its stores, and its ships from falling into the hands of the enemy, set fire to it. British soldiers spared the Marine Barracks but torched the unfinished Capitol and the President's House.[9]

Even as the war continued, Congress met in September and immediately proposed moving the capital from Washington City to some "more convenient and less dishonored place," as Congressman Charles J. Ingersoll later wrote. Thirty-eight local citizens, including Hill residents Daniel Carroll and Thomas Law, acted quickly. Using their

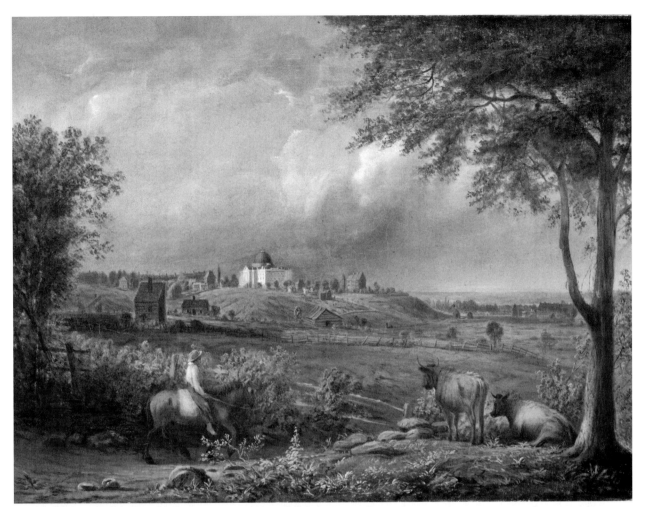

own funds, they erected a large brick building on the site now occupied by the Supreme Court and offered it to Congress for use as a temporary capitol. The federal government decided to stay, and in more good news, Gallatin and his fellow peace commissioners in Belgium succeeded in reaching a peace treaty with Britain. Congress used the "Brick Capitol" until it moved back to the rebuilt capitol across the street in 1819.[10]

By contrast, the years from 1820 to 1850 were relatively quiet ones on Capitol Hill. Its population grew; residents formed a Roman Catholic church, and the Methodists split into two congregations, one white, one African American. East Capitol Street, however, which ran due east from the Capitol's principal door, remained so undeveloped that part of it was used for horse races. The remodeled Brick Capitol joined the boardinghouses that billeted the national legislators during their seasonal sittings. The Eastern Branch proved too shallow for new ship designs, so the Washington Navy Yard turned increasingly to armament design and manufacturing. In addition to the two large ship houses built in the 1820s and still used for repair, the Navy Yard added a rolling mill; foundries; and mechanical finishing, gun-carriage, blacksmith, anchor-making, rigger, and

This view of the semirural District of Columbia in its early years, painted by William McLeod in 1844, emphasizes the pedestal that L'Enfant chose for the location of the Capitol. The view looks south from the approximate location of present-day Union Station, with the hill leading down to today's National Mall to the right of the Capitol, and the plateau that would become the Capitol Hill neighborhood behind it to the far left. Courtesy U.S. State Department, Diplomatic Reception Rooms, Washington, D.C.

This brick structure, built to house Congress after the destruction of the Capitol in the War of 1812, became a Civil War prison for Confederate soldiers, spies, and others, the function it was serving when this photograph was taken. The Supreme Court stands on this site today. Courtesy National Archives

painter shops — an entire industrial village. Eighth Street, as the principal street leading into the Navy Yard, grew likewise, and some of those pre–Civil War buildings remain there today. Modest antebellum houses, often wood and distinguished by flat fronts and sloped roofs, are still scattered about the Hill, right next to later styles — Italianate and Romanesque brick row houses of the later nineteenth century and front porch row houses from the World War I era.[11]

Newcomers to the Hill in this period included African Americans, native-born whites, and a wave of German, Irish, and southern European immigrants, all attracted by the prospect of a new life in the nation's capital. Many were talented building artisans and craftsmen who worked on the Capitol's expansion in the 1850s and 1860s. Others worked at the Navy Yard, made instruments for the U.S. Coast and Geodetic Survey near the Capitol, or went into business. Antonio Sousa, a Portuguese musician, emigrated from Spain to join the Marine Band as a trombonist and a cabinetmaker. In 1854 Antonio and his Bavarian-born wife, Elizabeth, gave Capitol Hill a citizen of the world: their son, John Philip Sousa, later known as the "March King." As a boy during the Civil War, young Sousa lived blocks from the Marine Barracks and roamed all over Capitol Hill soaking up the sights, sounds, and military atmosphere. After learning several instruments at a local conservatory, he plotted at age thirteen to run away to the circus, but his father discovered the plan and apprenticed him instead to the Marine Band. In 1880 Sousa became its director, and for twelve years he worked to shape the group into the nation's premier military band. He went on to tour the world with his own band, gaining international acclaim for spirited compositions such as *Semper Fidelis, Washington Post March,* and *The Stars and Stripes Forever.* The contemporaneous invention of the gramophone helped spread his fame.[12]

With the advent of the Civil War, the Union forces commandeered every public building, including the Capitol, and many private ones as well. Army troops were camped on empty lots and parks, while ovens in the basement of the Capitol turned out loaves of bread for soldiers. The government built temporary hospitals, including one on East Capitol Street near today's Lincoln Park. The old Brick Capitol became a prison for Southern soldiers, spies, cashiered Union officers, contrabands, and as many as two hundred political prisoners at a time. Wartime needs also led to Washington's first horse-drawn streetcar lines in 1862, linking the Navy Yard, the Capitol, the White House, and Georgetown.[13]

At the Navy Yard the foundries were blazing as skilled workers, both women and men, often toiled ten hours a day, including Sundays, to turn out mass quantities of

shells, musket balls, smoothbore cannon, and rifled guns. Some ships were repaired in the ship houses, and others were refitted at the docks. The ironclad USS *Monitor* thrilled the Navy Yard when it arrived on October 2, 1862, for alterations and repairs several months after its decisive victory over the Confederate ironclad *Merrimack*. William F. Keeler, the ship's paymaster, wrote, "The Monitor and her officers are the lions of the day . . . no caravan or circus ever collected such a crowd." President Lincoln, a frequent visitor to the Navy Yard where he enjoyed chatting with Commandant John Dahlgren and marveling at the gadgets and munitions, was one of those visiting the *Monitor*.[14]

Washington's wartime prosperity and population boom brought new investors to the Hill. Wealthy Philadelphia tugboat manufacturer and speculator Stephen Flanagan built a row of sixteen attached houses (124–154 11th Street, SE) a mile east of the Capitol. Called Philadelphia Row, the buildings in the new Italianate style had flat fronts of innovative machine-made "pressed" bricks. The bricks' smooth surfaces and crisp edges contrasted visibly with the coarser texture of older bricks, and after the war pressed bricks would dominate construction on the Hill. Flat roofs invisible from the street, modest brackets at the cornice line, four-panel doors, and larger windowpanes further distinguished Philadelphia Row from its Hill forebears. Another Italianate landmark from the Civil War era is the Old Naval Hospital on Pennsylvania Avenue, SE, at 9th Street. Under construction at the end of the Civil War, the fifty-bed hospital was built to serve Civil War naval forces on the Potomac. It later became a temporary residence

for veterans of other wars and then the home of the Hospital Corps Training School. At this writing, after years of neglect, it is slated for renovation as a cultural and educational center and community gathering place to be known as the Hill Center.[15]

During the early 1870s the city government provided funds to replace the worn-out Eastern Branch Market and to move it to a new site at 7th and C streets, SE, equidistant from the Capitol and the Navy Yard. German immigrant and noted architect Adolf Cluss was chosen to design the handsome, red-brick Italianate Eastern Market, completed in 1872. It stood almost alone at first, but new brick buildings filled the lots in the center of Capitol Hill between the 1870s and 1900, giving the neighborhood a cohesive look. Many were the first ever built on their site, while others replaced earlier frame structures.[16]

Most of the new row houses were two- or three-story, single-family residences for Washington's middle class. The city was expanding rapidly as the federal government grew in size and importance, and postwar improvements by the Board of Public Works in the 1870s fueled a renaissance in many older neighborhoods across the city, such as Capitol Hill. At the same time new public transportation meant people no longer had to live within walking distance of work and could escape, for example, the noisy, industrial Navy Yard. While Northwest Washington increasingly attracted the most affluent and socially elite, Capitol Hill appealed to the middle-income home buyer, a rapidly growing category after 1883 when the Civil Service Reform Act ended the whims of the spoils system and made government employment more secure.[17]

Thus the men who built the Capitol Hill houses during this era, often Hill residents themselves, tended to aim their projects at the middle-class market. Between 1875 and 1895, Charles Gessford, one of the city's prolific builders, constructed more houses on the Hill at one time than anyone else. A Maryland native, Gessford began his Washington building career as a carpenter's apprentice; he then made the transition from carpenter to builder and speculator. He excelled at building marketable row houses. Once he found a house formula that worked, he repeated it, usually with a square-cornered projecting bay that stretched from ground to roof, always in red pressed brick and often with stone trim. (A Projection Act that allowed the extension of such bays into public space passed in 1871.) Gessford further enhanced his most expensive houses with slate roofs as well as stained-glass door transoms and windows.

Gessford also contributed to the post–Civil War building trend of erecting small brick dwellings along the alleys within some of the larger squares on Capitol Hill. Such alley dwellings were built throughout the central city in the last half of the nineteenth century, as noted in the chapters on Foggy Bottom, Southwest, and Shaw. These simple row houses, often of two stories merely twelve feet wide and twenty-four feet deep, were home to some of the Hill's poorest residents, both black and white. They were commonly serviced by privies and community water pumps. While research has shown that such alleys provided sanctuary and supported community life for those with few

resources, their unsanitary conditions made them the focus of housing reform efforts from the 1890s into the 1940s. Some of Gessford's alley dwellings can be seen inside the block bounded by Independence Avenue, and C, 11th, and 12th streets, SE; he built some of the houses on the outside of the block as well, along the 100 block of 11th Street and the 1100 block of Independence Avenue.[18]

Although vacant lots were still common, by the turn of the twentieth century the building boom included all areas of the Hill, extending even a few blocks beyond Lincoln Park, which lay about a mile east of the Capitol. While residences accounted for most of the Hill's new buildings, for about thirty years the Hill continuously sprouted churches, one every third block or so. German Catholics led the way in 1868 with St. Joseph's, two blocks from the Capitol at 2nd and C streets, NE. Calvin T. S. Brent, Washington's first black architect, designed Mt. Jezreel Baptist Church (501 E Street, SE, now Pleasant Lane Baptist Church) for a black congregation whose members resided primarily between the Capitol and the Navy Yard. Nearby at 4th and D streets, SE, the oldest African American congregation on Capitol Hill, Ebenezer United Methodist, tore down its original small frame church — home of the city's first public school for black children (1864–65) — and built a brick church in 1870. (The present Romanesque Revival church was built in 1897 following a fire.) African American members of St. Peter's Catholic Church, who had been excluded from full participation in the church, were granted their own parish, St. Cyprian's, in 1893. The church they built at 12th and C streets, SE, was torn down in the 1960s when the parish merged with Holy Comforter parish at 14th and East Capitol streets.[19]

The building boom of the last quarter of the nineteenth century attracted large numbers of families, forcing the building of many new schools on Capitol Hill. Wallach School at 7th Street and Pennsylvania Avenue, SE, later replaced by Hine Junior High School, was the first of this wave in 1862, with a much-admired design by the prolific Adolf Cluss. The Romanesque Revival Peabody School facing Stanton Park, NE, was constructed in 1879 and continues its role in the education of the Hill's children today, as does Maury, built in 1886. Some schools of the period have been torn down for more modern buildings, while several (Carbery, Lenox, Bryan, and Lovejoy) have been converted to condominiums. Dent School became the Capitol Hill Day School, the B. B. French School served as base for the Capitol Hill Arts Workshop, and Giddings School was remodeled into Results the Gym. The plethora of schools in such a small area was due, in part, to the fact that separate schools were built for black and white children until 1954.[20]

Providence Hospital, begun in 1861 by the Sisters of Charity with 250 beds, grew to fill an entire square between 2nd, 3rd, D, and E streets, SE, with Folger Park built in the adjoining square for the pleasure of the patients. The buildings were torn down in the 1960s and both squares, although periodically and frequently singled out for development, remain parkland in because of residents' lobbying efforts. The other Hill hospital,

The imposing entrance to the Navy Yard commands the end of 8th Street at M Street, SE, on a winter day in the 1880s. Long the city's largest industrial employer, the yard offered opportunities for skilled and unskilled work to African Americans, European immigrants, and migrants from rural Maryland and Virginia, many of whom settled nearby. Courtesy The Historical Society of Washington, D.C.

Casualty at 8th Street and Constitution Avenue, NE, also expanded to fill the square it shares with St. James Episcopal Church, but at this writing it is known as Specialty Hospital of Washington.[21]

Most of the Hill's nationally known, nineteenth-century residents were men involved with the federal government, including Abraham Lincoln, who lived in a boardinghouse on 1st Street while serving in Congress. Journalist Emily Edson Briggs was an exception. After moving from Iowa to Washington in 1861 with her husband, she wrote an anonymous letter to the *Washington Chronicle* protesting the newspaper's allegations that women government clerks were inefficient. That letter led to a forty-year career in newspapers, including hundreds of nationally published columns written under the pen name "Olivia." When she became a widow in 1872, Briggs bought Duncanson's old mansion, the Maples, and resided there until she died in 1910.[22]

By 1898 the Navy Yard had become the world's largest ordnance production and engineering research center. It remained one of the city's largest employers for almost another fifty years. Its demand for unskilled labor helped a new immigrant group, Eastern European Jews, to establish an American foothold, while the old buildings outside its walls provided affordable housing. Capitol Hill's newest population soon sold kosher food, opened haberdashery stores, and formed the Southeast Hebrew Congregation at 417 9th Street (moved in 1971 to Silver Spring, Maryland), all within four blocks of the Navy Yard's main gate.[23]

Construction fell off dramatically across Washington and the nation during the Panic of 1893. When it began to pick up momentum in the first decades of the twentieth century, Capitol Hill developers concentrated on empty land north and east of the older sections. At first, red brick was still the material of choice, but the bay-front façades were swept almost clean of ornamentation. Front doors contained a single expansive pane of

beveled-edge glass, and concrete steps took the place of iron or wood. By World War I a new row house style had become popular. The typical house was slightly wider, with wider windows, and had a porch that extended across the entire front, all of which gave it more horizontal lines, whether Colonial Revival or Mediterranean in influence. These front porch row houses promised increased light and air because they were often only two rooms deep and thus every room had more window access. New materials came with the new styles — rough-surfaced bricks in pale shades of cream, tan, and gray, often topped with red tile roofs.[24]

The Hill's population swelled from the onset of World War I through World War II. Streetcar and bus lines crisscrossed the neighborhood, making it easy for residents to go downtown for work, shopping, or entertainment. But the Hill's three major commercial streets were attractions on their own and stretched for blocks with restaurants and bars, clothing shops and shoe stores, drug stores, dime stores, hardware stores, and movie theaters. All three major commercial streets — H Street, NE; Pennsylvania Avenue, SE; and 8th Street, SE, from Pennsylvania Avenue to the Navy Yard — attracted customers from all over the city.[25]

While most of Victorian-era Capitol Hill remained, there continued to be some physical changes. The Hill had lost some of its earliest structures for congressional office buildings, the Library of Congress, and the Supreme Court. The Navy Yard had expanded from sixteen acres in 1801 to 102 acres by the end of World War II. The Maples underwent major alterations in 1937 to become the headquarters of Friendship House, created in 1904 to provide social services to the Navy Yard area's immigrants and white working poor. It closed in 2008. The rebuilt Sewall house in 1929 became the home of the National Women's Party, which worked to secure equality for women. Today known as the Sewall Belmont House, it is still the headquarters of the party, as well as a house museum dedicated to women's history. Nearby at 2nd and East Capitol streets, on the site once occupied by the ornate Grant's Row, the handsome Art Deco Folger Shakespeare Library rose in 1932, destined to hold the world's most complete collection of Shakespearean materials.[26]

Most of the Hill's late nineteenth- and

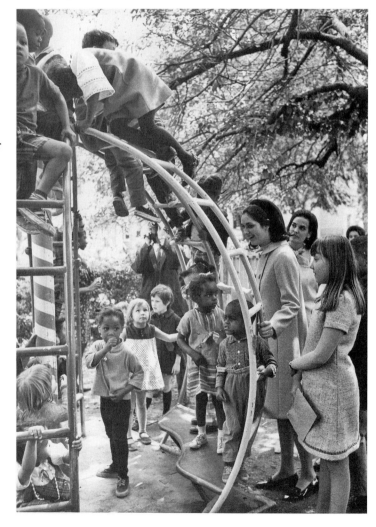

Lynda Johnson, daughter of President Lyndon B. Johnson and Lady Bird Johnson, watches children at Friendship House enjoy the new playground equipment given to her mother's Washington beautification project by Guadalupe Borja de Díaz Ordaz, wife of the president of Mexico, in 1968. The social service agency, now closed, operated out of the remodeled eighteenth-century estate of William Mayne Duncanson at 619 D Street, SE. Courtesy Star Collection, DC Public Library. © Washington Post

early twentieth-century buildings remained unchanged, however, and began to catch the interest of the restoration movement that gained momentum after World War II. With owners taking their cues from similar Colonial era–loving efforts in Georgetown and Alexandria, many houses "restored" at this time gained Federal door surrounds and shutters that masked their working-class origins. But by the 1960s the charms of the Hill's Victorian-era housing stock again began to be appreciated. The earliest restorations took place within a mile east of the Capitol and coincided with major changes in the demographics of the Hill. Its middle-class population, black and white, began to move away, lured by suburbia, low-cost Veterans Administration loans, and newer housing elsewhere. Some had lost well-paying blue-collar jobs at the Navy Yard when the yard stopped manufacturing weapons in 1961 and became an administrative, supply, and ceremonial center.[27]

At the same time, low-income families who had been displaced by the urban renewal of Southwest Washington moved into the Hill's older, rundown houses or into public housing on its fringes. Adding to the mix were the young families and singles, mostly white and college educated, who began to invest in and restore the houses between the Capitol and Lincoln Park. By 1960 the economic and racial mix had tipped from one that was largely middle-class black and white to one that included more low-income black and middle-to-upper-income white. The riots that engulfed Washington following the assassination of Rev. Dr. Martin Luther King Jr. in 1968 hit the H Street commercial corridor particularly hard, with scores of buildings burned.

By the 1970s the Hill had reaffirmed its reputation for civic activism, as new residents, dedicated to urban living, organized to shape their community. Their achievements were legion. Successes included the defeat of federal projects to turn East Capitol Street into a boulevard of elegant state society houses and to split the community with a six-lane, depressed freeway that would run from the Navy Yard northward along 11th Street. Persistence and innovative programs made some public schools magnets for more families with young children. Other parents started Capitol Hill Day School, which offered prekindergarten and after-school and summer camp programs. Protests and hard lobbying saved the historic police station at 5th Street and Marion Park, SE, and ensured that the former site of Providence Hospital would become a public park.[28]

Residents also established annual events such as the House and Garden Tour, begun in 1958 by the Capitol Hill Restoration Society; Market Day, a street fair sponsored by Friendship House; and the Capitol Hill 10K race by the Capitol Hill Cluster Schools. The Capitol Hill Association of Merchants and Professionals established a foundation to support programs benefiting a wide segment of the greater Capitol Hill community. It soon became the Capitol Hill Community Foundation, supported by both residents and businesses. The Capitol Hill Group Ministry, a consortium of local churches, sponsored a social worker to assist the homeless, those on welfare, and others struggling with survival issues. The arts were not neglected. Artists started the Capitol Hill Art League, singers the Capitol Hill Chorale, and drama aficionados the St. Mark's Players and the

Arts Workshop Theatre program. Author Sam Smith wrote of this period, "You didn't move to Capitol Hill. You joined."[29]

In 1973, led by the Capitol Hill Restoration Society, residents gained historic district status for a large portion of the neighborhood nearest the Capitol. Listed on the National Register of Historic Places in 1976, the Capitol Hill Historic District is one of the largest in the nation, with approximately eight thousand primary buildings protected from removal or insensitive alteration. In 2002, in the face of renewed economic pressure from a Navy Yard that is once again an employment center, the Restoration Society successfully nominated the seven surviving historic blocks nearest the Navy Yard for inclusion in the district. The society was recognized by the National Trust for Historic Preservation in 2004 as one of the most effective preservation organizations in the country.[30]

Projecting bays and pressed brick decoration characterize many of the row houses on Capitol Hill, such as these in the 100 block of 11th Street, SE, built by Charles Gessford in 1891. Building regulations first allowed bays to project into public space in 1871, after which they became very popular with builders of row houses throughout the city. Photo by Kathryn S. Smith

In the twenty-first century the historic district is surrounded by intense redevelopment on three sides. High-rise offices and condominiums have sprung up along M Street, SE, west of the Navy Yard leading to South Capitol Street where Washington's baseball stadium, Nationals Park, opened in 2008. Thousands are now drawn to the edge of the Capitol Hill neighborhood. Mixed-income housing financed by federal Hope VI funds is replacing Arthur Capper / Carrolsburg public housing north of M Street. On the north edge of neighborhood along H Street, NE, the Atlas Performing Arts Center in a renovated movie theater complex, a large condominium development near Union Station, and an active Main Street program are drawing new residents and businesses to a once-thriving commercial district that had been in decline since the riots of 1968. On the east, major redevelopment is planned for the site of the abandoned D.C. General Hospital and environs known as Reservation 13. With the changes come increased traffic, some tensions between older and newer residents with different ideas about redevelopment, and rising rents and home prices that displace poorer residents.

What continues to characterize this neighborhood is the dense network of social and civic organizations working to preserve the quality of life in this still very diverse urban community. The census tracts nearest the Capitol in 2000 were 89 percent white, but those at the center and the edges of the neighborhood were among the most ra-

Marines from their nearby barracks present the flag as Capitol Hill neighbors and others celebrate the two hundredth birthday of Congressional Cemetery at 18th and E streets, NE, in 2007. The burial place of 55,000 people, including senators, members of Congress, and other national dignitaries, the cemetery is being restored by volunteers. The tombstone of famous U.S. Marine Band leader and Hill native John Philip Sousa stands in the background. Photo by Fred Davis. Courtesy Association for the Preservation of Congressional Cemetery

cially integrated in the city; the population of census tract 81, for example, bounded by East Capitol, H, 8th, and 11th streets, NE, was 58 percent white, 36 percent African American, 2 percent Latino, and 4 percent people of Asian extraction. Through various organizations neighbors raise money to enrich public school programs, support a local arts center, run sports programs for youth, promote affordable housing, preserve historic houses and streetscapes, support neighborhood churches and their community outreach, and share child care, to name only a few of their efforts. The commitment of longtime residents to their neighborhood is evident in a new organization called Capitol Hill Village that will enable them to stay in their homes as they age.[31]

The community they value is a place where a U.S. senator may live next to a newspaper reporter, while high-level government officials, Hill staffers, and people who need public assistance join them at Eastern Market or on the soccer field. It is a rare mixture of people with very local as well as national and international concerns. It is in some ways an urban neighborhood like any other — except that the Capitol looms over it.

Seventh Street / Downtown

A PLACE TO LIVE AND WORK

ALISON K. HOAGLAND

Downtown Washington, so closely identified with stores and offices, is also a neighborhood, both historically and in the present. As new apartment buildings and condominiums attract an upscale clientele to this part of town, the new residents are repeating old patterns of living downtown, when shopkeepers and government clerks lived close to their places of work. Downtown's architecture wears two centuries' worth of change and adaptation: small row houses converted to restaurants, department stores converted to apartments, and stores converted to coffee shops. Despite the changes, the history of this place is still evident in the streetscape.

Washington's historic downtown is located generally between the Capitol and the White House, north of the Mall and south of Mount Vernon Square. Although much of this area was residential in the nineteenth century, only a small section retains some of the physical character of that early residential neighborhood. It can be found between 3rd, 9th, and G streets south of Massachusetts Avenue, with some of its historic commercial character preserved south of G Street. At its core — and at the center of this chapter — is 7th Street, long a commercial thoroughfare through the heart of the city. Under the name Georgia Avenue, it extends from the rolling hills of distant Maryland to Florida Avenue in the District, where it becomes 7th Street and travels over the hillocks of downtown, finally descending to the lowlands of Pennsylvania Avenue, and then across the Mall to the Potomac River wharves.

When Peter Charles L'Enfant designed the city of Washington, he selected two significant high points for a President's House and a Congress House, now known as the White House and the Capitol. While these two institutions were situated according to L'Enfant's intentions, much of the rest of the city was not. For example, at 8th and F streets, NW, halfway between the two most prominent points, L'Enfant had designated a site for a national church. Instead, the U.S. Patent Office was built there. At 8th Street and Pennsylvania Avenue, he suggested one of five planned grand fountains; instead the spot became

While the city's historic downtown is generally defined as it is in the accompanying map, this chapter focuses on the blocks surrounding 7th Street where some of the physical fabric of the nineteenth-century residential neighborhood remains. Seventh Street and the 600 block of H Street, the heart of Chinatown, form the core of the Downtown Historic District. Many who live and work in the old downtown now refer to the area as Penn Quarter. Map by Larry A. Bowring

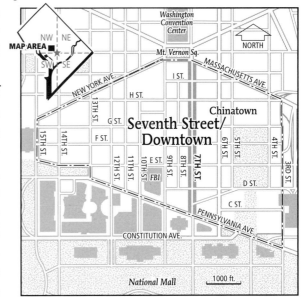

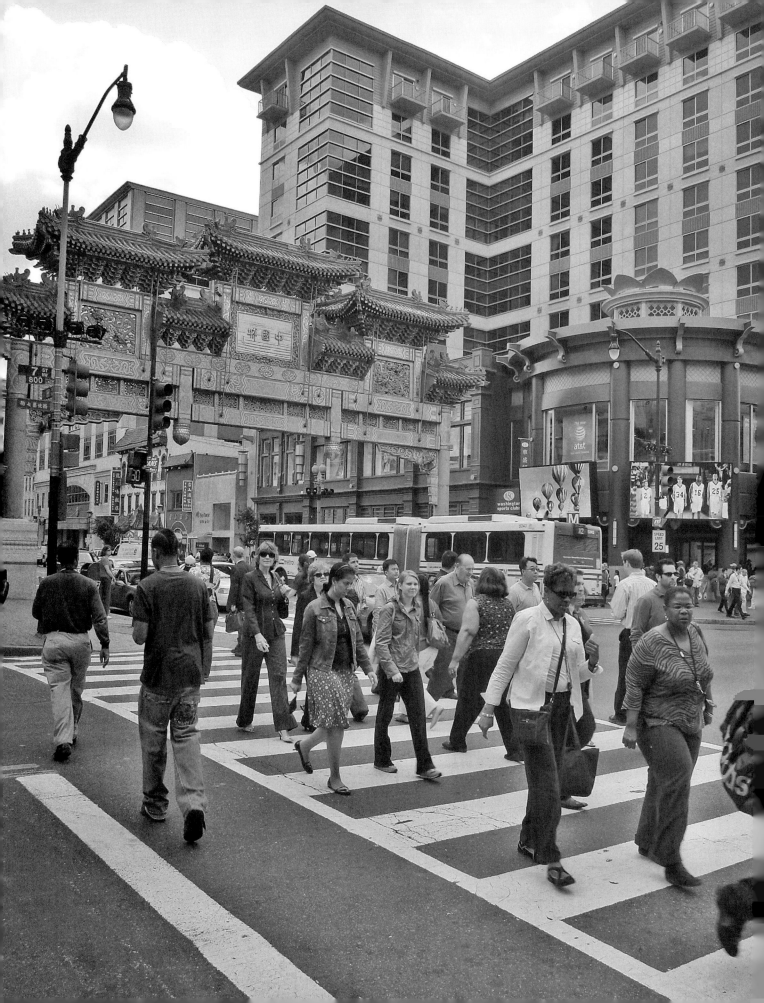

Center Market. L'Enfant designated fifteen squares to be assigned to the fifteen existing states to ornament as they saw fit, but the states never took up the offer. The would-be state square at the intersection of 8th and K streets and New York and Massachusetts avenues instead became Mount Vernon Square, site of a market house, park, and later the Carnegie Public Library. L'Enfant's location for the Supreme Court at 4th and D streets instead became the site of Washington's City Hall, constructed beginning in 1820 on Judiciary Square. Life in early central Washington would revolve around these places.

The White House and Capitol soon defined the edges of the central city, today's historic downtown, with the Patent Office centrally located between them. This massive Greek Revival–style building begun in 1836 on the blocks between 7th, 9th, F, and G streets would be joined across F Street by the neoclassical General Post Office, built between 1839 and 1842. The Treasury began to rise at 15th and F streets in 1836. On the north edge of Judiciary Square, the Pension Building opened in 1887. These federal buildings required hundreds of clerks and other workers to staff them, most of whom lived within walking distance. The other major employer in the area was the Center Market, situated on the south side of Pennsylvania Avenue between 7th and 9th streets since 1801. A gathering place for people both humble and grand, at a time when shopping for fresh food was done daily, the Center Market's assorted buildings and sheds were replaced in 1871 by a multitowered brick market house that covered two city blocks. At its height, the market included six hundred retail stands and twelve wholesale markets. Additional vendors sold from carts and wagons north of the market, a place that became known as Market Space.

Seventh Street developed into one of the most important thoroughfares of the early city, because it provided access to Center Market. Farmers from Maryland and Washington County, outside of the L'Enfant-designed city, brought their goods from the north to the market and beyond to the Potomac River wharves via 7th Street. The street was so important that in 1845 it became the first to be paved by city authorities, and in 1862 it received one of the first three horse-drawn streetcar lines. In 1890, when this line was converted briefly to cable cars, the cars ran three-and-a-half miles from the army post at today's Fort McNair in Southwest to Florida Avenue and back. At the streetcars' northern terminus was a resort known as the Maryland House, which was demolished in 1914 for construction of a baseball park named Griffith Stadium in 1920, the city's American League baseball field. With the introduction of the automobile just before 1900, 7th Street continued to be a thoroughfare, and today, less visibly, Metrorail's Yellow and Green lines follow the historic pattern underground.[1]

With important federal and municipal buildings clustered along 7th Street, downtown quickly developed offices and commercial enterprises interspersed with residences of workers, primarily clerks, merchants, and building tradesmen. For example, in 1853 Horatio King worked as a principal clerk in the Post Office and lived just one block away at 707 H Street. Merchants such as William M. Shuster, who ran a dry goods

(opposite)
Crowds cross the intersection of 7th and H streets at midday. Seventh Street, once the heart of a nineteenth-century neighborhood that was both residential and commercial, has become once again the centerpiece of a lively downtown where people live, work, and find entertainment. The arch marks the entrance to Chinatown, centered on H Street since the 1930s. Photo by Rick Reinhard

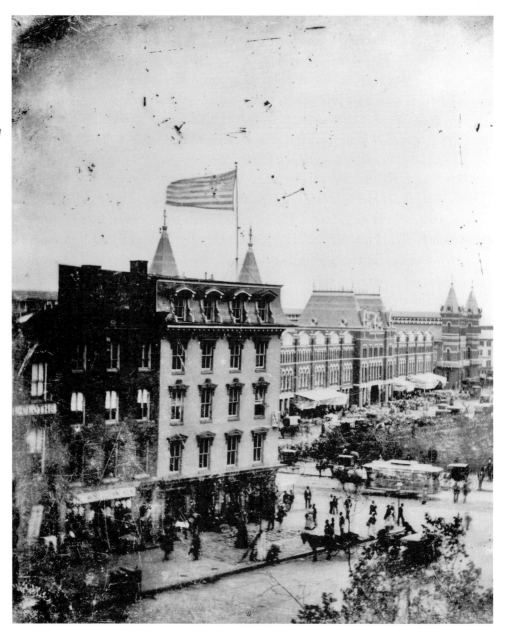

store across from Center Market and lived at 617 H Street, owned shops of all sorts on
the busier streets or in the market houses. With the amount of construction occurring
downtown, it is not surprising that builders also lived there. James Towles lived at 807
H Street and worked in the neighborhood as a "measurer of carpenter's and builder's
work in general, and real estate agent." Living in brick row houses with entrances several
steps above the street, such middle-class clerks, merchants, and craftsmen created early
Washington. Before the Civil War, Washington's commercial and residential buildings
were similar in appearance: two- or three-story brick buildings, two or three windows
wide, with a gable roof or, by the 1850s, a flat roof hidden behind an ornamented cor-

nice. Often only the storefront would give away a commercial building's purpose. Shop-keepers usually lived above their stores.[2]

Not everyone was a homeowner, however. Because of the part-time nature of Con-gress and general uncertainty about the viability of the capital city before the Civil War, boardinghouses were common. History remembers one of the more notorious board-inghouse proprietors: Mary Surratt. She was hanged for conspiracy in the assassination of President Abraham Lincoln, although her role consisted of hosting some of the con-spirators, among whom was her son John Jr. President Andrew Johnson said of Sur-ratt that "she kept the nest that hatched the egg." Recently, however, historians have expressed doubt as to whether she actually played a role in the assassination scheme.[3]

Notoriety aside, Surratt's circumstances and boardinghouse were typical of down-town Washington. Mary and her husband, John, owned a plantation and a tavern near Clinton, Maryland, in addition to their city house at 604 H Street. After the outbreak of the Civil War and John's death, Mary, in reduced circumstances, moved to their house downtown and began renting rooms. Testimony presented at her trial gives un-usual insight into how her house, a typical gable-roofed building, was used. The house was essentially two rooms deep, with stairways and halls along one side. On the ground floor, the dining room occupied the front space, with the kitchen in the rear. On the main floor there were double parlors, separated by folding doors. Mary Surratt and a young boarder, Honora Fitzpatrick, occupied the back parlor as a bedroom. On the floor above, John Holahan, a tombstone cutter, and his wife, Eliza, occupied the front room while their daughter, Nora, slept in an adjacent alcove. The back room housed Mary's son John (who was accused of the crime but escaped overseas) and a friend of his from college, Louis Weichmann (who was the chief government witness). In the attic lit by dormer windows, Mary's daughter, Anna, and sometimes her cousin Olivia Jenkins lived in the back bedroom. At the time of the trial, the front room was advertised for rent. As Mary Surratt's boarders reveal, single men and women as well as whole families occupied boardinghouses.

The pre–Civil War residents of this neighborhood supported a number of churches, including Church of the Ascension on H Street between 9th and 10th, Assembly Pres-byterian at 5th and I streets, and the Central Presbyterian Church on 8th Street be-tween H and I streets, soon sold to the Methodist Episcopal Church, South. During the Civil War, the Calvary Baptist Church formed as an antislavery congregation and built a handsome brick structure that still exists at 8th and H.

Another church indicated the presence of a significant immigrant group. Early land-holder John Van Ness donated land at 5th and G streets for a German Catholic Church, probably to attract Germans, who had a reputation for being industrious and hard-working, to that part of the city. In 1850 only 11 percent of Washington's population was foreign born, but of that group nearly 30 percent was from Germany. The failure of the revolution in Germany in 1848 increased immigration in the next decade, doubling Washington's German population, and the community continued to grow for the next

Mary Surratt ran a boarding house in the 1860s in this gable-roofed dwelling at 604 H Street (still standing), a house typical of pre–Civil War residential architecture around 7th Street. Her son John and several others implicated in the plot to kill President Abraham Lincoln stayed or visited here, and Mrs. Surratt herself was convicted and hanged as an accomplice, although many continue to doubt her involvement. House Courtesy The Historical Society of Washington, D.C. Surratt portrait Courtesy Library of Congress

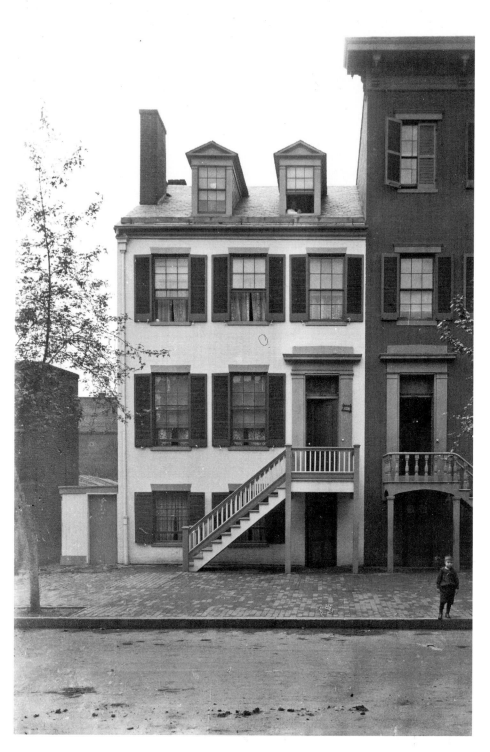

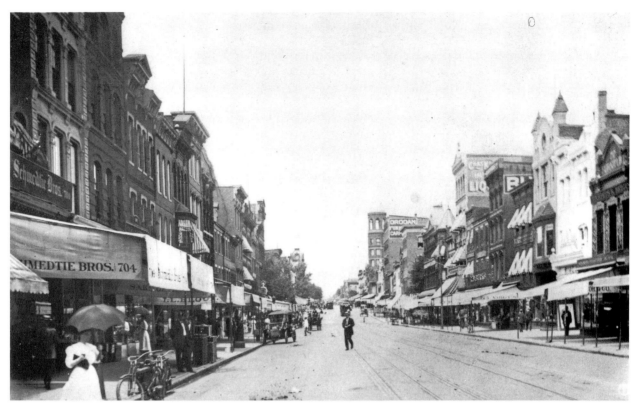

several decades. While they also settled in Foggy Bottom and in Southwest, many Germans were drawn to the commercial opportunities near 7th Street where they worked as dry goods merchants and craftsmen.[4]

By the time of the Civil War, downtown was nearly completely built up. Several pre–Civil War buildings can be seen today; the Surratt House and a few other structures at the corner of 6th and H streets illustrate the character of the early streetscape. Most of the remaining older buildings date from the latter half of the nineteenth century. Compared with prewar structures, they are easily recognized by virtue of their relative height (three or four stories) and greater ornamentation, with molded brickwork and elaborate cornices of wood, cast iron, or pressed metal. Bay windows, allowed to project into public space by a city ordinance of 1871, adorned the fronts of row houses, while shops had projecting plate-glass storefronts.

The impact of German merchants on downtown in the nineteenth century is well illustrated in the 700 block of 7th Street, between G and H streets. The west side of this block retains an ensemble of three- and four-story brick commercial buildings, the last built in 1913, whose carefully restored and somewhat modernized façades nevertheless preserve their historic character. The names of the original owners reflect their origins: Herman Gasch, August and Henry Schmedtie, Herman C. Ewald, Henry Sievers, Philip A. Sellhausen, Frederick Schmeir. The businesses, too, were typical: jewelers, dry

Awnings shade the hot summer streets of Washington on the 700 block of 7th Street early in the twentieth century. A number of successful German merchants had businesses here and lived with their families on the floors above. The buildings on the west side of the street (left) have been preserved for new uses. Courtesy The Historical Society of Washington, D.C.

goods retailers, grocers, confectioners, furniture merchants. This pattern continued up 7th Street, to Reinhardt's Silk House and Eisenmann and Bros. Dry Goods on the 800 block, to Burkhart's Furniture and Dunkhorst's Cigars on the 1000 block, and beyond. Typical of these new German merchants was Anton Eberly, who opened his stove and home furnishings store in 1868 at 718 7th Street, where he also lived. In 1881 he built a new store on the same site, one that still proudly bears his name on the cornice. That same year he started construction on a three-story house two blocks away at 740 5th Street, where he lived until his death in 1907. Active in the German community, Eberly served as the first treasurer of the *Saengerbund*, or singing society, which was founded in 1851, and he remained involved for the next fifty years.[5]

The presence of the Patent Office, which required applicants to submit working models before patents were granted, probably led William Ballauf, born in Hanover, Germany, to found his model-making firm here in 1855. Thirty years later Daniel Ballauf, presumably his son, ran the company at 731 7th Street, where he also lived. Ballauf advertised himself as a "practical mechanician and model maker." In 1913 Ballauf moved his firm and home to 621 H Street, where the business continued until the 1980s. Another model maker was Frederick Carl, who immigrated to the United States in 1882. For one year, 1885, Carl worked for Daniel Ballauf. In 1911 Carl established his own firm next door to Ballauf at 623–625 H Street, although he lived in Mount Pleasant. Carl advertised his "model maker and automobile repairing" businesses and soon founded the "Call Carl" service stations that dotted the city into the 1980s.[6]

An employee or visitor glances casually at the camera from the balcony of an elaborate hall in the Patent Office in 1893. Model makers, patent attorneys, and employees chose to live downtown to be close to their work. Courtesy Library of Congress

Much of the German community's spiritual life found expression in St. Mary's Catholic Church at 727 5th Street. Founded in 1844, the congregation replaced its first church in 1890 with the current handsome stone structure designed by Baltimore architect E. Francis Baldwin. A school, rectory, and orphanage built nearby indicated this German-language church's community involvement. Although Sunday announcements in German were discontinued during the anti-German fervor of World War I, at which time the German-born priest of St. Mary's was forced to leave the city, priests heard confessions in German as late as 1961.

Three synagogues in a six-block area indicated a sizable Jewish presence. In the mid-nineteenth century, the Jewish population was largely of German origin and maintained close ties to the Christian Germans. In 1860 there were fewer than two hundred Jews in Washington out of a total population of seventy-five thousand. The majority of Jewish men were merchants, which explains their settlement near the commercial core of 7th Street.[7]

This small Jewish population founded the Washington Hebrew Congregation in 1852 and eleven years later bought a church building from the Methodist Episcopal Church, South, on 8th Street between H and I. They altered the church extensively, converting it into a distinctive synagogue. In 1897 they replaced it with a stone, onion-domed structure and remained there until 1955, when the congregation moved to Macomb Street in Cleveland Park. Greater New Hope Baptist Church succeeded the synagogue.

In 1869 a second Jewish congregation formed when the Washington Hebrew Congregation undertook certain liturgical reforms. The new congregation, Adas Israel, built its first synagogue at 6th and G streets in 1876. After thirty years of growth, this congregation built a new, vaguely Byzantine-style synagogue two blocks north at 6th and I streets, and in 1951 moved to Quebec Street in Cleveland Park. The Jewish Historical Society of Greater Washington reclaimed the first synagogue when demolition threatened in 1969 and moved it to 3rd and G streets, where it serves as the Lillian and Albert Small Jewish Museum of Washington.

Albert Small, who was born in 1902 at 725 5th Street, recalled that "the neighborhood was our whole life in those days," with Adas Israel as the "focal point." He went to the public school on I Street between 1st and 2nd streets and took music lessons at St. Mary's, across the street from his house. The only time he left the neighborhood was to go to the Young Men's Hebrew Association at 11th and Pennsylvania. He also helped his father, Isidore, who owned a hardware store at 713 7th Street. Open daily from 8 a.m. to 6 p.m., and on Saturdays from 8 a.m. to 10 p.m., it was "a fairly well-ordered store. In those days, everybody had some of their merchandise outside, for show . . . [and] almost all of the merchants were Jewish."[8]

Some Jewish merchants were immensely successful. Max and Gustave Lansburgh, sons of the one of the first cantors at Washington Hebrew Congregation, came to Washington from Baltimore in about 1860 and started a dry goods store on 7th Street between H and I, moving to 406 7th Street in 1866. In 1882 they moved up the block

and developed their business into one of the major department stores in early twentieth-century Washington. Other German and German-Jewish department stores included Saks and Company at 7th Street and Market Space (1867–1932), S. Kann Sons Co. at 8th and Market Space (1886–1975), and the Hecht Company, operating at 7th and F from 1896 until it moved to a new building at 12th and G streets in 1985. Kann's and Hecht's were branches of established Baltimore stores.

By 1900 7th Street was the commercial core of Washington. Samuel Dodek, who was born in 1902 and whose father had a clothing store on 7th Street between H and I, recalled much later that "F Street hadn't been developed, and Connecticut Avenue was a residential area. [Seventh] was the business street. Kann's department store was there, Hecht's, and the Patent Office, and the Public Library — the Carnegie Library. That was the center of business, and the library was the center of culture, because Washington's degree of culture, in those days, just went about as far as the library." The Beaux-Arts Carnegie Library, situated grandly in the park at Mount Vernon Square, opened in 1903 and became a valued resource for Washingtonians for decades. Unlike other institutions of education and entertainment, the library was never racially segregated.[9]

In the 1880s Jews from Eastern Europe began to immigrate to Washington, swelling the ranks of the Jewish community from about 1,500 in 1878 to 3,500 in 1905, and 10,000 in 1918. These new immigrants formed a predominantly Eastern European congregation, Chai Adom, in 1886. Twenty years later, Chai Adom purchased the Assembly Presbyterian Church at 5th and I streets. The congregation, renamed Ohev Sholom, replaced the steeple of the picturesque wooden church with a more appropriate dome.[10]

In the late nineteenth century, German and Jewish merchants were the most visible immigrants downtown, but for most of the nineteenth century, the Irish were the largest immigrant group in Washington. They settled in a marshy area called "Swampoodle," northeast of Massachusetts and New Jersey avenues, and often worked at hard labor. In the early twentieth century, Italians and Greeks appeared downtown as merchants and residents. In 1880 only about a hundred Italian immigrants lived downtown, but their numbers swelled in the early twentieth century when major construction projects attracted Italian stone carvers and day laborers, many of whom succeeded the Irish as inhabitants of Swampoodle. Other Italians served as food and produce merchants throughout the city and in 1913 founded their own Catholic Church, Holy Rosary, at 1st and H streets. Between 1918 and 1923, Holy Rosary built its Italian Renaissance–style church at 3rd and F streets, where nearly life-size sculptures of Italian heroes line its façade. Greeks too were twentieth-century immigrants who succeeded in the produce trade and therefore clustered east of Center Market. By 1909 Greeks owned nearly thirty restaurants on 7th Street and Pennsylvania Avenue. Their church, St. Sophia Greek Orthodox, began in 1904 with meetings in coffee houses on 4½ Street (now John Marshall Place) near Pennsylvania Avenue. In 1906, when Adas Israel congregation sold its synagogue at 6th and G to Stephen Gatti, the Italian fruit dealer leased the upper floor to St. Sophia's. In 1921 St. Sophia's built its own church at 8th and L and stayed there until

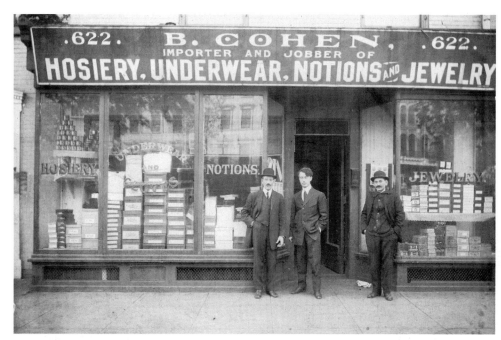

Barnett Cohen (left) stands next to his son-in-law Hymen Goldman in front of their store at 622 Louisiana Avenue (now Indiana Avenue) about 1913. The store stood just half a block from 7th Street where many retail establishments were owned and operated by members of downtown's large Jewish community. Courtesy Jewish Historical Society of Greater Washington

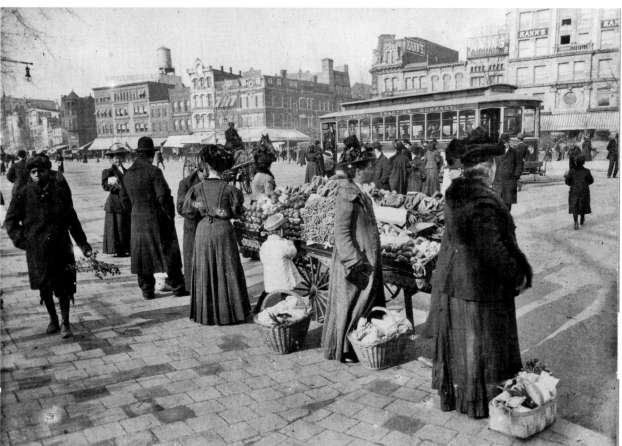

Shoppers congregate at a vendor's cart on Market Space north of Center Market in 1910. Kann's department store is seen in the background on the right. Courtesy DC Public Library, Washingtoniana Division

Members of Holy Rosary Catholic Church, a predominantly Italian congregation, celebrate their new sanctuary at 601 3rd Street in 1934. An Italian community clustered near the church. Courtesy The Historical Society of Washington, D.C.

1955, when it followed its population uptown to its present home at 36th Street and Massachusetts Avenue, NW.[11]

In the early twentieth century, just as Italians and Greeks were making an impact on downtown, 7th Street began to lose its commercial dominance. The Center Market area contained many of Washington's more prominent stores in the mid-nineteenth century, but beginning in the 1880s, some of these moved north to F Street. W. B. Moses, a furniture store, moved from 7th and Pennsylvania to 11th and F in 1885; Woodward & Lothrop moved to 11th and F in 1886; and Palais Royale, another department store, moved to 11th and G in 1893. By the early twentieth century, F Street was attracting a more exclusive clientele, while 7th Street offered a selection of less expensive stores. By 1930, when Garfinckel's opened at 14th and F, F Street's three major department stores provided a shopper's paradise: Hecht's at 7th, Woodies at 11th, and Garfinckel's at 14th. The small shops and restaurants that supported daily neighborhood life continued on 7th Street.[12]

The most recent ethnic group to take advantage of the old core of nineteenth-century small shops and restaurants was the one that gave part of this neighborhood the name "Chinatown." Washington's original Chinatown developed on Pennsylvania Avenue east of 4½ Street in the 1880s. By 1890 there were about one hundred Chinese living on or near Pennsylvania Avenue, and in 1892 the Toc Sing Chung grocery store opened. While Chinese-owned restaurants and laundries served a diverse clientele throughout the city, only Chinatown had Chinese groceries. Although the population grew to about four hundred by 1930, there were no more than fifteen women, due to restrictive immigration laws. By 1930 the Chinese community was dominated by two tongs, organizations that served as fraternal and benevolent societies. Outsiders mistakenly perceived

the tongs as sinister gangs; in fact, they were important social centers in a community of men who lived without their families amid an atmosphere of overt racism.[13]

In 1931 plans for a municipal center at the heart of the Chinese settlement on Pennsylvania Avenue forced the community to find a new location. (The center would never be built.) The tongs took the lead. On Leong Tong, the larger of the two, with about two hundred members, operated secretly through real estate agents and was able to obtain space on the 600 block of H Street for all eleven of the businesses operated by its members. Hip Sing Tong, On Leong's fifty-member rival, which had at first threatened to move elsewhere, eventually followed suit, and the new Chinatown was born. When the new location was announced, reaction among non-Chinese was immediate and negative. Area businessmen circulated a petition in opposition, and one was quoted in the newspaper, "It is not that we object to their coming because they are Chinese. It is just that we don't feel they will bring any business here."[14]

He was wrong. Besides bringing new and distinctive businesses to the 7th and H streets area, Chinatown continued to serve as the nucleus for a larger Chinese community. In 1936 the Chinese population in Washington numbered about eight hundred, with 145 laundries and sixty-two restaurants scattered throughout the city. Chinatown had twelve shops and eight associations. Only Chinatown had a distinctly Chinese atmosphere and appearance, achieved partly through the Chinese ornamentation applied to existing buildings. The On Leong Tong, renamed the On Leong Merchant's Association at the time of the move, again led the way. The organization bought a double building at 618–620 H Street and added a pent tile roof over the first floor, balconies at the third level, and a tile roof above the third floor. This standard arrangement for Chinese association buildings reflected the uses inside: shops on the first floor, offices and apartments on the second, and a meeting hall on the third. Today Chinatown design guidelines encourage the use of tile roofs, brackets, lattices, polychromatic painted decoration, and Chinese-character signage. The 600 block of H Street, in particular, still contains a cluster of flamboyantly decorated Chinese restaurants.[15]

However, major changes on 7th Street — such as the opening of the Gallery Place-Chinatown Metrorail station at H street in 1991 and the completion of the MCI (now Verizon) Center sports arena at F street in 1997 — encouraged redevelopment that, as this was being written, threatened to overwhelm the Chinese presence in the area. Nevertheless, Chinatown remains the symbolic hub of the much larger metropolitan area Chinese community, estimated at more than sixty thousand, and the dwindling presence of about five hundred Chinese in Chinatown for now allows the residential nature of this neighborhood to survive.[16]

By the early twentieth century, successful downtown merchants were beginning to move to what then were in-city suburbs such as Mount Pleasant, Petworth, and Brightwood, where they became commuters. As the Germans prospered and fanned out into Northwest, their former houses became homes to Italians, Greeks, Chinese, and African Americans. By 1910 African Americans constituted a little more than a third of the

population in Northwest Washington, living mainly but not exclusively east and north of the 7th Street corridor in some of its oldest housing. Washington's de facto segregation made African Americans unwelcome in the major stores downtown. Although department stores did not bar black customers completely, they used techniques such as segregating restrooms, refusing service at lunch counters, or prohibiting the trying on of clothing to send the message that African American business was not wanted. Consequently, secondary black-oriented shopping areas appeared on the periphery of downtown, including one on upper 7th Street between Massachusetts and Florida avenues. Here, black- and white-owned businesses were intermingled, serving a largely African American clientele.[17]

After World War II, citizen action forced downtown businesses to desegregate. Following picketing by a biracial coalition led by civil rights activist and educator Mary Church Terrell, Hecht's opened its lunchroom to all races in November 1951, and other department stores as well as restaurants along lower 7th Street followed suit. In 1953 the Supreme Court ruled that a number of "lost" nineteenth-century laws assuring access to public accommodations were still in force, opening the entire city to black patronage. The next year, the Supreme Court's ruling in *Brown v. Board of Education* desegregated public schools. Some whites left the city to avoid integrated classrooms. At the same time, a burst of suburban development inside and outside Washington lured affluent whites to more prosperous neighborhoods. As a result, downtown became an increasingly African American shopping district and residential neighborhood.[18]

This change was particularly apparent as synagogues followed their congregations to new sites in Northwest. In 1955 Washington Hebrew Congregation's 8th Street synagogue became Greater New Hope Baptist Church. Ohev Sholom synagogue at 5th and I was succeeded by Corinthian Baptist Church in 1957 (since 2007 the Chinese Community Church), and Adas Israel synagogue, 6th and I, became Turner Memorial African Methodist Episcopal Church in 1967. After the Turner Memorial congregation voted to move to Hyattsville, Maryland, near where most members lived, the synagogue-turned-church was purchased in 2003 by three local developers and restored with the help of the Jewish Historical Society of Greater Washington as a Jewish cultural center and is now known as the Sixth and I Historic Synagogue.

Beginning in the 1950s, many downtown merchants, both small businesses and department stores, followed their customers to the suburbs, relocating to small strip shopping centers and then, beginning in the 1960s, to large suburban shopping malls. The civil disturbances of 1968 following the assassination of Rev. Dr. Martin Luther King Jr. proved to be the final push for faltering businesses. Angry protestors as well as opportunistic looters smashed and burned businesses along 7th and F streets. For years after, former customers concerned about crime, black and white, avoided shopping downtown, and many burned-out businesses remained shuttered. Prominent stores such as Lansburgh's and Kann's closed. Widespread demolitions along 7th and F streets, and the moving of Hecht's to 12th and G streets in 1985, further diminished the shopping

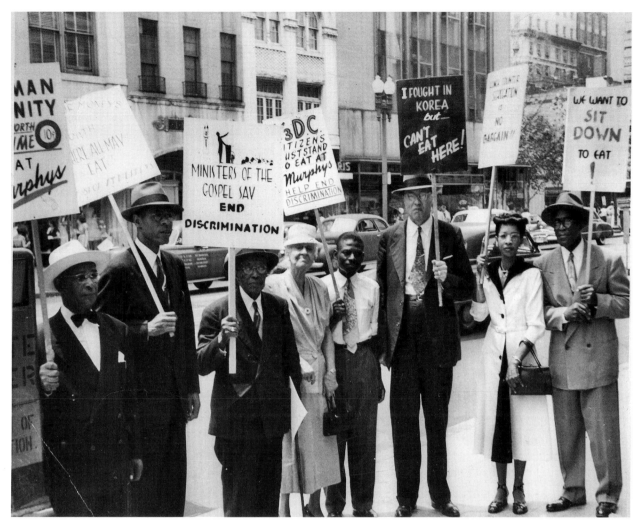

activity. With the dominance of suburban malls, downtown was no longer Washington's commercial center. The 1990s closings of Woodward & Lothrop and Garfinckel's — both their downtown flagship stores and suburban branch stores — marked the nadir.

The story of white-collar businesses downtown was similar to the commercial experience. A burst of building activity between 1900 and the late 1920s brought dozens of distinguished tall office buildings to the area. As the federal government expanded during this period, so did related private-sector services. An array of investors built impressive buildings to house offices, financial institutions, hotels, and even social clubs in addition to retail outlets. Between 1887 and 1916, close to sixty massive projects were completed, beginning with the nine-story Sun Building at 1317 F Street designed by Alfred Mullett. These would be the business anchors for the next fifty years. Then in the 1960s and 1970s the attorneys, accountants, lobbyists, and other white-collar professionals were lured from downtown's aging buildings to the blocky Modern office buildings

Octogenarian civil rights advocate Mary Church Terrell (fourth from left) led protests in the 1950s that opened downtown restaurants and stores to all races. Courtesy Prints and Photographs, Moorland-Spingarn Research Center, Howard University

of the "new downtown" centered at K Street and Connecticut Avenue and extending west to Foggy Bottom.[19]

In recent decades, the situation began to turn around. As the K Street corridor filled up in the 1980s, the construction of new office buildings began creeping eastward from 15th Street into the old downtown, and reworked landmarks such as the Homer Building and new blocks such as Columbia Square rose along F Street. The efforts of the federal Pennsylvania Avenue Development Corporation, or PADC, from 1972 until 1996 to revitalize Pennsylvania Avenue resulted in the demolition of most of the avenue's nineteenth-century buildings, although citizen action saved such landmarks as the Willard Hotel, the Old Post Office, and the *Evening Star* Building. However, PADC efforts also brought new government offices, hotel rooms, apartments, and parks. Decades-old efforts to return housing to the eastern end of the Pennsylvania Avenue corridor and downtown in general were finally bearing fruit. High-end condominiums and apartments on lower 7th Street — pioneered by the redevelopment of the old Lansburgh department store site into apartments in 1991 with a new Shakespeare Theatre on street level, followed by the Market Square condominiums at 8th and Pennsylvania — have brought a new residential population to the area. Business leaders organized the Downtown DC Business Improvement District to promote downtown revitalization in 1997, first putting uniformed workers on the street to promote cleanliness, to watch out for safety issues, and to greet visitors; it then began to work with business, government, and nonprofit leaders to rebuild downtown as a destination. Its 2005 annual report touted 2,500 new housing units built since 2000, with 1,700 more in process, and in the same five years eighty-one development projects with a total value of $5.4 billion built in the old downtown, stretching from Union Station to the White House and from Constitution to Massachusetts Avenue.

People from around the city and the region began to come back downtown in the late 1990s, but this time it was more for entertainment and cultural opportunities than for shopping. The Verizon Center, home to Washington's major-league basketball and hockey teams at 7th and F streets, took the lead in bringing crowds back to downtown when it opened in 1997. The popular International Spy Museum opened in restored nineteenth-century buildings at 9th and F streets in 2002 and the Newseum arrived in 2008 in a striking new building at 6th and Pennsylvania Avenue. They joined the Smithsonian Institution's National Portrait Gallery and American Art Museum in the original Patent Office and the National Building Museum in the Pension Building in enriching downtown as a destination for museumgoers. The old General Post Office became a luxury hotel, opening in 2001. The D.C. government contributed to the trend, moving its convention center in 2003 to vast new quarters north of the old Carnegie Library on Mount Vernon Square, which the same year became the new home of the Historical Society of Washington, D.C. While franchise restaurants moved into many of the nineteenth-century commercial buildings on 7th Street, the remaining Chinese

The glass-fronted Harman Center for the Performing Arts lights up a rainy night in the 600 block of F Street, shortly after it opened in 2007. It is the second venue of the Shakespeare Theatre Company in the 7th Street area. Photo by Tom Arban. Courtesy Shakespeare Theatre

establishments on H Street underwent a new round of renovation in a postmodern take on Chinese architecture.

Downtown's population has never been static for long. From the generally white, Anglo-Saxon, middle-class Americans who originally built the neighborhood; to immigrant Germans and Eastern European merchants who chose to live in the city's commercial core; to African Americans excluded from a fair role until the mid-twentieth century; to the Chinese of Chinatown; to conventioneers, tourists, and upscale condominium dwellers, downtown has seen many changes. Each successive group has left its impact in the form of buildings that, if they are permitted to remain, reveal an important part of Washington's past, while 7th Street has resumed its role as the heart of a downtown that is both a place to live and a place to work.

Foggy Bottom

INDUSTRIAL WATERFRONT TO PLACE OF POWER

G. DAVID ANDERSON AND BLANCHE WYSOR ANDERSON

With United States presidents for neighbors on the east and a bottomland, working waterfront on the west, Foggy Bottom grew up with a split personality. Its location on the Potomac adjacent to the port of Georgetown attracted industry and working people — Irish, German, and African American. Its proximity to power on the east attracted international organizations, diplomats, federal agencies, a major university, and the comfortable homes of the middle and upper class. Today old churches, a historic Naval Observatory, and a small historic district of nineteenth-century brick row houses and alley dwellings share the neighborhood with freeways, modern high-rise apartments, the Kennedy Center, George Washington University, the U.S. State Department, and the World Bank. Its history is as varied and interesting as the people who lived, worked, worshipped, studied, and played here.[1]

Although the origin of the name Foggy Bottom is not documented, the low, western end of today's neighborhood was originally a marshy bottom strongly associated with Washington's industrial history. The combination of river fogs and industrial soot and smoke may have led to the name people attached to the place. The Potomac River once lapped at its southern edge. In the 1880s, the Army Corps of Engineers created the land that would become the west end of today's National Mall, filling the area from 17th to 23rd Street south of today's Constitution Avenue with material dredged from the Potomac. Constitution Avenue became the southern boundary of today's Foggy Bottom. The other generally accepted boundaries are the Potomac River and Rock Creek on the west, Pennsylvania Avenue on the north, and 17th Street on the east.

The area's documented history begins with Jacob Funk, a German immigrant who in 1765 purchased and subdivided 130 acres bounded by today's H Street, the Potomac River, 19th, and 24th streets. The incorporated town was officially named Hamburgh, probably for Funk's native city, but it was more commonly known as Funkstown. Funk sold most of the more than two hundred lots to speculators, but few

Foggy Bottom's clear boundaries extend from the White House to Rock Creek and encompass an eclectic mix of uses including the State Department and other federal buildings, George Washington University, the John F. Kennedy Center for the Performing Arts, the famous Watergate complex, high-rise apartments, and a small historic district of nineteenth-century dwellings. Map by Larry A. Bowring

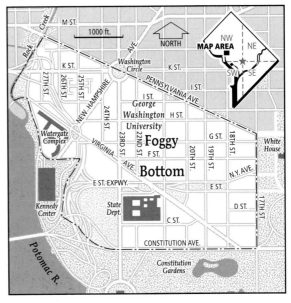

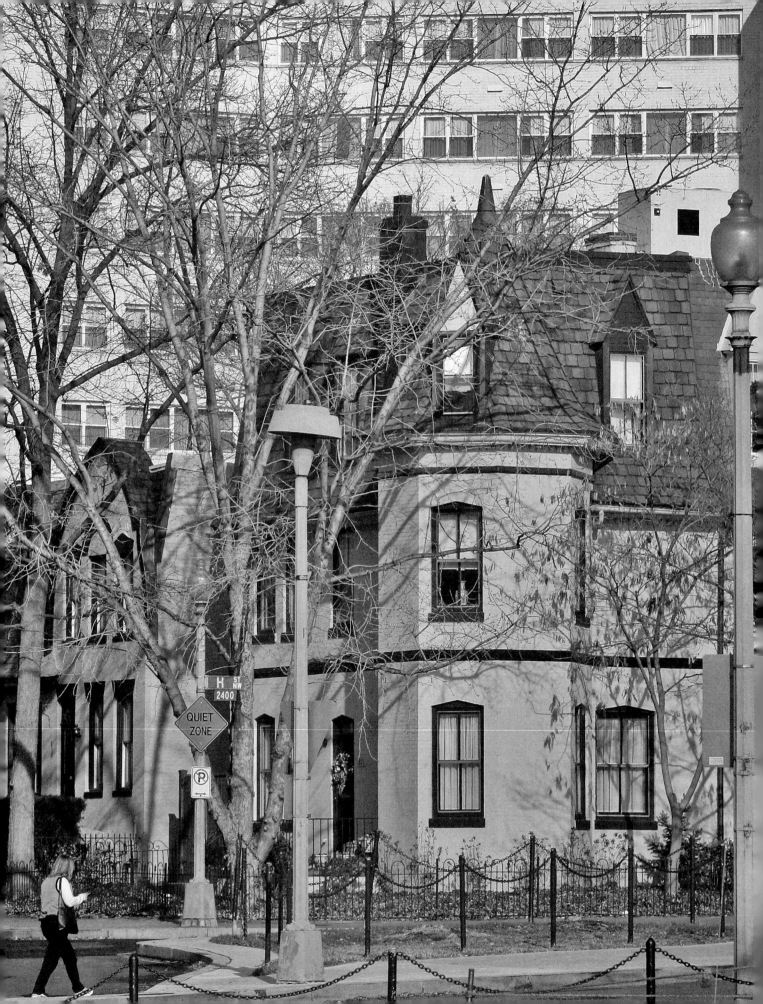

were able to sell or develop them prior to the formation of the District of Columbia in 1791. In that year Jacob Funk assigned his holdings in Hamburgh in trust to William Deakins Jr. of Georgetown and Benjamin Stoddert, a land holder and the first secretary of the navy, to "execute deeds to holders of lottery tickets issued for the sale of lots in Hamburgh." These lots were purchased by residents outside of the Hamburgh area, again mostly for speculative purposes. George Washington showed an interest and later purchased a lot in Square 21. He willed that lot to George Washington Parke Custis, his wife's grandson and his ward, who built a house that once stood between 23rd Street and Rock Creek on K Street.

Most remarkably, Thomas Jefferson thought the heart of the new federal city might be located in Hamburgh. He sketched a modest grid of three hundred acres, with the president's house on a small hill overlooking the Potomac between 23rd and 25th streets called Camp Hill, so named because of the remains of colonial-era fortifications. Peter Charles L'Enfant's design for the new Federal City, however, was much larger and more visionary; Hamburgh would be a small part. L'Enfant placed Washington Circle at the intersection of the major angled arteries that would become Pennsylvania and New Hampshire avenues and today's 23rd and K streets. He saw Camp Hill's value for military use.[2]

Hamburgh's real value was its proximity to the Potomac River and Rock Creek, once navigable as far as P Street. Wharves, warehouses, and businesses dominated the waterfront in the early nineteenth century. Tobias Lear, George Washington's former secretary, owned a wharf and warehouse near Rock Creek, and it was here that the federal records and personal belongings of members of Congress arrived in the new city in May of 1800. George Way and Andrew Way Jr. started a glass factory in 1807. They often opened the Glass House to the public when the Bohemian glassblowers made singing bottles and special toys for visitors. The Glass House would later become a lampblack factory. A brewery at B Street between 21st and 23rd opened in 1796. This began the waterfront's identification with the brewing industry, strengthened with the advent of the Heurich and the Abner Drury breweries in the 1870s.[3]

In the 1830s a third waterway encouraged business and industry in the low land along the river. Construction began in 1828 on the Chesapeake and Ohio Canal designed to connect the Federal City with the trans-Appalachian West. The Washington end of its route, completed in 1837, ran alongside the Potomac River from Georgetown east to 17th Street, where it linked with the short-lived Washington Canal. That canal ran through the city, around the Capitol, and on to the Anacostia River. The C&O Canal, an engineering marvel of its day with pump houses, locks, aqueducts, and dams, changed the landscape and provided the city with a critical link to raw materials from the hinterlands of Maryland and West Virginia. While lack of funds kept the canal from crossing the mountains, it was completed to Cumberland, Maryland, in 1850; by 1871, five hundred boats would be transporting goods along this waterway.

(opposite)
Nineteenth-century houses at 24th and H streets are dwarfed by a twentieth-century apartment, one of many high-rise and large-scale developments that now surround the smaller dwellings of the earlier neighborhood. Photo by Rick Reinhard

The Old Glass House, operated as a glass factory by George and Andrew Way from 1807 to 1833, stands at the center of this 1839 painting of the Foggy Bottom waterfront by Augustus Köllner. Bluffs like those seen to the left of the factory were typical of the banks of the Potomac and the Anacostia rivers at the time. The entrance to the Tiber Creek that once flowed along the course of today's Constitution Avenue is at the right. Courtesy Library of Congress

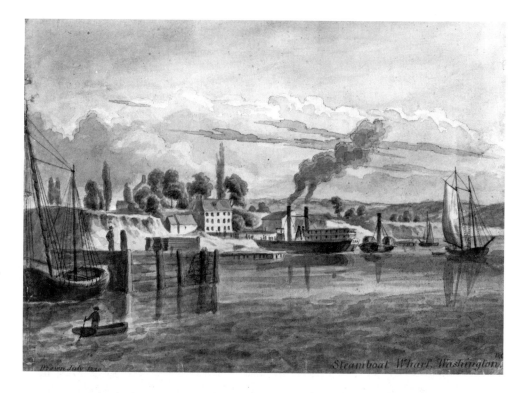

The canal attracted ambitious businessmen such as Captain William Easby, a York-shireman who had started a Foggy Bottom shipyard in 1829. Easby became the leading businessman in pre–Civil War Foggy Bottom; his ventures included a lime kiln and an ice house. Other entrepreneurs operated a wood yard and a factory producing plaster, ammonia, and fertilizer. In 1856 the industry that would dominate the neighborhood's skyline for almost one hundred years came to Foggy Bottom. In that year the Washington Gas Light Company built its first storage facility at Virginia and New Hampshire avenues, largely to power Washington City's new gas streetlights, which began to be installed in 1853.

The coming of the gasworks and the canal and its associated businesses caused a jump in the numbers and a change in the character of the residential population west of 23rd Street. There had been only forty households in that part of Foggy Bottom in 1822 and only sixty by 1843. By 1860 the number had increased three times, to 175. Most of that growth took place between 1850 and 1860, when the population of Washington City as a whole grew by 50 percent. The new residents were increasingly unskilled — 42 percent of the heads of household in 1860 as opposed to no more than 18 percent previously. Many were immigrants from Germany and Ireland. The western end of Foggy Bottom, which related more to the river than to the federal buildings to the east, was becoming one of the city's few industrial, ethnically diverse neighborhoods. Residents hauled water from two springs in the area, shopped in Georgetown across Rock Creek, fished along the river, hunted in the area, participated in sledding and ice-skating in the winter, and on occasion crossed the river to visit Arlington House to hear George Washing-

ton Parke Custis regale groups of local people with stories about his step-grandfather, George Washington.

The Civil War transformed life in Washington as the city became an armed camp. Foggy Bottom was crowded with barracks, wagon sheds, and corrals housing three thousand horses and mules. Camp Fry, located south of Washington Circle on both sides of 23rd Street, provided quarters for invalid soldiers, guards, military personnel, and members of the Veteran Volunteer Corps that guarded government buildings in the city. Many of the alley dwellings west of 23rd Street, homes of immigrant workers, were taken as lodgings for Union officers. The first sanctuary of the Union Methodist Episcopal Church, founded in 1846, served as a shelter and hospital facility for Union soldiers. (A later building still stands on the site at 812–814 20th Street; the church merged with Concordia church at 1920 G Street in 1975.) Simon Newcomb, an astronomer at the Naval Observatory, recalled the scene:

> An endless train of army wagons ploughed [the] streets with their heavy wheels. Almost the entire southwestern region, between the War Department and the Potomac, extending west . . . was occupied by the Quartermaster's and Subsistence Departments for storehouses. . . . After a rain . . . some of the streets were much like shallow canals. Under . . . the iron-bound wheels the water and clay were ground into mud, which was at first almost liquid. It grew thicker as it dried up. . . . By night swarms of rats, of a size proportional to their ample food supply, disputed the right of way with the pedestrian.[4]

Washington, while the capital of the Union, was a Southern city, and many of its residents were sympathetic to the Confederate cause. Lieutenant Matthew Maury, the first superintendent of the Naval Observatory, was from Virginia and felt he owed his loyalty to the Confederacy. Shortly after the war began he resigned his commission to serve in the Confederate navy. On the other hand, Maxwell Van Zandt Woodhull, who grew up in the home his father built at 2033 G Street, entered the Union army as a volunteer shortly after his nineteenth birthday. He was just past twenty-one when he was made a brigadier general for "conspicuously faithful and efficient service" to his country. The home still stands, donated by General Woodhull to George Washington University in 1921.[5]

With the war over, industries in the area west of 23rd Street returned to peacetime work. Now began a long period of industrial activity and the deepening of the area's identification as a working-class, ethnic neighborhood. Coal and raw materials coming down the canal supported a variety of industries, including the enterprises of William H. Godey who during the war had built lime kilns where the canal met the Potomac River. The limestone for making plaster came down the canal, and some of the plaster went back up. The Cranford Paving Company, responsible for paving most of the major streets in the city, settled on the land formerly occupied by Easby's shipyard. In the vicinity were a lumber yard, a coal yard, cement companies, an icehouse, a shipyard,

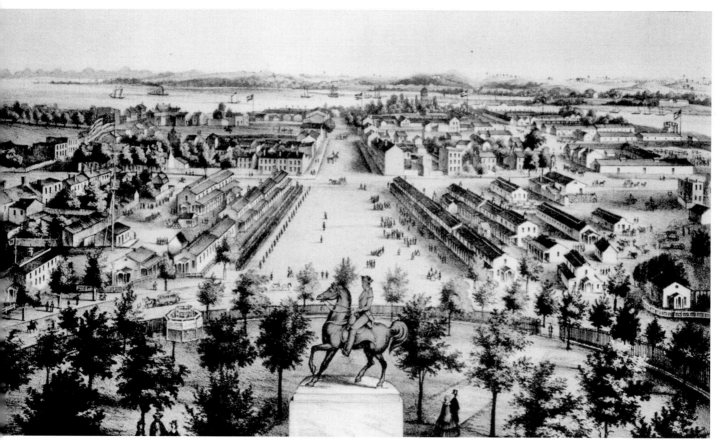

The Civil War transformed Foggy Bottom, as seen in this 1865 Charles Magnus lithograph of Camp Fry, located on both sides of 23rd Street south of Washington Circle. Corrals in the neighborhood housed as many as three thousand horses and mules. The equestrian statue of George Washington by Clark Mills was placed in the circle in 1860. Courtesy Library of Congress

Government scientists pose at the Naval Observatory on Camp Hill in 1897 before traveling to the Pacific to measure the transit of Venus across the sun. The observatory, established in 1844 on 23rd Street on a hill overlooking the Potomac, was a fixture of the neighborhood in the nineteenth century. The scientists were visiting their old home, because the observatory had moved to Massachusetts Avenue in 1893. Courtesy The Historical Society of Washington, D.C.

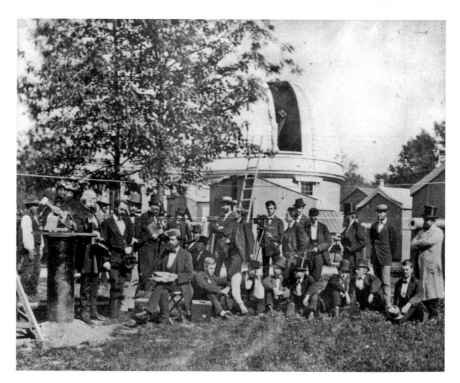

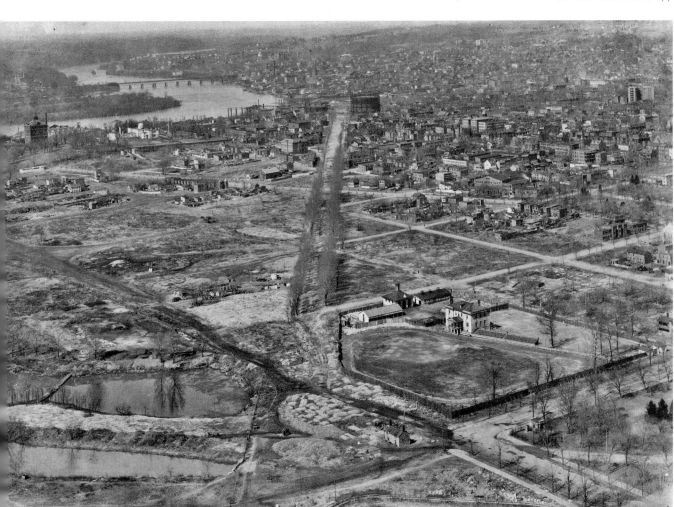

The undeveloped intersection of Virginia Avenue (center) and the future Constitution Avenue (angling off to the left) dominates the foreground of this photograph of Foggy Bottom taken from the top of the Washington Monument in 1894. The remains of the U.S. Government fishponds are at the bottom left. The Washington Gas Light Company gas tanks that marked industrial Foggy Bottom west of 23rd Street can be seen in the background. Courtesy National Archives

and a fertilizer factory, all of which offered job opportunities for skilled and unskilled workers.

As the canal encouraged trade and manufacture, the Washington Gas Light Company expanded its operations and increased employment, adding a second huge tank at Virginia Avenue and G Street. The complex was considered by many a blight on the landscape, its occasional bursts of flame from the gas house casting a garish glow. The unsightly facility would define the skyline and reinforce the neighborhood's industrial heritage until it was demolished in 1954.[6]

Two brewers chose Foggy Bottom as the location for their businesses. John Albert began operations under his name in the 1870s; in 1895 the business became the Albert Brewing Company, Edward T. Abner, proprietor. In 1898 the firm changed its name to Abner Drury. The second brewery would become well known. Christian Heurich, a German immigrant, and Paul Ritter established the Heurich Brewery in 1872 on 20th Street near then-rural Dupont Circle. Success and several fires at the first brewery

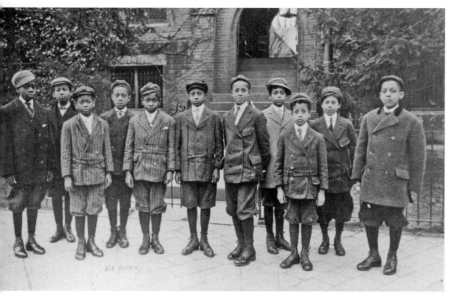

A Sunday school class lines up for a photograph in front of St. Mary's Episcopal Church at 728 23rd Street in 1907. The church provided community activities and social services as well as a spiritual home for the neighborhood's African American community. Courtesy St. Mary's Episcopal Church

prompted Heurich to build a new, all-brick, fireproof building at 25th and Water streets in 1895. Of the more than twenty breweries in the city, the Heurich Brewery was the most successful, eventually covering two blocks in Foggy Bottom. Over its eighty-three-year history the company would market thirteen different brands of beer and at its peak produced more than 130,000 barrels a year. It would survive Prohibition with profits from its ice business. Heurich would continue to manage it until his death at 102 in 1945. The brewery building was demolished in 1961 during construction of the access ramp to the Theodore Roosevelt Bridge. Today the Kennedy Center for the Performing Arts occupies this space.[7]

All of these industries required workers, and the jobs attracted many of the city's European immigrants. People from Germany and Ireland had started moving to Foggy Bottom before the Civil War, and now their numbers increased. Immigrants from Ireland tended to work at the Washington Gas Light Company, and Germans worked at the breweries. Modest, inexpensive row housing began to dominate the neighborhood, particularly west of 23rd Street. Many Irish workers settled on 23rd Street south of Virginia Avenue, a section called Connaught Row. They fielded their own baseball team, the Emerald Athletic Club, and a football team, the Irish Eleven. By the 1880s the West End Hibernian Society had been established at 19th Street and Pennsylvania Avenue. African Americans came to the neighborhood for jobs as well, creating yet another cultural community in the area. Those with the fewest resources lived in small row houses inside the city's large blocks, hidden alleys that provided shelter and some sense of community but that almost always had no running water or sanitary facilities.

The Irish, Germans, and African Americans attended different churches, reinforcing their separate social worlds. St. Stephen Martyr Catholic Church at Pennsylvania Avenue and 25th Street began in 1867, ministering to the Irish residents. Concordia Evangelical Lutheran Church, founded in 1833 by German immigrants at 20th and G streets, served the German community. African American members of the Church of the Epiphany downtown founded St. Mary's Episcopal Church in 1867 and erected the neighborhood's most architecturally significant sanctuary, designed by James Renwick, on 23rd Street between G and H in 1886. Longtime member of St. Mary's and Foggy Bottom resident Mary E. Brown recalled that the church served many needs — medical, educational, and social.

At St. Mary's . . . they had a clinic. . . . You would take the children there to get vac-

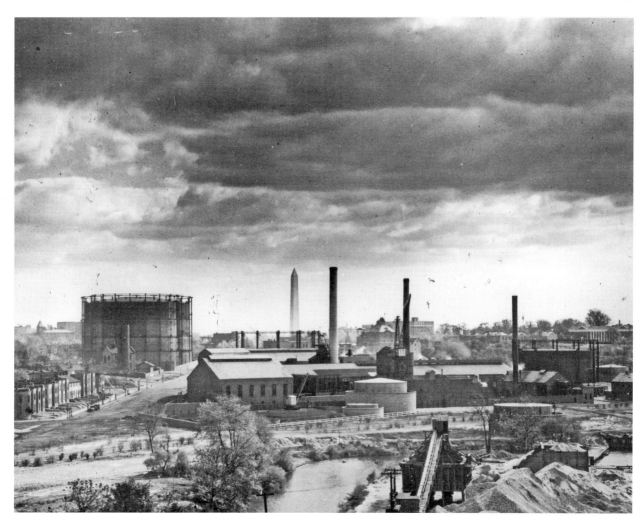

cinated before they started school or take them there if they had a minor illness and they would be treated, and they had all sorts of activities for children at the school, [and] at the church. . . . Some of the adults would take the children out on picnics and hayrides . . . the zoo and the Lincoln Memorial and the Monument were main places where they went, and along West Potomac Park, all along the Tidal Basin.[8]

While the area west of 23rd Street near the river and the canal became industrial, the streets to the east nearer to the White House housed middle-class civil servants as well as the prestigious and the well-to-do. This area was sometimes referred to as the West End or Potomac Park. A study of one block of G Street from the Civil War to the early twentieth century opens a window on this part of the neighborhood. Commander John Easby, chief of naval construction and son of shipbuilder William Easby, lived at no. 2027. The home of General Orville E. Babcock, secretary to President Ulysses S. Grant, at no. 2024, once served as General Grant's headquarters during the Civil War. The home of Admiral Charles H. Poor at no. 2030 was a mecca for Washington's

Smokestacks, many of them associated with the operations of the Washington Gas Light Company, vie for attention with the Washington Monument in this photograph of industrial Foggy Bottom taken about 1920. Courtesy Special Collections Division, Gelman Library, George Washington University

socially elite. Dr. John Frederick May, a graduate of Columbian College (which was to become George Washington University), occupied the home at 2020 G Street. General William Worth Belknap, secretary of war under President Grant, once lived at no. 2022; this house was later home to Admiral Samuel Ramsey and to James B. Lambie, a Washington businessman. Captain Archibald Butt, military aide to President Theodore Roosevelt, lived at 2000 G Street.[9]

Life for a child in the eastern part of Foggy Bottom after World War I was full of interesting people and places. Hazel Hanback lived with her family at 2159 New York Avenue, an area now occupied by the State Department. She remembered New York Avenue as a "gorgeous street," with luxury apartments built about the late 1920s, including the Boulevard, Mayfair, Potomac Park, and Riverside. With a valet shop, elevators, and a parking lot, the grand Boulevard apartment house was home to the popular singer Kate Smith. Another famous figure at the time, radio personality Arthur Godfrey, was a friend of her father's and lived nearby at the Mayfair.

> [He] used to have us kids come down to what was the Earle Theater, where his studio was, and we'd stay there until midnight, because the town was very safe. Nobody ever thought about crime, nothing ever happened to us, so a whole bunch of kids from the age of maybe 9 to 12 or 13 would go down and we'd be Arthur Godfrey's audience, and clap. And then when all the big shot movie stars were there, then we'd get their autographs, and then we'd all walk home like the Peanuts characters . . . from the White House to 22nd and New York Avenue. . . . It was wonderful.[10]

Hazel Hanback also remembered the benefits of growing up in a neighborhood with people of many different nationalities.

> In our neighborhood, we had German family, French, Swiss, Dutch and Italian. And most of them had children . . . and we always went in groups. And we all were invited at everybody's house, including my own and we just learned about all those foods. The Italians had the wonderful spaghetti; the German lady. . . . Her husband was the head brewer for Heurich's brewery. But she made us the most delicious apple pancakes, and liver soup. Can you imagine a bunch of little kids liking liver soup? We loved it. And the Swiss gave us lots of Swiss cheese, cream cheese. . . . My family was English Scots.

Hanback also recalled that children and adults enjoyed the municipal tennis courts and an Olympic-size municipal swimming pool near the Tidal Basin. Children rollerskated, walked and played around the neighborhood, and sledded down 23rd Street to Constitution Avenue. Milk in bottles, ice for the icebox, bread and vegetables were all delivered by different vendors. Before automobiles and buses, people traveled by foot, by horse and buggy, or the streetcars on F and G streets. She recalls that her mother purchased the first Model T Ford ever sold in Washington; the man from whom she purchased it taught her to drive with young Hazel in the back seat.

Over time, both the eastern and western sections of Foggy Bottom would become home to institutional uses of many kinds. Educational establishments would lead the way. The Stevens School at 21st and K streets, built shortly after the Civil War, was one of Washington's first public schools for African Americans. The Grant School was built in 1882 for white students at 2130 G Street. (It today houses the School Without Walls.) St. Stephen's Catholic Church ran a school at 24th and K streets from 1924 to 1954, when it became the Immaculate Conception Academy. (The building is now the St. James Apartment Hotel.) St. Rose's Industrial School for Girls, a school for needy children, operated at 2023 G Street.[11]

It was the arrival of George Washington University, however, that would stamp the neighborhood as an educational center and eventually change the face of central Foggy Bottom. Columbian College, when it began in 1821, was located between 14th and 15th streets north of Florida Avenue. In 1884 it moved downtown between 14th and 15th and H and I streets. With a reorganization of the university under the guidance of President Charles H. Stockton and trustee General Maxwell Van Zandt Woodhull, the College of Arts and Sciences moved to Foggy Bottom in 1912. The administrative offices, lecture halls, and the library were housed in old St. Rose's Industrial School and the building was renamed Lisner Hall in honor of university trustee Abram Lisner. (In 1939 the building would be demolished to build Lisner Library, today known as Lisner Hall once again.) The area the university moved into was very residential. Houses were described as standing "shoulder to shoulder up and down the streets." The only commercial establishment in the area was Quigley's Pharmacy, at 21st and G streets. Elmer Louis Kayser, the first university historian, said that "when the lights went out at Quigley's at ten o'clock, darkness locked the street up for the night."[12]

The university would transform the area. Almost immediately it began to acquire and remodel property to the east and west of Lisner Hall. By 1936 the university had purchased nearly all of the old homes in the block bounded by G, H, 20th, and 21st streets, as well as in other nearby squares, and had built two large buildings, Corcoran Hall and Stockton Hall, in the red-brick Georgian Revival style. The first residential hall built by the university, the Hattie M. Strong Hall for Women, was completed in 1935. During President Cloyd Heck Marvin's long tenure from 1927 to 1959 the university acquired nineteen additional properties. The university's principal architect, Waldron Faulkner, designed the new Lisner Hall, Lisner Auditorium, and the School of Government in styles of Modern architecture that set a new tone for the urban campus. In time, despite the concern of local residents, the university either demolished or reused most of the residential buildings in an area bounded by Washington Circle and 23rd, 19th, and F streets. It would continue to grow into the twenty-first century, with the most recent addition of a new hospital at Washington Circle in 2003, with security designed for the needs of the president of the United States.[13]

As the twentieth century progressed, governmental agencies and national organizations would join George Washington University in changing the residential character of

Foggy Bottom. Its proximity to the White House made it highly desirable. Along 17th Street at the neighborhood's eastern edge rose the national headquarters of the American Red Cross in 1917 and the DAR Constitution Hall in 1929. The National Academy of Sciences opened on Constitution Avenue in 1924. In 1937 the U.S. Department of the Interior moved into its massive new headquarters building, a Public Works Administration project that covered five acres on a site bounded by 18th, 19th, C, and E streets.

World War II deepened the involvement of the neighborhood in national affairs. Foggy Bottom's proximity to the executive branch encouraged agencies supporting the war effort to take up residence, some in empty large buildings once occupied by industry. Construction at George Washington University stopped, except for Lisner Auditorium, which was completed in 1941. After the 1943 season, varsity sports did not resume until the conclusion of the war. By the end of the conflict, the university had sent seven hundred students to war and developed training courses for over twelve thousand. The federal government recognized the university's strength in theoretical physics and awarded it contracts to develop rockets for use by the army and navy. This and other work for the War Department was done secretly, unknown to residents living very close by. The university's proximity to the White House and federal agencies would continue to deepen its emphasis on public policy and international affairs as the years went on.

After the war, dramatic changes transformed the Foggy Bottom neighborhood. The eastern and western sides of Foggy Bottom would become unified as large institutions

and government agencies claimed the landscape on both sides of 23rd Street. One of the most significant arrivals soon after the war was the Department of State, which moved in 1947 into premises originally built for the new War Department at 21st and Virginia Avenue. While university and government uses were growing, industry had all but disappeared. Commercial use of the C&O Canal had effectively ended in 1924. Railroads had replaced water transportation, and gas and oil were replacing coal for home heating. The Washington Gas Light Company began to dismantle its facility in 1947, with the last storage tanks demolished in 1954, symbolizing the end of an industrial era. Many Foggy Bottom residents moved also, following jobs to other locations. Now options for new roles — cultural and upscale residential — arose.

Soon housing developments for middle- and upper-income markets, such as the Potomac Plaza Apartments (1955) and Columbia Plaza (1963), began to rise along Virginia Avenue. Between 1963 and 1967, the sprawling Watergate complex, designed by Italian architect Luigi Moretti, took shape and became a commanding presence on the Potomac River. The John F. Kennedy Center for the Performing Arts opened adjacent to the Watergate in September 1971 on 18½ acres formerly occupied by a brewery, a restaurant, and a riding stable. The grand marble structure, designed by noted American architect Edward Durrell Stone, stretches six hundred feet and rises 135 feet above the Potomac River.

Organizations with worldwide missions were also drawn to the neighborhood after World War II. The World Bank began its work in 1946 at 1818 H Street, still the location of its current, dramatic glass-walled headquarters completed in 1997, though its operations now fill the entire block. The International Monetary Fund began at the same address, moved to 700 19th Street in 1973, and expanded to include a building at 1900 Pennsylvania Avenue in 2005. The Pan American Health Organization chose Foggy Bottom in 1965 when it built its current home at 525 23rd Street.

As houses were replaced by organizational headquarters, road construction in the form of the access ramp to the Theodore Roosevelt Bridge and a section of the never-completed Inner Loop Freeway further cut into the residential character of the area, causing the demolition of almost ten residential blocks. Many of the houses that were lost had just recently been renovated; the historic preservation movement in neighboring Georgetown had inspired new interest in the old houses of Foggy Bottom.

Local residents had tried to play a role in managing the change. As early as 1955 they had formed the Foggy Bottom Restoration Association to protect the interests of the residential community. The group hoped that the Redevelopment Land Agency, or RLA, and the National Capital Planning Commission, or NCPC, would involve them in a planning process that would preserve the historic and residential character of the neighborhood.

The Restoration Association faced powerful interests with many different agendas. Essentially, those involved in private development projects did not favor public participation, fearing delays that might cost time and money. Moreover, public agencies in the

(opposite)
By the 1970s, the curved enormous Watergate complex, the Kennedy Center, seen just beyond it at the right, high-rise apartments such as Columbia Plaza at the top center, and ribbons of roadways had dramatically changed the scale and texture of Foggy Bottom. Virginia Avenue runs along the left side of the picture and Rock Creek Parkway along the right. Courtesy Star Collection, DC Public Library. © Washington Post

late 1950s and early 1960s across the country and in Washington were looking to the urban renewal process as a way to revitalize neighborhoods, a process that in the District had begun with the demolition of Southwest. The RLA did consider using the federally funded urban renewal process in Foggy Bottom. An early study showed, however, that there had already been so much private restoration and redevelopment that such a plan might not be eligible for federal funds. For its part, the NCPC was waiting for decisions about the location of the Inner Loop and a possible cultural center, as well as for the university's expansion program, and thus discouraged any redevelopment plans until these matters were settled. With both agencies deciding not to use the urban renewal process to plan for the neighborhood, members of the Foggy Bottom Restoration Association were on their own in advocating managed growth.

Through their own efforts the Restoration Association members did succeed in having the Inner Loop routed along the west side of the neighborhood instead of down its center. They could not, however, stop the 1958 zoning decision that made way for the high-rise developments such as Potomac Plaza and Columbia Plaza. These buildings, the Kennedy Center, the Watergate, and other large developments would stand in sharp contrast to the small-scale row houses of the nineteenth-century neighborhood. Restoration Association efforts over a thirty-year period did result in the establishment of the Foggy Bottom Historic District, listed on the National Register of Historic Places in 1987, with approximately 135 structures located in four squares around 25th and I streets, including clusters of alley dwellings in two interior blocks. The district was established in recognition of its industrial role in the city, its German and Irish immigrant communities, and its characteristic modest row houses decorated with pressed and molded bricks.[14]

These modest homes, however, are now highly prized and expensive. They sit incongruously amid a neighborhood, once half working-class industrial and half fine residential, that is now as a whole characterized by major educational, cultural, governmental, and private organizations of national and international influence. Residents, students, and workers interact with the White House and executive offices on the east and with a waterfront on the west now focused on natural beauty and recreation rather than industry. The Kennedy Center and Lisner Auditorium provide rich cultural fare.

On the north, George Washington University maintains an ever-growing presence, with many new buildings, including a new university hospital, built during the recent tenure of President Stephen Joel Trachtenberg (1988–2007), as well as new, landscaped formal entrances and courtyards that create a campus setting within the urban streetscape. As in the LeDroit Park neighborhood with its adjacent Howard University, the need for more space for a growing university has caused tensions with the surrounding community. The university has established an informal Friends of Foggy Bottom group and an official office of D.C. and Foggy Bottom / West End Affairs to provide opportunities for dialogue with the city government, residents, and local business people.

The Foggy Bottom Historic District includes clusters of small alley dwellings in two interior blocks such as these in the block bounded by K, L, and 25th streets and Queen Anne's Lane. Once housing the city's poorest in unsanitary conditions without running water, the alley houses that survive are now often restored as desirable in-town residences. Photo by Kathryn S. Smith

It also has been forced to expand elsewhere, establishing a Virginia campus in 1991 and the Mount Vernon campus in the Palisades in 1997.

The mixture of educational and national and international organizations within a residential community creates a distinct milieu in Foggy Bottom. Conversations in many languages related to research and policy making at the World Health Organization, the State Department, George Washington University, and the like can be heard in the busy streets and in the growing number of restaurants and shops that have followed the influx of new students and international employees. Residents in apartments, high-rise condominiums, and historic houses speak out for the quality of life and character of their neighborhood. Foggy Bottom's new diversity adds its exciting mix to the rich tapestry of community life in the District of Columbia.

Southwest Washington

WHERE HISTORY STOPPED

KEITH MELDER

The Southwest Washington neighborhood represents a paradox: it is at the same time one of the city's oldest and one of its newest residential sections. A visitor to Southwest today, unless aware of its historic background, will assume that the area developed recently. But the neighborhood known as Southwest is old, not new; its modern appearance conceals evidence of physical destruction and population upheaval.

Familiar to Native American peoples who occupied the Potomac basin thousands of years before Englishmen arrived, seen by Captain John Smith in 1608, and settled by Marylanders in the late seventeenth century, Southwest Washington was included in the Federal City in 1791 and developed gradually from that time until the mid-twentieth century. Then suddenly, shortly after World War II, the process of gradual change halted. Most buildings in old Southwest were demolished and replaced with new ones, many streets were rerouted, and old residents moved away to be replaced by new populations. A handful of graceful late eighteenth- and early nineteenth-century buildings remains as well as a cluster of housing projects, incongruously reminding visitors that something else was here earlier.

The waterfront neighborhood of Southwest is the only neighborhood in the District that occupies almost an entire city quadrant. A small section of the Southwest quadrant exists across the Anacostia River. Largely occupied by a neighborhood known as Bellevue, its history is not part of this chapter. Map by Larry A. Bowring

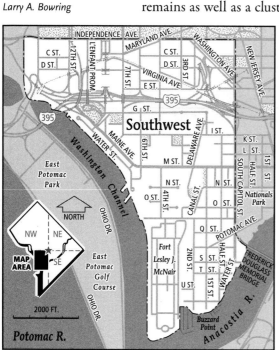

Southwest Washington is part of the original Washington City designed by Peter Charles L'Enfant. Because of its accessible waterfront, the section appealed to L'Enfant and early developers alike. For strategic reasons the planner assigned the southernmost point of Southwest to be a military site, and since 1794 Greenleaf's Point has served as a fort, an army arsenal, a hospital, and a federal prison. Today this land, one of the nation's oldest army posts, is known as Fort Lesley J. McNair, housing the National Defense University and other Defense Department functions.

Early private development in Southwest centered around the Potomac River. Rough wharves and maritime structures provided access for shipping and regular stopping points for freight and passenger vessels. Beginning in the 1790s, for more than a century, travelers could book passage on local ferries and ships bound downriver for Alexandria and points

Shoppers throng the seafood market on Maine Avenue in Southwest to buy fresh fish of all kinds and to snack on crab cakes and freshly shucked oysters. Fishmongers have been hawking their wares on the Southwest waterfront since the early nineteenth century. At this market, shopping is a festive experience. Photo by Rick Reinhard

beyond. Fishermen brought their catches into Southwest for sale to Washingtonians. Slave traders carried their human cargo in and out of the Federal City from Southwest docks.

Real estate developers believed that easy access to the river would make Southwest a popular location for homes and businesses. One of the city's earliest real estate tycoons, James Greenleaf, built several speculative ventures, including a row house project called the "twenty buildings" near South Capitol and N streets, SW. Never finished, owing to the speculator's bankruptcy, the houses stood in ruins for many years, symbolizing the city's vanquished hopes for early prosperity. Wheat Row, dating from 1793–94, Washington's oldest standing row house group, remains as part of Harbour Square on 4th Street near N. Several builders constructed elegant houses such as the Thomas Law House (ca. 1794–96) at 6th and N streets and the houses of Duncanson Cranch (ca. 1794) and Edward Simon Lewis (ca. 1817), still standing in the 400 block of N Street. But after the later 1790s, individual cottages and simple row houses dominated the neighborhood.[1]

Southwest early became a neglected, unfashionable section as development moved to the city's higher ground in Northwest and Southeast. After 1815 the Washington Canal, constructed to provide access by water between Georgetown, downtown, and the Eastern Branch, cut the Southwest off from more desirable parts of the city. (Part of the canal route became today's Constitution Avenue.) Becoming known as "the island," Southwest was home to a diverse population that included many low-income residents. Commerce in bulky goods such as fuel, building materials, and armaments, as well as trade in foodstuffs and slaves, set the neighborhood apart from the federal establishment and offered employment to tradesmen and laborers. Many householders kept pigs, chickens, and other livestock.

Before the Civil War, Southwest housed numerous African Americans, both enslaved and free. African Americans represented more than one-quarter of the population of the District of Columbia from before its founding, and by 1830 more than half of all African Americans were free. The city's free black community comprised laboring people as well as ministers, teachers, and businessmen. One of its early leaders was Rev. Anthony Bowen, who lived in Southwest on E Street between 9th and 10th streets, where he established a mission and a day school for neighborhood young people. During the 1850s he participated in the Underground Railroad, a network of activists that aided fugitive slaves fleeing from the South. Working in secret, Bowen met the freedom seekers at the Sixth Street Wharf in Southwest and assisted them on their way to Philadelphia and other points north where they could be absorbed and hidden from slave catchers.

In 1848 Southwest was the scene of the nation's largest single attempted slave escape when seventy-seven people sailed on the ship *Pearl* from an undisclosed spot on the riverfront. Hoping to reach Philadelphia, the fugitives, including many who belonged to prominent Washington slaveholders, were captured and returned to the Southwest waterfront, sparking a notorious riot publicized and denounced by abolitionists.[2]

During and after the Civil War, the neighborhood grew rapidly, expanding from about ten thousand to eighteen thousand residents between 1860 and 1870 alone. From waterfront docks, hundreds of ships carried armaments, supplies, and troops to wage war in Virginia and attack Richmond. A busy gun and powder factory operated at the armory at Greenleaf's Point. As a result of the war and its employment opportunities, thousands of newly freed slaves settled in Southwest; 18.5 percent of its population was African American in 1806, 37.3 percent in 1870.[3]

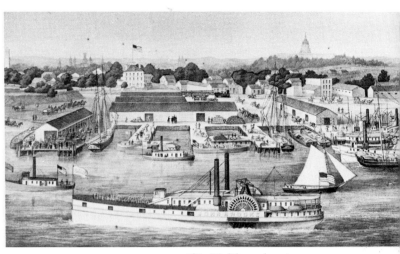

This 1863 lithograph captures the busy scene at the Sixth Street Wharf during the Civil War when it was the city's major port and shipped armaments, supplies, and troops in aid of the Union cause. The Southwest waterfront had been the site of the nation's largest attempted slave escape in 1848, when the Pearl, with seventy-seven escapees aboard, left from the area, only to be captured just short of freedom. Courtesy The Historical Society of Washington, D.C.

Southwest's population nearly doubled between 1870 and 1900 as hundreds of new row houses were constructed and commercial enterprises expanded. Hundreds of tiny dwellings for low-income residents also sprang up along alleys within city blocks. These evolved into small village-like communities made up chiefly of African American families and little known to outsiders. Although the residents were impoverished, the alleys nourished strong protective institutions and rich African American folk traditions. Among other low-income groups in the Southwest were newcomers from Europe — immigrants from Ireland, Italy, and elsewhere who found unskilled jobs and affordable housing in the neighborhood. Many who were Catholic established close ties with St. Dominic's Church, founded in 1852. From the farms and villages of Virginia and southern Maryland came other white families, adding more complexity to Southwest's population.[4]

Even though the Washington Canal had been abandoned and filled in by the 1870s, "the island" remained set apart by another physical barrier: the Baltimore and Potomac Railroad, built along Maryland and Virginia avenues during the late 1850s and 1860s. Railroad trains and busy grade crossings created new dangers and barriers to traffic between Southwest and other parts of the city. Around the same time, however, new horse-drawn streetcar lines offered regular connections to the other quadrants.

Beginning in the 1860s, Southwest welcomed still another group of immigrants — Jewish families from Germany, who worked at various trades and operated small businesses along 4½ (now 4th) and 7th streets. Their community expanded with the wave of Eastern European Jewish immigrations of the 1880s. Jewish entrepreneurs ran dry goods, tailoring, butcher, and bakery shops, and after 1900 specialized in family-run "mom-and-pop" corner grocery stores. At first worshipping in private homes, the immigrants eventually built two synagogues. The first, Talmud Torah congregation, was dedicated in 1906 and later employed cantor and rabbi Moses Yoelson. One of the rabbi's sons grew up on 4½ Street and later became a leading American entertainer, often appearing in black face and singing in a black dialect. Explaining his success, Al Jolson proudly recalled his youth on the streets of old Southwest, where he traveled with a "tough gang" and learned African American speech patterns.

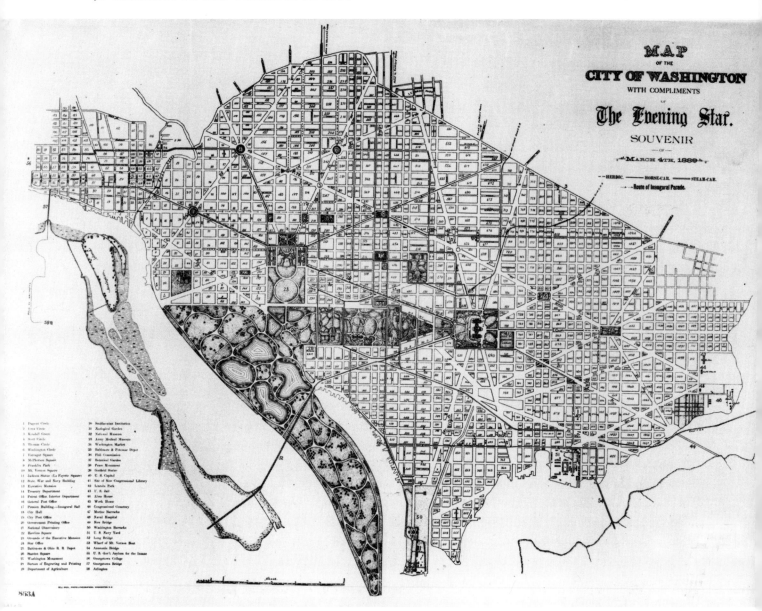

In the 1880s the Army Corps of Engineers dredged the Potomac River bordering Southwest and built up mudflats to create the parkland shown on this 1889 map, extending from the west end of the Mall to the end of today's Hains Point. The wharves along the Southwest waterfront thus enjoyed a safer, deeper harbor called the Washington Channel. Courtesy Library of Congress

As in other parts of the city around this time, a pattern of neighborhood racial segregation emerged. Black residents, formerly living throughout Southwest, were increasingly concentrated east of 4½ Street, and whites dominated west of that artery. Geographer Paul A. Groves argued that Southwest was one of Washington's first fully segregated neighborhoods: "The development of a black residential area in Southwest was a *fait accompli* by 1897." Yet 4½ Street, as the commercial center for all groups, served as a mixing bowl.[5]

Commercial activity on the waterfront, also a place where people mixed, benefited from significant harbor improvements in the 1880s. In 1881 a major flood brought the waters of the Potomac River to the foot of Capitol Hill. Alarmed, members of Congress

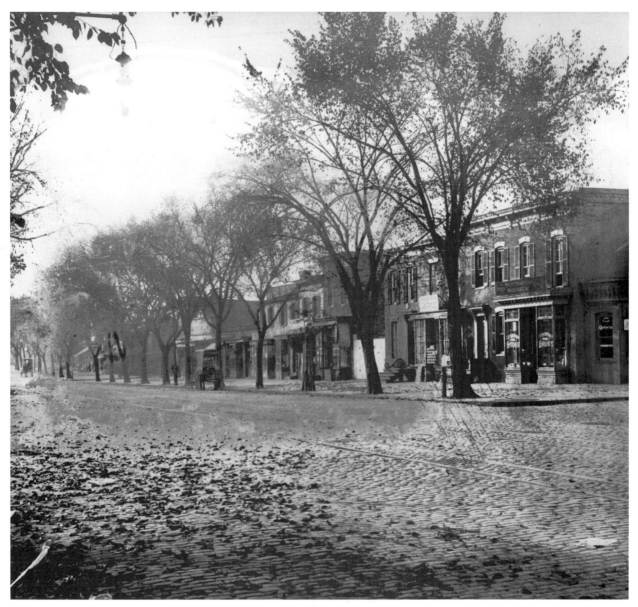

finally approved funds for long-awaited attention to the tidal flats building up in the river. The Army Corps of Engineers dredged the Southwest harbor and deposited the dredged material on the mudflats adjacent to the Southwest waterfront, creating today's Hains Point and the deep, protected harbor known as the Washington Channel. The engineers also created the Tidal Basin, originally envisioned as a series of four lakes, as a sluicing basin to provide fresh water to the channel. The Washington Channel, sheltered from silting and ice floes, was now far superior to the upstream port of Georgetown.[6]

The years between 1895 and 1930 may be thought of as Southwest's period of greatest growth as a diverse residential community. The population peaked at nearly thirty-five thousand around 1905. For many residents, churches and synagogues were the centers

Jewish entrepreneurs ran many of the small businesses on this and other blocks along 4½ Street, captured here about 1900. Jewish families from Germany began settling in Southwest in the 1860s, and their numbers expanded in the last decades of the nineteenth century. This view looks south from I to K streets. Courtesy Library of Congress

of social and community life. Several prominent businessmen lived or traded in South-west. Lewis Jefferson, a leading African American entrepreneur, at various times owned excursion steamboats, a shipyard, a fertilizer business, real estate, and an amusement park down the Potomac serving black Southwesters and residents across the city. An enterprising German Jewish resident, Sidney Hechinger, opened a Southwest salvage and wrecking firm early in the twentieth century that later expanded into hardware stores across the mid-Atlantic region before his heirs sold the business in 1997.

Community institutions reached their maximum growth between 1900 and 1903, with more than two dozen houses of worship, a rich assortment of voluntary associa-tions, social agencies, schools, and activities for young and old, black and white residents. The Jewish population grew from 30 to 190 families and supported a host of institutions in addition to the two synagogues, including social service agencies and the Hebrew Free Loan Association. The city's first social settlement house for whites, Neighborhood House (later Barney Neighborhood House) opened in 1900, followed a few years later by the Southwest Neighborhood House for African Americans and the Council House for Jewish residents. Southwest seemed like a self-contained small city, offering work, service, and entertainment for most of its inhabitants. Southwesters thought of them-selves as belonging to a distinctive, lively neighborhood.[7]

But Southwest's vital social networks concealed many problems that developed after 1900. Relentlessly competing for scarce space, federal agencies — the Bureau of Engrav-

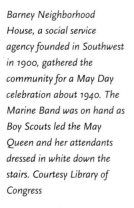

Barney Neighborhood House, a social service agency founded in Southwest in 1900, gathered the community for a May Day celebration about 1940. The Marine Band was on hand as Boy Scouts led the May Queen and her attendants dressed in white down the stairs. Courtesy Library of Congress

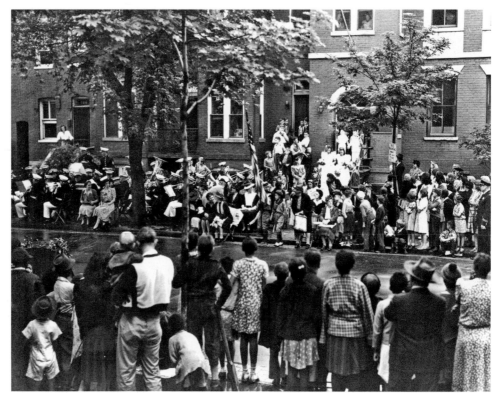

ing, the Department of Agriculture, and others — spread into residential areas, replacing streets of dwellings with office buildings. Private commercial interests also expanded, constructing warehouses, markets, and freight yards in place of residential blocks along the northern boundaries.

These changes increased noise, congestion, and dirt, making the area less desirable for residents who could afford to move elsewhere. Absentee landlords, especially owners of the alley houses, reduced property maintenance, diminishing the quality of low-income housing. Population fell to thirty-two thousand in 1920 and to twenty-four thousand in 1930, and the number of those living in poverty grew. With a mixture of commerce and poverty, Southwest acquired a reputation as a shabby, dirty, crime-ridden, "blighted" slum area. At the same time Southwesters complained of neglect by city authorities.

Residents organized to work for improvements, with Harry Wender often in the lead. A graduate of Central High School and Georgetown University Law School, in 1932 he became active in the Southwest Citizens Association. He later recalled the struggle in 1934 when the white citizens association and the African American civic association joined together to have the "obnoxious" 4½ Street repaired and renamed 4th Street. "We got the cobblestones removed and the street paved," he said. "We got the street widened and lights put up. Then we put on the biggest celebration in the history of the city. . . . It was the first time that Negroes and whites paraded together in the history of Washington." He later worked to protect and expand the local public library and to improve housing conditions. He successfully lobbied for the replacement of the antiquated Jefferson School located alongside the railroad tracks at 6th Street and Virginia Avenue, resulting in a new, elegant Jefferson Junior High School that opened in 1940 at 801 7th Street. Jefferson would be one of the few buildings to survive the wholesale razing of urban renewal.[8]

As Harry Wender began his involvement in the community in the 1930s, federal and local officials, most of them from more affluent parts of the city, also became concerned about conditions in Southwest Washington. They labeled the neighborhood an ugly and dangerous eyesore, often decrying its existence within "the very shadow of the Capitol." Photographers from government agencies and the mass media enjoyed capturing ironic images of dilapidated alley shanties with the Capitol dome in the background. City planners and federal housing reformers agreed that conditions needed to be radically changed. But what should be done?

Federal officials already had ample experience in planning and redesigning Washington's neighborhoods. The L'Enfant Plan of 1791, the McMillan Plan of 1901–2, and the massive Federal Triangle development of the 1920s and 1930s all had demonstrated the federal government's ability to shape the national capital. Moreover, New Deal housing reformers and planners had faith in the capacity of the federal government to improve housing for low-income people. National leaders in the field focused on the crowded and unsanitary houses in Washington's hidden alleys, hoping to make their demolition as well as healthy alternatives a model for the nation. However, in the 1940s, planners and

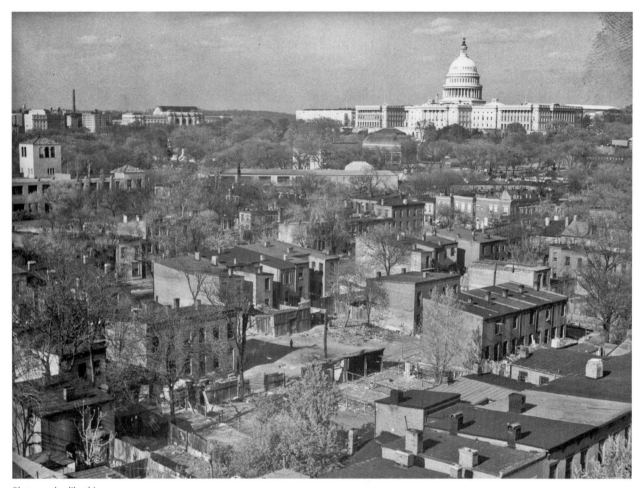

Photographs, like this one taken in the 1930s, were deliberately framed to show a rundown Southwest in the shadow of the Capitol dome and fueled the drive toward demolition in the name of urban renewal. Courtesy Library of Congress

federal officials turned away from an emphasis on housing the poor and instead set out to find radical solutions to ending so-called urban blight. Experts invented a process called urban renewal and chose Southwest Washington to be its first national laboratory. In 1946 Congress chartered a new city office, the Redevelopment Land Agency, or RLA, with ample powers to condemn, redesign, and rebuild whole neighborhoods. In another law, the National Housing Act of 1949, Congress offered subsidies for slum clearance, redevelopment, and low-rent public housing for cities across the nation. Neighborhoods could be planned and "renewed" or rebuilt using federal funds, with little participation from their inhabitants.[9]

By 1950 the pressure for urban renewal in Southwest seemed to be irresistible. A critical planning document written that year described Southwest as "obsolete." "The character of the buildings is so bad that partial rehabilitation is not justifiable economically," declared a federal commission. More than two-thirds of the residents at this point were low-income African Americans, with little political clout. The city's newspapers, led by the *Washington Post,* called for radical change. In a dramatic series of articles titled "Progress or Decay? Washington Must Choose!" the *Post* called for a "bold approach"

in rebuilding blighted areas, Southwest especially, to reverse "white flight" to the suburbs and improve the city's tax base by attracting more middle-income taxpayers.[10]

Control of the neighborhood's destiny had passed entirely out of the hands of Southwest residents. Because Congress and D.C. officials ruled the city in a kind of benevolent dictatorship through three appointed commissioners, their professional planners readily took charge of the neighborhood. They examined several alternatives, including a proposal by eminent planner and landscape architect Elbert Peets to preserve and upgrade the area's old street layout, shade trees, and many of its existing buildings, then reminiscent of those becoming prized in Georgetown. Instead of this option, the RLA chose to rebuild totally, to create a dramatic new neighborhood with high-rise towers and modern town houses and numerous open green spaces. Old houses and businesses, whatever their condition, even many old streets, would disappear.

What would happen to Southwest's people, many of them longtime residents, particularly low-income African Americans? Critics cited evidence of racism in the planners' bold designs, which clearly implied that poor blacks would be replaced by affluent whites. Officially some African Americans were expected to return after reconstruction, to be housed in new public housing projects. Many poor people, however, would have to move permanently — like it or not — to other unnamed locations.

Some observers, concerned with the human implications of uprooting thousands of people against their wishes, raised questions. Reporter George Beveridge of the *Evening Star* asked, "To what extent must the area provide for needs of its present residents?" James Guinan, a copyright examiner at the Library of Congress, wrote a letter to the editor of the *Washington Post* denouncing the plan as " 'bold' as tyranny is bold; and 'dramatic' as tyranny is dramatic," a "turning of our Nation's Capital, the citadel of democracy, into the city of the rich."[11]

While arguments raged, urban renewal moved forward. As residential and commercial areas were being rebuilt, highway engineers developed plans for a dramatic new six-lane highway, the Southeast-Southwest Freeway, which would displace people from hundreds of existing row houses. Despite lawsuits and planning disputes, the RLA began acquiring property for demolition in 1953. In spring 1954 building wreckers started knocking down Dixon Court, a group of alley houses, "a sore spot of crime, illegitimacy, refuse, and disordered lives," in the *Post's* hyperbolic words. Later that year, with many buildings gone, an aged African American grocer assessed the results for the *Evening Star*. "Well," he said, "it seems like they're handin' out a passel o' joy and a passel o' sorrow."[12]

Meanwhile in 1954 the planners had won an important victory in the Supreme Court. An opinion prepared by Justice William O. Douglas in *Berman v. Parker* declared D.C. urban renewal to be constitutional. Denying the argument of Southwest business people that the condemnation of their property was unfair or arbitrary, the Court found that upgrading housing and the urban environment was as much within the municipal police power as more traditional applications of that power.[13]

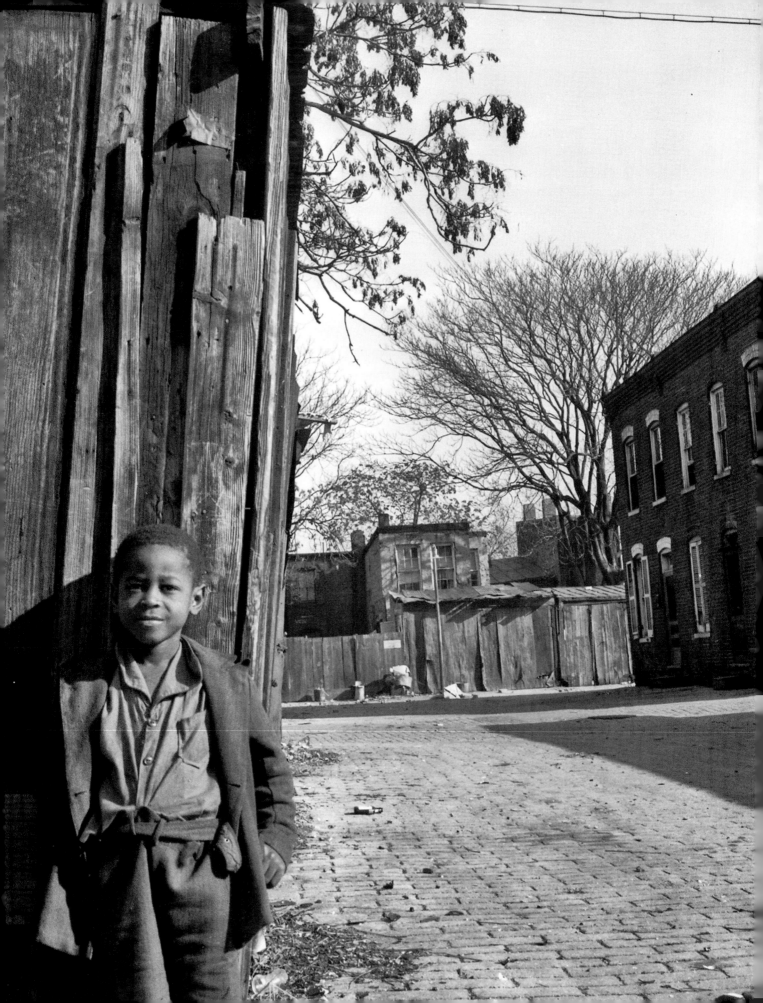

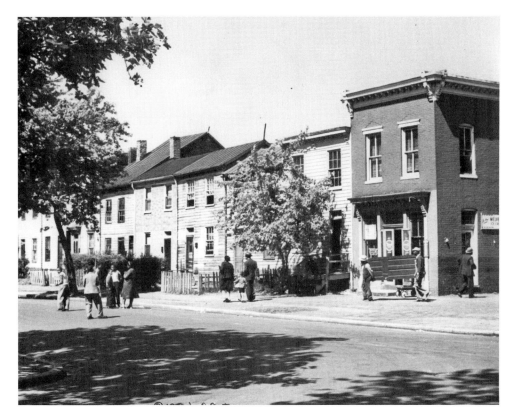

Neighbors visit and go
about their business at 2nd
and G streets in the 1940s.
Some who did not favor urban
renewal asked what would
become of such communities.
Photo by Joseph Owen Curtis.
Courtesy DC Public Library,
Washingtoniana Division,
Curtis Collection

And so, between 1954 and 1960 most of Old Southwest disappeared. Eliminating the old was easier than building the new, however. While new neighborhood designs had to be reviewed, revised, and sometimes reversed, the most difficult problems concerned human beings. Faced with having to rehouse and reorient more than fifteen thousand low-income residents, mostly African Americans, public agencies experimented with new social programs. In 1958 RLA social workers began a "human redevelopment" plan to teach homemakers about their new, more complex household environments, as well as unfamiliar social surroundings.

On the whole these efforts at human engineering were less than successful. Sociologist Daniel Thursz, in a 1966 study of displaced Southwest families, found "a substantial amount of dissatisfaction" among the old Southwesters interviewed. Families had suffered a social loss. "The fact is," wrote Thursz, "they had friends and felt a part of a community which had been theirs for many years. . . . It was home. . . . They resent more than ever before the forced disintegration of the social milieu which was theirs in the old Southwest." In sum, for many residents urban renewal had tragic consequences.[14]

About a quarter of those displaced from Southwest handled their own problems of relocation and adjustment. But even these residents — mostly white and middle class — seldom moved willingly, because they had chosen Southwest for its convenience and its location near the rivers. Many had made large investments in their homes and

(opposite)
World-famous photographer
Gordon Parks captured this young
sentinel at the edge of a Southwest
alley while taking pictures for the
Farm Security Administration in
1942. Although social conditions in
the hidden alleys of Southwest were
the target of reformers, there was a
social order outsiders did not see.
Courtesy Library of Congress

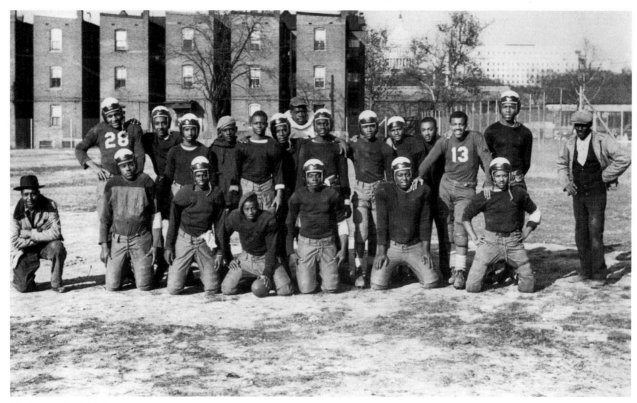

The Willow Tree Athletic Club football team is ready for a game at the Randall Playground about 1950. The team took its name from Willow Tree Alley, a densely populated alley totally demolished in 1916 by housing reformers. The playground took its place on the site. Photo by Joseph Owen Curtis. Courtesy DC Public Library, Washingtoniana Division, Curtis Collection

felt cheated when they were compensated for "condemned" property. Fifty years have passed since the old Southwest disappeared, but few former residents remember their experience of urban renewal with much satisfaction.

History seemed to stop in Southwest Washington in the early 1950s; it resumed in the late 1950s with the neighborhood's rebirth. Along its northern edge, developers built a new commercial center named L'Enfant Plaza — office buildings, hotels, an underground shopping mall, and parking garages. Federal agencies and privately owned buildings now crowded the area between Independence Avenue and the Southwest Freeway, arranged densely like giant filing cases. Adjacent to the waterfront were boat moorings with many "live-aboard" private cruiser and yacht owners. A waterside promenade attracted a few strollers and joggers, while large barnlike restaurants replaced a former jumble of docks, warehouses, markets, and municipal buildings such as the city morgue and a waterfront police station. Despite the waterfront promenade, the buildings along the Potomac River and their access roads tended to wall off the river from the neighborhood.

A few amenities, old and new, were still to be found on the waterfront, although elaborately planned tourist attractions never were constructed. Excursion boats still sailed from Washington Channel docks, and harbor safety facilities were reconstructed near their old location. Offering a hint of the old disorder and vitality, an outdoor fish mar-

ket remained to attract crowds of buyers seeking fresh seafood. In 1961 Washington's Arena Stage opened a new theater-in-the-round near the waterfront.

As one of the first neighborhoods anywhere to experiment with urban renewal, Southwest attracted architectural talents from nationally known as well as local firms. Even before urban renewal, Southwest welcomed the work of Albert I. Cassell, one of the city's leading African American architects, who in 1942 designed the attractive James Creek Dwellings, a public housing complex east of 3rd Street. At first it housed both black and white families, later becoming home only to African Americans. Cassell's development escaped "renewal."[15]

Prominent firms associated with the new Southwest include Harland Bartholomew and Associates of St. Louis, Missouri, which prepared an overall plan to redevelop Southwest in the 1950s in cooperation with Louis Justement and Chloethiel Woodard Smith of Washington. Harry Weese and Associates of Chicago (designers of Washington's Metrorail stations) designed the Arena Stage and Kreeger Theater and the Channel Square residential complex at 4th and P streets. I. M. Pei designed the Town Cen-

ter apartments (1961–62) near 6th and M streets. Chloethiel Woodard Smith and Associates was responsible for several major architectural projects: Capitol Park apartments and townhouses (1958–65), Harbour Square housing complex (1963–66), Waterside Towers apartments (1970), and the Waterside Mall commercial area (1968–72). Washingtonians Keyes, Lethbridge and Condon planned the very similar Tiber Island (1963–65) and Carrollsburg Square (1964–65) complexes. Charles M. Goodman Associates, also of Washington, designed River Park Mutual Homes, a housing cooperative combining town houses and apartments (1961–63). Lapidus, Harle, and Liebman designed Chalk House West (1963–66); the high-ruses of that complex are now known as the Riverside Condominium and the Edgewater Condominium apartments.

Taken together, the new Southwest displays the work and styles of an important cross section of mid-twentieth-century Modernist American architects. Or perhaps, as Christopher Weeks commented in the first edition of the *AIA Guide to the Architecture of Washington* in 1965, "This is Washington's showplace of contemporary building, and perhaps

One of the major architects of the new Southwest, Chloethiel Woodard Smith, poses with her blueprints at the barbeque pit of her Capitol Park apartments in June 1959. Courtesy Washingtoniana Division, D.C. Public Library. © Washington Post

it will in the future constitute an outdoor museum of the architectural clichés of the two decades following World War II." Indeed, in 2006 the DC Preservation League began to focus on Modern architecture in Washington with a crowded conference on that theme, which put the spotlight on the new Southwest, some of its buildings having reached the half-century mark.[16]

The mid-century planners also designed a new business district for Southwest, replacing the small shops along 4th and 7th streets with a shopping center and mall. Difficulties of agreeing on and financing costly commercial buildings delayed and distorted realization of the new retail area, and when finally completed in the 1970s, Waterside Mall patterned after suburban shopping centers of the 1960s, failed to meet neighborhood hopes. Largely tenanted by government offices of the Environmental Protection Agency, or EPA, Waterside Mall early in the twenty-first century contained one large supermarket, a drugstore, a liquor store, a few restaurants and fast food outlets, and other small service providers. While numerous Southwest residents preferred to drive elsewhere to shop, less well-off inhabitants in the neighborhood had little choice but to patronize the mall. Gone were the corner mom-and-pop grocery stores of the past.

The need to do something about Waterside Mall gained momentum in 1997 when the EPA announced it would move out of its office towers. (It did so gradually between 1998 and 2002.) With no immediate replacement in sight, the mall was threatened with large-scale abandonment and loss of many essential businesses. Thus in 1998 local voluntary groups and governmental and commercial interests engaged the nationally noted Urban Land Institute, or ULI, to assess the neighborhood's needs and opportunities. After much debate and discussion with residents, the ULI proposed a major rebuilding of Waterside Mall and other improvements to upgrade business and residential conditions. ULI recommendations included a reconstruction of 4th Street (interrupted by the mall) as the neighborhood's "Main Street," along with new waterfront and residential construction that would realize some of the original 1950s planning goals.[17]

The drumbeat for change picked up momentum during the administration of Mayor Anthony A. Williams between 1998 and 2006. Williams chose as one of his key initiatives the revitalization of the Anacostia River waterfront. The Washington Channel of the Potomac River in Southwest was included in the vision. Plans are currently in place and developers chosen for the redevelopment of the entire stretch of riverfront parallel to Maine Avenue, including condominiums, apartments, hotel rooms, office space, shops, restaurants, and cultural attractions, as well as new piers and a public promenade. In contrast to the 1950s urban renewal design that had largely turned away from the river, these plans focus on making the river more accessible. High-rise towers, however, are proposed to replace the one-story profile along the shore, blocking waterfront views in some places.[18]

In a parallel development, Waterside Mall has been demolished, to be replaced by a totally new set of buildings to house offices, shops, and many more residential units. Temporary quarters were provided for some key services, but the supermarket remained

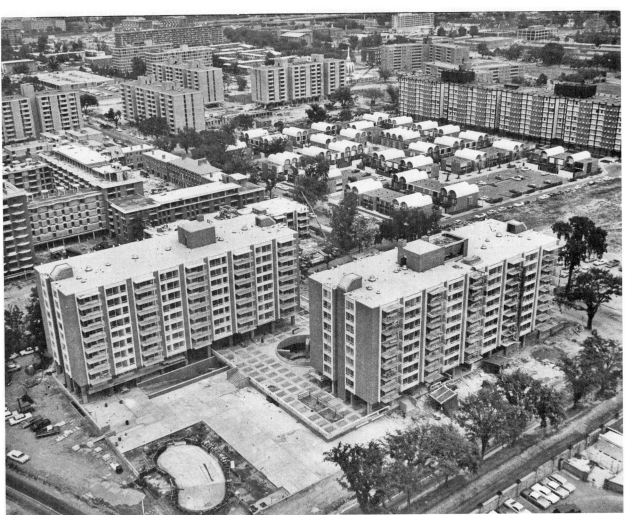

By 1965 the new Southwest was largely in place, a mixture of Modern apartment buildings and town houses. The two Chalk House West high-rises are in the foreground, Harbour Square is immediately behind them on the left, and Tiber Island sits behind it at the upper left. Carrollsburg Square is seen at the center top. The barrel-roofed town houses and the high-rise at the upper right made up the River Park complex. Fourth Street runs diagonally across the middle of the photograph. Courtesy Star Collection, DC Public Library. © Washington Post

in place. As the ULI had earlier recommended, 4th Street will be reopened as a major artery through the complex. Arena Stage, a landmark in the community since 1961, is expanding with a dramatic, glass-enclosed complex designed by internationally known architect Bing Thom. As these new developments emerged, some of the Modern buildings and landscapes of the 1950s and 1960s, newly appreciated by architectural historians, began to fall. Landscaping and sculptural elements on the grounds of Potomac Place (formerly Capitol Park) have been removed or altered. The Modern, stately, yet rundown structure of St. Matthew's Lutheran Church on M Street is gone, to be replaced by a new church, community center, and a residential structure. Other aspects of the new Southwest are slated to disappear, to the consternation of those who now see the neighborhood as an iconic example of post–World War II architecture.

The new Southwest, as it stands today, has undeniably handsome features. The absence of variety found in other areas, however, where structures were built at different times, gives the neighborhood a sterile look. Yet in many ways the Southwest story

resembles that of other city neighborhoods. Since 1950 the affluent have displaced the poor throughout inner-city Washington. But in Georgetown, on Capitol Hill, and in parts of Northwest, a process of restoration and gentrification has occurred — not wholesale, traumatic removal, razing, and rebuilding. Nevertheless, low-income residents, forced out of their homes by rent increases and real estate developers, moved from their communities just as surely as those displaced by urban renewal.[19]

Its handsome appearance and modern style make Southwest seem a new neighborhood, not an old one. Despite its glossy setting, however, some old-style community institutions have evolved to replace the dense social networks of former times. Even though few old church buildings remain, about a dozen religious congregations have survived or emerged since the urban renewal era. The Southwest Neighborhood Assembly, founded during the 1960s to represent all geographical, social, and economic segments of the neighborhood, strives to bring residents into a coherent community. It succeeds the earlier Southwest Citizens Association (white) and Southwest Civic Association (African American). The assembly sponsors regular projects serving the entire Southwest: a scholarship program, the monthly newspaper *Southwester,* lobbying efforts on issues such as crime, traffic, housing, education, and more. In 2001 the assembly sponsored a local parade with hundreds of participants celebrating neighborhood solidarity.

In some senses the new Southwest reflects urban America in the twenty-first century. Its people are unified by needs and geography, yet divided by race and income. While census statistics show a racially mixed population fairly well divided between African American and white, the races are not evenly distributed. African Americans remain as concentrated east of 4th Street, where low-income housing projects were spared from urban renewal, as they were a century earlier. And as in many inner-city areas across the nation, some physical and economic divisions defy efforts to bring people together. Auto traffic, for example, fragments the neighborhood. At rush hour several Southwest streets — M, I, and 7th streets and Maine Avenue — become dangerous, congested commuter thoroughfares.

Despite appearances, Southwest history never stopped. History instead took a new direction that wiped out much physical evidence from the neighborhood's past, uprooted people, and destroyed a diverse, fragile community. Southwest's urban renewal — its old-new, lost-and-found neighborhood — showed Americans the continuing advantages and drawbacks of dramatic urban change.

Early Settlements in Washington County

The District of Columbia beyond the boundaries of Washington City and Georgetown remained rural until after the Civil War. Known as Washington County, the area was governed by a levy court. Here the landholdings of the original proprietors were slowly being divided up into smaller farms and country estates, many worked by enslaved labor.

Amid the woods and fields were a scattering of small crossroads villages, some of which predated the arrival of the federal government in 1800. One grew up where the road between Georgetown and Frederick, Maryland (today's Wisconsin Avenue), met the road to Harper's Ferry (today's River Road). John Tennally built a tavern there in the 1780s. In 1827 the crossing was chosen as the site of a tollbooth on a new private turnpike following the old road to Georgetown, increasing its importance as a place that came to be called Tennallytown. Access to the heart of Washington City, however, required another road from Frederick on the east side of the chasm cut by Rock Creek. This route, today's Georgia Avenue, also had a tollbooth at the pike's crossing with Rock Creek Ford and Piney Branch roads, a place that took the name Brightwood. Tenleytown and Brightwood survive as neighborhoods in twenty-first-century Washington.

The history of another of today's neighborhoods, the Palisades, is rooted in an old transportation route that took cattle on the hoof from Virginia, across the Chain Bridge over the Potomac River, to Georgetown. The Palisades served agricultural purposes until the late nineteenth century. Its dramatic views of the Potomac and its location on the route to Great Falls lured

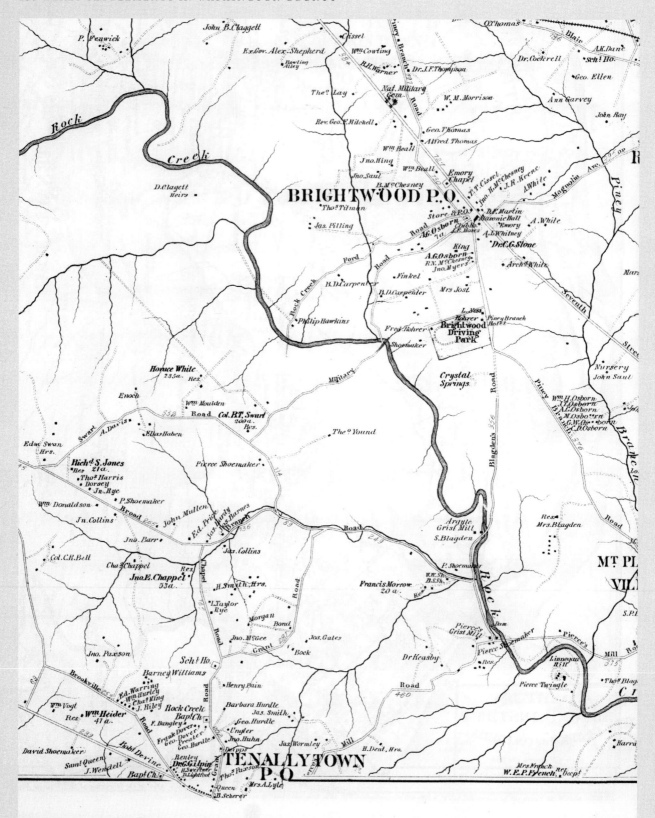

tourists, while dairy farms and cattle operations dominated its economy. Although the community first developed along an electric streetcar line, as did many neighborhoods described later in this book, its unique story lies in the history of rural Washington County.

While Good Hope, on the east side of the Eastern Branch, began as a crossroads trading village, the two largest early communities on that side of the river were planned. Uniontown, soon renamed Anacostia, was laid out as Washington City's first planned suburb in 1854 at the end of the 11th Street Bridge, with its access to jobs at the Navy Yard at the Washington City end of the bridge as a drawing card. Just to the south was the community of Barry Farm, later called Hillsdale, created as a freedmen's village just after the Civil War. They grew up together, both thought of by many as Anacostia, the former predominantly white until the 1950s, the latter always an African American community.

White Washingtonians and free African Americans often lived close together in the country in this period, as they did in the city. At Vinegar Hill in Brightwood and Stantontown near Good Hope, free people of color created their own communities. In the Palisades at Battery Kemble, white landowners helped African Americans who had clustered nearby for safety during the Civil War to acquire land and settle down.

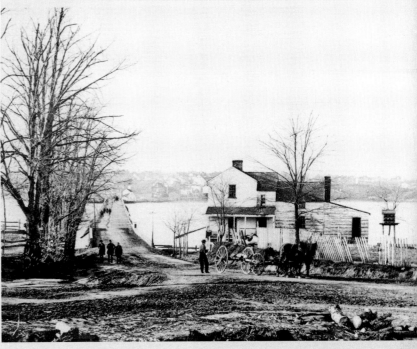

A horse-drawn wagon pauses at the southeastern end of the 11th Street Bridge across the Anacostia River in the 1860s. The City of Washington is seen across the river. Master Civil War photographer Mathew Brady took this picture near Uniontown (today's Old Anacostia), laid out in 1854 as the first suburb of Washington City. It was convenient to jobs at the Navy Yard, just across the bridge. Courtesy National Archives

(opposite)
Today's neighborhoods of Brightwood and Tenleytown both began at the juncture of several country roads. By 1878, when this map was published by G. M. Hopkins, they were still distinctly rural. Courtesy Library of Congress

Tenleytown/ American University Metrorail station, completed in 1984 at the intersection of Wisconsin Avenue and Albemarle Street, enhances Tenleytown's traditional role as a crossroads community. The Cityline at Tenley condominium, built on top of the onetime Sears rooftop parking lot, appears at the left. Photo by Kathryn S. Smith

Tenleytown

CROSSROADS

JUDITH BECK HELM AND KATHRYN COLLISON RAY

True to its origins as a place where pathways cross, the heart of Tenleytown at Wisconsin Avenue and River Road has evolved from the small village that grew around John Tennally's colonial tavern to a hub of urban activity. The subway, automobiles, and buses carry students to five schools in the immediate area — American University, St. Ann's Academy, Janney Elementary School, Alice Deal Junior High, and Woodrow Wilson High School. Radio and television broadcast towers, taking advantage of the neighborhood's location at the highest elevation in the city, mark the crossroads as the center of a communications network as well. Stores and restaurants provide meeting places where neighbors mingle with people from throughout the city. Just steps away from the urban bustle, residential streets of single family homes retain, in the eyes of many residents, a quality of village life.

Tenleytown's historical identity as a crossroads village was lost for many years. As the city grew around it, the twentieth-century developments of American University Park, North Cleveland Park, Chevy Chase, and Friendship Heights erased the place called Tenleytown from the map and from many people's minds. A resurgence of interest in local history, sparked by the nation's bicentennial celebration and the publication of a history of Tenleytown in 1981, resurrected the name. Its rediscovered past revealed a place that has been shaped by the city's transportation patterns from its earliest days to the present. The newly recovered name was applied to the new Metrorail station in 1984, sealing its presence in the lexicon.[1]

Tenleytown has never had exact boundaries, nor was it ever incorporated as a village, but most think of the neighborhood as beginning at Upton Street on the south and ending at Fessenden Street on the north. On the west it merges with American University Park and on the east with North Cleveland Park. This is a relatively limited area

Tenleytown began as a crossroads community and continues to be a transportation hub around which no boundaries can accurately be drawn. Centered on Tenley Circle and the intersection of Wisconsin Avenue and River Road just to the north, it is commonly perceived as extending from Upton Street north to Fessenden Street. On the east it quickly merges with North Cleveland Park and on the west with American University Park. Map by Larry A. Bowring

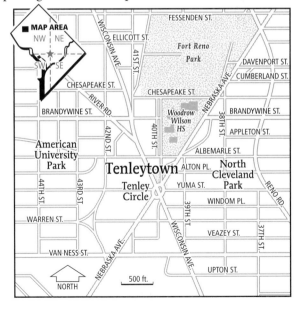

now, but a hundred years ago Tenleytown was the post office for farmers as far east as Rock Creek and beyond River Road and Western Avenue on the west.

There is evidence that Native Americans were the first to make this area a thoroughfare. Ancient inhabitants trod a path through the forest on their way from nearby quarries, the source of stone for tools and weapons, to their camps along the Potomac River. One quarry was located near the present-day northwest corner of Wisconsin Avenue and Albemarle Street, NW, and a number of others lay just to the east. Archaeologists estimate that most of the quarrying and stone-working activities near Tenleytown occurred between 3000 and 1100 BC, although more ancient artifacts of general Clovis type, dating between 9000 and 9500 BC, have been found within the District. The ancient inhabitants were of the Conoy tribe, a confederation of Algonquian-speaking people in today's Maryland whose territory reached as far north as Baltimore. Swiss nobleman and explorer Baron Christoph von Graffenried's 1712 map shows an established Conoy trail that roughly followed the route of today's Wisconsin Avenue. By the mid-eighteenth century, the ancient trail was a well-traveled route between the city of Georgetown and points to the north and northwest. Maryland farmers rolled their hogsheads of tobacco along the descent to warehouses on the Potomac, returning home with finished goods from Georgetown. This trade route came to be known as the Georgetown to Frederick (or Fredericktown) Road.[2]

This early passageway became part of the first military road in colonial America. In 1755 the British were planning an expedition against the French at Fort Duquesne, which was to be led by General Edward Braddock. To aid the movement of troops, Governor Horatio Sharpe of Maryland ordered the construction of a twelve-foot-wide road from Rock Creek to Wills Creek, beyond Cumberland. This "Braddock Road" followed the present-day route of Wisconsin Avenue to a point just north of what would become Tenleytown, veering right onto today's 41st Street and then onto Belt Road, both of which predated River Road and the upper section of today's Wisconsin Avenue. It resumed the route of Wisconsin Avenue just north of the District line and then angled left onto Old Georgetown Road to a point just south of Rockville. The construction of this road encouraged travel to and from the port of Georgetown and benefited the area that would become Tenleytown.[3]

The oldest name associated with the area was not Tenleytown but Friendship. In 1713 Thomas Addison and James Stoddert received a patent of more than three thousand acres in colonial Maryland from Charles Calvert, Lord Baltimore. This land grant, which they named Friendship, extended from today's American University on the south, to Bethesda on the north, to the Dalecarlia Reservoir on the west, and to 41st Street on the east. The northern half (above today's Fessenden Street) was claimed by Stoddert, and Addison claimed the southern portion. Twelve years later, in 1725, Joseph Belt patented Cheivy Chace, a tract that adjoined the northern half of Friendship. Belt Road, a narrow lane which winds through Tenleytown today, is named for this early landowner.[4]

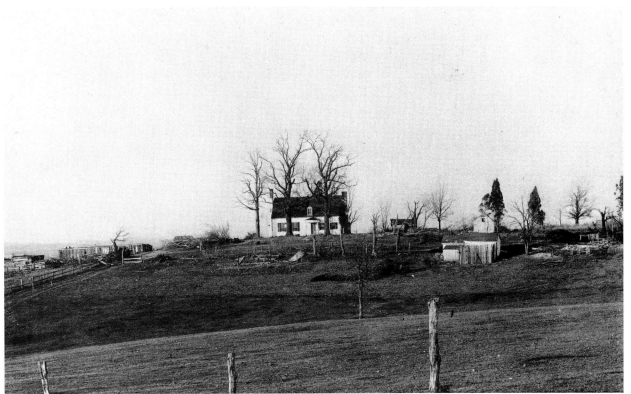

Perched on a knoll south of today's Massachusetts Avenue, Friendship, the 1760 home of John Murdock, had a view of Georgetown and the Potomac River far below. The house, photographed in 1897, stood on the present site of the president's building on the American University campus. Courtesy American University Archives and Special Collections

John Murdock, grandson of Thomas Addison, was the first to build a homestead on the Friendship patent, in about 1760. His house sat on the crest of a hill on today's American University campus, with views of the Potomac and Georgetown. The old Murdock house was torn down before 1918; however, sections of Murdock Mill Road are still extant. John R. McLean, publisher of the *Washington Post*, would later use the name Friendship for his lavish, early twentieth-century estate just south of Tenleytown, and this more euphonious name has subsequently been perpetuated in many ways in the area. Friendship Heights, for example, is used to refer to the area just north of Tenleytown, and cross-town buses carry the name as their destination.

The place that would become Tenleytown was established as an important crossroads site with the construction of River Road for horse-drawn vehicles by Jacob Funk about 1779. This was the same Jacob Funk who founded and promoted Hamburgh, a small German community on the Potomac east of Georgetown, today called Foggy Bottom. Funk's River Road began at the Georgetown to Frederick Road and continued west until it paralleled the Potomac River on its way to Great Falls, Seneca, and Harper's Ferry.

Sometime in the 1780s John Tennally and his family moved from Prince George's County to the crossroads of the newly constructed River Road and the Georgetown to Frederick Road. Tennally built a tavern on the west side of the Fredericktown Road, just north of River Road. Montgomery County court records show that in 1788 and

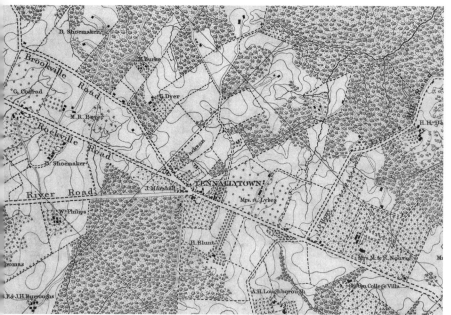

John Tennally set up his tavern in the late 1780s at the juncture of the road to Rockville, today's Wisconsin Avenue; River Road, which led to Harper's Ferry; and Brookeville Road, which no longer exists in that neighborhood. The area was still farmland when Albert Boschke published the larger map of which this is a part in 1861 (see full map on pages 6 and 7). Courtesy Library of Congress

1789 John Tennally (or Tennely or Fennely or Tennoly, as his name was variously spelled) was cited for "keeping a publick house of entertainment" without a license. It is not surprising that Tennally's surname would be corrupted in written records because he may not have known how to spell it himself. In 1776 he and his brother signed with an *X* the required Oath of Fidelity and Support to the State of Maryland. It is likely that members of the Tennally family pronounced their name with three syllables, for the earliest records all have an *E* or an *A* between the double *N* and double *L*. The confusion over the spelling, and pronunciation, of Tennally would continue well into the twentieth century.

Tennally's Tavern soon became a landmark in the undeveloped rural area. The fork in the road became known as Tennally's Tavern on maps, in newspaper advertisements, and in official documents. A village grew around the tavern and the crossroads became known as Tennallytown. As early as 1786 the official records of the Presbyterian Church lament that "Tenally Town" was without a pastor.

In 1791, when Maryland ceded land to Congress for the seat of government, Tennally's Tavern was situated within the ten-mile square, thus becoming part of Washington County in the District of Columbia. In 1797 the first stagecoach line from Georgetown to Frederick passed by Tennally's establishment, most likely adding to the tavern's clientele. John Tennally, who died in 1799, did not live to see Congress and the president take up residence in the new nation's capital. His sister, Sarah Tennally, however, lived for many years at the top of the hill near present-day Brandywine Street, in a house torn down in the 1950s.[5]

Around 1805 Henry Riszner built a new tavern in Tennallytown, south of the River Road fork. It probably replaced the old tavern as a stagecoach stop. The Tennallytown Road and its continuation to Frederick became a well-traveled road, a southeastern link in the Great National Road to the west, completed as far as Wheeling in what was then Virginia, by 1818. Its surface, however, was infamous for its poor quality, deeply rutted when dry and impassable with mud when it rained or snowed. Tales told by stagecoach riders between Georgetown and Frederick show they always feared capsizing when careening down a steep hill or crossing a creek, and their worst fears often came true.

Enterprising local landowners formed the Washington Turnpike Company and, beginning about 1827, widened and paved the road to Frederick. The company erected a series of tollhouses in 1829, one at Tennallytown, to cover the cost of improvements. The Tennallytown tollgate was at the top of the hill in the village, just north of the

River Road turnoff. By 1840 the original route along Belt Road had been changed to the shorter but steeper route of present-day Wisconsin Avenue from Brandywine Street to the District line.[6]

In the first half of the twentieth century, the well-favored land in the area was held by a very few, mostly interrelated families. Of the old estate houses, only three still stand. The Rest, built for Sarah Love in 1805, is a private home at 39th Street and Windom Place. The Highlands, begun by Charles Nourse around 1817, is now the administration building of Sidwell Friends School on Wisconsin Avenue. Dunblane (variously spelled Dumblane) was built in the 1830s for Clement Smith. For more than eighty years the home was used as classrooms for the lower school of Immaculata Seminary. In 1986, when American University purchased the Immaculata property, Dunblane became part of the university's Tenley Campus.

A post office, the first in the upper northwest part of Washington County, opened on December 19, 1846. It was named the Tennallytown Station. With the establishment of a post office, those living in the village, as well as farmers in most of that part of the county west of Rock Creek, would have had a Tennallytown address. The road from Georgetown to Tennally's Tavern became known as the Tennallytown Road. In the 1850s a new and larger Tennallytown Inn was built on the west side of the Tennallytown Road. It served as an overnight stopping place for horse and coach travelers, especially farmers and merchants going to and from Georgetown and Washington City. The ground floor doubled as a dining room and saloon. The inn was later owned by the German brewer Christian Heurich .[7]

Tennallytown's location and elevation made the village central to the Civil War defenses of Washington in 1861. A fort, named Fort Pennsylvania in honor of the soldiers who built and manned it, was hastily erected on a hill northeast of the crossroads, adjacent to Belt Road, near the farmhouse of Giles Dyer. At more than four hundred feet above sea level, it was the highest elevation in the city. (The brass marker in today's Fort Reno Park placed in 2008 identifies the city's high point at 409 feet; the U.S. Geological Survey, however, correctly lists it as 411 feet.) A year later it was the largest fort protecting the capital, with the heaviest artillery and the greatest number of soldiers. Its name was later changed to Fort Reno in memory of fallen Union Major General Jesse Lee Reno. The strength of Fort Reno was never challenged by the Confederate army, but some of its soldiers would provide back-up support when the South attacked Fort Stevens in Brightwood, the only Civil War battle fought in the District.[8]

Four years of army occupation had a significant impact on the village. The Dyer family resumed possession of their farm after the war, but in 1869 the heirs of Giles Dyer decided to sell the property to two men involved in real estate. Soon small lots were for sale in the first real estate development in Tennallytown. The modestly priced lots provided affordable homes for many African Americans. It is likely that at Fort Reno, as at other Union forts surrounding the city, those newly released from slavery had taken refuge nearby for security and assistance; thus it was not surprising that these affordable

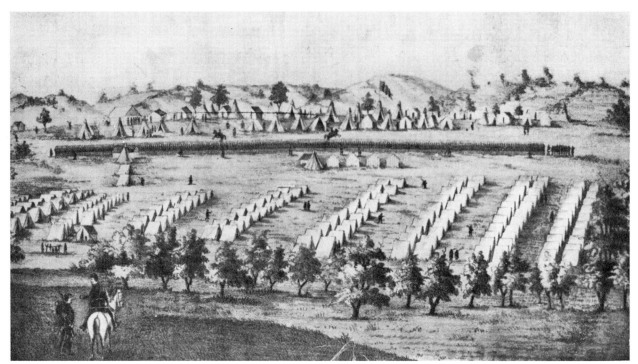

The tents of the 10th Pennsylvania Regiment form neat rows at Camp Tennelly, just south of Fort Pennsylvania, later renamed Fort Reno. Oregon Wilson sketched this view in October 1861. Courtesy DC Public Library, Washingtoniana Division

lots found a ready market among them. "Reno" subsequently became predominantly, but not exclusively, an African American community.

The enclave had a few stores and supported three churches: Rock Creek Baptist, St. Mark's African Methodist Episcopal, and St. George's Episcopal. From 1872 to 1906 the area was listed in the city directories as Reno City, but residents rarely used the word "city." By 1894 there were about sixty houses on the old fort site. Many of the small shacks built just after the war had been replaced by more substantial houses. In 1903 a fine new grammar school for African American students, the Jesse Lee Reno School, replaced a small frame schoolhouse on Grant Road. The structure stands empty at this writing on the grounds of Alice Deal Junior High School. Reno was a secure and healthy place, especially when compared with the more crowded conditions in the downtown sections of Washington. Relationships between the races were generally good, with black and white families well known to one another and in many cases interdependent.

In July 1890 the name of Tennallytown Road was officially changed to Wisconsin Avenue. That same year electric streetcars came clanging through Tennallytown from Georgetown on their way to the District line. The streetcars followed almost the same route traveled by stagecoaches a century earlier. The construction of the trolley line north from Georgetown closed the distance between Washington and Tennallytown and opened up adjacent land for development. In 1895 an act of Congress officially abolished Georgetown as a separate jurisdiction, although it had already been included in the short-lived territorial government of the District in 1871 and the presidentially appointed commissioner system of government that followed in 1874. The village of Ten-

nallytown was about to be absorbed by the growing capital. At the turn of the twentieth century the village was largely a working-class community. Most homes were frame cottages, some with Victorian details popular when they were built in the 1880s. A number of these still stand, particularly along Grant Road and 41st Street. Local men were farmers, butchers, storekeepers, stone masons, laborers, carpenters, policemen, or streetcar motormen. Most whites were of English or German heritage, but there were Irish and Italian families as well.[9]

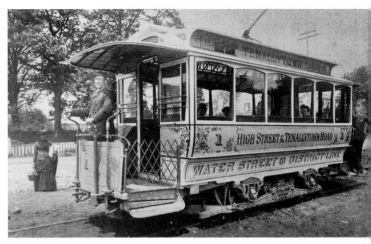

Electric streetcars like this one began to run between Georgetown and Tenleytown on their way to the District line in 1890. The route followed Wisconsin Avenue, the new name given the Tennallytown Road that same year. Courtesy Gladys Smith Clemons and Judith Beck Helm

Among some critics the village had a bad reputation because of its taverns, frequently the scenes of gambling, drunkenness, and fights. About once a year someone was shot or stabbed. Such people, however, were a minority, accepted by the majority as local color. After all, they were fellow parishioners, customers, and relatives.

Churches were central to community life. There were four white churches in Tennallytown. Mt. Zion Methodist Episcopal was the first, begun in 1840 and later renamed Eldbrooke Methodist. Because of dwindling membership, despite its historic status, the Eldbrooke church building was offered for sale in 2006. The Jesuits of Georgetown College established St. Ann's Roman Catholic parish in 1867. Mt. Tabor Baptist, later renamed Wisconsin Avenue Baptist, was founded in 1870. St. Columba's Episcopal Church was created in 1874 as a mission of St. Alban's Church.

Families in early twentieth-century Tennallytown tended to be large and intertwined. There were twelve common surnames in the village, and almost all white residents were related to one or more of these families: Burrows, Riley, Robey, Hurdle, Harry, Perna, Poore, Shoemaker, Chappell, Paxton, Queen, and Walther. C. H. M. Walther of Murdock Mill Road had the largest family in Tennallytown. He was the father of fourteen children by his first wife, although only six lived to maturity, and nine by his second wife.

A few well-to-do citizens chose to locate their fine homes and country estates in the Tenleytown area. In the summer of 1911 Samuel Hazen Bond hired the famous Gustav Stickley to design and construct a Craftsman-style mansion at the southwest corner of today's 42nd and Warren streets. Bond named his home Dumblane, which caused great confusion because the house just to the north was referred to as both Dunblane and Dumblane. The Stickley mansion narrowly escaped the wrecking ball in 1969 and remains a private residence.

In 1920 the centuries-old confusion over the spelling of Tennallytown (Tenallytown, Tenley-Town, Tennellytown, Tenleytown) was laid to rest when postal officials decreed that "Tenleytown" would henceforth be the official name.

By this time, the open spaces around the old village began to beckon real estate developers. The affluent suburbs of Cleveland Park to the south and Chevy Chase to the

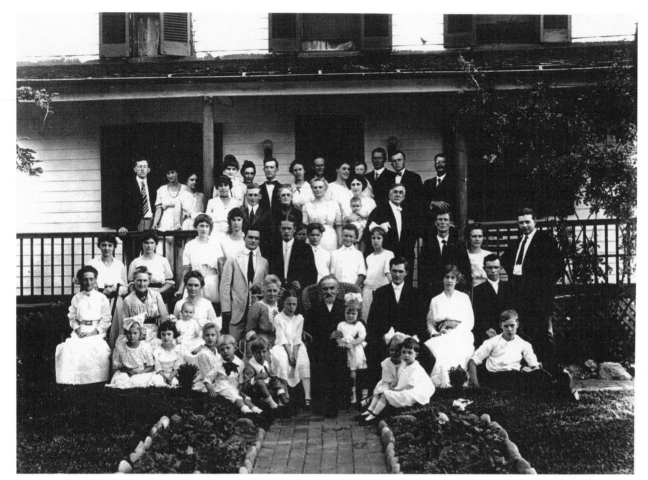

The fifteen children of patriarch C. H. M. Walther gathered along with their families on the porch of the Walther home on Murdock Mill Road. Walther is seated at the center with his second wife and mother of nine of his offspring, Sophronia, at his right. He headed the largest of Tenleytown's many large families when this picture was taken in 1915. Courtesy Mary Frances Brown and Judith Beck Helm

north had been laid out around 1900, but undeveloped land was still available on all sides. In the early 1920s Armesleigh Park rose on the east side of Wisconsin Avenue. It was an appealing subdivision of frame homes with distinctive stone foundations and chimneys. In the 1930s the subdivisions of North Cleveland Park, Friendship Heights, and American University Park offered solidly built brick Colonial-style homes.

The target market was the emerging middle class of white-collar workers, many starting careers and families. As newer houses were built, the village of Tenleytown began to lose its identity as a separate community. Realty brochures advertised the desirability of the elevated, beautiful, and undeveloped area. Wishing to disassociate the new developments from the working-class identity of Tenleytown, real estate agents referred to the area as Friendship. Tenleytown, after all, was never an incorporated place, never had exact boundaries, and did not appear on the city's neighborhood assessment map. By 1940 Friendship had replaced Tenleytown as the name of the neighborhood post office.

The new residents had high aspirations for their neighborhoods. They formed citizens associations to press for civic improvements. The Northwest Suburban Citizens Association was formed in 1892; in 1928 its name was changed to the Friendship Citizens Association. By 1940 this group had successfully lobbied for new schools, paved

streets, city services, an increased police force, and a library. Citizens groups with similar aspirations were at work nearby. Devonshire Downs (North Cleveland Park) Citizens Association was organized in 1926 and the American University Park Citizens Association in 1927.

The Reno community stood in stark contrast to the neat, new homes. Black and white people lived there together in an area east of Wisconsin Avenue, bounded by Chesapeake and Fessenden streets and Belt and Howard roads. The new suburban communities that were becoming the ideal for the middle class were segregated, sometimes by legal covenants. Reno was an eclectic mix of people and of old houses, some of which were dilapidated and lacked modern plumbing. The streets were not paved; chickens ran loose. Many of the Reno residents still had a horse and a cow or even a goat. The whole image of Reno, as quaint as some may have considered it, was thought of as undesirable by those whose concept of beauty was identified with red-brick or freshly painted white frame houses, neat fences, sidewalks and curbs, and closely mowed grass.

In the late 1920s and the 1930s, with the approval and encouragement of the civic associations, local and federal agencies took actions that resulted in the eventual demolition of all but a few of the Reno homes and the scattering of their residents. Land and houses were taken by eminent domain for a new water reservoir and tower in 1928 and 1929, for Alice Deal Junior High School in 1931, and for Woodrow Wilson Senior High School in 1935. In 1930 Congress approved the acquisition of the remaining fort site for a park, part of a larger plan to turn all the city's Civil War fort sites into recreation centers connected by a circular Fort Drive, a plan that has yet to materialize. The landowners of Reno, white and black, protested to no avail. By 1939 most of the Reno community was gone, although a few families would remain and Reno Elementary School would serve their children until it closed in 1950.

The late 1930s and early 1940s brought major changes to the neighborhood, and once again it was a shift in transportation technology that created them. Automobiles were now within the budgets of average citizens, and planners and entrepreneurs made an effort to accommodate them in Tenleytown. The paving of Nebraska Avenue from American University to Military Road connected Tenleytown more directly with Chevy Chase and Connecticut Avenue. Tenley Circle, at the intersection of Nebraska Avenue, Wisconsin Avenue, and Yuma Street, was paved in 1936 and became a busy bus and streetcar connection.

The arrival of chain stores, beginning with Giant Food in 1939 and the Sears, Roebuck and Co. department store in 1940, had a dramatic effect on the neighborhood. The large, innovative Sears replaced the old Tennallytown Inn as the crossroads' landmark. Both Sears and Giant Food, just across Wisconsin Avenue, featured rooftop parking lots that attracted shoppers from far beyond the immediate neighborhood. The Sears automotive repair center off River Road was crowded with cars from all over Northwest Washington. While some of Tenleytown's small stores benefited from the increased business, others could not compete. Traffic increased on Wisconsin Avenue, necessitat-

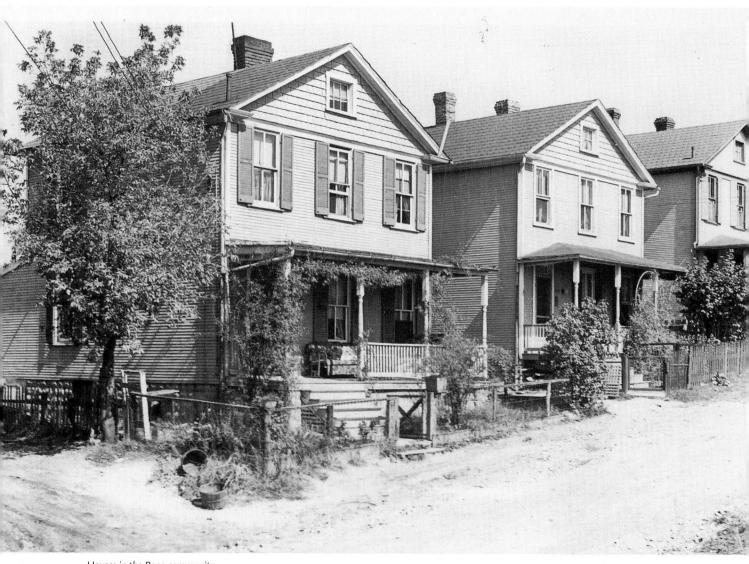

Houses in the Reno community, such as these on Ellicott Street uphill from Belt Road seen in the 1930s, stood in stark contrast to the more modern houses going up at the same time in adjacent neighborhoods such as American University Park. Courtesy National Park Service, Museum Resource Center

ing the installation of a traffic light at Albemarle Street to protect bus riders and children walking to St. Ann's and Janney schools. The small-town atmosphere was beginning to disappear; no longer did people recognize everyone on the street.[10]

On May 17, 1954, the Supreme Court handed down its decision in *Bolling v. Sharpe*, the District's companion case to *Brown v. Board of Education*. Racial segregation in the public schools of Washington, D.C., was brought to an end. Ray and Ralph Sanders, former Janney PTA copresidents, remembered the day African American children were first bused to Janney. They agreed, as quoted in a school history, that "we wanted the parents to feel a part of the Janney community. Desegregation went smoothly at Janney; we are all proud to say that."[11]

The Tenleytown-Friendship streetcar line, no. 30, the last of the overhead trolleys, took its final run in 1962. The tracks were removed, and Wisconsin Avenue from Georgetown

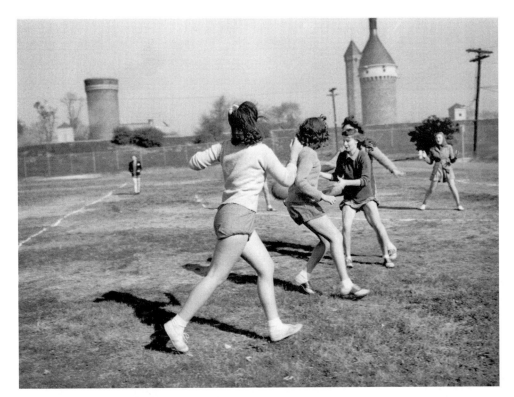

Woodrow Wilson High School students play speedball on the school playing fields in 1943. Wilson, Alice Deal Junior High School, a water reservoir, and a park took the place of the Reno community in the 1930s. Courtesy Library of Congress

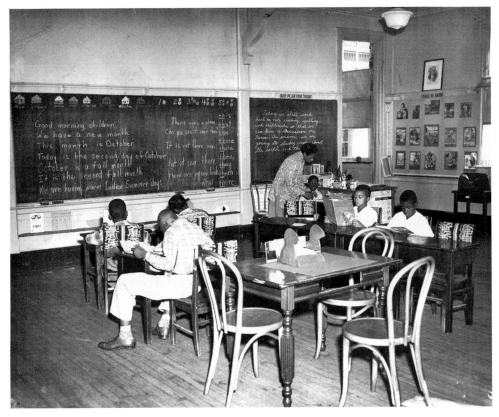

Six students, each in a different grade, apply themselves to lessons provided by teacher Flora L. Hill at the Reno Elementary School in October 1950, just before it closed. It was operating as a one-room schoolhouse, most of the nearby Reno African American community having been dispersed. Nearby Murch and Janney elementary schools were for white children only in 1950. Courtesy Washington Post

The modern Sears store, a landmark at Wisconsin Avenue and Albemarle Street beginning in 1940, lights up its corner on a rainy night in late November 1957. Sears and the 1939 Giant grocery store across the avenue, both with parking on the roof, attracted shoppers from far beyond Tenleytown. Courtesy Star Collection, DC Public Library. © Washington Post

to the District line was repaved. Buses replaced the streetcars that had served the area for seventy years. Local planners claimed that removing the tracks would ease traffic; however, congestion continued to increase. The four-lane avenue was increasingly lined with movie theaters, restaurants, and financial institutions. Stoplights multiplied to one every three or four blocks, and the River Road and Wisconsin Avenue intersection became a bottleneck. An early 1970s article in the *American Motorist* cited Wisconsin Avenue in Tenleytown as one of the busiest streets in the nation.

The neighborhood's historic significance in the city's traffic patterns continued in the 1970s as construction began for a Metrorail station to be named Tenley Circle. Streets were torn up for years; traffic was a nightmare. The Metrorail station finally opened in 1984, its name changed to Tenleytown as the result of citizen lobbying, spearheaded by Harold Gray, on behalf of the community's historic name.

By the mid-1980s, many original owners of the homes built in the 1930s and 1940s were ready to move. Couples with young children identified the area as ideal, located within walking distance of the subway, schools, playgrounds, stores, and a public library. The Metrorail subway station helped to resurrect the small-town feel of the neighborhood. People came out of their cars and onto the sidewalk. Energy was directed toward improving the public schools. Parents started camping out overnight to secure a space in Janney's prekindergarten, forcing the popular principal, Anne Gay, to create a lottery system for admission.

Major changes followed the closing of Sears in 1993. Locally based and family-owned Hechinger Company purchased the building and relocated one of its home improvement stores from the southeast corner of Wisconsin Avenue and Brandywine Street. Hechinger's old store, once occupied by Giant Food, became a twenty-four-hour CVS drugstore. Only four years later, the Hechinger chain was sold and subsequently in 1999 was forced into bankruptcy. Recognizing Tenleytown's appeal as a convenient residential neighborhood, Roadside Development and Madison Marquette purchased the building and built a four-story, 204-unit luxury condominium named Cityline at Tenley, using

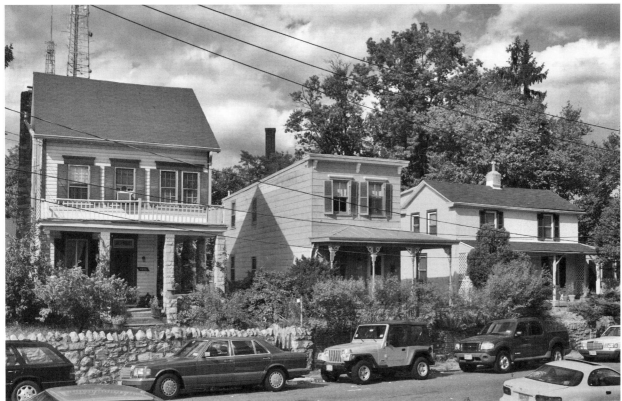

the old Sears rooftop parking lot as a base for new construction. Retail space was reconfigured to accommodate several national chain stores.

Not all Tenleytown residents thought the changes were positive, and those who were displeased let their voices be heard, continuing a pattern of citizen activism that had become noticeable in the 1980s when some in the neighborhood had protested the Metro stop. Neighbors had filed suit against the expansion plans of the Safeway on Davenport Street and countless lawsuits against the growth of the American University campus at Tenley Circle. Residents forced a developer to move a road, fought a jazz club, and shut down an adult video store. Multiple attempts by District planning officials to implement a Wisconsin Avenue comprehensive plan stalled because neighbors could not reach accord.

Development brought tensions but also a renewed sense of community. In 1999 the surprise razing by developers of the 1890 home built by Dr. John W. Chappell at 3901 Albemarle Street catalyzed a new citizens organization, Tenley Neighbors Association. It is dedicated to examining planning and development issues. These are issues that are hitting the Tenleytown neighborhood particularly hard in the twenty-first century. The neighborhood stands, as it did the nineteenth century, at the meeting of major arteries in the district, its historic crossroads character enhanced by a Metrorail station, at a time

These modest frame houses in the 4400 block of Grant Road stand as reminders of Tenleytown's nineteenth-century history as a working-class village. They were built in the 1880s by Tom Paxton, whose family bore one of Tenleytown's twelve most common surnames. Photo by Kathryn S. Smith

when planners, economic development officials, and smart growth advocates are promoting increased density around transportation hubs. Tenleytown provides a textbook example. The neighborhood currently faces the replacement of its two-story stand-alone Tenley-Friendship Public Library at Wisconsin Avenue and Albemarle Street, across the street from the Metrorail station, with a public-private development to include housing and an expansion of the adjacent Janney Elementary School.

Despite all the changes, a few reminders of Tenleytown's rural past remain. The oldest commercial building stands at 4425 Wisconsin Avenue at Grant Road, having housed a succession of local small businesses. Grant, Belt, and Murdock Mill roads follow their narrow, irregular paths through the area, small frame houses line the oldest streets, and original farmhouses still stand, though surrounded by 1930s-era brick Colonials. Tenleytown, resurrected by local historians and put back on the map by Metro, continues its historic crossroads role, offering residents the best of both worlds: the convenience of an urban neighborhood with the lively community spirit of a village.

Brightwood

FROM TOLLGATE TO SUBURB

KATHERINE GRANDINE

The past is etched on the landscape at the heart of Brightwood. The place is steeped in Civil War history, and the angled meetings of historic Rock Creek Ford Road, Georgia Avenue, Military Road, and Missouri Avenue, NW, suggest its storied past. Its location on high ground along the main nineteenth-century route north from the Federal City was guarded by Fort Stevens, site of the only Civil War battle in the District; the fort's remains are partially restored nearby at 13th and Quackenbos streets. Emery Park just south of the intersection preserves part of the estate of the city's last elected nineteenth-century mayor; his home, since demolished, served as a signal station during the war. The very name Military Road suggests its purpose: an 1862 road designed to connect the northwest section of the string of forts encircling the city.

Like Tenleytown, its counterpart west of Rock Creek, the community of Brightwood began as a nineteenth-century crossroads settlement in the rural area of the District called Washington County. Also like Tenleytown, Brightwood once had a post office that served a much larger area than the current neighborhood. Whereas Tenleytown was a gateway to Georgetown immediately to the south, Brightwood and its tollbooth along the 7th Street Turnpike stood astride the entry to the Federal City directly to its south. The chasm of Rock Creek separated the eastern and western parts of the city, as to a somewhat lesser extent it continues to do.

The name Brightwood, which was first applied to the area in 1861, survived despite the area's fragmentation by real estate developments with other names in the twentieth century. The Brightwood Community Association today applies the name to a neighborhood bounded by Aspen and Kennedy streets north and south and by Georgia Avenue and Rock Creek Park east to west. A development carved from landholdings south of Missouri Avenue called Brightwood Park carries that name today. Historically, a case can be made that both neighborhoods reach as far as Fourth Street on the east, intersecting and overlapping today's Manor Park.

Brightwood began as a crossroads community with a post office that served a much larger area than shown here, and its boundaries continue to be hard to define. The Brightwood Community Association serves the area described on this map. Organizations serving a neighborhood named 16th Street Heights now overlap with Brightwood south of Missouri Avenue. Map by Larry A. Bowring

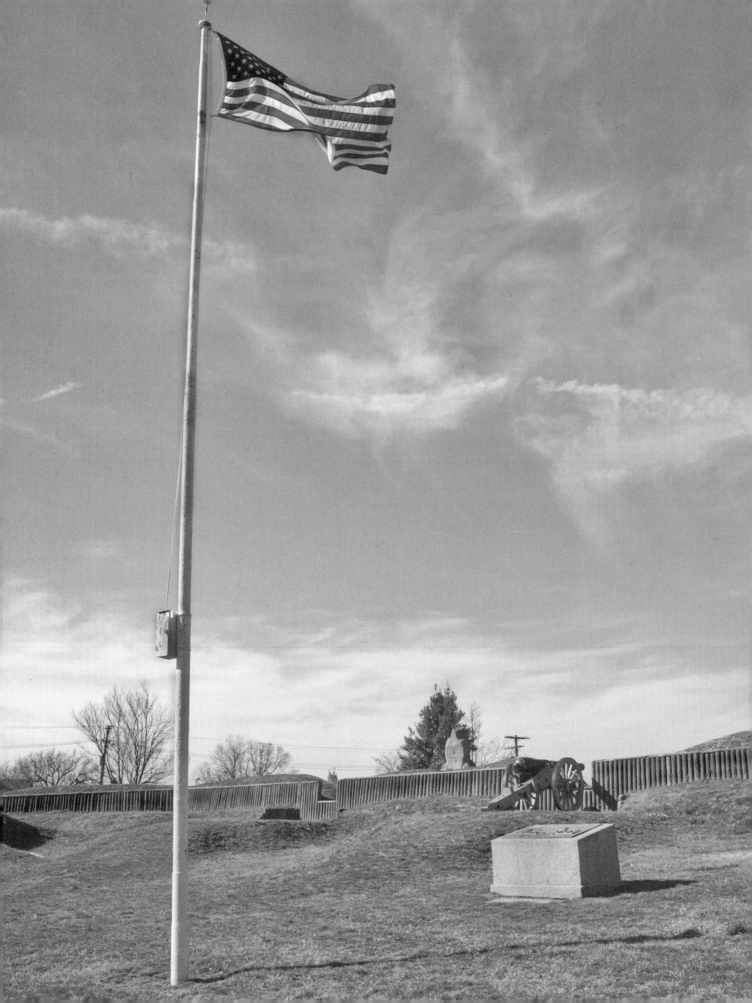

PLANK ROAD.

WASHINGTON AND ROCKVILLE TURNPIKE
COMPANY.

This is to Certify, That *Enos Ray* _____ is entitled to *Six* Shares in the Capital Stock of the Washington and Rockville Turnpike Company, transferable by the said *Enos Ray* _____ or Attorney, on the Books of the Company.

Given under our hands this *Thirtieth* day of *August* one thousand eight hundred and fifty-*four*.

CERTIFICATE OF STOCK.

The first recorded settler in the Brightwood area was James White, who received a patent for 586 acres known as Pleasant Hills in 1772. According to family tradition, White occupied the land as his primary residence, built a log cabin, and started to farm. White's descendants continued to live on portions of his original landholdings until the 1950s. In 1803 prominent Washington businessman Colonel John Tayloe bought property formerly owned by James White and named it Petworth after a town in England, a name that would continue in the urban neighborhood that today occupies that site, just south of Brightwood. Tayloe, who lived in the grand home called the Octagon that he built near the White House, used Petworth as a place to raise his thoroughbred racehorses.[1]

In 1790 the area that would become Brightwood was included in the new District of Columbia. The new capital city required a transportation network linking it to other towns in the region. In 1810 Congress granted a charter to a private company to construct a system of three turnpikes from Washington City to the District line. One of the proposed turnpikes extended 7th Street northward, paralleling Rock Creek to the District line, the route of today's Georgia Avenue, then turning west to Rockville, Maryland. After delays, the Rockville and Washington Turnpike Company took over the charter for the 7th Street route in 1818, presided over by its president, Benjamin Ogle Tayloe, son of the owner of Petworth. The 7th Street Turnpike opened in 1822, the last

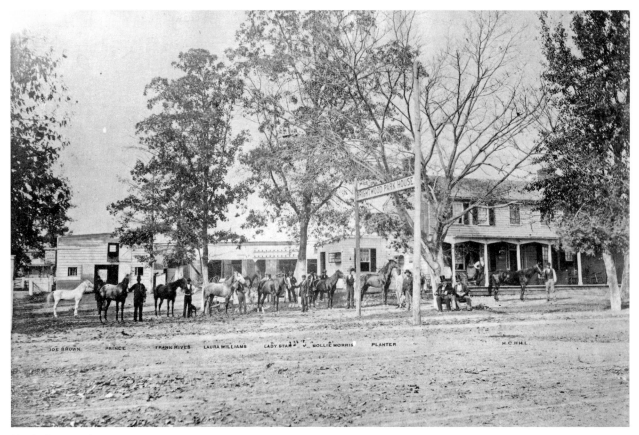

Trotting horses ready to perform at the nearby Crystal Spring Race Track line up in front of Brightwood Park House in the 5300 block of Colorado Avenue. Horse races and later bicycle races drew many people to the Brightwood track until it closed in 1909. Courtesy The Historical Society of Washington, D.C.

of the three to be completed. In 1825 local chronicler John Sessford reported travel along the road was "very considerable."[2]

The new turnpike funneled traffic from Montgomery County directly to the heart of Washington City, most significantly to the city's main public market at 7th and Pennsylvania Avenue, NW, and then on to the Potomac River wharves in Southwest. The 7th Street Turnpike remained a dirt road until 1852, when the section of the road to the District line was paved using hemlock planks. Tollgates were set up to pay for the new turnpike, one located just north of 7th and H streets. The second was located near the White homestead and adjacent to the historic intersection of Milkhouse Ford (later Rock Creek Ford) and Piney Branch roads (currently approximately the 6400 block of Georgia Avenue). With the tollgate at its center, the crossroads village came to include a roadhouse operated by Lewis Burnett, four dwellings, a hotel, Emory Methodist Episcopal Church (founded in 1832), and an enclave of black landowners in an area called Vinegar Hill, near the intersection of 14th Street and Rock Creek Ford Road.[3]

Another center of activity near the 7th Street Turnpike was the Crystal Spring Race Track, laid out in 1859 in an area bounded approximately by today's 13th, 16th, Longfellow, and Madison streets. It was a popular destination for city folks looking for recreation and an ideal spot for picnicking. A tavern operated in conjunction with the racetrack between 1863 and 1890. Stagecoaches ran to the racetrack twice a day from

downtown hotels and three times on Sundays during the summer. Before it closed in 1909, it was for a while a bicycle racecourse and a place to train racehorses.[4]

The 1855 Washington County assessment listed thirty-one property owners along the turnpike from Rock Creek Church Road, which crossed the turnpike just north of today's Columbia Heights, to the District line. Most owned small parcels; only six owned more than a hundred acres. The area was racially mixed. Five of the thirty-one landowners were black, and four of these were women. It is clear the majority of landowners were engaged in agriculture, for they were assessed the value of their horses and cows. Six landowners were slaveholders, but only two held more than one individual.[5]

One early landowner was a major figure in the city's business and civic life. Matthew Gault Emery bought a fine wood-frame country house on about twelve acres during the late 1850s on the turnpike just south of Missouri Avenue. He was a stonemason and a contractor responsible for the construction of many mid-nineteenth-century churches and government buildings in Washington City; he had laid the foundation for the Washington Monument. Emery was elected mayor of Washington City in 1870, his term ending abruptly when Congress abolished the elected city government in favor of a largely appointed territorial government. The house became home to Emery's daughter Juliet and her husband, William Van Zandt Cox, a banker and promoter of the Brightwood community. Cox served as the president of the Brightwood Avenue Citizens Association for five years during the late 1880s and early 1890s. In the late 1940s the property would be purchased for a community park and the house demolished.[6]

Three other major property owners had strong ties to Washington City: Thomas Carbery, William Cammack, and John Saul. Thomas Carbery owned Norway, a working farm directly north of today's Brightwood that would become the site of the Walter Reed Army Medical Center. In addition to his farm, Carbery managed a successful business, shipping and selling building materials, and had a home in the city at 17th and C streets, NW. He was also active in public affairs, serving as mayor of Washington City in 1822 and 1823, city council member, and justice of the peace.[7]

The country acreage of both William Cammack and John Saul directly sustained their businesses in Washington City. For these men, the Brightwood area offered agricultural land that was easily accessible to city markets via the 7th Street Turnpike. Cammack operated a florist and produce business that supplied high-quality fruit and vegetables. He had come to Washington City in 1820 and began his business by supplying produce to a local hotel. As his business grew, Cammack purchased property for greenhouses just south of the intersection of Rock Creek Church Road and 7th Street Turnpike. Cammack was credited with greatly improving the quality of produce generally available in Washington City.[8]

John Saul was a professional horticulturist born in Ireland. Saul came to Washington in 1851 to supervise the improvement of public grounds, including the Mall and Lafayette Square, under the direction of noted American landscape architect Andrew Jackson Downing. After Downing's death in 1852, Saul worked for the U.S. govern-

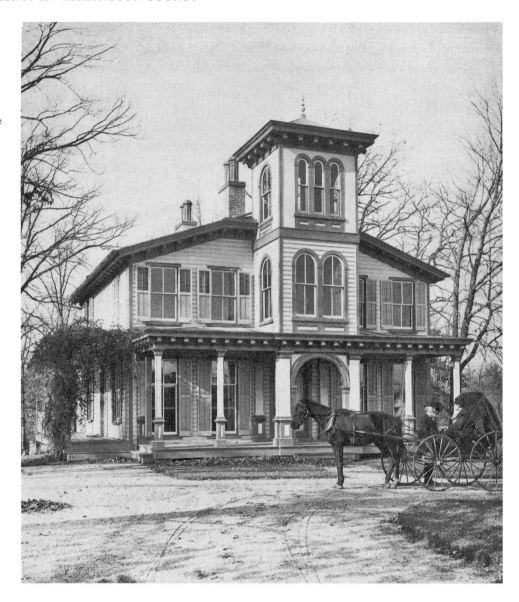

ment only one more year but decided to stay and make his home and build a business in Washington City. While he maintained a city address, he purchased land along the 7th Street Turnpike near today's Crittenden Street for his orchards and nurseries. Saul became nationally known as an importer and grower of evergreens, ornamental trees, fruit trees, shrubs, and greenhouse plants.[9]

The name Brightwood was first applied to this area in 1861 when Lewis Burnett was appointed as local postmaster. He relocated the post office from Oak Grove near the District line to his roadhouse on the corner of Milkhouse Ford Road and the 7th Street Turnpike. The name "Brighton" was first chosen for the new post office. However, that was the same name as a post office in northern Montgomery County, Maryland. The mail became so confused that the name was modified to "Brightwood" at the sugges-

tion of Lewis Burnett and Archibald White. This name came to designate a large area, including places now called Shepherd Park, Brightwood Park, and Petworth.[10]

The community of Brightwood began to develop its own identity just as the nation became divided by the Civil War. The federal government turned Washington into a major training, equipping, and supply center for Union troops. To defend the city, the Army Corps of Engineers constructed a ring of forts and supporting batteries on the hills surrounding the city; by the end of the war there were sixty-eight forts and ninety-three batteries. One of these, Fort Massachusetts, was constructed near the middle of Brightwood in August 1861, requiring the destruction of many houses and barns at the heart of the community. The earthwork fortification was built on land owned by Elizabeth (known as Betty) Thomas, née Proctor, a free black woman who earned her living as a dairywoman. She watched Union soldiers remove her furniture and tear down her house; its basement was needed for storing ammunition. She later reported, "In the evening, I was sitting under that sycamore tree . . . with what furniture I had left around me. I was crying as was my six months old child, which I had in my arms, when a tall, slender man dressed in black, came up and said to me: 'It is hard, but you shall reap a great reward.' It was President Lincoln, and had he lived, I know the claim for my losses would have been paid." There is no record that any monetary reward came her way. She would live on her land until she died in 1917 at the age of 96.[11]

Elizabeth Thomas, seen here in 1911, for decades told the story of the loss of her home for the construction of Fort Stevens and of her personal encounter with President Lincoln. Her land was part of a free black community called Vinegar Hill that predated the Civil War. Courtesy The Historical Society of Washington, D.C.

A signal station on Matthew Gault Emery's property linked the fort to Washington City. In September 1862 Military Road was built to connect the western portion of the ring of forts, becoming the third road to intersect the turnpike in the middle of Brightwood. Military Road forded Rock Creek south of Milkhouse Ford Road.

Because it defended a major turnpike, the fort in Brightwood was enlarged and armed with seventeen guns and mortars in 1863. At the same time, it was renamed Fort Stevens to honor Brigadier General Isaac I. Stevens, who had died leading Union troops to victory in Chantilly, Virginia, in 1862.

The fort was the focus of the only Confederate attack on the capital of the Union. In late June 1864 Confederate Major General Jubal A. Early marched his troops into Maryland and approached Washington from the north. A fight with Union General Lew Wallace near the Monocacy River on July 9 and intense summer heat slowed them down, and thus it was not until July 11 that Confederate cav-

alrymen rode down the 7th Street Turnpike and were deployed as skirmishers. Panic gripped the city as conflicting rumors circulated about the strength of the attacking force. Fort Stevens was, in fact, undermanned, and seasoned troops were hurriedly summoned from Petersburg, Virginia. Until they arrived, however, soldiers recovering from wounds or illness at nearby hospitals, untrained recruits, and even clerks from the Quartermaster Corps rushed into the breach. Skirmishing continued throughout the day as the Confederates reconnoitered and assessed the possibility of an assault. Meanwhile, Brightwood residents frantically protected their lives and property. As the Confederates advanced south along the turnpike, residents packed what they could and fled. At the same time Confederate sharpshooters took up strategic field positions, and both sides prepared for battle.[12]

On July 12 Union troops cleared the immediate area around the fort to ensure an unobstructed field of fire on the advancing Confederates. President Lincoln was present at the fort that day. (His summer retreat was nearby at the Soldiers' Home, today restored and open to the public as Lincoln Cottage.) Lincoln was in danger as he stood on the parapet of the fort, exposed to enemy fire in his recognizable stovepipe hat. A surgeon named Captain Crawford, who stood alongside Lincoln and Commanding General Horatio Wright, was struck by a Confederate bullet. Lincoln's safety worried many of the participants at the fight that day. General Wright threatened to remove the president under guard if he did not leave the parapet. Oliver Wendell Holmes Jr., future associate justice of the Supreme Court, present at Fort Stevens as an aide to General Wright, liked to tell in later years that he shouted at Lincoln "Get down, you damned fool," but there is no supporting evidence from those who were there, and a friend believed it was just a story he liked to tell to ladies and impressionable youths.[13]

At the end of the day, the Confederates retreated up the turnpike toward Silver Spring. The next morning it was discovered that Early had withdrawn his troops into Virginia, realizing that he had lost the advantage. The Confederate threat to Washington was at an end. Soon after the battle an official battleground cemetery was established a mile north of Fort Stevens, located near today's Georgia Avenue and Van Buren Street. In it were interred the bodies of forty Union soldiers who died in the battle. Contemporary sources vary widely on the number of troops involved in the fighting, but Brevet Major General J. G. Barnard reported there were 20,400 Union troops available in Washington, augmented by 2,000 quartermaster employees, 2,800 convalescents and artillerymen, and 900 seasoned troops sent by General Ulysses S. Grant from Virginia. Estimates of the number of Confederate troops vary from ten to twelve thousand according to General Early, up to twenty thousand according to Barnard, and even forty thousand according to the local press. Far fewer troops actually saw fighting. Casualties, including killed and wounded, numbered about nine hundred, although those estimates vary as well.[14]

After the fighting, Brightwood residents returned and began to rebuild their homes and replant their crops and orchards. Emory United Methodist Church replaced the

brick church demolished for Fort Stevens with a new one made of stone. Over the next decade, the community identity coalesced through the establishment of two schools and a social organization. A one-room wooden public school for white children was constructed on Military Road west of the 7th Street Turnpike in 1866, and about the same time a public school for black children was built near Vinegar Hill. In 1873 a group of men organized the Stansbury Lodge of the Ancient Free and Accepted Masons and built its first meeting hall on the southwest corner of the turnpike and Military Road, a site that would be a meeting place for the community in a succession of buildings until 1976. The current lodge building at that site dates from 1919.[15]

Fort Stevens, abandoned after the war, was left to decay on Betty Thomas's land, near present-day Quackenbos and 13th streets. The site was preserved during the early twentieth century through the efforts of Betty Thomas and William Van Zandt Cox until it was transferred to the U.S. government. The Civilian Conservation Corps, in 1937–38, reconstructed the outline of part of the fort, preserved today by the National Park Service.

The turnpike, renamed 7th Street Road, continued to be one of the most important transportation routes linking rural Montgomery County to Washington City. Sometime between 1865 and 1871 local residents, annoyed by continually having to pay at the tollgate in the center of Brightwood, extended Piney Branch Road parallel to the 7th Street Turnpike. This extension, still visible as a section of 12th Street, neatly circumvented the tollgate. In 1871, when all sectors of the District were unified under one territorial government, Congress authorized the city government to acquire the turnpike and maintain it as a free public highway. The tollgate was removed and 7th Street Road was paved in cobbles and later macadamized. By 1873 horsecar service operated along the road between Rock Creek Church Road and the wharves in Southwest.[16]

In 1880 Brightwood retained its rural character but had increased substantially in population. It then included 146 households, 86 white and 60 black. Although the area was racially mixed, the black and white populations tended to settle in separate places. African Americans continued to reside in Vinegar Hill along Rock Creek Ford Road and Military Road. This remained the highest concentration of black landownership in the area. Another group of people of color lived along Shepherd Road east of Brightwood Avenue, the name in use for 7th Street Road by 1887. The white residents settled along Brightwood Avenue and Piney Branch Road.[17]

This tavern at the southwest corner of Georgia Avenue and Military Road served as the headquarters of the Union Army during the battle of Fort Stevens. Among those pictured here are three generals, two majors, and two captains. In 1873 the Stansbury Lodge built the first of a series of buildings on this site that would be a centerpiece of community activity until 1976. Courtesy The Historical Society of Washington, D.C.

Some 45 percent of white residents had lived in Brightwood for more than twenty-one years. Many of the black residents, however, were newcomers; only ten of the sixty black heads of households had lived in the District before the Civil War. About forty thousand newly freed people came to Washington from the South and rural Maryland during and after the war, and this influx may explain the new families in Brightwood.

The occupations of Brightwood residents in 1880 remained slightly more oriented to the local community than to the central city. About 26 percent were agricultural, such as farmer, gardener, and farm laborer. More than 50 percent of heads of households were employed in occupations that probably were supported locally, including blacksmith, laborer, policeman, school teacher, and physician. Approximately 20 percent, including twenty-two families who boarded in the area, held jobs outside the community, working as carpenter, bricklayer, architect, broker, and government clerk.[18]

Throughout the late nineteenth century the growing population pushed northward from old Washington City into the rest of the District, as developers laid out new suburbs along 7th, 14th, and 16th streets. In 1887 Myron M. Parker and Brainard H. Warner, both important local businessmen who would become leaders in the Washington Board of Trade, developed the Petworth neighborhood south of Brightwood, keeping the name of the Tayloe estate. Petworth's amenities, including attractive streets with cement sidewalks and gutters and landscaped with trees, were designed to appeal to well-to-do residents, and several large houses were constructed. Parker believed that L'Enfant's plan for Washington City, with its grid system superimposed on radial avenues, should be extended throughout the District and therefore laid out Petworth accordingly. He was ahead of his time. Six years later the Highway Act of 1893 would make the extension of Enfant's plan a requirement. Thus Petworth at first stood out as different, compared with earlier suburbs such as LeDroit Park, which followed its own unique street design. Parker also predated the developers of Chevy Chase by several years in providing public transportation to his development. He and others obtained a charter for the Brightwood Railway Company in 1888 and promised the most up-to-date streetcar service, using a pneumatic system of compressed air for power.[19]

The opening of Petworth enhanced the growth potential of Brightwood. Petworth grew slowly, however, and represented the last major investment in real estate along Brightwood Avenue that was promoted to the Washington elite. After this time, large-scale real estate investors favored land along Connecticut Avenue, opened up in 1892 when Senator Francis Newlands built a bridge across Rock Creek at Calvert Street and extended the avenue — complete with streetcar service — to his new Chevy Chase development. Thus it was locally prominent men, with less capital and more modest ambitions, working through a local citizens association, who would be the primary force behind Brightwood's growth.

By 1891 the Brightwood Railway Company had still not produced the modern streetcar service its charter from Congress required it to provide. While waiting for the perfection of its experimental pneumatic system, the company offered instead used horsecars

and tired animals purchased from the Metropolitan Line. The bobtail cars frequently went off the tracks, and the horses were often too weak to make it up the hills. Horses sometimes literally fell down from fatigue, and passengers were required to walk the rest of the way to the city. Angered by what residents facetiously called the "G.O.P." (get out and push) line, Brightwood citizens formed the Citizens Association of Brightwood Avenue in March 1891 to press the company for improvements and to represent other needs of the community to the Board of Commissioners. The founders were inspired by the way that Mount Pleasant citizens had united to present their needs to the District commissioners and members of Congress; "they get everything they ask for," said a Brightwood Citizens Association founder, Dr. Charles G. Stone.[20]

The association set up committees to deal with the street railroad situation, as well as standing committees for streets, roads, and bridges; law and order; police and lights; and sanitation. In 1899 association president William Van Zandt Cox addressed residents celebrating completion of a new fire engine house and reviewed the group's successes since its founding and its extensive responsibilities. "Our association, under our form of government," he said, "is the town council of that portion of the District extending from Florida Avenue to the Maryland line, from the beautiful Soldier's Home to still more beautiful Rock Creek National Park west of us the entire northern section of the District." He praised the work of the District's three presidentially appointed commissioners and emphasized the importance of the organization's friendly relationships with them and with members of the U.S. Congress. "It should be our duty to help Members of Congress more to understand the relationship between the District of Columbia and the General Government, for we are utterly helpless without their aid. My experience has been that if you approach them as citizens of the District they appreciate it." One of the organization's many successes, he noted, had been the arrival of reliable electric streetcar service in 1892.[21]

The Brightwood Citizens Association organized in 1891 to lobby for a reliable electric streetcar line. This picture taken in the early 1890s is testimony to their success. Courtesy Robert A. Truax

Real estate investors developed new subdivisions in Brightwood. These parcels had to be small because of Brightwood's fragmented pattern of landholding. Most landowners had forty acres or less, and older members of the farming community were reluctant to sell. The first subdivision platted was eighty-two acres owned by Archibald White, a descendant of James White, the first resident of the region. White sold the property in 1891 for what he thought would be a university. The purchaser, however, ran into financial difficulties, and a

disappointed Archibald White watched as his land was divided into small building lots. The new development south of Missouri Avenue, called Brightwood Park, consisted of about thirty-three city blocks, bounded roughly by today's Georgia Avenue on the west and 4th Street on the east, between Hamilton and Madison streets, with an average lot size of 50 by 150 feet. By 1894, thirty-four frame houses were constructed at an average assessed value of $1,190. This general area continues to be called Brightwood Park.[22]

Diller B. Groff, a builder who resided in central Washington, owned the majority of lots in Brightwood Park and sold them directly to individuals or real estate agents. Groff built some houses himself and managed to dispose of them quickly; he rarely had more than one or two houses assessed to him per general assessment. William W. Herron and Daniel Ramey, Washington City real estate agents, promoted the suburb and played leading roles in the Brightwood Avenue Citizens Association. Since Congress had by now mandated the extension of the L'Enfant Plan throughout the District, a straight grid pattern was imposed on the community. Older roads were shifted, straightened, and widened, erasing much of the early physical identity of Brightwood. However, it is still possible to find remnants of such older roads as Shepherd Road, Rock Creek Ford Road, and the old segment of 12th Street.[23]

The social as well as the physical identity of old Brightwood changed as new residents, no longer tied to agriculture or the local community, moved in. During the first decade of the twentieth century, other subdivisions opened as older residents retired from farming or died, leaving heirs who were not interested in continuing to operate the family farm. By 1907 Whitecroft, Saul's Addition, North Brightwood, and Peter's Mill Seat had opened. The name Brightwood came to designate a smaller geographic area as each new suburb developed its own separate physical and social identity. However, it would in the end prevail, preserved in the names of major institutions such as the Brightwood Elementary School and the Brightwood Community Association, which succeeded the Citizens Association in the late 1950s.[24]

In 1910 there were 459 households in Brightwood, about three times as many as in 1880. A little less than half of the residents lived in the subdivision of Brightwood Park. The proportion of African Americans in the community had dropped dramatically, from 41 percent of all households in 1880 to only about 15 percent in 1910. Less than 5 percent of the residents remained involved in any agricultural employment; most residents commuted to work in Washington City or were employed outside Brightwood.[25]

Between 1900 and 1916 the Brightwood Citizens Association continued to pursue urban amenities under the leadership of Louis P. Shoemaker, an influential local businessman descended from several prominent families who had been major landowners in the Rock Creek Valley. After 350 acres of family property were sold in 1890 for Rock Creek Park, Shoemaker moved to Brightwood and involved himself in its development. He brought political skill to the citizens association, serving as president of that body for sixteen years, and succeeded in drawing the attention of District commissioners and congressmen to the area. He was instrumental in bringing Walter Reed U.S. Military

Hospital (later Walter Reed Army Medical Center) to land north of Brightwood in 1908. In hopes of more congressional interest, residents supported a bill in 1909 that changed the name of Brightwood Avenue between Florida Avenue and the District line to Georgia Avenue at the request of Senator Augustus Bacon from Georgia, who served in the U.S. Senate from 1894 to 1914. Unfortunately, Bacon died too soon after the name change to benefit the residents of Brightwood.[26]

By the time of Shoemaker's death in 1916, Brightwood had been fully transformed from rural to suburban. Its character would be shaped to some extent by one of the most colorful entrepreneurs in the history of Washington, Harry Wardman, described by the *New York Times* as the "man who overbuilt Washington." An immigrant from England, he arrived in the city in 1895. During his career he built hundreds of single-family dwellings, row houses, and commercial, office, and apartment buildings. At his death, it was estimated that between one-eighth and one-tenth of the city's residents lived in buildings he had constructed.[27]

Harry Wardman, seen here early in his career, built some of his first houses in Brightwood in 1897 and 1898. A prolific builder in Washington in the late nineteenth and early twentieth centuries, Wardman went on to develop the seven hundred houses of Fort Stevens Ridge. Courtesy Library of Congress

Wardman worked in Brightwood three times during his long and prolific career. In 1897 and 1898 he began by building six wood-frame houses on the corner of 9th and Longfellow streets in Brightwood Park. The houses were freestanding, single-family dwellings set close together on small lots. Wardman returned to Brightwood after World War I when Secretary of Commerce Herbert Hoover challenged local developers and builders to relieve the District's postwar housing shortage. Beginning in 1924 Wardman accepted the challenge and built seven hundred brick semidetached and row houses in a huge development named Fort Stevens Ridge. These houses can still be seen between 3rd and 8th streets, from Missouri Avenue to Tuckerman Street, an area many now think of as Manor Park. After losing everything in the crash of 1929, Wardman started building again in Brightwood and was active there when he died in 1938. Seven houses with deep front porches completed in 1933, with a model home at 1362 Sheridan Street, were among his last.[28]

Real estate maps show most of Brightwood fully developed by 1945. Only the site

of Fort Stevens and the former Emery estate remained open space. The National Park Service maintained Fort Stevens, and the Emery property had become a community park. Georgia Avenue was Brightwood's commercial street. Single-family and semide-tached houses dominated the area. By the 1940s many of the early wood-frame houses had been replaced with brick ones, and low-rise apartment buildings began to be constructed between 13th and 16th streets west of Fort Stevens, replacing what had been Vinegar Hill.[29]

Brightwood remained predominantly a white community from the 1930s through 1960. In 1930, 90 percent of the 18,677 people in census tract 18, defined as the area east of Rock Creek, north of Ingraham Street, west of North Capitol Street, and south of the District line, were classified as white, 6.5 percent of whom were foreign born. Only 3 percent were classified as Negro. Many of the white residents who moved to the community during the late 1930s and 1940s were Jewish, following this community's pattern of migration up 7th Street and Georgia Avenue through Petworth, Brightwood, Shepherd Park, and then on to Maryland, a movement that for some began in Southwest and downtown. Many Jewish businesses located along the Georgia Avenue corridor to serve this clientele.[30]

A rapid racial shift began during the late 1950s, a shift that took place in many Washington neighborhoods at that time, following the desegregation of schools in 1954 and the displacement of African Americans by Southwest urban renewal. Affordable suburban housing, much of it closed to African Americans, beckoned to white families. In addition, the real estate agents active in the city were directing black purchasers to residential areas located east of Rock Creek Park such as Brightwood. By 1970, out of a total population of 29,316 located in census tracts 18.2, 19, 20, and 21.1, a total of 25,157 (85.8 percent) were black, while 4,159 (14.2 percent) were white.[31]

African American residents moving into the community formed the Brightwood Community Association in 1958; the group now serves all neighborhood residents. Recently, a group of graduates and friends of Military Road School, which served the children of the black community of Vinegar Hill, began building a new awareness of that earlier African American community in Brightwood. The resulting Military Road School Preservation Trust successfully pressed for the restoration of the building at 1375 Missouri Avenue, which now houses a charter school.

At the beginning of the twenty-first century, the Brightwood community is again experiencing a period of transition and shifting ethnic diversity. Long-term, middle-class African American residents who moved to the neighborhood during the 1950s are aging and passing homes to the next generation, who may no longer reside in the neighborhood. In recent years, growing numbers of Latino residents have moved into the area. It is a migration northward up 14th and 16th streets and Georgia Avenue from Adams Morgan, Mount Pleasant, and Columbia Heights that mirrors the passage of Jewish people up those same streets from Southwest and downtown in the early twentieth century, and the movement of African Americans in a similar pattern beginning in the

1950s. Census tract 18.04 at the center of the neighborhood shifted dramatically from 10 percent to 25 percent Latino just in the years between 1990 and 2000.[32]

The ministry of the historic Emory United Methodist Church on Georgia Avenue adjacent to Fort Stevens reflects the change. Founded on this site in 1832, the church was torn down for the construction of the fort and its cellar hole used to store military supplies. The congregation built a new chapel in 1870; other larger church buildings followed. The predominantly white congregation had become predominantly African American by the 1960s. In 1966 the congregation's ministry to its neighborhood spawned a nonprofit community development organization, Emory Beacon of Light, Inc. It today offers a range of programs to a diverse community — immigration services, English as a second language classes, transitional housing, a food pantry, computer training, health and recreation programs, and more. The emphasis on services to immigrants reflects the change in the foreign-born population in census tract 18.04 from 9.2 percent in 1980 to 29 percent in 2000. In 2005 Emory Beacon of Light began a partnership with the D.C. Department of Housing and Urban Development to assist small businesses and promote economic development along Georgia Avenue. The organization has won widespread support; members of Tifereth Israel congregation in Shepherd Park just to the north, for example, are seen cosponsoring a march for the homeless on page 461.

Fifth graders at the Brightwood Demonstration School at 13th and Nicholson streets join hands to sing "We Shall Overcome" at the end of a school program in 1967. The Brightwood neighborhood, largely white before the 1950s, became racially integrated following the Brown v. Board of Education *Supreme Court decision in 1954. Courtesy Star Collection, DC Public Library. © Washington Post*

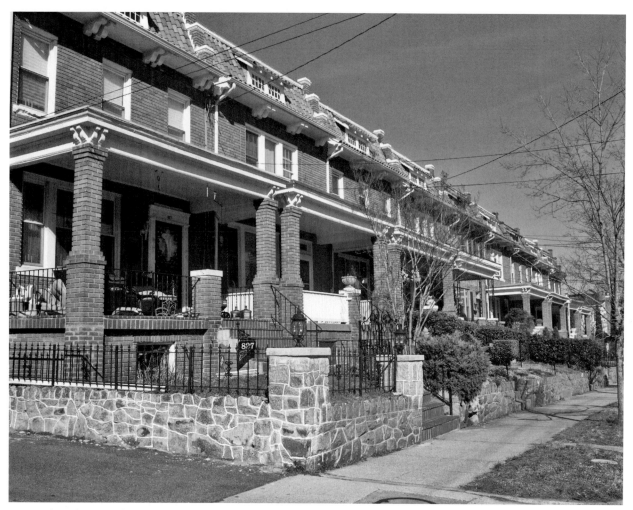

Front-porch row houses similar to these in the 800 block of Madison Street line many of the streets in Petworth, Brightwood, and Brightwood Park and can be found in many other neighborhoods in Washington. This style was popular with builders in the city beginning in 1907 and on into the 1930s. Prolific architect George T. Santmyers designed these houses, completed in 1925, for developer/ builder W. M. Ward. Photo by Kathryn S. Smith

The Brightwood community retains a mix of single-family houses, row houses, apartment buildings, and condominiums along streets lined with mature trees. Recreational amenities include easy access to Rock Creek, Fort Stevens, and Emery parks. A community landmark, the 1919 Stansbury Masonic Lodge building at Military Road and Georgia Avenue, an organization founded on that site in 1873, has been redeveloped and expanded as a condominium. As change goes on around them, many in the neighborhood have taken a new interest in its history. A local committee worked with Cultural Tourism DC to inaugurate a Neighborhood Heritage Trail that traces Brightwood's varied story as it changed from a rural settlement around a tollbooth, destined to play a critical role in the nation's Civil War, to the livable and lively multicultural urban neighborhood of today.

Palisades

WATERWAYS AND VIEWS

JUDITH H. LANIUS

The Palisades is a place shaped by its relationship to water and by its topography. Sharp cliffs rising above the Potomac River gave this neighborhood its name. Its history is linked to travel on the Potomac and across it, to the Chesapeake and Ohio Canal built alongside it, and to the city's water system, carried beneath its central boulevard. Water has made it a tourist destination, and water has made it a place of recreation. Its varied topography — made up of lowlands and highlands, valleys, and ravines — has made it a neighborhood of contrasts, with pockets of varied architecture and social history. Its separate developments did not take the common name Palisades until 1950.

Before the presence of Europeans in these hills, valleys, and lowlands, the indigenous population of prehistoric Native Americans lived in and journeyed through the area for some of the same reasons that attracted later settlers: travel by water, the abundance of fish and wildlife, and the rich natural environment of trees, berry bushes, and grasses that provided other life-sustaining resources. While Native Americans were present in the Potomac River Valley for at least thirteen thousand years, it was between 2000 and 1500 BC that the Piscataways began to frequent the Palisades. They were attracted by a shift in the ecology of Chesapeake Bay, as its increasing salinity drove anadromous fish north seek-

The boundaries of the Palisades neighborhood reflect the essential outline of nineteenth-century development plans adjacent to the Potomac River in what was once called West Washington. They have been adopted by the Palisades Citizens Association as accurately representing the extent of the neighborhood it serves. Map by Larry A. Bowring

ing fresh water in which to spawn into the Potomac Gorge. Spawning season took place in the late winter and spring, the leanest time of the year for the native population, so fishing camps would spring up on the flat land atop the bluffs in the Palisades. Consequently a major trail developed along the present course of MacArthur Boulevard. The location of the camps was strategic also because a nearby cove (the site of today's Fletcher's Boathouse) offered the best place to put in a canoe on the Potomac below the cascades of the Little Falls.

Intercultural wars, European diseases, loss of hunting grounds, and other causes forced many of the Piscataway Indians out of the District and adjacent Maryland by 1700. They had been a buffer between the Maryland colonists and more hostile Native Americans to the north and northwest. The colony of Maryland posted garrisons along its borders to

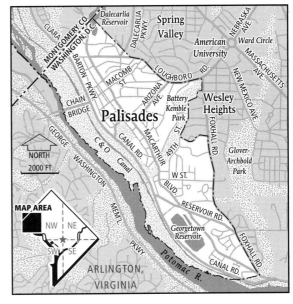

meet the threat, one of them established in 1692 in the same cove that had served the Pis-cataways, known for many years as Garrison Cove. The threat having lessened, the garrison was abandoned in the early eighteenth century.[1]

All of the landholding in what is now the Palisades descended from three colonial land grants belonging to Anthony Addison — St. Philip and Jacob, White Haven, and twelve hundred acres of Friendship. Addison's will was probated in 1753, after which the land began to be divided. However, it remained in only a few hands well into the nineteenth century. Before the Civil War, only fifteen individuals owned all the land, in parcels ranging from a high of a thousand acres to average holdings of fifty to a hundred acres. Farms, summer homes, and large estates were scattered on the landscape. At this time the area was known as West Washington. Large tracts continued to be privately held as late as the 1870s, when the area first began to be commercially subdivided, setting the stage for the large subdivisions, parks, and estates that remain in the twenty-first century.

The area's location along the Potomac River between Georgetown and the Great Falls made it a natural corridor for trade and shaped its early history. The first bridge to cross the Potomac in the new District of Columbia was built at Little Falls, downstream from Great Falls, in 1797. It was a covered wooden toll bridge at the location of today's Chain Bridge. The Georgetown Bridge Company constructed it at the narrowest portion of the river; it would be the first of many at that site, one after another swept away by flood waters. The first of three to be suspended by chains gave the crossing its current name in 1810. Virginia farmers, drovers of cattle, and others crossed the bridge on their way to Georgetown and Washington City by way of a road running along the river, part of the free Georgetown and Leesburg Pike. The bridge also spawned another primitive road through the area known as the Road to Chain Bridge, today's Chain Bridge Road, NW. By 1861, travel from West Washington to Tenleytown was possible by way of Ridge Road (now Foxhall Road) and a road later named Loughboro, and travel to Georgetown had been eased by New Cut (now Reservoir) Road.[2]

In the 1820s a waterway alongside the river added another passage through the area. George Washington himself had chartered the Patowmack Company in 1785 to build a ca-nal on the Virginia side of the river that would circumvent the rocky places in the Potomac and open the Ohio Valley to trade. It did not succeed but was followed by the Chesapeake and Ohio Canal Company, which began to plan a canal along the District side of the river in 1823. Construction began on July 4, 1828, stopping at Cumberland, Maryland, twenty-two years later. While falling short of its goal of crossing the mountains due to lack of funds, the C&O Canal would be a lifeline for Georgetown commerce and a defining pres-ence in the Palisades. Among those who made a living along its banks was Abner Cloud, who had opened a mill next to his stone house in 1801, immediately west of the junction of today's Reservoir and Canal roads at Garrison Cove. The coming of the canal allowed him to receive grain from farmers living in distant parts of rural Maryland and northern Virginia.[3]

(opposite)
Palisades dogs enjoy a late afternoon romp with their owners at Battery Kemble Park, once the site of a Civil War fortification guarding Chain Bridge. The park, one of many in the city on the site of a Civil War fort, is a regular gathering place for neighbors and their canines.
Photo by Rick Reinhard

THE POTOMAC AT THE LITTLE FALLS

From 1810 until the 1850s a series of three bridges, all suspended by chains, carried traffic from Virginia across the Potomac River at Little Falls. From there a road led through the Palisades and on to Georgetown and the Federal City. This image of the third chain bridge appeared in Morrison's Guide to Washington *in 1842. Courtesy The Historical Society of Washington, D.C.*

By 1864 another major thoroughfare had cut through the area, this time bringing the city's first public water supply from the Potomac River above Great Falls. The water system, designed by Montgomery C. Meigs of the Army Corps of Engineers, took more than a decade to build and involved tunnels, culverts, and bridges, including the dramatic and picturesque Cabin John Bridge in Maryland, the longest single-span stone arch in the world until the twentieth century. Water was distributed through the rural landscape, beginning in 1864, into a fifty-acre receiving reservoir and through today's Palisades neighborhood in an underground conduit with a new road on top, appropriately named Conduit Road, today's MacArthur Boulevard. The road would become a major route for sightseers through the picturesque countryside of the Palisades to the wonders of Cabin John Bridge and Great Falls beyond.

The area's location, its heights, and its transportation routes guaranteed that West Washington would be strategically important as the Civil War loomed. With the northern edge of the Confederacy so close to the Union capital, Chain Bridge required protection. In 1861 the federal government, fearing attack, began to construct forts and batteries in a complete circle around the city. Battery Kemble, strategically situated three hundred feet above Chain Bridge, was one of the first and eventually one of a cluster of six fortifications guarding this critical area.

The military presence was hard on area residents. Those living near the fortifications complained of marauding troops. "We could not raise a chicken or vegetable," Augusta Weaver of White Haven later wrote. "Not a pan or a cup could be left outside the door." The military took private land as needed and cleared trees and brush for two miles around any fort. William D. C. Murdock, who owned a thousand acres extending from Conduit Road north to Tenleytown, lost farmland, timber, and stone quarries when the government took his land for Battery Kemble. He went into debt and by 1872 had to sell all his land to pay his creditors.[4]

His misfortune turned into good fortune for a black community of freedmen, to whom he sold three- to five-acre plots at approximately $80 an acre. Seeking refuge during the war, they had squatted around Battery Kemble and then settled on Chain Bridge Road and today's adjacent University Terrace. Murdock, who had held ten enslaved people, may well have sold or given land to them, as did some of the adjacent landholders. Also settling there was John Cephus, who had been freed by Charles and Joseph Weaver, the owners of the four-hundred-acre White Haven estate. The Weavers, who had treated Cephus as a

Union soldiers guard the sturdy wooden bridge that replaced the earlier chain bridges at Little Falls, but kept their name, near the end of the Civil War in 1865. Its strategic location between the Union capital and Confederate Virginia across the Potomac called for protection on the heights above it, provided by batteries Martin Scott, Vermont, and Kemble. Courtesy Library of Congress

member of the family, helped him buy a few acres on Chain Bridge Road where he built a cabin for his family.[5]

Thus a vibrant African American community grew up around Battery Kemble. The life of the community on Chain Bridge Road and St. Phillips Hill, now University Terrace, centered on the African American Chain Bridge Road School built in 1865 and St. Phillips Church. The Union Burial Society of Georgetown secured a five-acre burial ground on Chain Bridge Road from the U.S. government, extant today, for the immediate community, Georgetown, and the surrounding area of Maryland. While still a racially integrated area at this writing, the original community began to disperse about 1941 with the closing of the Chain Bridge Road School in response to pressure from white neighbors.[6]

After the Civil War, agricultural uses increased in the area, even as the District became more urban and suburban. Drovers continued to herd cattle by way of Chain Bridge, the meat destined for the Georgetown and Center markets. Slaughterhouses had grown up along the drovers' routes, many on local farms, such as those owned by Henry Kengla and

Charles Homiller between Wisconsin Avenue and Ridge Road, as early as the 1840s. They worked their farms with enslaved labor and pursued their careers as master butchers, with stalls at the Georgetown market. They were members of a loose syndicate of butchers, most of whom did not raise cattle but purchased it on the hoof at Drover's Rest on the north side of Conduit Road near the juncture with New Cut Road, approximately where today's firehouse stands at 4811 MacArthur Boulevard. From there cattle could be driven to slaughter yards off High Street (Wisconsin Avenue) above Georgetown and the meat prepared for sale. Other slaughterhouses were grouped along the roads designated for drovers — four or five on Ridge Road and two near Canal Road.[7]

Drover's Rest was the major marshalling yard for cattle on the hoof, with extensive stockyards around a tavern owned by the Tavenner family, offering accommodations for drovers from Maryland and Virginia. Five hundred to seven hundred animals would be sold there every Saturday in the 1860s. The activity began to wane in the 1880s after the 1877 invention of the refrigerated railroad car made it possible to slaughter and ship meat from Chicago.[8]

Dairy farms also increased after the mid-nineteenth century. Among them were the Palisades Dairy Farm at the northeast corner of MacArthur Boulevard and Arizona Avenue owned by Michael Shugrue, the dairy run by George T. Knott north of MacArthur Boulevard at the present location of Fulton Street Circle, and the Horrigan Dairy located on the former site of Mt. Vernon College, opposite the location of today's Field School. Nine milk dealers were listed in the immediate area of Palisades in the 1880 city directory.[9]

This rural countryside, with its high elevations, cool breezes, and proximity to the Potomac, also appealed to city dwellers looking for summer retreats. In the early nineteenth century prominent businessman Henry Foxall built a frame summer house, Spring Hill, on sixty acres at today's intersection of Foxhall Road (named for Foxall but later misspelled) and P Street, near his foundry on the Potomac River. After the Civil War, a Bavarian immigrant named Ehrmanntraut (no first name available) transformed the house into a beer garden by reactivating the old equipment on the property to brew beer and ale, successfully creating a tourist attraction called Green Spring Pavilion. Other summer homes were scattered above Conduit Road, along the hilltop of present day Cathedral Avenue, and near the C&O Canal along Sherrier Place.[10]

But West Washington had more than the usual country charm. The rugged beauty of the palisades, the dramatic river views, and access to the Great Falls of the Potomac fourteen miles north of Georgetown made it a nationally known tourist attraction. Tourists began to be drawn to the turbulent drama of Great Falls early in the nineteenth century. Among them was traveler and author Frances Trollope, who visited in 1830. "To call this scene beautiful would be a strange abuse of terms, for it is altogether composed of sights and sounds of terror," she wrote. "The falls of the Potomac are awfully sublime; the dark deep gulf which yawns before you, the foaming, roaring cataract, the eddying whirlpool, and giddy precipice, all seem to threaten life, and to appall the senses. Yet it was a great

delight to sit upon a high and jutting crag, and look and listen." As early as 1832 a tavern welcomed visitors to the site.[11]

Nineteenth-century guidebooks urged visitors on their way to Little Falls and Great Falls to experience the dramatic vistas from overlooks along the Potomac palisades. *Keim's Illustrated Hand-Book of Washington and Its Environs,* published in 1874, told readers that "One of the most interesting excursions is the drive by the Aqueduct to the Great Falls of the Potomac. . . . The scenery on all sides is romantic in the extreme." This fascination continued well into the twentieth century. In 1924 *Rider's Washington Guide* was still describing the Great Falls of the Potomac as "the one great phenomenon of nature within the environs of Washington."[12]

Not only tourists but also residents sought out West Washington as a place for recreation as post–Civil War prosperity allowed the upper and middle classes more leisure time. When the vacation and physical culture movements became popular after the Civil War, city dwellers sought out the countryside along the Potomac River and the C&O Canal. Canoeing, rowing, and sculling on the river became popular pastimes. In 1887 Silversparre's

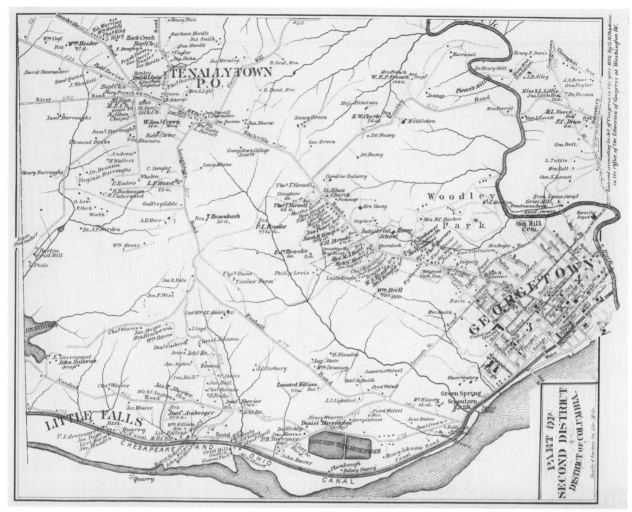

The area that would become the Palisades neighborhood retained its rural qualities into the late nineteenth century, as seen here in this 1878 map by G. M. Hopkins. The cattle marshalling yard around the tavern run by the Tavenner family is identified to the left of the distributing reservoir. Green Spring Pavilion, a beer garden and tourist attraction, shows up just upstream from Georgetown. Courtesy Library of Congress

Guide to Washington listed six boat clubs in Georgetown and Foggy Bottom. The members were men, but the clubs were lively centers of social life for female friends and families. They held suppers and dances in their large second-floor rooms and organized outings on the river.[13]

West Washington, however, provided one of the most popular accesses to the water at Fletcher's Boat House at the juncture of Canal and Reservoir roads, in what was once Garrison Cove and adjacent to the historic Abner Cloud house. Unlike the clubs, it was open to the public. The Fletcher family started making red rowboats and renting them to fishermen in the 1850s. Until it was purchased by new owners in 2004, Fletcher's was operated by fourth-generation family members, who had added canoes and bicycles to their business. A visit to Fletcher's in the nineteenth century might have included watching the barges on the C&O Canal carrying coal, building supplies, produce, and other cargo between Cumberland, Maryland, and Georgetown. As early as the 1830s some barges were outfitted for tourists. In 1884 one could take a daily, early-morning steam packet for the roundtrip excursion on the canal from Georgetown to Great Falls. Houses, inns, and taverns were

built alongside the canal parallel to Canal Road, as well as on the riverbanks.[14]

By the early twentieth century working- and middle-class people were building seasonal "camps" near the canal and the river: shanties and tents, large enough for several days of fishing, boating, and swimming. At the same time, the Washington Canoe Club and the Potomac Boat Club both set up summer camps for their members, with tents on the Virginia shore opposite the Three Sisters Islands. The camps were called Colonial Camp and the Classy Camp respectively. Women and children stayed at the camps for long periods, as they did in many summer communities, while the men commuted to work by canoe. During World War I, the District of Columbia War Camp Community Service set up a tent colony called Camp Columbia adjacent to Conduit Road to provide summer homes for women war workers. "Many girls have canoes on the canal and many groups enjoy swimming in the river each day. Camp Columbia is also the starting point of many delightful hikes," according to the *War Workers' Handbook* published in 1918.[15]

Conveyances such as this one, captured by a photographer in 1902 near Glen Echo, carried tourists and Washingtonians to the wonders of Great Falls. Courtesy The Historical Society of Washington, D.C.

There was actually a temporary falling off of interest in boating during the 1890s when the bicycle craze set in, and popular clubs such as the Capital Bicycle Club and the Century Cycle Club planned outings for their members. Taking advantage of the smooth macadam with which wide Conduit Road was now paved, young men bicycled out to the country, stopping at the wonder that was Cabin John Bridge and at the Cabin John Hotel. In 1896 a bicycle racing track opened south of Conduit Road between today's Norton and Newark streets.[16]

Residential development of the Palisades began modestly and slowly in the 1870s. The first subdivision was Harlem, platted in 1876 with thirty-three lots located at the eastern end of the Palisades closest to Georgetown, enlarged in 1880 by about forty acres. The frame houses first built there were constructed by carpenter builders and resembled the area's early farmhouses. The last lots were not sold until the 1930s. In 1892, almost twenty years after the debut of Harlem, a second subdivision called Hurst and Clark was begun west of Harlem and south of Conduit Road. Hurst and Clark was laid out as ninety-six small, narrow lots. A few of the mostly frame dwellings can be seen today along Clark, Elliot, Greene, and Hurst places.[17]

Palisades failed to draw significant numbers of homeowners, however, until the turn of the twentieth century because of its isolation and fierce real estate competition from other developments closer to central Washington and better served by the streetcar.

A lady alights from a small boat on the Chesapeake and Ohio Canal near Fletcher's Boat House about 1910. The onetime home of miller Abner Cloud, in the background, was built in 1801 and still stands. Courtesy Library of Congress

In 1890 alone more than 200 subdivisions were recorded: 156 in Washington City, 7 in Georgetown, and 63 in former Washington County.[18]

It took a boost from public transportation to make Palisades attractive to developers. In 1895, when the Washington and Great Falls Electric Railway began service from Georgetown, homeowners could finally entertain living in West Washington and taking the thirty-minute ride to work in the city. Leaving every ten minutes from 36th and Prospect streets in Georgetown, travelers in the cars marked "Palisades of the Potomac" experienced one of the company's most scenic routes along the bluffs of the Potomac, partly on elevated trestles, with stops in Palisades (along Sherrier Place and Conduit Road) and Glen Echo and ending at Cabin John. The trolley provided daily transportation through the Palisades until 1961.[19]

One of the earliest to see the development potential was Stilson Hutchins, founder of the *Washington Post*. In 1889 he retired as its publisher, and by 1890 he and his partners had formed the Palisades of the Potomac Land and Improvement Company, the most ambitious subdivision in the area. With Hutchins as president, the company bought approximately 350 acres of farmland in the original White Haven tract for $190,000 from the brothers Charles and Joseph Weaver. In less than five years the developers would lay out on paper 75 percent of the current Palisades community. Though they were involved for only

seven years, their projections would have a lasting impact because subsequent developers would largely follow their subdivision plans.

Stilson Hutchins had been positioning himself in Washington real estate for some time. Having started the first electric company in Washington, the Heisler Electric Light Company in 1880, he may have been aware of the nascent plans for an electric railroad along the Potomac River before it was congressionally authorized in 1892. In 1885 he and author and journalist Joseph West Moore published *The National Capital Past and Present: The Story of its Development* to promote the advantages of living in Washington. Hutchins's book advanced his own current and future real estate ventures, when he wrote with colorful exaggeration that summer in Washington was at all times full of cooling breezes, making it more comfortable than the popular retreats at Newport and Saratoga. In the midst of his hyperbole, Hutchins personally committed to the advantages of Washington in July and August by building himself a summer house beyond the District line on the site of today's Defense Mapping Agency in Maryland.[20]

He and his partners encouraged others to build lavish large-scale residences on Conduit Road in their first subdivision. Jacob P. Clark, vice-president of the company, built Castleview for himself on Conduit Road (the current 4759 MacArthur Boulevard), and Clark's partner on the future small subdivision of Senate Heights, J. C. Hurst, built an equally imposing stone, shingle, and timber mansion that stands today at 4933 MacArthur Boulevard.

The company laid out four subdivisions in 1890 and 1891, touting their land as "the most picturesque portion of the District of Columbia" with "scenery unsurpassed." The first three subdivisions, aimed at the middle-class market, were located above and below Conduit Road. The fourth, with larger lots, intended for the upper-class home buyer, was located in the hills north of Conduit Road, west of Chain Bridge Road, and south of Loughboro Road. However, no lots sold in this fourth subdivision, and after marketing the entire subdivision for only four years, the company dissolved in 1897 at the end of the depression of 1893. It is unclear why the company failed, but its investors may not have been able to sustain the long-term commitment required for such large developments. The Massachusetts Avenue Heights Syndicate created in 1884 farther east in the District, for example, spent more than twenty-five years preparing a tract of 138 acres that did not go on the market until 1911.[21]

Following the short-lived Palisades of the Potomac, two additional subdivisions were laid out by developers — Senate Heights in the vicinity of Conduit Road, 47th Place, and New Cut Road, and Potomac Heights on the south side of Conduit Road and all the streets immediately south to the bluffs of the Potomac. By 1909 the final subdivided areas in this part of West Washington had been surveyed and platted, but for many years developers and private owners would reconfigure lot sizes, primarily to make them smaller. Lots were still being sold well into the twentieth century, giving the area an unfinished, semirural character. A collection of small brick houses and frame bungalows owned by mid-level civil servants, police, small business owners, and blue collar workers, such as carpenters, elec-

A solitary wagon and a bicyclist share the rural scene along Conduit Road (now MacArthur Boulevard) about 1890, just as the Palisades of the Potomac Land and Improvement Company bought adjacent land for suburban development. The view looks southeast toward Georgetown, with the Georgetown Reservoir behind the fence to the right. New Cut Road (now Reservoir Road) angles off to the left. Courtesy Washington Aqueduct

tricians, and plumbers, grew up around the trolley line that stopped along Sherrier Place through Potomac Heights, south of Conduit Road.[22]

Churches were the first organizations to bring residents together. The earliest church was Little Falls Methodist Episcopal, which began in the 1870s on Canal Road and a country lane, later Arizona Avenue. St. David's Episcopal Church, presently located at 5150 Macomb Street, organized as a mission church of St. Alban's Parish in 1900. Catholics began to meet in a private home in 1906, a group that would found Our Lady of Victory Church now at 4835 MacArthur Boulevard.[23]

In 1916 the emerging white community created the Conduit Road Citizens Association to lobby for paved roads, water, sewer lines, gas mains, systematic house numbering, street lamps, a playground with a field house, a widened Conduit Road, and residential zoning. The city opened a firehouse in 1925 at the intersection of Conduit and Reservoir roads. The Francis Scott Key Public School opened three years later. Since the school system remained segregated, the African American children living on Chain Bridge Road and the surrounding area attended the Chain Bridge Road School, which in 1923 had been upgraded to a four-room school building. In 1928 a branch of the D.C. Public Library opened in the

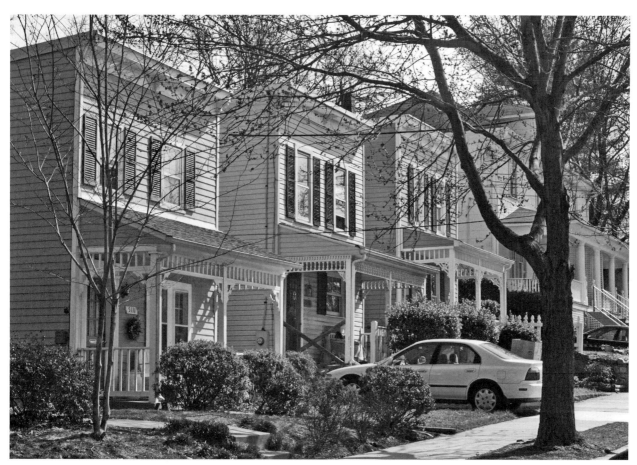

Frame houses such as these keep company with modest bungalows and small brick homes along Sherrier Place in what was once known as the Potomac Heights subdivision between Conduit Road and the C&O Canal. Developers carved up smaller lots after Stilson Hutchins's Palisades of the Potomac scheme failed during the economic depression of the mid-1890s. The trolley to Cabin John once ran along Sherrier Place. Photo by Kathryn S. Smith

historic one-room Conduit Road Schoolhouse, which dated to 1864. The library opened in its own building in 1964 at 4901 V Street, near MacArthur Boulevard.[24]

The twentieth-century commercial life of the neighborhood focused on MacArthur Boulevard, where drugstores, grocery stores, and gas stations began to cluster in the 1920s and 1930s, preceded by an early Sanitary Grocery in 1909, the precursor of the Safeway chain of today. One of the most popular was Barry Mauskopf's Market, a neighborhood fixture at MacArthur and Dana Place for thirty-four years. Safeway's arrival in 1942 and its expansion in the 1950s gradually drove out the smaller markets. The MacArthur Theatre, which opened on Christmas day in 1946, was another popular gathering place for fifty-one years before it lost is glamour and became a drugstore.[25]

Since Conduit Road never became the grand avenue of mansions envisioned by the developers of the Palisades of the Potomac, the enormous Castleview was sold in 1923 to the Florence Crittenden Home for unmarried mothers and later became the Lab School of Washington. The seller may have anticipated the disruption about to be caused by the expansion of the Washington Aqueduct that would take six years between 1922 and 1928, as a second conduit was laid next to the first and a modern filtration plant added at Dalecarlia

Reservoir. Between 1930 and 1934 the road was widened to four lanes with a median strip that protected the conduits installed beneath it.[26]

Changes were also occurring south of Conduit Road along the C&O Canal. A devastating flood in 1924 left the canal in ruins, ending a century-old system of barge transportation. In 1938, after another flood, the National Park Service acquired the canal with plans to restore it as a recreation area. However, the 1901–2 McMillan Plan called for an automobile parkway along its course, an idea that prevailed, fortunately unrealized, until Supreme Court Justice William O. Douglas joined with other preservationists in 1954 to defeat the plan. In 1971 the entire canal from Georgetown through the Palisades and on to its terminus in Cumberland, Maryland, was declared a national historical park, which preserved the canal, towpath, and adjacent land in perpetuity as a living museum.

The widening of Conduit Road and the closing of the C&O Canal coincided with a period of residential growth in the Palisades. Modest houses and shacks that had stood on attractive sites overlooking the river were being replaced by "a subdivision of attractive small estates," according to *Washington, City and Capital*, produced in 1937 by the Federal Writers' Project. In 1942 Conduit Road assumed its final name in honor of World War II hero General Douglas MacArthur. The citizens association adopted the name and called itself the MacArthur Boulevard Citizens Association. In 1950, in an effort to bring all the disparate subdivisions under one real estate name, the association chose its third name: the Palisades Citizens Association.[27]

The largest amount of uninterrupted housing construction occurred after World War II. Developers invested in the original and virtually undeveloped fourth subdivision of Palisades of the Potomac. Built in the popular Colonial Revival style, the entire section was called Kent by realtors, reaching for an upper-class cachet not generally ascribed to the Palisades at that time.[28]

In contrast to the traditional styles used by Washington developers, a group of individually designed Modern houses were built shortly after World War II by young couples who liked that style of architecture. Clustered on Chain Bridge Road and University Terrace, and later Arizona Avenue and Garfield Street, the houses took advantage of the hilly, heavily wooded lots, both small and large, with views of the surrounding countryside. The most defining aspect of this area in Palisades is that it was never subdivided by a single large-scale developer or subject to restrictive covenants for race or religion, as other developments in the neighborhood most likely were. The land was sold by individual owners over the years; the area had been racially integrated since the Civil War. Both the difficult topography and the integrated community had likely discouraged large-scale developers.

It was a welcoming place for a new group of educated and professional African American families in the 1940s at a time when housing discrimination persisted in the city. For example, noted African American architectural engineer Howard D. Woodson worked collaboratively with William Nixon's designs for an Art Deco house for Nixon's daughter, Dr. Ethel L. Nixon, her husband, Frank Mounsey, and their family. William Nixon taught art at Dunbar High School. His daughter held a medical degree from Howard University

Modern houses sprang up on the hilly, undeveloped land along University Terrace and Chain Bridge Road after World War II, occupied by African American and white families. William Nixon, an art teacher at Dunbar High School, designed this home at 2915 University Terrace for his daughter, Ethel Nixon Mounsey, and her family with assistance from noted architect and engineer Howard D. Woodson. Photo by Walter Smalling

and trained in psychiatry at the Johns Hopkins University. By 1952 the area was known as a hotbed of Modern architecture, with African American and white families living in more than ten houses by internationally and locally recognized architects. Thomas W. D. Wright, Lewis Fry Jr., Francis D. Lethbridge, Chloethiel Woodard Smith, Walter Gropius, Hugh Newell Jacobsen, Hartman and Cox, and J. P. Trouchoud all designed innovative houses in the Palisades, and the area developed a reputation for an eclectic mix of architecture ranging from the nineteenth to the twenty-first centuries.[29]

Perhaps as a result of the difficulty of building on hilly terrain, some large estates and farms persisted on the hills and ridges north of Conduit Road between Loughboro and Foxhall roads well into the twentieth century. Henry Carbery's forty-four acres called Cincinnati, west of Foxhall Road, was still intact in the early 1940s; the property became the estate of Nelson Rockefeller. In the late 1970s it was sold and developed as the large-scale luxury housing Foxhall Crescents. An eighteenth-century, fifteen-acre estate called Terrace Heights at the corner of Reservoir and Foxhall roads survived and in 1930 became the Uplands estate of the socially prominent and one-time minister to Norway Florence "Daisy" Harriman and her husband, J. Borden Harriman. The German government purchased the estate in 1964 for its Modern style chancery, and several years later it became the ambassador's residence. A 101-acre parcel owned by W. A. Maddox adjacent to Battery Kemble remained intact for more than fifty years. A portion of the land was sold to

brothers W. C. and A. N. Miller, developers of Spring Valley and Wesley Heights, who in turn sold fifty-seven acres of valley land to the National Capital Park Commission for Battery Kemble Park in 1931. Today residents enjoy the woodlands for walking in all seasons and the hills for sledding in the winter.[30]

MacArthur Boulevard remains the heart of the community. It brings people together for shopping and for its popular small-town–style Fourth of July parade. However, it also separates them, given the distinctions that have come to be made between those who live above and below it, with the lower sections being more affordable, except for the houses with views of the river. What is most noticeable is that the entire neighborhood has become highly desirable, with high-priced land and houses. There are private schools in the neighborhood along with the popular public elementary Francis Scott Key School. Well-to-do people have been replacing the mixture of blue collar and white collar residents of both races, although apartment buildings along MacArthur Boulevard provide some economic diversity.

The neighborhood's attractions have drawn developers, builders, and architects once again. As early as the mid-1980s, a cycle began to repeat itself in the Palisades. As in the 1930s, modest homes began to be torn down and replaced with larger ones, taking advantage of beautiful locations and views, a cycle that continues today. The community is once again in transition. Some residents oppose efforts to protect the special environment, while others work to moderate the changes to retain the character of Palisades that has made the neighborhood so pleasing from the beginning.

(opposite)
Neighbors gather on the 5000 block of Lowell Street in an area of the Palisades named Kent by its post–World War II developers, who favored the Colonial Revival–style architecture seen here. Photo by Kathryn S. Smith

Barry Farm / Hillsdale

A FREEDMEN'S VILLAGE

DIANNE DALE

Thanks to its bowl-like configuration, the capital city boasts elevations that afford wide panoramas from the tops of sets of terraces, formed by the gradual recession of an ancient waterway. Some of the most dramatic views exist east of the Anacostia River, where undulating hills rise rapidly from the edge of the river to some of the highest points in the city. Residents of Barry Farm / Hillsdale have enjoyed these thrilling views for generations.

In 1608 Captain John Smith became the first European to see these forested hills, teeming with wildlife, and to visit the centuries-old, Algonquin-speaking American Indian trading village Nacotchtank, located on the east side of the Eastern Branch. The people were called "Nacostines" by the Europeans, the source of the word Anacostia. The tribes, originally friendly and eager to trade, would be ravaged by disease and conflict and within about sixty years of European contact be gone from the area, replaced by the farms and plantations of English landowners, many worked by enslaved African Americans.

It was Secretary of State Thomas Jefferson in 1793 who suggested that the Eastern Branch be called "Annakostia" on surveyor Andrew Ellicott's maps of Washington City,

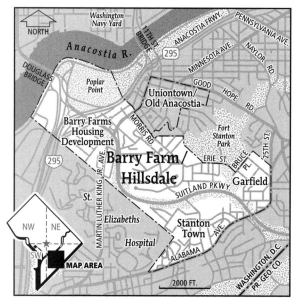

The outlines of historic Barry Farm/Hillsdale and other African American communities associated with it shown here are based on an 1887 G. M. Hopkins real estate atlas and the personal experience of the author, whose family lived in this area for four generations. All of these communities thought of themselves as living in black Anacostia. The planned suburb of Uniontown that met Barry Farm/Hillsdale at Morris Road, today known as Old Anacostia, was a predominantly white community until the 1950s. The name Barry Farms (with the S) has become associated with the World War II–era housing development west of Martin Luther King Jr. Avenue and just north of St. Elizabeths Hospital. Map by Larry A. Bowring

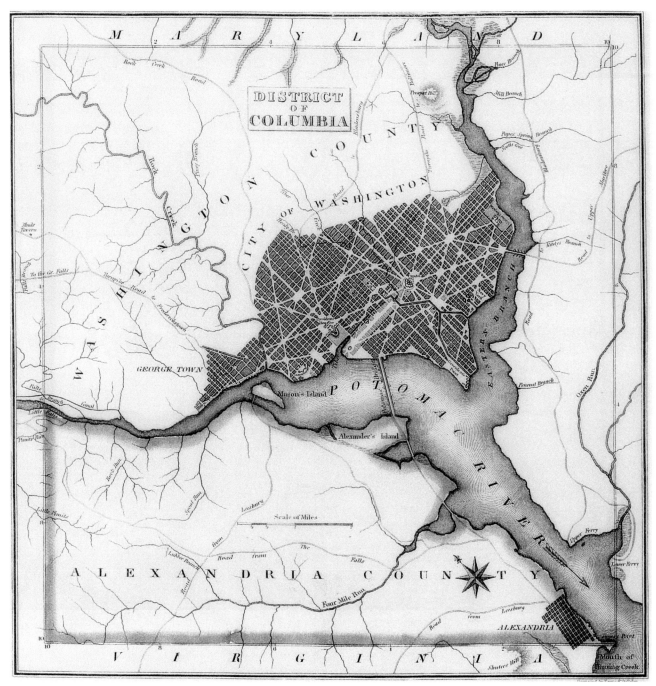

The City of Washington planned by Peter Charles L'Enfant stands out in dark, cross-hatched lines at the center of this 1823 map of the ten-mile-square District of Columbia by Carey & Lea. The District at that time also included the independent towns of Georgetown and Alexandria and the counties of Washington and Alexandria. The northern boundary of the City of Washington became today's Florida Avenue and Benning Road. The city and county of Alexandria retroceded to Virginia in 1846. Washington County filled up with suburban developments that are now urban neighborhoods. Courtesy Kathryn S. Smith

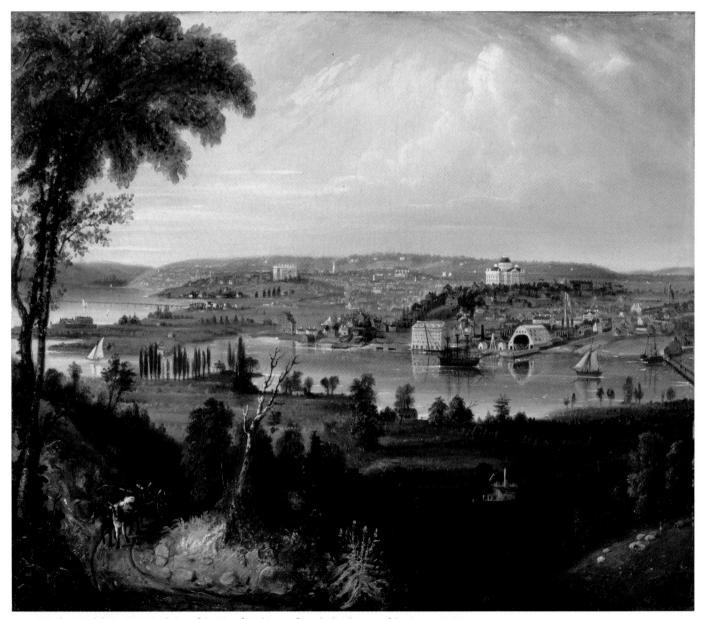

George Cook created this romanticized view of the City of Washington from the heights east of the Anacostia River, then known as the Eastern Branch of the Potomac, about 1833. The artist was likely standing near the future site of St. Elizabeths Hospital, between today's Barry Farm/Hillsdale and Congress Heights neighborhoods. The Navy Yard's ship building facilities are visible just across the river, with the Capitol on the hill behind them and the White House in the distance to the left. The hills east of the Anacostia River rise steeply to more than three hundred feet above sea level, affording residents of the neighborhoods there similarly grand views today. Courtesy White House Historical Association (White House Collection)

CITY HALL, WASHINGTON, D. C. *1855*

The pre–Civil War elected government of Washington City met in this City Hall at 4½ and D streets, NW, at the heart of a busy neighborhood where people lived as well as worked, a place today thought of as downtown. The nearby federal Patent Office and Post Office and the Center Market made the area a center of employment. The Greek Revival City Hall, seen here in 1855, was designed by George Hadfield and built in sections between 1820 and 1849. Its current use is as home to the District of Columbia Court of Appeals. Courtesy the Kiplinger Washington Collection

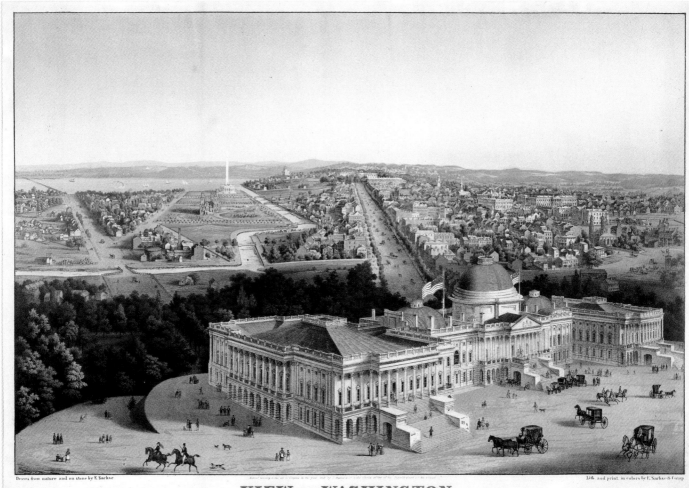

Drawn from nature and on stone by E. Sachse

Lith. and print. in colors by E. Sachse & Comp.

VIEW of WASHINGTON.

Published and sold by E. Sachse & Co., Baltimore, Md.

The growing City of Washington is laid out at the feet of the U.S. Capitol in this 1852 lithograph by E. Sachse & Co. City Hall, the Post Office, the Patent Office, and church spires stand out in what is today's downtown at the right, with Foggy Bottom and its Naval Observatory across Pennsylvania Avenue next to the Washington Monument on the horizon. Southwest is seen at the far left, so cut off from the rest of the city by the Mall and the Washington Canal that it was called "the island." The artist took liberties in producing this romanticized view in order to show off a new design for the extension of the Capitol, while putting the city in the best light. The Capitol, turned on its axis, is shown with as-yet-unbuilt wings designed by Thomas U. Walter that would later be altered by Montgomery C. Meigs. The Washington Monument, actually an unfinished stub in 1852, is shown here complete with the never-built circular colonnade designed by Robert Mills. Courtesy Albert H. Small Collection

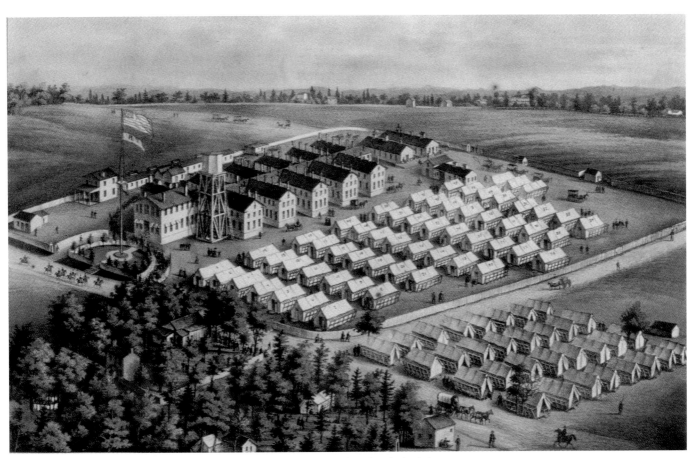

Hospitals such as this one in what would become Mount Pleasant were scattered about the District during the Civil War. The entrance to this hospital faced 14th Street, just north of its present-day intersection with Park Road. Like the neighborhood that would grow up here just after the war, it took its name from the thousand-acre estate that included this site, once owned by Robert Peter, a Scottish immigrant and tobacco merchant in Georgetown. Courtesy the Kiplinger Washington Collection.

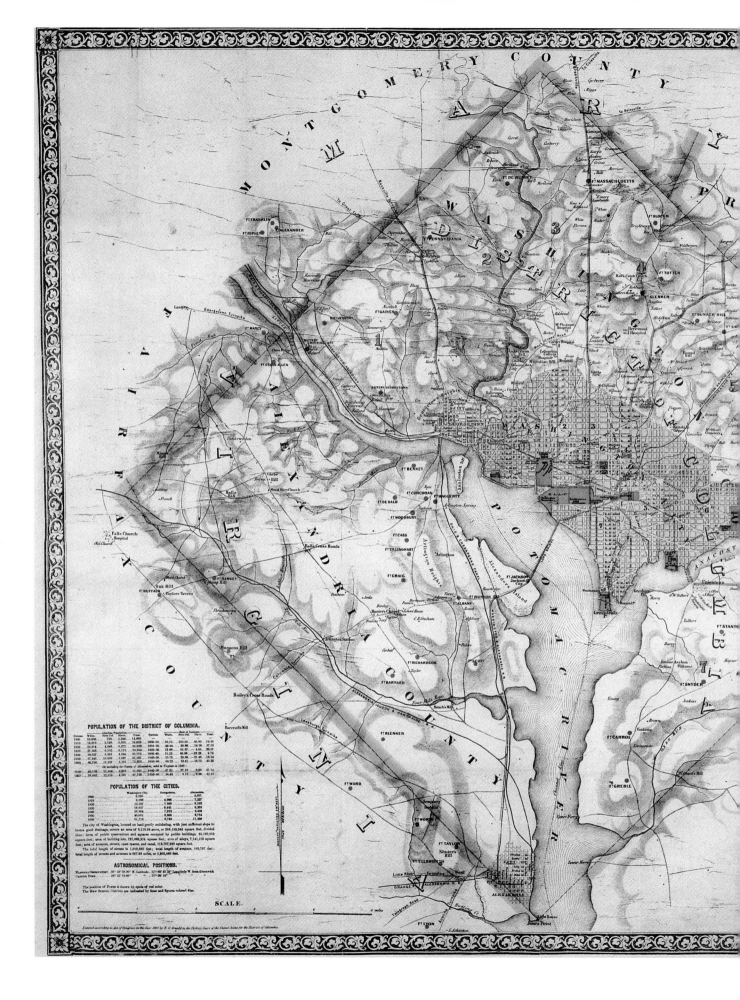

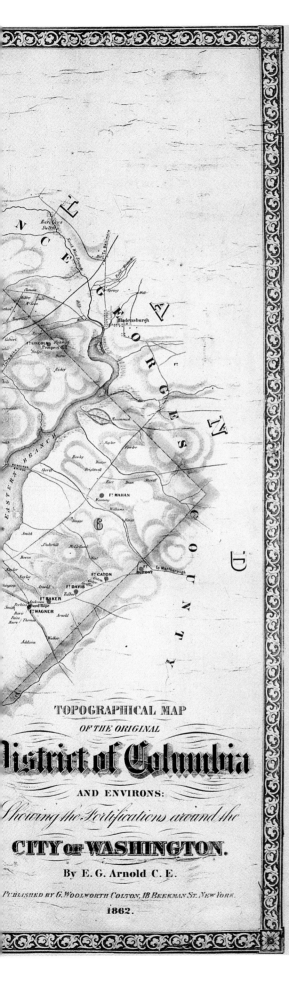

A close look at this 1862 topographical map of the original District of Columbia reveals the names of families that owned the rural land outside Washington City at the time of the Civil War, some of them farming, some of them occupying country retreats. The red dots indicate the location of the ring of forts constructed to protect the city from Confederate attack, sited at the highest points in the District. Fort Massachusetts, at the top of the map near the center, was later renamed Fort Stevens, the focus of the only Civil War battle in the District. Many of these fort sites are neighborhood parks today.

This rare map was published in New York by E. G. Arnold without the permission of the federal government and most copies were soon destroyed for security reasons. Courtesy Albert H. Small Collection

This 1872 map shows the streets paved by the Board of Public Works of the territorial government of the District of Columbia in that year, led by the board's most powerful member, Alexander Robey "Boss" Shepherd. Appointed territorial governor in 1873, Shepherd also installed street lights, laid miles of sewer lines, and planted thousands of trees that modernized the city seemingly overnight, polished its national image, and encouraged a real estate boom. Shepherd favored the parts of the city nearest the White House and thus sparked development in those areas, including a nascent Dupont Circle neighborhood. Capitol Hill and Georgetown received little attention. Courtesy Kathryn S. Smith

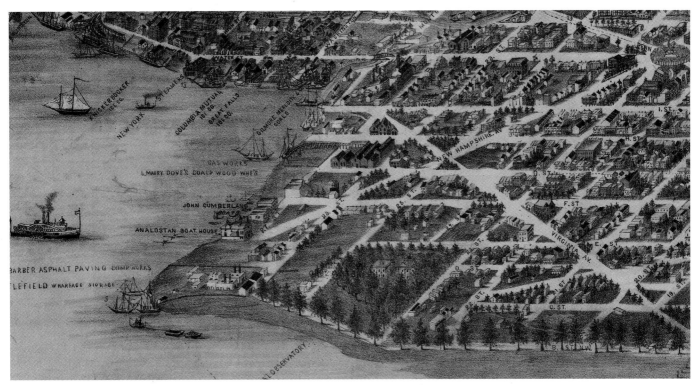

The port and industrial activities of Foggy Bottom stand out in this section of an 1884 bird's-eye view by E. Sachse & Co. The wooden houses of the working people of Foggy Bottom are shown in gray, in contrast to the scattered brick buildings in the neighborhood. The U.S. Naval Observatory, situated prominently on a hill overlooking the Potomac River, appears at bottom center. A portion of the Georgetown waterfront is seen at the left top; the three-masted schooners depicted here were involved in the busy ice and coal trade that dominated Georgetown's wharves in the 1880s. Courtesy Library of Congress.

The cover of a 1910 promotional booklet for these three suburban Washington developments celebrated the prospect of grand homes in tree-shaded neighborhoods that were very different from yet within easy reach of the central city. These neighborhoods became today's Cleveland Park. Courtesy DC Public Library, Washingtoniana Division.

(opposite) Dramatic scenery and promises of pure air and pure water beckon buyers in this flamboyant advertisement for new subdivisions laid out by Stilson Hutchins's Palisades of the Potomac Land and Improvement Company in 1890 and 1891. Courtesy American Antiquarian Society

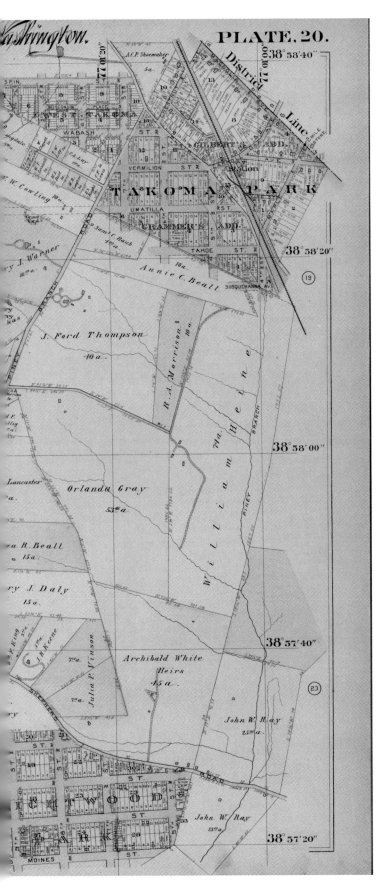

The street grids of the 1880s developments known as Brightwood Park and Takoma Park contrast with the irregular rural landholdings all around them in this portion of an 1894 plat map by the G. M. Hopkins Real Estate Company. The new subdivisions were both laid out adjacent to Brightwood Avenue, the major north-south road that connected Rockville, Maryland, and its agricultural produce to central Washington (where it became 7th Street) and the wharves of Southwest. The road would be named Georgia Avenue in 1909. The rich information in real estate maps such as these, produced from the 1870s to the 1960s, has proved invaluable to historians of Washington. Courtesy Library of Congress

The Club Crystal Caverns at 11th and U streets treated guests to name entertainment, including native son Edward K. "Duke" Ellington, in a night club setting beginning in 1926. This lively scene appeared on folders that held souvenir photos taken of guests in the 1940s. At the time the club stood on fashionable U Street, lined with movie theaters, restaurants, professional offices, shops, and clubs of all kinds at the heart of an African American community that is described in the chapter devoted to Greater Shaw. Operated as a club by various owners over the years, it was still in business in 2010 as the Bohemian Caverns. Courtesy The Historical Society of Washington, D.C.

Artist John A. Bryans captured the essence of a Washington about to change in this view of the activity at 21st and Pennsylvania Avenue, NW, in 1961. His centerpiece is a grand Victorian home about to be demolished, with parts of its lower floors turned to awning-shaded shops. The mixture of buildings includes a pre–Civil War Federal-style structure, with its sloped roof and dormer windows. All the streetcars in the city would be gone by 1962. The mixture of small-scale shops and residences on Pennsylvania Avenue, at the northern edge of Foggy Bottom, would soon be replaced by the high-rise commercial buildings of today. Painting by John A. Bryans. Courtesy the Kiplinger Washington Collection.

MARVIN GAYE PARK

WASHINGTON's LONGEST CITY PARK, running along the stream of Watts Branch through the neighborhoods of Capitol Heights, Northeast Boundary, Burrville, Lincoln Heights, Hillbrook, Mayfair Parkside, Deanwood, and Eastland Gardens.
©Mary Belcher and Washington Parks and People, 2006.

This artistic rendering of the winding route of the Watts Branch tributary on its way to the Anacostia River celebrates the renewal and renaming of the park along its banks for legendary entertainer Marvin Gaye, who grew up nearby. Residents and business people from Deanwood and adjacent neighborhoods, as well as volunteers from around the city, spent several years reclaiming the park, which had become overgrown and unsafe. Dedicated to Gaye in 2006, the park now provides educational and recreational programs for the communities of Ward 7. Map by Mary Belcher. Printed with permission of the artist, all rights reserved.

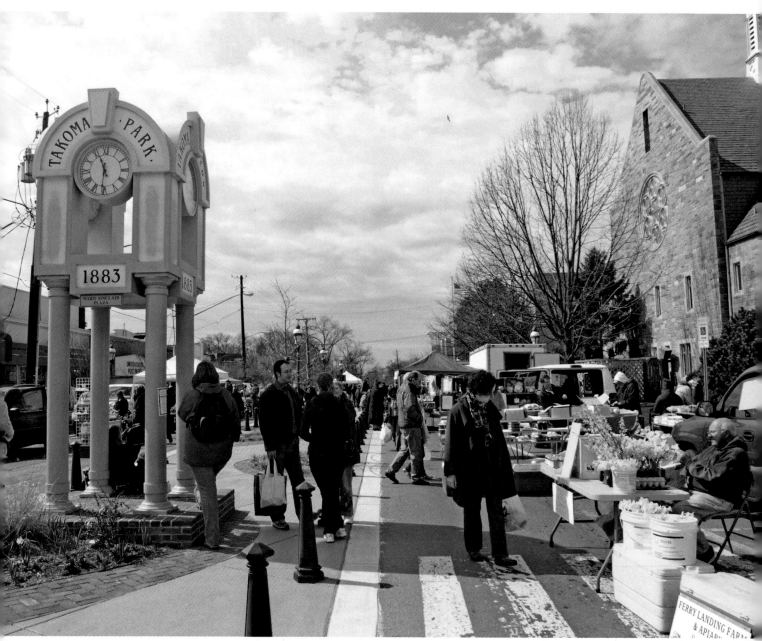

A shopper checks out the spring flowers at the Sunday morning farmers' market on Laurel Street in Takoma Park, Maryland. Just one block past the District line, the market attracts residents from the District and Maryland sides of the neighborhood. Farmers' markets now provide locally grown produce as well as community gathering places in many neighborhoods of the District of Columbia. Photo by Kathryn S. Smith

Views of central Washington such as this one from the Washington View apartments on the heights along Douglass Road in Barry Farm / Hillsdale are treasured by residents who live east of the Anacostia River. The early residents of Barry Farm chose this site, with its spectacular vista, for their first church, Mt. Zion African Methodist Episcopal, in 1867. The apartments, built in 1964, later deteriorated and have been fully renovated as affordable housing. Photo by Rick Reinhard

in recognition of the region's earliest inhabitants. Nonetheless the name Eastern Branch would persist for a century. Black astronomer Benjamin Banneker had assisted in the survey that set the boundaries of the District, including those east of the river. The name Anacostia became associated with the land that had been occupied by the Nacostines and has sometimes been used to mean the entire area of the District east of the Anacostia River. It correctly applies, however, to only two communities, one white, one black. The Anacostia Historic District at the end of the 11th Street Bridge, laid out in 1854 as Uniontown and in 1886 renamed Anacostia, was a majority white community for most of its history. Immediately south of it was a historically black community laid out as Barry Farm in 1867, renamed Hillsdale by the territorial government of the District at the request of local people in 1874. Black residents of this area in the past thought of themselves not only as living in Hillsdale but also as residents of Anacostia. This chapter focuses on this black community.[1]

While many African Americans were enslaved on plantations in the rural parts of the District east of the Eastern Branch before the Civil War, a free black community, now known as Garfield, formed near the crossroads village of Good Hope. It was located at the top of Good Hope Road, SE, where today's Naylor Road and Alabama Avenue intersect. Good Hope began as a trading village in the 1820s. These early residents of Garfield were artisans and laborers, and some sold goods and services at Good Hope. They established Allen Chapel African Methodist Episcopal Church on Alabama Avenue and 25th Street in 1850. The church remains at that location today, the oldest black congregation in the area, with memberships that span generations.[2]

The first bridge to connect this area to Washington City across the river was built in the early nineteenth century from Good Hope (Old Marlborough) Road across to the Navy Yard at 11th Street. This bridge would make possible the first planned community east of the Anacostia River, and indeed the first planned suburb of Washington City. In 1854 John Van Hook, John Dobler, and John Fox formed the Union Land Trust and purchased 100 acres of the 240-acre Talbert Farm at the foot of the bridge. They laid out a development in a grid pattern, with an oval park for community use, and called it Uniontown. They named the streets after presidents (later changed to be compatible with those of the L'Enfant city across the river) and offered lots for sale at the reasonable price of $60 to $75, payable at the rate of $3 per month. The intended market was the workforce at the Navy Yard, enticed to cross the river and enjoy the fresh air, clean water, and other benefits of country living. Potential black buyers were excluded by covenants in the deeds, as would be the case in many Washington suburban developments to follow.[3]

Cutbacks at the Navy Yard and rival real estate enterprises dampened sales, as did the Civil War. In 1877 John Van Hook declared bankruptcy. It was this circumstance that enabled famed abolitionist, orator, publisher, and women's suffrage advocate Frederick Douglass to purchase the hilltop mansion with a stunning view that Van Hook had

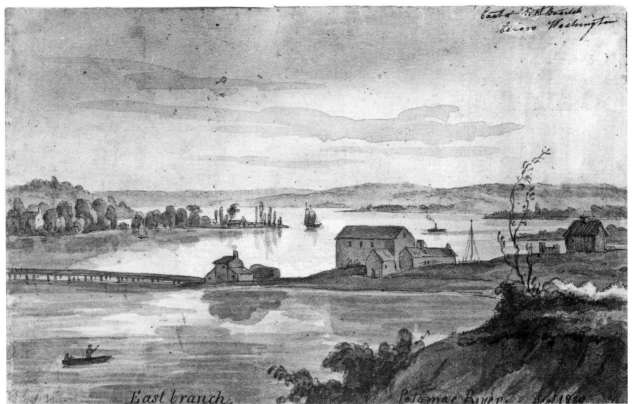

East branch. Potomac River

The simple wooden 11th Street Bridge across the Eastern Branch (today's Anacostia River), seen in this 1839 painting by Augustus Köllner, encouraged the development of Uniontown in 1854. Courtesy Library of Congress

built for himself. Because of the racial covenant, he bought through a white intermediary. Douglass named his nine-acre estate Cedar Hill and lived there until his death in 1895. Despite his presence, the community would remain predominantly white until the 1950s.[4]

The name Uniontown was changed to Anacostia by Congress in 1886 to distinguish it from the many other Uniontowns in the nation and to correspond with the designation of the Anacostia Post Office established in 1849 to replace the Good Hope Post Office. Early landowners built modest wooden houses in Italianate, Queen Anne, and Cottage styles, which continue to distinguish the community from the rest of Washington. In recognition of its early history as a planned suburb and its unique architecture, Uniontown/Anacostia was listed on the National Register of Historic Places in 1978.[5]

As Van Hook and his partners saw the potential for development at Uniontown, Dorothea Dix, a crusader for the mentally ill, discovered the grand vistas along the river just to the south. In 1852 she persuaded Congress to purchase 185 acres of wooded hills from the Thomas Blagden family for a federal hospital. The tract of land was known by its colonial patent name, St. Elizabeth. At first known as the Government Hospital for the Insane, it would provide a new model for the treatment of the mentally ill. The hospital was laid out along Piscataway Road, later called Asylum Road, and then Nichols

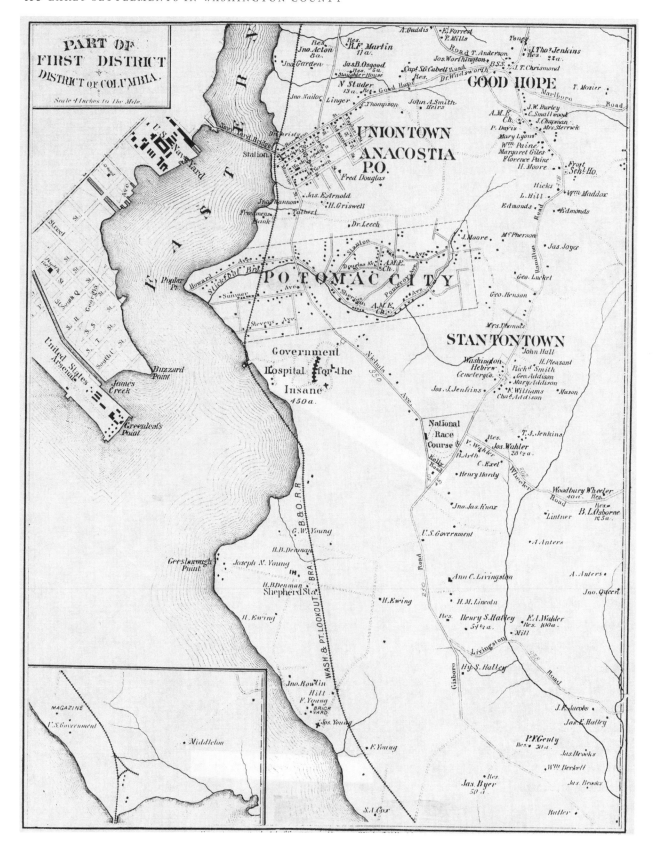

Avenue for Dr. Charles Henry Nichols, a respected resident of neighboring Uniontown who served as first superintendent of the asylum from 1852 to 1877. (The road is known today as Martin Luther King Jr. Avenue.)

The natural setting and lovely views were considered therapeutic and were factored into the landscape design. In a site selection report Nichols wrote, "The view which will be enjoyed by the patients, comprises all of the cities of Washington, Georgetown and Alexandria, the heights north of the former, the Virginia hills on the south, and the Potomac and Eastern Branch for several miles. These features are of immense consequence." Buildings were designed to complement the topography in a tree-lined campus-like atmosphere. Built to be self sufficient, eventually the campus included a creamery, a fire station, a bakery, an ice plant, a dining hall, farms, livestock, and greenhouses. Many local people would be employed here.[6]

St. Elizabeths was one of the first federal mental institutions to treat blacks, although they were housed in separate lodges, and the first federal hospital to treat mental illnesses of military personnel. During the Civil War it treated black and white soldiers, Union and Confederate, for mental and physical wounds in a special hospital building designated at that time as St. Elizabeth Hospital. Artificial limbs for amputees were manufactured and fitted on the grounds. The hospital's name allowed soldiers to use "St. Elizabeths" as the return address rather than indicate they were convalescing at the Government Hospital for the Insane. In 1916 Congress officially named the entire facility St. Elizabeths Hospital, without an apostrophe, which has troubled editors ever since. Cemeteries on the hillside overlooking I-295 and on the east campus of the hospital hold the remains of three hundred Confederate and Union soldiers lying side by side.[7]

Just to the south of the hospital was the Giesboro Cavalry Depot, responsible for shipping horses, supplies, and provisions to the Army of the Potomac from 1863 to 1866. Here former slaves from neighboring plantations and other freedmen could sell their goods and services, as they had at Good Hope village. It became common for black enclaves to develop around Union troops, camps, or forts. There was the opportunity for safe haven, for means of employment, or to take up arms and join the fight for one's freedom. In addition to Giesboro, there were Union forts all along the heights east of the Anacostia, including Fort Stanton above Uniontown, sited to protect the Navy Yard and the 11th Street Bridge. African Americans could find refuge and opportunity at such places.

Thus it was not surprising that land between Giesboro and Fort Stanton would be chosen for a national experiment in housing for freedmen after the Civil War. Slavery had been abolished in the District on April 16, 1862, an act of Congress that compensated slave owners, almost nine months before the Emancipation Proclamation. It added to the steady stream of escapees seeking freedom in the nation's capital. At the end of the war in 1865, Congress established the Bureau of Refugees, Freedmen and Abandoned Lands, known generally as the Freedmen's Bureau, to resettle those persons, black and

(opposite)
Uniontown was the first planned suburb of Washington City. The straight grid plan of its streets stands out in this 1878 map by G. M. Hopkins in contrast to the winding rural roads all around it, including those in Potomac City, the original name for the Barry Farm / Hillsdale community. Courtesy Library of Congress

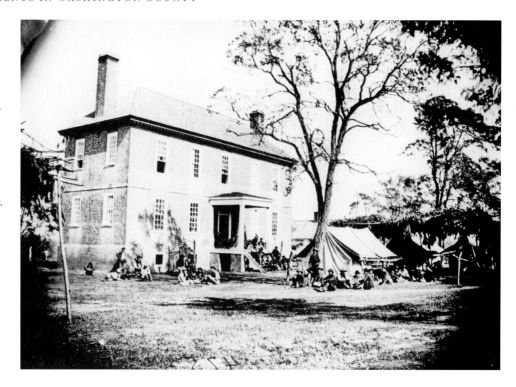

white, displaced by the conflict. For blacks, housing and job opportunities were scarce and hostile conditions remained. The Bureau provided them means for land ownership, employment, and education in their transition to freedom.

In Washington in 1867, General Oliver Otis Howard, a Civil War veteran appointed to head the Bureau, negotiated the purchase of a 375-acre tract of farmland just north of St. Elizabeths Hospital that the Bureau intended for resale to blacks only. The land belonged to heirs of early landowner James D. Barry. The sale was brokered through an intermediary, John R. Elvans, a local businessman and member of the Freedmen's Bureau board, because the climate was such that sale of land for use by black settlers would have met with resistance. The community to be built there was named Potomac City, but it became popularly known as Barry Farm.[8]

Barry Farm was divided into one- and two-acre parcels and sold to freedmen and ex-slaves for between $125 to $300 per acre, including enough lumber to build two rooms. Profits from the sale of these lots went toward the establishment of Howard University in 1867. Many of the early homes, the first built along Howard Road, were two-story, A-frame dwellings, none of which survive. Many settlers worked to clear the land, their pay applied to their purchase. With neighbor helping neighbor to construct their new homes, Barry Farm was settled by nearly five hundred families in only two years, most likely the large plots being shared by family and friends. The winding streets that followed the contours of the hills — Douglass, Stanton, Howard, Sheridan, Elvans, Pomeroy, Stevens, Eaton — were named for Civil War generals, abolitionists, members of Congress, and others associated with the development of the new community and the

bid for emancipation. Boundaries for the black settlement of Barry Farm were St. Elizabeths on the south to Morris Road on the north; Alabama Avenue on the east to the Anacostia River on the west. Residents were shop owners and craftsmen, professionals and laborers, all sharing the new experience of citizenship.[9]

Frederick Douglass moved to Uniontown/Anacostia ten years after the first lot was sold in adjacent Hillsdale. Three of the Douglass sons — Charles, Lewis, and Frederick Jr. — had settled in Hillsdale with their families, just over the rise from Cedar Hill. Following the Douglass tradition, the sons were actively involved in the affairs of the community and were well regarded. Black residents of Hillsdale were proud to be living in such proximity to the one who came to be known as the Sage of Anacostia. Longtime resident Erma Simon remembered that pride during her school days in the 1930s. "On Arbor Day," she reminisced, "we would make our pilgrimage up there [Cedar Hill] and plant a tree and have Arbor Day services."[10]

Another leading early citizen of Barry Farm / Hillsdale was Solomon G. Brown, a poet and scientist who worked for the Smithsonian Institution for fifty-four years. He was one of a group who had petitioned the Freedmen's Bureau to create the community there and was one of its first residents. He would be elected to three successive terms in the House of Delegates of the Territorial Government of the District of Columbia between 1871 and 1874, defeating both Frederick Douglass Jr. and a prominent white citizen, Henry Naylor. In 1874 his legislation changed the name of the community from Barry Farm to Hillsdale to acknowledge its topographical beauty. He was also a founding member of the Hillsdale Civic Association in 1890.

Brown founded the Pioneer Sabbath School, which sponsored gatherings for lectures, concerts, and programs each Sunday at four o'clock in the Douglass Hall at Howard and Nichols avenues. Eureka and Green Willow parks at the river's edge near Poplar Point provided the setting for Sunday band concerts, after-church picnics, dancing, and family entertainment. Elzie Hoffman, cofounder of the Hillsdale Civic Association and an accomplished, classically trained composer, was often the band leader. By 1885 Hillsdale was thriving with 1,543 residents; Mount Pleasant across the river, by comparison, had only 546 that year.[11]

The community was linked to the rest of the city by the horse-drawn streetcars of the Anacostia and Potomac River Street Railroad Company, which began operations in 1876 from the Navy Yard to Uniontown by way of the 11th Street Bridge. By 1898 the streetcars were powered by overhead electrical current. Lines now going farther along

Frederick Douglass poses for the camera with his grandson Joseph. The most famous spokesman for equal rights and justice for African Americans in the nineteenth century, Douglass lived in Anacostia (originally called Uniontown) adjacent to Barry Farm, where three of his sons made their homes. Courtesy Library of Congress

This section of Nichols Avenue, seen here looking north in 1903, served the black residents of Barry Farm. The avenue continued on through predominantly white Anacostia to the 11th Street Bridge across the Anacostia River. Courtesy Library of Congress

Nichols Avenue spurred development of the white Congress Heights community to the south of St. Elizabeths, laid out in 1890. Black Anacostia was now sandwiched between two white communities—Anacostia and Congress Heights. Hillsdale resident Everett McKenzie remembered that he and his friends could not go past the first gate at St. Elizabeths or whites would chase them away. Others remembered being sometimes challenged while walking the other way down Nichols Avenue through white Anacostia on their way to the 11th Street Bridge.[12]

In time black Anacostia came to include several distinct neighborhoods—Barry Farm / Hillsdale, Stantontown, and Garfield. It functioned, however, as one community. It felt like a small town, with one-family houses situated along the winding streets that climbed the steep hills overlooking the Anacostia River and the central city beyond. Kenneth Chapman, born in 1927, recalled, "It was a very close-knit neighborhood because you just about knew everybody, from down below the railroad tracks to Alabama

Avenue." Churches and schools appeared early and served as extended family. Mt. Zion AME Church began in 1867 on the heights along Douglass Road; it relocated to Nichols Avenue in 1890 because of the steep climb and was renamed Campbell AME for Bishop Jabez Campbell. In 1868 Rev. William Hunter, the first person to purchase a residence in Hillsdale, established Macedonia Baptist Church at Stanton and Pomeroy roads. St. John Christian Methodist Episcopal Church (formerly Hillsdale Station CME) and Bethlehem Baptist Church opened their doors in 1876. All are in existence at this writing, and all claim descendants of the founding members in their congregations.[13]

Black Anacostians helped to build St. Teresa of Avila Catholic Church in Uniontown/Anacostia in 1879 but were relegated to services in the basement. In protest, they built their own parish on a dramatic hilltop on Morris Road — Our Lady of Perpetual Help — completed in 1924 as the first Catholic parish in black Anacostia. It is community tradition to watch the fireworks on the Mall from Our Lady.

In 1871 Hillsdale carpenter Peter Wilkinson and fellow craftsmen built the first public elementary school in Hillsdale, Hillsdale School, a wooden structure on Nichols Avenue at Sheridan Road, on land provided by Wilkinson. A new, larger wooden structure replaced it across the street in 1889, renamed for abolitionist James Gillespie Birney. In 1901 Birney Elementary School moved to a fine, new, brick Italian Renaissance–style structure a block away at the central crossroads of Howard Road and Nichols Avenue. It became a community center as well as a school, the site of a branch of the D.C. Public Library, and a place for civic association meetings and adult education classes. In 1962 it was renamed Nichols Avenue Elementary School. (Currently, the building, restored and modernized, houses the Thurgood Marshall Public Charter School.) Garfield School, a second brick elementary school building still in use, opened on Alabama Avenue in 1908 to accommodate the growing school-age population there. It was designed by noted black architect William Sidney Pittman.[14]

Erma Simon said, "The leaders at Birney School were strong and determined people," and she remembered having "all that was needed for a good education" in the 1930s. They studied Greek history and how to debate, participated in spelling bees, and learned

A JOINT ENTERTAINMENT!

UNDER THE AUSPICES OF

CAMPBELL A. M. E.

AND

BETHLEHEM BAPT. SUNDAY SCHOOLS

At Campbell A. M. E. Church

NICHOLS AVENUE, ANACOSTIA, D. C.

FRIDAY EVENING, MARCH 3RD, 1911

The Program will consist of several Solos and an Interesting DEBATE upon a Bibical Topic between teams from the two Sunday Schools— Subject,
"Resolved: That DAVID was a Greater King than SOLOMON."

Campbell A. M. E. Sunday School AFFIRMATIVE	Bethlehem Baptist Sunday School NEGATIVE :
Samuel Warner, Lawrence Jackson, George Scott	Emerson Brown, John L. Smith, Jr. Leon Marshall

JUDGES.

Frank J. Blagburn Henry Braxton Horace Queenan
B. E. Madden C. W. Tignor

REFRESHMENT COMMITTEE
Mrs. R. S. Penn Miss Sadie Holly Mrs. I. V. Brown
Miss Bertha Howard Miss Artie Ross Miss Annie Johnson

COMMITTEE ON ARRANGEMENTS
Wm. H. Liverpool, Chairman
Rev. L. M. Beckett, Pastor of Campbell A. M. E. Church
Rev. Jos. Matthews, Pastor of Bethlehem Baptist Church
Superintendents.—I. V. Brown and J. T. Marshall

PROCEEDS FOR THE BENEFIT OF SAID SUNDAY SCHOOLS
DOORS OPEN AT 7:30 P. M.
Tickets, - 15 Cents
CHILDREN, under 12 yrs. 10 CENTS

Wm. A. Baltimore, Printer. 208 V Street. Northwest

A Campbell AME Church flyer announces an evening of entertainment and education in 1911, including a debate on the relative merits of biblical kings David and Solomon as well as music and refreshments. Black Anacostians gathered regularly at churches such as Campbell for meetings, concerts, lectures, and other community activities. Courtesy Smithsonian Institution, Anacostia Community Museum

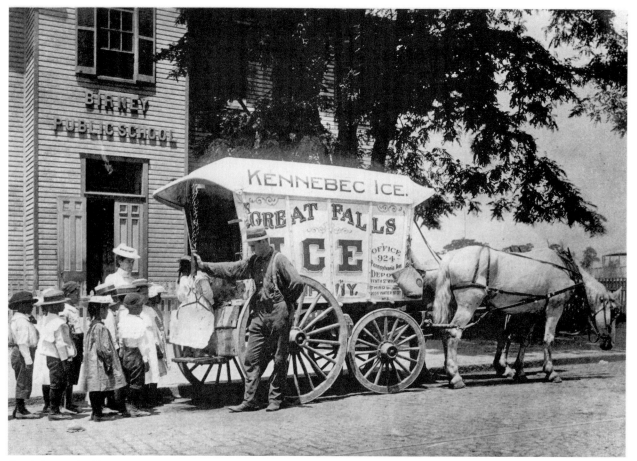

Noted photographer Frances Benjamin Johnston captured this image of Birney Public School students on a field trip just outside their schoolhouse doors about 1900. Courtesy Library of Congress

to sing and recite poetry. Upon reaching seventh grade, the boys learned to work with wood in carpentry class and the girls took home economics, their last project being to make their own graduation dress of white organdy. Once graduated from elementary school, however, students had to travel, often on foot, across the 11th Street Bridge to attend Randall Junior High School in Southwest, or Garnet Patterson or Banneker junior high schools in Northwest, and then Cardozo, Dunbar, or Armstrong high schools in Northwest. Until the *Brown v. Board of Education* decision desegregating public schools in 1954, the secondary schools east of the river, Anacostia High School and Kramer and Sousa junior high schools, were for whites only.

Changes came to the waterfront in the 1930s as the Anacostia River was dredged and a seawall constructed to create areas for recreation and gardens for public use following the East and West Potomac Park models. Anacostia Park was enhanced with a recreation center, tennis courts, swimming pool, and golf course — for whites only. Blacks were relegated to the less developed portion of the park south of the 11th Street Bridge.

The park would provide the setting for an event that captured the attention of the nation. In the depths of the Great Depression in May 1932, more than twenty-one thousand World War I veterans, dubbed the Bonus Army, came to Washington to de-

mand early payment of promised bonuses. Thousands settled in makeshift shanties in camps scattered throughout the city. The largest contingent — more than fifteen thousand — crossed the river to camp in Anacostia Park, some with their families. The fact that the veterans were racially integrated in a segregated Southern city was shocking to many; the veterans were only allowed in the African American section of the park. A former Hillsdale resident remembered that residents provided food and took in people when it rained. When, on orders from General Douglas MacArthur against the wishes of President Herbert Hoover, tanks and tear gas routed the veterans from the entire city, the petitioners scattered. Erma Simon remembered, "It was a pitiful sight to see them coming up Nichols Avenue, past our house where we lived at the time, going on toward Maryland and places South with what they were able to salvage." Some marchers settled in Anacostia, and some married into the community.[15]

That same decade Hillsdale residents could note with pride the major achievement of a native son. The story of this family opens a window to life in this community — its challenges and the way in which the community met them. In 1935 Frederick Douglass Patterson became the third president of Tuskegee Institute, now University, in Tuskegee, Alabama. He had been born on Elvans Road, just across from Our Lady of Perpetual Help Catholic Church, in October 1901. His father, William Ross Patterson, had passed a Civil Service exam in Prairie View, Texas, where he and his wife, Mamie Brooks Patterson, were teachers. Promised a job as a clerk in the Army Department, William brought their family of five children to Washington for better educational opportunities. When officials saw he was black, they reduced his pay to that of a messenger, and no effort on his part could change that status.

William Patterson eventually enrolled in Howard University Law School and graduated in 1901; five subsequent generations would receive a degree from Howard. That same year Frederick Douglass Patterson, his youngest child, was born, named for the much-admired Sage of Anacostia, whose home was a few blocks away. By the time Frederick was two years old both parents had succumbed to tuberculosis, and as provided in his father's will, the children were placed with neighbors. Frederick eventually moved to Texas with his oldest sister, Wilhelmina Bessie Patterson, who had lived with Solomon Brown and his wife until graduating from Miner Teachers College. When he became Tuskegee president, Frederick bought her a house on Morris Road in Hillsdale, where she taught music and lived until her death in 1962.

In 1941, just before the United States entered World War II, Dr. Frederick Patterson, who was a licensed pilot, prevailed upon First Lady Eleanor Roosevelt, in her capacity as a member of the board of the Rosenwald Foundation, to visit Tuskegee with other members of the board. They were asked to consider a grant to create a new airfield and a training program for black pilots. (The airfield would be built and named for Robert Russa Moton, second president of Tuskegee and Frederick's father-in-law.) Thus was born the first African American military flying unit, a storied group of pilots whose members came to be known as the Tuskegee Airmen.

Four generations of the Dale family lived in the Barry Farm / Hillsdale neighborhood beginning in 1892. Posing for a photograph in 1958, they are, left to right, John Henry Dale Jr., John Henry Dale Sr., seated with John Ivan Dale, and Almore Marcus Dale, father of the author of this chapter. Courtesy Dianne Dale

Three years later, Patterson would found the United Negro College Fund and, in 1983, create the College Endowment Program, to benefit the Fund. In 1987 he received the Presidential Medal of Freedom, the country's highest civilian honor, from President Ronald Reagan.[16]

Other members of this extended family lived in Hillsdale for generations. Another of Frederick Douglass Patterson's sisters, Lucille, married John Henry Dale Jr. in 1907. They met as teenagers at Campbell Church and eventually settled in Hillsdale on Sumner Road. John Henry Dale's grandfather, Marcus Dale, was an Oberlin graduate and Civil War veteran. John Henry Dale Sr., like William Patterson, had been called to Washington after passing a Civil Service exam and would be demoted from clerk to messenger pay status at the Pension Bureau when his race became known. He built a home and raised nine children in Hillsdale. John Henry Jr. raised four children in Hillsdale and served for thirty-five years as president of the Hillsdale Civic Association.

The community also looked for leadership to Florence Matthews, born in Hillsdale in 1891. A teacher trained at Howard University and New York City College, she began a D.C. Recreation Department program on Nichols Avenue in a little building near Sumner Road. A mentor to generations of youth, she created programs that included spelling bees, crafts, music and dance recitals, one-act plays and art shows, and homework guidance, as well as sports, games, and free movies in the summer. When Barry Farms housing was constructed for African American war workers and veterans in the early 1940s, north of St. Elizabeths and west of Nichols Avenue, Florence Matthews moved into larger quarters at Barry Farms playground on Sumner Road. (This housing development is often confused with the much larger 1860s community called Barry Farm and then Hillsdale.) Here she continued to work with neighbors, churches, businesses, and schools to provide the highest level of programming for the community. Her husband was Samuel P. Matthews, principal of Randall Junior High School in Southwest.

The Recreation Department spawned another community and citywide leader in Stanley J. Anderson, a 1948 graduate of Howard University who worked under Florence Matthews and took over the leadership of the Barry Farms Recreation Center on her death in 1955. His grandfather, John Anderson, a stonemason, had helped to build Bethlehem Baptist Church in 1876. Anderson also mentored community youth. He would become the first city councilmember from Ward 8, appointed by President Lyndon Johnson in 1967 when the three-commissioner form of government was abolished. He

was attending Sunday service at Bethlehem when he received word of his new post. As a D.C. Council member, Anderson would be responsible for the renaming of Nichols Avenue as Martin Luther King Jr. Avenue in 1971.

Residents of Hillsdale would play a key role in the desegregation of the public schools in the city and the nation. The Consolidated Parent Group, or CPG, formed by Gardner Bishop to challenge the deplorable conditions of the overcrowded and deteriorating colored schools, as they were then called, began to meet at Campbell Church on Nichols Avenue. In 1950 Bishop and Campbell pastor Rev. Samuel Everett Guiles led a group of twenty-five students into the recently built, underutilized white-only Sousa Junior High School on Ely Place in the Fort Dupont neighborhood. Transportation to the demonstration was provided by Mason Funeral Home, a neighborhood institution since 1890 owned by Campbell Church member and CPG secretary Frances Mason Jones. Two of the students, Adrienne and Barbara Jennings, were members of Campbell Church. When the students tried to enroll, all were turned away. The resulting lawsuit, *Bolling v. Sharpe*, would become a companion case to the *Brown v. Board of Education* Supreme Court decision in 1954 that desegregated schools across the nation. Adrienne and Barbara Jennings were among the plaintiffs in *Bolling v. Sharpe*.[17]

Other changes, however, were having a negative effect on this close-knit, family-oriented community. In 1948 the multilane Suitland Parkway, designed to take traffic to the new Andrews Air Force Base in Suitland, Maryland, plowed through the middle of the community, destroying homes and businesses. Coinciding with construction of the South Capitol Street (now Frederick Douglass Memorial) Bridge, Suitland Parkway split the community and heralded the slow, pervasive decline and destruction of a thriving, industrious community, its way of life, and its value systems.

The old community was equally disrupted by housing policies of the New Deal and World War II eras. Federal housing authorities sometimes took land by eminent domain for dense new apartment developments that dramatically changed the social and physical character of the place. One example was the eighty-one-acre tract on Alabama Avenue in Garfield that had been assembled by ex-slave Tobias Henson as a secure place for his family to live. He had purchased his freedom and that of many family members in the years leading to the Civil War. The National Capital Planning Commission took the land by eminent domain in the 1940s to build Douglass and Stanton dwellings, just as other parcels of land in Hillsdale were seized to make way for government war housing at Barry Farms.

Initially, applicants to these rental programs were required to demonstrate adequate means of support. Potential residents were carefully screened and those accepted stayed an average of only five years before acquiring property of their own and moving away. There was no cohabitation without matrimony, and there were no unwed mothers. "Authorities held to strict standards by which they judged applicants for admission," pointed out Anacostia native James G. Banks, an urban development expert and one-time director of the National Capital Housing Authority, in his book *The Unintended*

Boys look over the new Douglass Dwellings public housing project in July 1942. New apartment complexes such as these built in the 1940s changed the social and physical character of the neighborhood. Photograph by Gordon Parks. Courtesy Library of Congress

Consequences, published in 2004. "Employees of housing authorities often met potential residents in their homes to ensure that they were responsible parents and neighbors," he wrote. Eventually urban renewal policies that relaxed the rules on self-sufficiency and civic responsibility would transform these dwellings into areas of concentrated poverty.[18]

As the city's population continued to grow after World War II, private developers, encouraged by federal government subsidies, built low-cost and often poorly constructed garden apartments to meet the demand on abundant empty land in Far Southeast (the part of the Southeast quadrant that lies east of the Anacostia River) including Barry Farm / Hillsdale. The area "was seen as an attractive place to develop housing because of its considerable cheap, vacant land and beautiful views of the city," Banks observed. Although the 1950 Comprehensive Plan developed by the National Capital Planning Commission saw a problem in the growing concentration of multifamily rental units in the area, new zoning regulations in 1958 and subsequent changes prevented the construction of anything but garden-type apartments on about 75 percent of the residential

land in Far Southeast. (Only 20 percent of residential land was zoned for apartments in the rest of the city.) The need to house those displaced by Southwest urban renewal was a factor. Barry Farm / Hillsdale was soon overwhelmed with new residents, rendering schools, stores, and other services insufficient to meet the needs of so many newcomers. The apartments also changed the character of the neighborhood from one of mostly owner-occupied, single-family homes, to one occupied mostly by renters.[19]

The Interstate Highway System, funded for the first time by the Eisenhower Administration in 1956, was another assault on the character and topography of the village. When I–295 was built along the Anacostia River in 1960, it took away more housing, backyards, portions of Anacostia Park's golf course, and Anacostia High School's playing fields. In addition, I–295 connected to the Southeast/Southwest Freeway via a huge, new, double span of the 11th Street Bridge. Traffic patterns changed as did access to routes into and out of the community and the park, furthering the gap between neighbors and services. The Anacostia Metrorail station would bring a new entryway to the community in 1987, but it would also destroy historic homes and other valued community structures.

One positive development in this period was the creation of the Smithsonian Anacostia Neighborhood (now Community) Museum, which opened in the former George Washington Carver movie theater on Nichols Avenue in 1967. Of the six neighborhood theaters in the vicinity, Carver had been the only movie theater serving black Anacostians. It had also been a popular place for gala events and citywide talent shows. Falling on hard times after desegregation, the theater went through a series of uses until Stanley Anderson, once the manager of the theater, and three neighbors — Almore Dale, Alton Jones, and Marian Hope — met with Secretary of the Smithsonian S. Dillon Ripley to persuade him to create a neighborhood museum in Anacostia.

Ripley had noted the near-absence of African Americans on the National Mall and, in a revolutionary move, decided that if black Washingtonians wouldn't visit the Smithsonian "neighborhood," the Smithsonian would visit theirs. The founding director was John Kinard, who led the institution for twenty-five years until his death in 1992. Kinard was highly respected for his wisdom, his innovative, community-based approach, and his groundbreaking contribution to African American history and culture. The museum later relocated to a new building on Fort Drive, at the top of one the highest elevations in the city across from historic Fort Stanton, where a tree was planted to honor Kinard's legacy.

By the mid-1960s, however, stable black family units and solid homeowners in historic Barry Farm / Hillsdale had been crowded out as resources dwindled and the sense of community declined. The riots after the murder of Rev. Dr. Martin Luther King Jr. sent more residents and businesses fleeing to the suburbs, although rioting east of the Anacostia River was confined to a small shopping center on the Maryland line, at Wheeler Road and Southern Avenue. Still, shopkeepers bricked up their windows or moved away altogether. Old Anacostia/Uniontown, historically a predominantly white,

working-class neighborhood, lost many of its white residents. The population of Far Southeast, including Old Anacostia and Barry Farm / Hillsdale, had changed from 82.4 percent white in 1950 to 67.7 percent by 1960, largely in reaction to school desegregation. By 1970, after the riots, it was only 14 percent.[20]

As apartment complexes lost tenants, landlords turned to subsidized housing to offset costs. Poverty and lack of education led to societal dysfunction. Yet as this is written there are still well-kept homes and lawns on quiet streets, where neighbors know and look out for each other. Even today, people speak to you when you walk down the streets. There is a neighborliness, that small village feel that survives in the face of the regular and unkind assaults suffered over time.

At the same time, another round of changes seems imminent as once again the affordability of the Anacostia and Hillsdale neighborhoods is attracting developers. Currently, the city government is looking at various development options for the waterfront, including office buildings, hotels, casinos, and marinas. Residents fear for the loss of their historic vistas and their parkland. Housing prices have risen. Many of the public housing projects have been systematically razed for mixed-income town house complexes; the 1940s housing development of Barry Farms is slated for new housing construction as well. The historic west campus of St. Elizabeths has been taken over by the U.S. General Services Administration for the future headquarters of Homeland Security and the U.S. Coast Guard, which will most likely cut off all access for neighboring residents.

The river remains, however, an integral part of the community fabric. Rowboats, kayaks, and canoes ply the Anacostia daily. The Organization for Anacostia Rowing and Sculling (OARS), formed in 1987 by a group of community residents, encourages students in Anacostia schools to participate in rowing on their river. On any given day of the year one might find someone sitting by the shore with a fishing line in the water, bike parked nearby. The community sees Anacostia Park and the river as its own amenity, a place to relax and unwind — a place to bring the kids, have a picnic, play games, and enjoy nature in the quiet. As efforts to clean the river increase, the watershed has become a sanctuary for waterfowl. Blue herons, egrets, loons, and the ubiquitous Canada geese are plentiful. Here the spirit of black Anacostia carries on. A five-acre Frederick Douglass Gardens and Memorial at Poplar Point, approved by the National Capital Memorial Commission in 2008, is planned to honor the Sage of Anacostia and the communities of historically black Anacostia he so inspired.

(opposite)
This fine Italian Renaissance–style structure replaced the original Birney Elementary Public School building in 1901 at the heart of the Hillsdale community at Nichols (now Martin Luther King Jr.) Avenue and Howard Road. It also served as a library and community center. Renamed the Nichols Avenue School in 1962, it was restored and expanded and reopened in 2005 to house the Thurgood Marshall Academy Public Charter School. Photo by Kathryn S. Smith

A New Image for the Capital

Washington's fortunes changed with the Civil War — a conflict that made it clear the country needed a strong federal government and a more modern and attractive capital city to represent and serve it. The war left the District in shambles, both physically and socially, and serious suggestions that the capital be moved elsewhere forced some dramatic improvements. A more efficient, consolidated territorial government replaced the three separate governments of Georgetown, Washington City, and Washington County in 1871. All territorial officials were appointed by the president of the United States, except for an elected lower House of Delegates. Alexander Robey "Boss" Shepherd led a massive modernization project between 1872 and 1874, first as the most powerful member of the territory's Board of Public Works and then as governor. He graded and paved streets, laid sewer and gas lines, and planted thousands of trees, putting the L'Enfant plan in all its grandeur on the ground for the first time. Suddenly the image of the capital changed from a backwater town to a city of beauty and elegance.

The city's polished image and an expanding number of jobs in the growing federal government attracted a wave of new residents. The District population, which had doubled to about 132,000 during the wartime decade of the 1860s, jumped to almost 178,000 during the 1870s. The influx began a spurt of building activity that would continue through the end of the century, for the first time filling L'Enfant's Washington City with new housing on vacant lots in existing communities such as Foggy Bottom and Capitol Hill and creating new neighborhoods such as Dupont Circle and Shaw. The red-brick row houses in the Second Empire, Queen Anne, and Richardsonian Romanesque styles of the late nineteenth century that characterize Washington's inner-city

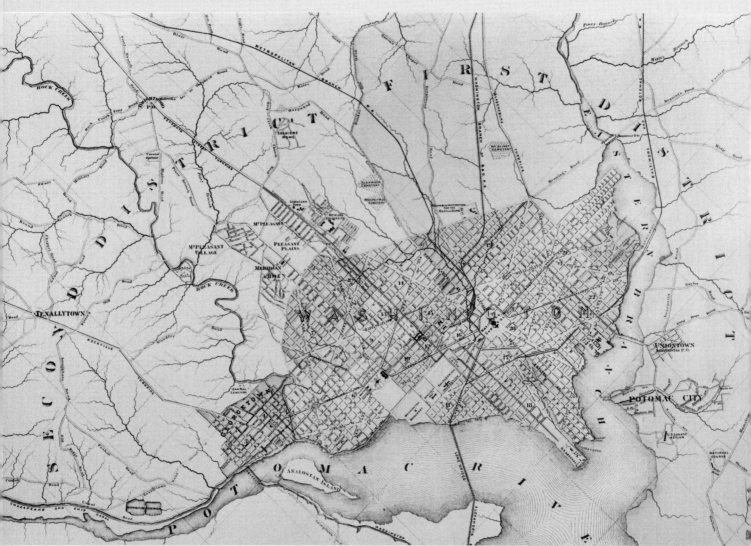

With the introduction of public, horse-drawn streetcars during the Civil War, developers began to lay out subdivisions in the District beyond the bounds of Washington City. By 1873 when this map was drawn, Meridian Hill, Mount Pleasant, and Pleasant Plains had been established along 7th and 14th streets north of the city. Uniontown and Potomac City (an early name for Barry Farm) appear across the Eastern Branch, today's Anacostia River. Courtesy Kathryn S. Smith

neighborhoods are testimony to the robust growth of the capital beginning in the 1870s.

At the same time a network of horse-drawn streetcar lines made possible the first suburban developments beyond Boundary Street, which was renamed Florida Avenue in 1890, and Benning Road, the northern limit of old Washington City. These new communities, laid out in open fields and woods and former country estates, were thought of as suburbs, even though they were within the District of Columbia. Mount Pleasant was the first, begun just after the Civil War by Samuel Brown, a newcomer from Maine. Early residents quickly organized to secure, among other amenities, a horse-drawn

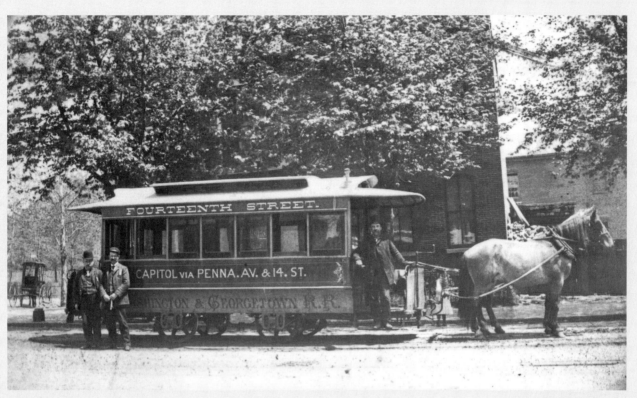

Motormen pose proudly with their Washington & Georgetown Railroad Company horsecar, most likely in the 1880s. The route north up 14th Street made possible the development of Mount Pleasant and Columbia Heights. Courtesy DC Public Library, Washingtoniana Division, Hugh Miller Collection

omnibus line up 14th Street in the early 1870s. Developers Amzi Barber and Andrew Langdon laid out LeDroit Park in 1873 just north of Boundary Street at the end of the 7th Street horsecar line. And in 1881 Senator John Sherman developed a parcel he named Columbia Heights, which would take advantage of the 14th Street horsecar line to Mount Pleasant. For the first time, Washingtonians could live in country-like settings and commute to work in the increasingly crowded city.

The District's first steam railroad suburb also dates from this period. In 1873 members of the Sheriff-Lowrie-Deane family subdivided their farm across the Anacostia River to take advantage of a stop on a new Southern Maryland Railroad Company line. Although it did not attract many residents at first, Deanwood foreshadowed, along with the city's horsecar suburbs, a trend toward suburbanization that would accelerate in the next decade.

What the city gained in prestige and size in this period, however, it lost in political autonomy. Shepherd's vast improvements had cost $20 million instead of the projected $6 million. Two congressional investigations led to the

replacement of the territorial government with three presidentially appointed commissioners in 1874, a total loss of home rule that would last for a hundred years. While Shepherd's overspending has been the generally accepted cause, underlying the change was fear of the growing influence of a newly enfranchised black male electorate, given the right to vote in the District of Columbia by the U.S. Congress in 1866, four years before the 15th Amendment guaranteed that right to all African American men in 1870. Disenfranchised residents of the capital were left on their own. To represent their needs to the appointed commissioners and to congressional District committees, they formed neighborhood civic and citizens associations — organizations that would perpetuate the names and the separate identities of the city's nineteenth-century suburbs until they became the urban neighborhoods of today. Shepherd himself would go on to make a fortune in silver mining in Mexico and return to the city in 1887 to be hailed as the father of modern Washington.

Dupont Circle

FASHIONABLE IN-TOWN ADDRESS

LINDA WHEELER

Dupont Circle and its namesake neighborhood ten blocks north of the White House are always a swirl of activity. At the circle, under the fountain's splashing water, children play and couples dangle their feet. The park circling the white marble memorial welcomes sunbathers, book readers, and chess players. The wide, concrete walkways fill with office workers, bicycle messengers, urban joggers, roller skaters, neighborhood shoppers, picture-taking tourists, dog walkers, and occasionally, anti-something protesters.

Beyond this National Park Service preserve, streets radiate like the spokes of a wheel. Some lead into residential sections crowded with vintage red-brick or gray stone Victorians — condominiums, co-ops, apartments, and single family homes. Others are commercial arteries with a stunning variety of restaurants, delis, bakeries, taverns, nightclubs, galleries, and stores offering art, antiques, furniture, books, clothing, shoes, jewelry, groceries, wine, flowers, and ice cream. Office buildings join the mix along the commercial corridors. Dupont Circle is perhaps the city's most cosmopolitan neighborhood.

About 135 years ago, the neighborhood consisted of open land on the outskirts of the growing city of Washington. The banks of Slash Run, a tributary of Rock Creek that meandered through the area, were dotted with slaughterhouses and farmers' gardens. The evolution from countryside to the city's most fashionable address at the turn of the twentieth century to the present lively, downtown neighborhood parallels the emergence of Washington as a sophisticated world capital.

It was the vast civic improvements completed by the Board of Public Works of the Territory of the District of Columbia in the early 1870s that opened this area for construction, and its fortunes were closely tied to the most prominent figure in the effort, Alexander Robey "Boss" Shepherd, the most powerful member of the Board of Public Works and then territorial governor. Shepherd chose to build his own grand home just south of Dupont Circle at the corner of Connecticut Avenue and K Street, NW. His critics maintained that he favored his new neighborhood over other, more established ones such as Capitol Hill and

The boundaries of the Dupont Circle Historic District and the primary service area of the Dupont Circle Citizens Association generally coincide as defined here. Some see the neighborhood extending as far north as U Street and east to 15th Street. Map by Larry A. Bowring

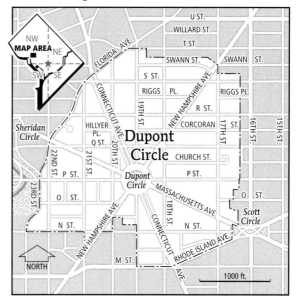

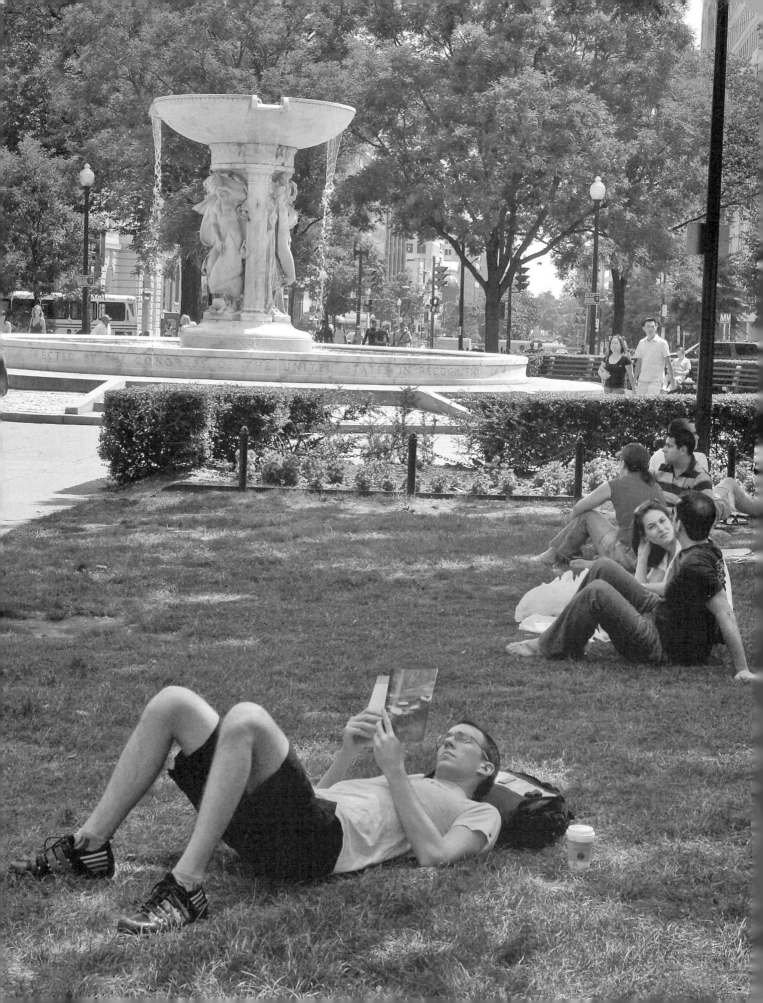

Georgetown, as he decided where streets would be graded, paved, and lit; sewers laid; and trees planted.[1]

Indeed, the board did pour many improvements into the central city and the undeveloped land just to the north. It converted Slash Run into a covered sewer, thus eliminating the unhealthy marshes along its course through the neighborhood. It replaced a low, covered bridge across Rock Creek at P Street with a more modern metal-truss bridge in 1871, thus improving connections between Dupont Circle and the older and much more developed neighborhood of Georgetown. The open space at the intersection of Massachusetts, New Hampshire, and Connecticut avenues and 19th and P streets was fenced in to form a federal park within the traffic circle, and Connecticut Avenue was paved as far north as Boundary Street. In 1873 the Metropolitan Railroad Company laid horsecar tracks along Connecticut Avenue from H Street to Florida Avenue and across the P Street Bridge to Georgetown, making the circle even more accessible and the neighborhood more desirable.[2]

The area immediately attracted investors of great wealth. The most prominent were part of a group called the California Syndicate, which included mining industrialist Curtis Hillyer, California miner Thomas Sunderland, and Nevada Senator William M. Stewart, who also had mining interests in the West. They saw the Shepherd improvements and the growing national importance of the federal government as reasons to invest in the capital. The new park at the circle became known as Pacific Circle because of the connection of these investors from the West.[3]

Stewart was the boldest and the first. As early as 1873, he decided to use some of the mining fortune he had amassed to build an extravagant Second Empire mansion designed by prominent architect Adolf Cluss on the practically empty circle at the intersection of Massachusetts and Connecticut avenues. It seemed so out of place in this still-remote part of the city that it was derided as Stewart's Folly or Stewart's Castle, but the handsome red-brick house with its five-story entrance tower would be followed by the homes of others with money to spend on appearances.

Stewart's wife purchased furniture for the house while traveling in Europe, and the couple was known for extravagant parties. Frank "Carp" Carpenter, a newspaper reporter, said attending receptions there made him feel like "a character in the Arabian Nights of Marco Polo at the Court of Kublai Khan." The upkeep of the house, plus a huge staff of servants and a stable of thoroughbred horses, was such a financial drain that the family lived in the house only for brief periods. By the 1890s Stewart was renting his fabulous house to the Chinese legation. Eventually he sold it to Senator William A. Clark, another millionaire miner, who tore it down anticipating building a more modern house on the site, but the land remained vacant until Riggs Bank (now PNC Bank) bought it in 1924.[4]

In 1874 another significant structure went up near the circle, and, along with Stewart's Castle, it helped create the impression that Dupont Circle was an up and coming neighborhood. British Minister Sir Edward Thornton decided in 1872 that renting

various Washington residences for the British Legation was uneconomical. Unable to acquire a site on Capitol Hill, Thornton took a chance and bought a site in the undeveloped Dupont Circle area. The land, on the west side of Connecticut Avenue at N Street, was purchased from Thomas Sunderland, one of the original land speculators. Designed by Washington architect John Fraser, the legation was, like Stewart's Castle, a Second Empire structure. It served as Thornton's offices and home. The activities that took place there added yet more prestige to this still-rural area. Guests arriving at the legation passed through an iron fence framed by ornate gas lamps and entered the building under an impressive porte cochere. Entering the tiled vestibule, visitors were confronted with a grand staircase and a portrait of Queen Victoria at eighteen years old. A hand-carved mahogany balcony made in England encircled the entire second floor, and the floor of the ballroom was covered with the rug Queen Victoria had walked on when she opened London's Crystal Palace exhibit in 1851.[5]

Stewart's Castle and the British Legation stood in sharp contrast to their surroundings, for despite their presence the neighborhood did not immediately develop as an enclave of elite residents. In fact, these two imposing buildings were at first flanked by mostly vacant lots dotted with a few crude shanties. Tradesmen, servants, and laborers began to choose the area as home along with the diplomats, government officials, and professionals. By 1880 the neighborhood consisted mostly of modest brick and frame structures. In that year just over half of its 3,100 residents were working-class people described in the federal census as black or mulatto. About 250 immigrants from Ireland, Germany, and Great Britain were counted among the white residents.[6]

By the mid-1880s, however, real estate agents were promoting the "West End," as it was then known, as a place of wealth and fashion. A statue honoring Admiral Samuel Francis du Pont was raised in the circle in 1884 to honor his Civil War service, and the circle was landscaped and named for him as well, although it is now written Dupont. The grand fountain of today, sculpted by Daniel Chester French with its figures representing Wind, Sea, and Stars, replaced the statue in 1921, paid for by the du Pont family, whose members did not like the statue.[7]

More mansions began to join Stewart's "castle" around the circle and on Massachusetts and New Hampshire avenues. James G. Blaine, who served at various times as the Speaker of the House, a senator from Maine, secretary of state, and three-time candidate for president, built the grand house that still stands at 2000 Massachusetts Avenue in 1881. Designed by architect John Fraser, the mansion was built while Blaine was secretary of state under President Garfield. His wife, Harriet, writing to a family member on May 31, 1881, said they had changed their minds about a building site on 16th Street. "Now we go to Massachusetts Avenue and 20th and P Street, beyond the Stewart House," she wrote. "This new locale gives us a frontage to the east on 20th Street, drawing rooms and dining on P Street, and library and hall and reception room on Massachusetts Avenue. A wonderful situation." Sold to George Westinghouse in 1901, the home would eventually house offices and shops.[8]

Many other grand houses of the turn-of-the-twentieth century still stand but have been given over to new uses. *Chicago Tribune* publisher Robert William Patterson built 15 Dupont Circle in 1903 to a design by noted architect Stanford White. His daughter, *Washington Times Herald* publisher Eleanor "Cissy" Patterson, would hold court and influence Washington politics here for decades. It is now owned by the private Washington Club. Nearby is the Sulgrave Club at 1801 Massachusetts Avenue, built in 1902 as the winter residence of millionaire and western New York gentleman farmer Herbert Wadsworth and his wife, Martha. Beginning around New Year's Eve, the couple held a continuous series of social events on Thursday evenings, the Wadsworths' official evening to entertain. During World War I, the Wadsworths turned the house over to the Red Cross and then sold it in 1932 to the present owners, a private social club.[9]

Another vintage house to survive the years is the Heurich Mansion, a dark red-brick and stone, late-Victorian–era home built between 1892 and 1894 for Washington beer brewer Christian Heurich. Home for many years to the Historical Society of Washington, D.C., it is today a house museum. The Townsend house at 2121 Massachusetts Avenue, a 1901 Beaux-Arts mansion built to incorporate an earlier 1873 house, became the Cosmos Club in 1950. The 1897 Georgian Revival home of art collector Duncan Phillips at 1600 21st Street became in 1921 the country's first museum of modern art, the

The British Embassy at Connecticut Avenue and N Street, left, and the "castle" built by mining millionaire William M. Stewart on the circle, its corner tower visible in the background, were built in the 1870s, so far from the center of the city that their locations were considered risky investments. This photograph was taken about 1900, when they had become architectural highlights of one of the city's most elite neighborhoods. Courtesy DC Public Library. Washingtoniana Division

A statue of Admiral Samuel Francis Du Pont, placed in 1884, anchored the circle when this photograph was taken about 1900. It would be replaced by today's fountain in 1921. Then, as now, the circle was a gathering place. Courtesy DC Public Library, Washingtoniana Division

Phillips Collection. Among many other distinguished houses of the period are the 1901 Walsh mansion at 2020 Massachusetts, now the Indonesian Embassy; the 1902 Anderson House at 2118 Massachusetts Avenue, now the Society of the Cincinnati; and the 1894 Whittemore/Weeks House at 1526 New Hampshire Avenue, now the Woman's National Democratic Club.

As these palatial mansions were going up, well-designed row houses of brick or stone became the dominant architecture of the numbered and lettered streets in the neighborhood. Many of the houses were built by speculators and purchased by professional people who could afford to pay $4,000 to $8,000 for the substantial houses, double to quadruple what houses were going for in less-affluent parts of the city. The Queen Anne style, with its large gables, bay windows, chimneys of various designs, and polychromatic materials, was the most popular. Most of these buildings still stand, for example, in the 1700 block of Q Street and the 1400 block of 21st Street.[10]

The 1880s also saw the introduction of apartment buildings to the area, offering luxurious hotel-like services for those who might only be in the city for a short time, the first being the Analostan at 1718 Corcoran Street, built in 1893. The height of the

Thomas Walsh and his daughter Evalyn repre-
sented the height of society when they struck this
pose early in the twentieth century. Evalyn was
once the owner of the famous Hope Diamond.
Courtesy Library of Congress

The center hall of the Walsh-McLean
mansion was dominated by a three-story Art
Nouveau staircase, inspired by one similar in
a White Star ocean liner favored by Thomas
Walsh. Photo by Jack Boucher. Courtesy
Commission of Fine Arts

twelve-story Cairo, designed by T. F. Schneider and built in 1894 at 1615 Q Street, raised immediate concern in Congress, lest others follow its example and dramatically change the character of the city's streetscapes. In response, Congress passed legislation in 1899 creating the city's first height limit, which restricted residential buildings to a height of 90 feet and commercial buildings to 110 feet. Many more apartment buildings would follow, a total of seventy-nine between 1900 and 1945.[11]

By 1900 the racial mix of the neighborhood had shifted, so that now the white population outnumbered the black. The number of families with servants had soared. In 1880, only 10 percent had live-in help; by 1900, 40 percent were in that category. The assessed value of real estate in the area rose dramatically during these years. Stewart's house, for example, which was assessed at 35 cents per square foot in 1874, was rated at $3.25 just sixteen years later. By 1900 Dupont Circle had earned its reputation as a fashionable, upper-middle-class neighborhood attractive to the financially successful. Other foreign missions had joined Great Britain in the area, among them China, Austria-Hungary, Spain, and Switzerland.[12]

The neighborhood attracted a black elite as well. Just before World War I, African American professionals began to move into the northeastern portion of Dupont Circle, an area listed on the National Register of Historic Places in 1985 as the Strivers' Section Historic District. The name comes from a 1929 book, *The Housing of Negroes in Washington*, by the former head of the Sociology Department at Howard University William Henry Jones, who described the community bounded by 16th, 18th, R, and U streets as "Strivers' Section" or "the community of the Negro aristocracy." Distinguished residents included leaders in business and education, the sciences, and the arts. Resident Inez Brown remembered the 1700 block of U Street "as being very beautiful . . . people had their yards and their hedges and their shrubbery and their trees and flowers, and it was just very attractive and very desirable." Black laborers and domestics lived in this area, too, but they settled on the short, narrow streets such as Seaton Street that had smaller, two-story houses. There was another historically black enclave in the neighborhood with more modest houses on Newport Street and nearby.[13]

Thus Dupont Circle had two very separate black and white communities whose social worlds did not mix. By the 1940s two separate community associations made the division highly visible. The Dupont Circle Citizens Association, all white, was formed in 1922, and the Midway Civic Association, all black, began in 1939.

As the neighborhood grew, so did the need for stores and services. African Americans were drawn to the blocks of U Street just to the east, which had become a cultural and commercial boulevard by the 1920s. White residents were drawn to Connecticut Avenue, where many shops were set up to serve an elite and prosperous clientele. The first stores included Maison Rauscher, a catering business which opened in 1896 at the corner of Connecticut and L Street, Demonet's Confectioner's at Connecticut and M Street, and Magruder's grocery store at Connecticut and K Street. Connecticut Avenue, served by a streetcar, offered an excellent retail environment. The avenue below the circle soon

became lined with stores catering to the affluent, with a selection of places to shop for clothes, shoes, hats, antiques, flowers, and even cars. The *Washington Post* predicted in January 5, 1908, that, "Connecticut Avenue in a few years will be the Fifth Avenue of Washington."[14]

At the same time, rents were rising in the old downtown, and some small businesses were forced to move. Some chose the stretch of Connecticut Avenue between K Street and Florida Avenue. Here they found, according to the January 12, 1912, *Evening Star*, that owners of residential buildings were eager to rent for office and retail use because they brought higher returns. The *Star* article noted that the trend was transforming much of the avenue from residential to commercial.

Patronizing the stores on Connecticut Avenue became a fashionable way to spend time, with many shoppers followed by retainers in carriages, and later automobiles, to help with the packages. A milliner who had an establishment on the avenue as late as the 1940s explained, "Women would come in their chauffeur-driven cars and go from one shop to the next, while cars lined up along the street. It was a social affair going from here to get shoes, a dress or flowers for a dinner party."[15]

Attention !

Residents of the 1700 block of U St.

You are automatically members of the Civic Betterment Club of the 1700 block of U St.

* * * * *

OUR AIMS ARE:

1. Grass on every lawn.
2. A bench on every front.
3. All hedges well trimmed.
4. Fronts swept daily.
5. Pick up all loose paper and put in trash cans.
6. Windows washed frequently.
7. All shades evenly drawn.
8. Alleys cleaned regularly.
9. Children kept clean when playing out front.
10. Adequate play space for children of this block.
11. Courtesy to all neighbors.
12. Respect for neighbor's property.

* * * * *

At an early date all the children will be organized into worker groups. Please cooperate with them when they approach you.

Let's make this the most beautiful colored neighborhood in Washington.

In short the Civic Betterment Club of the 1700 Block of U Street intends to demonstrate to our white critics that property need not deteriorate or become unsightly because its occupants are colored.

Here is a movement which every colored community can well follow.

MRS. DORCY RHODES, Sponsor
1743 You St., N. W. — DEcatur 0798

Hamilton Printing Company, 1353 You Street, N. W.

Residents of an elite African American neighborhood in the northern part of Dupont Circle, dubbed the Strivers' Section, distributed this flyer to encourage their neighbors to make their community "the most beautiful colored neighborhood in Washington." Courtesy The Historical Society of Washington, D.C.

Commercialization of the neighborhood was furthered when the city implemented zoning regulations in 1920 that for the first time regulated the uses of land throughout the city. Connecticut Avenue from Lafayette Square near the White House all the way north to Florida Avenue was designated as a commercial district, as was 17th Street from P to Riggs streets and P Street from Dupont Circle west to Rock Creek Park. In response to the new regulations, the Connecticut Avenue Association organized in 1921 to promote "high-class businesses" for the avenue, modeled after the Fifth Avenue Association in New York.

The Gilded Age lifestyle of Dupont Circle began to unravel with World War I, the arrival of a federal income tax in 1915, and the death of longtime residents. By 1926 no

The elegant Maison
Demonet pastry shop
epitomized the newly
fashionable shopping
area that developed along
Connecticut Avenue in
the first decades of the
twentieth century.
Courtesy The Historical
Society of Washington,
D.C.

large residences remained on Connecticut Avenue south of the circle. The *Evening Star* noted the changes in a February 20, 1926, article: "Instead of the quiet avenue where once strolled the elite of the nation's Capital and high personages of foreign lands, for their afternoon and Sunday promenades, with their high stepping horses, there is today a bustling crowd of business people and shoppers and others engaged in commerce who arrive on the street cars, in fast moving automobiles and commercial trucks."

As Dupont Circle lost its cachet for the wealthy, they looked for property in other areas, including Sheridan-Kalorama, Spring Valley, and Chevy Chase. In 1931 two seminal events occurred that made the transition from an elite, mostly residential neighborhood to a mixed-use residential, commercial, and business district obvious. One was the demolition of the British Legation, now the British Embassy — an anchor in the social scene since 1874 — and its move far out Massachusetts Avenue. The second was the construction of the eleven-story Dupont Circle Building on the south side of the circle, replacing the opulent home of Edson Bradley known to many as Aladdin's Palace. There was no attempt to fit this building into the three- and four-story environment of the neighborhood. Instead it made a bold statement that times were definitely changing. The advent of the Dupont Circle Building, designed by architect Mihran Mesrobian as a five-hundred-room hotel, opened the gates to other demolitions, and a wave of new commercial buildings and parking lots followed into the early 1970s.[16]

This major commercial intrusion, so shocking in 1931, would later be appreciated as an attractive addition to the neighborhood. In 1987, as the building was being sensitively restored without disturbing the façade, *Washington Post* architectural critic Benjamin Forgey wrote an appreciation for the hotel turned office building, pointing out its deceptive sliver that faces on the circle and the "fine rhythm of the narrow stone pilasters, metal spandrels and basic brick on its side facades. What an odd, big, fine building that is," he wrote. Mesrobian had been the architect of a number of other fine commercial buildings in Washington, including the Sheraton Carlton Hotel (1926), the Hay-Adams Hotel (1927), and the Wardman Tower (1928).[17]

The destruction of the British Embassy and the arrival of the Dupont Circle Building presaged the departure of the last of the wealthy residents of the turn-of-the-twentieth-century mansions. Some of them had died in the 1920s and 1930s, and by the 1940s their enormous homes either had found new uses or were destroyed. Some owners leased their homes to the government for offices during World War II, as row houses were being sliced into small apartments or rooming houses. The story of the Leiter Mansion, built in 1891 on a pie-shaped piece of land on the north side of the circle between New Hampshire Avenue and 19th Street, reflects the twentieth-century evolution of such properties.

Built by Chicago department store and real estate magnate Levi P. Leiter, the white brick, three-story, fifty-five-room mansion with its massive Ionic-columned porte cochere dominated Dupont Circle for fifty-six years. Leiter's social ambitions brought him and his family to Washington in 1883, when they first rented the Blaine Mansion. An extremely wealthy family, they split their time between their homes in Washington, Chicago, and Lake Geneva in Wisconsin, and travel in Europe.[18]

Leiter's son, Joseph, continued in business in Washington after his father's death in 1904, entertaining on a grand scale. "Anticipating Prohibition, he stocked the cellar with $300,000 worth of the choicest liquors and wines," according to James Goode in *Capital Losses*. The Leiter home was also known as the home of the "Dancing Class" in the decades between the two world wars. As the *Evening Star* explained in a 1967 article about the Dancing Class, its "purpose was implied by its name, a class where Washington's smart set could learn the latest dances." Membership was limited to "who you were and where you were born," according to Leiter's daughter, Nancy, who was a young child when her parents' house was the site of the dances.[19]

The Leiter mansion was well suited as a gathering place for this socially exclusive club. Nancy Leiter, who later married D. Thomas Claggett Jr. in the house in 1940, recalled that the elegant ballroom opened onto a long hall with the library at one end. The space could accommodate 350 to 400 people. She vividly remembered her mother's frequent entertainments and "still can see the gold chairs being whipped out for a party."[20]

At the beginning of World War II, the family rented the house to the federal government for office space. In 1943 they hired a firm to appraise the property and its future use. They were told that Dupont Circle was undergoing a change that did not enhance

the value of their property; the socially prominent and ultra-wealthy were leaving, and the neighborhood was becoming more middle class. In addition, many of the departing families were trying to sell their mansions, creating a glut on the real estate market that further lowered their value. The Leiter home was sold in 1947 and was soon demolished; its site is now occupied by a hotel.[21]

The once-gracious neighborhood took another hit in the 1940s when city highway officials decided to build a Connecticut Avenue underpass for automobiles beneath the circle and two semicircular tunnels for streetcars around its edge to relieve congested traffic on top. From before the turn of the twentieth century, both north- and south-bound tracks of the Cabin John streetcar line had run side by side, along with automobiles, around the western rim of the circle between P Street and Connecticut Avenue. The city first considered decongesting the western side of the circle by moving the tracks to the eastern side. That change did not happen but it gave birth to one of Washington's most enduring legends.

Highway officials had not moved the tracks, according to the story, because of objections from the aforementioned *Times Herald* publisher Cissy Patterson, who lived on the east side of the circle. Patterson supposedly did not want the noisy street cars running in front of her mansion. Later she was to tell a reporter that she was flattered that anyone

Chicago department store and real estate magnate Levi P. Leiter built this mansion on Dupont Circle between New Hampshire Avenue and 19th Street in 1891 so that his family could participate in the social opportunities of the capital. The fifty-five-room house accommodated up to four hundred for elegant parties. It stood on the circle for fifty-six years. Courtesy DC Public Library, Washingtoniana Division

thought she held that much power, but she denied the story, as did highway officials. When the underpass was first proposed in the early 1940s, there were few objections, but by the time the city was ready to begin work in 1947, there were many residents who were strongly opposed to the expensive, $3 million project that would destroy old trees, make the park in the circle unusable for a long time, and disrupt daily life of the residents. They had good reason to worry because the project was indeed disruptive, taking three years, during which the park was closed. Patterson, who at one time supported the underpass in her newspaper's editorials, changed her mind and called it a "blunderpass" and commented, "If it is ever finished, it will be the worst white elephant of them all." She was right. In 1961, eleven years after it was completed, the streetcars were phased out in favor of buses. The semicircular trolley tunnels were closed and the underpass was just another road for cars.[22]

About the time the streetcars were discontinued, the neighborhood park, as the residents thought of it, began to attract young people who considered themselves members of a counterculture. They dressed in odd ways, made their political opinions known, and were entertained nightly by the Drummers, a loose organization of mostly black men who kept up a steady musical beat into the early morning hours. From all across the country, hippies and others arriving in Washington knew to ask, "Which way to Dupont Circle?"

The new arrivals found inexpensive lodging in rooming houses and tiny apartments on nearby streets and took up residence, adding to the growing crowd of "strange" people who had claimed the park. Local homeowners were not going to give up their turf without a struggle. In 1966 the Dupont Circle Citizens Association called on the U.S. Park Police, who had jurisdiction over the federal park, to oust the "misfits, hoodlums, vagrants and perverts which . . . gather in large numbers" in the park, as reported in the *Washington Post*. Some even wanted the park fenced and closed at night. At the same time, the Dupont Circle Building, by then thirty years old and offering cheap office space, provided a haven for counterculture and progressive organizations as well as short-time headquarters for almost every protest group that came to the city. The location was perfect because it was on the circle where many an anti–Vietnam War demonstration began, and the building was easy to find for those arriving from out of town to swell the number of the marchers heading for the White House, the Pentagon, and the nearby embassies.[23]

There was never a resolution to the standoff between neighborhood residents and the counterculture except for the passage of time. Many of those who endorsed the casual lifestyle of the 1960s became renters in the neighborhood or even property owners when house prices fell to record lows after the 1968 riots following the assassination of Rev. Dr. Martin Luther King Jr. swept from downtown to areas within blocks of the Dupont Circle park. Eventually the newcomers who had taken up residence found themselves joining with the Citizens Association to save favorite buildings or deal with street crime issues.

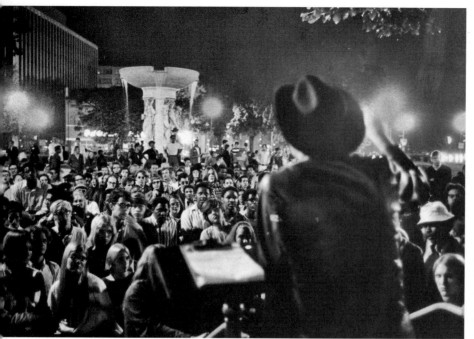

One of those who came in the 1960s and stayed was L. Page "Deacon" Maccubbin. He visited in 1968 and was drawn to the gay community around the circle and in the neighborhood. Gay people had been attracted to the area as early as the 1930s, by which time most of the wealthy had left the neighborhood as unfashionable, and many large houses were being divided up into affordable rental units. As a diverse place already taking on the role of an unconventional neighborhood, Dupont Circle felt hospitable to a nascent gay community, which predated the hippies who discovered the place in the 1960s. Finding the neighborhood welcoming in 1968, Maccubbin rented a room off the circle and then bought a home. He went on to open Lambda Rising bookstore in 1974, to organize the first, and now annual, Gay Pride Day celebration, and to be elected to the Advisory Neighborhood Commission. The neighborhood continues to be a center for the gay culture in Washington as this is written.[24]

In 1969 the Dupont Circle fountain provided the backdrop for a night-time organizing rally of the Black Panther party. During the 1960s and into the 1970s, the neighborhood was often the headquarters of counterculture, antiwar, and progressive organizations of many kinds, and the circle became their stage. Courtesy Star Collection, DC Public Library. © Washington Post

Concern about unwanted demolitions and multi-unit apartment building construction waned as residents succeeded in establishing a historic district listed on the National Register of Historic Places in 1978. Its original boundaries were expanded in 2005, including the entire area served by the Dupont Circle Citizens Association since its founding in 1922. The district now encompasses a variety of structures that illustrate how the neighborhood has changed, including mid-twentieth-century commercial buildings, horse stables that outlasted the houses they once served, and an unusual 1931 gas station. Included also is a visual feast of architectural styles — late Victorians of the Second Empire and Queen Anne styles, late nineteenth- and twentieth-century examples of Beaux-Arts, Colonial, Classical Revival, and Renaissance styles, as well as American Movement buildings of the Commercial and Chicago styles. There are even examples of the Moderne and Art Deco movements. While the Strivers' Section Historic District borders the Dupont Circle Historic District on the northeast, another historic district, the Massachusetts Avenue Historic District designated in 1973, runs right through it from 17th Street to 22nd Street. This historic district focuses on the row houses and mansions that house the embassies and chanceries that line the avenue, which has come to be known as Embassy Row. In 1978, the year Dupont Circle was first designated a historic district, residents and some members of the Dupont Circle Citizens Association formed the Dupont Conservancy, which still makes recommendations to the Historic Preservation Review Board on preservation issues in the area.[25]

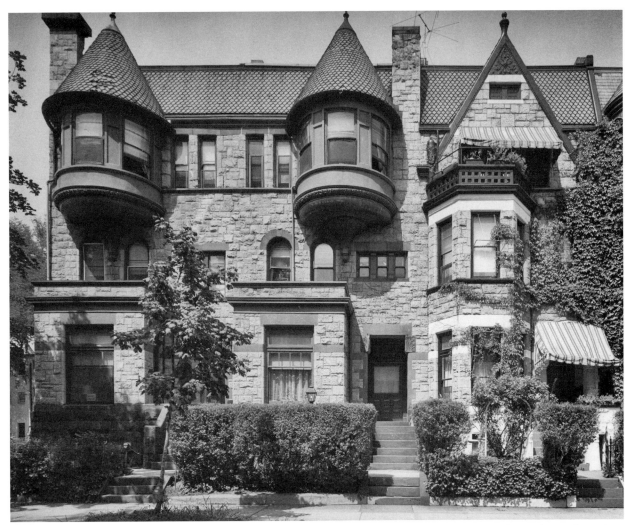

Fine row houses of many late Victorian styles, such as these Richardsonian Romanesque homes in the 1700 block of Q Street, give Dupont Circle a unique character. Designed by prolific nineteenth-century architect Franklin T. Schneider, this row was photographed in the mid-1960s. Photograph by William Barrett. Courtesy the Kiplinger Washington Collection

The neighborhood continues to change. Besides becoming one of the most expensive housing areas in the city, many of the small businesses that had made the place quaint and sometimes funky have closed, forced out by the high rents that chain stores can pay. Cosi, Ann Taylor Loft, Chipotle, Johnny Rockets, and early arriving Starbucks outlets, as well as others, replaced some longtime favorites that could not handle double and tripling rents. The Third Day plant shop, District Hardware, Golden Booeymonger, and others are now gone. Kathleen Ewing Gallery, a mainstay on Connecticut Avenue for twenty-five years, moved two blocks away to a smaller town house space because the owner couldn't keep up with the rent for her second-story walkup.

Washington Post reporter Chris Kirkham surveyed the neighborhood for a story on August 14, 2006, and found "sweeping change is underway in one of the most distinctive neighborhoods in Washington, driven by trends in the market for commercial real estate." Some residents see a unique cityscape slipping away, Kirkham reported. "I used to feel a lot more at home on Connecticut," Dupont Circle Citizens Association presi-

dent Rob Halligan told the *Post*. "But now it feels a lot more like somebody else's neighborhood I am walking through than my own."

The *Post* found that in 1991 there were sixty-one independent stores and three national chains along Connecticut Avenue near the circle. In 2006 there were only thirty-nine independents and eighteen national chains. Ed Grandis, president of the Dupont Circle Merchants and Professionals Association, told Kirkham that independents may contribute more to the community, but retail chains offer a stable retail base. "We want to have services that can meet the residents [needs] of today, not 15 years ago," he said.

While the neighborhood changes, it remains Washington's most cosmopolitan, its old buildings used for varied but integrated purposes as residences, offices, shops, embassies, and association and club headquarters. Some residents are able to both live and work in the area, much as people did in the nineteenth-century walking city. It has preserved its heritage of grand houses and attractive row houses, but has allowed space for the new as well. Dupont Circle has survived the stresses of 125 years of existence and remains an attractive, multilayered place to live and work.

(opposite)
The independent bookstores, restaurants, shops, and art galleries on Connecticut Avenue above the circle draw crowds day and night. The banner of the Dupont Circle Main Street program hangs over the scene at the left. Photo by Kathryn S. Smith

Greater Shaw

A GATHERING PLACE FOR BLACK WASHINGTON

JAMES A. MILLER

In the mid-1960s, District government planners took the name Shaw, thought of at that time as relating to 7th and 9th streets north of downtown, and applied it to a large area they named the Shaw School Urban Renewal Area, seen on this map. While many came to think of this large area as Shaw, long-time residents still related to the names of smaller communities within it, and these names are returning. Four are now distinct historic districts—Greater U Street, Blagden Alley/Naylor Court, Logan Circle, and Shaw, which has returned to its original, smaller definition. Some now refer to the 14th and U street corridors as MidCity. Map by Larry A. Bowring

If you ask people where the Shaw neighborhood is, their answers undoubtedly will vary, depending on who they are and how long they have lived in Washington. A certain haziness is understandable, however, because Shaw has come to signify different facets of D.C. life at different historical moments. Located in the central section of Washington, the neighborhood in its largest definition is roughly bounded by M Street to the south, Florida Avenue to the north, 15th Street to the west, and North Capitol Street to the east. Shaw overlaps with other communities with distinct identities, such as Logan Circle and Westminster. While it has been home to many different kinds of people, Shaw developed a strong identity during the first half of the twentieth century as the cultural, commercial, and professional gathering place for Washington's African American communities. Many stories could be written about this place, but this essay focuses on the history of the black experience in this large area directly north of downtown.[1]

The first designation of part of this area as Shaw occurred early in the twentieth century, after the opening in 1902 of Shaw Junior High School at 9th Street and Rhode Island Avenue, NW, the first junior high school for blacks in Washington. It was named after Colonel Robert Gould Shaw, the white commander of the famous black Union Army regiment, the Massachusetts 54th. This name was reaffirmed in 1966 when the National Capital Planning Commission and the city government used the attendance boundaries of Shaw Junior High School to create the Shaw School Urban Renewal Area, thus enlarging what was earlier known as Shaw near the school to include the larger boundaries described above.[2]

Until the Civil War, the area that came to be known as Shaw was a rural landscape. Running through it on the east was the Seventh Street Turnpike, a central trade route that connected the fertile farmlands of Maryland to Center Market on Pennsylvania Avenue and then to the docks of Southwest Washington. The Northern Liberties Market was established along this route at 7th and K streets in 1846, and it began to draw people to Mount Vernon Square, near

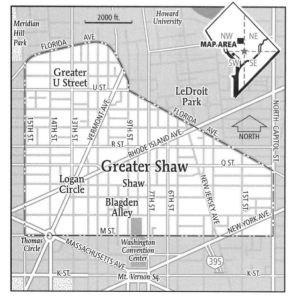

The upper façade of the 1910 Minnehaha silent film theater remains as a reminder of an earlier day on U Street. Ben's Chili Bowl, a popular neighborhood gathering place, has occupied the space since 1958. The Lincoln Theatre next door opened in 1922, its gilded interior now restored to its former glory. Photo by Rick Reinhard

the southern border of what would become Shaw. The streets around the market early on attracted a working-class population of immigrants and white laborers who lived in simple, two-story, four-room houses. Others, including growing numbers of African Americans, lived in alley dwellings constructed in the interiors of the large city blocks.[3]

The rural character of the area north of Mount Vernon Square began to change during the Civil War. In 1862 Congress granted the Washington & Georgetown Railroad Company the exclusive rights to introduce horse-drawn street cars north along 7th and 14th streets, significantly opening up the possibilities for residential development in the future Shaw. New housing was in demand, as the war expanded the role of the federal government and drew government workers to the city. At the same time, three Union Army camps were established in Shaw: the Wisewell Barracks at 7th and P streets, Campbell Hospital at Boundary and 6th streets, and Camp Barker at 13th Street between R and S streets. These camps were places of refuge for former slaves — as were camps and forts in Tenleytown, the Palisades, and elsewhere in the city — and became a magnet for the District's burgeoning black population during the Civil War.[4]

The population of Washington leapt from about 75,000 in 1860 to about 132,000 in 1870, taxing the available housing stock. After the war, land speculation flourished, as large lots passed into the hands of entrepreneurs who subdivided land, cut through streets and alleys, and built new housing. At the same time the District began to develop Shaw's infrastructure, as the territorial government of the early 1870s paved roads, planted trees, and installed water mains, sewers, and gas lines.[5]

From the 1870s to the turn of the twentieth century, builders lined the residential streets of Shaw with Italianate-, Second Empire–, and Queen Anne–style row houses, giving the neighborhood a cohesive physical character that remains today. At the same time workshops, sheds, and often poorly constructed two-story houses without plumbing filled hidden alleys inside the city blocks, which, though substandard, provided housing for people of few means. Given the new housing of all types and the new public streetcars going north from downtown through the area, Shaw immediately became a magnet after the war for a wide range of new residents: white, black, government employees, civil servants, politicians, professionals, and skilled and unskilled laborers.

Shaw remained a diverse neighborhood well into the twentieth century. The elegant homes in the area around Logan Circle at 13th and P streets attracted middle-class families, black and white. The Portner Flats at 15th and U streets, a luxury apartment building that became the Dunbar Hotel in the 1940s, was popular with white families into the 1930s. The three hundred homes on Bates Street near North Capitol Street erected by the Washington Sanitary Housing Commission housed working-class whites until World War II. Jewish families and merchants built a thriving community in Shaw in the 1910s and 1920s, with many owning businesses along both the 7th and 14th street commercial corridors into the 1960s.[6]

Amidst this diversity, the Shaw area had a particularly strong appeal for Washington's rapidly growing black population for a number of reasons. Initially drawn to Shaw by

Civil War military and refugee camps, many new black arrivals decided to stay. Howard University, founded in 1867 on the neighborhood's northern edge, with the Freedmen's Hospital on its campus, was one powerful attraction. The growth of African American communities in Shaw was also spurred by President Abraham Lincoln's abolition of slavery in the District of Columbia in April 1862, almost nine months before the Emancipation Proclamation. Between 1862 and 1865, forty thousand free, emancipated, or fleeing African Americans poured into the city, quadrupling its black population.[7]

They found in Washington a strong and self-reliant black community, with its own churches, schools, and social organizations. As early as 1830, the majority of black residents of the city were already free. The noted poet and scholar Sterling A. Brown described this community's pre–Civil War ancestors in his seminal essay in *Washington: City and Capital* published by the Federal Writers' Project in the 1930s. "Though forbidden by law to do so," he wrote, "many succeeded, through the connivance of

A crowd gathers in 1870 in front of Howard University, located just north of the area that would become today's Shaw. Founded in 1867 by the Freedmen's Bureau, the university's presence would encourage African Americans to settle nearby. Courtesy Moorland-Spingarn Research Center, Howard University, Howard University Archives

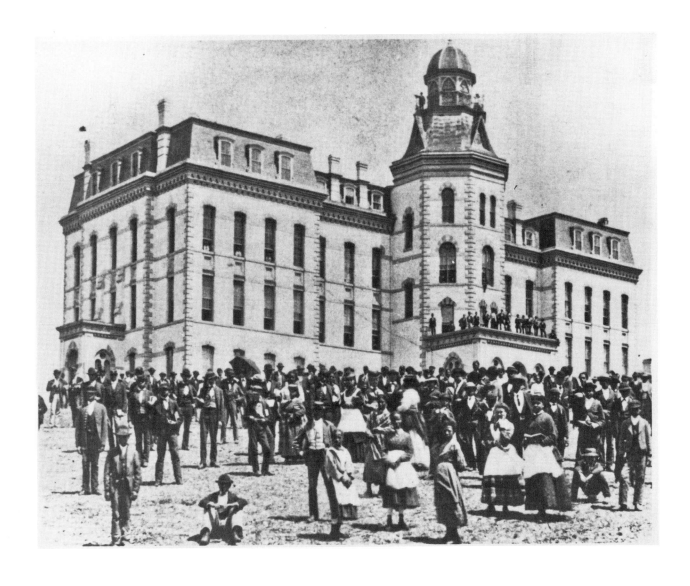

friendly whites, in opening and running such businesses as hotels, taverns, saloons, and restaurants. . . . There were many skilled carpenters, bricklayers, shoemakers, stonemasons, wheelwrights, blacksmiths, plasterers, printers, cabinetmakers, cabdrivers and draymen."[8]

Those who succeeded in business or gained status in other ways before emancipation laid the groundwork for a growing black elite after the Civil War. Many of the nation's most accomplished and most entrepreneurial African Americans were drawn to Washington during Reconstruction, when the city, under the influence of a Republican Congress, offered more opportunities than elsewhere, with voting rights granted in 1866 almost four years before the 15th Amendment was ratified, publicly supported schools for black children, and the added lure of Howard University. The capital became the center of a black aristocracy in the United States, a status that would last until about World War I. Many of these elite individuals would make Shaw and nearby LeDroit Park their home. They would have a significant impact on the character of the community, marking it as one that valued education and high achievement.[9]

One of the early settlers of this emerging community was Mississippi Senator Blanche Kelso Bruce. From 1875 to 1881 he was the first black to serve a full term in the U.S. Senate. Bruce and his wife, Josephine Willson Bruce, a founder of the National Association of Colored Women, occupied an elegant, five-story Second Empire–style house that still stands at 909 M Street. They were widely regarded as leaders of Washington's black aristocracy. Another important Reconstruction politician to settle in Shaw was P. B. S. Pinchback, who was elected the governor of Louisiana in 1872, making him the first elected African American governor of any state. Pinchback, also the maternal grandfather of talented Harlem Renaissance writer Jean Toomer, moved to Shaw in 1893 after a long and active career in politics and public service, taking up residence at 1341 U Street. Over the years Shaw became home to black politicians and civic leaders, ministers, doctors, lawyers, architects, dentists, educators, scientists, and businesspeople, as well as the black working class and new migrants from the South.[10]

Shaw emerged as a mixed-income, predominantly black community in the late nineteenth century as the tightening of racial restrictions forced African Americans into residential enclaves. Perhaps inevitably, the racial climate of the city began to spiral downward in the 1880s, consistent with the national mood of post-Reconstruction America. The country plunged headlong into hardened racial attitudes and practices. The rapid erosion of civil rights for newly enfranchised African Americans culminated in the historic 1896 Supreme Court decision *Plessy v. Ferguson,* which established "separate but equal" as the law of the land. In Washington, as Sterling Brown noted, the newly acquired suffrage of African Americans had been "swept away by the disfranchisement of the District in 1874, an act which was definitely influenced by the fact that Negroes comprised one-fourth of the population."[11]

As de facto segregation began to permeate all levels of everyday life in Washington, African Americans of all classes converged on areas still open to them. Shaw, just north

of downtown and within the boundaries of old Washington City, did not have the racial restrictions that were becoming common in the suburban areas being developed in the rest of the District. Between 1890 and 1920 Shaw became predominantly African American, and U Street became its commercial boulevard.[12]

Churches were indispensable to the consolidation of Shaw's African American community, particularly since they often provided the basis for the education many black children received for much of the nineteenth century. The Fifteenth Street Presbyterian Church, which moved to 15th and R streets in Shaw in 1918, had been organized in 1841 near 15th and I as the First Colored Presbyterian Church by John F. Cook Sr. Planning for the first black high school in the United States took place in 1870 in the church basement, a school that was the precursor of the highly regarded M Street School, later to become Dunbar High School. In 1878 the Reverend Francis J. Grimké stepped into the pulpit, presiding over the church for more than fifty years. Grimké was an outspoken advocate for civil rights who challenged racism in mainstream American churches, helped found the American Negro Academy in 1897, and was an organizer of the NAACP.[13]

Another Shaw church that played a prominent role in the social and political life of Washington's black community was St. Luke's Episcopal Church, the first independent black Episcopal church in the city. The Reverend Alexander Crummell, a Cambridge University graduate, a commanding speaker, and an uncompromising advocate of black solidarity, served as pastor of the church from its founding in 1878, when it broke away from St. Mary's Episcopal Church in Foggy Bottom, until his retirement in 1894. He rallied support for the building of an impressive Gothic stone church at 1514 15th Street, where he presided over the congregation's first service on Thanksgiving Day, 1879. He had hired Calvin T. S. Brent, widely acknowledged as Washington's first black architect, to design the church, modeled on an Anglican church he had known and admired in Coventry, England. Crummell was a leading force in the creation of the American Negro Academy in 1897 and also served as its first president. He had a significant influence upon both NAACP founder W. E. B. Du Bois and black nationalist leader Marcus Garvey.[14]

Like their Presbyterian and Episcopalian counterparts, black worshippers in nineteenth-century Catholic and Methodist churches either founded their own churches or broke away from the white ministries of the churches that professed to serve them. St. Augustine's Catholic Church, the oldest black Catholic congregation in Washington, was founded by emancipated blacks in 1858 as a chapel and school on 15th Street between L and M; it would move to 15th and S streets in Shaw in 1928 and eventually merge with St. Paul's Episcopal Church at its present location at 15th and V streets. John Brent, the father of the architect Calvin T. S. Brent, joined with several other members of Asbury Methodist Church to found John Wesley African Methodist Episcopal Church in 1847, which became a center of activity in the modern civil rights movement after it moved to 14th and Corcoran streets in 1913.[15]

A number of Shaw churches have their roots in the Civil War. The first congrega-

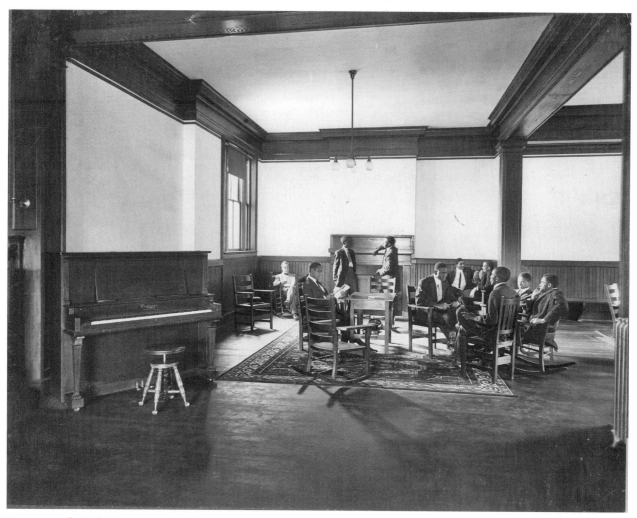

Young men gather in the formal parlor of the new 12th Street YMCA in 1913. Designed, built, and financially supported by African Americans, it was a place in which black Washingtonians took great pride when it opened in 1912. Courtesy Jesse Moorland Papers, Manuscript Division, Moorland-Spingarn Research Center, Howard University

tion of Shiloh Baptist Church migrated en masse to Washington from Fredericksburg, Virginia, in 1862, worshipping in various homes before purchasing a horse stable in the 1600 block of L Street. The church moved to its present site at 1500 9th Street in 1924. Lincoln Temple United Church of Christ at 1701 11th Street grew out of the Freedmen's Bureau Sabbath School at the Wisewell Barracks at 7th and O streets, established to serve those gathered in the nearby contraband camps. Major denominations such as these were joined by churches of other kinds, in particular a growing number of Evangelical churches, a surge that coincided with the rapid influx of southern black migrants beginning in the 1870s. Independent storefront churches also proliferated.[16]

African American businesses and institutions grew along with the black population in Shaw between 1890 and 1920. The research of Michael Fitzpatrick into black business development in the neighborhood revealed that in 1895 only about fifteen black-owned businesses operated in Shaw. By 1920 there were well over three hundred. These economic developments were spurred, in part, by the editors of two influential black

newspapers, whose pages promoted racial pride and advocated independent black enterprise — Calvin Chase of the *Washington Bee* (published 1888–1922) and John Cromwell of the *People's Advocate* (published 1876–84). Cromwell lived at 1439 Swann Street; Chase lived at 1212 Florida Avenue. These crusading journalists were later joined by Edward Elder Cooper, widely regarded as the father of illustrated African American journalism, who moved into 1706 10th Street in 1893, where he launched the weekly journal *The Colored American* (published 1898–1904). Another important voice was Andrew Hilyer, an outspoken government worker and, in 1892, one of the founders of the Union League of the District of Columbia, organized to promote the "moral, material, and financial interests" of African Americans, according to the Fitzpatrick study. To encourage black economic solidarity, Hilyer published the *Union League Directory,* a catalog of black businesses, organizations, and churches.[17]

"Through scathing editorials, lectures, sermons, and the publication of business directories, men such as Chase, Cromwell, Crummell, Cooper, and Hilyer had encouraged a new sense of business life and racial pride within the community," Fitzpatrick writes, pointing out that they spearheaded a movement that would have its greatest impact in Shaw. Furthermore, he argues, "The appearance of new types of business, such as printers, druggists, undertakers, and jewelers, indicates that black businessmen were responding to the demand for products and services that blacks formerly had to obtain outside their neighborhood from white merchants, sometimes at great inconvenience, cost, and humiliation." New black-owned financial institutions downtown made credit and loans more easily available to local black businessmen.[18]

Business development in Shaw even attracted investment from outside the city, as evidenced by the construction of the True Reformers Hall, completed in 1903 and still a landmark at the corner of 12th and U streets. Commissioned by the local branch of the Grand United Order of True Reformers, a fraternal and benevolent society based in Richmond, Virginia, the $100,000 building was constructed with funds raised exclusively by the black community and was designed by prominent black architect John A. Lankford, a Shaw resident. The magnificent modern structure included not only the offices of the local branch of the True Reformers but also a conference room, a concert hall, and a "Colored Business Center" that included a wide range of establishments — Chapman's Tailoring and Designing School, the Silver Slipper Club, and Gray and Gray druggists.[19]

Local business leader John Whitelaw Lewis provided another center of economic activity in his building on 11th Street just north of U Street, the headquarters of the Laborers' Building and Loan Association. Lewis, who had arrived in the city in 1896 and was a humble hod carrier as late as 1904, created this association in 1906 to encourage and support black workers who wanted to purchase housing. His building, constructed in 1909, also housed a number of black businesses and associations. In 1913 he founded the Industrial Savings Bank in a new structure next door, at the corner of 11th and U streets. In 1919 he added to his achievements the Whitelaw Hotel at 13th and T streets,

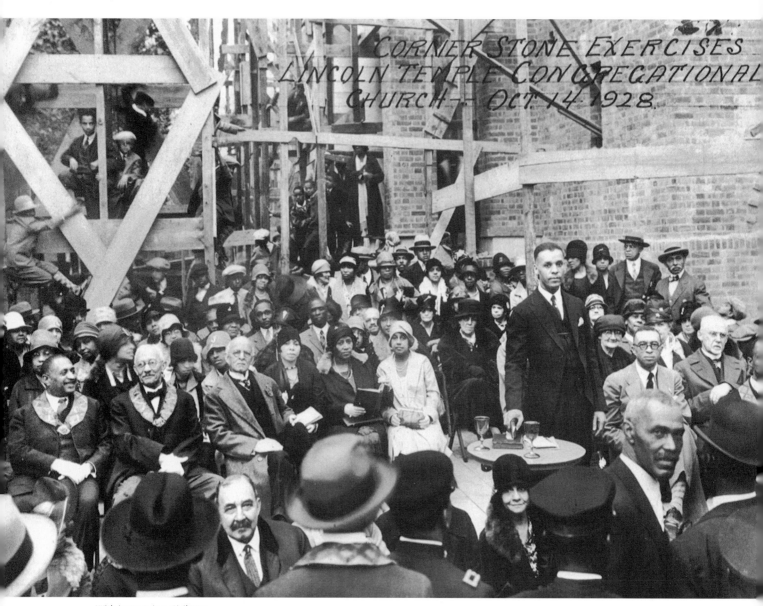

With its roots in a Civil War mission, the Lincoln Temple Congregational Church (now United Church of Christ) celebrates the laying of the cornerstone of a new church at 1701 11th Street in 1927. The Reverend Robert Brooks presides. Photo by Addison Scurlock. Courtesy Scurlock Studio Records, Archives Center, National Museum of American History, Smithsonian Institution

the city's only first-class hotel and apartment building for black visitors and residents. Both his new bank building and the Whitelaw were designed by black architect Isaiah T. Hatton.[20]

The 12th Street YMCA building stands today as another monument to black enterprise in this period. In 1853 an ex-slave, Anthony Bowen, founded the first YMCA in the world for use by "colored men and boys." It moved from site to site until Washington's black community launched an exceptionally successful fundraising drive to erect a fine Italian Renaissance–style building, designed by another black architect, William Sidney Pittman. It opened to great fanfare in 1912. In 1905 members of the Book Lovers Club met to plan the establishment of a YWCA to provide desperately needed shelter

Employees of the Murray Brothers Printing Company put out an edition of the company's widely read Washington Tribune newspaper about 1925. The Murray family also operated one of the community's most popular dance halls, Murray's Casino, on the building's second floor at 920 U Street. Photo by Addison Scurlock. Courtesy Scurlock Studio Records, Archives Center, National Museum of American History, Smithsonian Institution

for young black women in Washington. Their efforts led to the creation of the Colored YWCA, later renamed the Phyllis Wheatley YWCA, with headquarters at 901 Rhode Island Avenue.[21]

With the creation of these associations and commercial enterprises, by the early twentieth century Shaw had consolidated its claim as Washington's premier black residential and business neighborhood. Much of this activity centered on and around U Street. At the same time, 7th Street developed somewhat differently. Beginning in the 1870s, southern blacks poured into this section of Shaw, a pattern that continued to increase through World War I and on into the years of the Great Depression. With its pool halls, storefront churches, barber shops, liquor stores, lunch counters, and after-hours clubs, 7th Street was louder and brassier than the more upscale U Street, where professional offices and grand first-run movie theaters mixed with fine restaurants and elegant clubs. Ninth Street was the dividing line between the more genteel scene on U Street and the seamier action along 7th. Many of Washington's established black elite regarded the lives and behavior of African Americans on 7th Street with embarrassment and dismay. Culturally and socially remote from the African American masses, the elite rejected the idea that all blacks were social equals, arguing that it was patently absurd — and unfair — to judge all African Americans by the attitudes and behavior of its worst, rather than its best, elements. Nevertheless, the establishment community was sympathetic to the socioeconomic conditions facing the larger black community and was quick to express solidarity around issues of blatant racial injustice.[22]

Poet Georgia Douglas
Johnson created a literary
salon at her 1461 S Street
home beginning in 1925 for
the writers and artists of the
New Negro Renaissance.
Courtesy Georgia Douglas
Johnson Papers, Manuscript
Division, Moorland-Spingarn
Research Center, Howard
University

With the opening of the Howard Theater on T Street near 7th in 1910, Shaw emerged as a major destination for nightlife and entertainment in Washington. Founded by the white-owned National Amusement Company but under black management, the Howard quickly became a showcase for African American musical and theatrical talent. In its early years it was the home for two theatrical troupes, the Lafayette Players and the Howard University Players. Later it presented the great black entertainers, from Shaw's own native son Edward Kennedy "Duke" Ellington to the Motown groups of the 1960s. The Hiawatha Theater opened the same year as the Howard, in 1910. It was located in John Lewis's Laborers' Building and Loan Association building at 2008 11th Street and presented silent films in what was at the time one of the most modern and one of the largest theaters of its kind in Washington. The Minnehaha silent movie theater opened shortly thereafter at 1213 U Street; in 1958 it became the home of the widely popular Ben's Chili Bowl.[23]

Other theaters and nightclubs followed: the Dunbar movie theater in the Southern Aid Society Building in 1921 at 1901–1903 7th Street; Murray's Palace Casino in 1924 on the second floor of the Murray Brothers Printing Company Building at 920 U Street; the grand, first-run Lincoln movie theater with the popular Lincoln Colonnade hall at the rear at 1215 U Street, which opened under black management in 1922; and Night Club Bohemia (later renamed the Crystal Caverns and in the 1960s the Bohemian Caverns), which opened in 1926 in the basement of the Davis drugstore on the northeast corner of 11th and U streets. These major attractions were joined by movie theaters such as the Republic and the Broadway; cabarets such as the Oriental Gardens, the Clef Club, and the Phoenix Inn; and scores of nightclubs, restaurants, and after-hours clubs. There were also, as Howard University sociologist William Henry Jones, a contemporary observer of Washington's black community in the 1920s, solemnly noted, vice dens and "houses of prostitution that operate on 7th Street, Florida Avenue, Georgia Avenue, and a number of other trade streets in the Negro area."[24]

Thus during the peak years of the 1920s through the 1940s, U Street was the heart of black entertainment in Washington, attracting most of the great musicians, singers, and performers of the day. The street came to be known as Washington's Black Broadway, a place that rivaled Harlem as a mecca for those seeking the finest African American talent.

Shaw also nourished a flourishing literary culture. In a city where social and fraternal groups proliferated, there were numerous clubs devoted to literature and the arts, including the Lotus Club, the Nineteenth Century Club, the Monday Night Literary, and a women's reading group called the Book Lovers Club. The MuSoLit (musical, so-

cial, literary) Club was founded in 1905, with Francis Cardozo Sr., the first principal of the prestigious M Street School, as its first president. This was a men-only, Republican society that met in an attractive row house at 1327 R Street.[25]

Talented poet Paul Laurence Dunbar moved to neighboring LeDroit Park in 1897. He had come to Washington to work as an assistant to Daniel Murray, one of the first African Americans to be hired as a professional at the Library of Congress. In 1899 Murray, by then an assistant librarian, was asked to compile a collection of books and pamphlets by black authors for a Negro literature exhibit at the 1900 Paris Exposition. He dedicated the rest of his life to compiling an encyclopedia of the literary achievements of people of African descent, a project still not completed at the time of his death in 1925. Murray lived at 934 S Street in Shaw. Shaw was also home to Carter G. Woodson, who organized the Association for the Study of Negro Life and History in 1915, founded Negro History Week (now Black History Month) in 1926, and devoted his life to disseminating knowledge about the origins, culture, and contributions of African Americans. He worked from his home at 1538 9th Street until his death in 1950.[26]

Many of the figures involved in Washington's literary and cultural scene during the 1920s converged at the salons organized by poet Georgia Douglas Johnson at her residence at 1461 S Street. In 1908 Johnson and her husband, Henry, had moved from Atlanta to Washington, where he had been appointed recorder of deeds for the city. After her husband's death in 1925, Johnson began to open her house to many of the artists and writers associated with the Harlem (or New Negro) Renaissance, many of whom had their roots in Washington. Alain Locke, the Howard University philosopher who named and publicized the New Negro cultural awakening, was central to this group, as were other writers and intellectuals associated with Howard University. They were sometimes joined by Carter G. Woodson; Kelly Miller of Howard and his daughter, poet May Miller; playwright Willis Richardson; poet Angelina Grimké; writer-artist Gwendolyn Bennett; poet Lewis Alexander; younger writers Marita Bonner, Hallie Queen, Richard Bruce Nugent, Albert Rice; and many others.[27]

Jean Toomer and Langston Hughes, two of the creative spirits associated with Georgia Johnson's "Saturday Nighters," emerged as the most talented writers of the Harlem Renaissance. Both lived briefly in Shaw in the early 1920s, and both found artistic inspiration in the bustling street life of 7th Street. Toomer was born and grew up in Washington but began his life of restless wandering after he graduated from M Street High School in 1914. He returned to Washington in the early 1920s, long enough to complete writing his 1923 acknowledged masterpiece *Cane*, a work noted for its graphic portrayals of the black working-class culture of 7th Street. Langston Hughes, who shared Toomer's critical attitudes towards the established black elite, found in the sights and sounds of 7th Street the music and the subject matter that launched his career as a blues poet.[28]

In spite of the extraordinary development of Shaw in the late nineteenth and early twentieth centuries and the richness of its social and cultural life, the area was still subject to local and national racial attitudes and practices. In 1919, in the aftermath of the

Moviegoers line up to see a first-run film at the Republic Theatre in the 1940s, a scene that captures some of the excitement of nighttime U Street. Photo by Robert H. McNeill. Courtesy Estate of Robert H. McNeill

Griffith Stadium, the home of the Washington Senators and the Washington venue for games of the Homestead Grays of the Negro Baseball League, anchors this view down a busy U Street from 13th Street in the 1940s. The stadium was torn down in 1966. Howard University Hospital stands on the site today. Photo by Robert H. McNeill. Courtesy Estate of Robert H. McNeill

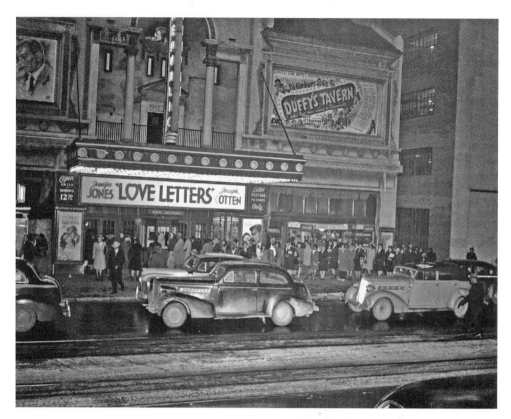

hardening of racial barriers during Woodrow Wilson's administration, the Red Scare nationwide, and growing hysteria over a crime wave in Washington that the white press explicitly blamed on black residents, racial antagonisms exploded. Beginning Saturday, July 19, of that year, white assaults on African Americans took place across the city until, on the fourth day, more than two thousand armed blacks, many World War I veterans, assembled along 7th and U streets to successfully defend their neighborhood and effectively end the white aggression.[29]

Nevertheless, de jure and de facto segregation remained in place, and adequate housing remained elusive, with restrictive housing covenants and the collusion of real estate agents influencing where African Americans could live. Many black residents continued to live in alley housing in such places as Blagden Alley and Naylor Court, bounded by 9th, 10th, M, and O streets, which together survive as a historic district. These housing problems were exacerbated by the accelerating pace of black migration to Washington during the Great Depression. Rampant economic discrimination remained a pressing issue, particularly in a city without a strong industrial base, where blacks and whites competed for jobs in service occupations and in the building trades, where African Americans had traditionally found work and where white unions routinely invoked the color bar.[30]

Deeply entrenched segregation and poorly funded schools for African American students were long-standing sources of resentment and protest. Writing in 1937, Sterling Brown commented, "The Negro of Washington has no voice in government, is economically proscribed, and segregated nearly as rigidly as in the southern cities he condemns. He may blind himself with pleasure seeking, with a specious self-sufficiency, he may point with pride to the record of achievement over grave odds. But just as the past was not without its honor, so the present is not without bitterness." These social, political, and economic conditions fueled organizations and actions that had direct implications for the transformation of Shaw in the years following the end of World War II.[31]

But active protest began earlier. In 1933 three young black men — John A. Davis, Belford Lawson, and M. Franklin Thorne — organized the New Negro Alliance to challenge the practices of white-run businesses that refused to hire black workers, starting with the Hamburger Grill at 12th and U streets and including such chain stores as Peoples Drug Store and the Sanitary (later Safeway) Grocery. The business owners sought an injunction against the Alliance's "Don't Buy Where You Can't Work" campaigns, arguing that the organization had no right to challenge their hiring practices if the pickets did not work there. The Alliance assembled a team of lawyers, including Thurgood Marshall, William H. Hastie, and James M. Nabrit Jr., all of whom were affiliated with Howard University. They fought the case all the way to the Supreme Court and won. *New Negro Alliance v. Sanitary Grocery Store* (1938) was a landmark decision in the right to picket and the struggle of African Americans against discriminatory hiring practices. This early civil rights victory, with its roots in Shaw, would be followed by the pivotal post–World War II Supreme Court decisions that made unconstitutional discrimina-

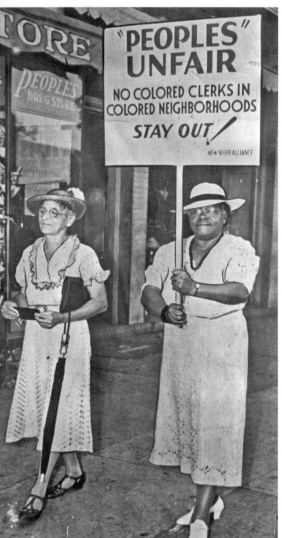

Mary McLeod Bethune (right), prominent educator and an advisor to President Franklin Delano Roosevelt, pickets Peoples Drug Store on behalf of the New Negro Alliance in the 1930s. Courtesy Prints and Photographs, Moorland-Spingarn Research Center, Howard University

tory practices in housing covenants (*Hurd v. Hodge* in 1948), public accommodations (*District of Columbia v. John R. Thompson Co., Inc.,* in 1953), and education (*Brown v. Board of Education* in 1954).[32]

Ironically, as new doors opened for African Americans, Shaw stood on the verge of a slow spiral toward social and economic decline. Many blacks turned their sights to neighborhoods north of Shaw and, eventually, to the suburbs, particularly Prince George's County. The African American commercial sector in Shaw began to decline as black shoppers took their trade downtown and to other parts of the city. Overcrowded housing continued to be endemic, especially after Southwest urban renewal forced thousands to relocate. Housing density increased, poverty grew, and social problems became more rampant. As the Southwest neighborhood fell to urban renewal, city planners turned their attention to Shaw and created the Shaw School Urban Renewal Area to tackle its ills. The community, led by Rev. Walter Fauntroy of New Bethel Baptist Church, organized to prevent the kind of wholesale destruction that was occurring in Southwest and to urge community-based plans that would benefit current residents. This organizing, done under the banner of the Model Inner City Community Organization, would bear fruit in the form of many church-based affordable housing projects in the 1970s. However, a powerful event would set economic development in the neighborhood back for decades. In April 1968 the riots that followed the assassination of Rev. Dr. Martin Luther King Jr. led to the burning and looting of scores of businesses in Shaw's commercial corridors. The consequence was the destruction of many of Shaw's oldest buildings, a marked exodus of businesses, and years and years of visible urban blight.

U Street has since emerged from the ashes of the 1968 riots, beginning with the construction of a D.C. government office building, the Frank Reeves Center, at 14th and U streets in 1986 and the opening of the U Street / African American Civil War Memorial / Cardozo Metro station on U Street in 1991. Historic preservation efforts followed with the restoration for new uses of the Whitelaw Hotel, the Lincoln Theatre, the Twelfth Street / Anthony Bowen YMCA, and the True Reformers Hall. These success stories plus a robust economy in the late 1990s spurred an already active interest in private restoration of the neighborhood's fine brick row houses, new apartment and condominium construction, and an array of new restaurants. As residents became more aware of the area's history, they began to reclaim the names and identities of the smaller communities within it, and to many the name Shaw once again refers most accurately to the 7th and 9th street corridors nearest the original Shaw Junior High School. Currently there are four distinct historic districts in the area — Greater U Street, Logan Circle, Shaw, and Blagden Alley / Naylor Court. Other even smaller communities have evolved, such as the one that identifies with Westminster Street west of 9th. Some now use the name MidCity to refer to the 14th and U street corridors.

The community adjacent to the 7th and 9th Street corridors north of Massachusetts Avenue organized a Shaw Main Streets program in 2002, which, as this was being written, was one of the most active in the city in revitalizing neighborhood businesses while promoting the preservation of its historic buildings and its social history. The new Washington Convention Center, completed at Mount Vernon Square in 2003, brings travelers to the neighborhood's southern edge. City planners envision the imminent restoration of the historic Howard Theater in the 600 block of T Street drawing some of these visitors north along 7th Street. Meanwhile a Whole Foods store at 14th and P streets has sparked redevelopment along 14th, including loft-style condominiums, and a nascent home furnishings shopping destination. The renaissance had begun in the 1970s with the opening of the Studio, Source, and other theaters.

At the same time U Street has reclaimed its historic role as a center for music and entertainment, including performance poetry at Busboys & Poets. The restaurant and bookstore honors Langston Hughes, who was discovered while working as a busboy at the Wardman Park Hotel. The Lincoln Theatre, True Reformers Hall, Bohemian Caverns, and Heritage Trail signs remind newcomers of the street's rich history, while new entrepreneurs, many in the 1100 block from Ethiopia, join the oldest black-owned businesses on the street — the Industrial Savings Bank, Lee's Flowers, and Ben's Chili Bowl.

The area's fine late nineteenth-century row houses, its convenient location on two subway stops just north of downtown, its nightlife, and its unique story are drawing higher-income residents to parts of the neighborhood, creating perhaps the most dramatic wave of gentrification in Washington in the first decade of the twenty-first cen-

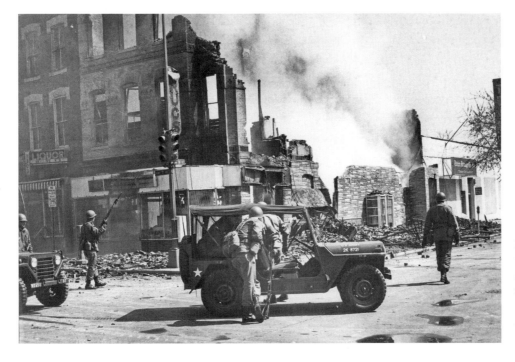

National guardsmen patrol 7th and N streets in April 1968 as neighborhood buildings go up in smoke following the assassination of Rev. Dr. Martin Luther King Jr. Photo by George Tames. Courtesy New York Times / Redux

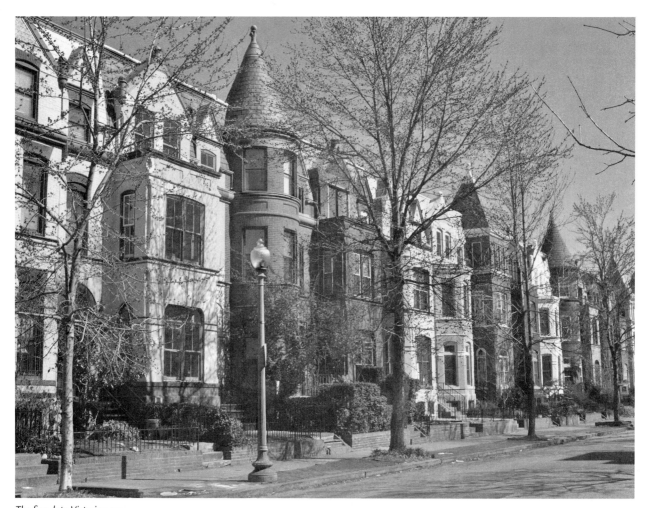

The fine, late Victorian-era row houses of Shaw, such as these in the 900 block of S Street, attracted new owners and inspired major restoration efforts in the late 1990s. Spurred by a new subway stop, a robust economy, and new interest in city neighborhoods with history and unique character, home prices in the area rose dramatically, with benefits for some and a negative impact on those not able to afford higher taxes and rents. Photo by Kathryn S. Smith

tury. In census tract 44.00, bounded by Florida Avenue and 7th, 14th, and S streets and centered on the U Street commercial corridor, the median sales price of a single family home rose from about $132,000 in 1995 to about $684,000 in 2006. The racial composition changed as well, with the African American population dropping from 77 percent to 58 percent of the total from 1990 to 2000 as the non-Latino white population rose from 8.7 percent to 22 percent, and the Latino population rose from 12 to 17 percent. In census tract 49.01, bounded by 7th, 10th, O and S streets and centered on 7th and 9th streets, house prices have made a similar leap, but the demographic change has been less, with the African American population decreasing from 88 to 81 percent between 1990 and 2000.[33]

Such changes are being greeted with trepidation and alarm by those who see its new incarnation as a cautionary tale about the excesses of gentrification. Still, Shaw maintains the deep imprint of its historic past as a place where African Americans from Washington and around the nation struggled, excelled, mixed, and made their way in the heart of the nation's capital.

Mount Pleasant

AN URBAN VILLAGE

LINDA LOW AND MARA CHERKASKY

Mount Pleasant, the sylvan neighborhood near the original entrance to the National Zoo at Harvard Street, has a reputation for ethnic diversity and political activism. Distinct boundaries — Rock Creek and Piney Branch parks on the west and north, broad 16th Street on the east, and wooded Harvard Street on the south — lend it a strong sense of place that is strengthened by cohesive architecture: row houses and a few grand detached residences strongly influenced by the Classical Revival style popular around 1900. Contributing to the harmony is the gracious contour of the land and the adaptation of traditional forms to unusual building sites in response to this topography. With its central plaza and its main street lined with low-rise commercial buildings dating from the early twentieth century, the neighborhood feels like a village to many residents.

The neighborhood did in fact begin as a small village in the countryside north of Washington City just after the Civil War. Most of its first inhabitants were transplants from New England, many of them Civil War veterans who remained in Washington after peace returned. In 1903 a new electric streetcar route connecting it to downtown turned the village into a fashionable streetcar suburb. By mid-century, Mount Pleasant had a mixture of working class and professional people — first all white and then majority African American. In the 1970s young professionals began to move to the neighborhood, while at the same time a significant Latino community began to develop. By the 1980s, the neighborhood included upper- and lower-income residents: blacks, whites, Latinos, and Southeast Asians. Since about 2000 its diversity has waned, its pattern of growth and change paralleling in many ways that of adjacent Adams Morgan.

For much of the eighteenth century, the land that became Mount Pleasant was held by James Holmead and his heirs. He received the land patent, named Pleasant Plains, from Charles Calvert, Lord Baltimore, in 1727. The land remained rural into the early nineteenth century, when a string of gentlemen's estates dotted the countryside. The remnants of one of these estates, Ingleside, still exist in

The boundaries of Mount Pleasant are the same as those that define its historic district. The neighborhood's origins as a post–Civil War settlement— before the extension of today's 16th Street—can be seen in the irregular, angled streets that straddle that artery on this map. At first centering around 14th Street, Mount Pleasant now lies entirely west of 16th Street. Map by Larry A. Bowring

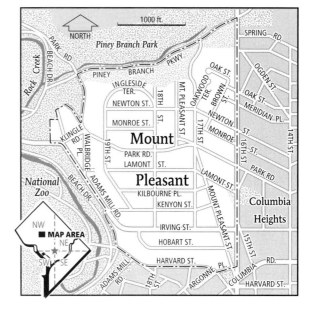

Mount Pleasant, at 1818 Newton Street, NW. This estate's story started in 1847, when Thomas Heiss, a Nashville journalist recently arrived in Washington, jumped into the city's speculative real estate market. He bought four adjacent properties north of Columbia Road to assemble a 139-acre parcel comprising all of what eventually would become Mount Pleasant west of Mount Pleasant Street. After naming the property Ingleside, Heiss sold it in 1850 to the Hewlings family, who engaged fellow Philadelphian Thomas Ustick Walter — architect of the new dome and wings for the U.S. Capitol — to design an elegant house. Although the Hewlingses apparently had planned to make Ingleside their home, they had barely completed constructing and landscaping it when they sold it at auction. A notice in the December 5, 1854, *Evening Star* described the "Italian villa residence" as "superior in point of construction and elegance to any dwelling within the limits of the District." It was "built in the most substantial manner of granite and brick, roughcast, and painted in imitation of brown stone, possessing . . . an extended view of the Potomac and many prominent parts of the city of Washington, together with an area of some fifteen miles of back country."[1]

Ingleside soon became known as the Walbridge estate. Its new owner, General Hiram Walbridge, was a New York businessman nearing the end of his first and only term in Congress. President James Buchanan and numerous cabinet members were among the guests at Walbridge's September 2, 1857, wedding at the estate. Walbridge family members occupied the Ingleside mansion for thirty-five years. Among them were Hiram's stepdaughter Helen and her husband, George Corkhill, who as U.S. attorney for the District of Columbia helped prosecute Charles Guiteau for the 1881 assassination of President James A. Garfield. "The trial of Guiteau . . . which is beyond question the most remarkable that has occurred in modern times, has made Mr. Corkhill one of the most conspicuous men of his day," according to a contemporary account. Even after the portion of the estate north of Park Road was sold in 1889 and subdivided, the Walbridge family retained the southern portion into the twentieth century.[2]

Frank Noyes, while treasurer and editor of the *Evening Star*, Washington's most important newspaper at the time, bought the mansion and 2.5 acres in 1896. But by then the front door faced an alley, so when Noyes renovated the house he moved the front to its current location on the north side. The dwelling subsequently housed the Presbyterian Home for Aged Women in 1917 and then the Stoddard Baptist Home beginning in 1961.[3]

Mount Pleasant's other early estates are long gone, but their names remain. When Walbridge bought Ingleside, the Hewlings retained the western corner of the property, known as Rorymorent, about seventeen acres with an old farmhouse. In 1855 Rorymorent went to Rev. John William French, the founding rector of the Church of the Epiphany downtown. Just two years later, Secretary of War Jefferson Davis, a member of the Church of the Epiphany, appointed French as chaplain to West Point. But even after his move from Washington, French kept Rosemount — as he had renamed the estate — until his 1871 death.[4]

*(opposite)
The pillared porches of the 1900 block of Park Road create a geometry many identify with Mount Pleasant. Photo by Rick Reinhard*

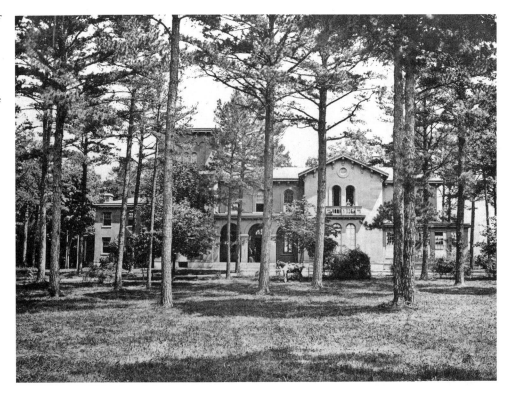

Rosemount's last owner was Harvey L. Page, a socialite architect who enjoyed hunting along the creek. About 1890 the federal government condemned the estate and later demolished the house to make way for Rock Creek Park. The present building, which sits slightly east of and above the old Rosemount estate house, was constructed by the Episcopal Association of Works of Mercy in 1911 as a "refuge and reformatory for outcast and fallen women." In 1971, thanks to changing mores, the House of Mercy, as it came to be known, became Rosemount Center / El Centro Rosemount, a bilingual school for young children.[5]

Just east of Ingleside was the estate that gave Mount Pleasant its name. In 1850 outgoing U.S. Treasurer William Selden bought a section of the old Pleasant Plains tract: seventy-three acres between today's Mount Pleasant and 14th streets north of the old Pierce Mill Road (now Park Road). Selden built a house and lived there more than ten years. At the time, he held the position of U.S. marshal for the District of Columbia, a job that required him to stand next to President-elect Abraham Lincoln during the inauguration and later keep watch at the White House as the public crowded in to greet the president and First Lady Mary Todd Lincoln. But, as a Virginian who believed in the Southern cause, Selden fled the city when the Civil War erupted.[6]

Samuel P. Brown, newly arrived in Washington to serve as naval procurement agent — at the invitation of Vice President Hannibal Hamlin, a fellow Mainer — snapped up Selden's land. Brown had the right experience for his new job. As the owner of Florida and Maryland timberlands, he had supplied yellow pine to the government, and he

had served four terms in the Maine state legislature. Brown quickly emerged as a major figure in the city, becoming president of Washington's first street railway company, the Metropolitan Railroad Company, in 1863. At the behest of President Lincoln, he also served as a judge of the levy court, which administered local matters in Washington County, the area of the District outside Washington City.[7]

At times during the war, Union troops camped on the land north of the city, including Brown's property. As soon as they were gone, he transformed his house, which stood near today's southeast corner of Mount Pleasant and Newton streets, into a thirty-room mansion and christened the estate Mount Pleasant. Nearby, on Holmead land north and east of Park Road and 14th Street, was the Mount Pleasant Hospital, one of a string of military hospitals along 14th Street. The Tivoli Theatre stands near this spot today.[8]

With the war's conclusion Brown laid out a number of one-acre lots between today's 14th and 17th streets and sought purchasers. However, the war had left the city in dis-

Samuel P. Brown, president of Washington's first streetcar company and a member of the levy court that governed Washington County, laid out the first lots in Mount Pleasant just after the Civil War. Courtesy Library of Congress

array, and Congress debated moving the capital to St. Louis or elsewhere in the country's heartland. As a result of this uncertainty, only five lots sold in 1865. Over time, however, sales picked up and Brown's property climbed in value, thanks in part to the new, more positive image of the capital created by the modernization of the central city in the early 1870s by Alexander R. "Boss" Shepherd's Board of Public Works. Brown, increasingly important in the city, was also a member of the Board of Public Works. The village expanded toward 7th Street as he and others bought up more land.[9]

Villagers met at the community well and town pump at the corner of Hiatt Place and Park Road. They kept cows and chickens and raised some of their own food, while a handful of stores at 14th and Park Road, the village center, provided other supplies. Mount Pleasant "is perhaps the most healthy suburb of Washington, proved by its exemption from chills and autumnal fevers of malarial districts which frequently prevail in the city," a journalist wrote in 1879. But in the winter, harsh weather and steep, muddy roads to downtown made travel difficult. Isolation — and the presence of so many New Englanders — resulted in Mount Pleasant's acquiring many characteristics of a New England village. Following the tradition of town meetings, residents formed the Mount Pleasant Assembly in 1870, which "fearlessly discussed all questions grave or gay, political or religious, historic or scientific."[10]

In the next couple of years groups spawned by the assembly organized religious meetings, Sunday schools for white and African American children, street improvements, an omnibus company, a temperance committee, and the Union Hall Company. The village's first, small school on Oak Street was replaced in 1871 with a new, larger building

on School Street (now Hiatt Place). A coal stove heated each of the four classrooms in the two-story structure, according to Edith Spears, whose family was among the first to settle in the village. "When the fires went out (which they did with suspicious frequency), we had one session [and were dismissed early]. It was astonishing how often those fires went out at noon when a skating party was in the offing," she recalled in a 1935 article in the *Washington Post*. The school served as the community center until Union Temperance Hall was built on Howard Avenue (now Newton Street) just east of today's 16th Street. The hall functioned as a church on Sunday and a place for meetings, parties, and balls the rest of the week.[11]

The strong separate identity residents felt was clear in their response to President Ulysses S. Grant's call for community histories during the 1876 United States Centennial. Villagers produced the "Annals of Mount Pleasant" and gathered to hear it read at Union Hall on July 4, 1876. Assembly president J. W. Buker, a city politician originally from Maine, presided over the festivities. His grand Victorian house, Oakwood, built in 1871 by S. P. Brown, still stands at 3423 Oakwood Terrace.

In the early 1870s, as a result of the efforts of the Mount Pleasant Assembly, a horse-drawn coach or omnibus began to run from the village center, at 14th and Park Road, downtown every morning and back every evening. But "so dark was Fourteenth street on moonless nights, so deep and spooky its shadows, so long and dreary its way, many feminine pioneers when detained in the city after dark played safe by carrying pepper shakers filled with cayenne to sprinkle in the eyes of possible bandits," wrote Spears about the 1880s. In 1885 the village comprised 137 houses. By the early 1890s, the assembly had evolved into the Mount Pleasant Citizens Association, representing the neighborhood's interests before the city commissioners on such issues as sewers, street paving, and streetcars. In 1892 a new electric streetcar line began running up 14th Street to Park Road.[12]

As public transport and street improvements speeded up the commute downtown, population spilled out of old Washington City into the countryside of Washington County. This growth, combined with new interest in restoring the plan of Peter Charles L'Enfant and expanding the city's national and international image, brought dramatic change to the District and to Mount Pleasant. In 1903 the city finished straightening and extending 16th Street from Florida Avenue up Meridian Hill to Spring Road. (Old 16th Street became Mount Pleasant Street.) The new thoroughfare cut right through the village. About the same time, the Metropolitan Railroad Company extended its Connecticut Avenue / Columbia Road streetcar line up Mount Pleasant Street. The first car arrived at the Park Road terminal on January 12, 1903.[13]

Within a few years, a new Mount Pleasant emerged between 16th Street and Rock Creek Park. The portion of the village east of the new boulevard developed as part of Columbia Heights. Businesses — many owned by immigrants — sprang up near the streetcar terminal and down Mount Pleasant Street. As land values soared, developers demolished many of the old frame houses and built apartments and row houses.

To make way for 16th Street, thirty-two houses had to be demolished, or moved. Some needed only to be pushed back several feet on their lots, but others traveled farther. Mary E. Sleman transported her frame house from 3008 15th Street (in today's Irving, 15th, and 16th Street intersection) to 1821 Newton Street, where it still stands. In general, however, the early frame houses that remain in today's Mount Pleasant are concentrated in the northeast corner of the neighborhood close to 16th Street. The angled streets in that area serve as further evidence of the original village. In 1893 Congress, concerned about the proliferation of "inharmonious subdivisions," had decreed that new streets must conform to the 1791 plan for Washington City by L'Enfant. But by 1893 the village had been laid out, so only the streets in the newer part of the neighborhood were affected by the law. Another anomaly exists just to the south where 15th Street, most likely an early path through the area, actually merges with 16th Street north of Irving, then reappears at the west side of Marconi Park, near the library, before ending at Lamont Street.[14]

Elizabeth Walbridge, widow of Hiram Walbridge's brother Heman and heir to the Ingleside estate, benefited greatly from the new streetcar route. The self-described "capitalist" owned virtually all of the land south of Park Road and west of Mount Pleasant Street, to Rock Creek Park. Working with her son-in-law, real estate broker Southwick Briggs, Walbridge made a fortune selling building lots. In 1899 the family had set the tone by hiring architect Glenn Brown to design two large duplexes at 1711–1713 and 1715–1717 Lamont Street. The Walbridges lived in 1717. Only a few years later Brown would play a central role in creating and promoting the 1901–2 McMillan Commission Plan for restoring L'Enfant's vision for the National Mall.[15]

The neighborhood attracted the best talents of Washington's budding architectural profession. Many of the first houses were given classical features, the style embraced by the McMillan Commission, which had in turn been inspired by the classical architecture of the 1893 World's Columbian Exposition in Chicago. Daniel Burnham, the architect and city planner who designed the Chicago fairgrounds, became the chair of the McMillan Commission, making Washington, D.C., the city where the aesthetics of the Chicago-inspired City Beautiful movement were first tried out. The impact on the Mount Pleasant neighborhood was epitomized by the large house at 1801 Park Road designed by Frederick Pyle in 1903 for Byron S. Adams, the owner of a printing business founded in 1872.

Other distinguished houses followed, including the monumental Georgian Revival–style 1841 Park Road, designed in 1906 by C. A. Didden for Charles Kraemer, a successful wine and spirits merchant; 1843 Park Road, designed in 1907 by A. M. Schneider for dentist Llewelyn Davis; 1827 Park Road, designed in 1907 by Harding and Upman for Thaddeus C. Dulin, a purveyor of fine china, silver, and glassware; 3346 Oakwood Terrace, designed in 1910 by A. H. Beers for physician Lewis E. Rauterberg; and 1770 Park Road, designed in 1906 by Nathan R. Grimm for Lewis Breuninger, developer of many of the row houses and semidetached houses on the south side of the 1700 and

The architecture of the World's Columbian Exposition in Chicago in 1893 inspired the Classical Revival style of many of the homes in Mount Pleasant, such as these at 1843 (left) and 1841 Park Road. Much of the neighborhood was built up around the turn of the twentieth century. Courtesy The Historical Society of Washington, D.C.

1800 blocks of Park Road. Row houses — many of them designed by prominent architects — also carried classical details in dormer windows, columned porches, and patterned rooflines.[16]

Demand was sufficient to support speculative buildings covering good portions of entire blocks. The neighborhood thus attained a unified physical character to match the largely homogeneous character of its residents, who were drawn primarily from the upper ranks of business and government. This new group was as civic-minded as its predecessors. In 1906 residents led by Byron Adams purchased a triangular lot on Park Road to prevent commercial building there. A few years later they transferred the lot to the city for a park, in the process reestablishing the Mount Pleasant Citizens Association. The group turned its attention to campaigning for a library and for a school to serve children west of 16th Street.[17]

When Bancroft Elementary School opened in 1924 at 18th and Newton streets, it was already too small and had to be expanded twice in the 1930s. The library, completed in 1925 as the third neighborhood branch in the city, was designed by Edward L. Tilton, architect of the Ellis Island immigration station. Funding came from the Carnegie Corporation, which spent double what it had spent elsewhere to construct a building in Mount Pleasant sufficiently elegant to match the mansions, embassies, and churches along 16th Street. With its fine draperies and tiled fireplaces, the new library resembled a private club, the *Washington Post* remarked in 1925. It quickly became a center of activity, hosting groups such as the Citizens Association and the Washington Water Color Club.[18]

By the 1930s, many of the neighborhood's prominent citizens had died or moved away. Some of the larger houses, including Byron Adams's 1801 Park Road, became

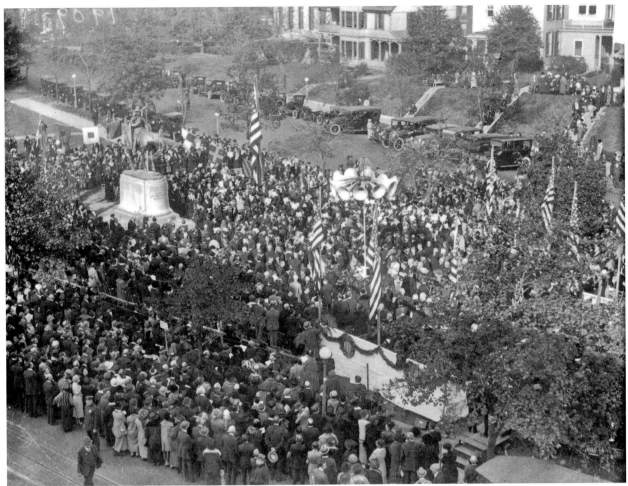

Sixteenth Street homes and a line-up of recently widely affordable automobiles provide the backdrop for ceremonies attending the dedication of a statue to Bishop Francis Asbury at 16th and Mount Pleasant streets in 1924. Situated where Mount Pleasant Street begins, the statue marks a gateway to the neighborhood. Courtesy DC Public Library, Washingtoniana Division, Hugh Miller Collection

homes for the elderly. Expanding government, unemployment in nearby rural areas, and war abroad brought a flood of people to Washington. Mount Pleasant's early row houses were exceptionally large, with as many as five to seven bedrooms, and many owners took in roomers or subdivided their houses into apartments. This trend accelerated during the housing crisis of World War II. The Najarian family of nine found the space to shelter an additional fifteen young women in their Kenyon Street row house. "We had one telephone," recalled oldest daughter, Clara Najarian Andonian. "Every time it rang, everyone would hang over the banister to see if it was for them."[19]

More changes occurred after the war as the U.S. Supreme Court began outlawing racial segregation in housing and schools, and new suburban developments lured many white residents away from older neighborhoods like Mount Pleasant. Beginning in the 1920s, the Mount Pleasant Citizens Association — like groups in many other neighborhoods outside the old Washington City — had promoted restrictive covenants, in which homeowners promised not to sell to "negroes." Although the Court ruled in 1948 in *Hurd v. Hodge* that racially restrictive covenants were no longer enforceable, the citizens association discussed various ways to continue controlling property purchases. One idea

pushed by the citywide Federation of Citizens Associations was to arrange to buy any property proposed to be sold to an "undesirable."[20]

In 1950 Dr. Robert A. Deane and his wife, Miriam Deane, became the first African Americans to purchase a house in Mount Pleasant covered by a covenant. Ignoring the agreement her parents had signed, owner Lillian Kraemer Curry sold 1841 Park Road (pictured on page 220) to the Deanes through a "straw" (white third party) who bought the house from Curry and sold it immediately to the Deanes. A few neighbors sued to stop the sale, but a judge threw out the case, and the Deanes moved into the house. Following the 1954 Supreme Court decision *Brown v. Board of Education*, real estate agents began showing Mount Pleasant houses to African American families relocating from Brookland, Foggy Bottom, and other parts of the city, as well as from outside the District.[21]

Racial change accelerated during the 1960s, as more white families departed for the suburbs. Some, refugees of wars and ethnic violence in Europe, were driven by their fears of similar strife here. For those who stayed, these fears were realized in the riots of 1968, which dealt a severe blow to the city, including Mount Pleasant. The nearby 14th Street corridor, with its array of shops, restaurants, and other businesses, was devastated, and some stores on Mount Pleasant Street were vandalized as well. Although the neighborhood's population had risen by about 550 between 1950 and 1960, during the next decade it dropped from 11,550 to 10,300, and the white population decreased dramatically in just ten years from 73 percent to 32 percent. The proportion of rental housing continued to climb, from about 68 percent in 1950 to 80 percent in 1970.[22]

The all-white citizens association had increasingly become a minority voice in the neighborhood, leaving it often on the defensive. To fill the gap some progressive residents joined in the late 1950s to form the interracial Mount Pleasant Neighbors Association. The group's goals included welcoming as neighbors "any person of good character regardless of race, color, creed or national origin," combating "community deterioration and aid[ing] property improvement," and reducing "prejudices and discrimination — lessen[ing] neighborhood tension."[23]

One of the Neighbors' first projects was to bring Barney Neighborhood House, a settlement house displaced by urban renewal in Southwest, to 3118 16th Street. The citizens association, denying that Barney's social services were necessary and fearing its presence would brand the neighborhood a "slum," fought this move. The two groups also clashed at the library in November

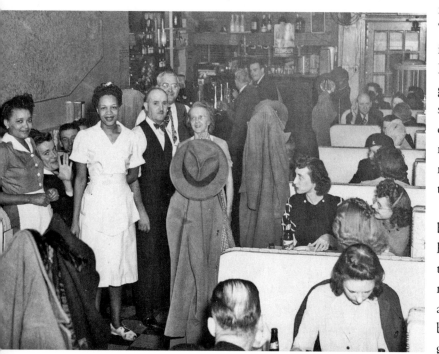

Servers and customers stop for the camera at a crowded Raven Grill about 1954. Opened in 1935 at 3125 Mount Pleasant Street, the Raven continues to be a popular gathering spot into the new millennium. Courtesy Mara Cherkasky

1961 when the Neighbors tried to attend a citizens association meeting. After members of the association abruptly adjourned the meeting, the Neighbors complained to the city commissioners about segregated groups using public buildings. The D.C. Department of Recreation responded quickly, denying the citizens association use of recreation department facilities. A few months later, the commissioners reacted as well, with a policy allowing racially segregated groups to hold meetings in the District's public buildings only if they allowed all comers to sit in.[24]

The Neighbors focused on planning events designed to emphasize the positive values of a racially and economically integrated neighborhood. Among the group's 1963 programs at the library were "Social Change and the Fundamentals of Community Organization" and "Cross-Cultural Organization and Understanding within the Community." After the 1968 riots, the Neighbors group began sponsoring an annual festival.[25]

As in many other close-in, older neighborhoods, it was only a matter of time before Mount Pleasant and its sturdy but inexpensive housing would find a new set of takers: young people, new immigrants, political activists, and artists. Group houses proliferated. The upheaval in the neighborhood, starting in the 1960s, paralleled national movements. The activist community centered around 16th Street and Columbia Road, the location of several progressive churches, including All Souls Unitarian. Early in the twentieth century, this church was one of the few places in Washington where interracial groups could meet, and its pastor in the 1940s, Rev. A. Powell Davies, helped lead the campaign to desegregate D.C. public schools. In 1965 a former assistant minister, Rev. James Reeb, was murdered in Selma, Alabama, while working in the voting rights movement.[26]

In 1972 the Antioch School of Law was launched at All Souls to train public interest lawyers. Shortly thereafter a gift to the school made it the reluctant owner of the Kenesaw Apartment House a block up 16th Street. By now the once-elegant building had fallen into near-ruin, and Antioch decided it was more liability than asset. It decided to sell the building to developers and in 1974 sent out eviction notices. However, the mostly low-income and immigrant tenants fought the move and, aided by community groups, organized to buy the building. Father (now Cardinal) Sean O'Malley of the Spanish Catholic Center, then housed in the Kenesaw, as well as the Neighbors Association and other neighborhood groups, joined the fight. The ordeal lasted several years but in the end the Kenesaw tenants kept their home and tenants citywide got a new law ensuring them the right of first refusal when their buildings were to be sold. The landmark 1980 legislation, which was cosponsored by D.C. Council member and Mount Pleasant resident David A. Clarke, has allowed tenants around the city to buy their buildings and form cooperatives. In the first decade of the twenty-first century, the Kenesaw was half a limited-equity cooperative known as the Kenesaw Phoenix and half the Renaissance condominiums.[27]

The Neighbors Association also got involved in historic preservation. In 1978 the group became alarmed at the proposed demolition of the grand classical house at 1801

Park Road. They saved it with a successful campaign to place all the houses and their carriage houses on the north side of the 1800 block of Park Road on the National Register of Historic Places.

These were the Mount Pleasant Neighbors' last projects. In the late 1970s, the group was overshadowed by a new neighborhood structure, the Advisory Neighborhood Commission, created by the Home Rule Act of 1973. Some of the first commissioners elected in February 1976 also were active Neighbors. As in other neighborhoods across the city, the commission's official government status and small regular allotment of city funds gave it an edge over earlier, totally voluntary organizations.

Meanwhile, the historic preservation movement intensified as the group that had coalesced around 1801 Park Road next focused its efforts on Ingleside, at 1818 Newton Street, whose owner, the Stoddard Baptist Home, wanted to demolish it to make way for a nursing home. In the end, the neighborhood and the owners struck a compromise calling for the new facility to be built around the original home. The old mansion remained, while a new addition was designed with repeating bays along Newton Street to reflect the neighborhood's row house style.[28]

The next step was historic district status for the entire neighborhood. While many residents championed this campaign as a way to preserve the neighborhood's architectural character, others publicly opposed it, fearing designation would mean displacement and the end of ethnic and cultural diversity. Despite the disagreements, the neighborhood in 1987 did become a historic district listed on the National Register of Historic Places. Historic Mount Pleasant, Inc., the new group that shepherded it through the designation process, continues to be an active neighborhood organization.

The historic preservation movement illustrated how the neighborhood was continuing to change. Although most longtime white residents had left during the 1960s, a new wave of whites began buying houses in the 1970s and moving in. Many of these were young professionals who were actively seeking an integrated urban neighborhood. According to a study by Dennis Gale, 77 percent of the newcomers were white and mostly migrants from rental housing in other parts of the city. By 1980 Mount Pleasant's population of 10,000 had shifted slightly to 35 percent white (up from 32 percent in 1970) and 49 percent black.[29]

But the bigger story in the 1980 census figures was that 13 percent of the neighborhood's population was Latino. As early as 1922, the Bolivian and Cuban legations and the embassies of Mexico and Spain had clustered near the intersection of 16th Street and Columbia Road, and their staff had called this area home. In 1962 Margarita Marrero

Mount Pleasant resident David A. Clarke campaigns for the chairmanship of the D.C. Council in his own backyard on 17th Street in 1982. Photo by Gary Cameron. Courtesy Washington Post

(opposite)
The extended family and friends of the Blue Skies group house at 1910 Park Road pose on their front porch in 1977. Group houses became common in the community in the 1960s and 1970s. Future Mayor Adrian M. Fenty is sitting on the fifth step, far left. The Fenty family lived elsewhere in the neighborhood. Photo by Rick Reinhard. Courtesy Rick Reinhard

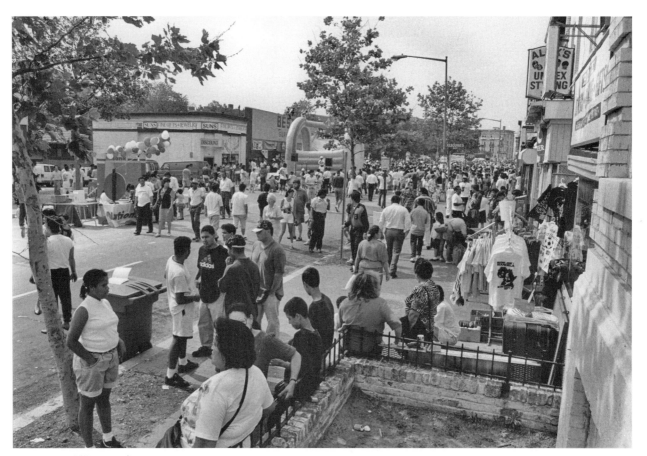

A diverse crowd fills Mount Pleasant Street in the 1990s during an annual neighborhood festival. By 1990 Mount Pleasant was 26 percent Latino, with black and white residents sharing the neighborhood in roughly equal numbers, at 36 and 35 percent respectively. Photo by Rick Reinhard. Courtesy Rick Reinhard

Diloné and Félix Diloné, immigrants from Puerto Rico and the Dominican Republic, opened Mount Pleasant's first *bodega,* Casa Diloné, at 3161 Mount Pleasant Street. Besides providing familiar foods and beverages, the little grocery store served as a social center and attracted more Latino businesses. The Latino stores shared the street with black-owned businesses such as the Launder Center and Logan Tailors, established in the early 1960s in the 3100 block, and older neighborhood businesses dating to the 1920s and 1930s. These included the Raven Grill in the 3100 block and Heller's Bakery in the 3200 block.[30]

Latinos settled mostly in apartment buildings and shared houses on the southeast side of the neighborhood, adjacent to Adams Morgan, where the Spanish-speaking population was growing even more dramatically. Carlos Rosario, a Puerto Rican immigrant who became one of the city's first Latino leaders, settled on Hobart Street in Mount Pleasant in 1957. Numerous social service agencies serving a Latino clientele arrived as well. For example, the Central American Refugee Center (CARECEN), moved into 3112 Mount Pleasant Street in 1981. It was established to help Salvadorans and other Central Americans who had fled to the United States seeking refuge from the wars, turmoil, and human rights violations in their countries. (See chapter 25 on Adams Morgan for more on the area's Latino community.)

Other immigrant groups also settled in Mount Pleasant, in particular a number of Vietnamese refugee families, in apartments in the 1600 and 1700 blocks of Park Road. While a few Vietnamese businesses opened in the 1400 and 1500 blocks of Park Road in Columbia Heights, this group did not leave lasting traces in Mount Pleasant. The 1990 census revealed that blacks and whites in the neighborhood now were sharing the neighborhood in almost equal numbers (36 and 35 percent of the total of 11,138), while those of Latino descent stood at 26 percent, and of Asian descent at 3 percent. By no means did the groups share power in the neighborhood, however.

In May 1991 tensions between the police and some members of the Latino community came to a head after a rookie officer shot a Latino man during a disorderly conduct arrest in the 3200 block of Mount Pleasant Street. When this news got out, young Latino men from across the D.C. metropolitan area clashed with police, burning vehicles and vandalizing public property in Mount Pleasant, Adams Morgan, and Columbia Heights. By the time the disturbances ended after three nights, 230 people had been arrested and 50 injured. In the aftermath, Mayor Sharon Pratt Kelly established the Latino Civil Rights Task Force to address the needs and concerns of the community, and the police department made changes in the way its officers treated Spanish-speaking residents. Jean and Pedro Lujan, the owners of Heller's Bakery, helped revive the neighborhood street festival to boost sagging spirits.[31]

Mount Pleasant retains its strong sense of identity. However, like other lively, close-in neighborhoods, it has become a victim of its own success. The 2000 census revealed the neighborhood to be shared in roughly equal parts by whites, blacks, and Latinos. However, in the subsequent years much of its diversity has been lost. Several trends were responsible for this situation. Low interest rates on mortgages, development spurred by the opening of the Columbia Heights Metro station at 14th and Irving streets in 1999, and political and cultural changes in the city at large have made Mount Pleasant a more attractive place to live for people of means. Although the economic downturn beginning in 2008 is slowing the pace, these conditions continue to make the neighborhood unaffordable for those of modest incomes.

Many of Mount Pleasant Street's longtime — and newer — family-owned businesses continue to thrive. However, national chain stores currently dominate a large new shopping complex near the new Metrorail station just a few blocks to the east in Columbia Heights. These new shopping opportunities, and the dwindling diversity of the Mount Pleasant neighborhood customer base, seem to threaten the welfare of the independent stores and the viability of the street's village character. Changes are, once again, on the horizon.

LeDroit Park

A SUBURB IN A ROMANTIC STYLE

RONALD M. JOHNSON

LeDroit Park combines an intriguing blend of the past with the present. A large number of the original houses, designed more than a century ago by the same architect in picturesque styles popularized by Andrew Jackson Downing, remain to give this geographically intimate neighborhood a unique physical character. There is a feeling, as one strolls around Anna Cooper Circle, of an earlier period in history. At the same time, many of the older houses have been recently restored, as diverse newcomers discovered the character of the place and moved in. This unique mix of continuity and renewal, of old and new faces, of different races and experiences in what was a historically black community throughout the twentieth century, was touted as the neighborhood's great appeal by Myla Moss, the LeDroit Park Advisory Neighborhood Commissioner, in an interview in the *George Washington University Hatchet* in 2006. "We have everything," she said. "We have good race relations, we have students, families with 2.5 kids, professionals, a gay community and a small group of elderly people." The article's author, Prerna Rao, came to her own conclusion. The neighborhood was "a peaceful oasis in the middle of a bustling city."[1]

The commonly accepted boundaries of LeDroit Park and the boundaries of the LeDroit Park Historic District match the extent of the 1873 suburban development by that name. The local civic association also accepts this delineation as its own.
Map by Larry A. Bowring

The neighborhood was one of the first planned suburbs of Washington City. It began in 1873 on a fifty-five-acre triangular tract of open land, situated just beyond the city's northern limits at Boundary Street between 2nd and 7th streets, NW. The project was the creation of Amzi Barber and Andrew Langdon, local land speculators, who had put together several parcels of property located just south of Howard University, which had been founded after the Civil War in 1867 by the Freedmen's Bureau. Amzi Barber, one of the founders of Howard, had married the daughter of successful real estate broker LeDroit Langdon. Barber decided to leave his position at Howard in 1873 and go into real estate with his brother-in-law, Andrew Langdon. They named their company A. L. Barber & Co. and their new suburb LeDroit Park after their father and father-in-law. While nearby Howard University was founded to provide higher education to all, especially

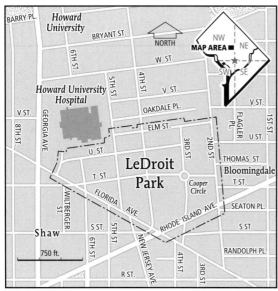

An entrance gate at Florida Avenue and T Street frames one of many fine LeDroit Park homes from the 1870s and 1880s. Now in the heart of urban Washington, LeDroit Park was laid out in 1873 as one of Washington City's first planned suburbs. Photo by Rick Reinhard

African Americans, and a number of its professors were African American, the new suburb would be open only to whites.[2]

Barber and Langdon conceived of their project as a planned community, a "romantic suburb" with streets beautifully landscaped and organized around a circular drive. To emphasize its separation from the rest of the city, the developers deliberately laid out the streets at an angle to the city's grid. To launch their plans, Barber and Langdon engaged James H. McGill, a local contractor and architect. In four years McGill designed and built forty-one detached and semi-detached houses, adding twenty-three more over the following decade.

The McGill designs incorporated picturesque styles such as Italianate and Gothic that Andrew Jackson Downing had promoted in *Cottage Residences*, his 1842 book with Alexander Jackson Davis. The house patterns in this book reflected Downing's belief that homes should be both beautiful and functional and should blend with the natural landscape. It was a style thought of as romantic because of its fanciful asymmetrical designs and its association with informal rural landscapes. Downing further popularized this aesthetic in 1850 in his book, *The Architecture of Country Houses*. The movement had an impact on the new capital. Downing himself designed a new landscape for the Mall in the late 1840s, some of which was realized adjacent to the new Smithsonian Institution. Franklin Park (now Franklin Square at 13th and K streets) was landscaped in the romantic manner after the Civil War, when it was the centerpiece of a fashionable residential district. Further, as LeDroit Park was being planned, Downing's fellow pioneer in the field of landscape architecture, Frederick Law Olmsted, was working on designs influenced by the romantic aesthetic for the terraces and grounds of the Capitol as well as for the campus of the Columbia Institution for the Deaf, Dumb, and Blind (today Gallaudet University). Thus the dwellings and landscaping of LeDroit Park were in the most popular contemporary style.[3]

Location dictated LeDroit Park's desirability as a place of residence. Although just outside the old Washington City limits, the subdivision was only a block from the terminal point of a recently built horse-drawn streetcar line, later electrified, which allowed for rapid commuting to government agencies and businesses. However, this closeness to the central city, a major reason for LeDroit Park's immediate success, soon threatened the rural atmosphere of the neighborhood. Other residential and commercial development began to spread to the south, west, and even north of LeDroit Park. One such development actually predated LeDroit Park — Howard Town — a black residential area created in 1867 when Howard University put up lots for sale adjacent to its campus. Howard Town would eventually extend from 2nd to 5th streets and from V to Bryant streets. The first lots were located along present-day 4th Street, directly north of LeDroit Park. Barber and Langdon had this section in mind when they encircled LeDroit Park with a combined cast-iron and wood fence. With no through traffic allowed and only the southern street entrances open, the neighborhood was insulated from its immediate surroundings. The developers hired a watchman to close the street gates at night and

keep out intruders, and they carefully screened all potential home buyers so that only whites were permitted.[4]

During the 1870s and early 1880s, government administrators and professionals, including doctors, lawyers, and teachers, purchased homes in the new neighborhood. Together they worked to maintain a climate of privacy. The physical setting was especially appealing, with abundant perennials and evergreens that helped to create a bucolic atmosphere. "LeDroit Park during that period," recalled former resident Charles Hamilton, "was the 'flower garden' of Washington. Every resident took pride in cultivation of all kinds, especially roses and chrysanthemums." Another observer noted that "the social life savored strongly of a village, and yet it was near to the city." In the late 1880s these unique attributes began to wane when, as the city spread northward, areas adjoining LeDroit Park became more densely developed.[5]

LeDroit Park residents became especially concerned as Howard Town expanded in area and population. As more black families settled there, they looked for a more direct route to downtown. Consequently, the numbers of individuals cutting through LeDroit Park and jumping the fence after the evening gate closings increased dramatically. In 1886, provoked by the enforcement of the ban against "intruders," a group of African Americans shouted their complaints across the fence at LeDroit Park residents. Two years later, led by local land developers who owned lots in Howard Town and wanted greater accessibility, a large group of men attacked the fence and dismantled it. The LeDroit Park Citizens Association replaced the fence with barbed wire, which also was torn down. Over the next three years the Washington newspapers reported on the "fence war." A final effort to restore the fence failed in 1891, leaving foot traffic to flow regularly through the subdivision. "With the opening of the streets," wrote one newspaper reporter, "the park soon lost its former characteristics and became a part of the city with all its advantages and disadvantages."[6]

For a while advantages still outweighed disadvantages for those living in LeDroit Park. The conversion of LeDroit Park streets into thoroughfares did not lead to any sudden turnover among residents. The convenient location and handsome dwellings kept individuals like Patents Commissioner Benjamin Butterworth and geologist Henry Gannett firmly committed to the neighborhood. In 1893, however, Octavius A. Williams became the first black homeowner in LeDroit Park. A barber in the Capitol, he brought a wife and young daughter to live in a McGill-designed house at 338 U Street. The Williamses faced a distinctly hostile response from some other LeDroit Park resi-

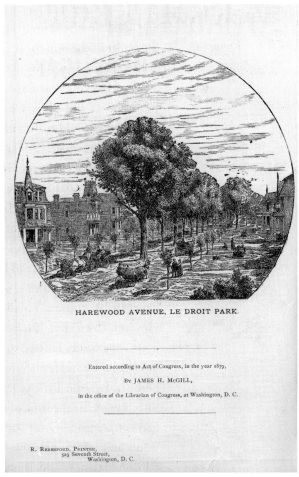

HAREWOOD AVENUE, LE DROIT PARK.

Entered according to Act of Congress, in the year 1879,

By JAMES H. McGILL,

in the office of the Librarian of Congress, at Washington, D. C.

R. BERESFORD, PRINTER,
523 Seventh Street,
Washington, D. C.

This romantic view of Harewood Avenue, today's 3rd Street, appeared in James H. McGill's Architectural Advertiser, published in 1879 to promote the sale of his homes in LeDroit Park. Picturesque homes in the popular Second Empire and Italianate styles set amid finely landscaped grounds were intended to set the suburb apart from the city and were its key selling points. Courtesy Historical Society of Washington, D.C.

dents. The daughter later recalled that "just after we moved in and were having dinner one night, someone fired a bullet through the window." She added that her father "left the bullet in the wall for years so his grand-children could see it." After this incident the Williams family was for most part left alone.[7]

The following year a second black family purchased a house in LeDroit Park. They were Robert and Mary Church Terrell, a young African American couple beginning careers that would eventually place them among the most respected Washingtonians of their day. A graduate of Harvard University, trained as a lawyer, Robert Terrell was then the principal of M Street High School. His wife taught foreign languages at the school and was just initiating her work in the women's suffrage and civil rights movements, an involvement that would bring her an international reputation. She was the daughter of the first black millionaire of Memphis, Tennessee.

In her autobiography, *A Colored Woman in a White World*, Mary Church Terrell described her first effort to buy a house in the District of Columbia. She wrote of overcoming many difficulties, beginning with persuading real estate agents even to show her available houses. "Finally I selected one," she wrote, "only one house removed from Howard Town" but "located in LeDroit Park." When the Terrells made a bid on the house, the owner refused to sell to them. A white real estate agent friend intervened to buy the house and transferred title to the Terrells. Four years later they moved to a larger home in LeDroit Park at 326 T Street (formerly Maple Street) and remained there for fifteen years. By the time of their second move, a growing number of black homeowners had come into LeDroit Park, including decorated Civil War veteran Christian Fleetwood and locally prominent professionals Robert L. Warring, Henrietta B. Turner, Clifton Hariston, and Thomas Warrick.[8]

The early conflict between black Howard Town and white LeDroit Park residents, followed by the gradual growth of black homeownership in LeDroit Park, reflected a major shift in the District's residential patterns. Once racially mixed, the city's whites and blacks began to regroup into larger concentrations of population along racial lines. As more whites moved into newer suburban communities, made possible and accessible by the electric streetcars, older neighborhoods such as LeDroit Park experienced a steady turnover from white to black. LeDroit Park became part of a larger African American area in the Northwest quadrant. Other black residential neighborhoods, social and cultural institutions, businesses, and shops slowly formed around LeDroit Park. As a result, a new focus for black Washington emerged at the meeting of U and 7th streets and Florida Avenue.[9]

This intersection was just a block west of LeDroit Park. In the general proximity, by 1920 black-owned shops and retail stores joined seven movie theaters, a YMCA, two newspaper and publishing firms, and restaurants and dining clubs to form a separate black business section in the area known today as Shaw. Also here were numerous Baptist and Methodist churches, elementary schools, Miner Normal School, and Howard University, which by 1900 had become the nation's most important black institution of

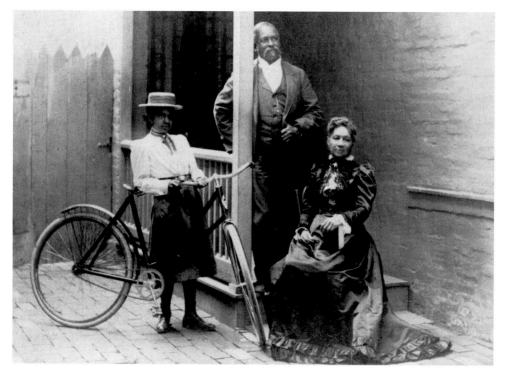

Civil War Medal of Honor
winner Major Christian
Fleetwood and his wife, Sarah,
superintendent of the Training
School for Nurses at Freed-
men's Hospital, pose with
their daughter outside their
LeDroit Park home around the
turn of the twentieth century.
Courtesy Manuscripts Division,
Library of Congress

higher learning. In time the District school board located Armstrong Technical High School, Cardozo Business High School, and Dunbar High School nearby. A growing black elite took up residence in the Northwest quadrant. They included members of old District families, such as the Syphaxes and Wormleys, but most were more recently arrived lawyers, clergy, business people, teachers, and school administrators, as well as large numbers of government clerks and skilled federal workers. To affirm their rising status and realize the fruits of hard work, they sought to buy houses in established neighborhoods such as LeDroit Park.

The most famous resident in the neighborhood during these years was Paul Laurence Dunbar, who was neither a homeowner nor a member of the black middle class. He was instead a young writer from Ohio, already acclaimed by William Dean Howells in *Harper's Weekly* as the best black poet in the country. Dunbar, then twenty-five years old, arrived in the District of Columbia in the fall of 1897 just after the publication of his *Lyrics of the Lowly Life*. Offered a position at the Library of Congress, Dunbar decided to settle in the city. Initially he stayed with Howard University professor Kelly Miller and family, spending his free time writing his first novel, *The Uncalled*. With help from Miller, the founder of black sociology and a celebrated teacher, and from Robert and Mary Terrell, Dunbar found a rooming house in LeDroit Park. By Thanksgiving he had written to his mother: "Come at once to 1934 Fourth St., N W. My house is very beautiful and my parlor suite is swell." He described his rooms in detail, alluding to "dark green plush and cherry-colored inlaid wood . . . polished floors . . . fine big Morris chair," and "a study off the parlor."[10]

Nationally acclaimed poet Paul Laurence Dunbar came to LeDroit Park from Ohio in 1897 and enthusiastically wrote his mother asking her to come at once to see his beautiful house and "swell" parlor. Courtesy Scurlock Studio Records, Archives Center, National Museum of American History, Smithsonian Institution

Even while his reputation soared, Dunbar experienced moments of depression over his battle with tuberculosis, a struggle that he would eventually lose. His job at the Library of Congress as a clerk, together with the stifling political atmosphere in the city, distressed him. In a letter written in 1898 he lashed out: "I still stagnate here among books in medicine and natural sciences, in what I have come to believe the most God-forsaken and unliterary town in America. I hate Washington very cordially and evidently it returns the compliment, for my health is continually poor here." Yet the record shows that he was not always so critical. "I am afraid the climate of Washington does not suit me," he later commented, "but there is much to hold me here. The best Negroes in the country find their way to the capital, and I have a very congenial and delightful circle of friends."[11]

Among his new friends was Mary Terrell. In 1899 Dunbar and his new wife, writer Alice Moore, moved into a McGill-designed house at 321 Spruce Street (today's U Street), no longer standing. There Mary Terrell came to know the famous poet well. He affectionately called her "Molly," and the two often discussed literature and art. "Precious memories rush over me like a flood," she later wrote, "every time I pass that house. I can see Paul Dunbar beckoning me, as I walked by, when he wanted to read a poem which he had just written or when he wished to discuss a word or a subject on which he had not fully decided." Indeed, Dunbar was happy in LeDroit Park, as seen in his rendering in *Lyrics of the Hearthside* of evening walks along Spruce Street: "Summah nights and sighin' breeze / 'Long de lovah's lane."[12]

While in the city, Dunbar closely observed life in black Washington. In his essay "Negro Society in Washington," published in the December 14, 1901, issue of the *Saturday Evening Post*, he spoke of the black middle-class experience in the city. "Here exists a society," he wrote, "which is sufficient unto itself — a society which is satisfied with its own condition, and which is not asking for social intercourse with whites." Thinking of residences like those in LeDroit Park, he spoke of "homes finely, beautifully and tastefully furnished." The next year, in failing health, Dunbar left the District, returned to Dayton, eventually succumbing to tuberculosis in 1906.[13]

Near to the center of black Washington, LeDroit Park thrived as a middle-class neighborhood. By 1920 T Street was home to Anna J. Cooper, pioneer in black adult education and president of Frelinghuysen University (and after whom Anna Cooper Circle is named); Fountain Peyton, prominent lawyer; and Ernest E. Just and Alonzo H. Brown, respected members of the Howard University faculty. All worked hard to maintain the original setting of the neighborhood. When former resident Charles Hamilton revisited

Dean Kelly Miller of Howard
University grew corn in the
garden of his LeDroit Park
home about 1909. Many
distinguished scholars lived in
the area, giving it a national
reputation. Photo by Addison
Scurlock. Courtesy Scurlock
Studio Records, Archives
Center, National Museum of
American History, Smithsonian
Institution

LeDroit Park, he found nothing changed except "the tint of the complexions of the in-
habitants." He concluded that "the darker race" had "now made LeDroit Park the most
orderly and attractive 'colored section' of Washington."[14]

While LeDroit Park's physical setting remained largely the same during the early de-
cades of the twentieth century, there was considerable change on its perimeter: even
more row housing, stores, and businesses. The largest development had come in 1919
when Clark C. Griffith constructed a 34,000-seat ballpark, complete with bleacher
seats and a centerfield fence abutting the backyards of houses on U Street. Until 1956
LeDroit Park residents made the annual adjustment to the crowds and noise emanating
from Griffith Stadium, home of the American League's Washington Senators and, dur-
ing the 1930s and 1940s, the Negro League Homestead Grays. Between 1937 and 1960,
the stadium served as the home field for the Washington Redskins. Also attracting the
public to the neighborhood was the Howard Theater, just east of 7th on T Street. Here
Edward "Duke" Ellington and Bessie Smith, among many others, performed regularly.
The Howard ranked along with the Apollo in New York and the Pearl in Philadelphia
as one of the nation's premier African American theaters.

A fire scene on a winter day about 1910 provides a glimpse of today's Anna J. Cooper Circle at 3rd and T streets. Courtesy The Historical Society of Washington, D.C.

During the 1920s and 1930s LeDroit Park continued to house prominent individuals and families. Living in the neighborhood at different times were Anita J. Turner and Hattie Riggs, well-known Dunbar High School teachers; Emmett J. Scott, one-time personal secretary to Booker T. Washington and secretary-treasurer of Howard University; Oscar de Priest, the first black congressman since the turn of the century; Garnet Wilkinson, highest-ranking administrator for the city's black schools; and poet Langston Hughes, who lived briefly with a relative before moving into the 12th Street YMCA at 1816 12th Street, NW. The fame of these and other individuals brought black Washington and LeDroit Park a national reputation, as documented in *Crisis*, the official magazine of the NAACP, edited by W. E. B. Du Bois. In 1926 Kelly Miller, a LeDroit Park resident and Howard University dean, published "Where Is the Negro's Heaven?" and pointed to the District of Columbia, a claim that some, including Langston Hughes, rejected in light of contemporary segregation laws and practices.[15]

The Elks home at the entrance to the neighborhood at 3rd Street and Rhode Island Avenue was a center of community activity. Its grand building and extensive grounds, purchased from the estate of original owner David McClellan, provided the setting for Sunday band concerts, bridge parties and teas, and musical evenings lit by Japanese lanterns on the lawn.[16]

The impact of the Great Depression was felt in LeDroit Park when the National Capital Housing Authority, or NCHA, using New Deal funding, placed public housing units on the neighborhood's northern boundary. When the Williston Apartments opened on W Street, all thirty units were immediately filled. The NCHA also opened

the V Street Homes and the Kelly Miller Dwellings, totaling 169 rental apartments. The V Street complex was built on the site of Bland's Court, an old alley community that Paul Dunbar had frequented during his years in LeDroit Park. The outbreak of World War II, however, ended all development, and the postwar period failed to bring needed investment to the aging neighborhood.

In the spring of 1951, *Evening Star* reporter George Kennedy visited LeDroit Park and noted that the residents had carefully maintained the "gingerbread gables, spiral pillars, stained glass windows and other romantic designs." At the same time he sensed a growing change in LeDroit Park. During the 1950s and 1960s many whites fled the District of Columbia for the suburbs, placing houses on the market that formerly had not been available for blacks. With the 1948 Supreme Court decision that made racial covenants unenforceable, large areas of the District opened to black middle-class buyers. In the 1950s urban renewal in Southwest forced many low-income black families to seek housing elsewhere. The combined result for LeDroit Park was a substantial loss of older, middle-class families and an equally large influx of low-income residents. By the 1970s the neighborhood was in the throes of population turnover and dislocation.[17]

Photographer Addison Scurlock, who documented the African American community in Washington for more than fifty years, captured educator and suffragist Mary Church Terrell in all her elegance in the 1920s. She and her husband, lawyer and educator Robert Terrell, were the second African American family to purchase a home in LeDroit Park. Photo by Addison Scurlock. Courtesy Scurlock Studio Records, Archives Center, National Museum of American History, Smithsonian Institution

In response to these conditions, which had bred extensive social problems and an increase in crime, neighbors created the LeDroit Park Civic Association. The Association was led by Walter E. Washington, later mayor of Washington, and his wife Bennetta Bullock Washington. They lived at 408 T Street, which had been the Bullock family home since 1918. Under their leadership, the civic association worked for increased police protection, better government services, and youth programs. The organization tried to involve Howard University in neighborhood improvement initiatives but was unsuccessful.[18]

Beginning in the 1970s, the civic association encouraged individual homeowners to restore their properties, particularly the original McGill houses. Concern over Howard University's projected expansion into the area led the civic association to organize the LeDroit Park Historic District Project in 1972, and the neighborhood was listed as a historic district on the National Register of Historic Places two years later. The neighborhood formed the LeDroit Park Historical Society in 1977 to work to preserve its historic character, under the leadership of Teresa Brown. For the next two decades, however, the neighborhood struggled with continued demographic turnover and physical decline. Then, in the early 1990s, Howard University reassessed its relationship with LeDroit Park and other nearby residential areas. In 1996, under the leadership of a new president, H. Patrick Swygert, the university founded the Howard University Community Association and appointed Maybelle Taylor Bennett as its director. The association's mandate

The Elks Public Appearance Club of the Elks Columbia Lodge No. 85 stand proudly before their headquarters in the former house of David McClellan at the 3rd Street and Rhode Island Avenue entrance to LeDroit Park in the 1930s. The house and grounds provided the setting for Sunday band concerts, bridge parties, and musical evenings under strings of Japanese lanterns. Photo by Addison Scurlock. Courtesy Scurlock Studio Records, Archives Center, National Museum of American History, Smithsonian Institution

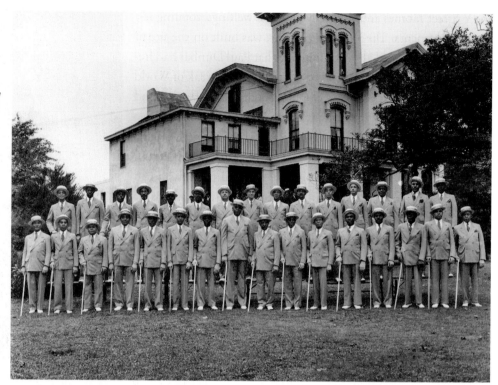

Students at Anna Cooper's Frelinghuysen University, which offered an evening education for working people, attend a class in the founder's home at 2nd and T streets in 1939. Photo by Addison Scurlock. Courtesy Scurlock Studio Records, Archives Center, National Museum of American History, Smithsonian Institution

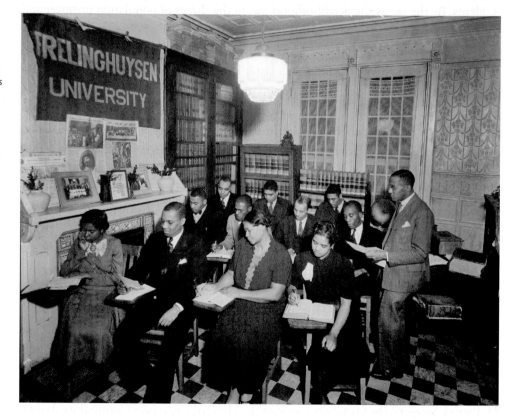

was to reach out to the larger community. With strong input from Bennett, the university soon launched the LeDroit Park Initiative, a comprehensive plan designed to revitalize the historic district now hugging the university's southern edge. The first order of business involved the renovation of twenty-eight vacant, university-owned houses and the construction of seventeen new ones on vacant land in LeDroit Park owned by the university. These homes were then sold with financing provided by the Federal National Mortgage Association, commonly known as Fannie Mae, the federal provider of mortgages for low-, moderate-, and middle-income families. Spurred by the university's effort, restoration and renovation efforts increased dramatically in the neighborhood.[19]

Despite these efforts to retain affordable housing in the neighborhood, house prices in LeDroit Park have risen dramatically since the late 1990s as new residents, white and African American, have discovered both the convenient location and the historic charm of this unique nineteenth-century planned community. And as elsewhere in neighborhoods throughout the city, people of fewer means have been forced to leave.

LeDroit Park is now in the midst of a cultural renaissance as well as new physical growth. The LeDroit Park Civic Association stands guard over the neighborhood. Restoration of many of the old McGill homes is under way, including the former residences of Anna J. Cooper and the Terrells. The latter is of particular importance because the Howard University Community Association, with the assistance of local historian Lauretta Chambers Jackson, is leading the effort to develop the property into the Robert and Mary Church Terrell House and LeDroit Park Museum and Cultural Center. Once fully established, the new organization will be at the center of a revitalized LeDroit Park and will share and perpetuate its story. Toward realizing that goal, a major symposium was held in April 2005 honoring the legacy of Mary Church Terrell and presenting the plans for the new center. It is developments such as this that ensure the neighborhood's history will be a living presence in its future.[20]

Walter E. Washington and his wife, Bennetta Bullock Washington, are seen here in 1971 in front of their T Street home, which had been in the Bullock family since 1918. Walter Washington was at the time the city's mayor-commissioner, appointed by President Lyndon Johnson. He would be elected mayor in 1974, the first to be elected to that position since 1871. Courtesy Star Collection, DC Public Library. © Washington Post

Columbia Heights

PASSAGEWAY FOR URBAN CHANGE

BRIAN KRAFT

Columbia Heights takes its name from early subdivisions adjacent to Columbian College, the first location of what would become George Washington University. Its boundaries are generally accepted on three sides, but on the east the neighborhood merges with Pleasant Plains, some say at 13th Street, some say at Sherman Avenue. From the mid-1960s to the late 1980s, parts of this area were known to many as Cardozo or Upper Cardozo. Map by Larry A. Bowring

In looking at Columbia Heights over time, the only constant one sees is change. Perched on a high terrace overlooking old Washington City, with four streetcar lines running north within it at one point in its history, this nineteenth-century suburb became a place to move through. Diverse waves of people have flowed into and out of the neighborhood, often with multiple demographic trends occurring simultaneously. Even its name has changed several times. Change is what Columbia Heights does best, and every change seems to reflect, in dramatic and exaggerated terms, the state of the city and the city's most powerful trends.

Appropriately for the theme of change, the first community to develop in the area had a name and an identity that moved elsewhere. Samuel P. Brown, a prominent figure in Washington City, subdivided a tract of land north of Park Road and west of 14th Street, NW, in 1865 that he called Mount Pleasant, taking the name from an early estate in the area. When 16th Street was extended just after 1900, that neighborhood grew to the west, leaving its traces in the strangely angled streets and wooden houses east of 16th Street between Park and Spring roads in today's Columbia Heights. That story is told in chapter 12 on Mount Pleasant.

The first development to call attention to the area that would become Columbia Heights, however, was Columbian College, founded in 1821 between 14th and 15th streets on the hill just above Boundary Street. The area came to be known as College Hill. The college was tiny by today's standards, starting with just four buildings. In its first fifty years, Columbian College averaged fewer than twenty-four graduates per year. All of those graduates were male, as women were not admitted until the university moved to downtown in 1882. The school moved to Foggy Bottom in 1912 and became George Washington University, honoring the man who had a vision of a national university located in the nation's capital.[1]

Despite its small size, Columbian College brought an identity to its dramatic hilltop. Over time it subdivided its

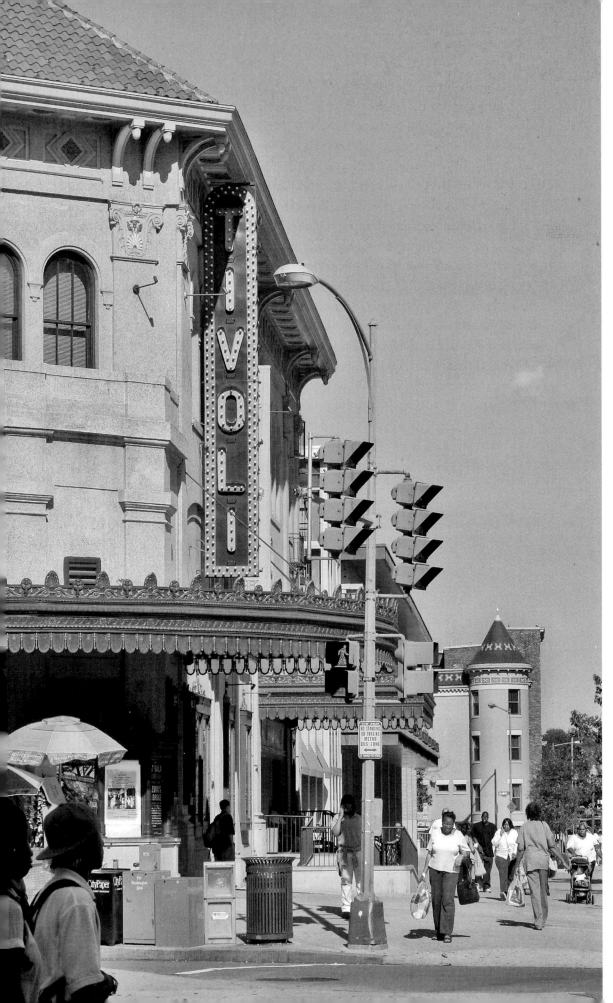

The restored 1920s Tivoli Theater at 14th Street and Park Road anchors a corner that has once again become a hub of commercial and social activity in Columbia Heights. The theater and the turreted Queen Anne row house typical of the 1880s seen here in the background remind residents of the neighborhood's history, as high-rise residential buildings and national brand stores sprout up around them. Photo by Rick Reinhard

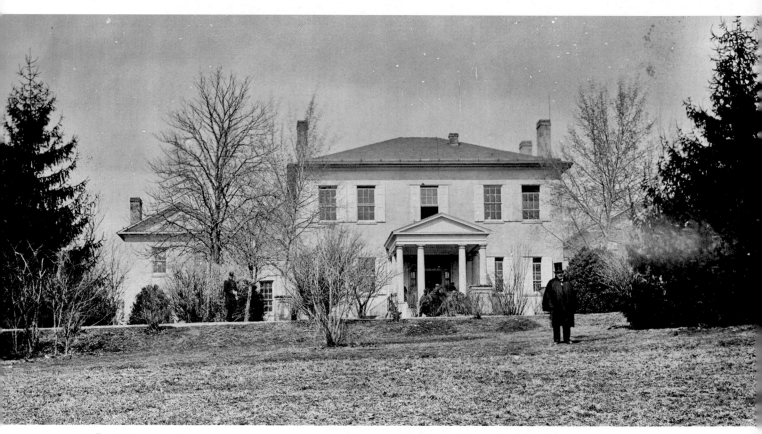

William J. Stone poses in front of his home on the rise above Boundary Street during the Civil War, when it was used, at his invitation, as a hospital. It would later be home to General John A. Logan and his wife, Mary, and, briefly, to presidential hopeful William Jennings Bryan. Torn down in 1925, the house was replaced by the Highview apartment building at 13th and Clifton streets. Courtesy National Archives

original forty-six-acre tract, sixteen acres on the south in 1867, and sixteen acres on the north in 1882. The old campus itself was divided in 1884. The grid of streets and several old street names from that early development, such as Euclid and Harvard, have survived.

The college occupied land once part of a thousand-acre estate known as Mount Pleasant, which lay south of Columbia Road. The estate had been consolidated and named in 1800 by Robert Peter, a Scottish immigrant and tobacco merchant who had served as the first mayor of Georgetown. The land north of Columbia Road had been granted to James Holmead by Charles Calvert, Lord Baltimore, in 1727, a patent named Pleasant Plains. Holmead's heirs sold this land in pieces throughout the 1800s. Today's Columbia Heights neighborhood includes parts of both of these large estates, with Columbia Road running east and west across its center.

In 1829 the *National Intelligencer* carried notice of an auction for the sale of part of the Mount Pleasant estate, including "the FARM of [Robert's son] George Peter, containing about *eighty-seven* acres, adjoining the Columbian College, on which there is a two story brick dwelling House, and a large thriving orchard of various fruits." That land was later purchased by William J. Stone for $50 an acre. Stone took up residence in George Peter's house, a Federal-style structure that stood at the cusp of the hill above Boundary Street across 14th Street from the college. Stone was an English immigrant, a

sculptor, and an engraver, whose trade brought him mixed national fame. He had made a copper facsimile of the Declaration of Independence for the Department of State. In doing so, he both preserved the image of that great document and caused the document itself to fade by unintentionally lifting off much of its ink.[2]

Stone worked his land with the help of fourteen enslaved people, according to the census of 1850. An early city map by Albert Boschke, compiled in the 1850s, shows a pond about where the 1100 block of Girard Street is today and a huge orchard on the hillside north of Boundary Street, both of which belonged to Stone. Stone's large house was used as a hospital during the Civil War.[3]

In 1881 John Sherman, a former senator from Ohio who had just completed a term as treasury secretary and was headed back to a seat in the Senate, became a major force in the area. He bought 121 acres between 11th and 14th streets, Boundary Street, and Park Road from Stone's widow, Elizabeth, for $200,000. Sherman laid out lots and streets, including an extension of 13th Street, which had ended at Boundary Street. He called his new subdivision Columbia Heights, taking inspiration from the college nearby.[4]

Senator Sherman was a lawyer by trade who at a young age had other successful business ventures, including a farm near Mansfield, Ohio. According to his biographer, Theodore Burton, Sherman left a fortune of over $2 million upon his death in 1900, "the result of careful and fortunate investments," the most profitable of which was Columbia Heights. His brother was Civil War luminary General William T. Sherman, after whom Sherman Avenue was named in 1867. The general had owned a large lot on 14th Street in Sherman's Subdivision, which was created by John Sherman in 1868.[5]

Stone's house, standing in the 1880s amidst the nascent Columbia Heights subdivision of large detached houses, was bought by Senator John A. Logan of Illinois, a champion of Civil War veterans and founder of what is now called Memorial Day. Logan had served in the House of Representatives and commanded the Army of the Tennessee in the Civil War and was the Republican Party nominee for vice president in 1884. After years of "great discomfort" living in Washington boardinghouses (due to the part-time nature of John Logan's government service), as Logan's wife, Mary, described it in her book of reminiscences, she convinced her husband to let her find a house they could purchase. The old Stone house had probably not been occupied for some years and was in dilapidated condition when the Logans purchased it. When General Logan died there in 1886, an honor guard was on duty in the house for two days. Mary Logan retained the house until well into the twentieth century, both residing in it and renting it out. From 1913 to 1915 her tenant was Secretary of State William Jennings Bryan, three-time candidate for president of the United States.[6]

Sherman's Columbia Heights subdivision would, over time, give its name to the greater neighborhood. This was no doubt due, in part, to the name's mellifluous ring. Lots in Columbia Heights were offered for sale through the real estate firm of A. L. Barber & Co. "Under the rapid growth of Washington," read their ad in the 1882 city directory, "this property will soon become the most desirable and fashionable part of

the city." In 1883 the firm's principal, Amzi L. Barber, purchased several large lots on the south side of Clifton Street for over $33,000, a huge sum at that time.[7]

Barber immediately set to work on a Queen Anne–style stone mansion that he called Belmont. The house was also set on top of the hill, between 13th and 14th streets, and its enormous turret could be seen from much of the city and greeted travelers as they entered Columbia Heights via 14th Street. Amzi Barber had headed the education department at Howard University before going into real estate and founding the suburb of LeDroit Park in 1873. Barber then entered the growing street paving industry, and by 1896, Barber Asphalt Paving Company advertisements claimed it had laid half of the asphalt pavement in the United States. Barber lived at Belmont until his death in 1909.[8]

Improved city services came to Columbia Heights in the 1890s when the U.S. Army Corps of Engineers, which oversaw the District's infrastructure at that time, brought water and sewer lines to Columbia Heights. Several neighborhood streets, including 14th Street, were paved in asphalt by private companies under contract with the city. The Washington & Georgetown Railroad Company changed its 14th Street line from horse-drawn service to cable in 1892, and then to electricity in 1898 after the cable powerhouse burned in 1897. At six miles per hour, the steady service opened up Columbia Heights to rapid and dense development.

Substantial brick row houses started to fill the large gaps between the smattering of detached houses. Despite an economic depression in the mid-1890s, 254 houses rose in Columbia Heights between 1893 and 1897, built mostly by developers who were moving beyond the old city. Real estate advertisements noted that the Columbia Heights subdivision was a "strictly three-story neighborhood," indicating its status as a prestigious residential enclave. The row houses exhibited the popular architectural styles of the time, including Romanesque Revival, Queen Anne, and Colonial Revival, and in the early twentieth century, Italian Renaissance and Spanish Revival.[9]

The new neighborhood attracted a remarkable number of Supreme Court justices, including Justice William R. Day for twenty years at 1301 Clifton Street and Justice John M. Harlan, at 14th and Euclid from 1887 until his death in 1911. Other prestigious residents included S. P. Langley, secretary of the Smithsonian; Director of the Bureau of Engraving and Printing William M. Meredith; Superintendent of Police Major Richard Sylvester; and District Commissioners John W. Ross and H. L. West, to name just a few.[10]

A promotional brochure published by the Columbia Heights Citizens Association presents a snapshot of the neighborhood in 1904. The brochure claimed its purpose was to "assist the [District] Commissioners by its recommendation of needed public improvements" and to inform "home-seekers of the desired class . . . of the facts commending the 'Heights' to favorable consideration." The association defined its territory as extending from Florida Avenue (the new name for Boundary Street) north to Spring Road and from Georgia Avenue west to 15th Street. Because 15th Street runs into 16th Street at Irving Street, it was implied that the boundary was 16th Street north of Irving. The area

west of 15th Street and south of Irving was part of the black, working-class Meridian Hill neighborhood. The all-white citizens association would later make 16th Street their explicit boundary and claim the area northward to Shepherd Street.[11]

The citizens association supported Senator John Sherman's original vision for the neighborhood, which was created, in part, by the covenants that Sherman placed in every property deed beginning in 1881. Such restrictions required "that when a building is erected upon the said lot herein described, it shall not be within thirty feet of the street line, nor shall it be used for manufacturing or mechanical purposes, nor shall spirituous liquor be sold therein." The thirty-foot setback created broad streetscapes, leaving room for greenery. The covenants also guaranteed the residential nature of Columbia Heights by forbidding other uses. Sherman's covenants made no mention of a prospective owner's race.[12]

The citizens association's 1904 brochure touted the area's high elevation, cooler temperatures, and soothing breezes. The brochure also claimed that Columbia Heights had the highest proportion of homeowners, as opposed to renters, in the District. "Nowhere in the District," the brochure emphasizes, "can be found a community freer from the objectionable classes than that on the 'Heights.'" This dubious claim may reveal the ultimate reason for the brochure. A boom was under way in the construction of row houses in Columbia Heights. The spatial, architectural, and social identity of the neighborhood was changing as the community was being swallowed by an expanding city. Eleventh Street was newly built, undeveloped, and up for grabs. Just to its east lay an area its residents called Pleasant Plains, the name inspired by the early estate on which it stood. It was a mixed-race community adjacent to Howard University on Georgia Avenue on the east, growing in size and prestige since its founding by the Freedmen's Bureau in 1867. The economic and racial status of Columbia Heights, and its property values, hinged, in part, the association believed, on the character of future development along 11th Street and the class and race of people it would attract.

One unquestionable claim put forth in the association's promotional brochure was that Columbia Heights was "unrivalled in street railway facilities." At the time, streetcar lines came up Georgia Avenue and 14th Street. The Mount Pleasant line came as far east as 16th Street at Columbia Road. Now the 11th Street line was being built with a terminus at Monroe Street. That meant there were four north-south lines going in and out in the space of just one mile, east to west. This made Columbia Heights even more convenient and desirable.[13]

Harry Wardman, an English immigrant who became Washington's famously prolific builder, was a major player in the Columbia Heights building boom. Wardman built and sold about seven hundred row houses in the neighborhood between 1906 and 1912. Most of these houses were in the Colonial Revival style and were at the forefront of the boom in front-porch row house construction in Washington. A concentration of these houses can be seen on the 1300 block of all the east-west streets between Monroe Street and Spring Road. In 1913 Wardman bought the late Amzi Barber's Belmont estate at

auction. Where Columbia Heights residents saw a welcoming community landmark in a parklike setting, Harry Wardman, a relentless builder, saw underused land ripe for profitable development. Neighbors united to save Belmont but were unsuccessful in raising the money necessary to preserve the ten-acre estate, despite the $1,000 that the beneficent Wardman himself offered to the cause. Neighbors also failed to convince the government to purchase Belmont for use as a public park and playground. The Belmont house came down in 1914, to be replaced by the five-story Wardman Court apartments, a development later known as Clifton Terrace. With 270 units in three buildings, Wardman Court was then the largest luxury apartment complex in the city. In 1925 William J. Stone's old estate house, at the northeast corner of 13th and Clifton streets, was replaced by the Highview apartments.[14]

Another significant building, however, found a new use — the 1892 streetcar garage at 3134 14th Street, which lost its purpose when the Washington & Georgetown Railroad Company extended its 14th Street line to Decatur Street in 1907. The building was visually striking, with a Richardsonian-style façade not unlike the car barn still standing at 36th and M streets in Georgetown. It became the neighborhood's market and recreation center, known as the Arcade. A city directory from 1930 lists two full-sized grocery stores, six small grocers, fourteen meat vendors, two poultry stands, two fish stalls, nine produce stands, eight dairy vendors, four delicatessens, and four baked goods stalls in the building. In addition, the Arcade housed a billiard hall, bowling alley, and a large auditorium/gymnasium area that hosted boxing, tennis, track meets, and dancing. The city's first professional basketball team, the Washington Palace 5, made the Arcade its home from 1925 to 1928, perhaps taking its name from the imposing façade of its home court. The building remained a neighborhood landmark until it was razed in 1947.[15]

In 1922 Riggs Bank hired local architect George N. Ray to design new branch bank buildings in Dupont Circle and Columbia Heights. These buildings were modeled after the Riggs headquarters on Pennsylvania Avenue across from the Treasury and were among the first branch banks in Washington. Before the insuring of bank accounts by the Federal Deposit Insurance Corporation, and before citizens were generally familiar with branch banking, Riggs needed to make a statement about the integrity of its new branches and did so with fine architecture. Riggs also needed these first branches to be successful; Riggs's choice of Columbia Heights was a reflection of the neighborhood's social and economic status. When the bank opened on the northwest corner of 14th Street and Park Road, it featured shops along the street level and commercial office space on the upper floors. The Riggs Bank building was the first home of WRC, Washington's second and currently its oldest radio station. Twin radio transmitting towers, a hundred feet high, sat atop the building until 1950.

The Tivoli Theater was built in 1924 directly east across 14th Street from the bank by Harry Crandall, then the leading theater operator in the Washington area. With 2,500 seats, the Tivoli was Crandall's largest and finest effort. It featured not just movies but also ballet, orchestral concerts, and stage shows. Inside its stuccoed, Italian Renais-

sance façade, the Tivoli had a huge dome with a magnificent chandelier, an orchestra pit that rose on an elevator to stage level, and a giant Wurlitzer organ, also on an elevator, which was the largest and most expensive south of New York. The Tivoli was designed by Thomas White Lamb, a Scot who was America's leading architect of motion picture palaces. It was one of the few of its class to be built outside of a downtown area anywhere in the country at the time.[16]

Completion of the Riggs Bank and the Tivoli Theater in 1924 marked the end of major development in the community, as practically all buildable lots were occupied. They also ensured Columbia Heights's role as a first-class commercial center. In the days before shopping malls, the 14th Street commercial strip drew shoppers from across the District but particularly from nearby neighborhoods such as Petworth and Mount Pleasant. All manner of goods, services, recreation, and entertainment were available.

In 1927 a young Mormon couple from Utah drove their Model T Ford across the country to fulfill their American dream in the nation's capital. Newlyweds J. Willard and Alice Sheets Marriott purchased the A&W Root Beer franchise for the Washington region and set up shop on the bustling commercial strip in Columbia Heights. That first Marriott business was located at 3128-B 14th Street. The Marriotts quickly moved into serving innovative, slightly spicy Mexican food, and the Hot Shoppe was born. In time there were sixty-five Hot Shoppes in eleven states. The Marriotts became pioneers in the food service industry; theirs was the first company to cater airline flights. In 1957 they opened their first hotel, the Twin Bridges Motor Hotel in Arlington, Virginia, near National Airport. When Alice Marriott died in 2000, the root beer shop had evolved into a global corporation that included five separate companies with combined annual sales of more than $20 billion.[17]

The early years of the twentieth century had brought an exodus of African Americans from their modest frame houses in the Meridian Hill subdivision around 16th Street. The half-dozen or so black professional families scattered around the old Mount Pleasant neighborhood also left at that time. In the wake of the Supreme Court's *Plessy v. Ferguson* decision in 1896, Jim Crow racial separation was setting in across the South and in Washington. Developers, who were buying up properties and furiously building row houses throughout the neighborhood at this time, now routinely placed racially restrictive covenants in the deeds for properties west of 13th Street. Such covenants stipulated that "said lot shall never be rented, leased, sold, transferred or conveyed unto any Negro or colored person" and were routinely applied by many developers throughout Northwest Washington. Thirteenth Street thereby became a dividing line between a white section to the west and a mixed-race section to the east.[18]

During the formative years of his career, Edward Kennedy "Duke" Ellington lived at 2728 Sherman Avenue. Ellington had grown up at 1805 and 1816 13th Street just south of U Street in Shaw. In 1918 he married Edna Thompson and they moved to Sherman Avenue about a year later, shortly after the birth of their son Mercer. Ellington was only twenty when he bought the house, which was listed in the 1919 telephone directory as

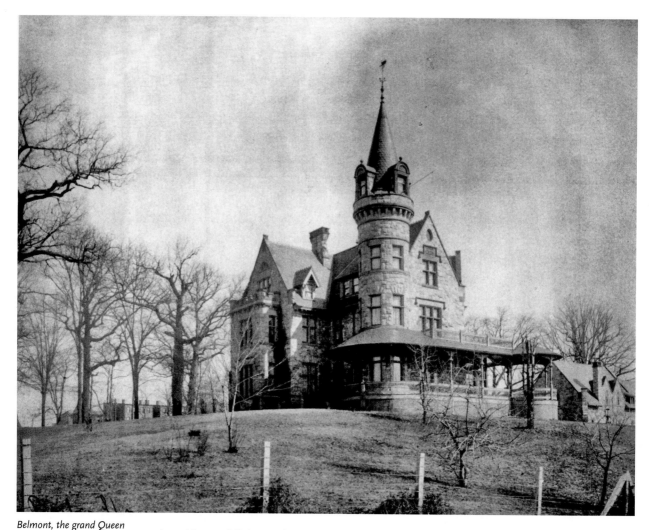

Belmont, the grand Queen Anne home of Amzi Barber seen here in the 1890s, stood sentinel on the top of the hill between 13th and 14th streets for decades. Barber, a major figure in the development of Columbia Heights, owned a nationally known paving business that led many to refer to him as America's Asphalt King. Photo by Frances Benjamin Johnston. Courtesy Library of Congress

the address of "The Duke's Serenaders, Colored Syncopaters, Irresistible Jass Furnished to our Select Patrons, E. K. Ellington, Mgr." Ellington kept several bands busy with his bookings, playing in nightclubs on fashionable U Street and more rough-and-tumble places like 7th Street, as well as for social events in Virginia's horse country. Shortly after Ellington left Sherman Avenue in 1922, he began his professional move to Harlem, but the modest brick row house on Sherman Avenue represents pivotal years spent by America's great composer, performer, and musical diplomat in his hometown of Washington.[19]

In the 1920s, as automobile-oriented development began to open up new, often racially restricted subdivisions around the northern perimeter of the city in the District and Maryland, many white families left Columbia Heights and other urban neighborhoods for newer housing. At the same time, black families were arriving in the city from across the South and settling in those older, urban neighborhoods. The homes east of 13th Street in Columbia Heights, lacking restrictive covenants, were open to them. At the same time, professors and administrators of Howard University, as well as other dis-

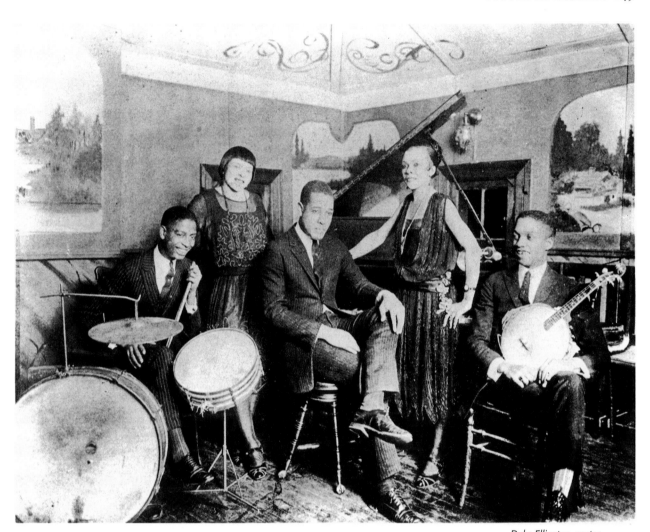

Edward Kennedy "Duke" Ellington placed this ad for his services while living at 2728 Sherman Avenue in Columbia Heights about 1920. Courtesy The Historical Society of Washington, D.C.

Duke Ellington, center, poses with his band at Louis Thomas's Cabaret at 9th and R streets about 1920. Courtesy Duke Ellington Collection, Archives Center, National Museum of American History, Behring Center, Smithsonian Institution

tinguished African Americans moved into the area, including Dr. Montague Cobb of the Howard Medical School; Dr. Paul P. Cooke, president of Minor Teachers College; and Dr. Charles Drew, who pioneered research on blood plasma. By the 1940s the area east of 13th Street was predominantly and increasingly African American.

The African Americans who moved westward into Columbia Heights brought with them the all-black Pleasant Plains Civic Association, and the name Pleasant Plains became associated with the area east of 13th Street. The association also reached across white Columbia Heights to include the remains of the black neighborhood of Me-

Abandoned in 1907, a huge 1892 streetcar garage at 3134 14th Street found new life as the Arcade, a bustling center of commercial and recreational action. The Arcade offered two full-scale grocery stores, fourteen butchers, nine produce dealers, and many other food vendors as well as a gymnasium/auditorium for sports events and dancing. This advertisement appeared in the 1924 Book of Washington. Courtesy collection of Wes Ponder

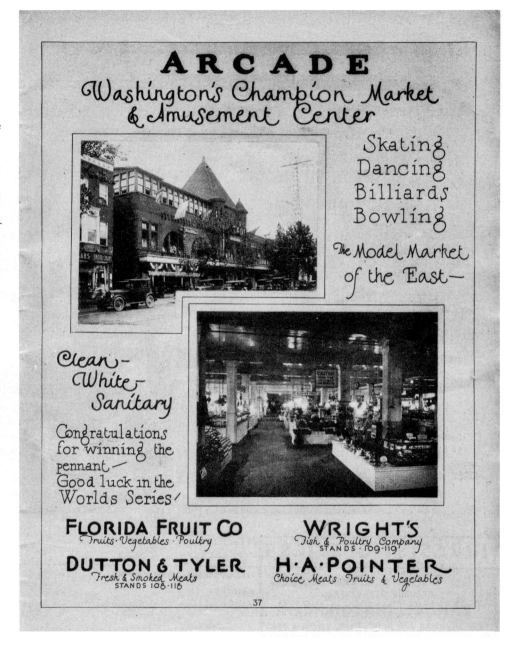

ridian Hill between 15th and 16th streets. Thus the segregation that was so prevalent throughout the country at that time created a dual neighborhood identity in Columbia Heights.

In 1941 Frederick F. and Mary Gibson Hundley, two African American public school teachers, bought a house at 2530 13th Street. Mary Hundley was a descendent of William Syphax, who founded the first colored high school in Washington in 1870. The Hundleys' house on the west side of 13th Street had a racially restrictive covenant in the deed. They were sued by two neighbors, but the U.S. Court of Appeals for the District

of Columbia ruled that the covenant was unenforceable because of the racial change that the neighborhood had undergone since the covenant was initiated in 1910. In 1948 the U. S. Supreme Court decided in *Hurd v. Hodge* that racially restrictive covenants in deeds were unenforceable, and the Hundley case was cited as precedent.[20]

The result was immediate. By 1950 many black families had moved across 13th Street into the west side of Columbia Heights, and white families stepped up their migration to newer suburban neighborhoods. The *Brown v. Board of Education* Supreme Court decision that desegregated schools in 1954 hastened the trend. Many wealthier black families took advantage of the new opportunity to live in previously restricted neighborhoods by moving farther uptown to neighborhoods such as Shepherd Park.

A watershed event in the demographic evolution of Columbia Heights was the dissolution of Central High School. For twenty-five years Central had been the crown jewel of Washington's white school system. The grand Collegiate Gothic building, designed by nationally prominent school architect William Ittner, had opened in 1916. But by the 1940s, with newer schools opening farther uptown and the area around the school increasingly populated by African Americans, Central's enrollment was less than half its capacity of 2,500.

Meanwhile, Cardozo, the business high school in the colored division of the public schools, as it was then known, was running well over capacity in an aging building at Rhode Island Avenue and 8th Street, N W. Civic leaders, led by Rev. Stephen Spottswood, president of both the Washington chapter of the NAACP and of the United Citizens Association, saw a solution for Cardozo. In December 1949 they placed a full-page ad in the *Washington Post* with the banner "CENTRAL for CARDOZO," insisting that "All the Cardozo High School students should be transferred to the Central High School building immediately!!!" That school year became Central's last. Columbia Heights no longer had a white high school, further incentive for whites to leave the neighborhood. Cardozo remains in the imposing structure at 13th and Clifton streets.[21]

In the 1950s the whole of Columbia Heights became a solidly African American neighborhood. Fourteenth Street rivaled U Street as black Washington's place to be. The clientele of the 14th Street stores changed, but the variety, jewelry, clothing, and drugstores remained. Many white-owned family businesses stayed and embraced their new customers, and many black-owned businesses moved in. There were few vacancies on the long commercial strip. Area businesses collectively placed ads in the *Washington Afro-American* newspaper, declaring "Upper 14th Street" to be "Washington's most convenient Shopping Center." Stores were "Open Every Nite 'Til 9." The Savoy and Tivoli theaters kept the community entertained, and at night 14th Street between Columbia Road and Irving Street was one of the busiest blocks in town.[22]

While the commercial area prospered, the residential area was increasingly suffering the social challenges common to densely populated inner cities at the time. University Place led the city in crime in the mid-1960s. In 1964 the community became the focus of an experimental program of the new Office of Economic Opportunity designed to al-

The grand Classical style of the Riggs Branch Bank (now PNC), built in 1922 at 14th Street and Park Road, was designed to inspire confidence in the new idea of branch banking. This photograph, taken in the 1930s, includes the transmitting tower of WRC radio, headquartered in the building. Courtesy Library of Congress

leviate poverty through innovative approaches to education, with Cardozo High School as its centerpiece. Columbia Heights now became widely known as Cardozo. The names Pleasant Plains and Columbia Heights seemed to drop out of the lexicon. A leader in working for positive change to the community, particularly during the turbulent 1960s, was All Souls Unitarian Church, at 16th and Harvard streets. The congregation was led by Dr. Duncan Howlett, who, among other positions, served on the D.C. Commissioners' Youth Council, the D.C. Crime Council, and the Washington Home Rule Committee. In 1963 he was named "one of the five most trusted white men" in the city by the *Afro-American*. All Souls Unitarian Church initiated the Girard Street Project in 1962, which established a credit union, tutored children, and set up a playground and a block

party. The project became a national model for private citizens addressing social problems.[23]

However, the neighborhood would suffer an enormous shock on Thursday, April 4, 1968, when civil disturbances rocked Washington and other large cities for days in response to the assassination of Rev. Dr. Martin Luther King Jr. Destruction was widespread and particularly intense around African American-oriented shopping districts such as H Street, NE, and 7th Street, NW, downtown. The hardest hit area was 14th Street in Columbia Heights, which saw $6.6 million in structural damage, half of all the destruction done in the city.[24]

Rioting began Thursday night, and by midnight police had gained control of the area around 14th and U streets. But up the hill in Columbia Heights, crowds grew, display windows were smashed, and stores were looted. It was 3:00 a.m. Friday before the last large-scale confrontation between police and rioters ended. Rioting erupted again Friday morning; two teenaged boys burned to death inside the G. C. Murphy variety store at 3128 14th Street. In the city as a whole, more than 1,200 buildings burned, 7,600 people were arrested, and property damage was estimated at $24.7 million.[25]

Nearly all of the businesses on 14th Street sustained some damage, and many were unsalvageable. Some shop owners struggled to reopen, only to find that they could not continue because 14th Street was no longer a destination shopping area. Others never could because of insufficient insurance and unfulfilled city government promises of relief. The 1967 *Polk's Washington City Directory* listed more than two hundred businesses along 14th Street between Florida Avenue and Newton Street; in 1970 there were about a hundred, and in 1980 only thirty-five.

In early 1970 the city enacted the Cardozo Urban Renewal Plan to rebuild 14th Street, using the Cardozo name initiated by the recent antipoverty program and identifying a target area that ran from Florida Avenue to Spring Street and from 11th to 16th Street. Under the plan, the city's Redevelopment Land Agency bought up much of the land in the vicinity of 14th Street and bulldozed seventy acres, but its attempt to attract developers failed. The Savoy Theater at 3030 14th Street, which burned in the riots, was razed in 1971. In the early 1970s the Hines funeral home, a longtime 14th Street fixture, moved to a new location in Silver Spring. The Tivoli Theater closed in 1976. In 1982 the Riggs Bank building was threatened with demolition, but citizen action put it on the National Register of Historic Places and paved the way for its renovation with 150 new apartments.[26]

The global business enterprises of the Marriott Corporation began with a root beer stand at 3128B 14th Street, set up in 1927 by J. Willard and Alice Sheets Marriott, new in the city from Utah. By the end of that year they were featuring spicy Mexican food and had changed the name of their business to the Hot Shoppe. © Marriott Photographic Services

This soda fountain at Smith's Pharmacy, 2518 14th Street, owned and operated by Larry Rosen, was among scores of businesses on that street destroyed in the riots that followed the assassination of Rev. Dr. Martin Luther King Jr. in April 1968. Courtesy Larry Rosen

In the 1970s Columbia Heights was a neighborhood flat on its back. At its heart, the 14th Street corridor was becoming a sort of urban desert of vacant lots and boarded storefronts. It was at that time that two distinct new groups began a migration into the neighborhood. Immigrants, largely fleeing wars in Latin America, and professionals, mostly young and white, came for the same reason: beautiful, sturdy, old houses were selling at very low prices. Many Latino families purchased houses in Columbia Heights after saving money by living in crowded apartments in Adams Morgan and areas along 16th Street. In 1974 the Latin American Youth Center opened to provide services to area residents. The center, now at 1419 Columbia Road, offered, among other programs, arts and recreation, employment and family services, and health and physical education classes. Other service agencies serving Latinos clustered nearby. The Latino population continued to rise, by the year 2000 ranging from 24 to 33 percent of the total in census tracts 36 and 37 respectively (Florida Avenue to Irving Street and 11th to 16th streets) and reaching a high of 51 percent in census tract 28.02 (Irving to Newton and 14th to 16th streets).[27]

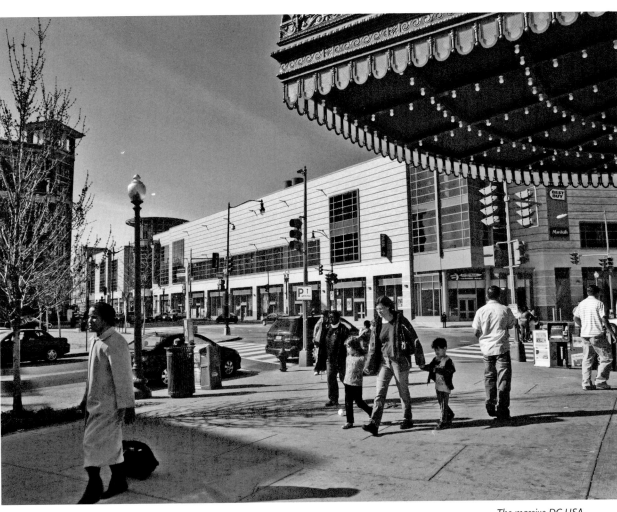

The massive DC USA complex, with 500,000 square feet of national retail shopping, along with adjacent offices and condominiums, brought dramatic change to the corner of 14th Street and Park Road in 2007-8. The ornate canopy of the 1922 Tivoli Theater, at the right, speaks to the area's earlier prosperity. Photo by Kathryn S. Smith

The last decades of the twentieth century also saw a shift in the name of the neighborhood itself. A new community development organization settled into 14th Street in the mid-1980s to encourage business development. Calling itself the Development Corporation of Columbia Heights, it reclaimed the neighborhood's historic name. The name Cardozo eventually disappeared except for scattered references, such as on the U Street Metrorail station.

When a wave of gentrification hit the city in the late 1990s, Columbia Heights was ripe for change once more. Redevelopment in Columbia Heights had been slow and spotty until the strong economy of the late 1990s spurred a burst of real estate transfers, led by young professionals seeking an urban lifestyle and an end to arduous commutes. The opening of the Columbia Heights Metrorail station at 14th and Irving streets in 1999 fueled the interest of developers. The neighborhood's historic center at 14th and Park Road, just one block north of the new subway stop, became symbolic of similar changes across the city. The restored Tivoli Theater, with the GALA Hispanic Theatre tucked under its grand dome and shops and offices below, opened in 2005, and cranes

rose in a dramatic arc around it, building new offices and condos and a shopping center that would bring national retailers to 14th and Irving just to the south. This crossroads has become a citywide shopping destination once again. Tension is accompanying gentrification, however, as longtime owners are seeing a rise in property taxes, and many are deciding it is time to sell and move elsewhere. Some renters are being priced out of apartments as buildings are renovated for the new housing market. Along with new apartment construction, these forces are changing the racial and economic composition of the neighborhood once again.

Thus this neighborhood, once with four streetcar lines running through it, has become not only a place for traffic to move through but also a convenient place for people of all kinds to settle in and then move through as well. From elite outpost on a hill, to streetcar suburb, to inner city neighborhood — home to white and black and Latino and others from around the nation and the world — the neighborhood is once again becoming an upscale address. Nothing has been more certain about the history of Columbia Heights, and perhaps its future, than change.

Deanwood

SELF-RELIANCE AT THE EASTERN POINT

RUTH ANN OVERBECK AND KIA CHATMON

Deanwood, located at the eastern edge of the District of Columbia, is one of Washington's oldest African American communities. Many of the families who live in the neighborhood have called it home for generations. Their presence has contributed to the neighborhood's stability and small-town feel. Homes have been passed from parents to children and sometimes to grandchildren. In Deanwood, it is not uncommon for someone to have the same neighbor for decades, a rare occurrence in a transient place such as the District.[1]

This tradition began to take root as early as 1910, when a stable nucleus of blue- and white-collar black families, with a network of laborers and skilled craftsmen working in the building trades, began to call Deanwood home. Many of these individuals were entrepreneurs. Their strong sense of economic independence and self-reliance has come to characterize Deanwood's black community for more than a hundred years.

The neighborhood is tucked just inside the city's eastern border and, according to the Deanwood Citizens Association, is bounded by the CSX railroad tracks on the west, Eastern Avenue on the northeast, Division Avenue on the east, and Nannie Helen Burroughs Avenue on the south. Longtime residents recognize a much larger triangular area with a southern boundary at East Capitol Street. The neighborhood historically encompasses three nineteenth-century suburbs platted from farmland in 1871 when the Southern Maryland Railroad cut through the area. It was born when the three daughters of Levi Sheriff, a white farm owner and merchant, divided the farm they inherited from their father. A series of subdivisions resulted: some black, some white, and some mixed, and all loosely tied after 1888 by the name Deanwood.

The Benning-Sheriff-Lowrie-Deane and Fowler farms, both carved from a 1703 land grant to Ninian Beall, undergird Deanwood's history. The Piney and Watts branches of the Eastern Branch (today's Anacostia River) crossed their land from east to west. The broad valleys they created left a high ridge near springs and provided a natural setting for

The area in the triangle above Nannie Helen Burroughs Avenue, is the neighborhood served by the Deanwood Citizens Association. Residents who have lived in the neighborhood for a long time think of Deanwood as being much larger, including the entire triangle north of East Capitol Street. This larger definition would include two early Deanwood developments—Burrville and Lincoln Heights. Map by Larry A. Bowring.

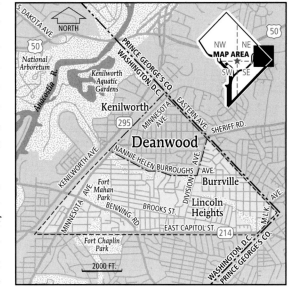

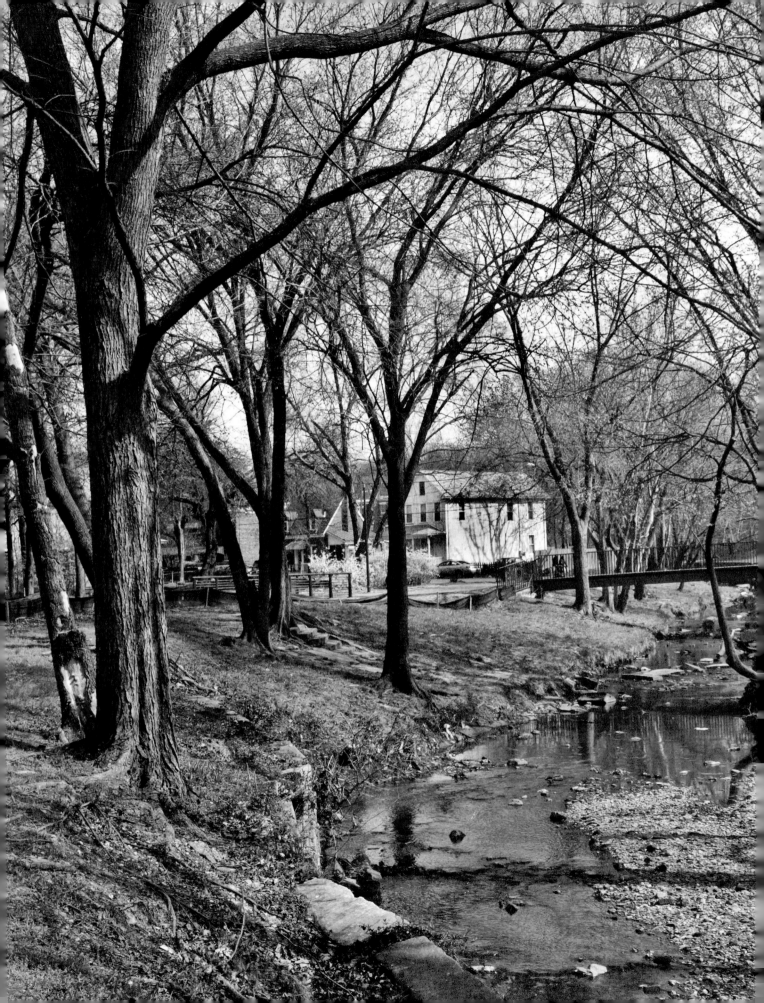

houses. The meadows that flanked the streams proved ideal for agriculture. During the mid-1700s a north-south road cut across the branches to link Bladensburg, Maryland, on the Eastern Branch to Piscataway, Maryland, the nearest important Potomac River port. The portion of Minnesota Avenue that is in Deanwood today follows approximately the same route.

The late eighteenth-century house that sat for some 125 years on the ridge above approximately today's 50th and Hayes streets, NE, was built for white farmer and slave owner William Benning around 1790, soon after he acquired 330 acres of Beall farmland. In 1823 he would purchase and in 1830 rebuild a wooden bridge to the area dating to about 1800, an Anacostia River crossing that carries his name today. Benning's nephew, Anthony, purchased the land after his uncle's death and in turn sold the farm in 1833 to Levi Sheriff. Sheriff, twice a widower, amassed 524 acres and retired to the farm. James H. Fowler, another white farmer, bought 83¼ acres that lay between the District of Columbia's eastern boundary and Sheriff's farm in 1838. Like Sheriff, Fowler depended upon the labor of enslaved people, although his operation was more modest. Both raised hogs and cattle and had fruit orchards and fields of corn, rye, hay, and vegetables. Sheriff also grew tobacco.[2]

In 1850 Levi Sheriff owned nineteen enslaved persons. Although the names of these individuals are unknown, Sheriff family records in private hands provide some insight into their daily lives. Supervised by a white overseer, the unpaid workers included laborers in the fields as well as a cook, who prepared the same food for the Sheriffs as she did for her family, and a man who was responsible for cutting wood, providing water, and caring for the riding horse and carriage. These workers and others had living quarters on the farm, distant from one another as well as from the main house. They maintained the gardens with raspberries and fruit trees and raised chickens and pigs for their own use. Some owned guns and hunted to supplement their produce. Sheriff provided allowances of meal, bacon, and fish and gave each hand "cash money" at the end of harvest.[3]

Sheriff's grandson, Randolph Lowrie, described the family cook, Harriet Watkins, as a "woman of great dignity," according to family records. She was tall and gaunt, wore a man's hat, used a very tall cane, and kept a corncob pipe in her mouth. Her cooking repertoire included cabbage stalk, pork skin, and skillet bread, and "better persimmon beer than anyone else could make." She could find the earliest poke leaves and the last chestnuts. Harriet Watkins was freed in 1862 under the D.C. Emancipation Act and was buried on the Sheriff's farm in 1864, with Levi's daughter, Margaret Lowrie, and her son Randolph in attendance.[4]

Levi Sheriff died in 1853 and left the farm to his three daughters, Emmeline, Margaret Lowrie, and Mary Cornelia Dean, who already lived there in separate houses. Emmeline, who was unmarried, suffered from tuberculosis; Margaret Lowrie, a widow, headed a household of two sons and two invalid daughters; and Mary Cornelia lived with her husband, John T. W. Dean, and son Julian.[5]

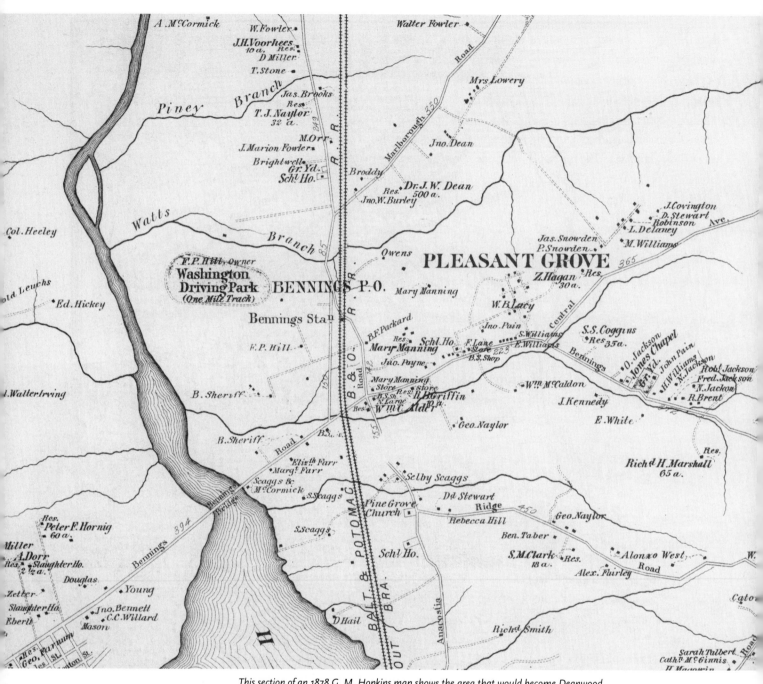

This section of an 1878 G. M. Hopkins map shows the area that would become Deanwood.
Property owned by the Fowler, Lowery (also spelled Lowrie), and Dean (also spelled Deane) families
is indicated along the Marlborough Road (now Sheriff Road) at the top center. Benning's Track
appears here as the Washington Driving Park. The name Pleasant Grove did not persist.
Courtesy Library of Congress

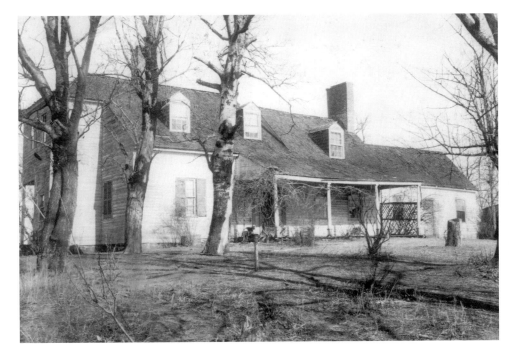

Built on a high ridge overlooking today's 50th and Hayes streets, this farmhouse was home to William Benning, after whom the Benning Bridge is named, and several generations of the Sheriff-Lowrie-Deane family. This photograph was taken in 1917, six years after the last family member had moved out. Courtesy Charles E. Kern II

The Civil War marked the beginning of the farm's decline. With the nearby Benning Bridge as an entry point, it is likely that Deanwood benefited from the influx of contrabands — a name given to enslaved blacks who sought refuge in Union territory. White soldiers, possibly aided by contrabands, cleared the woodlands to provide nearby forts, such as Fort Mahan, with unobstructed views of the area. The tree removal proved to be a boon to nearby black Methodists who sought to establish their own church, after losing access to their place of worship. They were locked out of the Benning Road building they used by Selby Scaggs, a white minister and slave owner, after he overheard their pro-Union prayers. However, their prayers were answered when John Dean, Mary Cornelia's husband, allowed them to build the new chapel with Sheriff farm trees felled to clear the view.[6]

Its fields put to use in the defenses of Washington, the Sheriff farm never recovered after the war. Emmeline's health and the health of the Lowrie daughters deteriorated; two Sheriff grandsons chose medicine over farming; and Randolph Lowrie entered the Episcopal priesthood. With their enslaved workers freed and the next generation unlikely to be farmers, Sheriff's daughters must have welcomed the Southern Maryland Railroad Company's arrival. In 1871 the company laid a track close to the old Bladensburg-Piscataway Road on its way to a Potomac River wharf at Marbury Point (now Shepherd's Point) and built a station near the farm. Almost immediately Margaret Lowrie, Emmeline Sheriff, and Mary Cornelia Dean mapped out three subdivisions. Whittingham, a triangular parcel, was bounded by railroad tracks on the west, Sheriff Road on the south, and present-day 45th Street on the east. A subdivision named Lincoln (now Lincoln Heights), apparently meant from the outset to be black owned, was platted near

the farm's south edge. Burrville, just east of the ridge, a name that continues today, completed the trio.[7]

Land sales did not go well. Home buyers in the 1870s could choose from new suburbs as far from downtown Washington as Falls Church, Virginia, or as close in as LeDroit Park, near Boundary Street (now Florida Avenue) in the District. Major civic improvements were under way in central Washington across the Eastern Branch. Whittingham, Lincoln, and Burrville had only the railroad. One lone purchaser paid $50 for two Whittingham lots in 1873. No other buyer appeared until 1874, when the Sheriff heirs traded all of Whittingham for two lots in Washington City with frame houses on them. A black minister, Rev. John H. W. Burley, acquired Whittingham and renamed it Burley's Subdivision but kept the original subdivision's street names. Burley lived in Northwest Washington from 1873 to 1879, while he served as the national secretary for the African Methodist Episcopal Church.[8]

While Sheriff's death and the Civil War marked the beginning of the farm's decline, it offered opportunity to African American families. According to the U.S. Census of 1880, there was a handful of non-farmers living with their families on Sheriff farmland. They included Levi Sheriff's grandson, Dr. Julian Willis Dean, a white physician; Charles Diggs, a black laborer at a brickyard; Jerry Smallwood, a mulatto brick-molder; and a black Methodist minister, Robert Charles.

Black residents began to establish a sense of community by creating institutions that met their needs. Recognizing the importance of education and religion, they began with churches and schools. In 1885 Contee African Methodist Episcopal Zion Church rose on Division Avenue, and in 1886 the church organized Burrville School on a tract of land bounded by Grant Street, Eastern Avenue, Division Avenue, and 56th Street. Burrville School was the first school building constructed in Deanwood and the first school to serve its African American children. White children in the area attended the Benning School, built in 1893 on Anacostia Road in the village of Benning, a small settlement near the eastern end of the Benning Bridge.[9]

Around 1888 Dr. Dean added an *e* to his name and initiated the place name Deanewood for a new development he planned. The *e* later was dropped by common usage. He mortgaged real estate to fund his project and built about twenty houses. At the same time he poured money into Benjamin Charles Pole's "energizer," a perpetual-motion machine that supposedly could use momentum as a source of power. Pole moved his family into one of Deane's houses and moved his experiments into a shop that Deane built for him. Pole's experiment failed and Deane went bankrupt. In 1895 Deane's real estate was sold at public auction. A Baltimore resident bought fifty-seven acres and about thirty buildings for $18,000, including three Sheriff-Lowrie-Deane family dwellings. Margaret and her son Randolph Lowrie retained ownership of the rest of the estate and the 1790s farmhouse. Dr. Deane died there in 1905; Randolph Lowrie's death in 1913 marked the end of the farm.[10]

Deanwood grew slowly in the late nineteenth and early twentieth centuries. By 1893 a few houses dotted each subdivision and the lots along Sheriff Road. Five families lived in Burley's Subdivision, where all the lots had changed hands since 1874. Two men named William Saunders — one black and one white — headed households within two doors of each other. Their buildings were similar in size, material, and cost. As their living arrangements suggest, blacks and whites lived as neighbors in Deanwood, a Southern residential pattern that persisted to a diminishing degree in the area until the 1930s, long after housing in most of the District of Columbia had become heavily segregated. From the beginning, however, there was clustering by race in the Deanwood subdivisions; some blocks were black, some white, and some mixed.

African American residents were quick to develop faith communities, including the First Baptist Church of Deanwood (1901), Zion Baptist Church (1908), Tabernacle Baptist Church (1911), Randall Memorial United Methodist Church (1912), and Antioch Baptist Church (1924). Deanwood's first Catholic church, the Church of the Incarnation, opened its doors in 1912.[11]

As Deanwood's African American community grew, so did the need for a public school. Finally heeding requests by residents, the D.C. Board of Education opened Deanwood's first public school in 1909. Designed by the municipal architect, Snowden Ashford, Deanwood Elementary School on Whittingham Place (now 45th Street) was a four-room schoolhouse built of stucco and brick. Black children from nearby Maryland

Julian Willis Deane held extensive land in the area that would take his name and become Deanwood. He invested heavily in the efforts of Benjamin Charles Pole to create a perpetual motion machine, a passion that ended in Deane's bankruptcy and led to the end of the family farm. Courtesy Charles E. Kern II

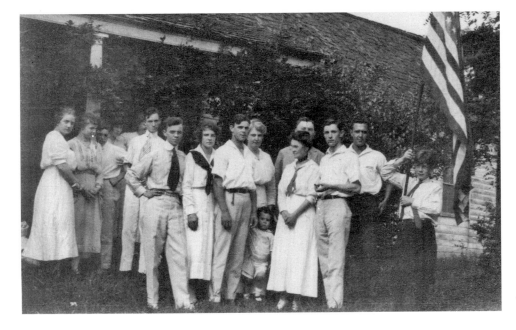

Descendants of the Deane-Kern family gather at the family homestead in 1917. Courtesy Charles E. Kern II

communities had no school and crossed the District line to attend. Expanded several times and renamed George Washington Carver School in 1945, it would become the IDEA Public Charter School in 1999.[12]

As the Deanwood School opened in 1909, Nannie Helen Burroughs was establishing the National Training School for Women and Girls in the Lincoln section. Burroughs, a clubwoman, activist, and lecturer, born in Virginia and educated in Washington, founded the school on behalf of the National Baptist Convention. Her program offered training in missionary work and domestic service, as well as an industrial curriculum that prepared women for nontraditional female employment such as printing, barbering, and shoe repair. By June 1910 the school had eight teachers, and its students came from as far away as Louisiana. In its first twenty-five years, more than two thousand women from across the United States, Africa, and the Caribbean enrolled at the high school and junior college levels. In 1964 the institution was renamed the Nannie Helen Burroughs School; it continues as a private elementary school, under the auspices of the Progressive National Baptist Convention.[13]

Most Deanwood adults enumerated in the 1910 federal census were U.S. citizens but not native Washingtonians. Many originated from Maryland and Virginia and had a mixture of white- and blue-collar jobs with a range of status, skill, and income levels. Some worked as laborers for the Navy Yard, the railroad, or the federal government. Others came from as far away as Kentucky to work at the Benning's Track, a horse-racing establishment just across the railroad tracks along the Anacostia River, the site of today's Mayfair Mansions. Maxwell Smart, one of America's most successful horse trainers, came to Washington from Columbia, South Carolina, moved to Sheriff Road in Deanwood, and worked at the track, where he became known as a skillful conditioner of young horses.[14]

One sizable trade represented in Deanwood had both black and white members — the unskilled laborers and skilled craftsmen who built Deanwood's houses. Black members of this network passed their skills on to family members or neighbors and also collaborated with whites. They helped one another locate jobs, build their own houses or additions to them, and make repairs. Thomas H. Stokes is an excellent example of this effective networking system. He was described in the federal census as a mulatto from Virginia who worked at the Government Printing Office and lived in Northwest. In 1907 Stokes put together an unusual team to develop a lot he bought in Deanwood. He chose architect W. Sidney Pittman to design his home and Owen H. Fowler to build it. Pittman, the son-in-law of Booker T. Washington, received his degree in architecture from the Drexel Institute in Philadelphia in 1900 and was one of the earliest academically trained architects to design a Deanwood building. Fowler, a white attorney, real estate broker, and builder, was a descendant of the old Fowler farm family. Fowler, in turn, engaged Stokes as the builder for about half of the projects he undertook between 1907 and 1915. Other white investors such as Gusack & Cohen and Joseph L. Tepper also employed Stokes as their builder.[15]

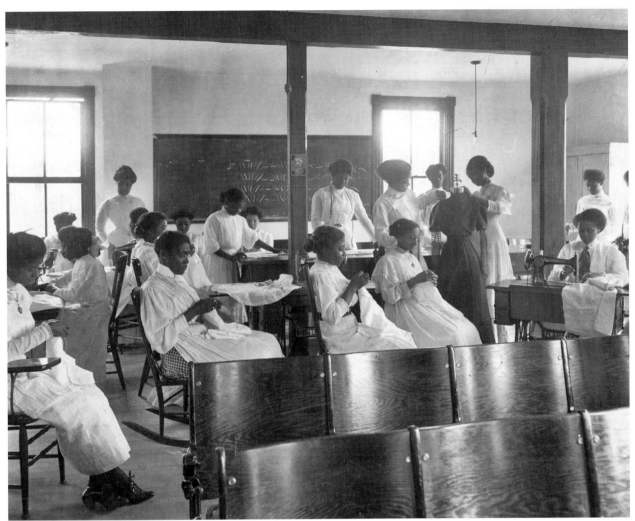

Girls practice sewing techniques at the National Training School for Women and Girls in the Lincoln section of Deanwood. Founded by Nannie Helen Burroughs on behalf of the National Baptist Convention in 1909, the school taught domestic science as well as industrial skills that prepared women for nontraditional roles such as printing and shoe repair. Courtesy Library of Congress

Two African American brothers from Deanwood, Jacob and Randolph Dodd, were also prominent craftsmen. Between 1921 and 1930, they built more than fifty houses, with Jacob serving as builder on about a third of them and Randolph on the rest. Many are still standing: 719–721 Division Avenue (Jacob Dodd); 4621, 4623, 4643–4647 Hunt Place (Jacob Dodd); 5020 Meade Street (Randolph Dodd's residence); and 1017, 1023–1027, 1031, 1035, and 1045 49th Street (Randolph Dodd).[16]

Randolph Dodd hired as many local black craftsmen and laborers as he could and provided on-the-job training as needed. His insistence on performance earned him a lasting reputation as the man who did more for Deanwood's building craftsmen than anyone else. He and his crews took pride in producing one house each week at a very low cost despite the fact that their approach was labor intensive. Due to the racism of the time, black contractors and builders had difficulty obtaining lines of credit. As a result, the Dodd brothers avoided the price of ready-to-install window frames and sashes by buying bundles of framing and sash pieces they could put together themselves. They also

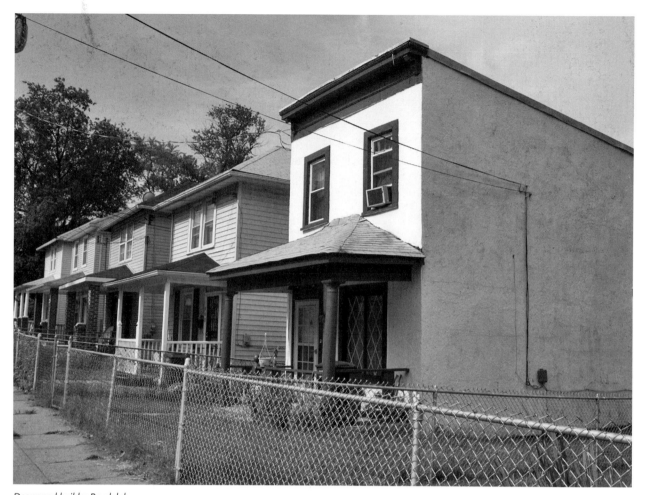

Deanwood builder Randolph Dodd constructed these modest houses to the design of Lewis Giles Sr. in the 900 block of 45th Place. To keep the price down to $2,000, the houses were built without side windows. Longtime Deanwood residents remember that grapes, apples, and black cherries grew in the backyards, which the neighbors shared for canning and making jelly. Photo by Kathryn S. Smith.

installed windows on front and rear facades only; purchasers could add side windows later. The results are still visible. Some Deanwood buildings have no side windows at all, while others have side windows that show they were later additions.[17]

In 1924 the District commissioners acquiesced to the influential American Institute of Architects, which argued that only those who had passed a rigorous licensing process had the right to call themselves architects. Men such as Randolph Dodd had become recognized as architects in their communities but didn't have the academic background to pass the licensing exam. The law applied equally to black and white but hit black architects practicing under the old system far harder.

There were licensed black architects working in Deanwood, however, including Lewis Giles Sr. and Howard Dilworth Woodson. Giles worked from his Folk Victorian–style home at 4428 Hunt Place until 1956, when he moved to the Deanwood Professional Arts Building at 4645 Deane Avenue. Prolific, he designed many houses in Deanwood and at least 1,069 buildings throughout Washington. Woodson, a Deanwood resident, architect, and noted architectural engineer, had worked for Daniel H. Burnham & Co. in Chicago on the designs for Washington's Union Station. He moved to Washington

in 1907 to work at the Treasury Department designing U.S. government buildings, one of the very few African American professionals so employed at the time. Woodson designed and built houses in Deanwood and founded many of its civic associations — the Northeast Boundary Civic Association, the Far Northeast Council, the Far Northeast Business and Professional Association, and the National Technical Association.[18]

There were opportunities for black homeownership in Washington, but home loans were hard to obtain and rates were often very high. The Deanwood market was largely defined and controlled by major white investors, such as Owen H. Fowler, Joseph L. Tepper, and Howard S. Gott. Gott, who began investing in Deanwood in 1911 through the Municipal Improvement Company, controlled large sections by 1920, including forty-four acres of the old Fowler farm and its subdivisions of Hampton Park and Hampton Heights. He advertised Hampton Park as "A PLACE TO LIVE: HOMES FOR COLORED PEOPLE," with "Lots and Homes sold on Monthly Payment." Some black purchasers, however, had to threaten Gott with lawsuits to get him to release their deeds, even after full payment had been made.[19]

Nevertheless more and more African Americans became homeowners in Deanwood and worked to strengthen neighborhood institutions, such as the Deanwood Civic Association, which dated back to 1893. When the community's nursery school needed furniture, mothers held a bake sale and used the proceeds to furnish it. The city-run streetcar ran only on Deane Avenue (now Nannie Helen Burroughs Avenue), the neighborhood's main thoroughfare. Seeing a need for a shuttle to other parts of the neighborhood, resident Bernie Chapman provided the "B.C. Bus #1." Many of today's residents remember his shuttle as so reliable that children used its last run of the day as a signal that it was time to stop playing and get home. Chapman's bus service, as well as his fleet of dump trucks, made him one of Deanwood's wealthiest men.[20]

The entrepreneurial spirit continued with the 1921 opening of Suburban Gardens, a black-owned and -operated amusement park at today's 50th and Hayes streets. Its counterpart, Glen Echo, was for whites only and located in Maryland. Suburban Gardens was a project of the Universal Development and Loan Company Incorporated, a real estate and development company that owned much of the property in Upper Northeast Washington. Howard D. Woodson was a company director and its supervising architect.[21]

Deanwood was accessible from downtown Washington by streetcar year-round, but an hour-long ride to Suburban Gardens in one of the open-sided summer cars that connected Connecticut Avenue to Deanwood was a breezy adventure. Passengers boarded anywhere along the side, and the conductor swung along the outside of the car on the running board platform to collect their fares. Drawing Washingtonians from throughout the region, Suburban Gardens offered a swimming pool, refreshment stands, merry-go-round, Tilt-a-Whirl, Skee-Ball, and a roller coaster known as "the Dip." It featured daredevil shows, circuses, and the big band sounds of Cab Calloway and Duke Ellington, which regularly wafted on the summer air. Women in their full-length evening

Suburban Gardens at 50th and Hayes streets, seen here about 1925, lives on in memory as a magic place for all those who frequented it. The city's only amusement park open to African Americans, its roller coaster, merry-go-round, daredevil shows, circuses, and big band entertainments brought families on the streetcar from miles around. Courtesy Scurlock Studio Records, Archives Center, National Museum of American History, Smithsonian Institution

dresses and men in their formal suits added to the fairytale-like quality of the dance pavilion, which was decked out in a thousand lights. Suburban Gardens closed in 1940 but continues to hold the distinction of being the only established amusement park ever operated within Washington's city limits.

Before it closed, Suburban Gardens was purchased and operated by Abe Lichtman, a Jewish entertainment entrepreneur. Lichtman owned a string of movie houses up and down the East Coast, including several specifically catering to African American patrons in Washington, such as the Lincoln Theatre on U Street and the Strand Theater, which he built in 1928 near Suburban Gardens at Grant Street and Division Avenue. The two-story, six-hundred-seat brick theater served the black community of Northeast Washington until it closed in 1959. It regularly employed Deanwood residents.

Deanwood's distance from downtown kept it semirural until after World War II. It was not until the 1950s that the city government provided services taken for granted in other areas — paved streets, sewers, and sidewalks. However, conversations with long-time residents reveal that there was never a sense of lack in the community. A 1938 celebratory program of the First Baptist Church of Deanwood advertised many services

Thelma Baltimore leads a student exercise in the purchase of defense stamps and bonds during World War II at the Deanwood Elementary School, a center of community activity in the neighborhood. Photo by Robert H. McNeill. Courtesy DC Public Library, Washingtoniana Division, Gregory Genealogical Collection

provided by African American professionals and entrepreneurs, such as Jones Drug Stores, which included luncheonette service; Clarence W. Turner Jr., carpenter and cabinet maker; Miss Faye Plummer, piano teacher; Garden Food Shop, operated by Mary B. Ware; and Sanitary Barber Shop, owned by Melvin Davis. Personal ties enriched the relationships between residents and business people. On Saturdays, Deanwood physician Dr. Theodore Pinckney "would make appointments to come to the homes of those who could not come to him," recalled longtime Deanwood resident Elaine King Bowman. He also accepted services in lieu of cash when times were difficult. Local carpenters provided carpentry work and electricians did electrical jobs for the doctor. Patients filled their prescriptions at Dr. Beasley's drug store on Sheriff Road, which also sold hamburgers and penny candy.[22]

King's Ice, Coal and Fuel Company, established in 1925 at 1046 Whittingham Place and moved to 4501 Sheriff Road in 1935, was a family-owned and -operated business in every sense of the word. The five children of Earl and Elizabeth King — Earlyne, Elaine, Earl Jr., Ernest, and Edith — all worked alongside their parents. In the 1940s King sometimes asked his brothers, Esau, Hugh, James, and Leroy, and his two nephews, Milton and Melvin Warren, to help deliver ice door-to-door. While they were out, his wife and children sold ice and coal from the backyard. King, like other Deanwood entrepreneurs,

watched for all opportunities. When the ice business slowed, he and his son Ernest took classes from Griffith Consumers on fuel oil, and when residents began to convert to oil heat in early 1950s, he bought oil trucks to serve them.[23]

Two family businesses served bereaved families — Washington and Sons Funeral Home, opened in the 1920s, and Rollins Funeral Home, dating back to 1936. Both are still in business, the former owned and operated by the original family. Alongside the black-owned businesses were stores operated by Jewish proprietors, such as Al and Ida Mendelson's family grocery store, Certified Market, at 4401 Sheriff Road. Ida Mendelson also owned a hat store on U Street in Shaw, which was frequented by the ladies of Deanwood for their church hats. Like Dr. Pinckney, the Mendelsons allowed patrons to make their purchases by signing "the book" and settling their bills at the end of the month. The Mendelsons later sold their grocery store and opened Murry's Steaks, which currently operates as Murry's Family of Fine Foods.[24]

While the small-town, family-friendly feel remained, Deanwood continued to grow in the 1960s and 1970s. A Metrorail station opened on the neighborhood's western edge at 48th and Minnesota Avenue in 1978, creating a faster transportation link between the far northeastern tip of the District and the rest of the city than ever before. Six years earlier in 1972, Deanwood's first and only senior high school had opened at 5500 Eads Street. Named in honor of Howard D. Woodson, it stood eight stories high and came to be known as the Tower of Power. The school's colors — red, black, and green — and its African warrior mascot reflect the Black Power era in which it was built. It is still the only senior high school in the District's Ward 7 operated by D.C. Public Schools. The building has deteriorated, however, and at this writing is scheduled to be replaced with a new structure on the same site.

Just as Washingtonians from other parts of the city once came to Deanwood to visit Suburban Gardens, new park improvements in the neighborhood may bring them back. The banks of the Watts Branch tributary to the Anacostia River form the longest municipal park in the city, dedicated in 1966 by Lady Bird Johnson as Watts Branch Parkway, an initiative of her beautification program for the nation's capital. The stream makes its way through Capitol Heights, Northeast Boundary / Deanwood Heights, Burrville, Lincoln Heights, Hillbrook, Deanwood, Mayfair Mansions, and Eastland Gardens. Just after the millennium, local residents and businesspeople as well as volunteers organized by the Watts Branch Community Alliance and Washington Parks and People began a multiyear effort to restore the park, which had become overgrown, trash filled, and unsafe. Legendary entertainer Marvin Gaye grew up not far from the park at 12 60th Street. To honor him and to call attention to the cultural heritage of the area, those restoring the streamside parkland succeeded in having it renamed Marvin Gaye Park. It was officially rededicated in April 2006 on what would have been the singer's 67th birthday. With a major entrance at 61st Street and Banks Place, the park features a new community center and the outdoor Marvin Gaye Amphitheater, which are both attracting new civic activity.[25]

Marvin Gaye Park lies just off of one of Deanwood's major commercial corridors, Nannie Helen Burroughs Avenue, where, over the years, many businesses closed and their neglected buildings along with the streetscape fell into disrepair. Deanwood residents have consistently raised their voices about this neglect, and as of this writing, the city government was moving to improve the avenue along with other older neighborhood commercial corridors.

Deanwood's other main thoroughfare, Sheriff Road, remains a mixture of residences and small businesses, and many community-based businesses and institutions continue to thrive there. For example, Battle's Religious Book Store, one of the oldest religious bookstores in the Washington Metropolitan Area, grew from humble beginnings in the basement of a house at 4311 Sheriff Road to become part of a two-store business complex located next door at 4315 Sheriff Road. Fruit of the Spirit Baptist Church, where the motto is "Dreamers have to become doers or their dreams die in their sleep," began in 1994 in the same house at 4311 Sheriff Road, organized by Rev. Clarence Turner III, whose family has been in Deanwood for generations.

Moviegoers gather for a Saturday matinee at the Strand Theater in this detail from an August 1948 snapshot by John P. Wymer, who photographed the entire city between 1948 and 1952. The Strand Pharmacy operated out of the lobby of the theater. Courtesy The Historical Society of Washington, D.C.

An enterprise that began in 1979 at 4800 Nannie Helen Burroughs Avenue, the Marshall Heights Community Development Organization, Inc., or MHCDO, has brought affordable homeownership opportunities and other services to Deanwood and other neighborhoods in Ward 7. The organization has developed, on its own or in partnership with others, a sixty-unit supportive housing facility, a 469-unit garden-style apartment complex, 220,000 square feet of retail/office space, 20,000 square feet of warehouse/industrial space, and more than 150 homes sold to low- and moderate-income buyers. The organization's most notable developments in Deanwood are the 1993 Deanwood Station Condominiums at 47th Street between Meade and Nash streets and the 1982 Grant Park Nursing Home at 5051 Nannie Helen Burroughs Avenue. Now located in a modern structure at 3939 Benning Road, MHCDO is locally and nationally known for its effectiveness and has hosted such dignitaries as former President William Jefferson Clinton and Queen Elizabeth II.

With all of the change on the horizon, residents are now increasingly involved in preserving Deanwood's rich past. They successfully sought, for example, a listing on the National Register of Historic Places for the Strand Theater that had played a critical role in the social life of the community. Interviews of longtime residents revealed how neighborhood children were entertained by the Saturday morning serials at the Strand, while the adults and teenagers came out in the evening to see the latest features. All over

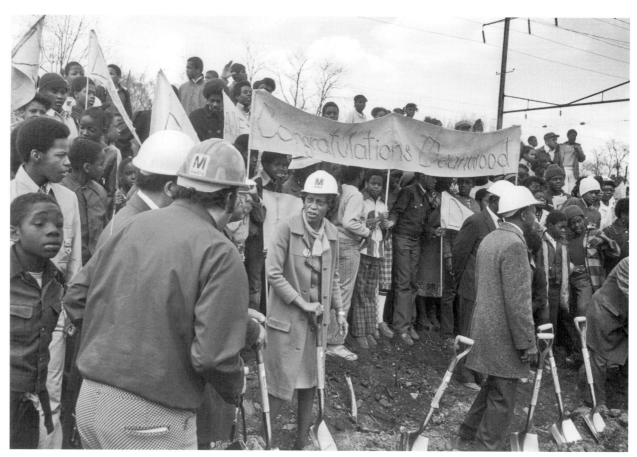

Metrorail officials and local residents turn the first spades of dirt for construction of the Deanwood Metro stop in 1975. Rhuedine Davis, a civic activist in the adjoining neighborhood of Kenilworth, addresses a colleague at the center of the picture. Photo by Paul Myatt. Courtesy Washington Metropolitan Area Transit Authority

Deanwood, remembered one resident, parents would tell their kids "if you do this or that, you can go to the Strand on Saturday." The Strand Pharmacy was located in the lobby, right next to Dr. Wolf's concession stand, where Katherine S. Chatmon, who grew up not far from the theater, remembered buying candy and potato chips to enjoy during the movie. Plans are under way for the theater's restoration for new uses beneficial to the community.[26]

The historical resources survey conducted in 1987 that provided much of the research for this chapter revealed the strong commitment of many longtime residents to their neighborhood. Residents renewed their interest in Deanwood's past with the research for and publication of *Deanwood: A Model of Self-Sufficiency in Far Northeast Washington, D.C. (1880–1950)*, a brochure prepared in 2005 by a group of community historians. At the same time, Deanwood retains many physical reminders of its history in the houses built by its own craftsmen, in the open spaces, in the overall low scale of its structures, and in the families who have lived here for generations. The community's location in the city's far eastern corner continues to give it a sense of a place set apart, a place where people still take great pride in their community's tradition of self-reliance.

Electric Streetcar and Railroad Suburbs

With its grand avenues lit and paved and the federal government growing in importance, Washington prospered in the 1880s. Federal government employment tripled in that decade, and with the passage of the Civil Service Act in 1883, the jobs were more secure, most no longer subject to political patronage. This job security encouraged newcomers to stay and buy homes. By 1890 the population had reached 230,000. A growing civic consciousness and pride swept the city. Prominent businessmen had created the influential Board of Trade in 1889. Land was set aside for Rock Creek Park in 1890. The elite formed private clubs, and in 1894 the Columbia Historical Society, now the Historical Society of Washington, D.C., started keeping records of the city's past.

The Spanish American War in 1898 began to position the new nation as a player on the world stage. Foreign governments increased their representation in the capital. Wealthy entrepreneurs from big cities around the country were drawn to power and built lavish homes in Washington, some for use only when Congress was in session, some hoping to marry their daughters to European royalty. To celebrate the city's centennial in 1900, Congress produced a plan to restore the National Mall — then a hodgepodge of varying landscapes with a train track across it in front of the Capitol — to the grandeur suggested by L'Enfant. The McMillan Commission Plan of 1901–2 set forth a vision for the Mall as well as the system of parks that Washingtonians enjoy today. By the time America entered World War I in 1917, Washington had become a mecca for job seekers as well as the social and political elite. In 1920, 438,000 people lived in the capital, almost double the population of 1890.

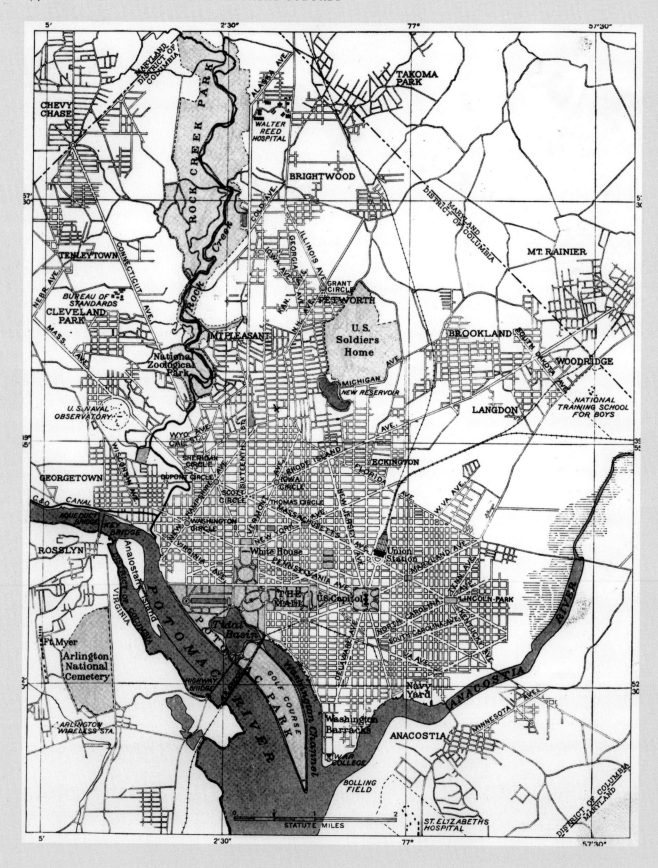

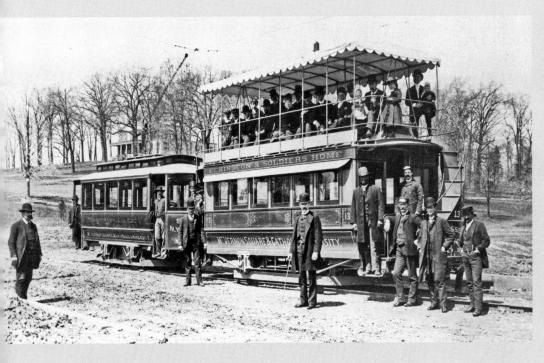

The electric streetcars of the Eckington & Soldiers line traveled the city's first motorized rail line in 1888. As other lines switched from horsepower to electricity, service became faster and more reliable. The innovation fueled development throughout the District. This photograph was taken about 1891 on North Capitol Street just north of Boundary Street. The double-deck trailer is a former horsecar being pulled by the electric car in front. Courtesy Washingtoniana Division, DC Public Library

It was during these decades bracketing the turn of the twentieth century that many of Washington's urban neighborhoods began as suburbs of old Washington City. Just as the need for new homes escalated, the invention of the electric streetcar opened up the rural landscape miles farther from the central city than the slower horse-drawn cars had been able to reach. In 1888 the city's first electric streetcar ran on the Eckington & Soldiers Home Railway Company line, and by the 1890s electrified routes were running in all directions from old Washington City and Georgetown to the District's boundaries. Another transportation boon to the city, the Baltimore and Ohio Railroad's new Metropolitan Line, with as many as fifteen trains in and out of the city daily, opened up other areas for development.

Kalorama, Chevy Chase, and Cleveland Park in Northwest Washington are all products of the new electric streetcar. So are Congress Heights in Far Southeast and Kenilworth in Far Northeast across the Anacostia River. Takoma Park and Brookland began around stops on the B&O Railroad Metropolitan Line but would soon benefit from electric streetcars as well. The stories of their development, and the entrepreneurs behind them, are on the pages that follow.

*(opposite)
By 1923 the suburban developments encouraged by the electric streetcar were being identified as distinct neighborhoods in the urbanizing District of Columbia. There were still significant open spaces between them. Courtesy Historical Society of Washington, D.C.*

General Philip Sheridan, in a pose created by Gutzon Borglum, the sculptor of Mount Rushmore, commands the circle that bears Sheridan's name in the heart of Sheridan-Kalorama. The residence of the ambassador of the Philippines (background) has many other embassies for company around the circle and nearby along Massachusetts Avenue. Photo by Rick Reinhard

Kalorama

TWO CENTURIES OF BEAUTIFUL VIEWS

EMILY HOTALING EIG

Located on a high ridge along Rock Creek, Kalorama's unusually hilly terrain sets it apart from other Northwest neighborhoods. Its mansions, fine town houses, and stylish row houses have been home to U.S. presidents, international diplomats, and the city's social elite, as well as the aspiring middle class. Today divided into two neighborhoods, the area's history extends back to the early nineteenth century when its idyllic character inspired its name, which is Greek for "fine view."

The site of expansive eighteenth- and nineteenth-century country estates, the area saw intense urban residential development in the early twentieth century as the growing population moved away from the old city's center toward higher ground in its quest for the suburban ideal. Today the broad boulevard of Connecticut Avenue, lined with stately apartment buildings holding court for the busy commuters passing to the north or south, delineates its center. To the east of Connecticut Avenue, long rows of attached three- and four-story houses and large and small apartment buildings stand along the undulating, tree-lined streets punctuated by pockets of green space. This area has come to be known as Kalorama Triangle, a small neighborhood generally considered part of today's Adams Morgan community. West of Connecticut Avenue is an area popularly known as Sheridan-Kalorama, distinguished by elegant freestanding single-family houses set amid verdant lawns and gardens, with fine town houses interspersed along the curvilinear streets. Splendid embassy chanceries and residences stand guard along Massachusetts Avenue at Rock Creek Park on its western edge, while large high-style apartment buildings congregate near the Connecticut Avenue line. The effect is that of an architectural quilt, a cohesive design harmoniously patched, carefully bordered, and skillfully stitched together.

Since the early years of the nineteenth century, this entire area has been referred to as Kalorama, named for the large estate that once dominated it. Documentation for the land reaches back to 1664 when John Langforth of St. Mary's County, Maryland, surveyed six hundred acres of what was

Sheridan-Kalorama, west of Connecticut Avenue, and Kalorama Triangle, east of the avenue, take their names from an early nineteenth-century estate on the heights above old Washington City. The commonly accepted boundaries of each also define historic districts of the same names. Kalorama Triangle is today generally thought of as part of the Adams Morgan neighborhood. Map by Larry A. Bowring.

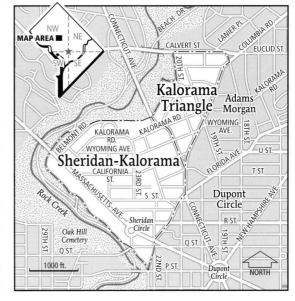

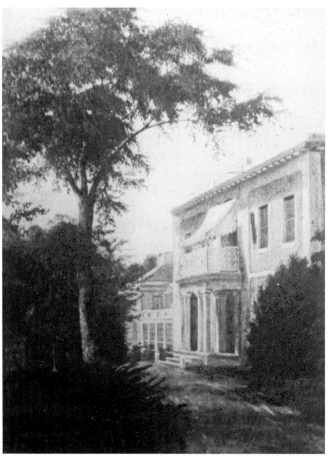

The Belair mansion, later renamed Kalorama, was home to a series of distinguished owners, such as epic poet and diplomat Joel Barlow. This artist's rendering dates from the 1840s. Courtesy The Historical Society of Washington, D.C.

then Charles County. In 1686 this land was patented by Lord Baltimore to Langforth's son, William. In the late eighteenth century, Anthony Holmead took possession of the part of Langforth's estate contiguous with Rock Creek and called it Widow's Mite. By 1750, he had persuaded his English nephew and heir, also named Anthony Holmead, to immigrate. The younger Holmead built a house he called Rock Hill near today's 23rd and S streets, NW. In 1795 the younger Holmead sold thirty prime acres, including Rock Hill, to Gustavus Scott, a Maryland native. Holmead retained a fifty-six-acre parcel with access to the newly established Boundary Street (today's Florida Avenue) and built a new, less pretentious house for himself northeast of his former house and west of today's Phelps Place.[1]

Scott renamed his new purchase Belair, and it is this property that would become the heart of modern-day Kalorama. Scott, who served as a commissioner for the District from 1794 to 1800, improved the estate's grounds in a manner he believed fitted his position. Soon, however, he felt the financial pressure of his expensive investment and sold off the grist mill and paper mill at the property's western edge. Despite this, Scott's financial situation worsened; he died in 1800. In 1803, his destitute widow sold the property to William Augustine Washington, nephew of the first president.[2]

Within five years, however, the estate was on the market again. In 1807, internationally recognized pamphleteer and poet Joel Barlow purchased the property, the same year he published his widely acclaimed epic poem, *The Columbiad*. Barlow and his wife counted presidents, congressional representatives, scientists, and military figures among their friends and acquaintances; they soon established their home as a political, literary, and social center. In appreciation of the property's location, Barlow renamed the estate Kalorama. Although Barlow expanded the mansion substantially, he spent only three years there. He left in 1811, sent to negotiate a commercial treaty with the French Empire, and died the following year while en route to Poland to meet with Napoleon I. His widow returned to the estate, continuing to live there with her sister and brother-in-law, Clara and George Bomford, until her own death in 1818. By 1822 Bomford had become the owner of Kalorama. He went on to embellish the house and grounds, expanding the estate to more than ninety acres before being forced to sell in 1846.[3]

In that year, Thomas R. Lovett of Philadelphia purchased Kalorama on behalf of his mother, Louisa Lovett Fletcher. During the Civil War the estate was commandeered by

the Illinois regiment for use as a smallpox hospital, but after the war Mrs. Fletcher returned. In 1871 her younger son, George Lovett, was responsible for the first division of the estate, selling off the western forty acres to the Freedman's Savings and Trust Company for $15,000 and using the proceeds to restore the house. Over time, the remaining estate was passed on through a number of other owners, but the name Kalorama prevailed, even after the estate had been entirely subdivided.[4]

The late nineteenth century found Washington City bursting its boundaries. Developers were buying and subdividing rural land in Washington County, politically joined with the city in 1871. Real estate agents were particularly interested in the Kalorama area because of its fine location, where they believed they could reap large profits. In 1882 the *National Republic* promoted the possibilities of "Suburban Residences":

> The city has extended so far to the north and west that the heights of the Holmead estate are now becoming the most attractive Portion of the city for residences. The summer temperature is at least five degrees lower than in the city, and refreshing breezes sweep over from the valley of Rock Creek. There is no city in the land that has been so lavishly supplied by nature with locations for rural homes. Within a few months some of our leading citizens have taken steps to utilize and beautify these elevations overlooking the city.[5]

Thus Kalorama was ripe for development. In 1883 real estate broker and land speculator William C. Hill purchased Freedman's Savings and Trust's forty acres for $30,000, double the 1871 sale price. Within two years the parcel was sold again, this time for $60,000 to Gardiner Greene Hubbard, later the founder of the Bell Telephone Company. Between 1871 and 1900, eighteen subdivisions were carved out of the three hundred acres bounded by Rock Creek, Biltmore Street, 18th Street, and Boundary Street, renamed Florida Avenue in 1890. Lot sales were furious, but despite the speculators' optimism, actual construction was slow to materialize. By 1890 what development there was centered on two Presbury and Goddard subdivisions just east of 19th Street, where the infrastructure was in place and the streetcar line was nearby. The reluctance of some owners to sell, complex lawsuits over ownership, delays and ambiguity owing to new road construction, and the economic panic of 1893 were all factors in the delay of the area's full development.[6]

Another major factor was congressional concern about rampant and uncoordinated subdivision of rural land in Washington County. In the Highway Act of 1893, Congress ordered the preparation of a street plan that would extend L'Enfant's design of the Federal City into the rest of the District. Confusion surrounded the Highway Act because it was not clear whether older suburbs already laid out would have to comply by redesigning existing roads. The city government's slow production of the required maps exacerbated the problem. Fear of the condemnation of expensive property for street rights-of-way virtually halted land transfers and construction across the District.

For Kalorama, a planned extension of Connecticut Avenue from Florida Avenue

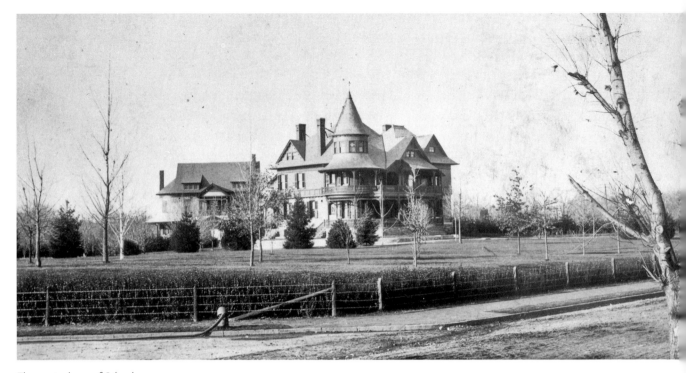

The country house of Colonel George Truesdell, called Managassett, sat on a large lot at Wyoming Avenue and Columbia Road in the 1880s as suburban developments were laid out all around it. The house in the background was built in 1887 by and for contractor/speculator J. H. Lane. Both houses are gone. Courtesy The Historical Society of Washington, D.C.

northerly across Rock Creek to Chevy Chase Circle at the District's boundary was the greatest concern. Condemnation of land for the new road through Kalorama all the way to the District line began in 1888 but the District commissioners dropped the effort when affected landowners, notably Otis F. Presbrey who was completing a house on Kalorama Avenue (later Road), strongly opposed the action. Plans to construct the road, however, continued as the District's engineer commissioner's office addressed the problems, topographical as well as legal, of cutting the new road. In 1896 when the engineer commissioner proposed a new scheme for the highway system, the plan for Connecticut Avenue was challenged by the Chevy Chase Land Company, which had been quietly purchasing most of the land along the avenue's route north of Kalorama. The company claimed it had been promised a straight route from Florida Avenue all the way to its planned suburban developments north and south of Chevy Chase Circle. On March 3, 1897, with the help of Senator James McMillan, chair of the Senate District Committee, a compromise between Kalorama landholders seeking to protect their holdings and the Chevy Chase Land Company was formalized in Congress. The plan maintained a straight path for the new road — except between Florida and Kalorama avenues where it varied to accommodate the Kalorama property owners.[7]

The next year, Congress passed a new Highway Act, complete with a map exempting subdivisions made prior to 1893. Coupled with major improvements in public services and transportation, this act was a catalyst for a surge of building activity around the city. The amended act relieved Kalorama's developers of uncertainties by legalizing its pre-1893 curvilinear street configurations, now a defining feature of the area, ensured

the location of Connecticut Avenue, and permanently bifurcated the area, creating two distinct neighborhoods on either side of the avenue.[8]

As Kalorama stood on the brink of urbanization, its landscape remained undeniably rural. A few large wood-frame houses, some dating to the early- and mid-nineteenth century, were in place, including the house constructed by Holmead in 1795, after he sold Rock Hill, and former Ohio governor William Bebb's 1865 octagonal house on Phelps Place. Some newer construction, such as George Truesdell's Managassett, in the present-day nook of 20th Street and Columbia Road; J. H. Lane's house at 1917 Kalorama Road; and LeRoy Tuttle Jr.'s stone house between LeRoy Place and California Avenue (now Street) at Connecticut Avenue, while not associated with large estates, possessed the character of "country houses." All are now gone.

Although expanding population was the major force behind the urbanization of Kalorama, turn-of-the-century transportation systems shaped its physical growth. In 1886 the District commissioners held public hearings on plans to extend Massachusetts Avenue north of Boundary Street, passing right through the Kalorama estate, and to construct along its route a circle to be named in honor of naval hero Stephen Decatur. Condemnation orders followed in October of that year, protested loudly and publicly by Emeline Lovett, widow of George and the last occupant of the Kalorama mansion. Unfortunately for Mrs. Lovett, she was the only remaining family member who wanted to keep the estate intact. When in late 1887 her three sisters-in-law sold their four-fifths share of Kalorama to a Philadelphia syndicate, Mrs. Lovett gave in to the pressure. As a result, its last remaining sixty acres were sold for subdivision at $5,900 an acre, "the highest [sale] ever made in this area for land beyond the Boundary," the *Evening Star* would later note. In 1888 the mansion was demolished and Thos. J. Fisher & Co. created the 350-lot Kalorama Heights subdivision. By 1889 Massachusetts Avenue had been extended through the western portion of the property.[9]

The circle along the new avenue was intended to honor Decatur because it was the site of the Barlow (later Bomford) family vault, where Decatur was briefly interred. However, in 1890 the circle was reassigned to General Philip Sheridan, who had died in 1888. By 1909 the circle and its equestrian statue of Sheridan, designed by Gutzon Borglum, sculptor of Mount Rushmore, were in place. After it was installed, the statue received more than its fair share of criticism, but, according to Washington historian Perry Fisher, "Mrs. Sheridan, of course, loved it instantly." It is believed that the town house designed for her by Waddy Butler Wood at 2211 Massachusetts Avenue was sited simply to be close to the statue. Mrs. Sheridan included a fourth floor balcony so that she and her daughters could overlook "Papa's Circle." Others may not have shared her reason, but they did share her preference for Massachusetts Avenue. Even before the street was completed, it became the fashionable choice of many members of America's industrial, social, and political elite who had begun to view the nation's capital as an attractive seasonal residence.[10]

By 1915 Massachusetts Avenue was lined with the grand houses that established its

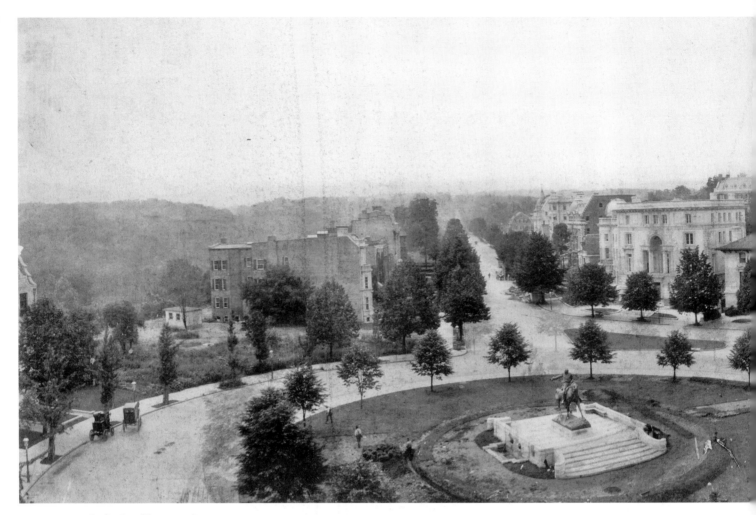

By the time this panoramic view was made in 1911, Washington's social and political elite had lined Sheridan Circle and Massachusetts Avenue that bisected it with the most elegant town houses in the city. Courtesy Library of Congress

reputation as the city's finest boulevard. These palatial residences were generally built by individuals who had made fortunes in business elsewhere and wished to establish themselves as a social presence in the nation's capital. (Their ambitions would be impeded by the federal personal income tax imposed in 1913.) Soon the city's finest residential architects would fill Kalorama's newly subdivided streets with fine urban mansions, their designs influenced by the World's Columbian Exposition of 1893 and its glorification of the Beaux-Arts, and the subsequent Panama-Pacific International Exposition of 1915 that celebrated the Mediterranean styles of architecture.

The other critical factor in the physical development of Kalorama was the planned extension of Connecticut Avenue directly over Rock Creek. Initially, the area was linked to the upper Northwest quadrant of the District by way of Calvert Street, then known as Cincinnati Street. The first bridge to connect this street on opposite sides of Rock Creek was a steel trestle built in 1891 for the Rock Creek Railroad Company, as part of the development plans of Francis Newlands for his Chevy Chase suburb. Public streetcar service began the following year. The first line ran north on 18th Street, then west

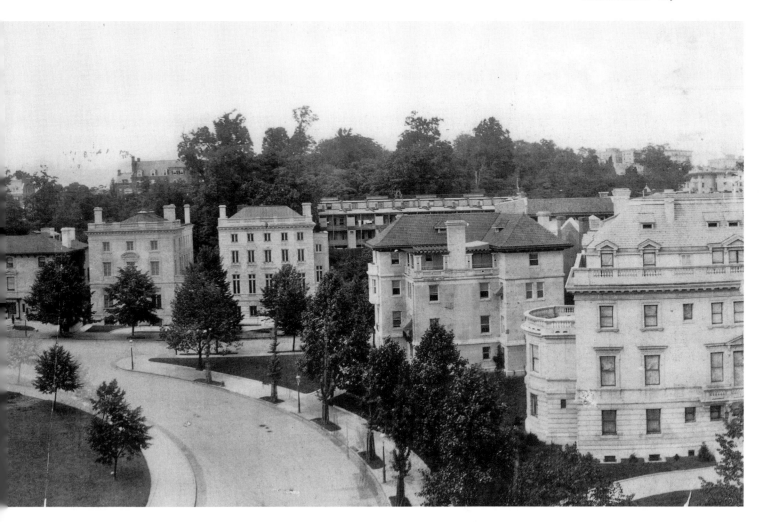

on Calvert Street, across the bridge, and north on Connecticut Avenue to Chevy Chase Lake beyond the District line.

Completion of the 1897 plan to extend Connecticut Avenue, however, required building a new bridge across Rock Creek that could support the newly fashionable — but still quite rare — automobile. George S. Morrison, the renowned railroad bridge designer, won the competition for the present Taft Bridge. Construction began in 1897, and by 1907 Washington possessed one of the first and largest unreinforced concrete bridges in the world.[11]

The earliest years of development east of Connecticut Avenue in today's Kalorama Triangle followed the expansion of the streetcar lines. The 1892 service to the area, up 18th Street, was not enough to spur activity. When a second streetcar line began to serve the area in 1897, running north on Columbia Road and connecting to the first line at 18th Street, new house construction began. By 1903 Kalorama Triangle was completely subdivided into narrow lots, soon to be the sites of numerous row houses. Over the next decades, the Capital Traction streetcar company provided residents of Kalorama

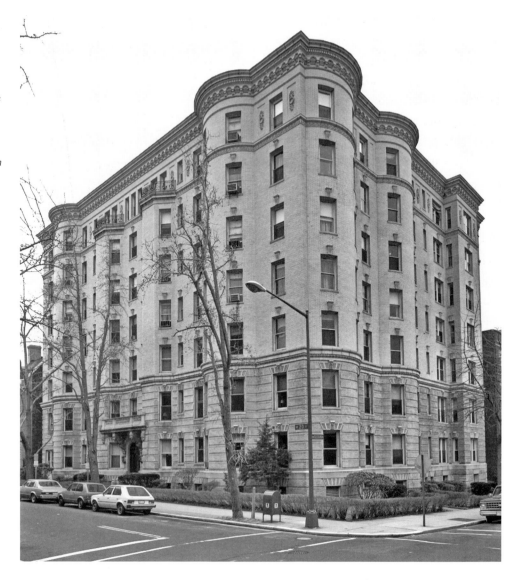

Triangle with convenient public transportation to downtown Washington, Georgetown, and the Navy Yard.[12]

The line of eight semidetached dwellings constructed along the 2000 block of Kalorama Road represents the initial building type east of Connecticut Avenue. Each pair (2003–2005, 2007–2009, 2011–2013, and 2015–2017), designed by prolific Washington architect Edward Woltz, consists of two units attached by a central party wall along the shared property line, which allows for front, rear, and side yards for each house. Developer Harry Wardman later popularized this type of construction throughout the city. Columbia Road proved to be an anomaly in the history of the area's construction patterns, when several prominent architects were commissioned to design large private residences on or near the corridor. These residences included the grand Lothrop Mansion at Columbia Road and Connecticut Avenue and a considerable number of semide-

tached houses, sometimes repeated in rows. Development continued in 1899 and 1900, when row houses were introduced to 19th Street, Calvert Street, Columbia Road, Kalorama Road, and Mintwood Place. From 1900 on, almost without exception, row houses and apartment buildings dominated construction east of the avenue. Architects applied the styles popular during this period to these specifically urban architectural forms, including English Arts and Crafts, Georgian Revival, and Mediterranean, with its Italian and Spanish derivatives. Their application in Kalorama Triangle beautifully illustrates the diffusion of high-style architecture to middle-class urban residences.

The area's first apartment building, the Mendota, opened in 1901 at 2220 20th Street in the Triangle. Grandly executed by James G. Hill and epitomizing the latest in middle-class living, the building offered a fashionable and practical alternative to the problems of acquiring and maintaining a single-family dwelling. Apartment living suited Washington, as so many of its residents were part-timers seeking short-term living quarters. Such notables as Nebraska's Progressive Senator George W. Norris and Missouri's Jeannette Rankin, who in 1917 was the first woman elected to Congress, made their homes at the Mendota. The Mendota was the first of nearly fifty apartment buildings constructed throughout the area over the next twenty-five years. These early apartment buildings provided amenities such as personal beauty and health services, concierges, and restaurants — luxuries that one might find in a fine hotel of the period.[13]

By 1930 Kalorama Triangle was built up almost entirely with row houses and apartment buildings, most of which were constructed rapidly in the same period and thus were cohesive in scale, size, material, and use. The developers had accurately assessed their market and produced buildings of good design and fine craftsmanship that attracted an upwardly mobile middle class. Though the location made them dependent on public transportation to downtown jobs, government clerks, salesmen, lawyers, real estate agents, artists, physicians, butlers, waiters, and teachers were attracted to a neighborhood that matched their high aspirations. A few high officials, including Harry M. Clabaugh, chief justice of the D.C. Supreme Court; Edward Stellwagen, president of Union Trust Company; and Senator Thomas P. Gore of Oklahoma, were also residents.

The first development west of Connecticut Avenue in Sheridan-Kalorama was in-

This elegant apartment hallway shows the grandeur of the early twentieth-century Wyoming apartment building at 2022 Columbia Road. Courtesy The Historical Society of Washington, D.C.

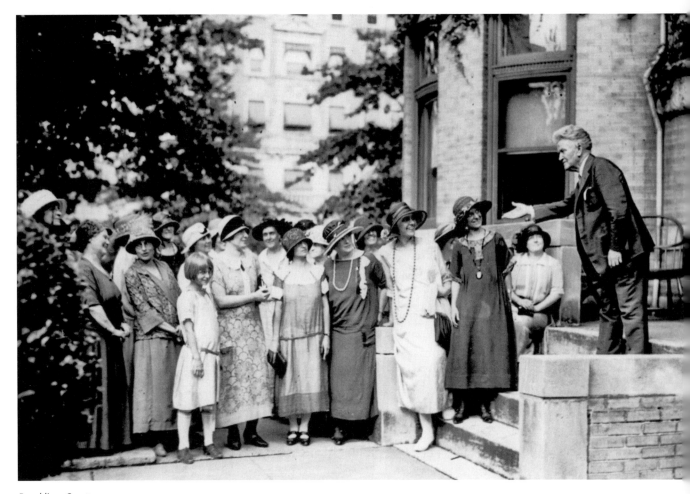

Republican Senator Robert M. LaFollette Sr. of Wisconsin speaks to women involved in the Progressive movement on the steps of his home at 2112 Wyoming Avenue. Residents of Kalorama were often treated to the sight of high government officials who lived in or attended events in the neighborhood. Courtesy Library of Congress

fluenced by the nearby urban areas: row houses appeared in small clusters near Dupont Circle and along the avenue, again because of convenient access to transportation. Large apartment buildings were introduced along California Street. Such fine edifices as the Westmoreland (no. 2122), designed by E. S. Kennedy and Harry Blake in 1905; Florence Court (no. 2153), the work of T. Franklin Schneider in 1905; and Albert Beers's Brighton (no. 2123) and Lonsdale (no. 2138), both dating to 1909, contributed to the high quality of residential living possible in Sheridan-Kalorama.[14]

The stars of the neighborhood, though, were the large, single-family residences that continued to be built as late as the 1980s. Notable local architects such as Waddy Butler Wood, Appleton P. Clark, Marshall and Hornblower, Arthur B. Heaton, Jules Henri DiSibour, George Oakley Totten, Porter and Lockie, and John J. Whelan designed some of their most fashionable residences in this neighborhood, as did such nationally renowned society architects as John Russell Pope, Carrère & Hastings, William Bottomley, and Pleasants Pennington. These designs were not avant-garde in their expression but instead were high-style presentations of the traditional styles that were the mainstay of architecture for America's wealthy. Many of the buildings employ the Geor-

gian Revival that epitomized Washington's Anglophilia of the early twentieth century. Other architectural designs illustrate the popularity of the Mediterranean and others of the Beaux-Arts. The dates of each style's early twentieth-century appearance in the neighborhood were remarkably timely, a testament to the rapid assimilation of nationally recognized trends in fashionable architecture in Washington.

The people attracted to Sheridan-Kalorama included some of Washington's most interesting and influential citizens. Such luminaries as lecturer and publisher Conrad Miller; Charles Walcott, secretary of the Smithsonian Institution; Perle Mesta, the "Hostess with the Mostes'"; Supreme Court Justices Charles Evans Hughes, Louis Brandeis, Harlan Stone, and Joseph McKenna; and Frances Perkins, the first woman to serve in the U.S. cabinet, sought out this neighborhood. Among the first residents were the developers who had orchestrated the subdivision of the Kalorama estate, including Edward Stellwagen, who with Thomas Gales (a resident of Kalorama Triangle), both sons-in-law of Thomas Fisher and executives in the real estate firm of Thos. J. Fisher & Co., turned Fisher's small business into a major financial force in the expanding city. The company would also be a key player in the development of Chevy Chase.

Gales built a large Colonial Revival house to the design of Appleton P. Clark at 2300 S Street. Later this house gained fame as the residence of Herbert Hoover during his appointment as secretary of commerce under presidents Warren G. Harding and Calvin Coolidge. In fact, Sheridan-Kalorama has been the home of five presidents: Hoover, as mentioned, from 1921 to 1928 and again from 1933 to 1934; Franklin D. Roosevelt (2131 R Street), while he was assistant secretary of the navy, 1917–21; Warren G. Harding (2314 Wyoming Avenue), during his term as U.S. senator from Ohio until becoming president, 1917–21; William Howard Taft (2215 Wyoming Avenue), from his return to Washington as chief justice of the Supreme Court until his death, 1921–30; and most significantly, Woodrow Wilson (2340 S Street), on leaving the presidency until his death, 1921–24.[15]

To date, Wilson is the only president to choose Washington for his primary residence. The Wilsons' fine Georgian Revival house, designed by Waddy Wood in 1915 for Boston businessman Henry Fairbanks, was purchased by the couple with the help of "some good friends" who wished to ensure the former president's well-being. Hundreds of supporters waited along the edge of S Street to welcome him to his new home. Wilson was in deteriorating health and died in 1924. Edith Bolling Wilson, the president's second wife, drew public attention for her role as the "first woman president" during Wilson's first stroke while in office. Edith Wilson resided in the house until her death in 1961. Two years later, the National Trust for Historic Preservation opened the house as a museum property.

Among the most special of the Sheridan-Kalorama houses is its oldest — the Lindens. This fine 1754 Georgian house at 2401 Kalorama Road, however, was not constructed in Washington. Its owner, George Maurice Morris, moved it from Danvers, Massachusetts, to Washington in 1936 because, explained his wife, she was unable to find a house in Washington that was quite historic enough to meet her requirements.[16]

Woodrow Wilson leaves his home at 2340 S Street in his Rolls Royce with his wife, Edith Bolling Wilson, in late 1923 or early 1924. In declining health at the time the photo was taken, he would die in 1924. Wilson was one of five U.S. presidents to make his home in Kalorama. Courtesy Library of Congress

The application for historic district status for the neighborhood in the 1980s described the lively but structured social life carried on by its prestigious residents between the wars:

> In the afternoons wives made social calls. Each household served tea on a specified day and the neighborhood ladies could spend their afternoons visiting several residences. During the evening, quiet private parties were held. For such occasions, awnings were rented to cover the front walks to the houses and so everyone knew who was entertaining. Because the area was the residence of many people employed by the government, it was often possible to greet the President when he attended affairs in the neighborhood.[17]

Not surprisingly, Sheridan-Kalorama incubated an unusually large number of Washington-area private schools. Founded in the first decades of the twentieth century, they served the area's growing population of upper middle-class families, many of whom considered the public schools unsuitable. Typically, the fledgling schools, sometimes started in the founders' residences, moved into nearby houses transformed to meet the needs of the new school. The Potomac School, founded near Dupont Circle in 1904 for elementary students, occupied a large residence at 2144 California Street from 1916 to 1951. As it grew it added a gymnasium and other buildings, developing a campus over the years. Claire B. Cook established the Sheridan School in 1927 as Mrs. Cook's School

Students gather in the late 1930s or early 1940s to study in the sun-drenched garden of the Holton-Arms School, founded in Kalorama in 1902. Photo by Theodor Horydczak. Courtesy Library of Congress

in her residence at 2344 Massachusetts Avenue, where it remained until 1962. After she retired, the school took its new name from nearby Sheridan Circle where its students played at recess.

Two schools constructed purpose-built school houses. The Holton-Arms School, opened in 1902, was a fixture in Kalorama for sixty years, serving both local area residents and boarding students. Founder Jessie Moon Holton and Carolyn Hough Arms oversaw the construction of its first permanent home at 2125 S Street in 1905; it served as their home as well. As the student body grew, the school purchased nearby vacant lots

and residences, but the original building and new construction maintained the residential appearance of the street. In 1911 Louise Maret and her sisters Marthe and Jeanne founded the Misses Maret French School for Children in their Connecticut Avenue home, and in 1923 moved into a purpose-built school at 2118 Kalorama Road designed by Horace Peaslee. The Maret School remained in Kalorama for thirty years. However, in the first decades after World War II, in keeping with the national trend toward suburbanization, Holton-Arms and Potomac moved to larger suburban campuses. Maret and Sheridan schools moved farther north in Northwest Washington. In 1974 the newly founded Field School moved into 2126 Wyoming Avenue in Sheridan-Kalorama but, after close to thirty years, it also moved to upper Northwest Washington.

One of Sheridan-Kalorama's earliest institutional buildings was also built as a school but not to serve the neighborhood's residents. St. Rose's Industrial School, a Catholic orphanage and school for girls founded in 1868 in downtown Washington, built new quarters in 1908 at the corner of California Street and Phelps Place. Its surrounding brick walls isolated its residents from the neighborhood. Baltimore ecclesiastical architect Francis Tormey designed the school's brick and stone building, which included dormitories, classrooms, and a chapel. The school provided vocational training, principally in dressmaking and the domestic arts, and in the 1930s its students monogrammed White House linens for Eleanor Roosevelt. Subsequently the building housed St. Anne's Infant Asylum and a Catholic high school for boys before becoming home to Our Lady Queen of the Americas, a Hispanic and Portuguese Catholic parish.

Early residents were quick to found new churches to serve the community. St. Margaret's Episcopal Church originally met in the basement of a private house in the early 1890s and built its first chapel in 1895 at the corner of Bancroft Place and Connecticut Avenue. James G. Hill designed a large addition in 1904, changing the church's orientation to face Connecticut Avenue, which was developing into an important artery. The complex was completed in 1913 with the construction of a parish hall. Its many famous parishioners have included First Lady Edith Wilson as well as President Franklin Roosevelt's secretary of state, Cordell Hull, and Secretary of Labor Frances Perkins. In 1904 Presbyterians formed the Church of the Pilgrims at 22nd and P streets and Florida Avenue. Its initial building was soon expanded to accommodate its growing congregation. Under the leadership of Dr. Andrew Reid Bird, its minister from 1911 to 1956, the church appealed to the nation's entire southern Presbyterian congregation for funds to build a national church. That campaign culminated in the construction of the present church in 1929 to the award-winning design of Baltimore architect Benjamin Courtland Flournoy.

A group of Quakers dedicated the Friends Meeting House at 2111 Florida Avenue in 1931. Mary Vaux Walcott, a close friend of both Herbert and Lou Hoover and a fellow member of the Society of Friends, purchased the site in the 1920s with the intention of donating it for construction of a meeting house suitable for a president's place of worship, if needed. After Hoover's 1928 election to the presidency, fundraising progressed

Crowds assemble outside the Islamic Center on Massachusetts Avenue at the time of its dedication in 1958. When built, it was the only Islamic cultural center in the Western hemisphere. Courtesy The Historical Society of Washington, D.C.

quickly. At First Lady Lou Hoover's suggestion, Philadelphia architect Walter Price modeled the building on Colonial prototypes. The Hoovers did attend services at the completed meeting house.

In the 1950s, the Islamic Center rose at 2551 Massachusetts Avenue as the first Islamic cultural center in the United States, the product of a collaborative effort between Egyptian architects, local architects Irwin Porter and Sons, and well-known local builder A. J. Howar.

Massachusetts Avenue, as it passes through Sheridan-Kalorama, became known as

Embassy Row. At this writing, more than twenty chanceries are located on the avenue and additional buildings serve as residences for foreign diplomats. Sheridan-Kalorama, with its concentration of large and elegant residences, has been a magnet for the diplomatic community since the early twentieth century. In the decades of the Great Depression and the Second World War, as fortunes faded, dowagers died, and lifestyles changed, many of the great mansions of the area were purchased by foreign governments for use as offices or as ambassadors' residences. Among these were the Luxembourg residence at 2200 Massachusetts Avenue, designed by Bruce Price and Jules Henri de Sibour, and three buildings designed by George Oakley Totten Jr.; the first Turkish embassy at Sheridan Circle, the embassy of Pakistan at 2315 Massachusetts Avenue, and the embassy of the Federal Republic of Cameroon at 2349 Massachusetts Avenue (formerly the embassy of the Czech Republic). In 1936 the French government bought the four-acre Hammond estate with a Jacobean-style house designed by de Sibour at 2221 Kalorama Road as a residence for its ambassador. The fine Georgian-style house at 2535 Belmont Road became the French chancery, where it remained until 1985.

The government of Siam (now Thailand) established the first purpose-built embassy in the area in 1920 at 2300 Kalorama Road. James Rush Marshall designed the building, and the Early Studios, the unique Washington decorative concrete firm, constructed it. The building included offices on the first floor and residential quarters for the ambassador on the second. In 1932 Japan built an embassy at 2516 Massachusetts Avenue designed by Delano & Aldrich. Since that time, Britain, Brazil, Japan, Egypt, the Philippines, Korea, Brazil, and Oman, among other nations, have selected Sheridan-Kalorama for their country's chancery and/or ambassador's residence. It is also home to the ambassador of the European Commission, one of the institutions that make up the European Union.

The presence of the diplomatic community contributed to the stature and stability of the neighborhood and, unlike many neighborhoods close to the city's center, Sheridan-Kalorama did not suffer a decline after World War II. However, as conversions of residential buildings to embassy office use continued in subsequent decades, the District of Columbia began encouraging foreign countries to select other Washington neighborhoods for their chanceries, thereby helping to maintain the residential character of the neighborhood.

Kalorama's only commercial area lies along Columbia Road, which forms the southeastern boundary of Kalorama Triangle. Before 1920 there were only a few shops on Columbia Road west of 18th Street, but by mid-century there were restaurants, grocery and drug stores, cleaners, and various small shops serving local residents. Kalorama was also served by the commercial corridor along Connecticut Avenue south of Florida Avenue in Dupont Circle. Catering to an upper-income clientele, the antique stores, automobile showrooms, and shops selling food, drugs, and furnishings had begun to appear in the early 1900s.

Residents of Kalorama established the Kalorama Citizens Association in 1919, one

(opposite)
Brick row houses, such as these that today march around the curve in the 1800 block of Mintwood Place, went up on 19th Street, Calvert Street, Columbia Road, and Kalorama Road in Kalorama Triangle in 1899 and 1900. Architects applied the popular styles of the day to these row house forms. Here are the Italianate style, with the bracketed cornices in the center of the photograph, and a restrained version of the Romanesque Revival style with dark red brick, brownstone lintels, and towers toward the end of the street. Photo by Kathryn S. Smith

of many citizens groups formed in Washington, D.C., in the late nineteenth and early twentieth centuries. The organization addressed both local issues, such as transportation on the Connecticut Avenue corridor, and citywide issues, such as water supply and taxation for the larger community. With the passing years, its focus became directed more to problems confronting Kalorama Triangle, continually challenged by the problems associated with an ever-changing and overpopulated commercial retail and restaurant and bar trade along its eastern edge and inappropriate (but legal) development on its few remaining vacant lots.[18]

Sheridan-Kalorama has not had to face commercial pressure but has been ever vigilant in its efforts to protect the neighborhood's physical character. The Sheridan-Kalorama Neighborhood Council, active since the 1950s in civic affairs affecting the neighbor-

hood, has led the charge against the proliferation, both in number and in size, of embassy residences and chanceries west of Connecticut Avenue. With the Advisory Neighborhood Commission, it has also worked with citizens to deal with the closing of the remaining public school within its boundaries, the noise and traffic caused by seemingly continuous construction as owners update early twentieth-century residences and transform large one-family houses into multifamily apartments, and ever-increasing parking pressures. Beyond acting as a voice for the residents on these significant urban issues, both the Kalorama Citizens Association and the Sheridan-Kalorama Neighborhood Council were behind the creation of formal historic districts to protect their respective jurisdictions. Kalorama Triangle was listed on the National Register of Historic Places in 1987; Sheridan-Kalorama in 1989.

While Kalorama Triangle and Sheridan-Kalorama have distinct characteristics, they both illustrate the fashionable aesthetics of the early twentieth century. Sheridan-Kalorama is a showcase of some of the city's finest privately commissioned single-family residential architecture; Kalorama Triangle provides testimony to the value of good design in middle-class speculative housing. Together, the neighborhoods open a window on Washington's middle- and upper-class twentieth-century ideals.

These twentieth-century neighborhoods have grown in harmony with the wooded and hilly topography. Their cohesive design—in architecture and landscape—illustrates a continuing respect for the pastoral character that prompted Joel Barlow to christen the land "Kalorama."

Chevy Chase

A BOLD IDEA, A COMPREHENSIVE PLAN

JUDITH HELM ROBINSON

Chevy Chase sits directly on the line between Maryland and the District of Columbia, with sections of development spilling into both jurisdictions and onto both sides of Connecticut Avenue. Exemplifying the new suburban ideal so admired in the last decades of the nineteenth century, the quiet, picturesque community of Chevy Chase today bears the indelible stamp of its founders' original concepts and the land-use tools used to shape it. The contemporary urban profile its founders sought to prevent — crowded alleys, row houses, industrial and commercial intrusions — is still absent. It is the "home suburb" they envisioned, stable, comfortable, and close to the heart of the city.

Broad verandas, patterned shingles and half-timbering, sleeping porches, decorative cornices, pergolas, and a variety of rooflines define a wide range of residential architectural styles. Quality of life today is defined by stately trees, broad streets, green lawns, and comfortable houses. The hub of Chevy Chase Circle establishes a strong sense of place, along with the churches that line its circumference, the Chevy Chase Village Hall, two quietly elegant private clubs, and two carefully defined and geographically restricted shopping areas on the west along Wisconsin Avenue and just south of the circle on Connecticut Avenue. A Metrorail station at Wisconsin and Western avenues and five Metrobus lines provide easy public transportation in and out of the central city.

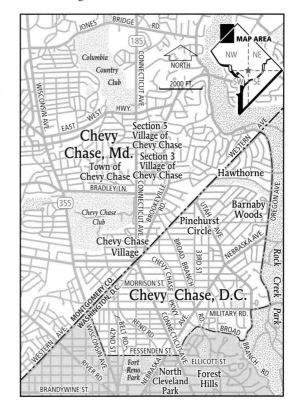

There are varied perceptions of the extent of Chevy Chase, D.C., but the most commonly accepted boundaries seem to be those represented by this map. The neighborhood as shown here overlaps with Friendship Heights on the west. The Chevy Chase Citizens Association serves an area south of Fessenden, overlapping with North Cleveland Park and Forest Hills. Residents also identify with the smaller communities of Hawthorne, Barnaby Woods, and Pinehurst Circle.

Chevy Chase, Maryland, is also variously defined. The Chevy Chase Land Company owned land up to Jones Bridge Road, and communities on both sides of Connecticut Avenue that far north consider themselves socially and historically part of Chevy Chase, Maryland. The neighborhoods named on this map are directly descended from the first Land Company developments, and each has its own locally elected community council. Map by Larry A. Bowring

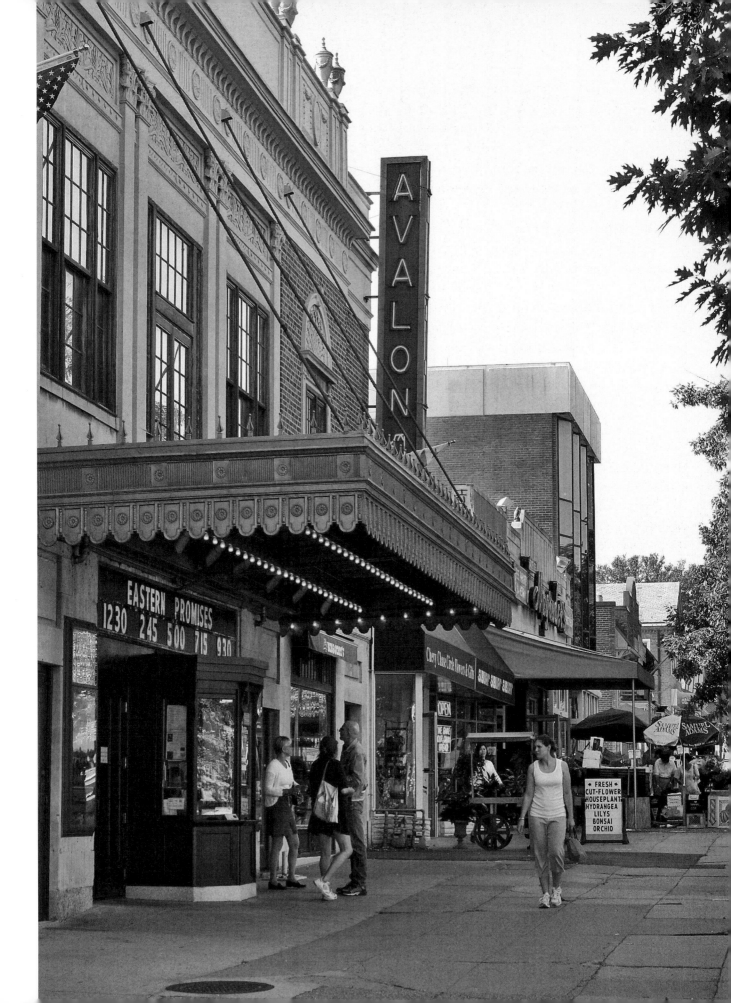

Chevy Chase is the result of a progressive, bold scheme that took long-term financial resources and decades to realize. It required the initial purchase of more than 1,700 acres of farmland; the formation of a development company with a capital stock of $1 million; the ambitious construction of Connecticut Avenue's broad reach of more than five miles above Calvert Street; the creation of an electric railway line; and the establishment of clubs, churches, and schools to fill the new residents' needs. And it was all done to the highest-quality standards.

Perhaps even more important, Chevy Chase illustrates a new suburban ideal that altered the city landscape in the late nineteenth century — one that favored the separation of residences from the workplace. Exemplifying the ideal of country living espoused by luminaries such as Frederick Law Olmsted, Chevy Chase provided then-unprecedented infrastructure and amenities that prompted new residents to live far outside the settled bounds of Washington. The suburb's founders provided transportation, electricity, sanitary sewers, telephone, and piped water, as well as strict building restrictions that banned commerce — in a comprehensive manner long before this type of planning was envisioned by others anywhere in the nation.[1]

In 1890 the area that was to become the new subdivision of Chevy Chase was well-settled farmland, studded with country estates and farmhouses and crossed by several country roads. Brookeville Road ran from Tennallytown to Brookeville, Maryland. Broad Branch Road, Jones Mill Road, and Milkhouse Ford Road wound through the farms. The only east-west connection between Brookeville and Old Georgetown roads was Jackson Road, now Bradley Lane. J. H. Bradley's large tract, later to form the key purchase of the Chevy Chase Land Company, straddled the line between Maryland and the District of Columbia.

Two wealthy and powerful westerners transformed this farmland into a suburban community. On June 5, 1890, Francis G. Newlands and Senator William M. Stewart (a member of a group known as the "California Syndicate" who at that time had land holdings around Dupont Circle) incorporated the Chevy Chase Land Company. Their long-range vision was extraordinary, for the site they chose to develop began far northwest of the settled bounds of the city of Washington and was to become the first big development west of Rock Creek. The bridge they built across Rock Creek at Calvert Street opened a large section of the Northwest quadrant of the city to new real estate ventures for themselves and others.[2]

At the time of incorporation, Francis G. Newlands was a young San Francisco lawyer. Early in his practice he had become attorney for William Sharon, a senator from Nevada from 1875 to 1882 who made a tremendous fortune revitalizing and managing the rich Nevada Comstock Lode. In 1874 Newlands married Sharon's daughter Clara Adelaide. Following her death in 1882 and William Sharon's death in 1885, Newlands became trustee of Sharon's huge estate, was himself one of the heirs, and managed major land holdings in California and Nevada. Newlands quickly moved some of his share of the assets to Washington. In 1892 he was elected to Congress, where he was a great

(opposite)
The 5600 block of Connecticut Avenue in the District draws Chevy Chase residents for shopping, indoor and outdoor dining, and movies at the Avalon. Photo by Rick Reinhard

Distinguished Senator Francis G. Newlands checks out the news. His Chevy Chase Land Company and associated enterprises privately financed the extension of Connecticut Avenue to and beyond the District line, bridged Rock Creek valley, and created an electric streetcar company to link his new suburb to downtown. Courtesy Library of Congress

proponent of irrigation and land reclamation in the West. He served as congressman from Nevada for ten years (1893–1903) and then as senator for fourteen years (1903–17).[3]

William M. Stewart, lawyer and two-time senator from Nevada (1864–75, 1887–1905), made his fortune investing in prospecting for gold in California and representing the legal interests of the original miners of the Comstock Lode. He was a leading political figure in the West, among other things carving out the Nevada Territory and representing western mining interests and railroads in Congress over a twenty-nine-year period.

Newlands and Stewart had experience with large-scale real estate ventures in California and Nevada and a shared confidence in the future growth of Washington. They had been involved in other speculative land ventures in the city — at Dupont Circle, for example — albeit on a smaller scale than in Chevy Chase.[4]

Newlands is most often credited with being the primary catalyst for the development of Chevy Chase. He attracted a powerful and talented group of men to his new Chevy Chase Land Company. Stewart was a partner, purchasing a large amount of the first issue of Land Company stock. Perhaps more important, Stewart was a strong legislative supporter in Congress, backing both the creation of Rock Creek Park and the charter of the streetcar line.[5]

Beginning in 1887, Newlands launched an ambitious plan. His goal was to buy any parcel that touched on his projected length of Connecticut Avenue. Through straw purchases made secretly by his agents under a variety of names, he quietly bought farmland amounting to more than 1,700 acres along the entire proposed length of Connecticut Avenue from Boundary Street in the District to what is now Jones Bridge Road in Maryland. Edward J. Stellwagen was in charge of the majority of operations, and Major George Augustus Armes acted as principal sales agent for the acquisitions. All holdings of the agents and trustees were transferred to the new Chevy Chase Land Company on June 5, 1890.[6]

Newlands's key early purchase was Chevy Chase, a 305-acre plot straddling the line between Maryland and the District of Columbia. The name, which he subsequently adopted for the entire new subdivision, can be traced to the larger tract of land called "Cheivy Chace" that was patented to Colonel Joseph Belt from Lord Baltimore on July 10, 1725. It has historic associations to a 1388 battle between Lord Percy of England and Earl Douglas of Scotland over hunting grounds, or a "chace," in the Cheviot Hills between Scotland and England. Part of the land patented in 1725 to Colonel Belt was sold in 1815 to Assistant Postmaster General Abraham Bradley. It was later acquired by businessmen and speculators, and then sold to the Chevy Chase Land Company.[7]

Newlands was a far-sighted businessman, intent on the finest quality of develop-

ment. His goals are captured by a 1916 promotional brochure titled "Chevy Chase for Homes":

> In the ordinary real estate development too frequently everything is sacrificed for quick financial returns, but this has not been done in Chevy Chase. Back of the development, so far as it has progressed today, is a big, comprehensive plan, and the men who formulated that plan believed that the best results could be obtained only where things were done right. . . . Instead of developing one small tract without regard to the surroundings, the owners acquired more than two thousand acres of land and have spent hundreds of thousands of dollars in street improvements and the installation of every municipal convenience.[8]

Roderick S. French in his study of Chevy Chase points out that Newlands succeeded in keeping control and holding to quality standards in a way few other developers in the nation were able to do. "Newlands had the utmost interest in shaping the form and quality of the development," French explained. "In order to achieve that control, he was willing to forgo profit for himself and his investors for 30 years. He had, or had at his disposal, the capital necessary to such a comprehensive, long-term undertaking."[9]

His vast share of his father-in-law's estate was the cornerstone of the plan. Two other important financial and real estate alliances were also crucial. The Union Trust Company, organized in 1899, was integral to the long-term financing necessary for large-scale development. The real estate mortgage investment banking firm, Thos. J. Fisher & Co., organized in 1872, became the real estate department of the Union Trust Company and the exclusive leasing agent for the Land Company business from their offices. Stellwagen, vice president of the Land Company, was a link to both organizations, as president of Union Trust and president of Thos. J. Fisher & Co.

Newlands was among the first speculators who saw the development potential for the electric streetcar, and Chevy Chase may be one of the first suburban neighborhoods nationwide that was intentionally planned and built to take advantage of this mode of transportation. The Land Company's first task was to connect the new subdivision with Washington. Newlands privately launched the construction of Connecticut Avenue far beyond the improved streets of the central city into the rugged countryside to the north, following the route of land he had purchased. Workers excavated more than five miles of roadbed, bridged ravines, and constructed a series of deep cuts and fills. Much of this was done using pick and shovel and horse-drawn carts. Trestle bridges were constructed over Rock Creek at Calvert Street and at Klingle Valley (Klingle Street) in 1891. The expense of the entire project was borne by the Land Company. The deep chasm of the Rock Creek Valley had effectively separated the rural areas of the District northwest of the creek from the central city; with the new bridge, they were now open for development.[10]

At the same time the company constructed an electric railway at an initial cost of $1.5

The trestle bridge built in 1891 by the Land Company across the deep Rock Creek gorge at today's Calvert Street dominates the center of this image from a 1910 promotional brochure. The 1907 Taft Bridge that carried Connecticut Avenue directly across the creek is seen at the left. Courtesy DC Public Library, Washingtoniana Division.

million. The Chevy Chase Land Company allied itself with the fledgling Rock Creek Railway Company, with Newlands as its president and principal stockholder. The first segment of the line opened in 1892 and the rest soon thereafter. On May 31, 1903, the *Washington Post* reported that streetcars made the six-mile run from the Treasury at 15th Street and Pennsylvania Avenue to Chevy Chase in exactly thirty-five minutes, leaving every fifteen minutes.[11]

At the northern terminus of the line, two miles beyond Chevy Chase Circle, the Land Company built a water reservoir for generating electric power with steam turbines. Shortly thereafter, it constructed a small lake and an amusement park to lure prospective home buyers (once located east of what is now the intersection of Connecticut Avenue and Chevy Chase Lake Drive). Pleasure-seekers flocked to Chevy Chase Lake on the trolley for concerts at the bandstand, which was a giant blue seashell covered with hundreds of twinkling lights. They rowed on the lake for five cents a half hour, bowled, rode the carousel and live ponies, tested their skills at the shooting gallery, and danced the two-step at the dance pavilion.[12]

The first section of the new suburb to be laid out was between Chevy Chase Circle on the District line and Bradley Boulevard in Maryland, a section that is known today as Chevy Chase Village, or Section 2. It opened in 1893. Plans included broad streets, large lots, and parkland. Strict building regulations and covenants governed what future residents could build. Houses fronting on Connecticut Avenue were to cost not less than $5,000 each, and on other streets not less than $3,000. Houses constructed on Connecticut required a setback of thirty-five feet, and on side streets, twenty-five feet. No lot could be less than sixty feet wide. Alleys, apartments, and row houses were forbidden, and no business was to be conducted in the section. The guarantee of an exclusively residential suburb was tied to the strict ban of any commercial enterprises on

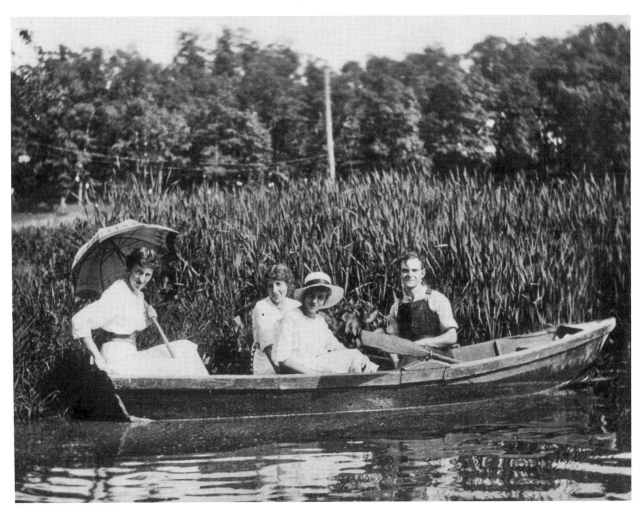

This group is enjoying a boat ride on Chevy Chase Lake, a popular recreational destination that enticed potential buyers to the new suburb. Dammed by the Land Company in 1893, the lake also provided water to the powerhouse that generated electricity for the streetcar and the residential neighborhood. *Courtesy Montgomery County Historical Society.*

Land Company lots. (Other areas were set apart for that purpose.) Stables and carriage houses were not to be erected within twenty-five feet of the front line of any lot. Similar restrictions were enacted in other sections developed later by the Land Company.[13]

The first houses in the Village were built by or for officers of the Chevy Chase Land Company, and three of the original four houses remain. An article in the November 1920 issue of the *Chevy Chase News*, written by Chevy Chase's first schoolmistress, Ella Given, names the first houses and their residents. According to her account, the four original homes — all in the vicinity of Connecticut Avenue and Irving Street — were designed by nationally known Philadelphia architect Lindley Johnson, with Washington architect Leon E. Dessez as his associate. Dessez himself was the first resident, moving into the house known today as the Lodge, just northwest of the circle at 5804 Connecticut Avenue, in May 1893. Senator Newlands was the resident of a grand house (originally built for Senator Stewart) at no. 9 on the northeast side of the circle. Howard Nyman, secretary of the Land Company, moved into the residence at the northeast corner of Connecticut and Irving (no longer extant), and Herbert Claude moved into the

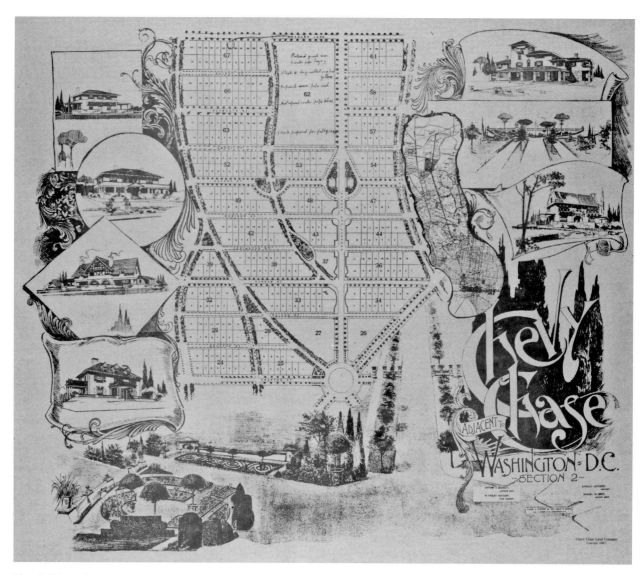

Thos. J. Fisher & Co., agents for the Chevy Chase Land Company, featured some of the suburb's fine houses and landscaped streets and parks in this 1890s map of Section 2 in Chevy Chase, Maryland, a section today known as Chevy Chase Village. Courtesy the Chevy Chase Historical Society

house at 5900 Connecticut Avenue on the northwest corner of the avenue and Irving Street. As described in Given's article, "These four houses, artistic and homelike, struck the keynote for the community which was to grow up around them."

From the outset Chevy Chase attracted the best of residential design, bolstered by the high minimum price for houses stipulated in the building regulations. Initially, the Land Company engaged the talents of architect Johnson and New York landscape architect Nathan Barrett. Johnson, a successful and sophisticated Beaux-Arts architect known for his large country houses and resort structures, received several key commissions in 1892, including six "cottages" (actually large residences) and homes for Stewart and Stellwagen. Barrett, who had been associated with Johnson at the prosperous early resort communities of Winter Harbor, Maine; Tuxedo Park, New York; Ponce de Leon, Florida; and other developments, devised the landscape plan in Chevy Chase. Along

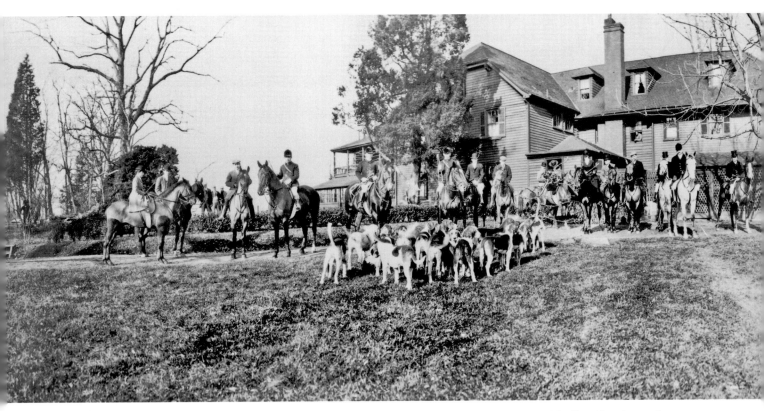

The Chevy Chase hunt gathers in 1903 in front of the pre–Revolutionary War farmhouse of Abraham Bradley, which served as the first clubhouse of the Chevy Chase Club from 1894 to 1911. The Chevy Chase Club was originally organized as a country club, rather than as a place to hunt or play golf, although those elements were there from the first. Courtesy Library of Congress

with local architect Dessez, who is perhaps best known in Washington for his design of the Admiral's House on Observatory Circle, NW (now the vice president's residence), they set a tone of gentility with a few late Shingle-style houses and Colonial Revival houses in vogue in the 1890s. Newlands made Dessez a director of the Land Company in 1893 and gave him the responsibility of preparing the strict building regulations and for building two houses for sale.[14]

Newlands and the Chevy Chase Land Company provided every comfort and convenience within their control, including water from artesian wells and attractive surroundings. Under Barrett's direction, a gracious landscape plan, with curvilinear streets, shade trees, and ornamental shrubbery, was devised and partially executed. In addition to native trees such as tulip, poplar, oak, and locust, he specified many imports such as English elms, Japanese boxwood, pin oak, linden, and sycamore. Distinctive double rows of trees lined major streets.[15]

The 1916 sales brochure published by Thos. J. Fisher & Co. maintained that "the best suburban section is always surrounding or adjacent to the leading suburban clubs." Land Company officers had, in fact, organized the Chevy Chase Club in 1890 soon after the formation of the company itself, with Newlands as its first president. It was a country club devoted mainly to riding and the hunt, in the days when members rode to the hounds two or three times a week in season. The club adopted golf when that sport became popular. The old Bradley farmhouse on Connecticut Avenue served as the first

clubhouse and was later remodeled into a guest house, incorporating portions of the old farmhouse.[16]

The Land Company donated land for the first public school. Opening its doors in 1898, it was a small, four-room building surrounded by an expanse of mud, with a plank for a front stairway. It was located on the east side of Connecticut Avenue at McKinley Street, NW, where the District's Chevy Chase Neighborhood Library stands today. In 1901 the Land Company also gave land on the northwest side of Chevy Chase Circle for the first church in the Village, the All Saints Episcopal Church, organized in 1897. The post office building, now the Chevy Chase Village Hall at 5906 Connecticut Avenue, was a small, pebble-dashed structure that also accommodated the public library, an "artistically decorated room" with a collection of one thousand books, as well as the fire apparatus, including a fire engine, hose cart, and hook-and-ladder. The fire bell was located just south of the building.[17]

Following the opening of Chevy Chase Village in 1893, the Land Company planned additional sections in both the District and Maryland. A core group opened in the following order: Section 3 (1905), east of Connecticut Avenue and north of Bradley Lane; Chevy Chase, D.C. (1907), located immediately southeast of the circle; Section 4 (1909), west of Connecticut between the Chevy Chase and Columbia country clubs; Chevy Chase Heights (1910), west of Connecticut about a half mile south of the circle; and Section 5 (1923), east of Connecticut above Section 3.[18]

The Chevy Chase, D.C., subdivision opened in 1907, east of Connecticut Avenue, bounded by Morrison Street, the District line, and a curved street to the east that became Chevy Chase Parkway. The subdivision mirrored the picturesque layout of Section 2 in Maryland. The Land Company restricted development to residential only, as it had in Maryland, and provided the same level of amenities — city water, electric lights, paved streets, sewers, and fine landscaping. However, the District plan had narrower lots, smaller setbacks (fifteen feet), and service alleys. The first home to be built in the new subdivision was P. L. Ricker's house at 3740 Oliver Street.[19]

The second Land Company development in the District, Chevy Chase Heights, followed in 1910, a larger area west of Connecticut Avenue that stretched north from Fessenden to Keokuk Street (now Military Road), bounded by Belt Road on the west, with Reno Road winding through it. A 1913 *Evening Star* article reported there were already forty-two houses in the subdivision and described it as "a miniature town within itself." In time this development and others nearby would come to share the common neighborhood name of Chevy Chase, D.C.[20]

Through the 1920s, the Land Company added a few sections and expanded others. Originally, Section 1 lagged behind in the development chronology because it was set aside as hunting grounds; land added to Section 2 in 1925 took this title on maps, although it never gained widespread use. Although each section maintained a slightly distinct character, the largest difference was the commercial hub just south of Chevy Chase Circle.[21]

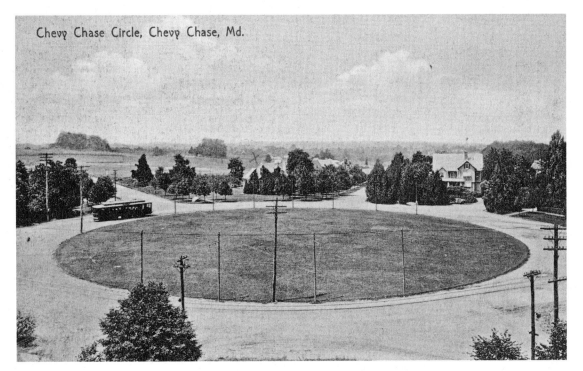

Chevy Chase Circle, Chevy Chase, Md.

Chevy Chase Circle and environs were still largely undeveloped in the first decade of the twentieth century, as is clear in this photograph taken about 1910 looking west toward Western Avenue, which enters the circle to the left. Grafton Street enters the circle at the top of the picture. Advertised as the "twin suburbs," development in Chevy Chase straddled the line between the District of Columbia and Maryland at Western Avenue. From a postcard published by Minnie E. Brooke of Chevy Chase, Maryland. Courtesy Julie R. Thomas. Collections of the Chevy Chase Historical Society

Local landowners and real estate speculators, aware of the opportunities presented by the new development, quickly took advantage of the undeveloped adjacent lands and were responsible for entire communities of homes. In the District, in 1907 and 1909, Fulton Gordon purchased two parcels of land from Charles C. Glover, the president of Riggs Bank. Gordon subdivided the land located west of Connecticut Avenue and north of Chevy Chase Heights as Connecticut Avenue Terrace and Connecticut Avenue Park. Gordon did not prohibit commercial development — or multifamily homes or apartments, as the Land Company parcels did — which would have major implications for the future of this section of Connecticut Avenue. In Maryland, Otterbourne, Norwood Heights, Sonnemann's Additions, Martin's Additions, Leland, Mikkelson's Subdivision, and additional lands were folded into Chevy Chase's boundaries. Often, however, the Land Company sold lots to individuals or in small groups for development. Evidently, in a few cases — perhaps to open a new section for development — the company built houses, but this was the exception.

Despite all of the amenities, land sales in Chevy Chase went slowly in its first decades. The first section, the Village, opened in the economic panic year of 1893. Only twenty-seven houses were occupied by 1897, and it required all the long-term financial

solidarity of Newlands and his company to withstand the collapse of the boom of the previous decade. In fact, disbursements exceeded receipts for years. The Land Company would pay no dividends to stockholders until 1922, five years after the death of Francis Newlands. Accounts of growth patterns in Chevy Chase are varied; however, it appears that there were fewer than fifty families (unidentified by location) by 1900.[22]

The Land Company was perfectly situated, however, to benefit from the expansionary period that followed World War I. Between 1918 and 1931, sales totaled more than $7.5 million. By 1916 Thos. J. Fisher & Co. reported that Section 2, Section 3, and Chevy Chase, D.C., were practically sold out, with sites still available in Section 4 and Chevy Chase Heights.[23]

Because Chevy Chase's commercial development was strictly limited and controlled, the Land Company arranged for goods to be delivered to early residents. The *Chevy Chase News* of November 1920 described the system:

> Coal was ordered through the Land Company, and during the summer months a wagon was sent into the city for ice several times a week. If medicine were needed it could be telephoned for and delivered to a car conductor at Fifteenth Street and New York Avenue, or anywhere along the route. . . . The conductor would get off the car at Connecticut Avenue and Irving Street and put the medicine into a small box erected for that purpose.

The only flourishing local store was Theodore Sonnemann's general store on Brookeville Road in Maryland. The Land Company had set aside one block in its Chevy Chase, D.C. subdivision, today's 5700 block on the west side of Connecticut Avenue just north of Northampton Street, for future business development, but nothing commercial would be built there until 1952.[24]

It was on Fulton Gordon's tracts on the same side of the avenue just to the south — which had no commercial restrictions — where the first stores were built in what would become the Connecticut Avenue shopping strip of today. By 1910 W. B. Follmer's grocery store was serving customers at 5630 Connecticut Avenue, and Doc Armstrong's drugstore, adjacent to it, opened soon thereafter. By 1915 there were four stores between McKinley and Northampton streets, and by 1927 almost thirty businesses shared the 5500 and 5600 blocks on the west side of the avenue. Some of these businesses were housed in the attractive small building called the Chevy Chase Arcade, built in 1925 by developer Edward Jones, also president of the Chevy Chase Savings Bank. The bank opened the next year in an adjacent building designed by noted architect Arthur B. Heaton. Commercial uses on Land Company land to the south and on the east side of the avenue were ironically slowed by neighborhood challenges to the company's own plans for appropriate development. It would not be until 1973 that a Safeway grocery store would open on the east. The Chevy Chase Library and Community Center were built nearby three years earlier, on the site of the old E. V. Brown School.[25]

The four blocks between Livingston Street and Chevy Chase Circle thus became

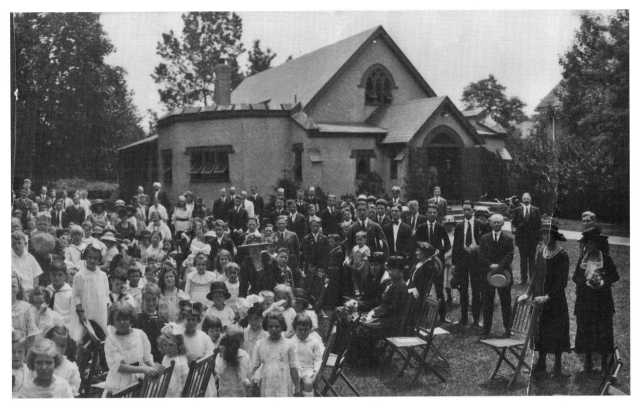

The Chevy Chase Presbyterian Church Sunday School gathers for a photograph in front of the church on Chevy Chase Circle on May 22, 1921. The growing congregation replaced this original church with a larger building on the same site in 1923. Courtesy Chevy Chase Presbyterian Church

something of a community center for the neighborhood. Peggy Fleming, who moved to the neighborhood in the 1960s, remembered walking to do her daily errands there and going to the movies at the Avalon. "On Sundays we picked a number and stood in line at Schupps to buy donuts. Once a week we had moo shi pork and pancakes at the Peking. On Christmas Eve, the dads met at Peoples for last-minute purchases of batteries for the toys Santa Claus would deliver later in the evening. . . . In 1968 our son got his first haircut at Chevy Chase Arcade Barbers from Jose Palupa."[26]

Aside from this hub of commercial activity, the character of Chevy Chase has always been a predominantly residential community. According to the 1916 promotional brochure: "The fixed purpose of The Chevy Chase Land Company was to provide for the National Capital a home suburb, a community where each home would bear a touch of the individuality of the owner, where each home would possess an added value by virtue of the beauty and charm of the surrounding homes."

Houses of all sizes make up the different sections of Chevy Chase. Although Chevy Chase was planned to "meet the requirements of discriminating people," the brochure noted "that does not necessarily mean, in our opinion, people of great wealth. Scores of those of moderate means make their homes there." Residents have always maintained a range of occupations, from judge, senator, and physician to teacher, bookkeeper, bureaucrat, lawyer, and accountant.[27]

When construction in the neighborhoods picked up after World War I, following

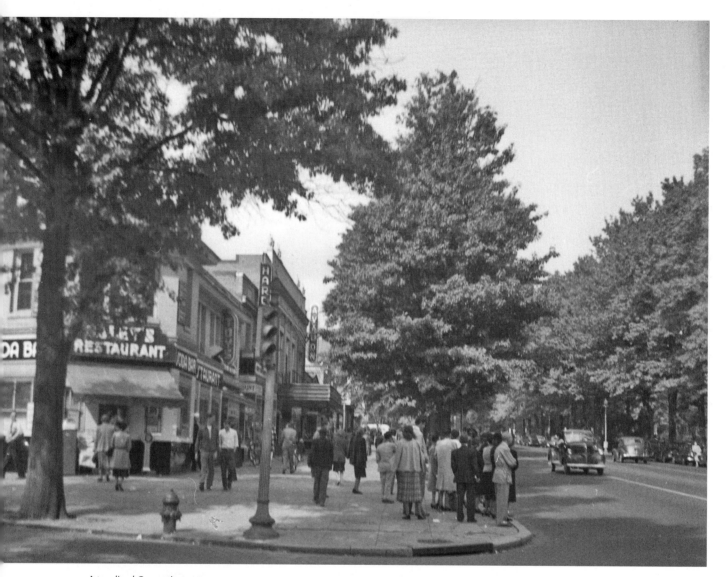

A tree-lined Connecticut Avenue at McKinley Street draws shoppers and strollers in October 1948. The blocks on the west side of the avenue between Livingston and Northampton streets had become a community gathering place. Photo by John P. Wymer. Courtesy The Historical Society of Washington, D.C.

the long slowdown after the panic of 1893, one style of architecture tumbled out on the heels of the preceding one. Virtually all of the late nineteenth- and early twentieth-century styles are represented today, including the Shingle, Colonial Revival, Tudor, French Eclectic, Spanish Eclectic, Mission, Neoclassical, Italian Renaissance, Prairie, Art Deco, and Craftsman styles. Only Modern and International style houses are largely missing. Bungalows mix with grand Colonial Revival mansions, and designs range from formal architect-designed houses to Sears prefabricated structures. An extraordinary mix of talented local designers is represented, including Arthur B. Heaton, George S. Cooper, Thomas J. D. Fuller, Edward W. Donn, Waddy Butler Wood, Clarence Harding, A. M. Sonnemann, Porter & Lockie, and Dan Kirkhuff, as well as prominent builders or developers such as Harry Wardman, Weaver Brothers, and M. and R. B. Warren.

The homes of Jocelyn Street provide the background for this neighborhood Fourth of July parade in the 1970s. Photo by Peggy Fleming. Courtesy The Historical Society of Washington, D.C.

Along Connecticut Avenue in the District, apartment houses began to dominate early in the twentieth century. Fulton Gordon's Connecticut Avenue Terrace and Connecticut Avenue Park developments allowed this form of housing, which became increasingly popular in a city with government employees and others coming to the city to work for a short time. As early as 1930, the few blocks between Military Road and Morrison Street offered accommodations in five different apartment buildings.[28]

Today the basic character of Chevy Chase as planned by the Chevy Chase Land Company in the 1890s has not changed, a powerful indication of the uniqueness of Newlands's enterprise. The large majority of the houses built over the years are extant, although the recent pressure to tear down existing houses to accommodate much larger ones is affecting the neighborhoods. Although there have been additions to the boundaries of the earliest land developed by the Land Company, the original sections still exist, each with its own character and identity. The Maryland sections each have an elected neighborhood government — headed by a section council or board of managers that can contract for street improvements, police and fire protection, and the like — while the corollary in the District of Columbia sections are the Advisory Neighborhood Commissions that advise the District government on issues affecting their communities.

Residents of both Chevy Chase, Maryland, and Chevy Chase, D.C., continue to identify with the shops, restaurants, and services on Connecticut Avenue south of the

Houses in Chevy Chase today display a wide array of late nineteenth and early twentieth-century architectural styles such as this residence in the 3700 block of Morrison Street, an eclectic mix of Prairie School and Colonial Revival. Photo by Kathryn S. Smith

Circle, now with sidewalk cafes, park benches, and flower boxes that make it even more of a gathering place. When Loew's closed the 1920s Avalon movie theater in 2001, alarmed residents created the Avalon Theatre Project, and the next year they leased the building and began to operate the theater as a nonprofit community venture. Over the years, the merchants have become more diverse: a 2005 survey revealed that people working in the area had been born in more than fifty countries, from Guatemala and Austria to Korea and Yugoslavia.[29]

Commercial incursions have continued to be strictly controlled in residential Chevy Chase, and in 1928 the thrust of larger commercial development shifted to the neighborhood's western edge, along Wisconsin Avenue. Here the Land Company built Chevy Chase Center in the 1950s, bringing additional shops and offices to that area. The area became a large and sophisticated commercial district centered on the Friendship Heights Metrorail station, with the Land Company involved in much of the new development even in 2008.[30]

The Chevy Chase Land Company still exists, largely owned by descendents of Senator Newlands and collateral heirs. After Newlands's death in 1917, Stellwagen became president, followed in turn by Edward L. Hillyer. Until the mid-1930s the company sold land and liquidated assets for distribution to shareholders. In 1946 William Sharon Farr assumed the presidency, and the company strategy changed as it began to develop its holdings into long-term, income-producing properties. Farr's son, Gavin, the great-grandson of Senator Newlands, currently serves as chairman of the board. A 1983 Land Company advertisement for an apartment building at 8101 Connecticut Avenue (occupying the original site of the streetcar barn at the northern terminus of the Chevy Chase line) fittingly described the structure as "built by the Chevy Chase Land Co. on land they selected and acquired in 1890."[31]

Despite the passing of several characteristic features — Chevy Chase Lake was filled in during the 1930s, the electric railroad service was discontinued on Connecticut Avenue in 1935, the bridges at Klingle Valley and Calvert Street have long since been replaced, and Connecticut Avenue has been regraded several times — Chevy Chase itself stands as envisioned, a residential neighborhood, stable, comfortable, and quiet. Over a century later, it is a tribute to its bold original plan.

Cleveland Park

COUNTRY LIVING IN THE CITY

KATHLEEN SINCLAIR WOOD

Cleveland Park, the name used in 1894 to identify the first houses on Newark Street, is now applied to the area outlined on this map. Its centerpiece is the historic district designated in 1986, bounded generally by Connecticut and Wisconsin avenues, Woodley and Klingle roads, and Rodman and Tilden streets, but historians and civic leaders believe that the area defined here captures the larger sense of the neighborhood. Map by Larry A. Bowring

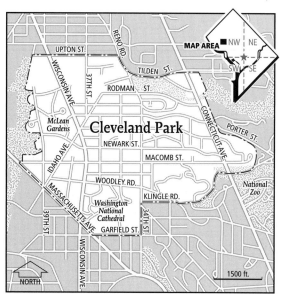

The tree-shaded streets of residential Cleveland Park are dominated by turn-of-the-twentieth-century frame houses, many with wraparound porches and front yards reminiscent of small-town America. Mixed among them are the remains of eighteenth- and nineteenth-century country estates, giving the neighborhood a layered physical presence that spans more than two centuries.

Inextricably linked to this quiet neighborhood are two shopping areas on the east and the west, along Connecticut and Wisconsin avenues. The avenues have a kinetic energy that has intensified since the late 1980s, in sharp contrast to the almost suburban quality of the adjacent streets. People arrive from all across the city by Metrorail, bus, and auto to join neighbors in restaurants, bars, coffee shops, and the Uptown Theater, the last movie theater in the city to boast a large screen. Tourists pass through on their way to the nearby National Zoo and the Washington Cathedral. On summer evenings both avenues are alive with people dining alfresco and strolling with friends and neighbors.

The apartment buildings, condos, and small businesses along the avenues add to the physical and social variety of the neighborhood, as do nearby churches, synagogues, and a multiplicity of schools, public and private. Even in the historic residential area, changes are occurring. New homes are filling the few empty lots, older homes are being renovated, and some development is taking place on the historic estates. Home prices have risen. However, after more than a century of growth, Cleveland Park, thanks in many cases to citizen action, retains its historic quality. The neighborhood retains physical reminders of all phases of its growth, from farmland in the eighteenth century, to country estates and summer homes in the nineteenth, to streetcar suburb by 1900. And long-time residents and local organizations continue to tout its dedication to the maintenance of a strong sense of community.

When the capital came to the Potomac, the area that is now Cleveland Park was rolling farmland in rural Maryland,

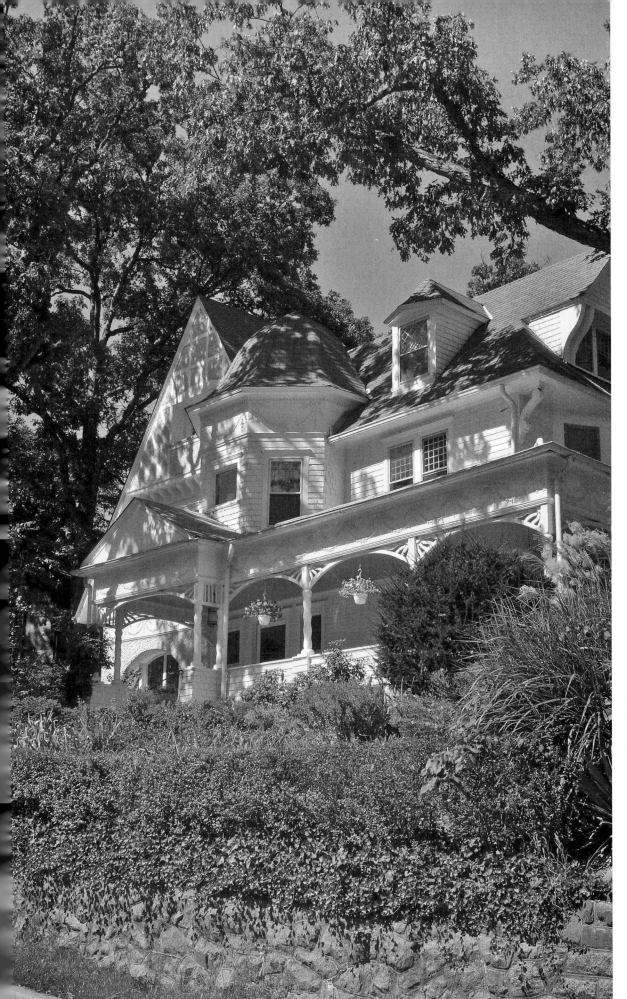

Large homes individually designed by a variety of accomplished architects, such as this Queen Anne–style residence on Newark Street near Highland Place, have characterized Cleveland Park since its early days as an 1890s suburb along the Connecticut Avenue streetcar line. Photo by Rick Reinhard

General Uriah Forrest, a former mayor of Georgetown and friend of George Washington, escaped the heat of the central city in a cottage near today's 36th and Newark streets. Naming the estate Rosedale, by 1794 Forrest had built this wooden farmhouse in front of the cottage. This undated image shows the house as it looked in the nineteenth century and substantially as it looks today. Courtesy The Historical Society of Washington, D.C.

part of a large land grant patented in 1723 by George Beall. It was adjacent to the road to Fredericktown, now Wisconsin Avenue, originally an Indian trail used by tobacco farmers taking their produce to the port of Georgetown. In the early 1790s part of this land grant was purchased by General Uriah Forrest, a former Georgetown mayor, delegate to the Maryland Assembly and Continental Congress, and friend of George Washington. He and his family spent the summers on the high land above Georgetown in a stone cottage, possibly constructed as early as the 1740s. By 1794 the Forrests had built a simple frame farmhouse in front of the cottage and named their expansive estate Rosedale. They became the first documented inhabitants of the area known today as Cleveland Park. The farmhouse and stone cottage remain in the 3500 block of Newark Street, with the latter now attached to the farmhouse. The cottage is likely the oldest extant building in the District of Columbia.[1]

During the first half of the nineteenth century the Rosedale property was gradually divided into smaller parcels and sold for country estates on the outskirts of the growing capital city. Philip Barton Key built Woodley House (now part of Maret School on Woodley Road) in 1801, Major Charles J. Nourse built the Highlands (now part of Sidwell Friends School on Wisconsin Avenue) in the 1820s, and H. H. Dent built Springland (still a private residence on Tilden Street) in the 1840s. English author Frances Trollope described this phenomenon in 1830: "The country rises into a beautiful line of hills behind Washington, which form a sort of undulating terrace on to Georgetown; this terrace is almost entirely occupied by a succession of Gentlemen's Seats."[2]

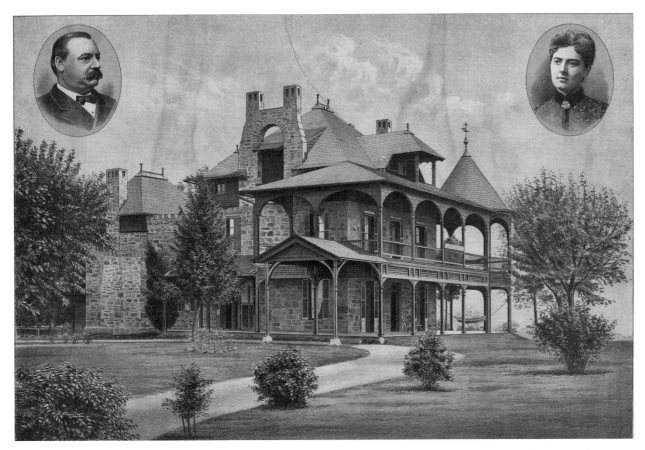

In 1885 President Grover Cleveland bought a stone country house, built by Uriah Forrest's grandson just south of Rosedale, and hired an architect to decorate it with fashionable porches and towers as a summer house for himself and his new young bride, Frances Folsom. Renamed Oak View, its corner tower afforded a grand view of the city below. Courtesy Library of Congress

By 1869 George Forrest Green, Uriah Forrest's grandson, had acquired some of the Rosedale estate and built his own home, named Forrest Hill, near the present-day southeast corner of 36th and Newark streets, NW. An early history of the neighborhood described it as "a roomy stone dwelling, built of native stone found on an adjacent field. It was a quiet home for a gentleman of moderate means and refined taste . . . on a hill commanding an extensive prospect, looking upon nothing but beauty and breathing nothing but health." It was this house that President Grover Cleveland purchased in 1885 on the eve of his marriage to his beautiful young ward, Frances R. Folsom. Extensive remodeling designed by W. M. Poindexter transformed the simple stone farmhouse into a fanciful Victorian summer house with a turret overlooking the city of Washington. Oak View, as he renamed it, served as the summer White House during Cleveland's first term in office from 1885 to 1889.[3]

Another summer resident was Gardiner Greene Hubbard, a Bostonian living at Dupont Circle and the founder of the National Geographic Society. In the mid-1880s he purchased fifty acres on Woodley Lane, bounded by today's Woodley Road on the south and the 3200 block of Macomb Street on the north. He hired Boston architect Francis R. Allen to design a frame Colonial Revival summer house. Situated on a hilltop overlooking a rolling lawn, Twin Oaks, as Hubbard named his estate, was the center

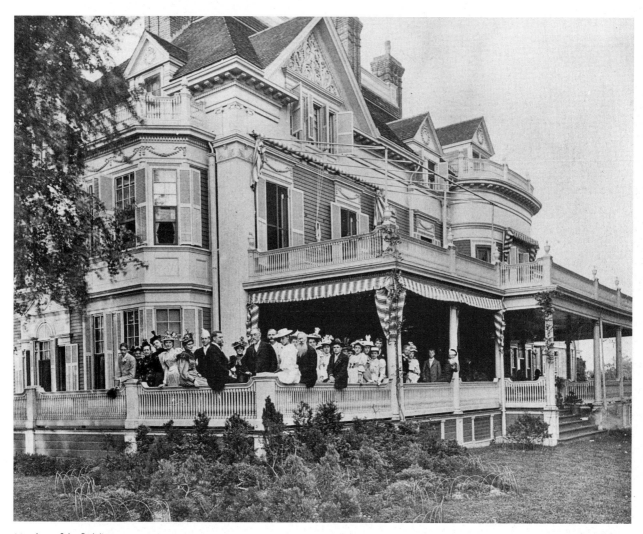

Members of the fledgling National Geographic Society gather on the ample porch of society founder Gardiner Greene Hubbard's fifty-acre summer retreat off Woodley Road. Known as Twin Oaks, the Colonial Revival–style house was designed by Boston architect Francis R. Allen in 1888. The house still stands, owned by the government of Taiwan. Courtesy Library of Congress

of family activities. The family included Alexander Graham Bell, an innovative educator of the deaf hired by Hubbard to teach his daughter Mabel. A romance blossomed between teacher and student: Bell became Hubbard's son-in-law and Hubbard became one of Bell's staunchest supporters and the financial backer of the nation's first telephone company. Twin Oaks remains as the only extant summer house in Cleveland Park; it is owned today by Taiwan, which continues to preserve this nationally designated historic landmark.

Tregaron, in the 3100 block of Macomb and extending south to Klingle Road, was built in 1912 as a year-round country estate named the Causeway on twenty acres, previously part of the Twin Oaks estate. Charles Adams Platt, a nationally known designer of country houses, was chosen by James Parmelee to design the Georgian Revival house. Platt, with the help of prominent landscape architect Ellen Biddle Shipman, prepared a landscape design and planting scheme for the grounds with rustic stone bridges and bridle paths. Ambassador Joseph Davies and his wife, heiress and socialite Marjorie

Alexander Graham Bell,
who married Gardiner
Hubbard's daughter Mabel,
poses here at Twin Oaks
with his wife and his mother-
in-law, Gertrude Hubbard.
Gardiner Hubbard would
become Bell's chief financial
backer in the creation of the
Bell Telephone Company.
Courtesy Library of Congress

Merriweather Post, settled here in the 1940s and added a Russian dacha after their re-turn from his post in the Soviet Union. In 1978 the Washington International School bought the house, dacha, gardener's house, and stable. The surrounding fourteen acres of landscaped gardens were bought by a developer, and the community spent the next twenty-eight years successfully fighting proposals for dense housing developments on the site.[4]

After Cleveland lost his bid for reelection in 1888, he sold his estate, but the president's brief presence was celebrated in the names chosen for three new subdivisions carved from his land and neighboring properties. Oak View, Cleveland Heights, and Cleveland Park were surveyed and platted by 1894. Of the three, Cleveland Park was the most suc-

cessful and over time absorbed the other two. Cleveland's house remained a summer residence for Colonel Robert I. Fleming, a successful Washington entrepreneur, but it deteriorated over the years and was razed in 1927.

Cleveland Park was one of many late nineteenth-century residential communities outside the old Washington City boundary designed to lure city dwellers with the advantages of country living close to the city. The *Washington Times* in 1903 hailed Cleveland Park as "Queen of the Washington Suburbs" and described its rural charms:

> The park is a cool and pleasant resort. The breeze from the hills makes life one grand sweet song, and the music of the birds stirs the soul.... It is within the District limits, and consequently enjoys every advantage which a downtown resident can claim and in addition, it is as beautiful a spot and as free from annoyance of the city as if it were in the heart of the Adirondacks.... There is every blessing of fresh country air, plenty of elbow room, woods and fields, peacefulness, coolness in summer and comfort in winter.[5]

The development and settlement of Cleveland Park was made possible by Senator Francis G. Newlands of Nevada, who created the suburb of Chevy Chase, Maryland, beginning in 1890. In the process, the Chevy Chase Land Company laid out Connecticut Avenue, built a bridge across Rock Creek at Calvert Street and a second bridge across Klingle Valley, and constructed the tracks for the electric streetcar, creating development opportunities all along its route. The opening of streetcar service in 1890 on Wisconsin Avenue and in 1892 on Connecticut Avenue connected the land that would become Cleveland Park with the city center, and real estate entrepreneurs soon recognized its potential.

In 1894–95 Thomas Waggaman and John Sherman formed the Cleveland Park Company and began constructing houses. It appears that Waggaman was the principal landowner and financier; Sherman, who was a younger cousin of Senator John Sherman, an early developer in the Columbia Heights neighborhood, was president of the Cleveland Park Company. He was responsible for the design, construction, and sale of houses from 1895 to 1909. Ella Bennett Sherman, his wife, was a New York-trained artist and active in the Cleveland Park Company from its inception. Records indicate that she probably designed most of the houses constructed between 1902 and 1909.

John Sherman had a vision for Cleveland Park that exceeded the usual speculative development pattern of buying cheap rural land, platting it in standard lot sizes, and selling the lots to homeowners who built their own houses. He took great pride in hiring fine architects to prepare individual designs for the houses in his streetcar suburb. Sherman also provided amenities for the residents. In 1898 he built an architect-designed stone lodge on Connecticut Avenue, which served as a community center providing comfortable heated space for neighbors attending meetings or waiting for the streetcar. The Cleveland Park Library occupies this spot today, marking the traditional entrance to Cleveland Park with a similar community-oriented facility. Sherman also provided

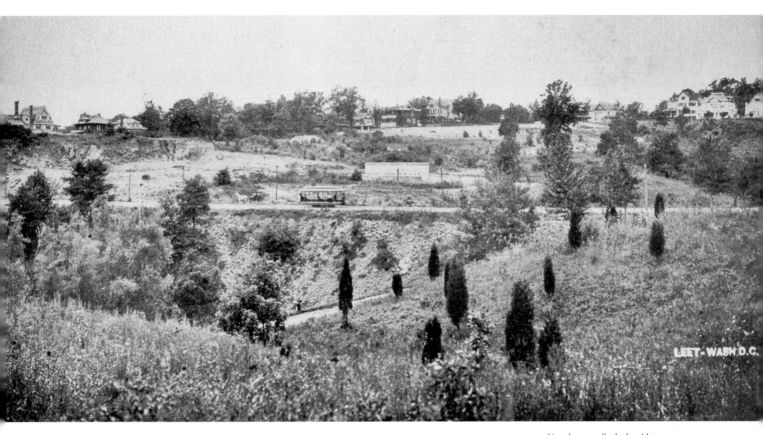

LEET-WASH D.C.

a stable for residents' horses and carriages, as well as a combined fire-engine house and police station.

Many notable local architects designed one-of-a-kind houses for the Cleveland Park Company. Between 1895 and 1901 Sherman employed Paul Pelz, one of the architects of the Library of Congress; Waddy Butler Wood, a popular architect of fine homes in Kalorama and elsewhere, including the Woodrow Wilson House; Frederick Bennett Pyle, a prolific commercial and residential architect; and Robert Thompson Head, whose numerous houses give the neighborhood an appearance of great architectural variety. The houses designed by these architects set the tone for the neighborhood and established its architectural character and distinctiveness.

A 1904 promotional brochure advertising the virtues of living in Cleveland Park emphasized its architectural variety: "Among the sixty houses of the Park, with a single exception there is no repetition of design. . . . The houses have been built in the last six years and planned by architects who combined in them beauty, durability and economy. . . . They are recognized as the most beautiful and artistic homes in the District. In fact, they are known and spoken of far beyond the limits of the District for their beauty and originality."[6]

The earliest houses were large frame structures resembling rambling summer cottages, with expansive porches and numerous Queen Anne– and Shingle-style details.

New houses climb the ridge along Newark Street in this extraordinary view of nascent Cleveland Park about the turn of the twentieth century. The electric streetcar is making its way downtown along Connecticut Avenue on its way from Chevy Chase. The sign to the right of the streetcar advertises Connecticut Avenue Highlands, an early development that became part of today's Cleveland Park. It sits in a stone quarry and marks the spot occupied by the Uptown Theater today. Courtesy Robert A. Truax

Connecticut Avenue's Park and Shop at Ordway Street, seen here shortly after it opened in 1931, was one of the first such complexes in the nation to feature parking directly in front of the stores. Its potential destruction for a high-rise development, encouraged by an adjacent Metrorail stop, spurred the community to seek historic district designation. The shopping center and the low-rise commercial district around it remain today. Courtesy Library of Congress

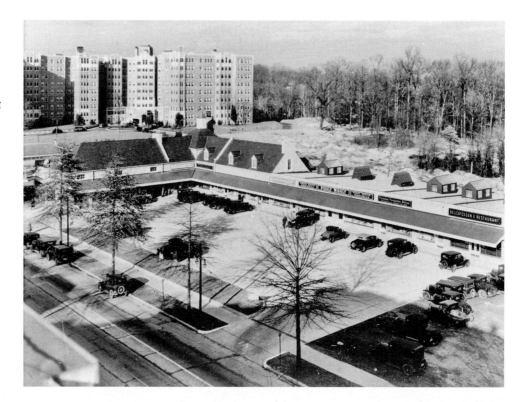

They were built with turrets, towers, steep gables, tall pilastered chimneys, and windows of all shapes and sizes, including bays, oriels, and numerous Palladian windows. Summer houses for the wealthy and suburban houses for the middle class were the two fastest-growing areas of housing design for architects during the last two decades of the nineteenth century, and their designs were published in architectural journals and popular magazines. Consequently, it is not surprising that there was some overlap and that many of the suburban homes have features reminiscent of summer homes built at the seashore. In both cases the architects were designing for people who were looking for an escape from the crowded and unsanitary city centers. The introduction of the electric streetcar finally made this possible for middle-class families.

The developers of this area of Northwest Washington sought to interest potential residents not only by featuring fine houses in a healthful and beautiful setting but also by calling attention to nearby amenities. As a real estate brochure promoting Connecticut Avenue Highlands published in 1903 by Fulton R. Gordon pointed out, Rock Creek Park — 2,500 acres of beautiful woods purchased by Congress for public enjoyment in the 1890s — lay just to the east. New opportunities for employment were opening up nearby: the Bureau of Standards began building its campus off Connecticut Avenue between today's Van Ness and Tilden streets about 1902 and the Geophysical Laboratory of the Carnegie Institution moved into a new building at 2801 Upton Street in 1907. The Naval Observatory had moved from Foggy Bottom to a hilltop just south of Cleveland Park in the 1890s, and the Cathedral of Saint Peter and Saint Paul (more commonly

known as the Washington National Cathedral) was rising on Mount Saint Alban at the neighborhood's southwest corner, with its affiliated schools. In addition, adjacent estates of the city's elite, such as Admiral George Dewey's Beauvoir, on Cathedral Avenue (razed and replaced by the Beauvoir School), and John R. McLean's Friendship, on the site of today's McLean Gardens, added prestige to the area.[7]

The occupations of the early residents of Cleveland Park suggest some were attracted to the neighborhood because of the nearby employment. In 1918 twenty scientists lived on Highland Place, Macomb, and Newark streets, including Lyman Briggs, later director of the Bureau of Standards, and Arthur L. Day, director of the Geophysical Laboratory. Cleveland Park homes were expensive by standards of the day, ranging between $5,000 and $8,000, and most of the early residents of the neighborhood were in professional and management positions. A significant number headed their own businesses. Prominent early residents included Judge Walter Cox of the District's supreme court; his Highland Place neighbor T. L. Holbrook, president of the Washington Brick Company; and O. T. Crosby, founder of the Potomac Electric Power Company. Admiral Robert Peary, the Arctic explorer, lived in Cleveland Park briefly, as did actress Helen Hayes as a child.[8]

Arthur B. Heaton, supervising architect of the rising cathedral, and Frederick Bennett Pyle, a prolific local architect, settled in Cleveland Park and designed houses within the neighborhood. W. C. and A. N. Miller, influential developers of Wesley Heights and Spring Valley, operated their first real estate office in their home on Highland Place and built their first houses down the street. As residential Cleveland Park continued to grow and expand in the 1920s and 1930s, new developers took up the mantle of John Sherman and filled in the bulk of the empty lots. Throughout the years, architects of local and national prominence, such as Appleton P. Clark, Marsh and Peter, Ayman Embury II, Hornblower and Marshall, Waldron and Winthrop Faulkner, William Lescaze, and I. M. Pei, designed new houses in a variety of styles for individual clients. Pei summed up the architectural character of Cleveland Park in the early 1960s when he came to inspect the site for one of his few residential designs: "This neighborhood interests me. I don't feel the heavy hand of conformity."[9]

Many early residents of Cleveland Park remained in the neighborhood for the rest of their lives; in a few cases the next generation still lives in the same house or nearby. However, beginning with the Great Depression and into the 1950s, the old houses and the neighborhood came to be considered less fashionable. Some houses stood empty in the 1930s, others were divided up during the housing shortage of World War II. Miriam and Elliott Moyer described their difficulties in getting financing to build a house in Cleveland Park. "As an indication of the status of Cleveland Park in 1941, the finance and real estate institutions regarded this as a neighborhood that was potentially to be blighted. . . . The interest rate was a point and a half higher than the usual rate because of the questionable future of this neighborhood." The Moyers persisted in their efforts, built their house, and lived in it for many years.[10]

While the neighborhood may have temporarily ceased to be as desirable as it had been in the early 1900s, it continued throughout its history to have a strong sense of community. From early days St. Albans Church and the adjacent cathedral, with its accompanying schools, became a gathering place where lifelong friendships were formed and community activities occurred. When John Eaton Public School opened at the northeast corner of 34th and Lowell streets in 1911, it immediately provided another focal point for the neighborhood. The elementary school became known for high-quality education, ethnic diversity, parental involvement, and special enrichment programs that drew many families who were committed to public education to the neighborhood.

The Cleveland Park Congregational Church at the southwest corner of 34th and Lowell streets has been a neighborhood institution since 1922 when its building was designed by C. L. Harding and constructed by the W.C. & A.N. Miller Company. It has provided another meeting place for residents, as well as space for the fledgling Lowell Street School in the 1970s, and for the Cleveland Park Historical Society's first office in the mid-1980s. In 1923 a group of neighbors founded the Cleveland Park Club in one of the oldest houses in the heart of the neighborhood as a gathering spot for members. Until the 1950s the club sponsored regular meetings and dinners attended by members in formal attire. The club continues to be active, emphasizing family-oriented events centered around its modest swimming pool as well as adult-oriented lectures, parties, classes, and amateur theater performances. The Cleveland Park Camp at the club began to be a regular summer attraction for neighborhood youth in 1978.

A strong sense of community emerged as an ongoing theme in an extensive set of oral interviews conducted by Rives Carroll as part of the Cleveland Park History Project of John Eaton School in 1984. Hilda and Sturgis Warner remembered that when they moved into the neighborhood in 1951, they were immediately impressed with the spirit of the community. Neighbors were running a scrap metal drive to help raise money to buy land for a public library. "Neighbors emptied their cellars of junk, old pipes and discarded metal toys and carted them down the hill in kids' wagons or cars and piled them on the lot," Hilda Sturgis recalled. Other longtime residents reminisced about initiating the Macomb Street playground, working for a renovation of John Eaton School, and starting an after-school program and an annual neighborhood "block party" on the playground to pay for it. "It's thrilling to see that playground fill up every year," said Sally Craig, a neighborhood activist who helped organize the event for many years.[11]

An influx of politically active residents rediscovered Cleveland Park in the late 1950s and early 1960s. Many were journalists, politicians, and academics with large families and small budgets who found the somewhat worn, rambling, old wooden houses appealing and affordable and the local public schools acceptable. The newcomers joined with longtime residents in fighting the citywide development pressures that began in the late 1950s; their organizational skill and political connections made them successful where other neighborhoods failed. In 1960 resident Elizabeth Rowe, two years later appointed the chair of the National Capital Planning Commission, and Peter Craig, a

lawyer who lived in the neighborhood, led the community in defeating a four-to-six-lane leg of the Northwest Freeway. It would have tunneled under Sidwell Friends School on Wisconsin Avenue, proceeded in a depressed highway just north of Cleveland Park, and then cut through Adams Morgan on its way to connecting with an Inner Loop Freeway about 8th and U streets, NW.

Craig would then work closely with Sammie Abbott and others in Brookland and Takoma Park to fight the next priority for the highway lobby, the North Central Freeway designed to plow through those neighborhoods. Another Cleveland Park lawyer, Roberts B. Owen, would be the lead counsel in successful court cases in 1968 and 1970 focused on stopping a highway bridge under construction at the Three Sisters islands above Georgetown, designed to take another leg of the Northwest Freeway running through Glover-Archbold Park across the Potomac River, and pivotal to the completion of the entire Interstate Highway system through the District. Such citizen action throughout the city stopped the highway construction entirely in the early 1970s, despite intense pressure from Congressman William H. Natcher, chair of the D.C. Appropriations Committee of the House of Representatives, who had been refusing to release funds for the city's Metrorail system unless the highways were built.[12]

In the mid-1960s neighbors organized Citizens for City Living, headed by Kay McGrath, and after twenty years of consistent work the members managed to save the World War II low-rise, low-rental McLean Gardens apartments, just to the west of Wisconsin Avenue, from replacement by high-rise commercial development. This same organization had the foresight in 1976 to hold a community-wide weekend devoted to the preparation of its own long-term Cleveland Park development plan. In the early 1980s neighborhood residents focused on threats to the Tregaron estate and fought back a proposed development of 180 to 220 houses. Friends of Tregaron succeeded, with the help of architect Richard Ridley's effective drawings and models, in convincing the zoning commission that the landmark estate should be protected. These activities led to a heightened awareness of the growing historic preservation movement in the city and how its tools might be used to preserve Cleveland Park from insensitive change. Members of the local Advisory Neighborhood Commission (3C) suggested that the neighborhood apply for a Cleveland Park Historic District designation and offered financial assistance. A community movement toward historic district status soon coalesced around a threat to the Connecticut Avenue commercial strip.

Commercial development did not come to this streetcar suburb until thirty years after it was laid out. The earliest Cleveland Park residents were dependent on distant places for all their needs, from groceries to doctors, and many patronized the stores at the opposite end of the Calvert Street bridge in today's Adams Morgan. "In 1918 there was a flu epidemic [and] my father had to go all the way down to the nearest drug store, at 18th and Columbia Road, to get medicine for us," one former resident remembered. It was not until the 1920s that the neighborhood began to get its own stores and services, first on Wisconsin Avenue and immediately thereafter on Connecticut Avenue.[13]

Until 1907 the trestle bridge on Calvert Street built by Senator Newlands provided the best access to the neighborhood from the central city. In that year the Taft Bridge across Rock Creek, one of the first and at the time the largest unreinforced concrete bridge in the world, replaced a series of smaller wooden and iron truss bridges that had crossed the creek at the bottom of the chasm. The Taft Bridge allowed passage directly north on Connecticut Avenue for the first time. The bridge did not immediately bring commerce to the neighborhood, but it did help spur residential development. In 1920 the city's first zoning law controlled the development of the avenue itself with a novel approach that reflected the city's strong lobby for planned growth. Four specifically limited areas along Connecticut Avenue, including one on both sides of the avenue between Macomb and Porter streets in Cleveland Park, were designated low-rise neighborhood shopping districts, and the rest of the avenue was zoned residential, allowing for high-rise apartment buildings. The 1916 firehouse designed by municipal architect Snowden Ashford heralded the imminent growth of the Cleveland Park commercial area. The Monterey Pharmacy opened in 1923 on the ground floor of the Monterey Apartments, followed in 1925 by the Great A&P Tea Company and Piggly Wiggly groceries, thus bringing basic needs within easy access of Cleveland Park residents for the first time.[14]

The competition among grocery stores along the avenue and the increasing use of the personal automobile led to an innovative concept in marketing, the introduction of an early shopping center, which proved to be a turning point in the history of local and national commercial development. The Park and Shop at the northeast corner of Connecticut Avenue and Ordway Street was planned and developed by Shannon and Luchs with Arthur B. Heaton as the architect. Opened in 1931, the complex introduced the idea of one-stop shopping — groceries to auto care — with a large off-street parking lot in front. It was a prototype for similar automobile-oriented shopping complexes across the country.

The Art Deco–style Uptown Theater opened in 1936 as a specifically neighborhood movie theater in a residential community, a forerunner of the 1950s suburban theaters. Ironically, all of the grand downtown theaters are gone, and the Uptown remains as the one undivided, large-screen theater in Washington, the site of many film openings and exclusive runs. The post office of 1940 and the library of 1952 completed the provision of essential services to Cleveland Park residents. The opening of the Cleveland Park Metrorail station in 1981 brought change and new development just as the electric streetcars had almost a century before. New businesses such as an ice cream parlor, coffee houses, outdoor cafes, and small ethnic restaurants brought new energy and life to the commercial strip.

However, by 1985 the new Metrorail stop was raising speculation that major high-rise buildings were being designed to replace the neighborhood's one- and two-story shopping district. The Park and Shop was the first target. The community responded by creating the Cleveland Park Historical Society, which organized the local designation of the neighborhood as the Cleveland Park Historic District in 1986. It was listed on the

A variety of architects of local and national prominence, including Frederick Bennett Pyle and Paul Pelz, created streetscapes such as this one in the 3500 block of Newark Street. Photo by Kathleen Sinclair Wood. Courtesy Cleveland Park Historical Society

National Register of Historic Places in 1987, at which time it became protected under the provisions of the D.C. Historic Preservation Law. Tersh Boasberg, a neighborhood lawyer with special expertise in historic preservation, realized that the neighborhood needed to bring zoning, which allowed high-rise development, into compliance with the protection offered by the historic district designation. In 1988 he spearheaded a successful application for a zoning overlay, limiting the height of buildings in the Cleveland Park commercial area on Connecticut Avenue to forty feet and thereby protecting the physical fabric of the 1920s and 1930s shopping strip and its small-scale village atmosphere.

Citizen action continued into the turn of the twenty-first century, this time focused on the grounds of the area's historic country estates, under pressure by developers in search of any open land in the District. The eighteenth-century Rosedale estate, much

Celebrants line up for the annual Cleveland Park Halloween parade at the Macomb Street Playground in 2008, organized by John Eaton Elementary School. The school and the playground have been central to community life for decades. Photo by Kathryn S. Smith

reduced and with new houses and school dormitories on its grounds, had been placed on the National Register of Historic Places in 1973. Its grounds, by agreement with the owner, were open to the neighborhood and were a favorite dog-walking and thus gathering place for neighbors.

When the property went up for sale in 2000 the neighborhood was quick to respond with an innovative approach. As a result of a binding covenant the owner had signed with a previously established neighborhood organization named the Friends of Rosedale, that group was given the right of first refusal when the estate was put up for sale. The Friends of Rosedale raised money and pledges from the neighborhood to cover the offered purchase price. The property has since been subdivided, allowing for the construction of eight new houses, far fewer than might have been possible. The remaining three acres are deeded to the Rosedale Conservancy, which will ensure the preservation, in perpetuity, of the front lawn and gardens as a community amenity. A new private owner occupies the Rosedale farmhouse.

At the same time, the community, through the efforts of the Friends of Tregaron, saved a significant portion of the Tregaron estate surrounding the Washington International School. After twenty-eight years of dispute over potential overdevelopment, the historic landmark designation for the entire property resulted in a settlement in 2006 that preserved the bulk of the historic gardens while allowing the addition of up to eight houses, under certain conditions, along the perimeter. The houses will generate income for a newly formed Tregaron Conservancy, which will be responsible for restoration and maintenance of the ten acres of landscaped grounds that will be open to the public.

The neighborhood has also discovered another, more modern gathering spot, the virtual Cleveland Park E-Group, where since 1999 information has been exchanged and recent community happenings discussed online. At this writing it involves more than five thousand members, thereby continuing the tradition of community involvement in this nineteenth-century neighborhood in the on-line mode of the twenty-first.

This twenty-first century community is, as it has been for all of its history, a predominantly white neighborhood, and rising real estate values since the 1980s have drawn increasingly high-income residents. Many in the neighborhood are involved in real estate, law, politics, journalism, as well as the arts, and some have reached national prominence. Apartments and condominiums along and east of Connecticut Avenue and west of Wisconsin Avenue are available to those with fewer resources. John Eaton Elementary School, which serves neighborhood as well as out-of-area children, takes pride in its multicultural character. Through citizen activism and skillful use of historic preservation and zoning tools, Cleveland Park turned development pressures into sensitive growth in the community, ensuring the preservation of the architectural quality and scale of the neighborhood, the continuing existence of open spaces, and the economic vitality of the low-rise commercial avenues. Members of the historical society involved in making a film about the neighborhood in 2007 believe that these recent successes were built on a tradition of local responsibility for the welfare of the neighborhood that goes back to its earliest days.

The 1936 Art Deco Uptown Theater on Connecticut Avenue near Newark Street, the only commercial big-screen movie theater that remains in the city, stands as a neighborhood icon and draws audiences from around the city to first-run attractions. Photo by Rick Reinhard

Congress Heights

A MANY-LAYERED PAST

GAIL S. LOWE

Congress Heights is one of the city's oldest inhabited places and one of its youngest neighborhoods. A streetcar suburb that remained partly rural as late as World War II, its history runs the gamut of the human experience in what became the nation's capital. Native Americans, English planters and their enslaved workers, tenant farmers, white families looking for jobs and affordable homes in a new suburb, African American families seeking a livelihood and a sense of community in a segregated city — all have made their homes on this high ridge above the Potomac and Anacostia rivers, so close to and yet so far from the center of the nation's capital.

Contiguous with Congress Heights are Washington Highlands, to the southeast across Oxon Run Park, and Bellevue (also spelled Bellview), at the southern tip of the District. Bellevue is incongruously part of the Southwest quadrant because it is west of South Capitol Street. Stretched out along the Potomac River below the ridge on which these three communities stand are Bolling Air Force Base, the U.S. Naval Research Laboratory, and the Blue Plains Wastewater Treatment Plant. The D.C. Department of Planning calls the entire area Cluster 39. The three neighborhoods in this cluster have shared a similar history in terms of settlement patterns, changing demographics, and civic and social concerns. Although not densely developed, the area has faced many of the most difficult social and economic issues in the nation's capital. At the beginning of the twenty-first century, these issues are all claiming more attention from the government and the private sector.

The Native American villages of the Nacotchtank (called Nacostines by European explorers) once spread along the

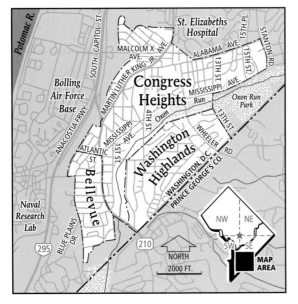

The boundaries of the 1890s suburb of Congress Heights are generally accepted on all sides, except on the northeast. The line drawn here at Stanton Road reflects the impression many have that the site of the former Camp Simms at Alabama Avenue and Stanton Road is part of the neighborhood. The adjacent neighborhoods of Washington Highlands, across Oxon Run Park on the southeast, and Bellevue across Atlantic Street on the southwest share, to some extent, a common sense of community in this Far Southeast/Southwest part of the city. Map by Larry A. Bowring.

The Washington Ballet, the Selma Levine School of Music, and the Boys & Girls Clubs of Greater Washington are among the many partners that program THEARC, a cultural and community center at 21st Street and Mississippi Avenue, SE, that opened in 2005. New housing, such as that seen in the background across Mississippi Avenue, is rising rapidly in Congress Heights and adjacent neighborhoods. Photo by Kathryn S. Smith

riverbanks below Congress Heights. Their way of life and their lands would be challenged and overrun by European settlers, and, here as elsewhere in the future District of Columbia, they would be mostly gone by 1700. Their lands had been granted to English gentlemen by Leonard Calvert, Lord Baltimore, in the mid- to late 1600s, and as the century wore on these colonists began to occupy the land patents given them. There were three patents in the area that became Congress Heights: Pencottes Invention (variously spelled), South Kirby, and Giesboro (also variously spelled). All fronted on the Potomac River just below its juncture with the Eastern Branch, with houses and wharves along the shore. Pencottes Invention lay just south of today's St. Elizabeths, South Kirby to its south, and Giesboro next to it, including a point of land that came to be known as Giesboro Point. The most notable of these houses was Giesboro, where Thomas Addison Jr. built a brick two-story plantation house in the Georgian style about 1735. It replaced an earlier wooden house and stood near the river at Giesboro Point.[1]

During the eighteenth century, when the area was part of Prince George's County, the rural residents related most closely to the port of Bladensburg on the Eastern Branch to the north and to the port of Piscataway on the Potomac River, a few miles southeast of today's Fort Washington. Martin Luther King Jr. Avenue now follows some of the old route between the two ports. The roadway was then called Piscataway or Bladensburg Road, and from the mid-nineteenth century to 1971 it was known as Nichols Avenue. In the eighteenth century it was also referred to as the "rolling road," since its downhill path allowed tobacco to be rolled in barrels called hogsheads down to the Potomac port. (The route of today's Wisconsin Avenue performed this function for the port of Georgetown in that same century.) One fork of the road went down to Marbury Point and the other to the mouth of Oxon Creek, where ferries took passengers across the Potomac to Alexandria, a service that ran from the middle of the eighteenth century into the early twentieth.[2]

Enslaved workers supplied the labor for the plantations in what would become Congress Heights. A 1776 census showed that there were seven white males, eight white females, and ninety-six Negroes living on the Giesboro tract. George Washington Young, who bought 624 acres of Giesboro in 1833 and lived in the manor house built by Thomas Addison, was the largest slaveowner in the District of Columbia. His estate would continue to rely on enslaved people until compensated emancipation came to the District in 1862, when Young would receive $17,771.85 for the sixty-nine people he held in bondage. Some of the freedmen would stay on in the area, some as sharecroppers.[3]

A community of African Americans gathered around the lands owned by Tobias Henson along Alabama Avenue northeast of Congress Heights, an area that came to be known as Stantontown. Henson purchased himself out of slavery in 1813 and then bought members of his family one by one. He initially acquired twenty-four acres of land on "the ridge" and added to it over the years. Other African Americans settled after 1865 in the nearby Freedmen's Bureau village of Barry Farm.[4]

The Civil War brought intense activity to the area, with the construction of a string

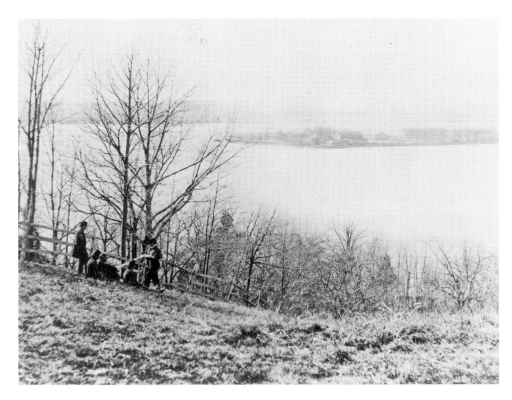

Civil War soldiers gather on the hillside above Giesboro Point, overlooking the confluence of the Potomac River and what was then called the Eastern Branch and is now known as the Anacostia River (foreground), the location of today's Congress Heights. In the middle distance is what was then called Arsenal Point, now the site of Fort McNair and the National Defense University in Southwest Washington. Courtesy Washington Aqueduct

of forts along the heights, including Fort Carroll in today's Congress Heights and Fort Greble in today's Bellevue. The federal government also leased Giesboro land from George Washington Young for an Army post called Camp Stoneman or Giesboro Depot. Its corrals and stables could hold as many as thirty thousand horses, making it the largest such cavalry depot anywhere. Officers used the 1735 manor house as depot headquarters, and tents around the grounds sheltered the troops stationed there. Young returned to the farm after the war but died in 1867. His heirs sold the farm in 1878 and it became a river resort known in stages as City View, Capitol View, and Buena Vista, until the mansion burned to the ground during a dance in 1888. Present-day enterprises, including convenience stores, liquor stores, and fast food establishments, use the historic names of Fort Carroll, Fort Greble, and Giesboro.

As suburban developments began to sprout west of the Eastern Branch, by this time also called the Anacostia River, the area east of the river that would become Congress Heights remained rural. Unlike the 1854 development of Uniontown/Anacostia on the other side of St. Elizabeths Hospital, which was connected to Washington City by the 11th Street Bridge, the future Congress Heights had no direct access to central Washington. Although a spur of the B&O Railroad was laid in 1873 from the village of Benning along the river to the old ferry landing at Marbury Point (later Shepherd's Point), the area was still a long way from jobs in the city. A land speculator named John Jay Knox, who was also the U.S. comptroller of the treasury, bought about forty-eight acres just south of the intersection of Nichols Avenue and 4th Street, SE, where the first school in

the area for white children, called Giesboro School, stood. (The old Congress Heights School building is on this site today.) Knox employed people to farm the land but made no move to develop it.

In 1890 real estate speculator Arthur E. Randle, alone in investing in this little-recognized section of the District, bravely purchased the Knox farm and laid out the first streets in what would become Congress Heights. Born in Mississippi and educated at the University of Pennsylvania, Randle was prevented by ill health from practicing law, and he turned instead to the real estate profession in Washington. He had the resources to weather the economic depression that began in 1893, but slow land sales encouraged him to seek a charter to bring an electric streetcar line to his new community. By 1894 only six lots in his eleven-block subdivision southeast of today's Martin Luther King Jr. Avenue had improvements on them, and Randle held two of them. In 1896 he won an eighteen-month struggle with Congress, the city commissioners, and competitors who had operated a horsecar line to Uniontown/Anacostia since 1876. He laid his own tracks across the 11th Street Bridge and up Nichols Avenue in 1896 and began service in 1898.[5]

Randle ran a contest to name his neighborhood, an exercise that produced the name Congress Heights and drew attention to the new development. He worked with the city government to obtain street lights, policing, and postal service for the community, and, again successful with Congress, obtained a federal appropriation for a public school to replace the one-room Giesboro School on the same site. As in other outlying developments at this time, the community did not have city water or sewer service. Randle himself lived in a large wooden house at the end of Randle Lane (now 5th Street). The community from the beginning was populated only by whites, a common practice in a segregated town, either subtly encouraged by developers or actively structured by restrictive covenants in the deeds. It is likely Randle employed some such tactics in Congress Heights. He would insert restrictive covenants that forbade sale of land or buildings to any "negro or colored person, or person of negro blood" in the deeds in his next community development to the north, Randle Highlands.[6]

Congress Heights attracted other developers, and by 1900 men named Horner and Longnecker and the team of Barnard and Johnson had created new subdivisions, all called "Addition to Congress Heights." Randle added a second development to his portfolio, this time on the northwest side of Nichols Avenue. However, his attention soon turned to a much larger new venture, the aforementioned Randle Highlands, along Pennsylvania Avenue, SE.

Congress Heights would keep its semirural character for decades. Before 1910 there were few houses in any of the subdivisions, and old farms turned to woodland. Residents kept chickens and livestock; there were no paved streets or sidewalks. A large ferry with an inside lounge stopped regularly at Shepherd's Landing near the mouth of Oxon Creek, taking families to Alexandria for shopping and social visits. In 1907 men in the community created a civic association. Other early organizations included the fraternal orders of the Knights of Maccabees, the Knights of Pythias, and the Royal Acranan.

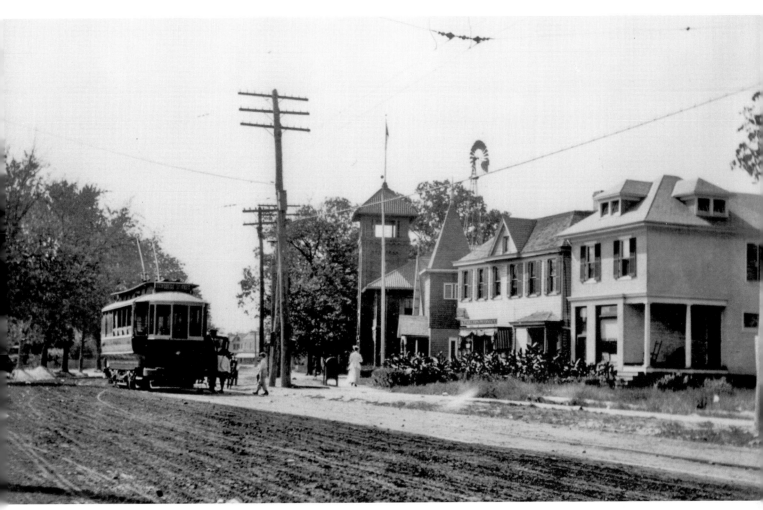

Women were involved in church activities, including an active Ladies Guild of the Esther Memorial Protestant Episcopal Church.[7]

There were only two brick buildings in Congress Heights in 1907, and they remain today as community landmarks. The first was the previously mentioned Congress Heights Elementary School, built in 1897 at 3100 Nichols Avenue, and the second the 1903 firehouse at 3203 Nichols Avenue, designed by noted D.C. government architect Snowden Ashford. The other government building still standing today is the structure at 3127 Martin Luther King Jr. Avenue, built in 1905 as a home and drug store but later the site of the local post office.[8]

In a city dominated by government employment, Congress Heights stood out as a place with easy access to industrial jobs. About 1908 the Washington Steel and Ordnance Company, commonly called just the "steel plant," arrived on the riverfront at the foot of Portland Street (now Malcolm X Avenue). In 1910 more men in Congress Heights worked in the steel plant than anywhere else. The Navy Yard across the 11th Street Bridge was the next most common employer, followed closely by St. Elizabeths

Teacher Helen White kept a personal photo album with pictures of her charges at Congress Heights Elementary School, including these third grade students on the school steps in June 1916. Built in 1897, the school at 3100 Nichols Avenue rose early in the community's history. Courtesy The Historical Society of Washington, D.C.

Hospital at the northern edge of the neighborhood. While most jobs at St. Elizabeths were unskilled, the Navy Yard offered many opportunities for craftsmen of many kinds.[9]

Pre–World War I homes in Congress Heights were single-family dwellings of wood, many with the porches and projecting bay windows that had been popular at the end of the previous century. Local builders constructed many of them, including Charles A. Lohr, who worked in the neighborhood for more than thirty years and called himself a carpenter, but who also appeared on building permits as the builder and the architect. Two of his earliest homes stand at 634 and 913 Alabama Avenue.

World War I brought a military presence to the neighborhood reminiscent of the massive Giesboro cavalry depot of the Civil War. In 1917 the Navy chose a portion of the original Giesboro tract to set up the Anacostia Naval Air Station, originally a sea-plane base. In 1918 the Army opened Bolling Field just to the north of the Naval Air Station, and two runways were laid out for land planes, to be shared by the Navy and the Army. Ferry service for employees between the military installations and Hains Point meant less interaction with the community on the hill above it than might have been expected. The steel plant was at work around the clock making shell casings, and the sound of banging metal was heard in Congress Heights at all hours of the day and night. Neighbors took in war workers to supplement income, and some women prepared "Liberty lunches." The D.C. National Guard trained at Camp Simms, established in 1904 on part of Henson family land on the eastern edge of Congress Heights at Alabama

Avenue and Stanton Road. The U.S. Naval Research Center would come to the waterfront in 1923. New houses went up as the population swelled.[10]

While residents of Congress Heights remained largely middle-class whites of northern European ancestry in the 1930s, members of other racial and ethnic groups began to make their mark. Max Simon, a Russian immigrant, invested in real estate in Congress Heights, built a department store on Nichols Avenue, and made himself a multimillionaire. He went into construction in 1927 and hired a number of architects, including Deanwood resident Lewis W. Giles Sr., one of Washington's first black professional architects. A 1937 Tudor Revival home designed by Giles stands at 534 Newcomb Street; a Moderne / Art Deco house he designed can be found at 617 Mellon Street. Another black architect, Romulus C. Archer Jr., designed four homes at 452, 456, 460, and 464 Lebaum Street, which originally were probably identical but have since been altered.

Firefighter Izzy Neumeyer stands proudly with the power that pulled the fire engines of Company 25 at the Congress Heights fire station about 1920. The horse on the left is also named Izzy; Frank and Joe are on the right. Courtesy Historical Society of Washington, D.C.

An increasingly multiethnic community, Congress Heights became home to a thriving Jewish population, especially from the 1920s to the end of the 1960s. Many Jewish entrepreneurs began businesses here, mostly "mom and pop" stores that fit into the small-town feel of the neighborhood. Larger stores dotted the neighborhood as well, however, such as S. Kravitz's Congress Heights Department Store at 2713 Nichols Avenue. Temple B'nai Jacob and the Washington Highlands Jewish Center, founded in 1941 and 1946 respectively, arrived to serve the religious needs of the community during and just after World War II. Sheila Gallun Cogan, whose bat mitzvah service was held at Temple B'nai Jacob, remembered an active and closely knit Jewish community life that revolved around Hebrew school, youth activities, and outings with the Young Men's and Young Women's Hebrew Associations.[11]

As early as 1852, Jewish congregations in other sections of the District of Columbia purchased land in Congress Heights for congregational cemeteries. These cemeteries (most still in use) remain along Alabama Avenue near the Congress Heights Metrorail station. In fact, the station's location was shifted to protect the nearby cemeteries and archaeological sites. Washington Hebrew and Adas Israel cemeteries on Alabama Avenue and Ohev Shalom-Talmud Torah and Elesvetegrad (shared by Beth Sholom, Hebrew Benevolent Society, Southeast Hebrew, and Tifereth Israel) cemeteries off Congress Street at 15th Street continue to provide havens of rest.[12]

While the Jewish community and its religious institutions grew, Christian churches prospered as well. The Congress Heights Methodist Church, the Congress Heights Baptist Church, and the Episcopal Church of the Holy Communion were all centers of community activity. Two commercial areas of small shops also brought neighbors together — one on the northern edge of Congress Heights near the intersection of Ala-

Anthony Munz, an early aviator with the U.S. Navy, took this picture of a young Anacostia Naval Air Station on the riverbank below Congress Heights about 1920. The opposite side of the river is in Southwest Washington. Courtesy The Historical Society of Washington, D.C.

bama Avenue and Stanton Road, and one along Nichols Avenue from St. Elizabeths Hospital to Alabama Avenue.

The community grew despite the closing of the steel plant in 1937 and cutbacks at the Navy Yard during the 1930s. Second- and third-generation residents were so common that one mother told her children never to speak ill of anyone publicly because they might be related to people within hearing. At the same time, young couples with modest incomes found the neighborhood a good place to buy an affordable first home. The electric streetcar was replaced by a bus in 1938, but residents, old and new, continued to call the place where Upsal Street, First Street, and Nichols Avenue met the "end of the carline."[13]

World War II and the population explosion that accompanied it would finally change the small-town, semirural character of Congress Heights. Between 1939 and 1942 military employment at Bolling Field mushroomed from 450 to 5,000, and the number of civilian workers surged as well. With Bolling Field and the Naval Research Laboratory at its feet, and the Navy Yard and the U.S. Capitol complex not far across the river, Congress Heights was among the neighborhoods most pressed for new housing. There was still open space, as elsewhere east of the Anacostia River, and the Federal Housing Administration was making it easy for developers to secure financing, offering to insure 90 percent of the mortgage for approved apartment projects, a program known as FHA 608. Among other developments, Bolling View came on the market in 1942 with 290 rental apartments; Bolling Gardens offered 124 units in 1943, and 176 more in 1944. The

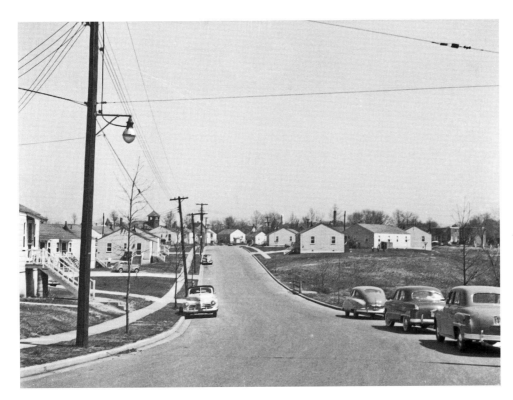

This suburban-looking tract housing on Savannah Street north of Horner Place, photographed in 1950, was constructed for noncommissioned officers at Bolling Field early in World War II. With military installations all around it, Congress Heights's open spaces filled up with new houses and apartments during the war. Photo by John P. Wymer. Courtesy The Historical Society of Washington, D.C.

largely undeveloped land at the southeast end of the neighborhood filled up with houses and garden apartments. The principal of the Congress Heights School during the war recalled that she had to shift to morning and afternoon sessions to fit 1,100 children into a building designed for 500.[14]

By the time the South Capitol Street Bridge (now also known as the Frederick Douglass Memorial Bridge) was completed in 1949, linking Congress Heights directly to the center of the city for the first time, about 90 percent of its land area had been developed. The community stood on the brink of major change. The Navy Yard in peacetime switched to white-collar employment, and the many skilled machinists and engineers who lived in Congress Heights retired or moved away. By the mid-1950s, large public housing units, such as Stanton Dwellings, had been constructed on the neighborhood's edges, attracting, among others, African Americans who lost their homes when most of Southwest was demolished in the 1950s urban renewal.

Most significant was the change brought about by the 1954 Supreme Court decision in *Brown v. Board of Education* that desegregated the nation's public schools. In the District of Columbia, where Congress had control and President Dwight D. Eisenhower himself pressed for immediate compliance, the effect was dramatic and swift. Sheila Cogan recalled how rapidly the change came:

1954 was an extraordinary year in my life and I think in the life of the city. I came to understand as I graduated Anne Beers elementary in 1954 that during that summer

Parishioners greet one another outside the Congress Heights Methodist Church at Nichols and Alabama avenues in 1950. Bob's Frozen Custard, at the right, called by some DeMoreland's after its owner Robert DeMoreland, was a popular neighborhood destination. Photo by John P. Wymer. Courtesy The Historical Society of Washington, D.C.

the Supreme Court decision regarding school integration had been made. And as I look back on it, I knew . . . that Washington was the crucible. . . . We were the social experiment. Between June and September of 1954 the schools of Washington, D.C., were integrated, just like that. . . . There was nothing, really nothing, to prepare us . . . as pupils to understand the magnitude of the changes that were occurring.[15]

Tremendous demographic changes followed. By 1960 white flight was in full force. Parents took their children out of the newly integrated schools, and longtime residents sold their homes and moved to the suburbs. Some real estate agents engaged in block-busting, selling a house to a black family and then fanning fears of declining property values in the neighborhood. The concern they raised enabled them to buy homes cheaply from frightened white residents and resell them at inflated profits to African Americans eager to move into neighborhoods formerly closed to them. The number of white children in D.C. public schools declined rapidly after integration, from about 55 percent in 1946 to just over 9 percent by 1966. During the same period the overall percentage of white families in Far Southeast (east of the Anacostia River and south of East Capitol Street) fell headlong from nearly 82 percent in 1950 to only 14 percent in 1970.[16]

Religious institutions that had served the white community changed or left. In 1965 the Washington Highlands Jewish Center and Temple B'nai Jacob joined with the Beth

These houses on Portland Street (today's Malcolm X Avenue) east of 7th Street lead right up to the grounds of St. Elizabeths Hospital in this 1950 photograph. Congress Heights wrapped around two sides of the hospital, one of the major employers of neighborhood residents. Photo by John P. Wymer. Courtesy The Historical Society of Washington, D.C.

Israel congregation in Far Northeast to form Congregation Shaare Tikvah (Gates of Hope), and by 1967 the combined congregation had moved to Temple Hills, Maryland. A map accompanying a 2003 study of the Jewish community in the Washington metropolitan region showed virtually no Jewish households in Far Southeast. The all-white Congress Heights Methodist Church began to serve an African American congregation; the Congress Heights Baptist Church sold its property in 1969 to Rehoboth Baptist Church, a long-standing African American congregation that had met in Southwest until urban renewal took part of its land.[17]

The availability of rental apartments built during World War II, some poorly constructed and some converted to public housing, exacerbated the demographic change. Zoning changes beginning in 1958 that set aside as much as 75 percent of residential land in Far Southeast for apartments encouraged more multifamily complexes, including more public housing, and the shift from a community once characterized by owner-occupied, single-family homes became dramatic. The apartments and public housing attracted families with few financial means, many of them refugees from Southwest urban renewal and from rising prices and changing demographics in Georgetown. City services did not keep up with the rising population and its many needs.[18]

When the Reverend James E. Coates, pastor of Bethlehem Baptist Church, was elected in 1974 as the first Ward 8 councilmember under the D.C. Home Rule Charter,

he addressed his constituency's five major complaints: lack of new single-family houses, lack of shopping facilities, lack of city responsiveness to problems, high unemployment, and a large youth population with few recreational outlets. Many residents felt isolated from the rest of the city and lived in fear, dejection, and world-weariness.[19]

For several decades, well into the 1990s, the area suffered from overcrowding, few city services, poor health care, and increasing poverty, crime, and drug use. Many homeowners moved elsewhere; newcomers were mostly renters. St. Elizabeths Hospital, Bolling Air Force Base, and the Naval Air Station took up land that could have been used for residential development: fully 30 percent of the land area in the Office of Planning's Cluster 39 currently remains occupied by military or other government purposes. The city's largest and most notorious public housing complexes were in Washington Highlands: Valley Green, Ridgecrest Heights, and Highland Dwellings—human warehouses and drug hangouts in idyllic surroundings. The only hospitals on the east side of the river were Greater Southeast Community Hospital in Washington Highlands, where services were strained by increasing demand and high medical costs, and Hadley Memorial Hospital in Bellevue.[20]

For years the neighborhood endured severely overcrowded schools. The Congress Heights School simply could not keep up with increasing enrollment as new residents poured into the area. Deteriorated and inadequate, it closed during the 1970–71 school year, although the building still stands as a community landmark. The small neighborhood is now served by five public elementary schools (M. C. Terrell, Simon, King, Malcolm X, and Green) and one public middle school (Hart). A charter school, Friendship Southeast Elementary Academy, has a permanent home on Milwaukee Place and plans to develop adjacent land for a high school and athletic field. Friendship partners with the Smithsonian's Anacostia Community Museum to host an innovative after-school program, the Museum Academy, which continues through the summer.[21]

The area's one senior high school, Ballou at 4th and Trenton streets, did not open until 1961. Named for a former superintendent of the D.C. Public Schools, Frank W. Ballou Senior High School has had its share of academic and societal troubles. Yet the school has fielded one of the best marching bands in the city, the Ballou Marching Knights. Renowned for their precision and spirit, the marching band has been called an "instrument of opportunity" for many of the students in the area and has been featured in the 2007 film documentary "Ballou." The band director, Darrell Watson, was himself a Ballou graduate.[22]

Even crossing the river to jobs, family, and entertainment in central Washington proved difficult. The electric streetcar that had opened Congress Heights for residential development in the late nineteenth century could not handle all the transportation demands of a growing neighborhood. Trolley cars from Congress Heights to downtown Washington were often crowded. When buses replaced the trolleys in 1938, fewer buses on the long Congress Heights route carried many more people than did the short bus route from Good Hope above Old Anacostia to Barney Circle just across the river at

The annual Martin Luther King Jr. parade makes its way down King Avenue in a snowstorm in January 1984. A Congress Heights tradition, the parade was moved from King's birthday month to April because of weather like this. Courtesy The Washington Informer

Pennsylvania Avenue. Before Anacostia High School was desegregated in 1955 and until Ballou opened in 1961, black high school students often decided to walk miles to school across the river rather than wait for a packed bus.[23]

One incident illustrates the decades-long volatility of social relationships in Congress Heights as well as the effectiveness of community activism. On Monday night, August 15, 1966, a group of African Americans attacked a white man because he had verbally accosted blacks in front of the 1023 Club on Wahler Place in Congress Heights — a predominantly white club in a majority black neighborhood. The police arrested a black suspect as well as a community worker who had only inquired about the arrest. Feeling this was unfair, and amid general tensions surrounding the treatment of black residents by predominantly white police officers, residents decided to demonstrate. They chose to do so at the 11th Precinct (now the 7th District) station house at Nichols Avenue and Chicago Place in Old Anacostia, where most of the officers and the commander were white. The demonstrators, many of them young people, marched around quietly carrying picket signs. For some reason, someone at the precinct called a private security agency. The company showed up with police dogs, whose presence enraged the protestors. Things went from bad to worse as some in the crowd began throwing rocks at the dogs, which made the police feel that they were under attack. All segments of the community were full of anger.

After the incident, city commissioner Walter N. Tobriner ordered that police dogs be kept out of the precinct and set up a citizens' commission to study the causes of the unrest and consider possible remedies. By the weekend, community leaders, including

D.C. civic leader and prominent businessman John W. Hechinger shakes the hand of Ward 8 Councilmember Wilhelmina Rolark in 1986 as they celebrate the coming of cable television services to the ward, the first in the city to be linked to a cable network. Rolark preceded Councilmember Betty Ann Kane (center) as chair of the council's Public Service and Cable TV Committee. Robert L. Johnson, whose company was awarded the franchise to operate the network and who was the founder of Black Entertainment Television cable network, stands at the far left. Photo by Alonzo Green. Courtesy The Washington Informer

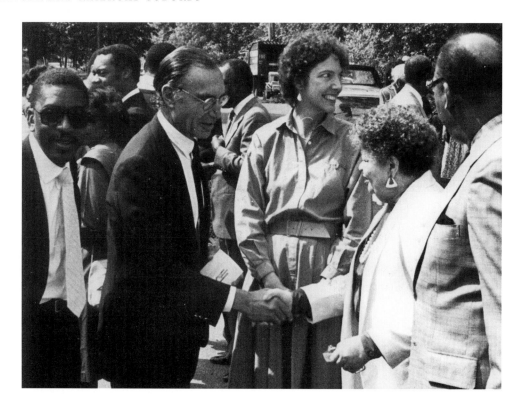

those associated with the Congress Heights Neighborhood Development Center, were working together with police patrols to keep the neighborhood quiet. The protest had a positive outcome. Captain Owen W. Davis, an African American, was transferred from the 2nd Precinct to become the first black commander of the 11th Precinct. There was an accompanying improvement in police attitude toward the communities in Far Southeast.[24]

In 1981 the community began to build local pride and celebrate its leaders with an annual Martin Luther King Jr. Parade and Celebration. The early April parade begins at Ballou High School in Congress Heights and wends its way through the community to the intersection of King Avenue and Good Hope Road. In 1984 the D.C. Library added the Parklands-Turner Community Library, a small prefabricated building adjacent to Turner Elementary School at Stanton Road and Alabama Avenue. The community's only other library is the Washington Highlands branch, which opened in 1959.

Decades of citizen activism and even outrage at the city's neglect of basic city services seem to be having an effect. In recent years the city and private developers, in consultation with residents and community activists, have created new cultural and recreational resources for the area. Former Washington First Lady Cora Masters Barry founded the Recreation Wish List Committee of Washington, D.C., in 1995; by 2001 it had opened the Southeast Tennis and Learning Center at 701 Mississippi Avenue. Its programs have won accolades from families in the community. Farther north at 1901 Mississippi Avenue, THEARC (the Town Hall Education Arts & Recreation Campus) opened in

2005. Founded by Chris Smith of the William C. Smith Company, a developer who has invested widely in mixed-income housing in Southeast Washington, the $26 million project won the support of foundations and political leaders throughout the city. Operated by the nonprofit Building Bridges Across the River, THEARC features a 369-seat theater (the only one east of the river) and offers performances and arts education programs provided by resident partners: the Boys & Girls Clubs of Greater Washington, Children's National Medical Center, the Corcoran Gallery of Art ArtReach Program, Covenant House Washington, Levine School of Music, Trinity University, the Washington Ballet, and Washington Middle School for Girls. Also present at THEARC is Parklands Community Center, a neighborhood-based local and cultural organization founded in 1980.[25]

The arrival of these cultural amenities parallels the construction of new housing. The District government, economic interests, and developers have worked together since 2001 to complete forty-four housing and office building developments worth $1 billion within a two-mile radius of Congress Heights. The infamous Ridgecrest Heights public housing project has been replaced by a gated community, Walter Washington Estates, named after the District's first elected mayor, and the disreputable Valley Green has given way to the charming Wheeler Creek. The District government used federal Hope VI funds to build the mixed-income Henson Ridge development of six hundred new homes along Alabama Avenue, replacing two troubled public housing projects, Stanton Dwellings and Frederick Douglass Dwellings.[26]

With the latest wave of real estate development, the city and private entrepreneurs have responded at last to the community's steady petitions for economic development along its commercial corridors. In 2007 the Shops at Park Village, anchored by the largest Giant grocery store in the District, opened on the former site of Camp Simms on Alabama Avenue at Stanton Road, bringing an air of suburban convenience and sophistication to the neighborhood. (The neighborhood's previous grocery store, a Safeway, had closed in 1998.) A joint partnership of the William C. Smith Company and the East of the River Community Development Corporation, the development also includes seventy-five new single-family homes in Asheford Court. Only sixteen have been marketed as affordable housing, which still may not be within the reach of those with the lowest incomes. While change is bringing upscale services and housing to the neighborhood, there are fewer places for the city's poorest.[27]

The Shops at Park Village are convenient to the Congress Heights Metrorail station at Alabama Avenue and 13th Street, which opened in January 2001. The last stop on the Green Line in the District of Columbia, the station has been a factor in the recent economic renaissance. However, it is only one of two Metrorail stops in Far Southeast Washington, the other being Anacostia, and residents, many of whom cannot afford cars, have to take connecting bus routes from their homes to the stations. Buses in the neighborhood are still crowded.

As new developments begin to change the area's appearance and its demographics,

churches remain at the center of community life for many. The Congress Heights Methodist Church and Rehoboth Baptist, formerly Congress Heights Baptist, mentioned above, continue their long service to the people of the neighborhood. The Anacostia Ward of the Church of Jesus Christ of Latter-day Saints (meeting on Southern Avenue) and the Roman Catholic Church of the Assumption of the Blessed Virgin Mary offer outreach programs to those in need. Imam Ghayth Nur Kashif leads an African American Muslim congregation, Masjidush Shura, on King Avenue. Other Congress Heights congregations include Temple Mission Baptist Church, Jubilee Outreach Ministry, Garden of Prayer Pentecostal Church, Harvey Memorial Baptist Church, Jerusalem Church of God in Christ, and Liberty Temple African Methodist Episcopal Zion Church. In the Bellevue neighborhood, Covenant Baptist Church and Redemption Ministries, a street ministry, offer programs to assist residents as well as to save souls.[28]

As longtime and new residents live together in this once-again changing neighborhood, Congress Heights seems to be at the forefront of city engagement, rather than the last place to have its needs addressed, as in the past. Issues of poverty and crime continue to trouble the neighborhood, but social services and cultural organizations are redoubling their efforts to bring effective programs to the neighborhood. Community activists and local public servants continue to raise awareness of this part of town and lobby for expanded city services. Moreover, residents are taking an active role in imagining and designing their own futures in this place. As this happens, Congress Heights and its adjacent neighborhoods may be transformed into a twenty-first-century version of the original stable, comfortable, affordable, and welcoming community envisioned by Arthur Randle more than a century ago. Slowly but surely the area is finding once again its quiet small-town feeling in the midst of urban hustle and bustle, so close and yet so far from the heart of the nation's capital.

Kenilworth

A WATER GARDEN AND ITS NEIGHBORHOOD

JOE LAPP

The neighborhood of Kenilworth, most famous for its unique marshland water gardens, formed as a white suburb on the edge of the District but evolved into a primarily African American neighborhood. Now a mixture of public housing and private homes, this community faces typical urban challenges while retaining some of the open space, wetlands, and gardens of its rural past.

The history of the Kenilworth area began, geologists suspect, when the inland sea that once covered much of the District receded, leaving marshy land to line the Potomac River and its Eastern Branch below the hills that had once been seashore. The Eastern Branch became a rich habitat teeming with wildlife and water plants. Native Americans chose to live along the waterfront, where the game was abundant, the land well suited for growing crops, and the river provided easy transportation for hunting and trade. By 1608, when Captain John Smith first sailed up the Potomac River and made the first written European observations on the area, a tribe called the Nacotchtanks lived in a settlement a few miles downstream from where Kenilworth is today. Their small family homesteads spread up and down the Eastern Branch of the Potomac, the river now known as the Anacostia.

As Europeans came to the New World, they colonized the area around the junction of the Potomac and the Eastern Branch and began to divide up the land for family farms. Their presence would soon cause the native population to disperse, forced out by disease and conflict. By the first decade of the 1700s Ninian Beall, the famous Prince George's County landowner and Indian fighter, owned land around — and probably including — the present-day Kenilworth. The names of these early tracts were Fife and Beall's Adventure. Joshua Beall, probably a relative of Ninian, received a deed for land in the area in 1764. Parts of this land eventually came down to the Sheriff family, for whom Sheriff Road in neighboring Deanwood is named.[1]

The nearest early settlement was Bladensburg. Founded in 1742, it was a port town at the upper navigable reaches of

Kenilworth is tucked between the Anacostia River and the CSX railroad tracks. Its northeastern edge between Kenilworth and Minnesota avenues was separated from the community by I-295. Map by Larry A. Bowring

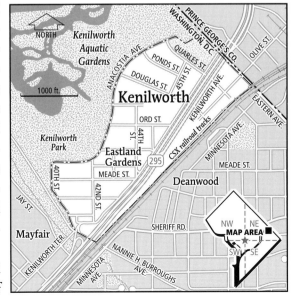

the Eastern Branch. Oceangoing ships sailed there to trade in tobacco, other farm goods, and slaves. A rutted country road ran along the eastern bank of the river — roughly where the I–295 / Kenilworth Avenue corridor is now — a section of the early route between Bladensburg and Piscataway on the Potomac River to the south.

The 1791 establishment of the District as a capital for the new United States government did not much affect the land on the eastern side of the Eastern Branch because it was across the river and outside L'Enfant's planned city. In 1792, however, government surveyors visited what is now Kenilworth as they put stone markers every mile along the diamond-shaped borders of the District of Columbia. A stone that marks the eighth mile south and east from the city's northern tip can still be seen in the woods behind 4500 Quarles Street, NE.

The area that would become Kenilworth was first an outlying part of the village of Benning. The Benning settlement gathered around the intersection of what was then called the Eastern Branch or Anacostia Road (in this section now called Minnesota Avenue) and Benning's Road (now simply Benning Road). Taking its name from farmer William Benning, who bought Beall land in what is now the Deanwood area, by 1879 the Benning settlement boasted a post office and a train station. It was connected to Washington City across the Eastern Branch by Benning's Bridge, which dated from about 1800 and took Benning's name after he reconstructed it as a toll bridge in 1830.[2]

Residents of this area on the northern outskirts of Benning included James Fowler, a government clerk; F. Naylor, a coppersmith; and T. Brightwell, a farmer whose household also included a dentist. They all owned property fronting on a section of the Anacostia Road that was soon to become part of Kenilworth Avenue. (Changes in Anacostia Road over time were complex, but, generally speaking, its route north of Watts Branch became part of today's Kenilworth Avenue; its route south of Watts Branch became part of today's Minnesota Avenue.) One family, the McCormicks, had a big house close to the present-day intersection of Quarles Street and Anacostia Avenue. It was surrounded by oak trees and farmland. The 1880 census shows Alexander, a farmer, married to Elizabeth, a housewife, with seven of their children still at home. The household includes Robert Jones, a black farm laborer.

A horse-racing complex known as Benning's Track, which opened in the 1870s, established the area as a destination for visitors. From 1890 until 1908, when a Congressional antibetting law effectively ended the races, thousands of spectators came out Benning's Road to sit in the large grandstand and crowd the turns, betting, socializing, and watching the horses run. It was here that then-stable-hand Bill "Bojangles" Robinson, the popular African American dancer and entertainer, probably saw for the first time the traveling minstrel shows that inspired his later career. Horse trainers continued to use the track into the 1930s, and popular auto races took place there on Labor Day. The outline of the track is still visible within the Mayfair Mansions development, built on the site in the mid-1940s for middle-income African Americans. The complex was designed by noted architect Albert I. Cassell and financed by popular radio evangelist Elder Solo-

*(opposite)
Giant lotus leaves attract the attention of a photographer at Kenilworth Aquatic Gardens at the annual Waterlily Festival in July 2007. Begun as a hobby by Civil War veteran Walter B. Shaw, the gardens have been a centerpiece of the neighborhood since the late nineteenth century. Photo by S. Cole Rodger*

Benning's Track, opened in the 1870s, drew attention to the rural area that would become Kenilworth. A horse racing track where popular entertainer Bill "Bojangles" Robinson once worked as a stable hand, it was also the site for Labor Day auto races, as seen here in 1916. Courtesy Library of Congress

mon Lightfoot Michaux. An adjacent parcel of land held by the Washington Jockey Club, which administered the Benning track, became the Eastland Gardens subdivision in the 1930s.[3]

In 1879 Civil War veteran Walter B. Shaw bought thirty-two acres of land from his in-laws, David and Lucianna Miller, who had a farm in this rural part of Washington east of the Eastern Branch, then increasingly also referred to as the Anacostia. Located on the Anacostia Road just north of Benning, his eighteen acres of usable farm land fronted on what would soon become Kenilworth Avenue, with fourteen acres of Anacostia River marshland to the rear.[4]

As the oft-repeated story goes, Shaw sent to his native Maine for a few water lilies and planted them in an unused ice pond. They grew so well he carved more ponds out of his marshy acreage and began to experiment with new varieties. Despite having lost his right arm at the Battle of Spotsylvania Courthouse, Shaw proved a capable water gardener. Soon his hobby became a full-time business, and he quit his copywriting job at the Treasury Department. By 1908 Shaw's Water Gardens was doing a brisk trade in cut lily and lotus flowers. Aquarium fish, aquarium plants, water lilies, and other water plants also sold well.

Shaw's daughter Helen inherited his love of water plants and gardening. She married James Marion Fowler Jr., a member of the Fowler family that owned land in both Kenilworth and adjacent Deanwood, and had a child. When her husband and child both died within the first years of marriage, Helen threw herself into work at the ponds, and the lilies became her family.[5]

Around 1912 Helen Fowler took over the water gardens from her father. She continued to expand the operation, traveling to South America to bring back exotic species. During the summer months Helen and her helpers sometimes gathered three thousand blooms a day, shipping them to elegant New York City hotels like the Waldorf-Astoria and as far away as Chicago. She took painting classes at the Corcoran School of Art and began to illustrate her own catalogs, lovingly put together with many tips for the beginning water gardener.[6]

The beauty of Helen's lilies became famous in the city, and many society folk, already familiar with the area through their attendance at horse races at nearby Benning's Track, came to her gardens on Sunday mornings to have a picnic breakfast in the shade of the weeping willows that lined the ponds. President Woodrow Wilson visited the gardens, as did presidents Coolidge and Harding, and Helen counted first ladies among her friends.

In the early 1900s the Army Corps of Engineers began an effort to improve navigation on the silted-in Anacostia River. Working north from the Potomac River, they used dredge material to fill in marshy land along the river's banks. Valued as pollutant traps and vital habitats in the early twenty-first century, marshes were regarded in the early twentieth as malarial flats good only for breeding mosquitoes.

Helen early on became aware that the Corps' dredging work might threaten her thriving business. In the mid-1930s the Corps did indeed try to seize her ponds without compensation, saying that the land had always belonged to the city. Helen successfully fought the seizure. In the end, the federal government bought the land from her and

This early 1900 view shows the marshes along the Anacostia River near Kenilworth before they were dredged away by the Army Corps of Engineers. Considered important to the environment today, these marshy flats were seen then as sources of mosquitoes and disease. Helen Fowler successfully fought to save her adjacent gardens, today operated by the National Park Service. Courtesy Ruth Shaw Watts

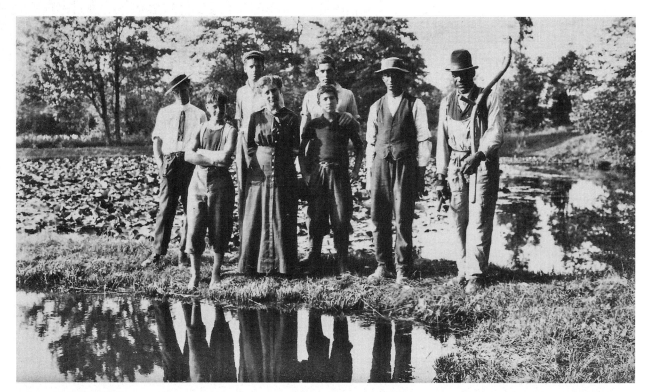

Helen Fowler poses with her workers amidst her lily ponds about 1910. She traveled widely to find exotic species for her water gardens, and her lilies were prized by presidents. Courtesy Ruth Shaw Watts

made the site a national park, naming it the Kenilworth Aquatic Gardens. Helen Fowler continued to live on the banks of her father's ponds until her death in 1957. The Shaw land outside the gardens became part of the tract on which the Kenilworth Courts housing complex would be built. Kenilworth Aquatic Gardens continues to be operated by the National Park Service and draws visitors from around the world.

Even as W. B. Shaw began his water gardens in the 1880s, the rural land around him was changing. By the late 1800s subdivisions began to appear in the small corner of Northeast Washington that is east of the Anacostia River, and this outlying area began a slow change from rural to suburban. In 1895 the name Kenilworth first appeared when real estate developer Allen Mallery bought farmland from the Fowler family and subdivided it. He named this new neighborhood after Kenilworth Castle in England, the ruins of which can still be seen in Warwickshire. Mallery's wife had just read *Kenilworth*, the novel by Sir Walter Scott that immortalizes the story of the visit of Queen Elizabeth I to this famous castle in 1575, and she chose the book's title as the name for her husband's new subdivision.[7]

The up-and-coming suburb with the high-class name was originally laid out along Olive Street and Kenilworth Avenue, with an additional tract of Naylor family land added in 1898 that became Ord Street. The Washington and Suburban Real Estate Company paid for an extension of the existing trolley line, which started at the Treasury Department downtown and came out H Street and Benning Road, NE, and then up Kenilworth Avenue to its new community.[8]

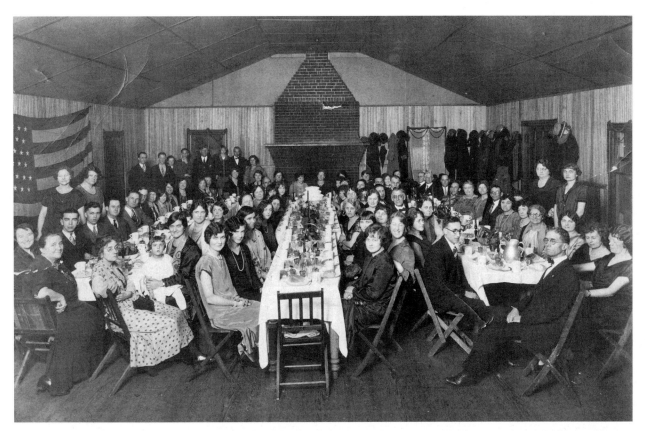

With Benning's Track and Shaw's Water Gardens nearby and an easy trolley commute to jobs downtown, Kenilworth attracted white, middle-class residents who wanted inexpensive land on which to build a modest home. By 1903 houses dotted the newly platted streets, and an elementary school and the Kenilworth Presbyterian Church had been built.

Those who grew up in the original Kenilworth suburb recall that the neighborhood had a small-town atmosphere. The church, though Presbyterian, welcomed the faithful no matter their religious affiliation. It had an active Sunday school with lively traditions such as the yearly open-streetcar trolley outing to Glen Echo Amusement Park on the other side of the city. Local shops on Kenilworth Avenue included a hardware store and a dry goods store owned by brothers Sidney and Isadore Wiseman, as well as Benson's, a variety store. Shaw's Water Gardens presented wonderful possibilities for outdoor exploration, had ice skating in the winter, and gave employment to neighborhood youth.[9]

Kenilworth Elementary School, whose teachers often lived in the neighborhood, was a community institution as well. When, in 1931, cracks in the walls of the building at Ord Street and Kenilworth Avenue made it unfit for use, the city tore down its top stories and erected a community center on the old foundation. Opened in November 1934, the center had a small auditorium, game rooms, workshop space, and an active recreation program. A new school building was built at 1300 44th Street.

Members of Kenilworth Council No. 13 assembled for dinner in a hall in the nearby village of Benning in 1926. The suburb of Kenilworth had a small-town atmosphere at this time, with a cluster of small shops and a Presbyterian Church that welcomed all. Courtesy Carol Nida

Esther Dunkley (left) and her sister Mary (right) stand for a family snapshot with their aunt Carrie Sharpe in the front yard of the William Dunkley home at 1508 Olive Street about 1925. The child is their niece, Ruth Lewis. Two other married sisters also lived in Kenilworth. William Dunkley, an English immigrant, moved to Washington from Pennsylvania to work as a carpenter on the construction of the Wardman Park Hotel. Courtesy Carol Nida

It appears that the suburb was self-consciously and almost exclusively white. Though black families lived close by, the original Kenilworth Elementary School served only the white residents of the area. A racial controversy put the school in the news when, in 1904, Allen Mallery accused an area man, John Colvin, of being a Negro and of sending his nonwhite children to Kenilworth Elementary. The Kenilworth Citizens Association, part of a network of such associations vital to city governance at the time, asked to have the children removed. John Colvin insisted that he and his offspring were white. These attacks eventually forced Colvin and his family to move elsewhere.[10]

By the early 1950s the white suburb of Kenilworth was almost fully surrounded by the growing, historically black neighborhoods of Deanwood to the east and, to the south, Eastland Gardens, which had been subdivided by real estate developer Howard Gott around 1930. Under pressure from civic associations in these neighborhoods, the city opened Kenilworth's community center to African Americans in May of 1952. The Kenilworth school, which by 1953 had only twenty-eight students, was transferred to the "colored" schools, as they were then called, in the middle of the academic year, with full integration coming to District schools in 1954.[11]

Thus white families had already begun to leave the neighborhood in the early 1950s when highway engineers began to plan for the widening of Kenilworth Avenue into a six-lane highway. It was designed to connect the new East Capitol Street Bridge (now the Whitney Young Memorial Bridge) completed in 1955, with other newly completed highways just across the Maryland line. Planners widened the avenue on its western side, razing more than thirty-five Kenilworth and Eastland Gardens houses, several stores, the

newly rebuilt Kenilworth Presbyterian Church, and the community center. The much-loved trolleys also disappeared, their tracks torn up during highway construction.

The new highway brought the end of the white suburb of Kenilworth. Gradually, the white families still living there sold their houses and moved to nearby Maryland suburbs such as Cheverly. John Haizlip, an African American who moved onto Olive Street in 1952, remembered that the street was racially mixed during this time of transition. Black and white children played together and adults were friendly, though there was little social interaction between grown-ups. He did appreciate, though, that as white families moved out they often gave first chance to buy to their African American neighbors. In this way many residents helped their friends and family acquire houses nearby.[12]

Over time Ord Street merged into the identity of Eastland Gardens, which was expanding north to meet it. Olive Street, with Kenilworth Avenue to the west now as much of a barrier as the train tracks to the east, came to be more identified with neighboring Deanwood than with the name of Kenilworth, a change solidified by the addition of Metrorail's Deanwood Orange Line station at the intersection of Olive and Polk streets in 1978. The name Kenilworth persisted for the area in the titles of local green space (Kenilworth Park and Kenilworth Aquatic Gardens), in the name of its highway (Kenilworth Avenue), and in Kenilworth Courts, a government housing complex built in the late 1950s on open land adjacent to the original Kenilworth suburb.

About the same time as the white suburb of Kenilworth was laid out in 1895, a small African American community began to grow close by on Douglas Street between Kenilworth Avenue and Anacostia River marshland. This three-block-long stretch first appears on real estate maps in 1903, subdivided out of land held by L. A. Stone. None of the real estate fanfare that accompanied the beginning of Kenilworth occurred in this area, and no one knows for sure how the street got its name.

Douglas Street formed as a secure place for middle-class African Americans to own property and build a house at a time when many neighborhoods were closed to them. The street attracted hardworking civil servants, teachers, and small-business owners who could afford a bit of the American dream close enough to the city for convenience, yet rural enough for plenty of space and quiet.

It appears that the black community on Douglas Street and the white community of Kenilworth coexisted peacefully. Both races shopped at nearby Benson's Store, and black families could get credit there same as white families. Georgia Johnson Herron remembered that when a member of the Johnson family had scarlet fever and the house was under quarantine, Mr. Benson brought groceries and hung them on the gate just like he would have for any other family.[13]

Racial exclusion, however, at the Kenilworth school and the community center — both closed to blacks into the 1950s — contributed to the lack of social interaction between the races. Also, many on Douglas Street, while grateful for government jobs that allowed them a decent life, faced prejudice that kept them from career advancement.

The Matthews family built on Douglas Street in 1907. Frank Matthews, who worked

Bernetta Matthews plays with neighbor children about 1950. They were part of a middle-class African American community along Douglas Street that grew up about the same time as the adjacent white suburb of Kenilworth. Courtesy Frank Matthews

for the Census Bureau, and his wife, Sadie, passed the house on to their son Thomas. Thomas learned underwater photography in the Navy, then continued in that profession as a civilian, and with his wife, Beatrice, raised three children on Douglas Street. Their son Frank, who loved growing up there amid woods and open land for his go-carts and motor bikes, still lives in the family home and takes great pride in keeping its grounds beautiful.[14]

The Thomas brothers, Charles and Allen, lived next door to each other on Douglas Street. A Harvard-educated professor, Charles was a dean at the DC Teachers College, while Allen worked for the post office. Charles's wife often went door to door to distribute cards on special occasions and made sure neighbors worked together to care for each other.

Gardening was an especially important part of neighborhood life. Richard Johnson Sr. used horses to work a large vegetable garden beside his 4335 Douglas Street address, when he moved his family there in the first decade of the 1900s. This gardening tradition continued into the twenty-first century, with the last occupant of the house, Richard Johnson Jr., using a mechanical tiller to work the same land until his death in 2003. Folks up and down the street remember the pleasure of receiving fresh produce from him, especially his round, ripe tomatoes that a neighbor would line up on her porch rail and eat like peaches.

Change came to Douglas Street in the late 1950s when the Kenilworth Courts public housing complex, built on adjacent farmland, brought thousands of new residents to the area. Some of these new residents became friends to the families on Douglas Street. One was Reggie Glover, virtually adopted as a son by Naomi Wilson, longtime Douglas Street homeowner. Other new residents vandalized fruit trees in their neighbors' backyards, effectively ending a long tradition of fruit-growing on the street.[15]

In 1965 white, Amish-Mennonite missionaries Elmer and Fannie Lapp moved onto Douglas Street. (The author of this chapter is their son.) They and other Mennonite volunteers provided recreation for area youth in the form of a supervised playground and weekly craft classes, as well as faith-based activities like summer Bible school and summer camp. They would serve the community until 2001. A church building, built in 1975, still stands at 4459 Douglas Street in 2008.

Another church, Jericho Baptist, came to Kenilworth in 1969. Under the direction of Bishop James Peebles, the congregation built a modest brick sanctuary at 4417 Douglas Street. In 1977 and 1988 the church expanded, and by 1996 it had graduated fifteen thousand students from its evening Bible school. In 1997 the church moved to the multimillion-dollar Jericho City of Praise complex in Landover, Maryland.[16]

Douglas Street is now a street in transition. Some of its older homes burned or were torn down to make room for Kenilworth Courts and for Jericho Church. A few have sat empty for years. Others were passed down to children or sold to a new generation of black families looking for a good home in a decent neighborhood within the city limits. Recently, the District's real estate boom has caused housing prices to skyrocket even on out-of-the-way Douglas Street. Only time will tell whether the street will retain its rural flavor and African American composition.

Both Kenilworth and the adjacent Douglas Street community had shared a common nuisance since World War II. In the 1940s the city chose filled-in marshland on the eastern shore of the Anacostia River — just north of Benning Road and a little south of the Kenilworth neighborhood — as a waste site. After the Kenilworth Dump opened in 1942, a constant stream of trucks brought trash from all over the city to be burned. By the 1960s the site was burning up to 250,000 tons of garbage a year.

The chapter author's mother, Fannie Lapp, an Amish-Mennonite missionary living with her family on Douglas Street, works in her kitchen about 1967 with Cynthia Sharpe, a resident of the new Kenilworth Courts. Courtesy Cynthia Sharpe

Living close to the dump was not a pleasant experience. The dark smoke rising from piles of smoldering trash became an infamous landmark visible around the city. When the wind shifted just right, the smoke and smell invaded nearby neighborhoods and houses, and laundry on the line turned black with soot.

However, its piles of trash supported a cottage industry of men with trucks who salvaged items, fixed them up, and sold them. Children from the surrounding neighborhoods delighted to play in the dump, finding toys, money, comic books, bicycles, and other castaway treasures in its heaps of discarded goods. Adults scavenged there, too, with families furnishing whole apartments at the dump.

The negatives outweighed the benefits, though, for most area residents, and they complained and staged protests. Their pleas began to gain a hearing when, with national attention focusing on poor air quality in cities, some in Congress became embarrassed by the smoke and pollution rising daily from the dump in their own backyard. With replacement incinerators delayed by red tape, open burning at the Kenilworth Dump continued past a stated deadline of January 1, 1968. That February a boy playing in the dump burned to death. Amid public outrage, Mayor Walter Washington halted the flames. After several years as a "sanitary landfill" where trash was packed down and covered with dirt, the site was transformed into Kenilworth Park in the 1970s, with sports fields and a recreation center. However, concerns about soil contamination and illegal dumping have limited park use and continue to be an issue for the community.[17]

In the 1940s, about the same time that the still-rural nature and abundant open land of the Kenilworth area led the city to locate a dump there, these assets also caught the eye of U. S. government housing officials. They needed such open land to build housing for the thousands of workers who came to the District to help fight World War II. In 1943 the Lily Ponds Houses opened for white war workers. This complex of one-story

red-tile and cement-block town houses centered around the 4400 and 4500 blocks of Quarles Street on the western side of Kenilworth Avenue and featured a community center with day care facilities and an activity room. In the mid-1950s, the nearly empty Lily Ponds Houses were demolished.[18]

With new houses needed to replace aging ones nearby, and to resettle residents displaced by the demolition of most of Southwest Washington, a larger complex, Kenilworth Courts, soon appeared on the same site. Opened by the National Capital Housing Authority in 1959, it was among the first public housing in the city to be planned as a racially integrated complex. The 422-unit, orange-brick complex of two-story, garden-style town houses — with a few three-story apartment buildings thrown in — ran along the old Quarles Street with new stretches on 45th Street, Anacostia Avenue, and Ponds Street, and some frontage on historic Douglas Street.[19]

Walter McDowney remembers that, when his family moved into Kenilworth Courts in 1959, he thought their new home a palace. The kitchen shone with brand-new appliances, and they had an indoor bathroom, much better than the outdoor privy they had shared with other families in Southwest. Early residents describe a well-ordered community. Everyone respected Fletcher Morton, the manager, and he visited homes to check on cleanliness and upkeep, levying fines on untidy housekeepers. The complex held yearly parades, and the Kenilworth drum and bugle corps was the pride of the neighborhood. Mothers congregated in kitchens and on front porches, keeping an eye on the neighborhood's children while socializing and trading stories.[20]

As years passed and families who were economically able moved out of the neighborhood, they were replaced by an increasingly transient population that did not value the promise of the property as highly. Management by the National Capital Housing Authority became less strict, and the complex began to deteriorate. Gradually, headlines about Kenilworth changed from news of a well-ordered community to sensational stories of an emerging rough-and-tumble street life.

By the mid-sixties Kenilworth Courts was an almost exclusively black neighborhood with a new generation of youth who felt increasingly alienated from the prosperity they saw others enjoying. When the death of Rev. Dr. Martin Luther King Jr. in 1968 sparked riots in the city, the unrest that simmered in Kenilworth spilled over as well. Looters ransacked the neighborhood Safeway on Kenilworth Avenue, and it did not reopen.

Trash pickup became sporadic, and rats ran freely in some sections. Wild dogs, drawn to the nearby Kenilworth Dump, terrorized residents. Heat and hot water were unpredictable. Lisa Moore Reynolds remembers having to boil hot water on the kitchen stove, then carry it upstairs to the bathtub for a warm bath. The property declined to a point where, in 1971, a mayoral aide called the once-proud Kenilworth Courts "hell on earth."[21]

Even during this difficult period, however, a network of neighborhood leaders, mostly mothers, worked hard to keep the area safe for their children. One such leader was Vernita Wimbush. She helped organize activities for children and ran a day care

Young boys play touch football in the street in Kenilworth Courts in 1971. The public housing complex opened in 1959, one of the first to be available to black and white residents. Walter McDowney, who moved there as a boy from Southwest, remembers thinking his family's new home was a palace. Photo by Matthew Lewis. Courtesy Washington Post

center that, housed in nearby Zion Baptist Church in Eastland Gardens, provided jobs for area youth. She also called attention to the serious overcrowding at Kenilworth Elementary School, a result of the sudden increase in attendance there when Kenilworth Courts filled with families. During the winter of 1967–68 she led a protest over broken windows and poor heating in the school that made citywide headlines and resulted in repairs personally ordered by Mayor Walter Washington.[22]

In 1974 an innovative program called College Here We Come began under the leadership of neighborhood resident Kimi Gray. Kimi, a young mother of five who moved into Kenilworth Courts in 1965, had become a leader in the community and president of the Resident Council. College Here We Come began to offer a variety of college prep services to area teens, hoping that they could "get out of the ghetto" and receive an education, then come back and help the neighborhood. The scheme worked. By 1985 the group had sent more than five hundred teens to college, where before only a handful had gone.[23]

Inspired by the success of College Here We Come, Kimi Gray banded with other concerned mothers like Gladys Roy in a concerted effort to improve their neighborhood. Their work gained the attention of Stuart Butler, an economic theorist with the Heritage Foundation in downtown Washington. He introduced Gray and her group to Congressman Jack Kemp from Buffalo, New York. Leaders like Kemp and Robert Woodson of the National Center for Neighborhood Enterprise were thinking about tenant management as a way for problem-ridden complexes like Kenilworth Courts to turn themselves around. Gray understood that this was exactly what her neighborhood needed. After forming the Kenilworth-Parkside Resident Management Corporation, or

KPRMC, Gray, Roy, and others were trained in running public complexes. (The organization included the smaller Parkside public housing project a mile southwest of Kenilworth.) KPRMC began to manage Kenilworth Courts in 1982.

The new tenant management was a success. Since the complex was now run by people they knew, more residents paid their rent on time. Maintenance workers hired from the neighborhood fixed problems quickly: if the heat or hot water went out, they had to do without as well. "The office," as the resident management center became known in the neighborhood, instituted a series of fines for everything from littering to breaking a window, as Gray and the other managers stood conventional wisdom on its head in an all-out effort to improve their neighborhood. New drug and alcohol treatment programs began to combat a surge of substance abuse problems. Neighbors tired of the drug trade formed close relationships with police and began to put pressure on the dealers camped out on Quarles Street. Residents obtained high school equivalency degrees, found jobs, and left the welfare rolls.[24]

Kimi Gray's contacts with Jack Kemp — who would soon become the secretary of Housing and Urban Development — D.C. Mayor Marion Barry, and other political leaders continued. As problems in rundown public housing complexes gained national

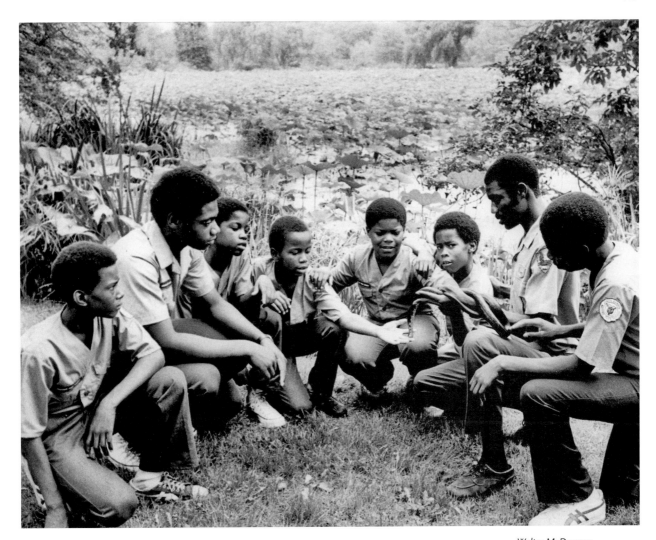

attention, the Reagan administration made tenant management and ownership a cornerstone of its housing policy.

To Kemp and others, Kenilworth was an ideal place to try the concept of tenant ownership. KPRMC received funds to renovate the property, and, on October 25, 1988, to much political and media fanfare, a ceremony was held in Kenilworth, during which KPRMC "bought" the property from the city for a dollar, conditional on timely completion of renovations. Problems plagued the renovations, however, and in the end only 132 units went to KPRMC in 1990 as promised. Then, in March of 2000, Kimi Gray, the complex's dynamic leader, became ill and passed away.[25]

At the time of this writing, KPRMC was managing 132 units in Kenilworth Courts, continuing to find ways to improve its housing and inspire its residents. In the remaining units, turned back to the D.C. Housing Authority, residents still worked in "the office" at 4500 Quarles Street and on the maintenance crews, and a resident council continued the strong tradition of community activism.

Walter McDowney, who had moved to Kenilworth Courts from Southwest as a boy, is seen here, second from right, as a National Park Service Ranger at Kenilworth Aquatic Gardens in about 1980. He is showing a snake to neighborhood boys in a Junior Ranger program. Courtesy Walter McDowney

With the neighborhood so dominated by public housing stock and public parkland, government decisions will ultimately determine the course of community life in Kenilworth, both for Kenilworth Courts residents and for Douglas Street homeowners. Demolition of aging public housing complexes around the city around the turn of the millennium has raised questions about the future of Kenilworth Courts. Some area residents hope that redevelopment will come and bring more stability to the neighborhood, while others do not wish to lose the physical complex that they have worked so hard to make livable for themselves and their families. Currently, the Kenilworth area is also included in plans to revitalize the Anacostia River waterfront, with two thousand new housing units and five hundred thousand square feet of commercial and retail space scheduled to replace the Parkside housing development south of Kenilworth. New connections between residential areas and the Anacostia are planned, including a new riverside trail. No matter what development decisions are made, however, the last surviving Anacostia River marsh will remain nearby at the Kenilworth Aquatic Gardens, where a quiet stroll easily reminds the visitor of the area's rural, riverside roots.

Takoma Park

RAILROAD SUBURB

ROBERT MCQUAIL BACHMAN

After more than a century of citizen effort to build, protect, and preserve this late nineteenth-century community, Takoma Park, Maryland and D.C., is a living museum of the American suburbanization process. Made possible by the railroad, succeeding transportation technologies — the electric streetcar, the automobile, and the modern subway system — propelled and shaped its growth. Its spacious early design reflected the newly embraced concept of suburban living. Its single-family homes on large lots were central to the late nineteenth-century "rural ideal" that emphasized private family life, the security of small community settings, and the enjoyment of natural surroundings. In Takoma Park, as in other early American suburbs, residents brought the rural and urban elements they valued the most to their new environment. Takoma Park stands out, however, in the exceptionally active way that its citizens met the challenges involved in growing, and later preserving, their rural, and now urban, suburb.[1]

Takoma Park arose from the vision of Benjamin Franklin Gilbert, who came to Washington from New York State in 1862 to pursue the many opportunities brought by rapid population growth during the Civil War. In 1865 he opened the Temperance Dining Room on F Street between 9th and 10th streets, NW. Two years later he moved into real estate with the development of Grant Place between G and H and 9th and 10th streets in central Washington. Convinced that the city would grow to the north and northwest, he watched with interest as the Baltimore and Ohio Railroad completed its Metropolitan Branch rail line from Point of Rocks, Maryland, to Washington City. On November 24, 1883, he acted, investing $6,500 in ninety acres of the G. C. Grammar estate straddling the District line with Montgomery County, Maryland.[2]

Despite the property's location seven miles from the center of the city, it was a practical decision. The new B&O rail line ran northwest from downtown Washington right through his property and provided freight service and passenger trains to city jobs, shopping, and cultural attractions. The elevation, three hundred to four hundred feet above

Benjamin Franklin Gilbert's 1883 Takoma Park suburban development straddled the line between the District and Maryland. The boundaries of the District section, today most often referred to as Takoma, are generally accepted by current residents. The municipality of Takoma Park, Maryland, has grown far beyond the first investments by Gilbert. Each has small historic districts within it. Map by Larry A. Bowring

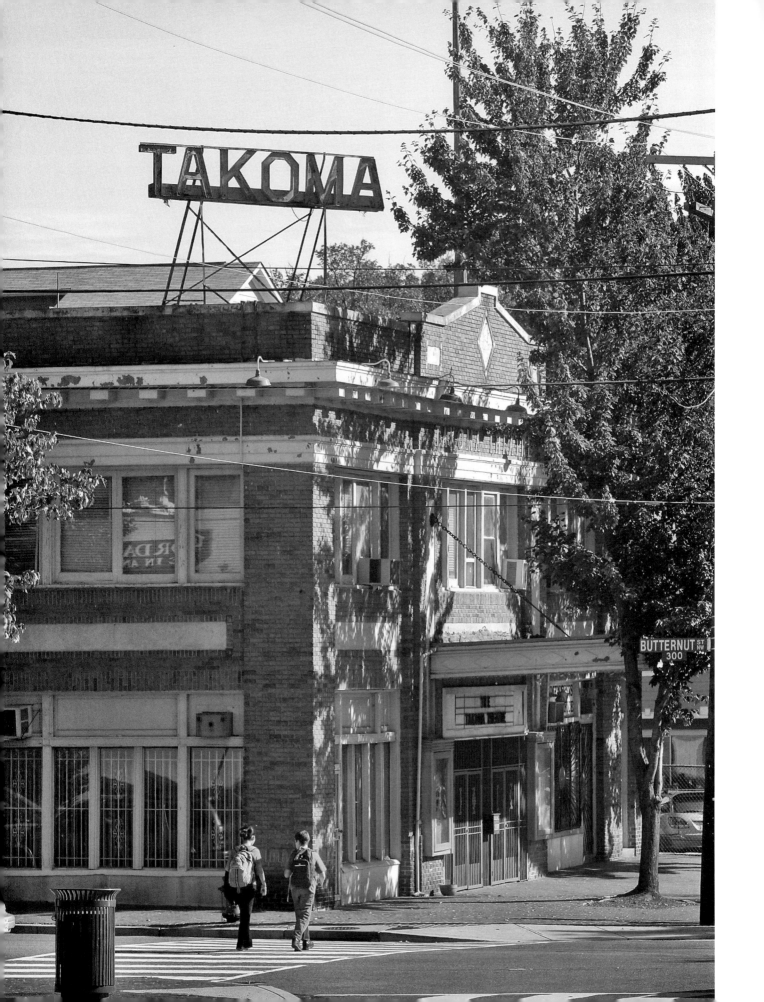

the Potomac River, kept it free of the malarial mosquitoes that plagued Washington in summer. Natural springs provided an excellent supply of water, and an abundance of mature trees kept the area ten degrees cooler than the city. Gilbert named his new community Takoma, an Indian word meaning "high up, near heaven," changing the *c* to a *k* to avoid confusion with Tacoma in Washington State. He soon added the word "Park" to emphasize its rural charms.[3]

Gilbert had disregarded jurisdictional lines, confident the District of Columbia and Maryland sections would always be part of Takoma Park. Although the Maryland section incorporated as a municipality in 1890 and the District section remained a neighborhood without local autonomy, jurisdictional differences were not a barrier to cooperation or community identity in the early years. Marylanders and Washingtonians worked together to persuade the various governments—federal, district, state, and county—to meet their needs. The majority of Gilbert's later land purchases, however, were on the Maryland side, perhaps suggesting he encountered fewer restraints there.[4]

Gilbert subdivided his first parcel into fifteen blocks of homes on Carroll, Cedar, Chestnut, Highland, and Maple streets in the District and on Carroll, Cedar, Chestnut, Maple, and Tulip avenues in Maryland. The first 265 lots were fifty feet wide and had deep backyards that stretched two hundred to three hundred feet. He priced them competitively at 1.5 to 5 cents per square foot, compared with 48 cents per square foot in the city, for a total cost of $150 to $750 per lot. Gilbert appealed to prospective buyers among the swelling ranks of people coming to the city for jobs in the growing federal government with his 1886 real estate brochure, *The Villa Lots of Takoma Park: A Suburb of Washington City.* "All you need is a modest income," the brochure advised. "Many department clerks are paying out sums as monthly rentals that would buy a home in Takoma Park if applied to purchase money. Living expenses can be further reduced by the keeping of a cow, the raising of chickens, and a garden spot."[5]

The B&O Railroad encouraged the development of communities along its Metropolitan Branch, and in 1886 built the Takoma Park station on Cedar Street, NW, near the present-day Takoma Metrorail station. Baldwin & Pennington, the architects of all the stations on the Metropolitan Branch, designed the new station to serve a town of five thousand to eight thousand, an expression of the railroad's confidence in the future of the new suburb. While Gilbert's lots were affordable, he understood the attraction of high style. He asked his best architect, William Skinner, to design and build the first large, elaborate homes close to the tracks to advertise the affordable elegance of his "sylvan suburb." By 1890 the new suburb had attracted 163 residents and had fifteen trains a day running through it on the way between Point of Rocks, Maryland, and downtown Washington.[6]

A special spirit developed as early residents on both sides of the District line shared the challenge of creating a community from a cluster of homes located amid acres of tangled vines and trees, with no electricity, piped water, paved roads, or sidewalks. Takoma Park's "pioneers," as the first residents liked to call themselves, were aggressive, coopera-

(opposite)
Students on their way home on a sun-dappled afternoon pass the Takoma Theatre at 4th and Butternut streets, a neighborhood landmark designed by John J. Zink in 1923 and the focus of current neighborhood restoration efforts. Today the D.C. government and many residents and organizations in the District section of Takoma Park call their neighborhood simply Takoma. Photo by Rick Reinhard

tive, and public spirited. Forced by circumstances to transplant only the most important elements of city and small-town life to their new suburban community, early residents pressed for the essentials. Soon a drugstore, livery stable, blacksmith shop, coal merchant, grocer, general store, and Takoma Hall—a community center with a library, meeting rooms, billiards, and bowling—clustered around the Cedar Street station.[7]

Residents tutored their children in one another's homes until 1887, when the Montgomery County Board of Education responded to their urgent petitions and built a four-room frame schoolhouse on Tulip Avenue between Maple and Willow avenues in Maryland that enrolled twenty-nine students from both sides of the line. Residents organized the Takoma Park Citizens Association in 1889 and persuaded the District of Columbia government to build the Neoclassical-style Takoma Elementary School at Cedar Street and Piney Branch Road in 1901. Both District of Columbia and Maryland children attended the new school until 1910, when Congress ruled that non-District residents had to be turned away. Residents worshiped in each other's homes until 1888, when Gilbert donated land to the Union Chapel Association for a cooperative church for all to use for worship according to their different faiths.[8]

Takoma Park's first suburban lots and houses broke the spatial restraints of Washington City and expressed a nostalgia for small-town, rural living. Trees were preserved to maintain the area's woodland character. The homes were neither farm houses nor city row houses. Their suburban style, according to architectural historian Vincent Scully, was "one of the major vehicles of American architectural invention in the nineteenth century." Such houses supported family life in the new industrial era by combining the benefits of the country with the advantages of the city. Architectural pattern books popularized such styles, and local builders used them for the first Takoma Park houses. They used frame and shingle wood construction to create distinctive multistory dwellings with spacious family-oriented interiors. Scattered throughout the earliest Takoma Park subdivisions are homes in the Queen Anne, Stick, Shingle, Colonial Revival, and Italianate styles incorporating stained-glass windows, turrets, towers, corner bays, clapboard siding, fish-scale shingles, lattice work, wraparound porches, multi-gabled or hipped roofs, decorative slate roofs, and tall, almost medieval-looking chimneys. The cost of most of the homes varied from a very affordable $1,000 up to $5,000, a price equal to that of houses in Chevy Chase. There were a few architect-designed "villas" priced between $10,000 and $15,000.[9]

By 1888 Gilbert had purchased additional land and platted subdivisions for a thousand-acre community. In 1893 he completed the 140-room North Takoma Hotel,

A prosperous Benjamin Franklin Gilbert poses here at the height of his success as the founder of Takoma Park, laid out on land he purchased in 1883 along the Metropolitan Branch of the Baltimore and Ohio Railroad. He had come to the capital from New York State during the Civil War at the age of twenty-one, expecting that rapid population growth would open a host of opportunities. Courtesy Historic Takoma, Inc.

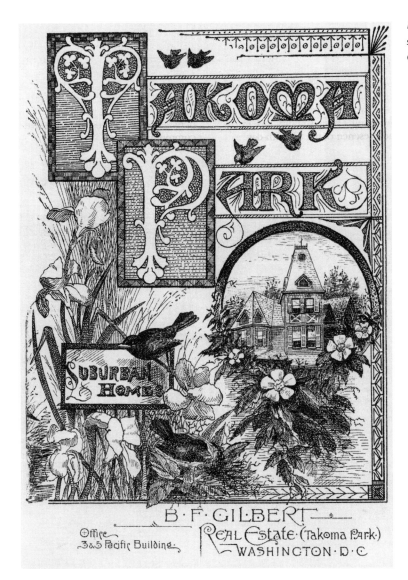

Flowers and birds announce Takoma Park as a suburban haven from the crowded central city. Courtesy Historic Takoma, Inc.

complete with its own railroad stop, at the corner of Takoma Avenue and Fenton Street on the Maryland side as a resort for visitors and potential home buyers. In the same year, he persuaded Boston physician R. C. Flower (for whom present-day Flower Avenue is named) to purchase land above Sligo Creek for a hospital. In less than ten years, Gilbert had put his grand design for the long-term growth and success of his suburb in place, with railroad service, houses, business district, resort hotel, plans for a hospital, and room to grow.[10]

The stage was set for the next phase of growth as electric streetcar lines extended their reach into this community. In 1893 the Brightwood Railway Company ran a spur from its Georgia Avenue line east to 4th and Cedar streets. Soon thereafter, the competing Capital Traction streetcar company ran a spur from its 14th Street line to a terminal in the heart of the Takoma Park's business district at Laurel and Eastern Avenue, NW.

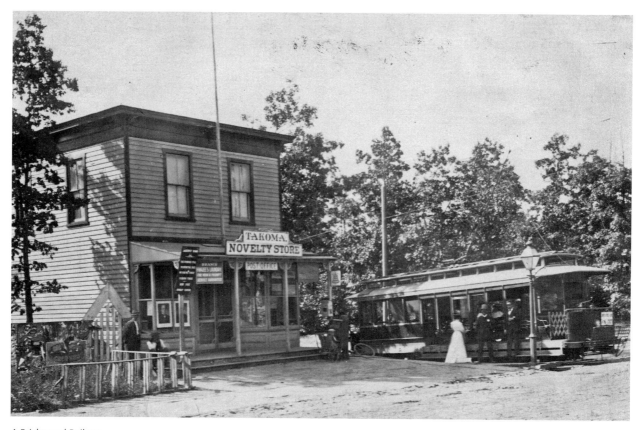

A Brightwood Railway Company electric streetcar takes passengers right to the front door of the Takoma Novelty Store and Post Office at the turn of the twentieth century. Service on the Brightwood line began in 1893. Courtesy Historic Takoma, Inc.

Then in 1897, the new Baltimore and Washington Transit Company ran a line from that intersection deep into the Maryland side, with a terminus near present-day Heather and Elm avenues. Where streetcars went, people, homes, and businesses soon followed. In 1900 Boston promoter Alva M. Wiswell built the Glen Sligo Hotel overlooking Sligo Creek near the streetcar terminus and developed the Wildwood Amusement Park on the banks of the creek, offering dancing, vaudeville acts, bowling, and boating. Amusement parks were a common promotional feature of early suburbs to lure potential lot buyers as well as to generate off-hour revenues for streetcar companies; another example at about the same time was Chevy Chase Land Company's Chevy Chase Lake and Amusement Park. Unfortunately Wiswell's enterprises were short-lived; floods destroyed the amusement park in 1902, and the hotel was sold to Baltimore gambling interests. The B&W Transit Company streetcar line, nicknamed the "Dinky Line," however, continued to provide streetcar service into the Maryland side until 1916 when the town bought the line and removed the tracks. The hotel casino soon closed due to lack of customers. The Glen Sligo Hotel building was torn down in 1920.[11]

But there were more serious signs of economic trouble for the town. The economic panic of 1893 blunted Takoma Park's emergence as an upper-middle-class suburb. While the Washington area real estate industry was temporarily affected by the panic, B. F. Gilbert's land development business never fully recovered. When Gilbert could not

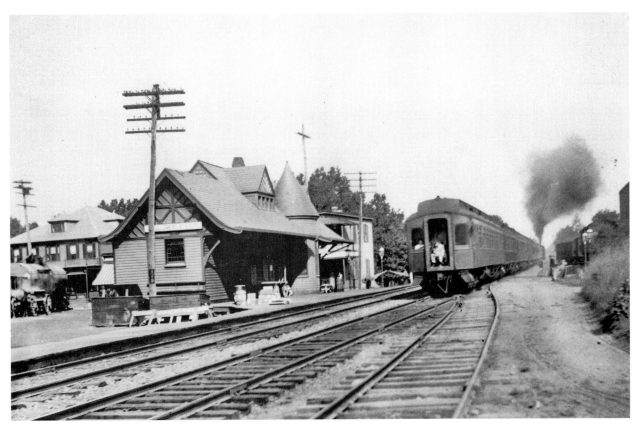

Trains stopped fifteen times a day at the 1886 Takoma Park Baltimore and Ohio Railroad station on Cedar Street in the late nineteenth and early twentieth centuries. This picture was taken between 1911 and 1915. Courtesy Historical Society of Washington, D.C.

convert his land holdings in Takoma Park into cash to pay recalled notes, he sold his mansion there and moved into the North Takoma Hotel to live and personally oversee its management. His diminished role as principal developer and promoter proved permanent, and no subsequent land developer filled the void. Gilbert's financial ruin as a suburban land developer and its impact on the future development of Takoma Park contrasts sharply with the experience of Francis Newlands, whose extensive capital allowed him to ride out the 1893 depression and keep control of his grand vision for Chevy Chase as an upper-middle-class suburb of fine large residences. Subsequent developers in Takoma Park lacked Gilbert's grand vision and laid out smaller subdivisions with smaller lot sizes that would attract less-affluent buyers.[12]

Gilbert's last major contribution to Takoma Park's development came in 1903 when he persuaded Elder Ellen G. White to relocate the world headquarters of the Seventh-day Adventist Church from Battle Creek, Michigan, to Takoma Park, D.C. The Adventist Church's emphasis on clean air, clean water, vegetarian diets, exercise, and other health reforms was a natural fit with Gilbert's lifelong belief in temperance and healthful living and the local ordinance forbidding production or sale of alcoholic beverages within the town. The arrival of large numbers of Seventh-day Adventist leaders, employees, and followers to live and work in the community brought new life and new influences. The Adventists bought a large parcel of land near the town center on the District side and

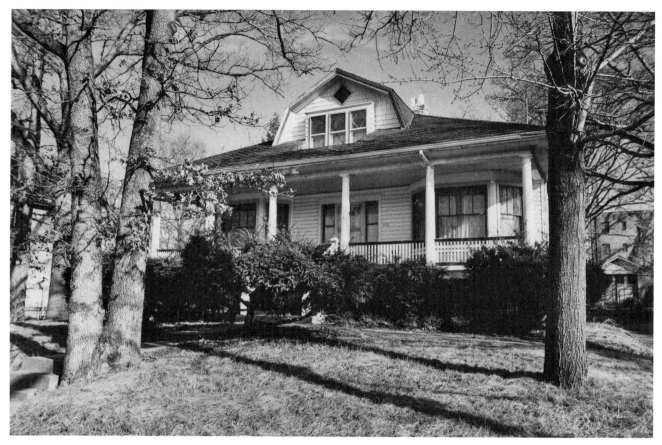

Bungalows such as this one at 202 Cedar Street, NW, constructed in 1908, were popular with the middle-class residents of Takoma Park, and many were built between 1900 and 1930. Courtesy Historic Takoma, Inc.

in 1906 completed their General Conference headquarters building and their *Review and Herald* Publishing Association printing plant on Eastern Avenue between Willow and Laurel streets. The church also purchased fifty acres of Dr. Flower's undeveloped hospital site above Sligo Creek on the Maryland side of town and opened the modern Washington Sanitarium (now known as Washington Adventist Hospital) in 1907. All of these new buildings required electric power lines, natural gas mains, and telephone service. While the extension of water and gas mains to the neighborhood had begun in the late nineteenth century, the arrival of the Adventists in 1903 sped the delivery of these and other modern conveniences to the entire community.[13]

From 1900 to 1920, Takoma Park's population more than quadrupled, from 756 to 3,198. The arrival of the Adventists was a critical factor; in 1910 a fifth of all Takoma Park households included members employed in church-related jobs. The boom in employment related to World War I affected the community as well. Nurses and rehabilitation aides treating wounded soldiers and victims of the influenza epidemic at Walter Reed Hospital found homes in nearby Takoma Park, as did clerks in the burgeoning War Department. These newcomers brought a new socioeconomic diversity to the community. The 1920 U.S. Census listed the jobs held by Takoma Park, D.C., residents as government clerk, engineer, mechanic, machinist, bookkeeper, carpenter, draftsman, salesman,

teacher, plumber, railroad freight agent, and conductor. Many new residents were buying smaller lots and building more modest American foursquare and bungalow homes, while some more affluent middle-class families continued buying larger lots and building larger houses.[14]

The foursquare and bungalow home styles were popular from about 1900 to 1930 and were well suited to the drop in economic confidence and the increase in lower-middle-class workers that followed the depression of 1893. The two home styles fit the reduced lot sizes in Takoma Park so well that, despite a doubling of house density per acre, they did not change the spacious, wooded appearance of the neighborhood. The typical American foursquare house built in Takoma Park had an efficient footprint for long, narrow lots. Of wooden or stucco construction and two stories, the foursquare had a simple box shape with a four-room floor plan, a hipped roof with a large central dormer window in the front, and a full front porch whose roof design matched the main roof. There was also a side entrance for coal and milk delivery. Bungalows were single story with a partial front porch, low-pitched gable roof, and limited attic space made usable by a dormer window in the roof or gable. Most bungalows built in Takoma Park and across the nation incorporated larger second-floor living space into the gable roof, a variation dubbed "bungaloid" by architectural historians. Some Takoma Park residents ordered foursquare and bungalow homes directly from Sears & Roebuck, Montgomery Ward, or other popular catalogs and had them delivered by the railroad in pieces and assembled on the site by local builders. Examples of bungalow or bungaloid and foursquare homes can be seen on 4th through 9th streets, as well as Aspen, Cedar, Dahlia, Umatilla, Vermillion, Whittier streets, NW, and on Flower Avenue and Baltimore Avenue on the Maryland side. Beginning in the 1930s, houses in the Tudor Revival, English Cottage, and Cape Cod styles introduced brick, half-timbering, and mixtures of stone, stucco, and wood to Takoma Park neighborhoods.[15]

Takoma Park continued to attract important institutions. In 1908 Dr. Louis Denton Bliss, an associate of Thomas Edison, purchased the debt-ridden North Takoma Hotel and moved his Bliss Electrical School from downtown Washington to the Maryland side of the Park. He immediately remodeled the wooden hotel for classrooms and dormitories, only to have it burn down within the year, possibly due to poor gaslight pressure at the time. Bliss rebounded with three new, modern fireproof buildings on the seven-acre site. Electricians trained for military and civilian jobs there until 1950, when Montgomery County bought the campus and buildings for the new home of Montgomery Junior College (now Montgomery College). In 1911 a successful citizen-led campaign that involved Maryland and District residents brought Washington's first branch of the D.C. Public Library to Takoma Park at 5th and Cedar streets, NW. Residents raised funds to purchase the site, persuaded philanthropist Andrew Carnegie to donate $40,000 to construct the building, and lobbied Congress to appropriate the funds for ongoing maintenance and operation.[16]

In the early 1920s the lines between the District of Columbia and Montgomery and

Prince George's counties, Maryland, began to matter in Takoma Park. While the three jurisdictions continued to cooperate, each found it was politically more effective to act separately to acquire services for their sides of the line. The multi-jurisdictional Takoma Park Citizens Association formed a separate Community League of Maryland in 1922 to lobby for new schools on the Maryland side, while the Takoma, D.C., Citizens Association was formed in 1924 to improve schools and community services on the District side. Over a six-year period, the Community League shepherded the approval and construction of the Philadelphia Avenue Elementary School and the Takoma Park-Silver Spring High School on Piney Branch Road in Montgomery County and the J. Enos Ray Elementary School in Prince George's County. In a similar fashion, the Takoma, D.C., Citizens Association successfully supported the construction of a second-story addition to the Takoma Park Elementary School and the construction of Paul Junior High School on the District side. The D.C. neighborhood also welcomed its first major motion picture theater and community auditorium at 6834 4th Street in 1924 with the opening of the five-hundred-seat Takoma Theatre, designed by noted theater architect Jacob Zinc.[17]

In 1933 Takoma Park marked the fiftieth anniversary of the town with three days of celebration that included a parade, an old settlers' banquet, a tour of "pioneer" homes, and united church services. The 1930s saw continued growth, despite the Great Depression, with the completion of a new steel and concrete bridge over Sligo Creek in 1932 to handle increased automobile traffic, the arrival of an F. W. Woolworth's in 1939, and the construction of the ten-room Takoma Park Junior High School in 1940 on Piney Branch Road in the Montgomery County section of the suburb.[18]

Between 1920 and 1940 the population of Takoma Park increased dramatically to reach 8,939 on the Maryland side and 5,215 in the District. The affordable automobile, the construction of apartment buildings in Takoma Park, D.C., and the expansion of the federal government all contributed to the area's growth. New roads were built and old ones widened and extended, connecting previously separate subdivisions and neighborhoods. East West Highway threaded formerly unconnected roads together in Takoma Park and joined a necklace of suburbs north of Washington that ran from Hyattsville and Riverdale in the east, through Takoma Park and Silver Spring to Chevy Chase and Bethesda to the west. Less than three years after a four-lane extension of New Hampshire Avenue opened in 1938 from the District line to what is now University Boulevard, nine subdivisions appeared on the Prince George's County side of town. University Boulevard and East West Highway moved development eastward, away from the old railroad and streetcar-oriented town center. As the automobile became king, buses replaced streetcars on transit lines. The last Takoma Park streetcar ran in January 1960.[19]

The World War II years brought population pressures to Takoma Park, as they did to the rest of Washington. Many large homes on both sides of the line in Takoma Park were divided up into apartments to house war workers. After the war, the Takoma Park

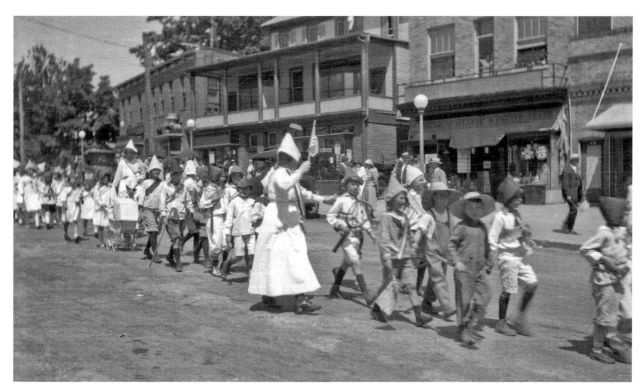

A youthful contingent of the Takoma Park Fourth of July parade marches down Cedar Street at Blair Road in 1920. Courtesy The Historical Society of Washington, D.C.

business district, which had expanded over the years from its center on Cedar Street, NW, down Carroll Street, Willow Avenue, and Eastern Avenue into Maryland, began to wither as residents on both sides of the District line increasingly drove their cars out Georgia and New Hampshire avenues to new shopping centers in Silver Spring and Langley Park, Maryland. Many of the homes converted into apartments for war workers would never again be single-family residences.[20]

Major changes and challenges on both sides of the line, beginning in the 1960s, severely threatened the social as well as physical fabric of the community. As black families bought homes in Northwest Washington neighborhoods, some real estate dealers intentionally frightened white residents into selling their homes to them at a low price, so they could then sell the homes to black families at a higher price, a process known as blockbusting. Takoma Park, D.C., joined with its adjacent neighborhoods Manor Park and Shepherd Park to form a new organization, Neighbors, Inc., whose mission was to create neighborhoods where blacks and whites could live together in an orderly, small-town atmosphere. The extraordinary success of this important organization is fully described in the Shepherd Park chapter. Neighbors, Inc. provided a structure within which Takoma Park, D.C., residents proudly worked to maintain the neighborhood's diversity and stability as the community changed dramatically from 18.4 percent black to 63.3 percent black in just ten years, 1960 to 1970. To reflect their new sense of community identity, some Takoma Park, D.C., residents made a point of calling their neighborhood Takoma, D.C., dropping the word "Park" to distinguish it from the Maryland section,

A cartoon by commercial artist and anti-freeway activist Sammie Abbott portrays the havoc the proposed North Central Freeway would unleash on Takoma Park. Courtesy Historic Takoma, Inc.

which was experiencing racial changes and integration at a much slower pace. Indeed, some institutions and individuals on the District side had used this simpler term even earlier. Today many residents and the city government just use Takoma as the name for the D.C. neighborhood.[21]

About the same time, all of Takoma Park joined the front lines in the highway battles of the 1960s and early 1970s. The U.S. Department of Transportation was eager to build a network of multilane highways to move traffic in and out of Washington, connected to the circular Capital Beltway, which was completed in 1964. The design for one such highway thrust I–95 through Takoma Park, Brookland, and Michigan Park, threatening to displace hundreds of homes and thousands of residents. Takoma Park resident Sammie Abbott stepped out in front with others to organize the Save Takoma Park Committee. A coalition of Maryland and D.C. neighborhoods, residents, schools, and colleges in the projected freeway's path, the committee succeeded in attracting the support of influential advocacy groups such as the Metropolitan Citizens' Council for Rapid Transit, American Institute of Architects, Sierra Club, and National Audubon Society. With calls to "Stop the Concrete Octopus," the coalition characterized the proposed highway as "White Men's Roads through Black Men's Homes" and argued that rapid transit, not highway construction, was the cure for metropolitan Washington's traffic congestion. The fight went on for years; Takoma Park's future hung in the balance.

Amazing to many, citizen activists won the day, defeating the powerful interstate highway lobbies. As the citizens had proposed, federal transportation funds were redirected to create the Washington Metropolitan Area Transit Authority subway system. Paradoxically, the initial planning for Metrorail also threatened the future of Takoma

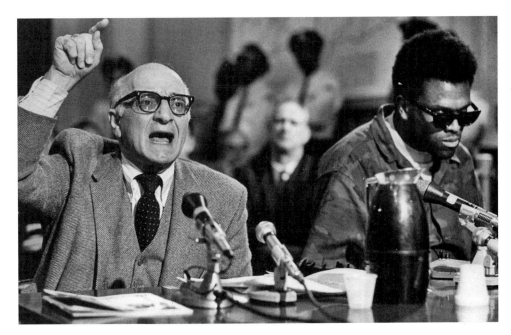

Sammie Abbott makes his point before the D.C. Council as he testifies with fellow freeway fighter Reginald Booker against the proposed North Central Freeway on January 29, 1970. A civic activist used to working outside the system, Abbott became an insider in 1980 when he was elected to the first of three terms as mayor of Takoma Park, Maryland. Courtesy Star Collection, DC Public Library. © Washington Post

Park. A 1971 master plan for the Takoma subway station called for rezoning forty-two acres of older residential and low-density commercial properties in Takoma Park, Maryland and D.C., to accommodate high-density development, a five-hundred-car parking lot, and the widening of major residential streets for anticipated heavy automobile traffic. Residents resurrected the Save Takoma Park Committee and in 1974 successfully restored the existing low-density residential and commercial zoning. The Takoma Metrorail station opened for service in 1978 off Carroll Street, NW, in the District, and in 1979, the ever-vigilant Neighbors, Inc., organization established a new nonprofit group called Plan Takoma, Inc., to monitor zoning decisions in and around the new Metrorail station and to translate the community's concerns into a coherent revitalization and development plan.[22]

While dealing with the Washington Metropolitan Area Transit Authority over development issues, the community faced yet another challenge, this time from Montgomery College. In 1971 the college announced plans to improve and expand its seven-acre Takoma Park campus in the North Takoma subdivision on the Maryland side, a plan that required the demolition of twenty-one houses of historic significance. Residents formed a new citizen group, Citizens United for Responsible Expansion, to address the issue. In 1976, after five years of citizen protests to city, county, state, and federal authorities, the demolition of a few fine Victorian houses, and the construction of two new college buildings in a residential area, the federal government acknowledged the historic value of Takoma Park and placed the earliest subdivisions on the National Register of Historic Places. Montgomery College was forced to withdraw its plan to build additional buildings in residential neighborhoods and, as citizens had suggested from the beginning, the college purchased nearby commercially zoned property to build new classroom build-

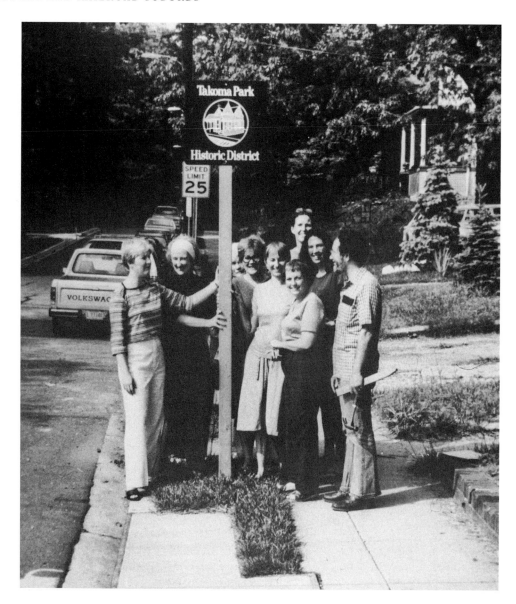

ings and a parking structure. The District side, led by Plan Takoma, Inc., then worked to preserve its earliest sections, and in 1983 the oldest D.C. subdivisions were also placed on the National Register of Historic Places. The D.C. historic district is called Takoma Park, D.C., rather than the Takoma, D.C., adopted by some earlier, in acknowledgment of its historic connection to its Takoma Park, Maryland, counterpart.[23]

The National Register of Historic Places designation inspired a new organization, Historic Takoma, Inc., to publish a comprehensive pictorial community history, *Takoma Park, 1883–1983: Portrait of a Victorian Suburb,* in time for Takoma Park's centennial celebration in 1983. This community history pointed out that Takoma Park had come full circle on its hundredth birthday. A portion of the new Metrorail system was running along the old B&O Railroad right of way and, once again, commuters were

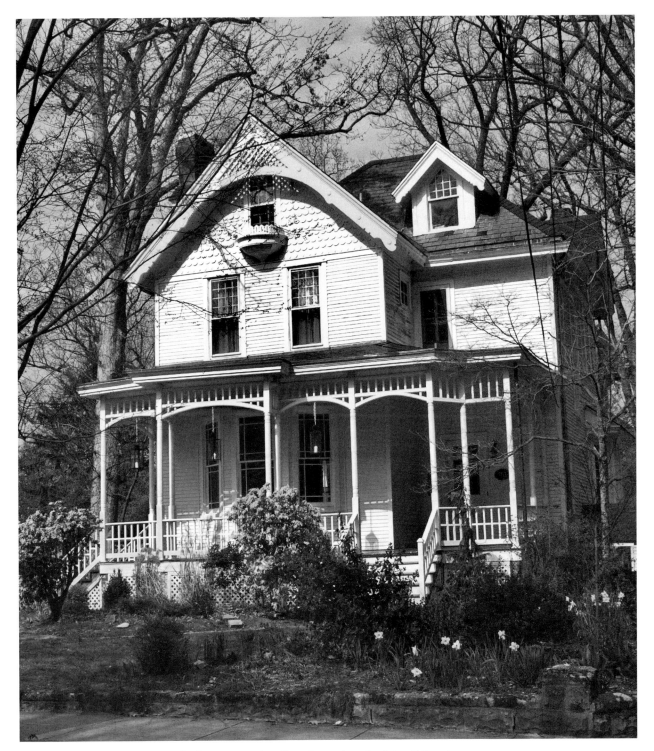

A historic district in Takoma Park, Maryland, protects a variety of late nineteenth- and early twentieth-century architecture, including Queen Anne–style houses such as this one in the 7100 block of Cedar Street. Photo by Kathryn S. Smith

glimpsing the affordable elegance of this turn-of-the-nineteenth-century suburb from the tracks of a train pulling into the Takoma station.

The citizen-led defeat of the North Central Freeway, the Takoma Metrorail station commercial rezoning plan, and the Montgomery College expansion into residential neighborhoods marked the emergence of Takoma Park resident Sammie Abdullah Abbott as the most prominent community advocate and protector since founder B. F. Gilbert. Born in Ithaca, New York, in 1908, the grandson of Arab Christian immigrants fleeing religious persecution, and a witness to the economic and social injustices of the Great Depression, Abbott quit his art and architecture studies at Cornell University in the early 1930s to ride the rails and fight for the rights of the common working man across New York State. He served in the Air Force in Europe during World War II and developed a lifelong opposition to nuclear proliferation when the United States dropped atomic bombs on Japan to end the war. He settled in Takoma Park in the 1940s to raise his family and pursue his career as a commercial graphic artist. There is an interesting distinction to be made between Sammie Abbott and B. F. Gilbert. Gilbert advocated development projects that would establish and improve Takoma Park. Abbott, a hundred years later, protested developments that would destabilize and destroy it. Gilbert gave birth to the suburb and planned for its growth; Abbott worked to prevent its dismemberment and secure its future in time for its centennial in 1983 and beyond.[24]

In 1980 at age 72, Abbott was elected mayor of the City of Takoma Park, Maryland, and went from perennial political outsider to neophyte political insider. As mayor from 1980 to 1985, he increased citizen participation in government, strengthened rent control and tenant protections, upgraded commercial districts, and expanded the city's peace and justice agenda. One of his major goals was realized when, at the urging of Prince George's County residents, the Maryland General Assembly allowed the Montgomery County, Maryland, portion of the city of Takoma Park to annex the Prince George's County portion, thereby consolidating the Maryland portion of the town under one county jurisdiction.[25]

To this day, a high degree of civic activism continues to characterize the Takoma Park neighborhoods on both sides of the District line, and the community maintains its image as an independent, integrated, energetic, family-oriented suburban community. The 2000 census reported that Takoma Park, D.C., had a population of 5,200, with 86 percent black and 14 percent white, and Takoma Park, Maryland, had a population of 17,299, with 49 percent white, 34 percent black, and 14 percent Latino. Takoma Park, Maryland, has evolved into an extremely liberal community and is sometimes called "the Berkeley of the East" and even "the People's Republic of Takoma Park." Its current laws provide for same-sex marriages; allow noncitizens to vote in municipal elections; and forbid the city to purchase from, or invest in, entities that make nuclear weapons, components, or delivery systems.[26]

Various community organizations in both Maryland and the District continue to

work to enhance the physical appearance of their historic business district by rehabilitating historic buildings and promoting new construction that respects the community's physical design. Takoma, D.C., residents and the D.C. Office of Planning produced a "Takoma Central District Plan" in 2002 that envisioned a town center with traditional charm, providing unique stores and services to both nearby neighbors and visitors. Takoma Park, Maryland, opened a combined municipal and community center in 2005 to replace its aging municipal building. The new facility balances the needs of the city government with the needs of the citizens by housing an art room, teen lounge, dance studio, game room, and community meeting rooms together with the city government offices and the police department. Fittingly, the exterior façade of the new municipal building evokes the 1892 architectural style of the grand North Takoma Hotel. Founder Benjamin Franklin Gilbert and defender Sammie Abdullah Abbott would be pleased with the continuing efforts of citizens in each jurisdiction to preserve the suburb's past and plan for its future.[27]

Brookland

SOMETHING IN THE AIR

JOHN N. PEARCE

There is a bucolic air about Brookland, its late nineteenth- and early twentieth-century single-family homes set in the thick greenery of street trees, parks, and the landscaped grounds of nearby institutions. Its location is marked on the city's skyline by the grand dome and campanile of the Basilica of the National Shrine of the Immaculate Conception, symbolic of the strong presence of Catholic institutions in the community. Fort Bunker Hill Park, Turkey Thicket Recreation Center, and an eight-mile hiking trail contribute to the openness that makes it feel like a country town in the city. The expansive settings of educational and religious institutions add to the sense of light and air; the Franciscan Monastery alone offers forty-four acres of gardens.

Indeed, the people who settled Brookland thought there was "something in the air." And perhaps the air *was* different. At Brookland's heart, known as the old Brooks farm, Jehiel and Anne Brooks built in 1840 the handsome mansion they called Bellair — "beautiful air." Nearly 150 years later John Facchina would recall the reason his father, an immigrant Italian mosaicist, gave for settling there in the early 1900s: "It was for better air." And in 1938, as longtime resident Thea Reachmack recounted, her doctor advised the Reachmacks to move from Dupont Circle "to the country" so that her asthmatic son would have better air to breathe — and Brookland's air was known as "pure and clean, healthy."[1]

The Brooks Mansion, which still stands at 901 Newton Street, NE, almost as patriarchal as Brooks in his old photographs, is a prominent image of Brookland. Some Brooks descendants long lived in Brookland and nearby. Brooklanders have loved the old mansion, too, and their early and ongoing preservation efforts focused on it, achieving listing on

The boundaries shown here are based on eight contiguous subdivisions laid out adjacent to the Baltimore and Ohio Railroad track between 1887 and 1901 and on the advice of present-day residents. There is a strong "Brookland influence" beyond these borders because of linkages with the Catholic University of America and other cultural and religious institutions in the region. Some would say that the neighborhood overlaps on the north with Michigan Park, on the east with Woodridge, and on the west with Edgewood. Map by Larry A. Bowring

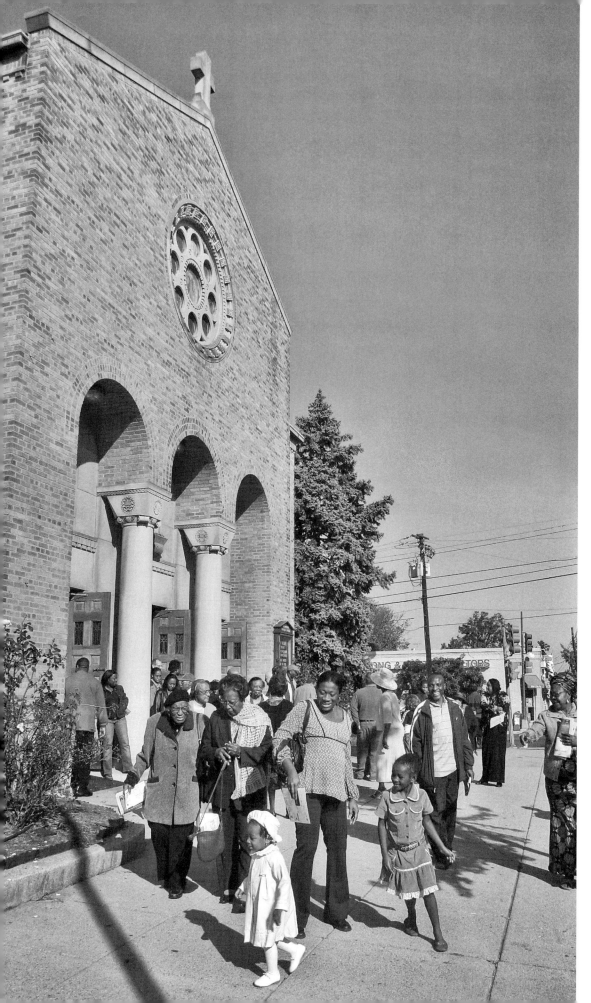

Parishioners leave Mass at St. Anthony's Roman Catholic Church at 12th and Monroe streets on a sunny Sunday morning. St. Anthony's has been a center of community activity since the early twentieth century in Brookland, a neighborhood with many Catholic institutions. Photo by Rick Reinhard

the National Register of Historic Places in 1975. Another preservation effort was the lively reuse of a once-decaying, turn-of-the-century pickle works, revitalized as Colonel Brooks' Tavern, where a photograph of Brooks welcomes visitors.[2]

Although the name of Jehiel's wife, Anne Queen Brooks, is not marked on any present place, she is the connection to the eighteenth- and early nineteenth-century families who farmed this acreage. Anne received from her father, Nicholas Queen, 150 acres, part of 1,500 colonial Maryland acres Nicholas's ancestor, Richard Marsham, had owned. Nicholas Queen was proprietor of Queen's Hotel, a Washington hostelry, where many congressmen and other notables stayed, and Jehiel and Anne Queen Brooks had many Washington connections. It is not surprising that the Brookses chose the Greek Revival style for the house of brick and granite they built in 1840 near the northwest corner of their Bellair land; it echoed the Greek Revival character of Arlington House, the White House porticoes, and the Treasury in the grand style of the Federal City to the south.[3]

Not long after the Brooks Mansion was built, the needs of the growing city brought new public facilities to the very borders of the farm. First, in the 1850s, the racially integrated Columbian Harmony cemetery was moved from the city to a large tract south of

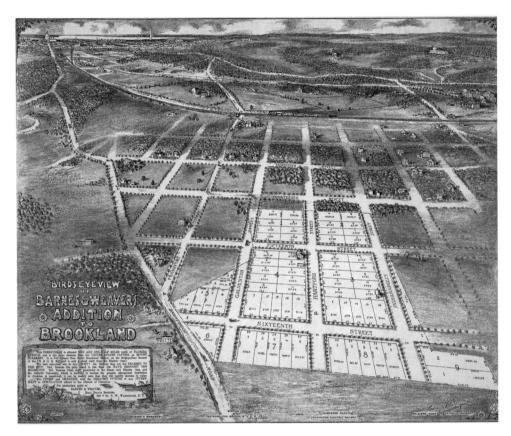

The railroad that gave birth to the first Brookland developments is seen running through the center of this bird's-eye view of a mid-1890s addition to the new suburb. The Capitol and the Washington Monument are drawn on the horizon, to underline the easy access by train to the center of the city. Courtesy Library of Congress.

the Brooks farm boundary along old Brentwood Road, near the present line of Rhode Island Avenue. (It would later be moved again to Landover, Maryland.) Then, in 1873, the Baltimore and Ohio Railroad built a branch along the western edge of the farm, with a stop at the Brooks Station below the mansion where farmers loaded their vegetables for shipment to the city's markets. The stop also served a few Brookland commuters. In 1885 the Catholic University of America, a suburban campus of national importance, was established just beyond Brookland's western edge, northwest of Brooks Station. In the more than one hundred years in which the university and Brookland have existed side by side, the two have been intertwined both physically and culturally, as suggested in the name of the current Metrorail stop, Brookland-CUA.[4]

In the 1880s the arrival of cemetery, train, and university set the stage for eventual subdivision of the Brooks farm. After Colonel Brooks's death in 1886, his heirs sold the property, and in 1887 the new owners recorded a plat of subdivision of 140 acres into narrow, deep lots — then the standard of suburban development. This was apparently the first recorded use of the name "Brookland." In the winter of 1889–90 the Eckington & Soldiers' Home Railway, the first electric streetcar line in the city, beginning in 1888, reached 4th and Bunker Hill Road in Brookland, linking Mount Vernon Square to Catholic University and vastly increasing interest in the development of the area.

When the streetcars came into Brookland, longtime resident Helen Brosnan recalled, her mother was so delighted at this new convenience that she called the trolley bells "the sweetest sound I've ever heard."[5]

Shortly thereafter the original subdivision of Brookland was proving both attractive and successful, as reflected in the additional subdivisions recorded with the Surveyor's Office of the District of Columbia. These additions extended the suburb east from the Brooks Farm to the line of 18th Street. All of these subdivisions, though bearing names of their own, were perceived then and now as one place called Brookland.

Brookland's population reached about seven hundred by 1891. A map of 1894 shows that at least one house had been built on most of the blocks. By then the community had a post office; the stylish, brick Romanesque Brookland School (1891); a Baptist church; and more than fifty oil lamps along the streets of the first subdivision. In 1892 the real estate firm of McLachlen & Batchelder ("Telephone 432") summed up Brookland's virtues:

> Brookland . . . has an elevation of two hundred feet high above THE POTOMAC RIVER AT HIGH TIDE. The Metropolitan Branch of the B. & O. R. R. and the Eckington and Soldiers' Home Road furnish rapid transit to the business part of the city. A charter has been granted the Suburban Street Railway Company to build an electric road from the Centre Market to Brookland. . . . The District . . . [has] built a Brick Schoolhouse erected Street Lights, and, LAID PLANK SIDEWALKS on a part of the streets.[6]

In 1896 the Brookland School building was doubled in size. In 1903 it was enlarged again, this time in the newly stylish Georgian Revival mode. Also by 1903 Brookland boasted a firehouse and St. Anthony of Padua Catholic Church. Many of the streets crossing and parallel to the 12th Street corridor had been paved with gravel, and most of Newton Street and parts of 12th, Irving, and Evarts streets had macadam surfaces. In 1904 the street names and numbers were changed to conform to the pattern of the rest of the city.[7]

By the 1880s the building regulations for what had been Washington City, south of present-day Florida Avenue and Benning Road, no longer permitted the construction of wooden dwellings, but this was not the case outside the boundary in old Washington County. The middle-class suburbanites and speculators of Brookland built mostly wooden homes in simplified versions of the Victorian, Queen Anne, Colonial Revival, and Craftsman styles. The ready availability of precut wood framing and cladding and of machine-made nails of every type made it possible to build almost any shape or decoration. There were a few high-style, architect-designed houses and some highly individual ones, such as builder John Louthan's Round House, designed by Edward Noltz at 1001 Irving Street, and suffragette/botanist Carrie Harrison's "Spanish Villa" at 1331 Newton Street, built in 1909 of concrete piers infilled with terra cotta blocks.[8]

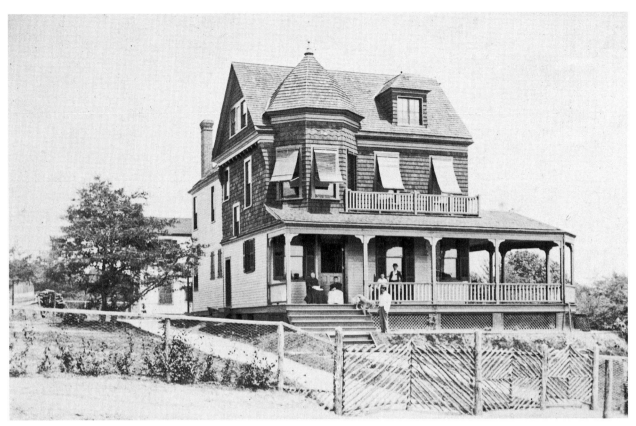

A number of employees of the Smithsonian Institution and the Government Printing Office gave a scientific, intellectual, and engineering cast to parts of the community. The great Smithsonian ornithologist Robert Ridgeway built Rose Terrace at 3413 13th Street, and botanist Theodore Holm built a house for himself and another for Joseph Krause at 1432 and 1440 Newton Street. Several immigrant artisans and mechanics were among Brookland's early residents, including Italian mosaicist Charles Facchina. Facchina's proudest achievement was the great mosaic panel of Minerva (after the drawing by Elihu Vedder) visible at the top of the stairway to the visitors' gallery of the Library of Congress's main reading room. Facchina, recognizing that the edges of Brookland near Michigan Avenue would develop more densely, built the first apartment building in Brookland, the Brookland Courts Apartments at 1210–1218 Perry Street, in 1924.[9]

A permanent home to many bright and creative people, Brookland also nurtured bright and creative children, including novelist Marjorie Kinnan Rawlings, later the author of the popular novels *The Yearling* and *Cross Creek*, who grew up at 1221 Newton Street. Brookland provided temporary quarters for creative people on the rise as well, such as Pearl Bailey, who lived briefly at 1428 Irving Street in the 1930s. Notwithstanding these notable residents, Brookland has always been a middle-class community offering everyday families a secure, neighborly home. This was remembered with pride

The family of Smithsonian Institution ornithologist Robert Ridgeway comes together for a photograph on the porch of their home at 3413 13th Street in the new suburb of Brookland about 1895. A number of employees at the Smithsonian and the Government Printing Office were among the early residents. Courtesy The Historical Society of Washington, D.C.

A view from the Ridgeway family's rooftop about 1895 shows the proximity of Catholic University, with two early buildings seen at the center right. The tower of the Sherman Building at the Soldiers' Home is seen over the trees on the horizon. Courtesy The Historical Society of Washington, D.C.

and humor by one of Brookland's early developers, James L. Sherwood. "For a time we thought we were going to have a nabob neighborhood. We had about eight families of social prominence. But they discovered their mistake about 1910 and moved elsewhere."[10]

Although early Brookland was mostly white — and mostly segregated in work, play, and society — it always had black residents. Racial differences affected daily life, but outright conflict was rare. In the mid-twentieth century a number of African Americans who had distinguished careers in education, politics, and the arts made the neighborhood their home. Among the most prominent was Robert Weaver, the first black cabinet member, who served as secretary of Housing and Urban Development under President Lyndon B. Johnson; Weaver lived at 3519 14th Street. The neighborhood was particularly favored by Howard University professors, among them Ralph Bunche, a diplomat and United Nations official who in 1950 was the first African American to

win a Nobel Peace Prize. He lived in an International-style house at 1510 Jackson Street that had been designed for him by African American architect Hilyard Robinson, also a Howard University professor. Poet and critic Sterling Brown lived for forty years at 1222 Kearney Street. A key figure in the New Negro Renaissance of the 1920s and 1930s and the Black Arts Movement of the 1960s and 1970s, Brown welcomed his Howard University students to this home for decades to discuss matters academic and political. Noted artist Lois Mailou Jones, who taught at Howard University for fifty years, hosted an artists' collective in the 1940s in her home at 1220 Quincy Street.[11]

From the 1920s through the 1940s, the neighborhood's density increased, marked by brick row houses with Colonial Revival details, precut mail-order houses of a mainly Craftsman architectural character, and the simplified, streamlined architecture of the largely one-story brick commercial strip along 12th Street. In 1927 Brooklanders paraded in the street to celebrate the paving of this major artery from Rhode Island Avenue to Monroe Street. In 1931, 12th Street was paved as far as Otis Street, although its village-like character was maintained throughout the decade with vendors' carts hawking everything from ice to produce to rabbits.[12]

The stores on 12th Street were built from the late teens to the early 1930s by a few developers who lived in the community. Among them were James L. Sherwood, manager of the Brookland branch of the Hamilton National Bank; his son, Jesse R. Sherwood; Dr. R. R. Hottel, a local physician; and George C. Heider, who owned and operated a grocery store at 3507 12th Street.

The business people along 12th Street reflected the ethnic diversity of Brookland. Their names in the city directories over the years suggest their diverse origins. In addition to George Heider, at no. 3507, were Salvatore Chisari, shoe repair, no. 3508; Paul F. Moore, hardware, no. 3509; Hong Lee, laundry, no. 3512; John Kotsanas, restaurant, no. 3513; Frederick Klotz, billiards, no. 3533; Marion F. Cord, beauty shop, no. 3523; and James J. Hannon and Michael J. McGettigan, hardware, no. 3524. The strong Catholic presence in the neighborhood attracted many Brooklanders of that faith who were of Irish or Italian extraction. Catholic University had begun to influence the neighborhood as early as 1889, when the Brooks Mansion was converted to a Catholic school later operated by St. Anthony's Church. The foreign-born Smithsonian naturalists and Europeans among those associated with Catholic University also contributed to the old-world atmosphere.[13]

Catholic University attracted other major Catholic institutions to Brookland. In 1899 the Franciscan order dedicated its Byzantine-style church and monastery, later adding gardens surrounding replications of holy shrines from around the world. In 1927 the lower church of the landmark Basilica of the National Shrine of the Immaculate Conception was completed on the grounds of the university. Its grand dome and 329-foot campanile, built between 1954 and 1959, became a striking element in the Washington skyline from every point of view. It remains the largest Roman Catholic church in America and one of the ten largest churches in the world. Trinity College, now known

In the 1920s trolley wires created a canopy over 12th Street, the one-story commercial center of the neighborhood then as now. In the right foreground is the 1911 Masonic Lodge. The Brookland Baptist Church in the background was torn down and replaced with the Newton Theatre in 1938. Courtesy The Historical Society of Washington, D.C.

as Trinity (Washington) University, opened its doors in the neighborhood in 1900. The Ukrainian Catholic National Shrine, the Dominican College, and the Pope John Paul II Cultural Center are also located in Brookland. Over time, many Brookland houses were rented or bought by international Catholic orders. In the years between the world wars more than fifty religious orders were represented, and their members, walking from home to church or university in their distinctive religious dress, helped Brookland earn the nickname "Little Rome." The 1979 visit of Pope John Paul II to the university is remembered fondly by the people of St. Anthony's as "the Pope in our Parish."[14]

In the 1920s and 1930s Brookland retained much of its small-town character. Its streets were lively with children and adult neighbors passing the time of day. The value of friendly relations among residents influenced the design and use of houses. Helen

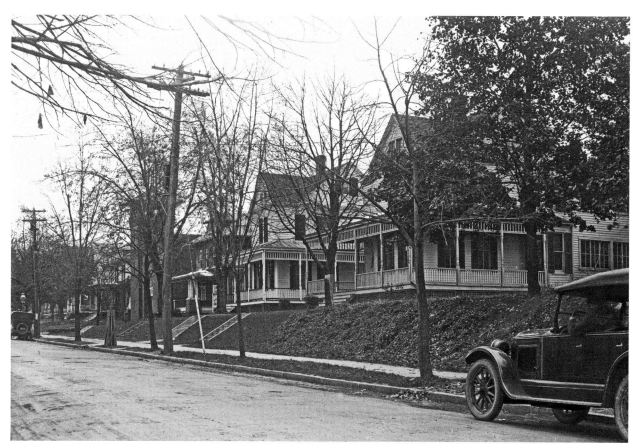

Krause Caruso recalled the house she and her husband built in the 1930s: "[When I was a girl in Brookland] we used to live out on the front porch. And when my husband built this house [at 1437 Otis Street], I told him there were three things I wanted and one of them was a front porch. So he had one built, and I still sit out there. Not too many people do that today but a few do. I love it. I knit and read."[15]

For children the highlight of the winter season came after heavy snowfalls. Local police closed Newton Street between 15th and 18th streets and built bonfires at each end of the hill. "The sledding was great on Newton Street," former resident Harry Tansill recalled. "It was a mysterious phenomenon how the snow and ice lingered longer there long after it had melted away on other streets. Quite a break for me and my Flexi Flyer!" Ice skaters flocked to the pond near Slow School. Teenage boys and girls met at chaperoned dances at St. Anthony's and the Masonic Hall and attended parties at one another's homes. There young people cranked up the Victrola and, recalled Leo Stock and his sister, Betty Stock Hardy (great-grandchildren of Jehiel and Anne Queen Brooks), they listened to such popular hits as "The Sheik" and danced the Turkey Trot or the Paul Jones. Dates were treated to the movies or maybe an afternoon soda at the fountain in Baldwin's Bakery or Peoples Drug Store. Beginning in the 1920s silent movies were

regularly shown at St. Anthony's Church. In the mid-1930s commercial movie houses opened: the Jessie Theater at 18th and Irving streets and later, in 1938, the Newton Theater on the site of the old Brookland Baptist Church at the corner of 12th and Newton streets. The Newton's Streamline Moderne design by noted theater architect John J. Zink and its formal opening ceremony underscored the important status given to movie theaters in that era.[16]

Family and friends were often also neighbors in Brookland. Helen Krause Caruso grew up in the neighborhood and returned after starting her married life in Southwest Washington. When she came back with her own family in 1938, she found herself sharing her Brookland block with the close friends and next-door neighbors of her childhood, the Theodore Holmeses, as well as with her father, her father-in-law, her uncle, and her husband's aunt. Such strong kinship networks were typical of the neighborhood.

Although still village-like, Brookland was nonetheless part of the changing metropolitan scene. The influence of the automobile was reflected in the number of garages added to existing Brookland houses in the 1920s and 1930s. In-town houses with car accommodations could not compete, however, with the new automobile-oriented suburbs to which rising young professionals aspired. As a result, many of the earlier railroad and streetcar suburbs were bypassed by young home buyers. After World War II, Brookland was one of many older suburbs that witnessed the accelerated transition from a predominantly white population to a predominantly black one. Residents of Brookland have mixed remembrances of the effects of racial integration that began in the southern portion and moved northward. Some white residents have said that fuller integration was not an event that substantially changed their world. Although the community became more mixed racially, it was still their community, to which they were loyal. In Helen Brosnan's words, "We didn't intend to move. It was home. That was all."[17]

Others recall strong resistance to integration by some white residents. Until they were declared unconstitutional, racially restrictive covenants allowed some property owners to exclude blacks. Sometimes blockbusting techniques were used: a real estate agent would purchase a home and immediately resell it to a black family, causing other white families in the neighborhood to feel they must sell their houses. Poet and Howard University professor Sterling Brown was not a blockbuster, but he remembers that when he moved to Brookland in 1935, "For Sale" signs in the neighborhood seemed to sprout overnight. By 1945 the desire for a neighborhood Sunday school for children of the black community had led to the founding of the Brookland Union Baptist Church, the first black church in Brookland. After the desegregation of the public school system in 1954, the schools became predominantly African American, reflecting both the number of young black families moving to the area and the exodus of many white families to new suburbs in Prince George's County, Maryland.

Many of the black families found Brookland appealing for the same reasons that at-

tracted the original residents, white and black. Helen Brooke, mother of former Massachusetts senator Edward Brooke, recalled that her family chose Brookland because it was "a nice, quiet neighborhood and my friends lived there. It was a pretty place to live, and we loved it very much."[18]

From the 1950s through the 1970s Brookland went through a period of struggle over the shape of its future and emerged stronger and more conscious of itself as a community. Part of the struggle for racial integration in the 1940s and 1950s had focused on the Brookland Citizens Association refusal to admit blacks and its resistance to open housing and recreation. By the 1960s black residents had formed the Brookland Neighborhood Civic Association; in the 1970s and 1980s theirs became the organization that integrated and has since outlived its rival, the all-white citizens association.

Also unifying the neighborhood in the 1950s and 1960s was the protracted struggle against the city's plan to sacrifice a block-wide swath of Brookland to build a multilane freeway as part of the Interstate Highway System next to the railroad right-of-way. This North Central Freeway (I–95) would also have plowed through Takoma Park as it made its way from the Inner Loop in the central city to the Beltway in Maryland. The highway threat spurred an outpouring of individual and collective civic energy, and Brookland leaders, black and white, worked with activists from Takoma Park and across the District to spearhead the anti-freeway fight on behalf of the entire city. Consequently the interstate highway was blocked, and in the process citizens from all parts of the city found themselves unified for the good of their neighborhoods. In addition to the revitalization of the Brookland Neighborhood Civic Association, the highway battles led to the creation of the Upper Northeast Coordinating Council, an umbrella organization for regional civic concerns.

In what must be seen as a victory for Brookland activists, the "highway houses," which had been acquired for the highway right-of-way, were finally rehabilitated in the late 1970s and early 1980s and returned to the market after years of neglect. But when plans were made for sites for Metrorail lines and stations, the Brooks Mansion itself was threatened. A decline in the school-age population led St. Anthony's Parish, the mansion owner, to sell the property to the Washington Metropolitan Area Transit Authority in 1970. The WMATA planned to demolish this historic structure, a central symbol of Brookland's identity, to provide more parking spaces at its Brookland-CUA station. But once again citizens and local political leaders managed to secure the preservation and reuse of the Brooks Mansion, which still stands as a neighborhood centerpiece.[19]

The neighborhood commitment to historic preservation and to Brookland's history

Poet and Howard University professor Sterling Brown reads by his fireplace in his Brookland home. He was one of the first of many distinguished African Americans to live in the neighborhood, and he regularly invited students to his home for informal conversations about literature and politics. Courtesy Sterling Brown Papers, Manuscripts Division, Moorland-Spingarn Research Center, Howard University

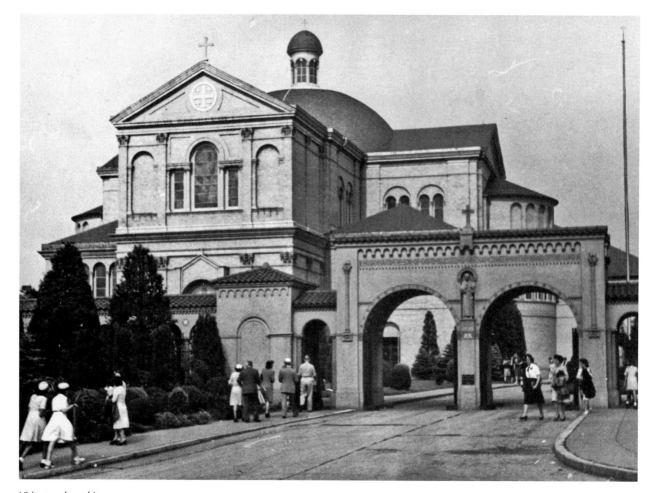

Visitors and worshippers pass through the gate to the Franciscan Monastery at 14th and Quincy streets about 1945. The monastery, with its extensive gardens and replicas of holy places from around the world, is one of many local institutions that contribute to the strong Catholic presence in Brookland. Courtesy The Historical Society of Washington, D.C.

continues to reveal itself in a number of ways. Special events surrounded the hundredth anniversary of Engine 17 and Number 4 Chemical Company in 2002. Signs mark the location of sites on the city's African American Heritage Trail. A new Brookland Community Development Corporation sponsors special events that often honor the community's unique history, including an annual Brookland Festival of Lights, and the opening of a visitor center for the neighborhood. Research by students at the George Washington University, and especially studies and plans by students at Catholic University, now mesh with both professional and amateur preservation and revitalization activities.

The old pickle factory turned Colonel Brooks' Tavern continues to attract a devoted clientele to its 12th Street location, particularly to weekly Dixieland performances of a band called the Federal Jazz Commission. Organizations and individuals associated with theater, dance, the arts, and writing have made their homes in or near Brookland, as is suggested by the creation of the Brookland Artists and Writers Association in 2001, and art and antique dealers are among the lively additions of recent decades.

Brooklanders march past the 1920s storefronts of 12th Street in the annual Brookland Festival in 2006. Photo by Robert Roberts. Courtesy Brookland Community Development Corporation

Brookland's people in the twenty-first century include those who have moved homes or businesses there only in the past few years and those who have lived there for many decades, with memories reaching back to the days of unpaved streets and rural vistas. There is a racially integrated neighborhood culture that includes shopkeepers and residents of Asian and Latino extraction. In Brookland, as in other neighborhoods of Washington, much remains to be done to pass on, intact and enhanced, those places that connect neighbor to neighbor and the present to the many-layered past. But for Brooklanders, new and old, something beautiful still lingers in the air.

Twentieth-Century Communities

The federal establishment mushroomed in the first half of the twentieth century as the nation fought two world wars and grappled with a severe economic depression. The city grew apace, as new jobs, federal contracts, and the needs of the now international capital drew thousands of residents to Washington. Despite the constraints of the Great Depression, the National Mall as envisioned by the McMillan Commission Plan of 1901–2 finally came to fruition in the late 1930s. A power plant, temporary buildings, and nineteenth-century landscaping gave way to the grand expanse of green flanked by museums and monuments that we know today. In the same decade federal agencies left scattered quarters for a bank of new neoclassical buildings called the Federal Triangle that stretched from 6th to 15th Street between Constitution and Pennsylvania avenues just north of the Mall. The wall it created between the Mall and the city's commercial downtown seemed to make a physical distinction for the first time between the white marble federal city of government and the red-brick city of neighborhoods. As tourists increasingly flocked to the museums and monuments on the Mall, it was now possible to visit one city without seeing the other.

Thus the federal and the local city grew, together and apart. Between 1920 and 1950, the city's population leaped from 438,000 to just over 800,000. The empty spaces between the streetcar suburbs filled in with new developments made possible by the automobile, within reach of middle-class families by the 1920s. Real estate entrepreneur Arthur Randle had purchased land stretching the length of Pennsylvania Avenue, SE, east of the Anacostia River in the late nineteenth century. But it was not until the 1920s that this huge parcel,

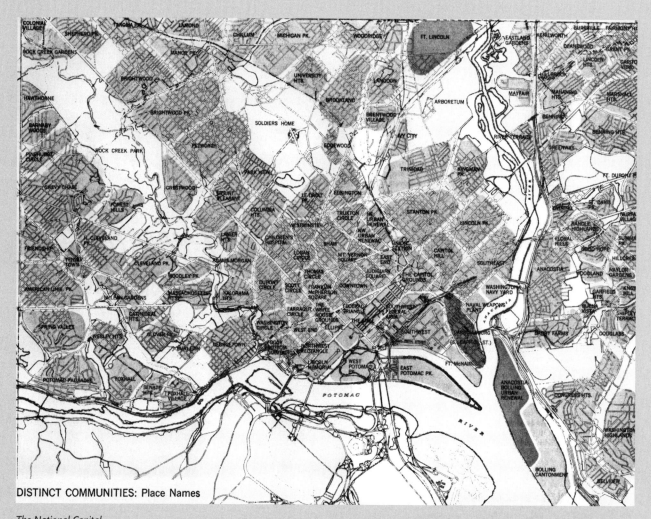

DISTINCT COMMUNITIES: Place Names

The National Capital Planning Commission included this map of distinct communities in its 1967 Proposed Comprehensive Plan. Although the suburban developments of the late nineteenth and early twentieth centuries had become urban neighborhoods, they retained their identity as different places. Many of the names and locations given here have since changed, as they are always likely to do.

dubbed East Washington Heights by earlier owners, began to be transformed into the twentieth-century neighborhoods of Randle Highlands, Hillcrest, Penn Branch, and Dupont Park. Likewise Wesley Heights and Spring Valley sprang forth in the 1920s and 1930s far from public transportation and fully developed to accommodate the automobile, with garages a key part of a home environment that now turned to the backyard instead of the front porch of the old pedestrian city.

The last two neighborhoods in this book are focused primarily on social rather than physical change from the 1950s through the 1970s, as already established communities strove to meet the challenges of rapid racial integration, made more difficult by the 1968 riots following the assassination of Rev. Dr. Martin Luther King Jr. Huge demographic changes occurred in many

Students start their day at Randle School in Randle Highlands at 30th and R streets in Far Southeast
Washington in the late 1930s or early 1940s, perhaps one or more transported by the automobile at the
curb. Randle Highlands, at the eastern end of the Pennsylvania Avenue bridge across the Anacostia River,
was one of many neighborhoods that grew because of the car, which was within reach of the middle class
by the 1920s. Photo by Theodor Horydczak. Courtesy Library of Congress

neighborhoods at the same time that Congress returned a measure of local self-government to the city after a hundred years — an elected school board in 1968, a non-voting delegate to Congress in 1970, and an elected mayor and D.C. Council in the Home Rule Act of 1973 — while it retained a line item veto over local legislation and budgets, control of the judiciary, and other significant powers. The capital in this period was a swirl of political activity; organizations for social change sprang up in neighborhoods across the city.

Adams Morgan recreated itself when a black and a white elementary school worked with citizens to create a biracial community in the 1950s and 1960s. It would become the city's most diverse neighborhood in the 1970s, as thousands of newcomers from Central and South America began to call it home. In the 1960s Shepherd Park became more socially cohesive as it became racially more diverse. Joining with other neighborhoods such as Manor Park and Takoma Park, it took aggressive action to create a healthy, integrated neighborhood through the new organization named Neighbors, Inc. Both are stories that exemplify the fact that, while neighborhoods are physical places, the people who reside in them make and maintain them as living communities.

East Washington Heights

RANDLE HIGHLANDS, HILLCREST, PENN BRANCH, DUPONT PARK

JIM BYERS

"In a few years I expect to see the city cover every inch of the land between Pennsylvania Avenue and Benning, along two miles of the highlands with [as] commanding views of Washington as those to be had from Arlington and the Soldiers' Home," Colonel Arthur E. Randle prophesied to a group of Pennsylvania businessmen in 1909, as reported in the *Evening Star*. He was speaking of Randle Highlands, his sprawling new residential development in an area that is today referred to as Far Southeast Washington. Originally straddling present-day Pennsylvania Avenue, SE, from Minnesota Avenue to the District line, Randle's burgeoning new community was emerging from an earlier, more upscale vision for this same area by late nineteenth-century developers who had named it East Washington Heights.[1]

Today the area encompasses four distinct residential neighborhoods perched upon most of three miles of wooded hillside high above the Anacostia River — Randle Highlands, Hillcrest, Penn Branch, and Dupont Park. These neighborhoods are attracting more attention from potential home buyers as well as city officials looking to address a tradition of inattention to development and social needs "East of the River," as all of Wards 7 and 8 are currently known to many who do not live there.

Although less than three miles east of the Capitol, the area's location across the Anacostia River from central Washington has for generations branded it a separate place. Early in the city's history, many expected a rapid eastward expansion of Washington. Peter Charles L'Enfant had envisioned a center of commerce along the west bank of the Eastern Branch, as the Anacostia River was then known, which would have brought development directly across the waterway from Randle's future landholdings. It is noteworthy that both the official front entrance to the Capitol and the statue of Freedom that crowns its dome face toward the east. However, eastern development stalled early on when the Eastern Branch — once deep enough for ships to travel as far north as Bladensburg, Maryland — filled in with silt from adjacent farms and from the added runoff resulting

The area once named East Washington Heights by a late nineteenth-century real estate syndicate covered eight hundred acres on either side of Pennsylvania Avenue, SE, east of the Anacostia River, all the way to the District line. Over time a number of distinct communities have emerged on this hilly terrain with the dramatic views that captured the imagination of early investors. Map by Larry A. Bowring

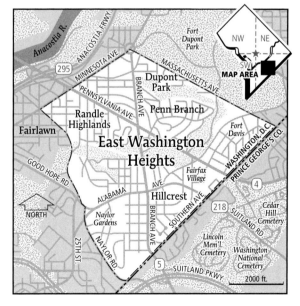

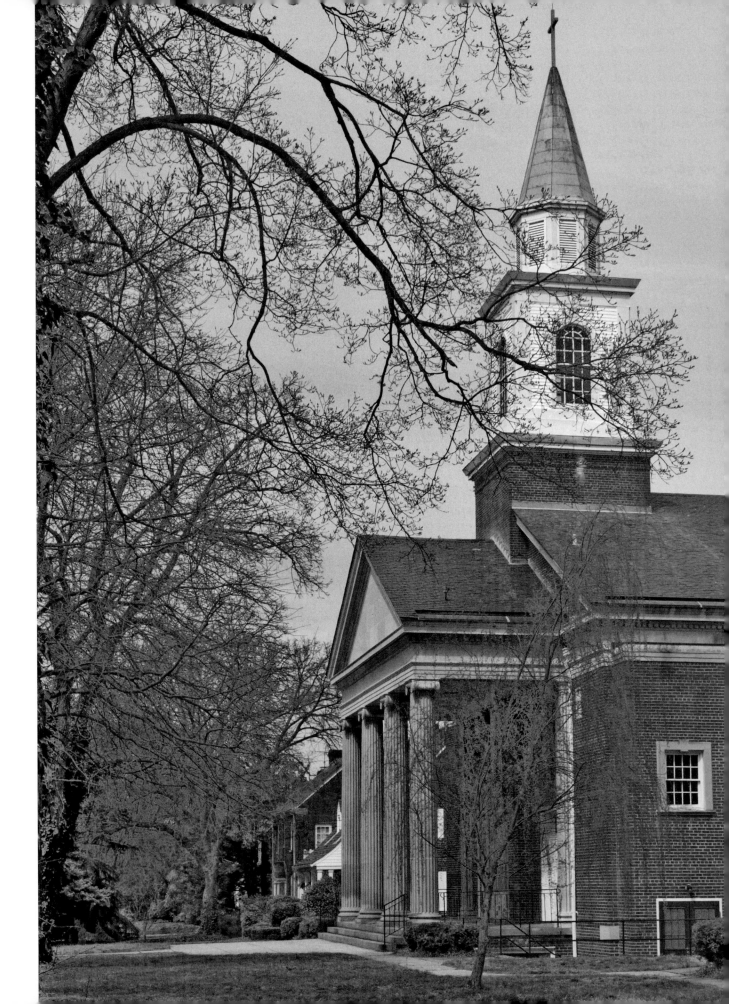

There was no crossing of the Anacostia River at Pennsylvania Avenue, SE, for forty-five years until this iron truss bridge was completed in 1890. Courtesy The Historical Society of Washington, D.C.

from deforestation during the development of the city. Thus early residents found it convenient to cluster around sources of employment at the Capitol and the President's House and closer to the settled, thriving town of Georgetown.[2]

Transportation across the Eastern Branch had been problematic from the beginning, particularly at Pennsylvania Avenue, leading to the area Colonel Randle had chosen for development. First chartered by the Maryland state legislature in 1795, the original wooden Pennsylvania Avenue bridge opened in 1804 but was set ablaze on purpose in 1814 to protect the Federal City from the invading British. It was replaced in 1815, but after steamboat sparks burned this bridge down in 1845, there would be no replacement at all for the next forty-five years. Meanwhile, the Benning Bridge served the village of Benning to the north and the 11th Street Bridge served the planned suburb of Anacostia to the south. Frustrated residents finally formed the East Washington Citizens Association to lobby for action and in 1887 won authorization for a $110,000 iron and masonry truss bridge. Still, at only twenty-four feet wide, the narrow bridge was behind the times even before it opened in 1890.[3]

Given this history, Colonel Randle's forecast of a bright future for the miles of mostly undeveloped farmland across the Anacostia River in the District's eastern section was bold indeed. However by 1909 Randle had earned the right to be taken seriously by

(opposite)
The East Washington Heights Baptist Church at Alabama and Branch avenues is the only institution to perpetuate the name given to the highlands on both sides of Pennsylvania Avenue, SE, by the Bliss-Havemeyer Syndicate about 1890. Photo by Kathryn S. Smith

OVERLOOK INN

(HAVEMEYER SYNDICATE PROPERTY.)

EAST WASHINGTON HEIGHTS

Located near the extension of Pennsylvania avenue east.

Across the Eastern Branch,

WILL BE OPEN TO THE PUBLIC ON AND AFTER JULY 11, 1894

The Inn has been handsomely furnished; there are a number of private dining-rooms, a gentleman's buffet, and ample porches, commanding sightly views of the river, city, and country.
Refreshments served a la carte at all hours. The cuisine the finest, and greatest variety. JAS. F. BOHEN, Manager.

EAST WASHINGTON HEIGHTS

Overlooking the city at an elevation of 285 feet above datum, and 185 feet above the highest part of the city, and on

ARCHIBALD M. BLISS'

sub-division, comprising the properties of the HAVEMEYER, WASHINGTON, NEW YORK, and CALIFORNIA SYNDICATES.
Streets and avenues correspond in width with those of the city, and have been graded, graveled, gutters laid, and shade trees set out. Gas and city water mains have been introduced; also police patrol.
Beautiful and eligible building sites for sale on easy terms, and money advanced to build homes, and payable on the installment plan if desired.
For plats and prices inquire at office of OVERLOOK INN.

the businessmen assembled at Bedford Springs, Pennsylvania, to hear his address titled "Washington the Beautiful and Cultured." Among the most dynamic early developers in late nineteenth- and early twentieth-century Washington, Randle had made his mark by developing the thriving village of Congress Heights, located about four miles south of his new venture, bordering St. Elizabeths Hospital. He had been instrumental in securing a congressional charter to extend electric streetcar service to Congress Heights in 1896, beginning service in 1898. The rail line was crucial to his success in attracting workers from both St. Elizabeths Hospital and the Navy Yard to reside in Congress Heights. It seemed reasonable that Randle could also make a success of a new development just minutes across the Anacostia River from the Capitol. He was also aware, and perhaps encouraged by, the fact that some two decades prior, a powerful syndicate of Washington politicians and millionaire industrialists had envisioned the Southeast highlands as Washington's most desirable address.[4]

In 1889, surmising that the city's rapid growth meant that a development boom was destined for Washington's eastern sector, a group of nationally known business and political leaders — the Bliss-Havemeyer Syndicate — had begun acquiring land in the area that now borders Pennsylvania Avenue east of the Anacostia River all the way to the District line. The syndicate was led by sugar magnate John W. Havemeyer, whose family's American Sugar Refining Company (makers of the Domino brand) then controlled 70 percent of the U.S. sugar industry. Other investors included California Congressman Thomas J. Clunie, New York businessman E. C. Carpenter, and soon-to-be-former Congressman Archibald M. Bliss.[5]

Over the next year, the Bliss-Havemeyer Syndicate purchased about eight hundred

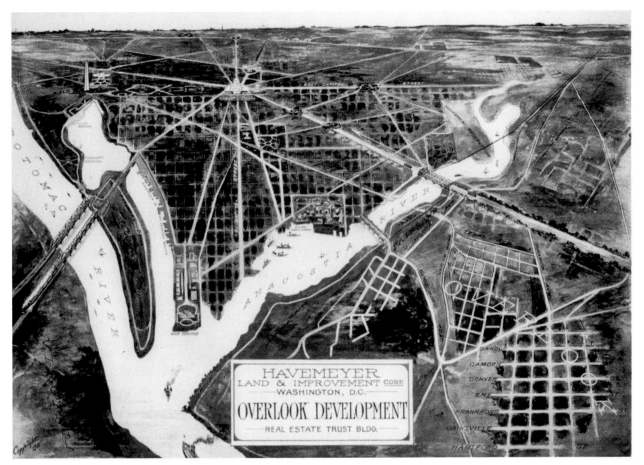

acres of farmland in the Southeast highlands and began selling lots for an upscale residential development that they named East Washington Heights. Other prominent investors quickly surfaced, including millionaire California Senator George Hearst, father of future publishing magnate William Randolph Hearst, and New York Senator Chauncey M. Depew, general counsel and later president of the New York Central Railroad. Streets were laid out and landscaped, beginning with areas adjacent to today's Pennsylvania, Alabama, and Branch avenues in the heart of today's Hillcrest neighborhood. "Roads were built, trees that still bear mute evidence of their symmetric beauty were planted on each side; spacious pavilions, sunken gardens and stately groves of a variety of trees were kept in immaculate order. . . . This was the picnic ground of Washington for many years," rhapsodized the writer of a neighborhood history in a 1928 *Hillcrest Bulletin*.[6]

Following the nineteenth-century pattern of building a resort or other amenity to attract visitors and potential buyers, Congressman Bliss opened the Overlook Inn as the development's centerpiece in the summer of 1894. Located roughly at today's Westover Drive near 31st and Pennsylvania Avenue in today's Hillcrest, the supper club and hotel was instantly popular. "The sudden and pronounced success of the Overlook Inn of East

This 1890s promotional map for the Overlook Development of the Havemeyer Land and Improvement Corporation emphasized the short, direct route to the U.S. Capitol just across the new Pennsylvania Avenue bridge and the proximity to the Navy Yard across the 11th Street Bridge. Courtesy Library of Congress

Washington Heights is beyond question," proclaimed the *Washington Post* in August 1894. "Situated 280 feet above tide water there has not been a day during all this terrible hot visitation when its spacious piazzas have not been crowded with swell dinner parties composed of the leading citizens and sojourners of the Capital." In a brilliant stroke of marketing, Archibald Bliss transformed the difficulty of crossing the Anacostia River into a saleable feature by creating a fad among Washington's power elite. "The popular amusement just now among the fashionable set is the forming of coaching parties to Overlook Inn," observed the *Washington Post* in 1895, with regularly scheduled "caravans" leaving from the city's top apartment hotels.[7]

As Washington's elite organized their coaching parties, Bliss and his associates formed the East Washington Heights Traction Railway Company and began lobbying Congress for an electric streetcar line across the Pennsylvania Avenue Bridge. Given Arthur Randle's success with the line to Congress Heights, it is not surprising that in 1896 the syndicate turned to him to spearhead their efforts. However, in February 1897 Congress flatly denied their request. Plans were under way to reclaim the Anacostia flats, the marshy area along the shore seen as a source of disease, and building a new bridge for a streetcar, it was felt, would delay that important effort. Thus East Washington Heights completely missed out on the trendsetting 1890s development boom that followed both the electric streetcar and the railroads into Washington's new northwest suburbs.[8]

Despite this setback, the development might still have succeeded, given its prestigious leaders. But in rapid succession, the syndicate's highest-profile members, sugar magnate John Havemeyer and Senator Hearst, both died unexpectedly. Archibald Bliss, who had been appointed agent for the late Senator Hearst's East Washington concerns, himself took seriously ill. During the next several years, Bliss suffered all manner of misfortune, from being thrown from an automobile to being struck by lightning. Without consistent leadership, the East Washington Heights project stalled entirely. The Overlook Inn fell from high society's favor and by 1900 was no longer a public facility, but rather the increasingly rundown home of the ailing Archibald Bliss. Only a handful of homes had been built in East Washington Heights, along with the East Washington Heights Baptist Church, a small structure commonly referred to as "the little white church on the hill." In 1934 the original building was replaced with the imposing church complex located in the heart of present-day Hillcrest, at Branch and Alabama avenues. Today its name is the only specific evidence of this first major attempt at residential development in the Southeast highlands. It would be left to another noted developer to turn those hopes into action: none other than Colonel Randle himself.[9]

Arthur E. Randle was born in Mississippi in 1859 and sent north to Pennsylvania for an education. After graduation from the University of Pennsylvania, he traveled south with his older brother, Dr. William Henry Randle, whom President Rutherford B. Hayes commissioned to combat yellow fever in the southern United States. In 1885 Arthur Randle settled in Washington, D.C., and began investing in real estate, his first major development project being Congress Heights. In 1903, using part of the fortune

he made from the sale of his hard-won railroad rights in Congress Heights, Colonel Randle formed the United States Realty Company. He immediately purchased the majority of the Havemeyer-Bliss Syndicate's stalled East Washington Heights tract, renaming all of it Randle Highlands. The Columbus Cooperative Corporation, controlled by Randle's nephew, Oscar C. Brothers, finally purchased the missing 225-acre Overlook property in 1915, after a decade of negotiations with Archibald Bliss's heirs. The colonel proclaimed, "I intend to make of Randle Highlands [to Washington] what Brooklyn is to New York City."[10]

For several decades into the twentieth century, Randle Highlands fit entirely into the earlier East Washington Heights footprint. It was centered on Pennsylvania Avenue east of present-day Minnesota Avenue to the District line and was bounded on the south by the established villages of Anacostia and Good Hope, and on the north by land that Colonel Randle sold to the federal government in 1912 for the creation of Fort Dupont Park. On the west, between Minnesota Avenue and the Anacostia River, Randle Highlands bordered a tiny 1888 settlement, named Twining for a well-liked city commissioner, Major William Twining. As in other real estate ventures across the city, smaller sections within the original Randle Highlands development gradually took on independent identities of their own — Penn Branch, Dupont Park, Hillcrest, Fairfax Village, Naylor Gardens, and Fairlawn among them. Today the name Randle Highlands is generally applied only to the area bordered by Minnesota Avenue to the west, Pennsylvania Avenue on the north, a portion of Texas Avenue to the south, and 30th Street on the east, adjacent to modern-day Hillcrest.[11]

Randle, by 1905 included in the city's list of social elites, shrewdly used his own increasingly respected name to rebrand his new development. (The title of colonel was honorary.) Through savvy negotiation and sheer force of personality, Randle finessed congressional objections and obtained a charter for his East Washington Heights Traction Railroad Company, with approval to lay tracks on the bridge at Pennsylvania Avenue in 1902. The first phase of the line went into operation in 1905. Even though it ran only about three-quarters of a mile along Pennsylvania Avenue — across the bridge, through the tiny settlement of Twining City at its base, and then to the east side of Minnesota Avenue — residential development in the Southeast highlands seemed to be taking hold.[12]

Randle's United States Realty Company had first offered lots for sale in Randle Highlands in 1903, starting in the sector bordered by Pennsylvania Avenue, 30th Street, and Naylor Road, an area that retains the original Randle Highlands name today. Large full-page ads appeared regularly in the local press by 1905, extolling the virtues and promise of Washington's eastward expansion. As was the case in many real estate subdivisions in the District at the time, Randle inserted racially restrictive covenants in his deeds, specifying that "no negro or colored person or person of negro blood" could own land there.[13]

The success of the initial offerings in Randle Highlands was followed by an even

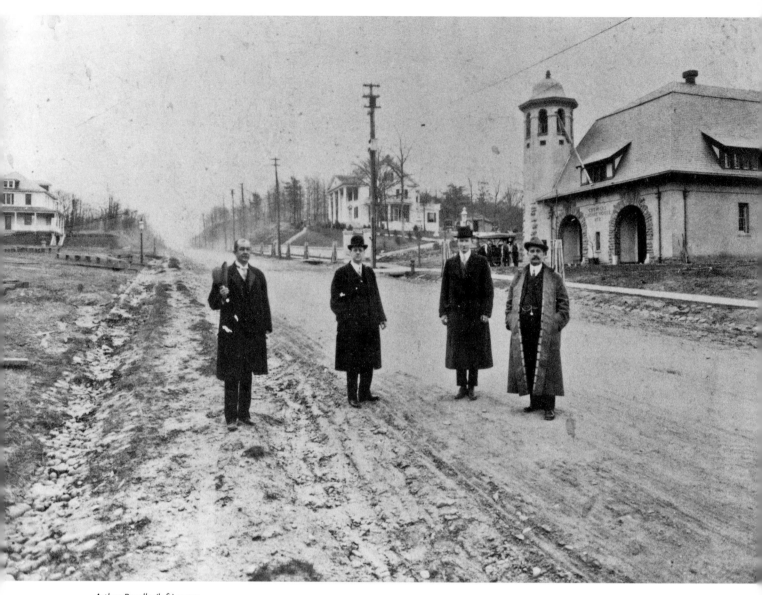

Arthur Randle (left) poses with colleagues on an almost empty Pennsylvania Avenue, SE, about 1915, with his 1910 Greek Revival home and his 1911 Dutch Colonial firehouse as backdrops. Both, he hoped, would encourage others to build grand homes along the avenue. Courtesy Library of Congress

larger development to the north of Pennsylvania Avenue in 1906. Logically named North Randle Highlands, the new section extended north all the way to Massachusetts Avenue. It sold even more quickly than the original section, now that the electric rail line had been secured. Although no evidence of racially restrictive covenants has been found, those who purchased in the neighborhood were white. Thousands attended special promotional events, such as an Easter egg-rolling contest in 1906 featuring music by the Naval Gun Factory Band, when hundreds of children from all parts of the city had to be turned away. A 1906 *Washington Post* article proclaimed Randle Highlands "among the largest real estate enterprises ever successfully carried through in the District."[14]

In 1910 Randle moved from his residence in Congress Heights into an impressive

Greek Revival home he constructed at 2909 Pennsylvania Avenue, just east of his growing development. With impressive two-story columns and a semicircular portico looking west towards the Capitol dome, the house, which still stands, was quickly nicknamed "the Southeast White House." The Randles entertained many of the city's rich and powerful, including Vice President Thomas R. Marshall and his wife in 1914. While his plans for Randle Highlands were decidedly more middle class than was the earlier syndicate's vision for East Washington Heights, Randle clearly hoped that his gracious mansion would inspire more grand residences along prestigious Pennsylvania Avenue, with its direct views of the Capitol. In 1911 he donated land just west of his own home for the picturesque Dutch Colonial firehouse at 2813 Pennsylvania Avenue, lasting evidence of his grand vision for the avenue.[15]

Ultimately, the area just south of Randle's home would develop the most urban character among all of the hillside neighborhoods. In 1939 the 1890 truss bridge at Pennsylvania Avenue was replaced by the modern John Philip Sousa Bridge, named for the famed Marine Corps band leader native to Capitol Hill. The bridge would stimulate the Pennsylvania Avenue commercial corridor and greatly improve access to all neighborhoods of the eastern highlands. When the green space at L'Enfant Square was finally completed in the late 1930s, that bustling convergence of Pennsylvania and Minnesota avenues boasted the Art Deco Dobkin's clothing store (later known as Morton's) and a collection of attractive row houses and storefront shops. The year 1940 brought several blocks of modern retail on Pennsylvania Avenue between 25th and 27th streets, with a new A&P grocery and the streamlined eight-hundred-seat Highland cinema anchoring the block. In the nearby residential areas, row houses and small apartment buildings were built along the main roads, while the side streets of Randle Highlands featured tidy Edwardian frame houses, foursquares, and bungalows.[16]

Other developers had become involved in the Southeast highlands in the 1920s. Fairlawn, for example, took shape along Minnesota Avenue between present-day Historic Anacostia and 25th Street. Possibly due to Colonel Randle's failing health in the early 1920s, a large tract of Randle Highlands on the south side of Pennsylvania Avenue surrounding the old East Washington Heights Baptist Church was sold to Alger & Company. Once also the centerpiece of the syndicate's fashionable East Washington Heights concept, this section would become the heart of today's Hillcrest. Indeed, through the late 1920s, it would seem that most of Colonel Randle's dreams for development in Southeast were being realized.[17]

Then, on July 5, 1929, the 70-year-old Randle inexplicably took his own life while visiting a friend's Santa Barbara, California, ranch. Although he had largely retired for health reasons a few years before, it was reported that he was recuperating quite well. It was a sad end to the life of a man who had successfully transformed this rural sector of Washington into a fast-growing residential community.[18]

The progress that Randle sparked continued, however, under the leadership of his son Ulmo S. Randle, who showed flashes of his father's talent for attracting attention,

even in the midst of the Great Depression. In 1933 hundreds turned out to see Ulmo's new model homes — two quaint English-inspired brick bungalows that still stand at 1804 and 1806 28th Street. The homes featured new all-gas Electrolux (in no. 1804) or all-electric G.E. (no. 1806) appliances, endowing "the moderate-priced residence the luxury of equipment usually found only in homes costing many thousands of dollars more."[19]

As Ulmo Randle continued his father's work in Randle Highlands, Alger & Company began to subdivide Hillcrest, centered on Branch and Alabama avenues. It was the first major subdivision to emerge from the original Randle Highlands tract. Like the earlier Randle Highlands development, its deeds restricted ownership to whites only. Its particularly fine architecture and large lots have long appealed to upper-income buyers, first white, and later African American after racial covenants became unenforceable in 1948. Many of its residents have been civic, political, and business leaders in the neighborhood and in the city at large. Hillcrest saw its first major residential development in the mid-1920s aided by the new affordability of mass-produced automobiles for the middle class. More significantly, the East Washington Heights electric rail line that stopped at Minnesota Avenue was replaced in 1923 by Capital Traction bus service, which went all the way up Pennsylvania Avenue and steep Branch Avenue into the heart of Hillcrest. Suddenly, the daunting hills of the neighborhood were transformed from a deterrent into an amenity.[20]

In the early 1920s the neighborhood was entered at Hillcrest Drive, an extension of 28th Street that curves south and east through a portion of the meandering Fort Circle Park system, separating the new development from the earlier houses of today's Randle Highlands to the south. At that time Hillcrest encompassed an area that extended east to Pennsylvania Avenue, south along the District line at present-day Southern Avenue, and west all the way to Naylor Road. However, in the late 1930s and early 1940s, the Fairfax Village and Naylor Gardens apartment complexes filled large undeveloped parcels of land at Hillcrest's eastern and western extremities and came to be thought of as separate communities.

Nationally acclaimed actor Robert Downing kept a summer estate in what is now Fort Dupont Park, where his performances on the lawn attracted audiences from across the city. He is pictured here in 1889 as Marc Antony in Julius Caesar. Courtesy Library of Congress

Long before the Bliss-Havemeyer Syndicate and Arthur Randle were attracted to these heights, today's Hillcrest neighborhood was the heart of the sprawling plantation of George Washington Young. In 1826 Young inherited his father's 150-acre tract and Nonesuch manor house. After 1833 he was also the owner of the 624-acre Giesboro plantation, extending from the vicinity of Congress Heights south to the District line. By the Civil War, Young was the largest slaveholder in the District of Columbia and the wealthiest man in Southeast Washington. The much-altered Nonesuch manor remains today at 3703 Bangor Street. Around it are fine examples of the architecture of the 1920s to the 1940s. Hillcrest's charmingly eclectic streetscapes feature Tudors, foursquares,

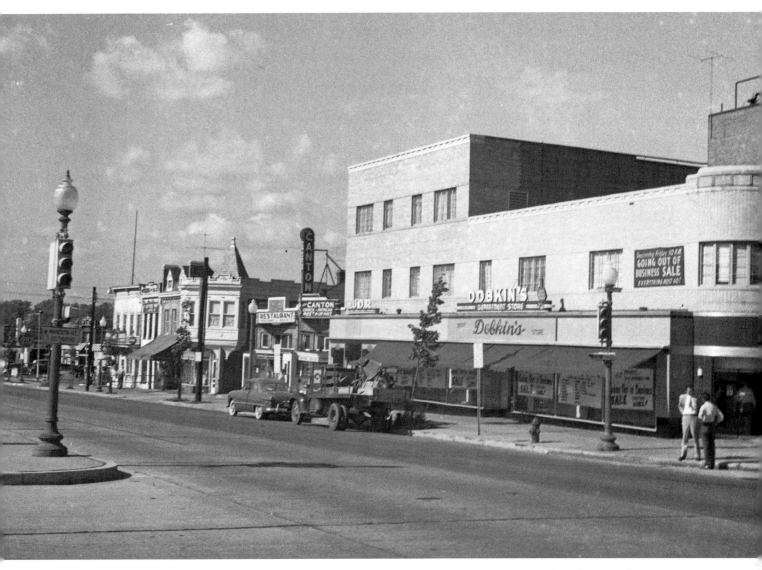

A small commercial area grew up around the crossing of Minnesota and Pennsylvania avenues, known as L'Enfant Square, in the 1940s after a new, more modern Pennsylvania Avenue bridge, named for John Philip Sousa, was completed in 1939. Photo by John P. Wymer. Courtesy The Historical Society of Washington, D.C.

Cape Cods, and bungalows, as well as Dutch, Spanish, and center-hall Colonials that boast unrivaled views of the Mall and downtown from numerous streets. Highly coveted today, Sears "Honor Built" mail-order houses abound in the earliest sections of the neighborhood, including the Gateshead, a striking English Tudor (2133 31st Place); the Fullerton classic foursquare (2317 Branch Avenue); and the Hillsboro, an English cottage (2140 31st Street). An entire block of Sears Dutch Colonials sits on the west side of the 2700 block of 33rd Street, including two examples of the Priscilla (nos. 2706 and 2708).[21]

As middle-class African Americans began replacing white homeowners in the late 1960s, Hillcrest came to be called "the Silver Coast" in a nod to "the Gold Coast," the popular nickname for already established enclaves of African American professionals along upper 16th Street, NW, such as Crestwood. It is an apt comparison, because from

the early 1930s into World War II, the much-admired firm of realtor-builders Paul P. Stone and Arthur S. Lord had simultaneously developed large sections of Crestwood in Northwest, Woodridge Gardens in Northeast, and Hillcrest in Far Southeast. Stone and Lord's advertisements boasting of their involvement in all three comparably upscale communities were staples of the real estate section of local newspapers for more than a decade.[22]

Hillcrest had subdivisions of its own, notably an exclusive section called Summit Park, designed to encircle the Nonesuch manor house and its expansive grounds. Resembling such Northwest neighborhoods as Chevy Chase or Shepherd Park, the substantial brick center-hall Colonials and Tudors of Summit Park are set on especially large lots. By the mid-1930s, Summit Park was considered a separate neighborhood from Hillcrest entirely, with its own very active Citizens Association. However, by the 1950s most of the land surrounding Nonesuch had been built upon, and Summit Park was absorbed into the fabric of surrounding Hillcrest.[23]

Among the numerous prominent residents of Summit Park was the Curtis family, owners of one of the largest retail furniture chains on the east coast. The Curtis Brothers' trademark Big Chair in front of their former flagship store in Historic Anacostia on present-day Martin Luther King Jr. Avenue remains a Southeast landmark. The Curtis family also developed a significant number of houses throughout Hillcrest, including a modern Colonial purchased in 1979 by newly elected Mayor Marion Barry and his then-wife Effi, sparking a wave of interest in the area among upwardly mobile professionals.

Another important Hillcrest subdivision came to be considered a separate neighborhood from its very inception: the 1939–41 development of Fairfax Village. Like Fairlington, McLean Gardens, and other garden apartment communities around the city, it was built through the Federal Housing Administration's efforts to house the influx of federal workers during World War II. It is anchored on the north by Fairfax Village Shopping Center at the intersection of Pennsylvania and Alabama avenues, a then-innovative Park-and-Shop strip mall built in a complementary Colonial style. Fairfax Village is bounded by Pennsylvania and Southern avenues, Suitland Road, and 38th Street. Currently, this affordable development is an exceedingly well-maintained mixture of rental units, garden apartment condominiums, and owner-occupied semidetached townhouses.

As Fairfax Village went up, and as the Great Depression began to loosen its grip, single-family residential development resumed and expanded across to the north side of Pennsylvania Avenue, stretching east from 28th to 38th Street. Once considered an expansion of Randle Highlands, a portion of this section has developed its own identity as Penn Branch. Unlike the earlier Randle Highlands and Hillcrest sections, which included a number of wood frame houses and bungalows, Penn Branch houses are almost entirely built of brick and stone, including center-hall Colonials, Cape Cods, and Tudors, as well as more modern 1950s and 1960s split-level, ranch, and contemporary dwellings. In 1965 a used car dealership on the prominent northeastern corner of the

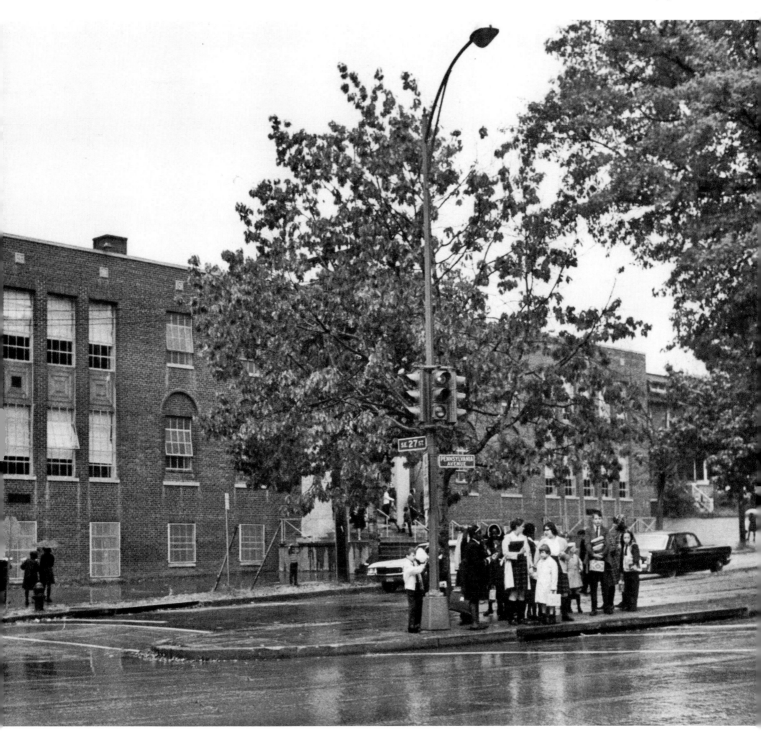

A diverse group of students waits for traffic on a rainy day outside St. Francis Xavier Catholic School at Pennsylvania Avenue and 27th Street in 1968. A group called Southeast Neighbors worked to maintain a racially mixed neighborhood after the 1954 Brown v. Board of Education *Supreme Court decision spurred the flight of white residents. Courtesy Star Collection, DC Public Library. © Washington Post*

Pennsylvania and Branch avenue intersection gave way to the Penn-Branch Shopping Center. Designed by architect Ben Rosin, it was celebrated as the first multilevel retail-office complex in Washington, using both elevators and escalators to transport patrons between the twenty stores located in the 102,000-square-foot space, including a large Safeway supermarket, a bank, and other amenities. Residents and the general public soon began to refer to the community to the north and east of the Pennsylvania and Branch Avenue intersection as "Penn Branch," with 38th Street and Pope Branch Park as its eastern and northern boundaries.[24]

As onetime East Washington Heights filled with new, differently named communities, the city's second largest park began to emerge along its northern edge. In the 1930s, after decades of assembling privately held properties, including land once owned by Arthur Randle, the National Capital Park Commission had control of most of the remains of the Civil War forts that had surrounded the city. It planned to create a system of Fort Circle Parks. This necklace of protected green space would be more fully realized in less-developed Southeast than anywhere else in the District and remains a cherished amenity for current residents. Fort Dupont Park, just north of today's Massachusetts Avenue, would become the largest of these parks at 376 acres, second in size only to Rock Creek Park in Northwest Washington. A protected greensward south and east of Fort Dupont Park picked up the remains of old Fort Davis as the chain of Fort Circle Parks threaded its way through the Randle Highlands development toward Fort Stanton Park to the south, making the area even more attractive to residents.[25]

The hills in and surrounding Fort Dupont Park had been lightly settled by farms and country estates in the late nineteenth century, including the homes of post–Civil War Washington Mayor Sayles Bowen and S. M. Clarke, comptroller of the currency under President Abraham Lincoln. Surely the most colorful early resident was Robert Downing, a Washington-born actor who, beginning in 1886, achieved national celebrity after his star turn as Spartacus in playwright Dr. Robert Montgomery Bird's *The Gladiator*, which toured nationally to great acclaim. An 1894 article in the *Washington Post* chronicled the actor's life at Edgemore, his country estate in Southeast. Downing and his equally famous wife, actress Eugenia Blair, were living with their two daughters on twenty acres on the south side of what is now Ridge Road, just east of present-day Fort Davis Drive, nestled in what is today part of Fort Dupont Park.[26]

"The house is a roomy frame," the *Post* reported, "and one of the out-houses is fitted with a bath-tub and gymnastic paraphernalia. In it, Mr. Downing spends at least an hour every day, taking precautions against the adipose, which proves such an embarrassment to stage heroes." The article went on to say that Downing had given a performance of *Ingomar* at his country home, "with natural forests for scenery, his lawn for a stage, and the setting sun for a calcium light. He played the part in his usual able manner, and the Massillians with sandaled feet trod un-dismayed through the dew." These alfresco frolics became a summer tradition, attracting theater lovers from across the city for per-

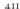

Young skaters show off their skills at the Fort Dupont Ice Arena, the only public indoor ice rink in Washington. Built in 1976 in Fort Dupont Park, the arena draws skaters from across the city for classes, children's programs, and free skating, and provides practice space for school and adult league ice hockey teams. Courtesy Friends of Fort Dupont Ice Arena

formances that benefited organizations such as the Knights of Pythias, the fraternal charity organization to which Downing belonged.

The eventual purchase of Edgemore and its surroundings for Fort Dupont Park set the stage for the modern development of the area between its southern border and Pope Branch Park. This neighborhood came to be known as Dupont Park. The opening of the nine-hole, privately owned Fort Dupont golf course in 1948 sparked the construction of a block of stately brick Colonials and Tudors on Massachusetts Avenue, just west of Alabama Avenue.[27]

The golf course was improved and expanded in 1957 to eighteen holes, inspiring the construction of modern brick split-level homes and ramblers in the Dupont Park community during the decade following the 1956 paving of Massachusetts Avenue — one of the few thoroughfares in Southeast designed to align with the L'Enfant grid across the river. Many of the homes in this neighborhood have excellent views of the Capitol and the Mall. The new Dupont Park community differed from Randle Highlands and Hillcrest in that it did not have racially restrictive housing covenants in its deeds, or as an early Hillcrest advertisement had delicately put it, "sensible restrictions for Home Owners." Dupont Park was created just as the 1948 *Hurd v. Hodge* Supreme Court ruling made such covenants unenforceable. Among the long-time Dupont Park residents was the city's first African American fire chief, Burton Johnson.[28]

Contrary to present-day assumptions, all of Far Southeast Washington (east of the Anacostia River and south of East Capitol Street) was historically predominantly white. The process of change began during the mid-1950s after the desegregation of public

Spring breaks out on Highview Terrace in Hillcrest. The fine homes of this neighborhood in Far Southeast were built about the same time as those in Crestwood and Hawthorne in Northwest Washington, all areas developed by the real estate and builder team of Paul P. Stone and Arthur S. Lord beginning in the 1930s. As the street name suggests, this house affords a fine view, as do many in the neighborhood. Photo by Kathryn S. Smith

accommodations and schools by the Supreme Court rulings in 1953 and 1954. Demographic change in Far Southeast was accelerated as the District satisfied the postwar demand for public housing by constructing sprawling public housing projects on the abundant and inexpensive open land still to be found south of the neighborhoods of East Washington Heights, concentrated in the city's Ward 8 (the East Washington Heights neighborhoods are in Ward 7). Further, Ward 8's numerous modest Federal Housing Administration garden apartments — built for working-class white federal workers during World War II — attracted thousands of African Americans displaced by the redevelopment of Southwest Washington in the early 1960s. As these trends drew African Americans toward Far Southeast, urban unrest in the city following the assassination of Rev. Dr. Martin Luther King Jr. in 1968 caused whites to move away. As is noted in the chapter on Barry Farm / Hillsdale, Far Southeast Washington's population shifted dramatically from 82.4 percent white in 1950 to 86 percent African American in 1970. Initially the process was not without tension for new African American families. Pearl Cross, a nurse, remembers that for the first several years her late husband, Lawrence — a D.C. public school teacher who for decades also taught sign language to the parents of deaf students at Gallaudet University — was routinely stopped and questioned by police while driving back to the 33rd Street home they have occupied since the late 1960s.[29]

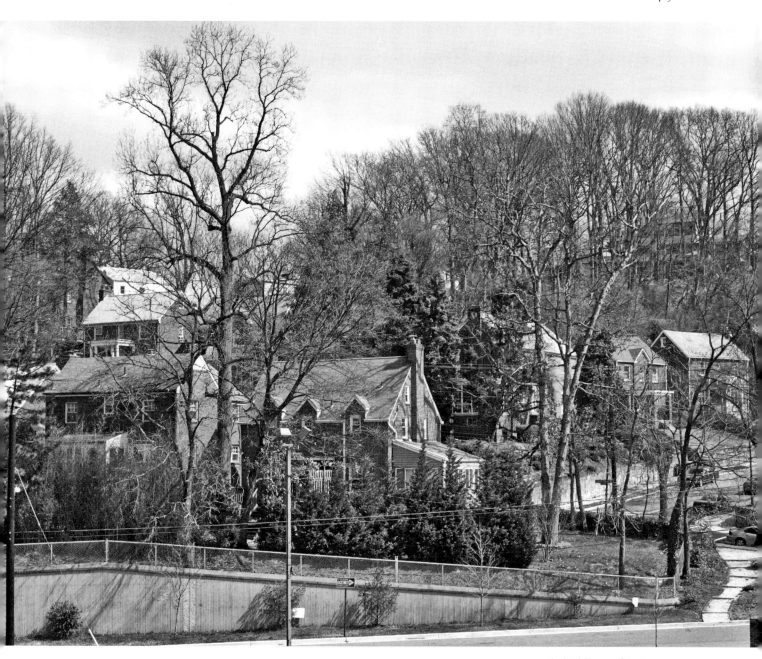

The brick houses of the Penn Branch neighborhood climb up the hilly terrain just east of the Penn Branch Shopping Center at Pennsylvania and Branch avenues. Colonial Revival, Cape Cod, and Tudor styles prevail in this community, which were popular in the 1930s when this neighborhood began. Photo by Kathryn S. Smith

The impact of white flight on Hillcrest and Penn Branch was significantly minimized through the efforts of an organization called Southeast Neighbors, according to Franklin G. Senger III, who since 1960 has been pastor of Holy Comforter Lutheran Church in Hillcrest. "It was organized around 1964 by Harry Kaplan, and modeled after Neighbors, Inc.," recalls Pastor Senger, who was himself integral to this organization. Since 1959 Neighbors, Inc. had built coalitions between longtime white residents and new black home buyers in Northwest District neighborhoods such as Shepherd Park, Manor Park, and Takoma Park. With tactics ranging from simple community meetings and

socials, to vigilantly exposing discriminatory housing practices, Southeast Neighbors facilitated a relatively smooth, gradual integration in Hillcrest and Penn Branch. This lasting legacy of inclusiveness and community involvement is evidenced by a variety of indicators, including the presence of numerous lifelong white residents now in their eighties and nineties, a grounded longstanding base of African American professionals, and a significant gay and lesbian population of both races that make up the fabric of these communities today. The exodus of major stores from the Pennsylvania Avenue retail corridor following 1968 makes this highly visible gateway to Southeast a misleading introduction to the miles of quiet, diverse, tree-shaded communities with their remarkable views that lie just up the hill.[30]

Many residents west of the Anacostia River discover the beauty of the eastern section through visits to Fort Dupont Park. The Fort Dupont golf course, closed in 1971, became the site of a much-utilized community garden and recreation center, while another tract became an outdoor amphitheater offering popular free summer concerts by jazz and blues artists such as Little Jimmy Scott and Roy Ayers. The Fort Dupont Ice Arena opened in the mid-1970s at the park's northern edge on Ely Place. Through the Friends of Fort Dupont Ice Arena's Kids On Ice program, the arena has offered excellent skating programs to about ten thousand underprivileged youths from across the region since 1995. Since 2002 serious skating students from all over the Washington and Baltimore suburbs come regularly to study with resident coach Nathaniel Mills, who competed with distinction in the Olympics in 1992, 1994, and 1998. Frequently visited by other Olympians and professional skaters, the program is considered among the best in the region. In addition, with miles of peaceful hiking trails and new bike lanes along Alabama and Massachusetts avenues, the park and its tranquil environs are increasingly enjoyed by bicyclists and hikers from throughout the city.[31]

Most current residents are not familiar with the area's past as East Washington Heights beyond the name of the church at Branch and Alabama avenues. In an interesting turn of events, however, the name of the church has recently inspired some to suggest reclaiming the "East Washington" moniker, which they perceive as a more unifying label than "East of the River," a term still widely used but one that many feel has come to symbolize only economic distress and separateness.

Most significantly, the political power and visibility of the entire eastern portion of the District increased markedly in the early twenty-first century. For the first time four key members of the D.C. Council came from Far Southeast, including the representative from Ward 8, Marion Barry, and three residents of Hillcrest in Ward 7 — Council Chair Vincent Gray, At-Large D.C. Council member Kwame Brown, and Ward 7 representative Yvette Alexander. With a politically active citizenry and prominent representation, many believe that the golden era of East Washington — so long envisioned — might well be on the horizon.

Wesley Heights and Spring Valley

PERSISTENCY IN CONSISTENCY

DIANE SHAW

"Wesley Heights: The Garden Spot of Washington," proclaimed a 1930 advertisement in the Washington *Evening Star*. The ad outlined the W.C. & A.N. Miller Company's pledge to home buyers: "The owner of a home in Wesley Heights is assured of three things: That his home, being of Miller design and construction, represents the best in type, material, and craftsmanship. That it has enhancing intrinsic value by reason of its location. That the present exclusive character of the 'Garden Spot of Washington' is definitely fixed for all time through Miller control." Three years later, an advertisement touting Spring Valley as "the garden of homes" promised similar oversight, including quality architecture in a natural setting with a "careful selection of resident" families.[1]

Wesley Heights and Spring Valley offered white, upper-middle-class families a new kind of city living during the 1920s. These subdivisions, opened in 1923 and 1929 by the Miller Company in upper Northwest Washington, offered buyers more than a beautiful house and Edenic yard, they offered a community — a community planned and controlled by a single developer on a scale not seen elsewhere in the District. The physical and social characteristics of these two newly developed neighborhoods reflected a nationwide trend in real estate in which the speculative subdivider of old gave way to a new breed of self-styled "community builders."

Progressive developers such as the Miller Company were designing entire neighborhoods from the ground up, overseeing street layouts, landscaping, and the design and construction of houses. This new breed of community builder preserved its original architectural tableaux through in-house design teams and land use restrictions that discouraged unsympathetic changes to the meticulously planned residential neighborhoods. Going beyond architectural and

The boundaries of Wesley Heights and Spring Valley remain as they were when these subdivisions were laid out by the W.C. & A.N. Miller Company in 1923 and 1929 respectively. Map by Larry A. Bowring

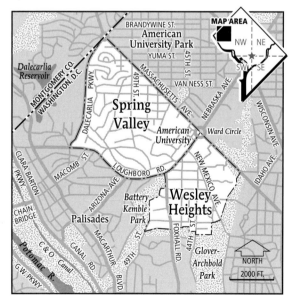

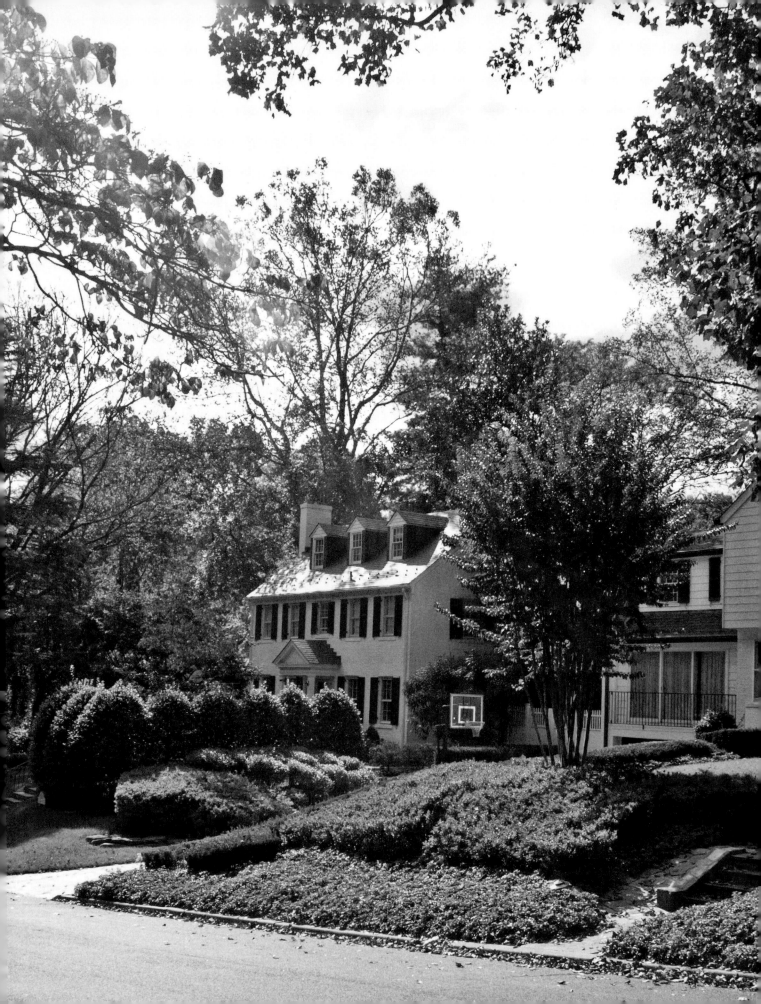

landscape design, the Miller Company also designed a community whose social bonds were built in the community clubhouse and recorded in the pages of the community magazine. What is more, they protected the social composition of the neighborhoods by implementing racially restrictive covenants that were in effect until 1948, when the U.S. Supreme Court ruled them unenforceable. In their role as determined community builders, the Miller Company assumed control over their developments to promote the immediate appeal and to protect the long-term value of living in Wesley Heights and Spring Valley. A 1929 Miller Company advertisement promised home buyers "Persistency in Consistency."[2]

When the W.C. & A.N. Miller Company launched its subdivisions of Wesley Heights and Spring Valley, it attracted buyers not only with the amenities of the moment but also the promise that the neighborhood was stable and the homeowner's investment would hold its value. The company concluded that the key to preserving a lasting suburban idyll was to maintain tight control over the architectural and social development in order to forestall change and, with it, decline. The Miller Company was part of a new trend in real estate development that combined business savvy with the progressive sentiments of the early twentieth century in promoting closely managed social reform.

In 1924 a real estate industry journal presented the new role for developers as community builders as being one of national importance, citing the wise use of land and widespread home ownership as essential for no less than "the survival of our civilization." The Miller Company accepted the challenge. The Miller brothers, William C. and Allison N., entered the real estate business in 1912 with a $2,000 gift from their mother and two lots on the 700 block of Kenyon Street, NW. After building semidetached double houses on Kenyon and Van Ness streets and on Woodley Road, the brothers also constructed single houses in Cleveland Park. Returning home after serving in World War I, they expanded the scope of their real estate business with renewed vigor and a new rhetoric. As W. C. Miller earnestly explained, "The more progressive subdivider has become a builder. . . . We went further than the subdivider generally goes, and went in to the class of community builders. . . . This is a step in the right direction and America will be the better for it."[3]

Wesley Heights was developed first, though it had a fitful start. The acreage that the Miller Company began to assemble in 1923 had been earmarked for residential development during the 1890s by Washington developer John F. Waggaman. He had christened the subdivision Wesley Heights, as a nod to plans for the neighboring Methodist college, American University, and to the eighteenth-century Methodist theologian John Wesley. The financial panic of 1893 and subsequent lean years, however, forced Waggaman to abandon his project after laying out only a few streets and building a few houses.

The Miller Company purchased the Wesley Heights acreage during more favorable circumstances, with an expanding national economy, a growing capital city, and an increasing middle-class housing shortage. By the 1920s neighborhoods once outside the city core had been enveloped by the city. As the row house and double house neighbor-

(opposite)
Many houses in Spring Valley, such as these in the 5100 block of Tilden Street, sit on heavily wooded, curved streets without sidewalks, the result of street plans that followed the terrain. Photo by Kathryn S. Smith

Celebrants parade past Hurst Hall on their way to the laying of the cornerstone of the McKinley Building on the American University campus in 1902. John F. Waggaman made the first attempt to lay out a real estate development adjacent to this new Methodist university in the 1890s, naming it for the great Methodist theologian John Wesley. Courtesy American University Archives and Special Collections

hoods closest to the central city became increasingly urbanized, Wesley Heights and Spring Valley offered new options, providing a convenient distance from the undesirable city elements within the sanctuary of a community of detached dwellings surrounded by parkland. Indeed, a study of fifty-five families who moved to Wesley Heights and Spring Valley in the early years shows that nearly all came from upscale Northwest neighborhoods that had at one time been on the fringes of the city and were now urbanized. They moved from Dupont, Logan, and Scott circles and from Kalorama and the area around 18th Street and Columbia Road now called Adams Morgan. Others moved from row houses in Woodley Park and from luxury apartments on Connecticut Avenue to gain more space and greenery.

Before foraying into large-scale subdividing or community building, however, the W.C. & A.N. Miller Company studied the best and most ambitious suburbs and subdivisions in the nation. The company looked at the models of Shaker Heights outside Cleveland, Ohio; Forest Hills Gardens, New York; Radburn, New Jersey; and Roland Park in Baltimore. The work of the developer — or rather, the community builder — J. C. Nichols and his Country Club District in Kansas City stood out as one of the best comprehensively planned communities in the nation. Its street and lot layouts were sensitive to natural topography, while its winding tree-lined streetscapes added beauty and reduced platting expenses. Major arteries were distinguished from minor residential streets, rendering the latter quieter and safer. Playgrounds and parks offered family rec-

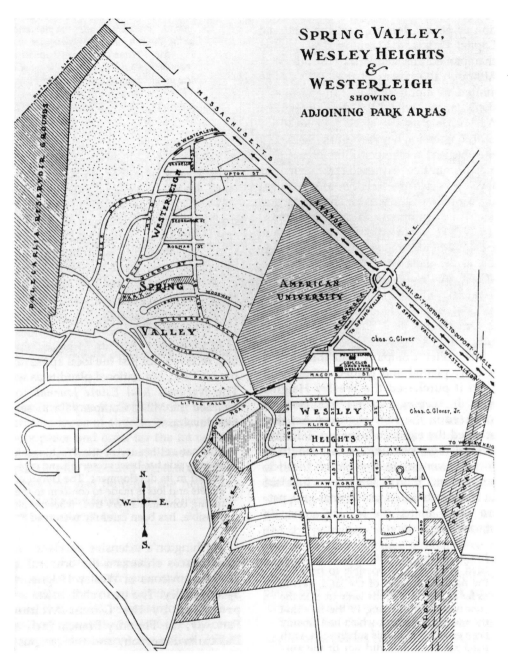

SPRING VALLEY,
WESLEY HEIGHTS
&
WESTERLEIGH
SHOWING
ADJOINING PARK AREAS

The Miller Company was
constrained by the grid plan
in Wesley Heights but was
free to follow the natural
contours of the land in
Spring Valley, as seen clearly
in this map. The community
clubhouse, company offices,
and the public school cluster
on Macomb Street between
44th and 45th streets.
Courtesy DC Public Library,
Washingtoniana Division

reation. Architectural design controls and a sliding scale of minimum house construction costs ensured a neighborhood's harmonious appearance and class homogeneity. A homeowners association enforced community rules set forth in restrictive covenants. J. C. Nichols's work was well known to the Miller Company. During the 1920s Nichols was appointed to the National Association of Real Estate Boards and was an active speaker and author. He was also a member of Washington's National Capital Park and Planning Commission.

The preservation of natural topography was a key feature in progressive subdivisions.

Even the "heights" and "valley" names of the Miller Company neighborhoods them-selves conjured up images of the natural lay of the land. In Wesley Heights, the Miller Company kept the natural contours of the land where possible and saved individual trees as it landscaped, but it had inherited L'Enfant's gridded streets and diagonal av-enues. L'Enfant's plan for Washington City had been extended to the entire District by the 1893 Highway Act and followed by Waggaman as he platted his unsuccessful Wes-ley Heights development in that decade. During the 1920s, however, planners increas-ingly advocated accommodating nature's design as an aesthetically superior and less ex-pensive way of laying out new developments. The National Capital Park and Planning Commission championed the new topographic standard in Washington as exceptions were increasingly made to the 1893 Highway Act. Thus while street layouts and names in Wesley Heights were predetermined by the straight extension of existing streets, in unplatted Spring Valley, the Miller Company was liberated from the straitjacket of a leveled grid, and its new winding roads offered colorful naming possibilities inspired by the topography, such as Rockspring, Rockwood, and Glenbrook lanes.[4]

The clever title of the neighborhood magazine started by the Miller company in 1925, *Leaves of Wesley Heights*, invoked the very trees that made the neighborhood spe-cial. The text of one 1928 advertisement targeted nature-loving urbanites "who enjoy the quiet of the woodland, broken only by the chirping of birds and zephyrs singing through the trees." A greenbelt of parklands, parkways, and institutional grounds, such as the Glover-Archbold Parkway, the Foundry Branch Park, the Dalecarlia Reservoir, and the campus of American University, buffered Wesley Heights and Spring Valley from urban encroachments. Nebraska and Massachusetts avenues and MacArthur Bou-levard routed traffic to the edges of the developments. Electrical wires were buried below ground, eliminating another modern eyesore. The company was proud of the fact that it designed a specific house for each lot, without cutting down mature trees or destroying interesting landscape features such as a brook that cut across a yard.[5]

The Miller Company was equally concerned about the architecture of the houses nestled in these bucolic settings. The slogan "Miller-built" was a promise that each and every building in the subdivisions would be designed, situated, and built under Miller control. It was a promise of unheralded ambition. Several area developers had tried to ensure a certain level of taste in their houses. In Chevy Chase, deeds set a minimum threshold for house costs, in the hopes that expensive houses would be beautiful, sound, and home to an elevated class of neighbor. In other cases, developers settled on a unify-ing style for a neighborhood. Tudor had been used in Waverly Thomas's Foxhall Village duplexes, and Shannon and Luchs gave their Burleith row houses a cottage picturesque-ness. In a 1928 national study of American subdivisions, sixty-one of eighty-four sites were governed by minimum dwelling costs, and forty required prior design approval for new construction or alterations. The Miller Company was again in progressive com-pany.[6]

Wesley Heights and Spring Valley were carefully crafted tableaux. The Miller Com-

The Reality of the Present is the Promise of the Future

In The Garden Spot of Washington there is no investment jeopardy. What this community is today it will be throughout the years to come. That is made sure by Miller-control; and guaranteed by Miller-construction.

A home in Wesley Heights is an example of modern comfort and convenience, with an exterior of artistic designing and period type; while residence here carries with it a prestige unequalled elsewhere for obvious reasons.

Homes of varying sizes and types, completed and nearing completion are open for your inspection, every day and evening, including Sunday.

Motor out Massachusetts Avenue, crossing Wisconsin Avenue, turning left into Cathedral Avenue—the main thoroughfare into Wesley Heights.

W. C. & A. N. MILLER

OWNERS and DEVELOPERS

1119 Seventeenth Street Decatur 610

pany created a design team, led by architects Gordon E. MacNeil and Edward Spano and landscape architect John Small III, that left little to chance and even less to the vagaries of customer taste. As W. C. Miller explained, "No longer are the purchasers left entirely on their own resources in developing the property. More and more the subdivider is assuming these responsibilities for them. . . . He is developing the home and home-site complete." Miller Company architects did more than simply design individual houses; they created a harmonious relationship among them. MacNeil, it was said, "saw architectural perfection as a picture rather than as a group of individual homes. It was seldom that he planned a single house. Instead he planned a street." Uniform setbacks created a garden buffer between house and street. Deed restrictions prohibited

changes to the houses or lots without Miller Company approval, adding another level of protection that inevitable future changes would be sympathetic to the character of the neighborhood.[7]

"Miller-built" did not mean a single signature style. Architectural variety was important. But that variety was disciplined by being couched within the conservative language of architectural revivals such as the Colonial Revival, Dutch Colonial, Spanish Colonial, English Tudor, and French Norman. The architects varied the motifs and materials on each block. A brick Georgian neighbored a stone and stucco half-timber Tudor. A stuccoed Mediterranean villa with red-tiled roof complemented a fieldstone farm house. The Miller Company won frequent architectural awards from the Committee on Municipal Art of the Washington Board of Trade.

The Georgian, also known as Colonial Revival, emerged as one of the favorite styles during the 1920s. The National Better Home, built in 1922 on the National Mall in Washington, was an adaptation of a seventeenth-century New England colonial home. The sponsor, Better Homes of America, Inc., was a private organization with a mission to build better families by encouraging homeownership. Their selection of a colonial model not only honored America's English roots but also meshed neatly with a rising interest in the country's Anglo-American heritage, sparked by the Rockefellers' restoration of Colonial Williamsburg. One Wesley Heights model home, Woodlawn, a brick, central-hall dwelling at 4335 Cathedral Avenue, invoked in name and style the plantation home of George Washington's granddaughter, and thus by association connoted wealth, importance, patriotism, and perhaps unconsciously an image of white authority and exclusivity. Such traditional styles persisted in the two neighborhoods in the ensuing decades.

The Miller Company's houses were not simply public façades; they were homes to private families. The internal configuration of rooms accentuated privacy by reorienting family life to the sheltered rear or side yards. Living rooms often stretched from front to back, and some only faced the backyard. The backyard was no longer a service area but a miniature park. Although it could be as manicured as the front, the informality of the rear yard often contrasted with the serene street image of the home. A contributor to the *Leaves* sighed that if one truly wanted to know a man, one should look at his backyard. "A front yard is more or less like evening clothes, formal and sedate and dignified, each yard like another. But a back yard is like your independence enjoyed at rare intervals."[8]

The rotation of the front porch around to the side or rear of the house completed the privatization of family life. While the change reflected the reorientation of activity to the back of the house, it also paralleled the rising importance of the automobile. The sight, smell, and sound of automobiles on the street made front porch sitting less enjoyable. People were now more likely to take a recreational spin in the car than to take a walk in the neighborhood. In parts of Wesley Heights and Spring Valley, the developers did not even include sidewalks. The front porch was becoming an anachronistic vestige of an earlier, pedestrian era.

LEAVES
OF
WESLEY HEIGHTS

VIEW OF 44TH STREET AND CATHEDRAL AVENUE
WESLEY HEIGHTS

JULY, 1927

The automobile, featured so prominently on Cathedral Avenue on the cover of this 1927 issue of the Miller Company magazine, allowed the development of Wesley Heights, despite its distance from the nearest public transportation. Courtesy American University Archives and Special Collections. © W.C. & A.N. Miller

The very existence, not just the design, of Wesley Heights and Spring Valley depended on the automobile. Carved out of an undeveloped wedge of land in Northwest Washington, the properties had been poorly served by public transportation, with the nearest route running up Wisconsin Avenue at least a mile to the east. But the automobile had liberated developers and their clients. Wesley Heights was touted as offering the best of both worlds: a "virgin forest, where the great arms of nature extend their welcome and fold you in an embrace," at the same time being "only ten minutes by motor from the White House."[9]

The auto-dependent nature of Wesley Heights and Spring Valley significantly shaped

their exclusive character. Garages became pieces within the architectural setting of a home, and suitably revival-styled garages were tucked behind landscaped driveways. Alleys were eliminated. Residents had to be wealthy enough to own a car, ensuring a certain minimal economic standing. Isolated from public transportation, the neighborhoods had few strangers walking its sidewalks or buses clogging its streets. Pocketed in an underdeveloped area of Washington, there was little through traffic bringing outsiders, speeding, or congestion to the quiet streets.

The Miller Company acknowledged the necessity for limited public transportation. Picking up on advice in professional real estate journals that community builders should take care "to see that people using the transportation line have to associate only with those of their own class," the company purchased a bus and hired a driver who took residents to Wisconsin Avenue. Residents recalled that the original driver, Herbie Carter, didn't live in the neighborhood but certainly knew everyone; the free service was a private shuttle for the community. By 1941 the neighborhoods had expanded to the point of anonymity, so the Miller Company instituted a bus pass limited to "families and domestic help residing in Miller-Built homes in the Spring Valley-Wesley Heights area." Homeowners could expect a controlled-access environment even on the bus.[10]

When investing in a Miller-built house, a home buyer also received "Miller guardianship" over the careful selection of residents who could live in Wesley Heights or Spring Valley. Miller Company restrictive covenants specifically prohibited sales to African Americans and "any person of the Semitic races," including "Armenians, Jews, Hebrews, Persians, and Syrians." While such distinctions are highly offensive to today's sensibilities, these covenants reflected widely accepted and publicly expressed prejudices common before the revolutionary social changes of the mid-twentieth century. Although

the Miller Company boasted that their farsighted restrictive covenants were unusual, this was not true, even by District standards. Racially restrictive covenants were already an established Washington practice, and not just for high-income subdivisions. As early as the 1850s, covenants in Uniontown, a working-class neighborhood across from the Navy Yard, prohibited sales to blacks and the Irish. White Brookland residents appended restrictive covenants to their deeds from the late 1920s into the 1940s to stem the tide of black purchasers. Since covenants were private agreements and not publicly legislated, enforcement depended on individual initiative; some also contained expiration dates that required renewal. Shepherd Park, developed in 1911, also had covenants against blacks and Jews, but the restrictions were eventually ignored and the neighborhood became racially and religiously integrated.[11]

In the minds of many white and Christian Americans, the physical decline of urban neighborhoods was intertwined with the shifts in their ethnic, racial, or religious composition. In Washington and elsewhere, urbanites could point to changing neighborhoods close to the city center where the oldest buildings were being passed on to the city's poorest residents, typically racial and ethnic minorities with fewer choices in housing or employment. Apprehensive homeowners and conservative bank lenders thus linked stable property values with nonminority residents.

The National Association of Real Estate Boards, the National Housing Association, and Better Homes of America, Inc., all encouraged the use of restrictive covenants. When in 1917, in *Buchanan vs. Warley*, the Supreme Court ruled that it was illegal to use municipal zoning to segregate cities, many developers and communities turned to the individual property deed with restrictions to keep a property or neighborhood in white hands. Resting on the assumption that individuals had the right to control the disposition of personal property, house owners could refuse to sell to any particular person or class of persons. In fact, Washington was the venue of the 1922 precedent-setting case of *Corrigan v. Buckley*, in which the Appeals Court determined that "the constitutional right of a negro to acquire, own, and occupy property does not carry with it the constitutional power to compel sale and conveyance to him of any particular private property." In a 1928 national study of real estate covenants, thirty-nine of eighty-four sampled subdivisions and suburbs had either explicit racial restrictions or implicit restrictions that required a seller to secure the approval of the development company for the sale.[12]

The Miller Company used its racial exclusivity as a visible selling point. A 1929 advertisement included a black nanny walking a white toddler in front of a Wesley Heights home, an image invoking southern traditions of racial segregation, The text mentioned that Wesley Heights offered "community features that are peculiar to itself," including design, construction, natural surroundings, and "protective restrictions." Given the prevalence of maid's quarters in many of the house plans, it seems likely that minority live-in help was allowed. Day workers were also permitted on the private bus. Restrictive covenants were preserved until the Supreme Court ruled the practice legally unenforce-

able in its 1948 decision *Hurd v. Hodge*. Until then, Wesley Heights and Spring Valley advertisements proudly touted the protection of covenants.[13]

The Miller Company thus effectively designed subdivisions attractive to Christian, upper-middle-class whites of Washington, a trend that fed on itself and gained momentum. To show their commitment to the neighborhood, W. C. and A. N. Miller moved their own families to Wesley Heights. Promotional literature meticulously recounted the positions held by each neighbor. Within a decade the local press was able to gush that "Wesley Heights and Spring Valley cover 400 acres in Northwest Washington and half a dozen pages in the Social Register." Among the many politicians and civic leaders who have lived in the subdivisions, the most famous resident was likely Richard Nixon, who lived in a frame Colonial Revival house at 4801 Tilden Street in Spring Valley during his years as a U.S. senator and in a stone Tudor manse in Wesley Heights at 4308 Forest Lane while later serving as vice president. Other presidential aspirants lived in the neighborhood as well. Lyndon B. Johnson once lived at 4040 52nd Street in Spring Valley, and George H. W. Bush once resided at 4429 Lowell Street in Wesley Heights.[14]

Once admitted, residents of Wesley Heights and Spring Valley enjoyed numerous amenities that encouraged a community identity. Real estate journals counseled developers on how to foster community spirit and loyalty, and the Miller Company followed almost to the letter a plan proposed by J. C. Nichols, who suggested that subdivisions have an annual field day, nature hikes, a community playground, community Christmas activities, sport clubs, a homeowners association to enforce rules, architectural standards, and a landscape code. The Miller Company deviated only in not implementing a homeowners association, instead vesting all enforcement power in the development company. The Miller Company staged holiday events such as Christmas tree lighting and caroling and a Fourth of July field day. The *Leaves* magazine kept neighbors apprised of neighborhood activities and the news of local families, including vacation plans, births, graduations, engagements, and marriages.

In 1927 the Miller Company constructed a community center at 45th and Macomb streets to replace a makeshift clubhouse in an old farmhouse at 44th and Lowell streets. The domestic scale of the clubhouse, built of brick in an eclectic Tudor-inspired style, matched the residential architecture of the neighborhood. The sloping, gabled, multiuse structure housed the community hall on the upper story, and a grocer, pharmacist, and the Miller Company office at street level.

The community club quickly became one of the vital components of the Miller Company's neighborhood plan. Old-fashioned neighborliness had become harder to find. As front porches slid to the back, and foot traffic gave way to motor, there were fewer chance encounters for impromptu socializing. Moreover, Washington was a city of newcomers. And the subdivisions were new and not densely settled. As one early resident recalled, "In those early days of the community, Wesley Heights had fewer than thirty new residences, and this small group of young married couples recognized the need for an organization that would be both social and civic in purpose."[15]

The company launched programs to bring families out of their homes and into the community. Socializing was institutionalized in weekly open houses held at the community center and hosted by a rotation of volunteer families. Mothers groups, Boy Scouts, teen dances, and bridge parties all met at the clubhouse, where the annual membership was three dollars. The success of the community programs suggests that first-generation Wesley Heights and Spring Valley families appreciated the contrived social opportunities. W. C. Miller proudly noted in 1930, "Our community club, while small, is well attended and I believe is one of the finest things we have ever promoted in our subdivision."[16]

The brick clubhouse with its grocer and pharmacist on the ground floor anchored the little downtown of the neighborhood. The block became a small civic center, with the Metropolitan Methodist Church and the public Horace Mann Elementary School. Neighborhood resident Frank Ballou, who was conveniently the superintendent of the

D.C. Public Schools, helped launch Horace Mann in 1927. In its first incarnation the school consisted of two portable buildings, each holding three grades. There was no electricity. The buildings were heated by coal stoves, the toilets were in a separate structure, and all water came from an outdoor pump liable to winter freezing. The first teacher, Octabia Webb, was determined not to be alone in what she termed "this woodland on New Mexico Avenue" and asked for a policeman to watch over her school. She was rewarded with a National Park policeman on horseback "who gave us protection as well as prestige," she recalled.[17]

The Miller Company limited large-scale commercial and professional offices to the busy avenues. In the 4800 and 4900 blocks of Massachusetts Avenue it built a grocery store, a gas station, a new office building, and, in 1942, a branch of the upscale Garfinckel's department store. "Respecting the traditional in architecture," the management of both Garfinckel's and the Miller Company "went first to Williamsburg for inspiration," *Leaves of Wesley Heights* reported, and thus maintained the Colonial Revival feel of the neighborhoods.[18]

Wesley Heights and Spring Valley have in fact seen less change in their physical and social character than most other District neighborhoods. Publication of its company magazine (the name officially shortened to *Leaves* in January 1986) continued until its demise in summer 2008. Its covers often evoked the timelessness of the community. "Now and Then" pictures showed the persistence of neighborhood events and values, even if the fashions had changed. Even some families persisted. A 1995 cover reprinting a 1932 portrait of a resident with her great-granddaughter triggered the discovery that her descendants still lived in Spring Valley. The contents of *Leaves* also demonstrate

Students at Horace Mann Elementary School in Wesley Heights celebrate the school's fiftieth anniversary in 1984 with a parade of balloons. Courtesy Horace Mann Elementary School.

the persistence of homeowners' concerns, with articles on gardening, birding, interior decorating, raising children, and weddings, although the intimacy of the early years was gradually replaced by a more commercial feel. Just as a 1929 advertisement proclaimed "Persistency in Consistency has made a model community of Wesley Heights" and promised "and so it will continue," more recent advertisements invoke the same language of enduring quality, convenience, and exclusivity. A 1995 advertisement for "New Luxury Homes in Spring Valley" urged families to "discover the tranquility of an established neighborhood and the convenience of an uptown address."[19]

The tranquility of Spring Valley was disturbed in 1993 when a backhoe operator digging a sewer line unearthed unexploded mortar and artillery shells in the neighborhood. Unknown to residents, but suspected by the Department of the Army since 1986, sections of Spring Valley had been used as a chemical weapons testing ground and dump during World War I. A second Spring Valley cache of unexploded chemical weapons and munitions scrap was unearthed in 1999 and a third in 2007. Testing by the Environmental Protection Agency also revealed inconclusive but troublesome levels of arsenic, a component of chemical gas, in some soils. From 1917 to 1919 a financially struggling and patriotic American University had permitted the government to use its buildings and

grounds for the war effort, and the campus became part of the Army's chemical weapon research lab and training grounds. The adjacent federally owned lands, which the Miller Company purchased in 1926, were pocked with trenches dug for mustard gas experiments as well as for dumping waste. Buried and largely forgotten, the unearthed trenches made national news and prompted lawsuits from residents, the Miller Company, and American University against the government. Federally directed cleanup, remediation, and health monitoring in scattered sections of Spring Valley have been ongoing.[20]

Nevertheless, Spring Valley and Wesley Heights continue to attract new families drawn to the picturesque architecture, quality construction, leafy landscapes, sense of neighborhood, and convenient location that the Miller Company had originally promoted. During the past several decades, however, the neighborhoods have fallen victim to their own cachet. As is the case in other attractive older neighborhoods across the nation, the scale and interiors of the pre–World War II houses sometimes no longer suit contemporary clients. Houses are then purchased only to be torn down and replaced.

In Wesley Heights and Spring Valley, zoning codes have replaced Miller control, providing more latitude for change. During the late 1980s and early 1990s, zoning laws permitted 40 percent lot coverage, although the original Miller Company designs were based on approximately 20 percent lot coverage. As homeowners began to remodel or tear down based on this larger allowance, the ambience of Wesley Heights and Spring Valley began to change. Where the Miller Company had carefully positioned a Tudor-style dwelling at Cathedral Avenue and 44th Street to preserve a picturesque stream, in 1989 a developer relocated the house and bulldozed the stream to make room for two houses on the lot. The following year, a developer razed two houses on the original 4400 block of Klingle Street and replaced them with a pair of identical larger houses. The oversize relationship of the houses to their lots, the difference in setbacks, and the unimaginative replication of style in these and other new, oversize houses have eroded the neighborhood tableau nurtured by the Miller design team.

As a result of changes such as these, a neighborhood commission formed and pushed for an adjustment to the zoning code. The zoning board acknowledged competing property rights and prefaced a new 1992 zoning overlay with the explanation that the zoning is intended to "preserve in general the current density of [the] neighborhood" and "preserve existing trees, access to air and light, and the harmonious design and attractive appearance of the neighborhood," while at the same time "allow reasonable opportunities for owners to expand their dwellings." The zoning overlay now generally limits lot coverage to 30 percent, although there are exceptions, and also requires houses to respect the context of neighborhood setbacks: "All residential buildings shall have a front yard setback equal to or greater than the average setback of all structures on the same side of the street in the block where the building in question is located."[21]

Advocates for the original style of Wesley Heights argue that they are not trying to freeze the neighborhood but rather are trying to ensure that changes are compat-

ible with its character. Other residents disagree, arguing that it is "an elitist attempt at imposing the views of a few." Tensions over design restrictions are nothing new. J. C. Nichols urged cooperation between the developer and the purchaser, recognizing their entwined interests as he wrote in *The American City* magazine in 1927: "The results of planning should be considered always from two angles — one the effect on land values, and the other, the effect on the community. We should not allow ourselves to be so idealistic in our desire to create a better community that in so doing we destroy real property values. On the other hand, we should not permit the landowner to do something for a quick personal gain which would work a serious injury to the community and to other landowners." Community builders then and neighborhood advocates now argue that controls should be seen not as limitations on their property rights, but rather as a form of protection from rogue neighbors.[22]

The power of the early vision of the W.C. & A.N. Miller Company, which remains in business as of this writing, is still visible on the land. Indeed, in celebration of the ninetieth anniversary of the founding of the Miller Company, Mayor Anthony Williams de-

Richard Nixon lived in this house at 4308 Forest Lane in Wesley Heights when he was vice president of the United States. Presidential aspirants Lyndon B. Johnson and George H. W. Bush also made the area home, Johnson in Spring Valley and Bush in Wesley Heights. Photo by Kathryn S. Smith

This Georgian-style house at 4965 Glenbrook Road in Spring Valley was the house of the month in the September 1942 issue of Leaves of Wesley Heights. *The owners particularly enjoyed the flagstone patio in the garden at the rear, the magazine reported, and valued the distance of the house from the street—a change from the front-porch preferences in earlier Washington neighborhoods. Photo by Kathryn S. Smith*

clared April 24, 2002, "W.C. & A.N. Miller Day." In addition to the company's charitable activities and commercial and corporate developments in the city, the proclamation specifically noted that the company "played a key role over its long history in shaping the appearance and character of many of Washington's most prominent neighborhoods." The promises made in early advertisements turned out to have a great deal of truth to them. "Persistency in Consistency" has proven the watchword of Wesley Heights and Spring Valley.

Adams Morgan

DIVERSITY WITH A LATIN BEAT

OLIVIA CADAVAL

Adams Morgan has been known for decades as a popular night spot, once made famous by Charlie Byrd's jazz and then by Latino salsa music and dance. Adams Morgan has also distinguished itself as a community that celebrated social activism and cultural and economic diversity. By the turn of the millennium, however, the Latino beat and the multicultural essence of its 18th Street and Columbia Road commercial corridors had become more a vestige of the neighborhood's past than representative of its residential character. Rising property values and the transformation of affordable rental units into condominiums were displacing its diverse and longtime lower- and middle-income residents, and a new cycle of change was under way.

The area known today as Adams Morgan includes several early suburban subdivisions about two miles north of the White House. Their original attractions were country charm, the breeze on the heights, and proximity to the city. In the 1920s and 1930s the area was considered elite: "It was a fine area. Fine people, fine houses. We had many friends who were prominent then or who became prominent later on," Joseph Rod, a long-term resident, remembered.[1]

This impression of homogeneous gentility prevails in the recollection of some of the neighborhood's older residents. However, the neighborhood has always been home to people of different backgrounds and aspirations. After World War II it grew into one of the most culturally and economically diverse neighborhoods in Washington, a racially mixed community that became the center of the city's growing Latino population. At the height

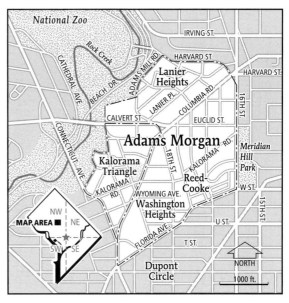

Adams Morgan overlays three nineteenth-century neighborhoods—Lanier Heights, Washington Heights, and Meridian Hill. The Adams Morgan name came into use during the 1950s, when residents began working together to address common issues. Kalorama Triangle, originally thought of in partnership with Sheridan-Kalorama west of Connecticut Avenue, is now generally considered part of Adams Morgan. The boundary for today's Advisory Neighborhood Commission follows the lines on this map but extends to U Street on the south. In the 1980s most of the original Meridian Hill subdivision (which extended from 18th Street east to 15th Street) came to be called Reed-Cooke. Map by Larry A. Bowring

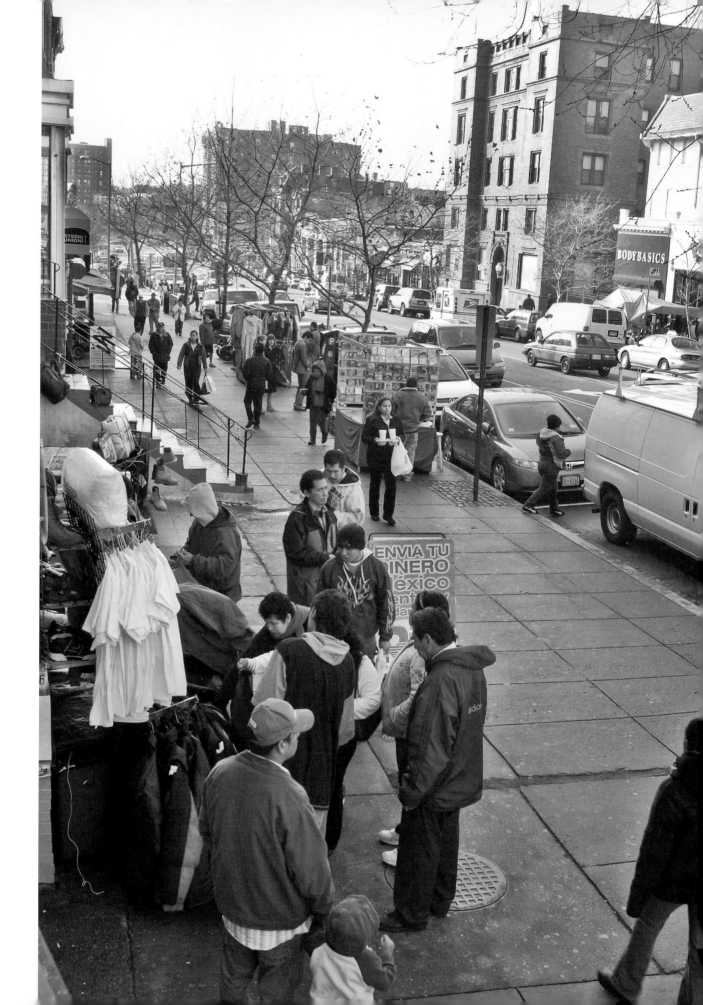

of its diversity in 1984, the *Washington Post* described it as "a blend of rich and poor, black, brown and white, young and old — a vivid kaleidoscope of individuals and experiences constantly changing."[2]

There are many stories to be told about this place. After summarizing the neighborhood's early history and its special brand of activism and diversity, this chapter focuses on the evolution of the Spanish-speaking community centered here and in neighboring Mount Pleasant and Columbia Heights, beginning in the 1950s. The term Latino rather than Hispanic is used throughout, as it is the name used by the community itself.

The hub of the neighborhood is the intersection of 18th Street and Columbia Road, NW. On these two commercial streets, Latino restaurants and stores, bearing the stamp of many Caribbean and Latin American cultures, share the scene with Ethiopian, Eritrean, Ghanaian, Chinese, Vietnamese, Japanese, Italian, French, Indian, Middle Eastern, and traditional American restaurants; clubs; fast-food stores; and a variety of other locally owned and national chain shops and services. Though diverse, the place has a very strong identity and sense of community. In the 1950s it began to develop a reputation for being one of the most organized and community-conscious neighborhoods in the city.

Adams Morgan's name and generally recognized boundaries are about fifty years old, the products of a late 1950s biracial community effort to improve the area. The boundaries overlay three nineteenth-century developments — Meridian Hill, Lanier Heights, and Washington Heights. Many also consider Kalorama Triangle to be part of Adams Morgan. Geographically contiguous, these communities overlooked the city from the hills just above Boundary Street. They were all considered fashionable through the early twentieth century and were served by the genteel commercial area around 18th and Columbia Road.

Perhaps the most famous resident of the Meridian Hill neighborhood was Mary Foote Henderson. In 1888 she and her husband, Republican Senator John B. Henderson of Missouri, built a Victorian version of a medieval castle, known as Henderson Castle, at 16th and Boundary streets, where they held countless dinner parties and other social events. Mrs. Henderson was a tireless promoter of 16th Street as the "Avenue of the Presidents," supporting an unsuccessful effort to build a new White House on Meridian Hill across the street from her home in 1898, and later urging, also unsuccessfully, a 16th Street location for a permanent home for the vice president. She did, however, attract foreign embassies, a number of which occupied a series of mansions she had constructed along 16th Street for that purpose between 1906 and 1927. After Mrs. Henderson's death in 1931, her castle became apartments and then an after-hours club. The house was razed in 1949, and the site stood vacant until the construction of the Beekman Place town houses in the mid-1970s. Remnants of the brownstone entrance remain at the corner of 16th Street and Florida Avenue, the new name for Boundary Street after 1890.[3]

Mary Henderson's vision for 16th Street also led her to persuade the federal government to create a European-style, twelve-acre park on land she donated on Meridian Hill,

(opposite)
A busy Columbia Road east of 18th Street retains the Latino flavor of Adams Morgan, with vendors, clubs, restaurants, and grocery stores that offer the food and the music of homelands across Central and South America. Photo by Rick Reinhard

The castle-style mansion of Mary Foote Henderson dominated the northwest corner of 16th and Florida Avenue from 1888 until its demolition in 1949. Mrs. Henderson brought prestige to the area by attracting embassies to 16th Street and by giving the land for today's Meridian Hill Park. Courtesy DC Public Library, Washingtoniana Division

across the street from her home. The hill takes its name from the 1815 Meridian Hill House, home of Commodore David Porter. His residence straddled what was accepted in much of the nineteenth century as the nation's prime meridian, the starting place for all mapping of the United States. Today's 16th Street follows this old line, which was abandoned in 1884 when the United States adopted the Greenwich (England) Prime Meridian.

During the Civil War, the hill was the site of Union army hospitals and camps. Here, as at other army installations and forts around the city, escaping and later newly freed African Americans settled for protection and support. A black community evolved in the area as a result, with 15th Street as its centerpiece. However, in the late 1880s, when Mary Henderson bought the land that is now the park, some residents were forced to

Smithsonian scientist George Brown Goode built this fine home for his family on Summit Place in the new Lanier Heights development north of Columbia Road, pictured here between 1890 and 1895. He and Archibald McLachlen created the new subdivision, now considered part of Adams Morgan, in the 1880s. Courtesy Smithsonian Institution Archives, Record Unit 95, No. 9384

move, a number finding their way west into a community between 16th and 18th streets, today known as Reed-Cooke. This area had been part of the original Meridian Hill subdivision, laid out in 1867. In a perhaps fitting turn of events, civil rights activists would adopt Meridian Hill Park for major demonstrations in the 1960s. In 1970 Angela Davis gave it the unofficial name Malcolm X Park. In 2006 one of the feeder marches to the National Day of Action for Immigrant Justice, culminating on the National Mall, started at Meridian Hill / Malcolm X Park.[4]

Another early development considered part of Adams Morgan today, Lanier Heights, lies northeast of the juncture of Columbia and Adams Mill roads. George Brown Goode, noted scientist and director of the Smithsonian's National Museum, and Archibald McLachlen, an early real estate speculator, were central to its development in the 1880s as a fine residential neighborhood. They bought a large tract and laid out the first streets. Goode sold many lots to members of his intellectual and social circle. A third early subdivision, Washington Heights, was laid out to the west of 18th Street and was

The elegant Knickerbocker Theatre at 18th Street and Columbia Road epitomized the upper-class character of the neighborhood in the 1920s. It is seen here in January 1922 after a twenty-eight-inch snowfall tragically caused the roof to collapse, killing ninety-eight people and injuring many more. Courtesy Library of Congress

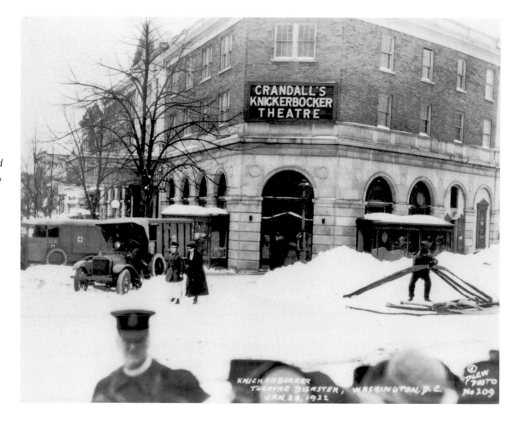

built up with substantial row houses in the first decades of the twentieth century. Kalorama Triangle just to the west, in the wedge between Columbia Road and Connecticut Avenue, developed a similar character. Some of the District's first prestigious apartment buildings began to rise in Lanier Heights, Washington Heights, and Kalorama Triangle in the first decades of the century, when this style of urban living began to be popular in the city. Fine examples of these buildings remain today, such as the Wyoming on Columbia Road and the Ontario on Ontario Place.[5]

By the 1920s the entire area had entered into what political scientist Jeffrey Henig has termed its "white glove era." The fashionable bakery Avignon Frères had opened in 1918 on Columbia Road, serving an elite clientele. The year before Harry Crandall had brought the elegant Knickerbocker Theatre to the community at 18th Street and Columbia Road, a 1,700-seat facility that attracted audiences from across the city. However, tragedy struck the neighborhood in 1922 when a twenty-eight-inch snowfall caused the collapse of the theater's roof. The disaster took the lives of ninety-eight people and injured hundreds more. Crandall built a new theater on the spot, called the Ambassador. Its fortunes would reflect later changes in society and in the neighborhood. As television stole theater audiences, the Ambassador hosted rock concerts and, in 1967, an anti–Vietnam War rally. The theater met the wrecking ball in 1970, and local activists went to work to ensure the site would be developed in the local interest. They defeated a proposed gas station and then, in 1978, persuaded the new owner, Perpetual Savings and

Loan, to hire a bilingual staff, offer special loans to area residents, and create a plaza for a farmers' market.[6]

The area began to change during World War II, when a city-wide housing shortage prompted owners of many larger residences in Adams Morgan and elsewhere to turn their homes into rooming houses. Change accelerated through the early 1950s, when many white families chose to move from the city to new homes in the suburbs, a shift spurred by Supreme Court rulings that struck down housing covenants in 1948 and segregated schools in 1954 and encouraged by favorable home loans and the increasing use of the automobile. The prices and rents of the elegant old apartments and row houses were now within reach of a less affluent group, and they began to attract a new and younger population. African Americans had been moving into the neighborhood since the 1940s, and by 1970 they represented about one-half of the population. A mixture of working-class people and young middle-class intellectuals — black, white, and Latino — moved into the area and changed its social character. Some were in the forefront of the social and political movements of the 1960s.[7]

A leader in antiestablishment politics, Angela Davis addresses an audience from the pulpit at All Souls Unitarian Church in 1979. The church, at the juncture of the Adams Morgan, Columbia Heights, and Mount Pleasant neighborhoods at 16th and Harvard streets, played an important role in the social and civic life of these communities. © 1979 Shia Photo

Lanier Place, in particular, became home to people involved in antiestablishment politics, including members of Students for a Democratic Society and the Mayday Tribe commune, an antiwar group. Houses on the street hosted Black Panthers, American Indian Movement workers, and the Berrigan brothers, Catholic priests who were leaders in the anti–Vietnam War movement.

St. Stephen and the Incarnation Episcopal Church, off 16th Street on Newton, and All Souls Unitarian Church, located on 16th Street near Columbia Road, both in neighboring Columbia Heights, played an important role in the civic and social life of the Adams Morgan, Mount Pleasant, and Columbia Heights communities. Reverend David Eaton, the first black senior minister at All Souls Church, led the congregation in social activism and service. Reverend William Wendt at St. Stephen Church was active in national civil rights, women's rights, and antiwar movements, as well as local issues. The Church of the Saviour created the Potter's House coffee house on Columbia Road, designed by founders Mary and Gordon Cosby to serve as "the church in the marketplace." It would become a favorite gathering place for social and civic activists.

In the 1950s general physical decline of the area, new federal government interest in urban renewal, and the integration of schools stimulated community action. The several neighborhoods, which previously had not identified with each other as one community, coalesced into what is now known as Adams Morgan. Local activists fought for community control of neighborhood schools, first in the black Morgan School and then in the predominantly white Adams School. In 1955 the principals of the two schools were instrumental in organizing the Adams Morgan Better Neighborhood Conference,

As young, politically active people discovered affordable places to live in Adams Morgan in the late 1950s and early 1960s, the Potter's House on Columbia Road became a popular gathering place. Seen here shortly after it opened in 1960, the coffee house was sponsored by the ecumenical Church of the Saviour, which was involved in issues of social justice and peace. Photo by James McNamara. Courtesy Washington Post

which brought together residents and representatives of a variety of community organizations to plan neighborhood improvement. The Adams Morgan Community Council, formed the same year, also drew neighborhood organizations together across racial and economic lines. The Community Council defined Adams Morgan as extending to New Hampshire Avenue and R Street on the south, 16th Street on the east, Harvard Street on the north, and Connecticut Avenue and Rock Creek on the west. Except for the southern boundary at R Street and New Hampshire Avenue, this created the generally accepted outline of today's Adams Morgan. The Community Council included Kalorama Triangle, bounded by Columbia Road, Connecticut Avenue, Rock Creek Park, and Calvert Street, in its territory. (Because this area is historically linked to Sheridan-Kalorama, west of Connecticut Avenue, its history is more fully covered in the chapter on Kalorama.)

While the community was coming together, its unity was both threatened and energized by the prospect of urban renewal. In 1958 the city government gave a contract to American University researchers to consider solutions to the area's "urban blight," as it was then called. This was understood by many as the first step toward urban renewal, at a time when the demolition of Southwest was the urban renewal model of the day. Some, including the Adams Morgan Planning Committee headed by businessman Donald Gartenhaus, whose Gartenhaus Furs store had its roots in the neighborhood's elite era, saw it as an opportunity to use planning and public money to upgrade the

community. Others in the poorer sections of the neighborhood feared the loss of affordable housing, and those in the wealthier areas feared declining property values. While the planning committee saw the semi-industrial area between 16th and 18th streets, for example, as a deteriorating influence, others saw it as providing important housing for low-income residents. The Adams Morgan Organization, Jubliee Housing, Adams Morgan Community Development Corporation, King Emmanuel Baptist Church, and others worked to preserve affordable apartments in that area. Unable to reach consensus, by 1962 the federal, city, and local planners decided against urban renewal in Adams Morgan.[8]

Meanwhile, the old fashionable businesses along Columbia Road began to fade. With declining rents, 18th Street became attractive and affordable to nightclubs. Jazz guitarist Charlie Byrd brought fame to the Show Boat Lounge at 2477 18th Street in the 1950s and 1960s; he and bass player Keter Betts and saxophonist Stan Getz introduced Americans to Brazilian jazz. The Show Boat closed in 1967. The riots of 1968, when a number of local stores were looted and smashed, were the final blow for many, and such elite businesses as Gartenhaus Furs and Ridgewell Caterers moved away.

Many nonresidents of Adams Morgan knew the neighborhood as the location of the Show Boat Lounge on 18th Street, where guitarist Charlie Byrd played regularly to enthusiastic crowds. The photographer captured him there in 1960 with bass player Keter Betts and drummer Eddie Phyfe. Courtesy Alan White Advertising

The most notable change in mid-twentieth-century Adams Morgan was the influx of thousands of Spanish-speaking people from Central America, South America, and the Caribbean. Their presence had begun to be noticeable in the 1950s. Though an accurate count of this community has always been difficult, the 1970 U.S. Census numbered the Latino population in the District at 17,561; by 2000 the census counted 44,953. In 2006 the census estimated a total of 47,774, or 8 percent of the city's total population. While these numbers make Latinos the fastest-growing minority in the District, recent research indicates the numbers are leveling off.[9]

Washington always had a small Spanish-speaking population; it grew along with the rest of the city in the twentieth century as Washington became a world capital. Members of the Spanish-speaking embassies and world organizations, professional staff members as well as domestic workers, took up residence in Adams Morgan because of its convenience to many embassies situated around 16th Street and Massachusetts Avenue just to the west. Many of the embassy domestic workers stayed after diplomatic tours of duty ended or after their host families left the city, settling in the area and encouraging family and friends from home to join them. Latin American students in area universities and white-collar Mexican Americans, attracted by federal jobs in New Deal and World War II agencies, were part of this early growth, but they mostly remained separate from the rest of the nascent Latino community.

Rapid growth of the Latino population came in the 1960s. Economic hardship and political turmoil in Latin America, combined with the allure of the United States, created a flow of legal and illegal immigration. Adams Morgan, with its established

Spanish-speaking population, was a magnet to these immigrants. Luis Rumbaut, a lawyer from Cuba working for the Latino social service agency Ayuda, described the typical process in 1978. "The first person to arrive here from a given village sends his address back home, and he's the first stop when the next person arrives." Whole communities were transplanted, as exemplified by an apartment building just north of Ontario and Columbia roads where the residents almost recreated their village in the Zacapa province of Guatemala.[10]

Cubans came in the greatest number in the late 1950s and early 1960s, South Americans in the 1960s and 1970s. By far the largest in number, however, were Central Americans in the 1980s — a result of the growing Central American conflicts. These varied migrations made the Spanish-speaking population of Washington, and of Adams Morgan, much more culturally diverse than those of other large American cities in that decade. In New York, for example, Puerto Ricans and Dominicans tended to live in separate communities and neighborhoods. In the District, people from various countries in Central and South America and the Caribbean settled together in Adams Morgan, Mount Pleasant, and Columbia Heights. At first no one group was large enough to form its own community or to appeal to those in power to meet their needs. Therefore the different nationalities organized themselves around a shared language and common issues, and in the process shaped a unifying Latino identity, unique to Washington. As new immigrants arrived, this Latino cultural and social support structure incorporated them without supplanting their other identities, whether associated with a country, region, or town.[11]

But in the early 1960s there was still little sense of community. Many Latinos were embassy employees, mainly women, who were discouraged from going out into the streets that were described to them as dangerous. Casilda Luna, a Dominican who came in 1961 as a domestic worker for a general, seldom went out during her first year in Washington. When she did, she managed to find a few people who spoke her language at an Italian-owned grocery store on Columbia Road.[12]

Language and food became basic organizing forces. In Adams Morgan and in neighboring Mount Pleasant, family stores began to open. The Sevillana on 18th Street was the first, in the 1950s. In 1962 Casa Diloné opened on Mount Pleasant Street. Casa Lebrato, El Gavilán, and La Americana followed on Columbia Road. The stores became the hub of social interaction. As Gerald Suttles writes in his study of Chicago communities, "Most business establishments are not just a way of making a living but also of enjoying an enduring set of social relations where money is only one of the tokens that change hands." Within this setting the concept of Latino began to acquire a special meaning. A unique mix of people, sharing a common language yet representing different cultures of the Caribbean and South and Central America, came seeking familiar foods. They found they were all facing similar problems with language, housing, and employment, and a sense of solidarity began to emerge.[13]

Besides the stores, the churches and a movie theater were also meeting places for La-

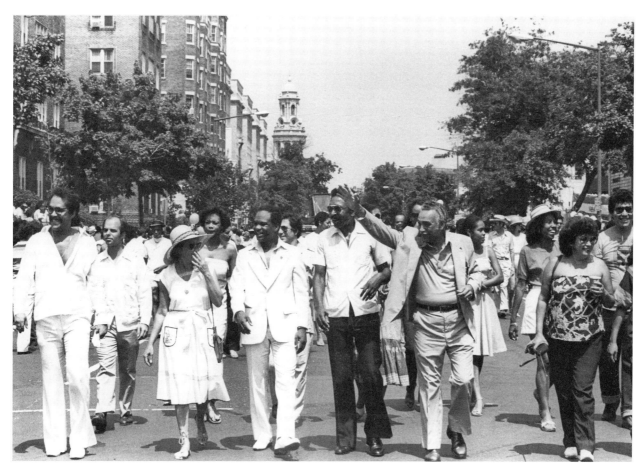

Carlos Rosario, center with arm raised, leads a Latino Festival parade in 1983. Rosario had spearheaded the Latino community's drive for public recognition, beginning in the 1960s. On the far left is Willie Vasquez, director of the Office of Latino Affairs, a government entity that Rosario's efforts helped to create. © 1983 Shia Photo

tinos in the 1960s. Carlos Rosario, who became a key figure in the organization of a self-conscious community, established the first Latino theater program in 1962 at the Colony Theater on Georgia Avenue in adjacent Columbia Heights. There, weekly films in Spanish and announcements about local events, available jobs and housing, and places to go for assistance drew crowds. "I always announced: any person who is looking for a job call me, and I would help them," Rosario reminisced in 1981. "And there were people who wanted to bring others into the country but they had to have an assured place here and I'd help them.... This is how the community began to grow, overnight it grew."[14]

Saturday night dances at St. Stephen and the Incarnation Episcopal Church on Newton Street in Columbia Heights provided the other major gathering place in the 1960s. These dances and the programs at the Colony Theater provided the basis for the later development of more formal social and political leadership.

By the late 1960s community leaders had begun to use bureaucratic mechanisms to obtain government funds for their people. While in the minority among Washington Latinos, people from Puerto Rico were often in the lead. They were already American citizens and did not have to worry about immigration officials, who raided local businesses and restaurants in search of undocumented workers. They had steady jobs, were

Crowds line up for information and services at a health fair sponsored by Clinica del Pueblo at the Wilson Center at 15th and Irving streets in the 1980s. Located in the education building of the Central Presbyterian Church adjacent to Adams Morgan, the center became a beacon for Spanish-speaking people in Adams Morgan, Columbia Heights, and Mount Pleasant. Photo by Rick Reinhard. Courtesy Rick Reinhard

familiar with the American system, and spoke English. The new political awareness of the community coincided with and was encouraged by many new government programs, such as the United Planning Organization, created by the U.S. Office of Economic Opportunity. Help also began to come from the city's Department of Human Resources.

The first funds for local social services came in 1966 through Barney Neighborhood House, a social service organization founded as a settlement house in Southwest, where it had been meeting the needs of the black community. It had been forced by Southwest urban renewal to relocate in 1960 to Mount Pleasant, just north of Adams Morgan. Then, in 1968, another social center for the Latino community emerged. In that year a Presbyterian minister from Colombia, Rev. Antonio Welty, established a Latino congregation, La Iglesia Presbyteriana Buen Pastor, in the education building of the Central Presbyterian Church at 15th and Irving streets. This formerly large Presbyterian congregation had counted President Woodrow Wilson among its members, but its numbers dwindled as the neighborhood changed. Welty was sensitive to the tensions between the different groups of Latinos that had settled in Adams Morgan and the surrounding neighborhoods, but he also recognized the potential for community collaboration. He

organized eight o'clock breakfasts at the church so that people could meet to discuss their problems and differences. Later, Welty founded a Latino social service agency at this site, calling it the Wilson Center. Just outside the Adams Morgan boundary, the center became a lighthouse for the entire Spanish-speaking community.

Carlos Rosario, often referred to as *El Viejo* (the Old Man) or the Godfather of the community, was instrumental in the formation of the D.C. Office of Latino Affairs, which was first established in 1969 as the Office of Spanish-Speaking Affairs. Born in Puerto Rico, Rosario served in the Army during World War II and came to the United States in 1950, going to work for the Department of Health, Education and Welfare in Montana. In 1957 he was transferred to Washington, where he became a leader in getting the local government to recognize the Latino community. In an interview in 1981 he recalled the way he and a group of other local residents began to "make noise" to let the city government know the needs and frustrations of the community. When Walter Washington was appointed mayor in 1967, Rosario wrote to him and received a telegram in reply: "Rosario, I want to meet with you." Rosario's group decided to ask for an office of Latino affairs. "Well, promises as usual," Rosario remembered. "The only thing that came out of that was that he named me to the board of the Office of Human Rights."[15]

The group continued to press the newly appointed D.C. Council. A meeting with Senators Robert F. Kennedy and Joseph Tydings and Governor Marvin Mandel of Maryland was pivotal. "Tremendous luck," Rosario recalled. "They asked us did we want them to write the mayor." The mayor responded again with a call and said he would talk with the council, telling Rosario, "If that is what you want, you get it."[16]

As the newly political and culturally self-aware community took shape, its presence became known to the city at large through the annual Latino Festival, which was first celebrated in 1970. It was inspired in part by the 1970 U.S. Census, which the community felt had greatly undercounted Latinos in the city; the festival would dramatize their numbers. Casilda Luna remembered that, to finance the first festival, she and several others organized a dance and charged one dollar for admission. The first event, including twenty-one makeshift booths and fifteen floats, drew ten thousand people. By the mid-1980s the event had become the biggest and oldest community festival in the city, drawing crowds numbering more than 150,000 every year — an institution whose growth paralleled that of the Latino community. The much-celebrated parade started on Mount Pleasant Street and moved down Columbia Road to Kalorama Park, uniting the neighborhoods of Mount Pleasant and Adams Morgan.[17]

In the 1990s the organizers moved the festival to the National Mall in an effort to raise it to national prominence, moving it also from July to September. Due to the tragedy of September 11, 2001, it was cancelled that year and never recovered. There were by then many other Latino festivals in the growing Latino communities in the suburbs. In 2004 District community organizers resurrected the festival, calling it Fiesta DC, holding it first on the grounds of Cardozo High School in Columbia Heights and then in

2006 moving it back to Mount Pleasant Street, where the first parades started. The La-tino Festival early on inspired another regular community gathering, the Adams Mor-gan Festival, which has attracted thousands to 18th Street in September since 1978.

In the mid-1970s new styles of leadership and cultural differences surfaced with each wave of immigrants from South America and Central America, many of whom left their countries for political reasons. According to Arturo Griffiths, a Panamanian who came to the area in the 1960s, many of the South Americans came from middle-class back-grounds, which contrasted with the majority of the earlier immigrants. "South Ameri-cans are different," he said. "They are not the poor, the worker, but they want to organize the poor."[18]

In 1975 several South Americans, with other community members, organized the first Latino community cultural center, El Centro del Arte. This group of young artists, activists, and intellectuals began to depict the struggles and experiences of the Latino community in large murals on building walls in the neighborhood. They saw the mu-rals as being by, for, and about the people. Lucho Salvatierra, a Chilean who lived in a group house in Adams Morgan at the time, remembered that the artists would gather in favorite spots like La Churrería and El Cafedón and discuss design ideas over a cup of coffee. Carlos Salazar, originally from Chile, designed one of the first murals, on Adams Mill Road just off Columbia Road. Neighborhood residents contributed to the project by bringing the artists sandwiches and lemonade. The mural includes a musical group and dancing couple drawn, according to Salazar, as almost one figure, "trying to show people are one . . . trying to show unity. It shows the cultural aspects of the Latino community — their music, their dances." The image of the dancing couple has become an iconic figure for the community in Washington and beyond, often used as a design element to promote Latino cultural events. The mural also reflects concerns about physi-cal changes in the area, depicting a group of developers "playing with housing, playing with money. They are speculating with neighborhoods," Salazar continued.[19]

Under the auspices of the local activist arts organization Sol & Soul and with the blessing of the original artists, local Salvadoran artists Juan Pineda and Horacio Quin-tanilla revitalized the mural in 2005, using a variety of graffiti and brush techniques. Recognizing the mural's significance in the history of the Latino community in the Dis-trict, Sol & Soul said in its organizing material that it was eager "to bring this important cultural marker back to life. We are working in the same spirit as when it was originally painted — as a powerful way of using art to share the stories of ordinary people and to keep the 'public' in 'public spaces.' "[20]

The growing interest in Adams Morgan real estate that Salazar saw in the 1970s in-tensified in the 1980s, so much so that a 1985 headline in the neighborhood newspaper, *The Intowner*, posed the question: "Adams-Morgan Diversity: Will It Fade Away?" The development pressures, however, were up against a large and growing number of Latino immigrants that still considered Adams Morgan and adjacent Mount Pleasant home. By the mid-1980s, the District had the second largest Salvadoran immigrant popula-

This 1970s mural on Adams Mill Road by Latin American artists with El Centro del Arte community cultural center celebrates the music, dance, and unity of the Latino community. It also depicts the threat the community has felt from changes brought by real estate development in the neighborhood. The mural was restored in 2007. Photo by Kathryn S. Smith

tion in the country, second only to Los Angeles. Strengthening the Latino image of the community were a growing number of nonprofit organizations addressing health, economic, social, and educational needs, many located in Adams Morgan and nearby. In 1977 they had formed the Council of Latino Agencies to coordinate efforts and make common cause. Krishna Roy, in a 2006 study on Latinos in Washington, observed that these agencies provided needed infrastructure in the inner city, through difficult periods when the city government was not able or willing to do so.[21]

Increasingly, however, many new immigrants no longer chose Adams Morgan as the first place "people put their bags down," according to the October 2006 issue of *Washingtonian*. The magazine article noted that many of the region's Latinos, with low wages, were "crowded into lower rent garden apartments inside the Beltway in places like

South Arlington, Arlandria, Langley Park, and Hyattsville." Recognizing the expanding needs in the suburbs, the Council of Latino Agencies began to extend its expertise and services beyond the District line, and changed its name to the Latino Federation of Greater Washington, with thirty-nine member agencies. As many Latino immigrants headed straight for the suburbs, others in Adams Morgan, Mount Pleasant, and Columbia Heights, forced out by development or condominium conversions, began to look for more affordable housing in neighborhoods farther up 16th Street such as Brightwood, or in the suburbs.[22]

However, a Latino imprint persists on the commercial strip along Columbia Road and 18th Street. Latino restaurants and stores continue, though many with new proprietors. Some businesses formerly owned by Dominicans or Cubans, for example, are now owned by Salvadorans and Vietnamese. Recently opened Mexican businesses are evidence of new immigrant populations in the area. National Latino franchises, attracted by the commercial success of these streets, are increasingly part of the commercial mix. While they often displace early mom-and-pop stores, they contribute to the international scene.

Though many have scattered, Latinos have left their mark in this place. They helped make Adams Morgan an activist community and stamped it as the city's most diverse and international. The Latino beat continues on Columbia Road, the heart of the community, where weekends find many Latinos, including past residents, strolling the street, shopping, enjoying a meal, and taking in the sights and sounds of the *barrio*.

Shepherd Park

CREATING AN INTEGRATED COMMUNITY

MARVIN CAPLAN AND RALPH BLESSING

The only Civil War battle fought in the District took place at Fort Stevens and on land just to the north that would later be known as Shepherd Park. In July 1864, when the area was a mix of woods and rolling farmland, Union soldiers repelled a Confederate attempt, led by Major General Jubal A. Early, to overtake the fort so that they could reach the heart of the capital of the Union.

Nearly a century later, Shepherd Park was again a battleground when residents in that upper Northwest community found themselves immersed in a struggle of their own as they resisted the race-exploiting tactics of local real estate speculators. Such was their success that in the late 1980s, the African American head of the citizens association said she moved in because she considered it "the only integrated middle-class neighborhood in Washington." According to the U.S. Census categories of 2000, Shepherd Park was 72 percent African American, with Hispanics and Asians as a new part of the mix, signaling the continuance of a stable, diverse, middle-income community.[1]

The neighborhood derived its pastoral name not from any agricultural enterprise but rather from onetime resident Alexander Robey "Boss" Shepherd, the most powerful member of the Board of Public Works (1871–73) and then governor (1873–74) of the Territory of the District of Columbia. He was one of the city's ablest politicians, initiating major physical improvements that included street paving and lighting, sewers and water mains, and extensive tree plantings that set the stage for the city's post–Civil War real estate boom. His overspending, however, along with white fear of growing African American political power, led the federal government to abolish

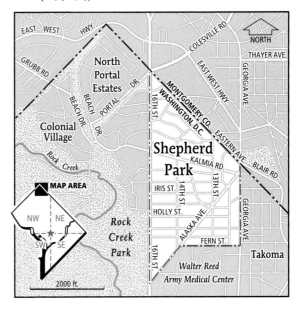

Shepherd Park, which takes its name from onetime resident Alexander Robey "Boss" Shepherd, has generally agreed-upon boundaries except for the line on the west. The Shepherd Park Citizens Association has always assumed representation of an area all the way west to Rock Creek Park, an area that has historical connections and is consistent with the Shepherd Elementary School boundaries and Census Tract 16. The distinct communities of Colonial Village and North Portal Estates west of 16th Street, however, think of themselves as separate places. Map by Larry A. Bowring.

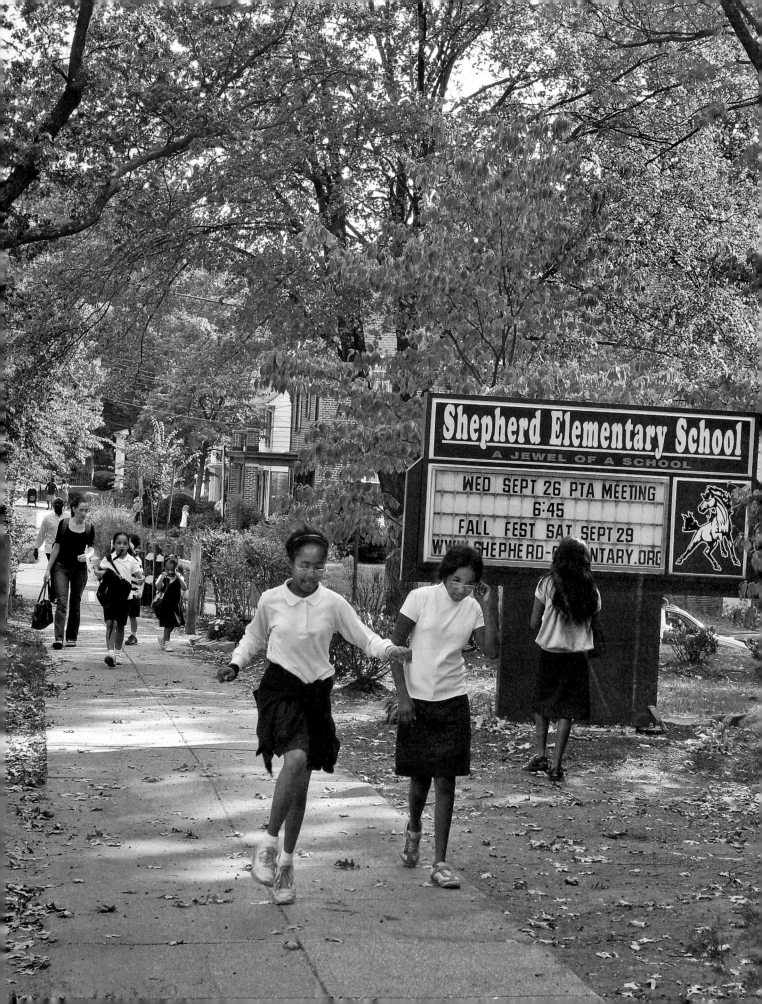

the short-lived territorial government and assume direct oversight of the District, the status the city endured until the Home Rule Charter one hundred years later. Before being named governor of the District, Shepherd bought a tract of land off the Seventh Street Turnpike (now Georgia Avenue) and built a large summer home that he and his wife called Bleak House, after the Dickens novel they were reading at the time. When Shepherd later left the District, he became a silver magnate in a small Mexican town where he resurrected his role as public works benefactor, implementing improvements unheard of elsewhere in that country outside of Mexico City.[2]

A stately three-story structure at 7714 13th Street, NW, is mistakenly identified by many Shepherd Park residents as "the Shepherd Mansion," when, in fact, Bleak House stood near 14th and Geranium streets until it was demolished in 1916. The 13th Street house is most likely Pomona, the pre–Civil War summer home of Darius Clagett, a prosperous dry goods merchant who operated "the largest and handsomest store on Pennsylvania Avenue," according to the leading newspaper of the day, the *National Intelligencer,* in 1837. More recently Pomona was the home of Esther Peterson, a prominent member of the administration of President Jimmy Carter.[3]

Until the first part of the twentieth century, when it was still considered part of Brightwood, the area was given over to large farms and the summer estates of wealthy Washingtonians who sought refuge in its wooded hilltops from the muggy downtown heat. Change came in 1909 when Congress appropriated $300,000 to enable the Army to purchase land and build the hospital at 16th Street and Alaska Avenue that eventually became the Walter Reed Army Medical Center, named for the noted sanitarian and bacteriologist who confirmed the theory that mosquitoes were the carriers of yellow fever. In its early years the hospital's capacity was less than one hundred patient beds, though World War I saw that number quickly jump to 2,500. During subsequent decades — and wars — hundreds of thousands of military personnel, as well as presidents, vice presidents, and members of Congress, have been treated there. In 1977 a new main hospital was constructed on the Georgia Avenue side of the campus, causing some damage to nearby homes and concerns about added traffic. Issues of that sort aside, Walter Reed has always been viewed as an integral part of the neighborhood; its outreach efforts, such as partnering with Shepherd Elementary School for science-related activities, have helped the facility forge strong ties over the years with the community at large. Until the events of September 11, 2001, brought an end to pedestrian access from Alaska Avenue, a gray stone memorial chapel on the grounds welcomed neighborhood residents to Catholic and nondenominational services each Sunday.[4]

About the same time Walter Reed Hospital was taking root, land developers discovered the open space north of the hospital. A large part of the Shepherd estate was sold to

Alexander Shepherd assumes a pose as powerful as his position in the territorial government of the 1870s, when he modernized the city in just three years. His country home near 15th and Geranium streets gave Shepherd Park its name. Courtesy The Historical Society of Washington, D.C.

(opposite)
Students make their way to Shepherd Elementary School on a fall morning. Photo by Rick Reinhard

The fanciful country home of Alexander Shepherd belies the name Bleak House, which Shepherd and his wife chose while they were enjoying the Dickens novel with that title. The Shepherd estate was broken up in 1911 and the home was demolished in 1916, paving the way for suburban development in the area. Courtesy The Historical Society of Washington, D.C.

an investment company in 1911. The contours of new streets appear on real estate maps for that year. As the alphabetized sequencing of city streets had already exhausted three-syllable names just south of Walter Reed, tree and flower names were assigned to the new streets in Shepherd Park, giving the community one of its unique characteristics.[5]

The razing of Bleak House in 1916 made way for the construction of new houses in styles that set the pattern for the neighborhood we see today — spacious Colonial and Tudor houses of red brick, stone, or stucco, interspersed with bungalows and large frame houses. At the outset there was little mass development. The three builders most active in the area, W. Latimer, Robert E. Heater, and L. E. Breuninger, built to order or sold building lots. Breuninger, working on the largest scale of the three, labeled his development — bounded by Kalmia, Holly, and 14th streets and Alaska Avenue — Shepherd Park, a name that eventually came to identify the entire community. The builders, all old-school white, Anglo-Saxon Protestants, adopted a real estate practice common during that era: racially restrictive covenants. Almost all of the deeds contained clauses designed to keep out "any negro or colored person or person of negro blood or extraction," as well as Jews and other Semitic peoples.[6]

While there is no way of knowing the attitudes of those early buyers toward the restrictive covenants, they were, nonetheless, energetic, civic minded, and influential. In 1917, when there were more jackrabbits than homeowners, they formed a citizens association. Priorities in those early years included the extension and paving of 16th Street

The original 1909 building
of Walter Reed General
Hospital, now Walter Reed
Army Medical Center, presides
over Easter egg roll festivities
in 1923. The federal facility
encouraged interaction
with the Shepherd Park
community and has always
been considered part of the
neighborhood. Courtesy
U.S. Army

from Alaska Avenue to the District line and persuading the city government to build an elementary school for neighborhood children, in the process attracting more families to Shepherd Park.

It is notable that the association was seeking the paving of 16th Street rather than a streetcar line, as was the case for the Brightwood Citizens Association's earlier efforts just to the south. The automobile was coming within reach of the pocketbooks of the middle class, and it would be the automobile, not just public transportation that would spur growth in Shepherd Park. In 1925 the streetcar went up 14th Street only as far as Kennedy Street in Brightwood Park, and while the Georgia Avenue streetcar went to the District line, it was not as convenient to the developments closer to 14th and 16th streets.[7]

In 1928, after more than a decade of lobbying on the part of residents, the school board responded to petitions from parents of 143 children and agreed to provide a school. But in 1928 that meant two wooden, one-room portables parked near Kalmia on the farmland that the citizens association had recommended as a building site and, for the first couple of years, a principal shared with nearby Takoma Elementary. It took another four years but finally the red-brick Alexander R. Shepherd Elementary School opened in January 1932. The descendants of Governor Shepherd — a daughter, a son,

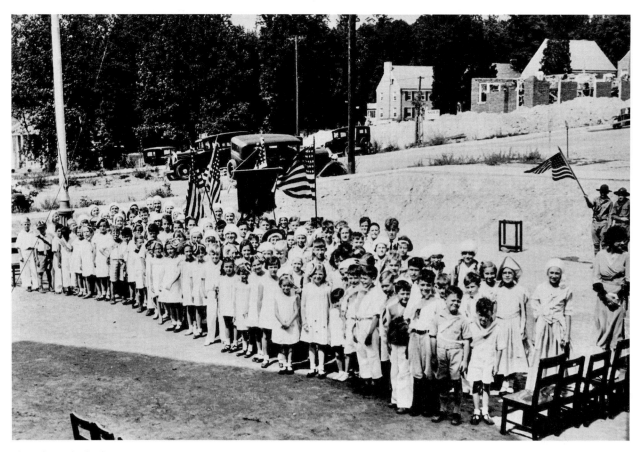

Alexander R. Shepherd Elementary School students celebrate Flag Day on June 15, 1932, just six months after their new school opened at 14th Street and Kalmia Road. The neighborhood was only about twenty years old; residential construction can be seen in the background. Courtesy Sumner School Museum and Archives

and a grandson — helped dedicate the facility and unveiled a photographic portrait of its namesake.[8]

Indicative of Shepherd Park's early character was its first house of worship, Northminster Presbyterian Church, long the neighborhood's largest church. The result of a 1906 merger of two century-old congregations, Assembly Presbyterian and North Presbyterian, Northminster followed its parishioners from downtown to the suburbs. In 1926 the church established a chapel at the corner of Kalmia and Alaska, just inside the District line, on land it had bought from one of the area's largest developers, L. E. Breuninger and Sons. When its downtown church burned down in 1935, the congregation decided to rebuild on the chapel grounds. The citizens association contributed to Northminster's building fund, and a door-to-door solicitation in the community produced sizable donations from residents, many of whom weren't even members, perhaps further evidence of the neighborhood's homogeneity.[9]

Marjorie Webster Junior College for women opened in the neighborhood in 1928, the same year as Shepherd Elementary. Named for its founder, the school moved to 17th Street and Kalmia Road after outgrowing the row house on Thomas Circle where it had operated since its founding in 1920. The college's new campus, a complex of Spanish Romanesque buildings that included a gym, swimming pool, and dormitory, spread

dramatically across ten acres of farmland on a high ridge just west of 16th Street. Essentially a family enterprise involving Marjorie Webster, her brother, sister-in-law, and two nephews, the school had begun with twenty-three students but expanded to more than five hundred by 1966. At that time and throughout its fifty-one-year history, the school's upper-middle-class students came mostly from out of town.[10]

In the late 1960s, however, Webster began experiencing declining enrollment and other problems and was forced to close in 1971. From 1983 to 1995 the complex was used as a satellite campus by Gallaudet University, Washington's internationally known school for the deaf. In 1999 the site became the home of the Lowell School, yet another educational institution that had outgrown its earlier sites. An elementary school with a purposefully diverse student body, Lowell became a vibrant member of the surrounding neighborhood, making its campus available for numerous community events, including the annual picnic sponsored by the citizens association.

The Marjorie Webster Register for 1929–30 gives the college's address as Rock Creek Park Estates, suggesting a confusion about Shepherd Park's boundaries that exists even today. During Shepherd Park's earliest phases, the Estates was one of the area's three major subdivisions. The other two were Shepherd Park (L. E. Breuninger's name for his development) and Sixteenth Street Heights. When they first organized in 1917, the residents called their organization the Sixteenth Street Heights Citizens Association. It did not become the Shepherd Park Citizens Association until sometime in the 1940s, when one of its members, retired Superintendent of Police Ernest W. Brown, noted how easy it was to confuse the neighborhood with Sixteenth Street Highlands, as an area immediately to the south was then known.[11]

There has always been agreement about Shepherd Park's boundaries to the north (Eastern Avenue), south (Aspen Street), and east (Georgia Avenue). How far west the neighborhood extends has been the point of debate. The citizens association has long assumed that it represented the blocks all the way to Rock Creek Park. That is consistent with the boundaries of Shepherd Elementary School as well as census tract 16, which comprises some eighty squares between Georgia Avenue and Rock Creek Park. The area west of 16th Street, however, includes two enclaves, Colonial Village and North Portal Estates, whose residents generally do not view themselves as part of Shepherd Park.

Colonial Village and North Portal Estates were both developed after much of Shepherd Park was already established. Begun in 1931, Colonial Village's theme, as the name suggests, was early America. The eighty houses designed for the development west of Beach Drive included reproductions of such famous Colonial-era structures as Washington's boyhood home, his headquarters at Valley Forge, and the Yorktown house in which Lord Cornwallis signed the articles of surrender to end the Revolutionary War. The houses were expensive and the village exclusive. As in the earlier developments east of 16th Street, the deeds included restrictive covenants, barring "negroes ... Armenians, Jews, Hebrews, Persians, and Syrians." The discriminatory measures were relatively short-lived, however, as a 1948 U.S. Supreme Court decision, *Hurd v. Hodge*, ruled ra-

cially restrictive covenants unenforceable. In the wake of that ruling, Jewish developers constructed the community that came to be known as North Portal Estates west of 16th Street and north of North Portal Drive. Its 220 houses were larger, showier, and more contemporary than the older homes in Shepherd Park, and they became a haven for wealthy Jewish families.[12]

Even before the overturning of racial restrictions, Jews began to move into Shepherd Park. While the wealthier German Jews of an earlier immigrant generation had largely settled west of Rock Creek Park in neighborhoods free of covenants, such as Forest Hills and other pockets of open housing in far Northwest, Jews of eastern European extraction followed a different pattern. Beginning early in the twentieth century, they moved, for the most part, due north from Southwest and downtown along the 7th and 14th street corridors. As their wealth and standing improved, Jewish families moved into Petworth and Brightwood, accompanied by their synagogues, and their kosher bakeries, delicatessens, and butcher shops. Shepherd Park, located just north of Brightwood and boasting a newer housing stock, became a logical next step in this northward migration, especially with the demise of housing covenants. By 1964 the Reverend Roland W. Anderson, pastor of Northminster Church, estimated that his parish — largely Shepherd Park — had become 80 percent Jewish.[13]

Georgia Avenue, the area's only commercial strip, began to reflect the community's new clientele. From 1947 to the late 1950s, four kosher meat markets, a Jewish bakery, and Posins', a Jewish delicatessen, opened on the corridor that borders Brightwood and Shepherd Park. Hofberg's, one of the District's major delicatessens, set up shop near the corner of Georgia and Eastern avenues. In 1957 a Conservative synagogue, Tifereth Israel, was dedicated on 16th Street, and an Orthodox synagogue, Ohev Shalom, moved in diagonally across the street. Soon Jews assumed positions of leadership in the citizens association and the Shepherd Elementary PTA.[14]

A few years later Shepherd Park underwent still another profound change: African American families began moving into the neighborhood. The housing market for Washington's middle-class black families in the two decades following World War II was even more limited than it was for Jews. Notwithstanding the Supreme Court's 1948 nullification of discriminatory covenants, the practice of denying housing to African Americans in many neighborhoods still prevailed. No fair-housing laws protected their rights. The burgeoning subdivisions in the suburbs — Levitt and Sons' huge Belair development in Bowie, Maryland, for instance — were explicitly shut to them. By tacit agreement most real estate agents sought to keep the neighborhoods west of Rock Creek Park exclusively for whites. Blacks seeking to buy homes were directed to areas east of the park. Such housing segregation was reinforced by the city's three newspapers, which permitted the use of racial designations in classified housing ads and thus facilitated the exclusion and "steering" of black homebuyers. Civic-group protests and, eventually, congressional pressure led by Senator Hubert Humphrey persuaded the papers to discontinue the practice in 1960.[15]

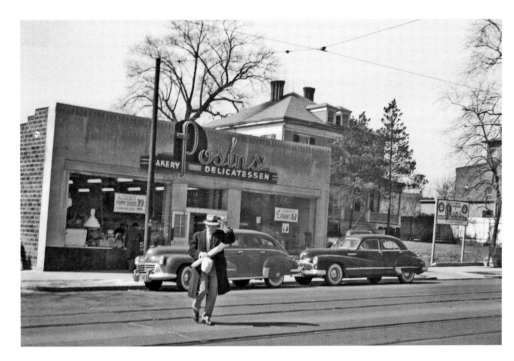

Clutching his purchases, a man holds his hat against the wind as he leaves Posins' delicatessen on Georgia Avenue just south of Shepherd Park in March 1948. Jewish-owned businesses such as Posins' followed the Jewish community up Georgia Avenue as it moved north from Southwest and downtown into the Petworth, Brightwood, and Shepherd Park neighborhoods. Photo by John P. Wymer. Courtesy The Historical Society of Washington, D.C.

Even after racial designations in housing ads ended, the speculators were still able to exploit the situation. Their general tactic, known as blockbusting, was to move a black family onto an all-white block and then harass the white homeowners into selling their homes, warning them that property values would fall now that African Americans were moving in. In the ensuing panic, that warning became a self-fulfilling prophecy. The sudden dumping of a large number of houses onto the market did depress prices — at least for the frightened whites who sold and fled to the suburbs. The speculators then resold the houses at inflated prices to blacks long hungry for decent places to live. Petworth, Brightwood, and Manor Park, neighborhoods of relatively modest homes south of Shepherd Park, underwent these agonizing upheavals. While whites fell prey to the fearmongering of the real estate agents, black families found themselves in hostile situations in unwelcoming neighborhoods that were in the midst of change.

In 1958 a group of black and white homeowners in Manor Park, a neighborhood a few miles southeast of Shepherd Park, decided to take a stand. Unable to persuade their community's established citizens association to amend its bylaws and accept black residents as members, they formed a new, racially integrated organization, North Washington Neighbors, Incorporated. With a $10,000 grant from the Eugene and Agnes E. Meyer Foundation, Neighbors, Inc., as it came to be known, undertook a two-front program: to fight the speculators and to bring white and black families together in a genuinely integrated community. In 1959, warned by real estate agents friendly to the organization's efforts that the blockbusters' next targets were Shepherd Park and Ta-koma, D.C., Neighbors, Inc., quickly extended its operations into those communities.[16]

Shepherd Park was generally cordial to the efforts of Neighbors, Inc. The blockbust-

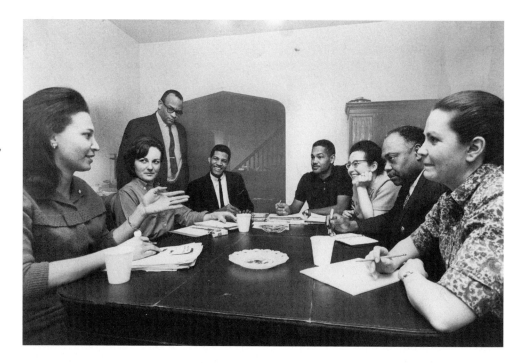

ers arrived, but a number of factors dampened the panic they sought to provoke. For one thing, the houses in Shepherd Park were considerably more expensive than those in the other neighborhoods. It was harder to scare their owners into selling, and it took longer to resell them. And Neighbors, Inc., already was there, holding block meetings in living rooms throughout the area, counseling homeowners that property values would not fall if they didn't sell, introducing them to one another and to the people moving into the area, and encouraging all to make common cause against the speculators. Other civil rights organizations followed suit. The Congress on Racial Equality, for example, chose to hold some of its organizational and planning meetings in a private Shepherd Park residence when it was sending out testers to uncover the discriminatory practices of downtown real estate agents.[17]

The success of Neighbors, Inc., captured the attention and the imagination of many home seekers in the area. Many of the old-time residents were also ready to accept black neighbors. And the Shepherd Park Citizens Association, which, unlike its fellow members in the citywide federation of citizens associations, had never specifically prohibited African Americans in its bylaws, was receptive to black members. Most new families also joined Neighbors, Inc., bringing with them fresh ideas for community projects. For example, Dr. Robert Good, Neighbors' second president and later the first U.S. ambassador to Zambia, organized a community reception in the spring of 1961 for diplomatic families of newly independent African nations, an event that received nationwide media attention.[18]

Attorney General Robert F. Kennedy was on hand to open the first Neighbors, Inc., Art and Book Festival at Shepherd Elementary School in June 1963. He declared, "What

is so impressive about what you have done here is that you have shown the way, that it can be done, that it is possible. . . ." Annual home and garden tours, monthly open houses, a garden club, and a children's singing group were among the other means used to attract newcomers and bring residents together.[19]

And yet, in spite of the idealistic white and black newcomers who helped build a genuine community spirit, the ongoing religious and ethnic changes made even the most committed wonder whether integration was an attainable goal. The Reverend Anderson of Northminster Church noted that by 1974 Jewish residents had joined their non-Jewish white brethren in moving to the suburbs, shrinking the Jewish population in Shepherd Park to 17 percent. Since their homes had been sold to Christians — albeit black Christians — the synagogues' loss resulted in a gain for the churches in the area, especially (at least in the short run) Northminster.[20]

The 1960 U.S. Census, taken at the beginning of the neighborhood's racial transition, counted 93 African Americans in a community of 5,458. By 1970 African Americans constituted 48.3 percent of a total population of 5,913, and by 1980, 66 percent of 5,101. When the 2000 census was taken, African Americans accounted for more than 72 percent of the total population of 4,030 in census tract 16, the area that covers Shepherd Park, Colonial Village, and North Portal Estates.

Like the Jewish families whom they had followed northward, the new black residents proceeded to involve themselves in civic matters and assumed leadership roles in the citizens association, Neighbors, Inc., and the Shepherd Elementary PTA. Wealthier Jews had already moved into Colonial Village, and African Americans of means followed them there. Many black community leaders and professionals were attracted to North Portal Estates, where by the early 1980s they constituted two-thirds of its homeowners. That number has continued to grow. The convention of calling an affluent black neighborhood, such as the upper 16th Street corridor, the "Gold Coast" was altered in some circles to convey North Portal Estates's cachet: it became known as the "Platinum Coast."[21]

The changing religious and racial composition of Shepherd Park strongly affected the fortunes of its churches and synagogues, often in ways the institutions found disappointing. Northminster Church, for example, had 1,200 members in 1962, many of them within walking distance. By 2006, as the church celebrated its hundredth anniversary, it had only about 250 members on its rolls, though former members in the suburbs often come back for special services and events. Shepherd Park Christian Church, a white congregation that moved uptown from Park Road in 1947 with about four hundred members, in 2007 had fewer than sixty active members but hosted many community activities.[22]

Other white Christian churches sold their properties to black congregations. St. Mary's Baptist Church, a congregation currently comprising mainly Silver Spring residents, owns the sanctuary that was home to St. James Lutheran Church from 1951 to 1972. First United Church of Jesus Christ Apostolic purchased the sanctuary of the

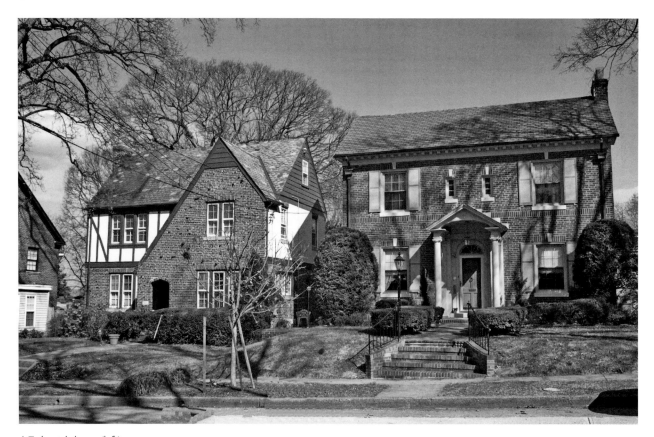

A Tudor-style house (left) keeps company with a home in the Colonial Revival style on the 1300 block of Jonquil Street. These types of architecture were popular in the 1920s and 1930s when most of Shepherd Park was built and are prevalent in the neighborhood. Photo by Kathryn S. Smith

Christian and Missionary Alliance, which decided to follow its members to the suburbs in 1975.

The Jewish congregations that had followed their people from the center city to Shepherd Park in the 1950s and 1960s were experiencing similar changes as their members left for the suburbs. One, Beth Shalom at 13th and Eastern Avenue, sold its place of worship to the Ethiopian Evangelical Christian Church and moved to Potomac, Maryland.

The aging and dwindling congregations of Ohev Shalom and Tifereth Israel, however, by the turn of the millennium were seeing an unexpected renaissance. Ohev Shalom, near extinction in the late 1990s, welcomed a dynamic young rabbi, Shmuel Herzfeld, in 2002. He brought new vitality to the congregation and promoted social activities that became an invigorating presence in the community, which has helped its membership dramatically rebound to nearly three hundred families in less than four years. Along with the relocation of the Jewish Primary Day School to 16th Street and Fort Stevens Drive, just south of Shepherd Park, the rebirth of Ohev Shalom helped fuel a renewed interest in the area on the part of Washington Jews.

The Conservative congregation of Tifereth Israel has sustained its high level of commitment to the neighborhood since the 1960s, when newly arrived Jewish families, attracted to Shepherd Park by Neighbors, Inc., helped vote down an attempted move to the suburbs by some older members who were alarmed by the neighborhood's changing

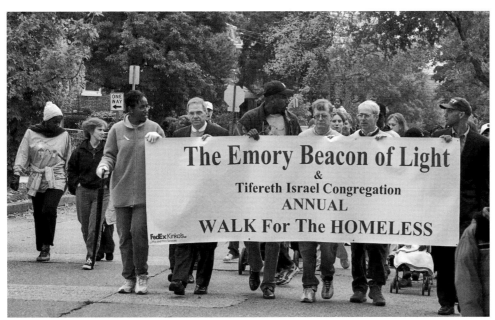

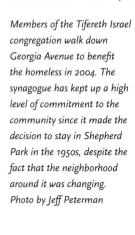

Members of the Tifereth Israel congregation walk down Georgia Avenue to benefit the homeless in 2004. The synagogue has kept up a high level of commitment to the community since it made the decision to stay in Shepherd Park in the 1950s, despite the fact that the neighborhood around it was changing. Photo by Jeff Peterman

demographics. Its educational and charitable initiatives are still thriving and, like Ohev Shalom, its membership is growing, although a shrinking number of members live in the immediate neighborhood. In a development notable for synagogues and Christian churches, black and white, fewer congregants are coming from their surrounding communities. Their members seem to be using various criteria, not only proximity, in choosing a place of worship. Some churches and synagogues continue to seek neighborhood members; others focus on a citywide constituency. Suburbanites commuting to services, in Shepherd Park and elsewhere in the city, have raised new issues of traffic and parking in the city's neighborhoods on days of worship.[23]

Other religious groups, drawn to the neighborhood as it began to integrate in the 1960s, continued to grow and thrive into the new millennium. In 1961 Our Lady of Lebanon Maronite Seminary, which trained priests for Maronite Catholics throughout the United States, bought an old house on Alaska Avenue opposite the Walter Reed campus, where its students — an average of nine to twelve at any time — could study without distraction. The seminary built a new wing in 2001 to accommodate the growing demand for new priests, and added a sanctuary for Our Lady of Lebanon Church in 2006. The Washington Ethical Society, which chose to build in Shepherd Park in the 1960s because it wanted an integrated neighborhood for its meeting place and its small high school, became, like the Maronite Church, a gathering spot for fellow believers from throughout the metropolitan area. The Ethical Society later came to share its facility with Fabrangen Havurah, an egalitarian and participatory Jewish congregation founded downtown in 1971.

In spite of changes, Shepherd Park maintained a tranquil environment during much of the 1960s. That pacific aura, however, was shattered in the early 1970s by two terrify-

ing events involving the Hanafi Muslims, a small sect that had moved into a large stone house on 16th Street in 1972. By an irony that subsequent events made even more pronounced, they shared the block with Ohev Shalom and opposite corners with Tifereth Israel. On January 18, 1973, assassins from a rival sect descended on the house and killed five children and two adults in what police said was the largest mass killing in Washington's history. The neighbors were shocked, but, put off by the barred windows and the guards who marched around the Hanafi compound all day armed with machetes, they made no attempt to convey their sympathy.[24]

Many regretted that lapse when four years later ten of the Hanafi Muslims forcibly occupied the national B'nai B'rith headquarters downtown, the Islamic Center on Massachusetts Avenue, and the D.C. Council chamber. Killing a young reporter and wounding others, including D.C. Council member Marion Barry, they held more than a hundred people hostage for thirty-eight hours in the B'nai B'rith building before surrendering. It troubled consciences in Shepherd Park when the Hanafi leader expressed his conviction that the community had never properly appreciated the tragedy that had befallen his people. And yet, a few years later when a deranged man broke into Ohev Shalom in the middle of the night and began vandalizing the sanctuary, it was the Hanafi Muslims who notified the police. And in 1982, when on Yom Kippur Eve a young woman going to services at Tifereth Israel was struck by a car and lay in the street waiting for an ambulance, the Hanafi Muslims brought a blanket to shield her from the rain.[25]

The major civic concern in the early part of the twenty-first century, as in past years, continued to be the development of the Georgia Avenue commercial corridor. Never known for elegant shopping, the avenue has always been lined with small family enterprises — places you could go for hardware, shoe repair, dry cleaning, appliances, liquor, or a quart of milk. Some services disappeared in recent years, and fast-food chains and carry-outs outnumbered the sit-down restaurants that some sought. While many residents felt that the changes they hoped for were slow to come, others were noting progress. In July 1990, for instance, Shepherd Park got its own library, named for its chief neighborhood advocate, Juanita Thornton. More recently, the Gateway Corporation, led by local resident Marc Loud and supported by the D.C. government's Main Street program, made significant storefront improvements along the avenue and lured new small businesses to vacant properties.

Strengthening community support for Shepherd Elementary School remained a top priority as well. While the area within its boundaries (Shepherd Park, Colonial Village, and North Portal Estates) continued to be quite diverse, the students at Shepherd Elementary were overwhelmingly African American by the year 2000. Despite the school's good reputation, many white and African American parents opted for alternative public and private choices. Meanwhile, led by an innovative principal, in 2006 Shepherd became one of only four schools in the public school system to be approved for the International Baccalaureate Programme, its rigorous curriculum expected to further strengthen Shepherd's solid academic credentials.

At the millennium, Shepherd Park residents were apprehensive about massive new construction to the north in Silver Spring that, while bringing desirable new amenities, could also bring unwanted new traffic and parking woes. To the south, the future of the Walter Reed campus was a bigger question mark. Stunned to learn in May 2005 that the Department of Defense had slated Walter Reed for closure about 2011, Shepherd Park residents joined the District government in lobbying the Defense Department to turn over some or all of the campus to the city, especially the portion facing Georgia Avenue, because of its residential and commercial development potential. The Department of Defense made a preliminary decision to divide the entire property between the Department of State and the General Services Administration. However, at this writing, there remains the possibility that the District may be offered use of some of the property fronting on Georgia Avenue.[26]

The real estate boom in the first years of the new millennium brought the neighborhood an influx of young professional families, many with young children. Among the newer residents were Latinos and Asian Americans, two groups not part of the earlier ethnic mix in the community. Many of them, like their predecessors, have become actively involved in community activities such as improving the physical structure and grounds of Shepherd Elementary School and the green space along Georgia Avenue.[27]

After a lull of some years, the citizens association resurrected some of the community activities once sponsored by Neighbors, Inc., in particular the garden tours. A New Year's potluck and a summer picnic, both held at the Lowell School, along with annual Halloween parades and yard sales foster a strong sense of community on both sides of 16th Street. It is clear that the diverse, yet cohesive, middle-class character sought by the founders of Neighbors, Inc., continues to be carefully tended.

Notes

In the notes below, the authors frequently refer to a variety of sources that are particularly useful in researching the history of urban neighborhoods. To encourage and facilitate further research, we list those sources here and where they can be found. The major repositories of materials useful for the study of the history of Washington, D.C., are the Kiplinger Library of the Historical Society of Washington, D.C. (HSW); the Washingtoniana Division of the D.C. Public Library (DCPL), located at the Martin Luther King Jr. Memorial Library; Special Collections at the Gelman Library, George Washington University (GWU); the National Archives (NA); and the Library of Congress (LC). Specialized collections can be found in the archives of various groups, such as the Jewish Historical Society of Greater Washington, neighborhood historical societies, and, if access can be gained, local businesses, religious institutions, and schools.

Real estate atlases. The plat maps in these atlases, published from the 1880s to the 1960s, identify each property in the city by square and lot number (useful for accessing tax assessments and building permits). They name all the streets and show all the buildings in the city, as well as the names of major businesses, institutions, and landowners. G. M. Hopkins of Philadelphia published atlases of Washington in 1887 and 1892–96. G. W. Baist, also of Philadelphia, began publishing in 1903, with new editions appearing irregularly into the 1960s. Available at DCPL, HSW, and LC. The years available at each site vary. The Library of Congress has posted high-resolution scans of the Baist atlases for 1903, 1907, 1909, 1913, and 1919 on its "map collections" website: http://memory.loc.gov/ammem/gmdhtml/gmdhome. html. Similar detailed and large-scale maps, for use by fire insurance companies, have been published by the Sanborn Company since 1888 in various formats up to the present. Available in the original at LC and other libraries; also on microfilm at LC, DCPL, and GWU.

City directories. These publications provide an alphabetical list of residents of the city, their addresses, and their occupations; they were produced at irregular intervals from 1822 to 1858 and then annually until 1973. The directories are particularly useful for neighborhood research beginning in 1914 when they start to list residents by street address as well as by name, allowing the researcher to construct an occupational profile of neighborhood street by street and year by year. Various publishers produced directories until 1858, when *Boyd's Washington Directory* became established. In 1906 R. L. Polk began to publish the directory, retaining the title until 1943, when it was changed to *Polk's Washington City Directory.* The *Haines Directory: Washington, D.C.,* started in 1974, lists residents by address but not by name. Available at MLK, HSW, and LC.

Building permits. Beginning in 1872 the city required a building permit to construct a building or an addition, or to demolish a structure. These documents provide the names of builders and architects, the size and purpose of the structure, the building materials, and sometimes architectural drawings. They are filed chronologically, and within dates by addresses, subdivisions, and square and lot number, available from the plat maps. Available on microfilm from 1877 to 1949 at NA and for 1877–1907 and 1915–1930 at DCPL. (Architectural drawings, when they exist, are filed separately in the Cartographic and Architectural Branch at Archives II in College Park, Maryland.) The Washington, D.C., Building Permits Database, compiled by Brian D. Kraft, includes information on permits from 1872 to 1949; the addition of permit records from later years is ongoing. The database can be accessed at DCPL and other local research centers.

Real estate assessments. These records list the owners and the value of all land and buildings in the District of Columbia. Because they indicate when improvements were made to lots, they are especially useful for researching property before building permits began to be issued in 1871. Information is listed by square and lot number, available on the real estate atlas plat maps. Assessments after 1887 are available on microfilm, and beginning in 1982 in book form, at DCPL and HSW. Earlier records,

including some for Georgetown dating back to 1800, must be accessed in Record Group 351 at NA.

U.S. Census. The manuscript schedules of the decennial federal census (the original documents created by the individual census takers) provide a wealth of information for neighborhood research. They are available on microfilm at NA. They are particularly useful beginning with the 1880 census when individuals were listed by address for the first time, enabling the researcher to construct demographic profiles of blocks or whole areas of the neighborhood, or to describe individual households. These documents provide increasingly more information in various categories with each census. In 1880, for example, the names of all members of the household and their relationships, occupations, race, sex, age, place of birth, marital status, whether literate, whether ill or disabled. The 1890 manuscript census was destroyed by fire. The 1900 census adds dates of immigration and naturalization, home ownership, and other information; 1910 adds workplace as well as occupation. The most recent manuscript census open for research is 1930. For statistics for the 1940–2000 censuses, consult the printed volumes published by the U.S. Census Bureau at LC. Data began to be kept by census tract in 1940. For statistics for D.C. census tracts in 1980, 1990 and 2000 visit www.neighborhoodinfodc.org/censustract/census.html.

Deeds. Deeds to land in the District of Columbia show who owned or leased the land and when it changed hands. A card file index at the D.C. Recorder of Deeds, arranged by square and lot number, provides this information for the years 1900 to 1923 and 1937 to the present. The same office also has general name indexes for deeds issued from 1792 to 1900. Copies of deeds and other land records are also available for various years at DCPL, NA, and the Daughters of the American Revolution Library.

Vertical files. The Kiplinger Library and the Washingtoniana Division both keep files of newspaper clippings, brochures, fliers, and other paper materials by topic, often a rich source for historians of the city.

CHAPTER 1. GEORGETOWN

1. The material on pre–Civil War Georgetown, summarized in this chapter, is taken from the following: Grace Dunlop Ecker, *Portrait of Old Georgetown* (Richmond, VA: Dietz Press, 1951); Richard P. Jackson, *The Chronicles of Georgetown, D.C., from 1751 to 1878* (Washington: R.O. Polkenhorn, 1878); U.S. Commission of Fine Arts and National Park Service, Department of the Interior, *Georgetown Historic Waterfront, Washington, D.C.: A Review of Canal and Riverside Architecture,* 2nd ed. (Washington: Government Printing Office, 1974); and Mathilde Williams, "Old Georgetown as Chronicled in the Peabody Collection," *Records of the Columbia Historical Society* 1960–62 (1963): 54–74. Unless otherwise cited, information is from these sources.

2. The best source of information on the eighteenth-century tobacco trade is Richard K. MacMaster, "Georgetown and the Tobacco Trade, 1751–1783," *Records of the Columbia Historical Society* 1966–68 (1969): 1–33.

3. Janice Artemel, Elizabeth Crowell, and Norman V. Mackie, "Georgetown Waterfront Park Archeological Overview and Assessment," prepared by Engineering-Science, Inc. Washington, D.C., for National Park Service, National Capital Region and Washington Harbour Associates, DC, *SHPO Archaeology Report 66*; Mary Mitchell, *Glimpses of Georgetown, Past and Present* (Washington: Road Street Press, 1983), 54.

4. MacMaster, "Georgetown and the Tobacco Trade," 27–33; Commission of Fine Arts, *Georgetown Historic Waterfront,* 17–19; Wilbur E. Garrett, "George Washington's Patowmack Canal," *National Geographic* 171, no. 6 (June 1987): 726.

5. Constance McLaughlin Green, *Washington: Village and Capital, 1800–1878* (Princeton: Princeton University Press, 1962), 21; Williams, "Old Georgetown," 66–67, 69–70; Jackson, *Chronicles of Georgetown,* 44–46, 64–65, 74–75.

6. Williams, "Old Georgetown," 69–70; Commission of Fine Arts, *Georgetown Historic Waterfront,* 15–19; Jackson, *Chronicles of Georgetown,* 39–40, 49–53, 127, 174–75; Harold W. Hurst, "Businesses and Businessmen in Pre-Civil War Georgetown," *Records of the Columbia Historical Society* 50 (1980): 161–62.

7. Hurst, "Businesses and Businessmen," 162.

8. Ibid., 163–64.

9. Green, *Washington,* 21; Mary Mitchell, *Chronicles of*

Georgetown Life, 1865–1900 (Cabin John, MD: Seven Locks Press, 1986), 91.

10. Pauline Gaskins Mitchell, "The History of Mt. Zion United Methodist Church and Mt. Zion Cemetery," *Records of the Columbia Historical Society* 51 (1984): 105; Mitchell, *Chronicles*, 8.

11. Mary Mitchell, *Divided Town: A Study of Georgetown during the Civil War* (Barre, MA: Barre Publishers, 1968), 15–19, 109.

12. Mitchell, *Chronicles*, 25; D.C. Code, vol. 1, "An Act Changing the Name of Georgetown," Feb. 11, 1895, 28 Stat, 650, ch.79.

13. Mary Mitchell, "After Hours in Georgetown in the 1890s," *Records of the Columbia Historical Society* 51 (1984): 83–92.

14. Kathryn Schneider Smith, *Port Town to Urban Neighborhood: The Georgetown Waterfront of Washington, D.C. 1880–1920* (Washington: George Washington University, 1989), 18–20; Walter S. Sanderlin, *The Great National Project: A History of the Chesapeake and Ohio Canal* (Baltimore: Johns Hopkins Press, 1946), 226–57.

15. Smith, *Port Town*, 1, 30–35, 39–46; Mitchell, *Chronicles*, 86.

16. Mitchell, *Glimpses*, 61: Mitchell, *Chronicles*, 48; Jackson, *Chronicles of Georgetown*, 230–44.

17. The description of the economic changes in Georgetown between 1889 and 1920 in this and subsequent paragraphs is taken from Smith, *Port Town*, 17–30.

18. The figures are taken from Dennis Earl Gale, "Restoration in Georgetown, Washington, D.C., 1915–1965," Ph.D. diss., George Washington University, 1982, 176. The analysis is that of the author of this chapter.

19. Tanya Edwards Beauchamp, *Georgetown Historic District* (Washington: D.C. Historic Preservation Office, 1998), 21. The description of the preservation movement in this and subsequent paragraphs is taken from Gale, "Restoration in Georgetown."

20. Mathilde D. Williams, "Georgetown: The Twentieth Century, a Continuing Battle," *Records of the Columbia Historical Society* 1971–72 (1973): 785–86.

21. Bobbie Leigus, "A Georgetown Childhood at Mid-Century," *Washington History* 8, no. 2 (Fall–Winter 1996–97): 24–27.

22. Pauline Gaskins Mitchell, "Growing Up to See the Transformation of the Village," *Washington Post*, July 13, 1987; Kathleen M. Lesko, Valerie Babb, and Carroll R. Gibbs, *Black Georgetown Remembered: A History of Its Black Community from the Founding of "The Town of George" in 1751 to the Present Day* (Washington: Georgetown University Press, 1991), 93–97.

23. Linda Newton Jones, "Georgetown Waterfront Zoning Voted," *Washington Post*, Nov. 21, 1974; "On with the Waterfront," *Washington Post*, Nov. 9, 1977; Patricia Camp, "Rezoning to Revitalize Georgetown Area," *Washington Post*, Nov. 15, 1977.

24. Zachary M. Schrag, *The Great Society Subway: A History of the Washington Metro* (Baltimore: Johns Hopkins University Press, 2006), 155–56.

25. U.S. Census tract 1.00 lies east of Wisconsin Avenue; tract 2.02 lies to the west of the avenue. See www.neighborhoodinfodc.org/censustract/census.html.

CHAPTER 2. CAPITOL HILL

1. Ruth Ann Overbeck, the author of this essay in the first edition of *Washington at Home*, passed away in 2000, and her text has been updated by Nancy Metzger. For her original text see *Washington at Home: An Illustrated History of Neighborhoods in the Nation's Capital*, ed. Kathryn Schneider Smith (Northridge, CA: Windsor Publications, 1988), 31–41. See also Lucinda P. Janke and Ruth Ann Overbeck, "William Prout: Capitol Hill's Community Builder," *Washington History* 12, no. 1 (Spring–Summer 2000): 122–39. There are research materials related to Overbeck's work in the Ruth Ann Overbeck papers, Gelman Library, GWU.

2. Elizabeth Hannold, "Barracks Row / Eighth Street Historic Context," 19, available at Barracks Row Main Street office and the D.C. Historic Preservation Office; Kimberly Prothro Williams, *Capitol Hill Historic District* (Washington: D.C. Historic Preservation Office, 2003), 1; Judah Delano, *Washington Directory* (Washington: William Duncan, 1822).

3. Margaret Brent Downing, "The Earliest Proprietors of Capitol Hill," *Records of the Columbia Historical Society* 21 (1918): 19.

4. U.S. Census, 1800; *National Intelligencer*, especially the classified section; Historic American Buildings

Survey, LC; Thomas B. Grooms, *The Majesty of Capitol Hill* (Gretna, LA: Pelican, 2005), 29.

5. Allen C. Clark, *Greenleaf and Law in the Federal City* (Washington: W. F. Roberts, 1901), 263–83; D.C. Recorder of Deeds, Washington, DC; *National Intelligencer*, variously.

6. Edward J. Marolda, *The Washington Navy Yard: An Illustrated History* (Washington: Naval Historical Center, 1999), 1–8. Andrew Ellicott labeled the river "Eastern Branch or the Anacostia River" on his 1794 topographical map at the suggestion of Thomas Jefferson. Eastern Branch alone persisted on maps until the Civil War, after which both names were commonly used again. A 1901 map prepared by the McMillan Commission was the first significant map to use only the name Anacostia River. The name Eastern Branch subsequently disappeared. See Iris Miller, *Washington in Maps: 1606–2000* (New York: Rizzoli, 2002).

7. Janke and Overbeck, *William Prout*, 122–39; Letitia W. Brown and Elsie M. Lewis, *Washington from Banneker to Douglass, 1791–1870* (Washington: National Portrait Gallery, Smithsonian Institution, 1971), 12–13. See also Letitia Woods Brown, *Free Negroes in the District of Columbia, 1790–1846* (Oxford: Oxford University Press, 1972).

8. Constance McLaughlin Green, *Washington: A History of the Capital 1800–1950*, vol. 1 (Princeton: Princeton University Press, 1976), 27; W. Ferguson, *Methodism in Washington, District of Columbia* (Baltimore: Methodist Episcopal Book Depository, 1892), 30–43; Kenton N. Harper, *History of Naval Lodge, No. 4, F.A.A.M., of Washington, D.C., May 1805 to May 1905* (Washington: Naval Lodge No. 4, 1955), 20–21.

9. Anthony S. Pitch, *The Burning of Washington: The British Invasion of 1814* (Annapolis: Naval Institute Press, 1998), 101–3, 134–35.

10. Ibid., 223–26; Annals of the 14th Congress; Charles J. Ingersoll, *History of the Second War between the United States of America and Great Britain*, vol. 2 (Philadelphia: Lippincott, Grambo & Co., 1852), 264; Clark, *Greenleaf and Law*, 291–95; W. B. Bryan, *A History of the National Capital* (New York: Macmillan, 1914), 637.

11. Rita Cooksey, "A History of St. Peter's Parish, Washington, D.C.," MA thesis, Catholic University, 1940, available at the church rectory; U.S. Census, 1820–50; tax assessment records, DCPL; Marolda, *Navy Yard*, 11–20.

12. U.S. Census, 1850 and 1860; city directories, 1858–1943; Silvio A. Bedini, "Edward Kubel (1820–1896), Washington, DC Instrument Maker," *Journal of the Washington Academy of Sciences* 85, no. 4 (Dec. 1998); files of the Architect of the U.S. Capitol; files of the Historian of the U.S. Marine Corps.

13. Richard M. Lee, *Mr. Lincoln's City: An Illustrated Guide to the Civil War Sites of Washington* (McLean, VA: EPM Publications, 1981); LeRoy O. King Jr., *100 Years of Capital Traction: The Story of Streetcars in the Nation's Capital* (College Park, MD: Taylor Publishing, 1972), 3.

14. Marolda, *Washington Navy Yard*, 15–34; Robert W. Daly, ed., *Aboard the USS* Monitor: *1862* (Annapolis: United States Naval Institute, 1964), 228.

15. Williams, *Capitol Hill Historic District*, 12–14.

16. Tanya Beauchamp, "Adoph Cluss: An Architect in Washington during Civil War and Reconstruction," *Records of the Columbia Historical Society* 1971–72 (1973): 338–58.

17. Susan H. Myers, "Capitol Hill, 1870–1900: The People and Their Homes," *Records of the Columbia Historical Society* 1973–74 (1976): 276–99; *Evening Star*, June 10, 1882; U.S. Census, 1880 and 1900.

18. Melissa McLoud, "Craftsmen and Entrepreneurs: Builders in Late Nineteenth-Century Washington, D.C.," PhD diss., George Washington University, 1988; Ruth Ann Overbeck and Melissa McLoud, *In a Workmanlike Manner: The Building of Residential Washington, 1790–1900* (Washington: Charles M. Sumner School Museum and Archives, 1987), 15–16; D.C. Building Permits Database, DCPL; James Borchert, *Alley Life in Washington: Family, Community, Religion, and Folklife in the City, 1850–1970* (Urbana: University of Illinois Press, 1980); Howard Gillette Jr., *Between Justice and Beauty: Race, Planning, and the Failure of Urban Policy in Washington, D.C.* (Baltimore: Johns Hopkins University Press, 1995), 112–13, 116–19, 139–42.

19. Nancy Pryor Metzger, *Brick Walks and Iron Fences* (Washington: Brickyard Press, 1976), 14, 39, 51, 56; D.C. Building Permits Database.

20. Antoinette J. Lee, "Public School Buildings of the

District of Columbia, 1804–1930" (1989), available at the D.C. Historic Preservation Office; Williams, *Capitol Hill Historic District*, 26.

21. James M. Goode, *Capital Losses: A Cultural History of Washington's Destroyed Buildings* (Washington: Smithsonian Institution Press, 1979), xix, 392.

22. Maurine Hoffman Beasley, *The First Women Washington Correspondents* (Washington: George Washington University, 1976), 12–14.

23. U.S. Census, 1900 and 1910; city directories, 1890–1942.

24. D.C. Building Permits Database; Judith M. Capen, "Building Styles in the Capitol Hill District," Capitol Hill Historic District Guidelines (Washington: Capitol Hill Restoration Society, 1991), 3.

25. Oral interviews touching on this and later periods, collected by the Ruth Ann Overbeck Capitol Hill History Project, can be accessed at www.capitolhillhistory.org.

26. Metzger, *Brick Walks*, 14, 39, 51, 56; Marolda, *Washington Navy Yard*, 79.

27. Williams, *Capitol Hill Historic District*, 27–28; Hannold, "Barracks Row," 76–79.

28. Records of the Capitol Hill Restoration Society, active in many of these civic affairs, are held in the Gelman Library, GWU; local activities are covered in two neighborhood newspapers, *The Hill Rag* and the *Voice of the Hill*.

29. Sam Smith, *Captive Capital: Colonial Life in Modern Washington* (Bloomington: Indiana University Press, 1974), 83.

30. 2004 Trustees Award for Organizational Excellence.

31. See http://neighborhoodinfodc.org.

CHAPTER 3. SEVENTH STREET / DOWNTOWN

1. Walter F. McArdle, "The Development of the Business Sector in Washington, D.C., 1800–1973," *Records of the Columbia Historical Society 1973–74* (1976): 565; LeRoy O. King Jr., *100 Years of Capital Traction: The Story of Streetcars in the Nation's Capital* (College Park, MD: Taylor Publishing, 1972), 19, says that the first paved street in Washington was Pennsylvania Avenue, but that street was paved at federal expense; James M. Goode, *Capital Losses: A Cultural History of Washington's Destroyed Buildings* (Washington: Smithsonian Institution Press, 1979), 175–76.

2. Alfred Hunter, *Washington and Georgetown Directory* (Washington: Kirkwood & McGill, 1853); tax assessment records, Washingtoniana Division, DCPL. Volunteers gathered much of the information on specific buildings during the Downtown Survey undertaken in 1979–81 by Don't Tear It Down (now the D.C. Preservation League), which resulted in the Downtown Residential Historic District nomination. In 1984 the city designated part of the area as the Downtown Historic District. Survey and nomination files are in the D.C. Historic Preservation Office.

3. Quote from Guy W. Moore, *The Case of Mrs. Surratt: Her Controversial Trial and Execution for Conspiracy in the Lincoln Assassination* (Norman: University of Oklahoma Press, 1954), 38; other information from Moore and from John Bishop, *The Day Lincoln Was Shot* (New York: Harper and Bros., 1955), 75.

4. Mona E. Dingle, "*Gemeinschaft und Gemutlichkeit*: German American Community and Culture, 1850–1920," in *Urban Odyssey: A Multicultural History of Washington, D.C.*, ed. Francine Curro Cary (Washington: Smithsonian Institution Press, 1996), 117–18.

5. City directories, 1868, 1881, 1907; D.C. Building Permits Database, DCPL; Frank H. Pierce III, *The Washington* Saengerbund: *A History of German Song and German Culture in the Nation's Capital* (privately printed, 1981), 2.

6. City directories, 1885, 1911, 1913; D.C. Building Permits Database.

7. Susan D. Bradford, "The Jews in Immigrant Washington, 1876–1906" (report submitted to the Jewish Historical Society of Greater Washington / Lillian and Albert Small Jewish Museum of Washington, Sept. 17, 1979), 3; Robert Shosteck, "The Jewish Community of Washington, DC, during the Civil War," in *The Jews of Washington, DC: A Communal History Anthology,* ed. David Altshuler (privately printed, 1985), 167.

8. Albert Small, interviewed by Stella Bernstein, Aug. 13, 1981, Oral History Project, Jewish Historical Society of Greater Washington (JHSGW).

9. Samuel Dodek, interviewed by Phyllis Dreyfuss, Aug. 4, 1981, Oral History Project, JHSGW.

10. Hasia R. Diner and Stephen J. Diner, "Washington's

Jewish Community: Separate but Not Apart," in Cary, *Urban Odyssey*, 138.

11. Gibbs Myers, "Pioneers in the Federal Area," *Records of the Columbia Historical Society* 44–45 (1944): 129; Constance McLaughlin Green, *Washington: A History of the Capital, 1800–1950* (Princeton: Princeton University Press, 1976), 1:183; Bradford, "The Jews in Immigrant Washington," 3, 9; Fourteenth Census of the United States, *Compendium: District of Columbia* (Washington: Government Printing Office, 1924); Howard Gillette Jr. and Alan M. Kraut, "The Evolution of Washington's Italian-American Community," in Cary, *Urban Odyssey*, 157–59, 166; Christine M. Warnke, "Greek Immigrants in Washington, 1890–1945," in *Urban Odyssey*, 175, 177, 181.

12. Don't Tear It Down, "Downtown Commercial Historic District," application to Joint Committee on Landmarks of the National Capital, Apr. 28, 1981, available at the D.C. Historic Preservation Office.

13. Esther Ngan-ling Chow, "From Pennsylvania Avenue to H Street, NW: The Transformation of Washington's Chinatown," in Cary, *Urban Odyssey*, 191–93.

14. "Building Program Drives Chinese to Seek New Center," *Washington Post*, Aug. 16, 1931; "Ousted by U.S. Project on Avenue," *Washington Times*, Oct. 8, 1931; "Chinese Invasion of H Street Irks Property Owners," *Washington Post*, Oct. 10, 1931; Chow, "From Pennsylvania Avenue to H Street," 194–95.

15. Chow, "From Pennsylvania Avenue to H Street," 195; Christopher L. Yip, "Association, Residence, and Shop: An Appropriation of Commercial Blocks in North American Chinatowns," in *Gender, Class, and Shelter: Perspectives on Vernacular Architecture*, ed. Elizabeth Collins Cromley and Carter L. Hudgins (Knoxville: University of Tennessee Press, 1995), 5: 109, 115; AEPA Architects Engineers, "Chinatown Design Guidelines Study" for D.C. Office of Planning (1988), 34–42.

16. Linda Wheeler, "New Year's in Chinatown," *Washington Post*, Feb. 8, 1993.

17. U.S. Census, 1920; see also Jenell Williams Paris, "*Fides* Means Faith: A Catholic Neighborhood House in Lower Northwest Washington, D.C.," *Washington History* 11, no. 2 (Fall–Winter

1999–2000): 25–45; Marya Annette McQuirter, "Claiming the City: African Americans, Urbanization, and Leisure in Washington, D.C., 1902–1957," PhD diss., University of Michigan, 2000, 255, 267, 272.

18. Constance McLaughlin Green, *The Secret City: A History of Race Relations in the Nation's Capital* (Princeton: Princeton University Press, 1970), 297–98; McQuirter, "Claiming the City," 281; *District of Columbia v. John R. Thompson Co., Inc.*, 346 U.S. 100 (1953).

19. Richard Longstreth, "The Unusual Transformation of Downtown Washington in the Early Twentieth Century," *Washington History* 13, no. 2 (Fall–Winter 2001–2): 51–68.

CHAPTER 4. FOGGY BOTTOM

1. This essay is an expanded version of the chapter by Suzanne Sherwood Unger, "Foggy Bottom: Blue Collar Neighborhood in a White Collar Town," in *Washington at Home: An Illustrated History of Neighborhoods in the Nation's Capital*, ed. Kathryn Schneider Smith (Northridge, CA: Windsor Publications, 1988), 55–63; see also Suzanne Berry Sherwood, *Foggy Bottom 1800–1875: A Study in the Uses of an Urban Neighborhood*, G.W. Washington Studies, no. 7 (Washington: George Washington University, 1978). Her work remains the definitive source on Foggy Bottom west of 23rd Street. Where not otherwise noted, this essay is based on this research.

2. Jessie Fant Evans, *Hamburgh: The Colonial Town that Became the Seat of George Washington University* (Washington: General Alumni Association of George Washington University, 1935).

3. Constance McLaughlin Green, *Washington: A History of the Capital, 1800–1950* (Princeton: Princeton University Press, 1962), 1:3.

4. Simon Newcomb, *Reminiscences* (Boston: Houghton, Mifflin, 1903), 334–35.

5. The George Washington University and Foggy Bottom Historical Encyclopedia, http://encyclopedia.gwu.edu.

6. Elmer Louis Kayser, "Move to Foggy Bottom and 2023 G Street," *George Washington University Alumni Review* 27, no. 2 (1962): 19–24.

7. Candace Shireman, "The Rise of Christian Heurich,"

Washington History 5, no. 1 (Spring–Summer 1993): 25–26.

8. Mary Brown, interviewed by Laetitia Combrinck, June 3, 1997, George Washington University Oral History Collection, Gelman Library, George Washington University (Gelman).

9. Evans, *Hamburgh*.

10. This and the Hanback quotes following are from interviews with Hazel Hanback by G. David Anderson in 1995 and 1996, Gelman.

11. G. David Anderson, ed., *Fantastic Foggy Bottom: A History of a Neighborhood* (Washington: George Washington University, 1996).

12. Kayser, "Move to Foggy Bottom," 19–24.

13. This and the following information about twentieth-century George Washington University is based on G. David Anderson, "Brief History of the George Washington University," George Washington University Planner and Student Handbook (Washington: George Washington University Student and Academic Support Services, 1997), 57–60. See also http://encyclopedia.gwu.edu.

14. EHT Traceries, *Foggy Bottom Historic District* (Washington: D.C. Office of Historic Preservation, 2003), 1.

CHAPTER 5. SOUTHWEST

1. Allen C. Clark, *Greenleaf and Law in the Federal City* (Washington: W. F. Roberts, 1901), 123–43; Christian Hines, *Early Recollections of Washington City*, rep. ed. (Washington: Columbia Historical Society, 1981), 7.

2. Mary Kay Ricks, *Escape on the Pearl: The Heroic Bid for Freedom on the Underground Railroad* (New York: William Morrow, 2007).

3. Paul A. Groves, "The Development of a Black Residential Community in Southwest Washington: 1860–1897," in *Records of the Columbia Historical Society* 1973–74 (1976): 260–75.

4. See James Borchert, *Alley Life in Washington: Family, Community, Religion, and Folklife in the City, 1850–1970* (Urbana: University of Illinois Press, 1980).

5. Groves, "Development of a Black Residential Community," 274.

6. Frederick Gutheim and Antoinette J. Lee, *Worthy of the Nation: Washington, DC, from L'Enfant to the National Capital Planning Commission*, 2nd ed.

(Baltimore: Johns Hopkins University Press, 2006), 94–96.

7. "Life in the Old Southwest," a taped panel discussion, Mar. 5, 1968, in Jewish Historical Society of Greater Washington, *Records* 3 (Nov. 1968): 7–8.

8. Harry S. Wender, "Recreational Facilities in Southwest Washington," unpublished manuscript, Oct. 1935, vertical files, Kiplinger Library, Historical Society of Washington, D.C.; panel discussion, "Life in the Old Southwest," 9.

9. For a detailed description of housing issues in Washington, see Howard Gillette Jr., *Between Justice and Beauty: Race, Planning, and the Failure of Urban Policy in Washington, D.C.* (Baltimore: Johns Hopkins University Press, 1995), and Steven J. Diner, Jerome S. Paige, Margaret M. Reuss, and Irving Richter, *Housing Washington's People: Public Policy in Retrospect* (Washington: D.C. History & Public Policy Project, University of the District of Columbia, 1983).

10. Chalmers M. Roberts, *The Washington Post: The First 100 Years* (Boston: Houghton Mifflin, 1977), 296–97.

11. George Beveridge, "Architects Call Southwest Plan 'Unimaginative,'" *Evening Star*, Nov. 21, 1952; James Guinan, letter to the editor, *Washington Post*, Nov. 13, 1953.

12. Wes Barthelmes, "First Walls in Squalid Dixon Court Pulled Down," *Washington Post*, Apr. 27, 1954; *Evening Star*, Nov. 21, 1954.

13. Redevelopment Land Agency, *Annual Report 1955*, 4–5.

14. Daniel Thursz, *Where Are They Now?* (Washington: Health and Welfare Council of the National Capital Area, 1966), 55–57, 62.

15. Jerry Blasenstein, "Building Bridges: A Chat with Phyllis Martin," *Southwester,* a publication of the Southwest Community Council, Inc., Feb. 1993.

16. Hugh Newell Jacobsen, ed., *A Guide to the Architecture of Washington, D.C.,* 1st ed. (New York: F. A. Praeger, 1965), 157: D.C. Modern, Symposium, sponsored by the D.C. Preservation League, Jan. 13–14, 2006.

17. Urban Land Institute, *Southwest Washington, D.C.: A Strategy for Revitalizing Waterside Mall and the Waterfront* (Washington: Urban Land Institute, 1998).

18. Dana Hedgpeth, "Southwest Waterfront Will Finally

Get Over the '60s," *Washington Post*, Oct. 9, 2006, D1.

19. Lynne Cheney, "Southwest," *Sunday Star Washington Magazine*, Apr. 29, 1973, 8–22.

CHAPTER 6. TENLEYTOWN

1. Unless otherwise noted, see Judith Beck Helm, *Tenleytown, D.C.: Country Village into City Neighborhood,* 2nd ed. (Washington: Tennally Press, 2000); the first edition of Helm's book, published in 1981, was also influential in the movement to reclaim the area's historical name.

2. Robert L. Humphrey and Mary Elizabeth Chambers, *Ancient Washington: American Indian Cultures of the Potomac Valley,* G.W. Washington Studies, no. 6 (Washington, DC: George Washington University, 1985), 7, 23, 37; "The Graffenried Manuscript C," *German American Annals,*" new series, vol. 12, Mar.–Oct. 1914, map facing page 188.

3. Correspondence of Governor Horatio Sharpe, vol. 1, 77, 79, Maryland State Archives, Annapolis, Maryland.

4. A list of the earliest land grants in Northwest D.C. as platted by Priscilla McNeil can be found on page 5 of Helm, *Tenleytown*, 2nd ed.

5. Oliver W. Holmes, "Stagecoach Days in the District of Columbia," *Records of the Columbia Historical Society* 1948–50 (1952): 13–14.

6. Doree Germaine Holman, *Old Bethesda* (Gaithersburg, MD: Franklin Press, 1956); Charles T. LeViness, *A History of Road Building in Maryland* (Baltimore: Maryland State Roads Commission, 1958).

7. Chester M. Smith Jr. and John L. Kay, *The Postal History of Maryland, The Delmarva Peninsula and the District of Columbia* (Burtonsville, MD: The Depot, 1984), 47.

8. J. Harry Shannon, "The Rambler," *Sunday Star*, Jan. 3, 1915; U.S. Geological Survey, Board on Geographic Names, *Quarterly Review List* 398, July 16, 2008, http://geonames.usgs.gov.

9. D.C. Code, vol. 1, "An Act Changing the Name of Georgetown," Feb. 11, 1895, 28 Stat. 650, ch.79.

10. "New Sears, Roebuck Store to be Opened Tomorrow Morning," *Evening Star*, Oct. 1, 1941.

11. Jeanne Beck Hanrahan and Ginny Callanen, *Janney Days: 1925–2000* (Washington: Janney

Elementary School Parent-Teacher Association, 2001), 75.

CHAPTER 7. BRIGHTWOOD

1. John Clagett Proctor, "City Growth as Reflected in Petworth Development," *Evening Star*, Apr. 16, 1944; Proctor, "Brightwood Has Grown Rapidly with Able Leaders," *Evening Star*, Jan. 31, 1937; Proctor, "Plank Road in Brightwood Was Historic, Much-Traveled," *Evening Star*, Apr. 21, 1929; Proctor, "Early Georgia Avenue," *Evening Star,* Apr. 7, 1946; George Kennedy, "Thriving Brightwood Section Can Recall Rich Historical Past," *Evening Star*, Sept. 4, 1950. The Maryland State Archives Land Records Patent Index, at www.msa.md.gov, confirms that James White's patent of 586 acres of Pleasant Hills occurred in 1772; the 1712 date in Kennedy is inaccurate.

2. Lee W. Formwalt, "Benjamin Henry Latrobe and the Development of Transportation in the District of Columbia, 1802–1817," *Records of the Columbia Historical Society* 50 (1980): 36–66; John Sessford, "The Sessford Annals," reprinted in *Records of the Columbia Historical Society* 11 (1908): 274, 279, 347.

3. Sessford, "The Sessford Annals," 356; Albert Boschke, *Topographical Map of the District of Columbia, Surveyed in the Years 1856–1859* (Washington: D. McClelland, Blanchard & Mohun, 1861).

4. John Clagett Proctor, "Brightwood Is Linked with Memories of Crystal Spring Track," *Evening Star*, Apr. 7, 1929.

5. General tax assessment, Washington County, 1854–55, NA.

6. William Van Zandt Cox, "Matthew Gault Emery, The Last Mayor of Washington, 1870–1871," *Records of the Columbia Historical Society* 20 (1917): 21; Henry B. C. MacFarland, *American Biographical Directories* (Washington: Potomac Press, 1908).

7. James M. Goode, *Capital Losses: A Cultural History of Washington's Destroyed Buildings* (Washington: Smithsonian Institution Press, 1979), 21–22.

8. Proctor, "Early Georgia Avenue"; Washington Post, *A History of the City of Washington, Its Men and Institutions*, ed. Allan B. Slauson (Washington: Washington Post, 1903), 436–37.

9. Proctor, "Brightwood . . . Crystal Spring Track";

Edith Ray Saul, "Notes on Saul Family Genealogy," typescript, November 1974, Kiplinger Library, Historical Society of Washington, D.C.

10. Rita L. Maroney, *Reference Report on Post Offices in Washington, D.C.* (Washington: U.S. Postal Service, 1982); Arthur Hecht, "Postal History of the District of Columbia," *Bulletin*, Washington Philatelic Society (January 1968); Proctor, "Plank Road."

11. William Van Zandt Cox, "The Defenses of Washington: General Early's Advance on the Capital and the Battle of Fort Stevens, July 11 and 12, 1864," *Records of the Columbia Historical Society* 4 (1901): 138.

12. Benjamin Franklin Cooling, *Jubal Early's Raid on Washington, 1864* (Tuscaloosa: University of Alabama Press, 1989), 129–55, and Cooling, *Symbol, Sword, and Shield: Defending Washington during the Civil War* (Hamden, CT: Archon Books, 1975), 190–210.

13. Philip Ogilvie, "Vinegar Hill Area 1715 to 1964," unpublished timeline, 2002, available at the Kiplinger Library, Historical Society of Washington, D.C.; *Evening Star*, Sept. 9, 1883; Sheldon M. Novick, *Honorable Justice: The Life of Oliver Wendell Holmes* (Boston: Little, Brown, 1989), 422.

14. J. G. Barnard, *Report of Bvt. Major General J. G. Barnard, Colonel of Engineers, United States Army, on the Defenses of Washington, D.C.* (Washington: GPO, 1871), 13, 77, Appendix A; Stanley W. McClure, *The Defenses of Washington 1861–1865* (Washington: U.S. Department of the Interior, National Park Service, 1957), 27–29; *Evening Star*, July 11–14, 1864, and Sept. 9, 1883.

15. John Clagett Proctor, "The Brightwood Public School," typescript, John Clagett Proctor Papers, Kiplinger Library, HSW; Proctor, "Plank Road"; Proctor, "Brightwood . . . Crystal Spring Track"; John Clagett Proctor, "Memories of Brightwood and Surrounding Country," in John Clagett Proctor, *Proctor's Washington and Environs, Sunday Star 1928–1949* (published by the author, Washington, 1949), 98.

16. Proctor, "Plank Road"; Proctor, "East Georgia Avenue."

17. U.S. Census, 1880; G. M. Hopkins, *A Complete Set of Surveys and Plats of Properties in the City of Washington, District of Columbia, Compiled and Drawn from Official Records and Actual Surveys* (Philadelphia: G. M. Hopkins, 1887), plate 43.

18. U.S. Census, 1880.

19. Proctor, "City Growth"; LeRoy O. King, *100 Years of Capital Traction: The Story of Streetcars in the Nation's Capital* (College Park, MD: Taylor Publishing, 1972), 17, 19.

20. "City and District: Citizens of Brightwood," *Evening Star*, Mar. 18, 1891; "Citizens of Brightwood," *Evening Star*, Apr. 11, 1891; "Brightwood Citizens," *Evening Star*, Oct. 10, 1891.

21. William Van Zandt Cox, "An Address of Welcome," 1899, vertical files, Washingtoniana Division, DCPL.

22. General tax assessments, Washington County, 1893–94, 1896–97, 1899–1900, DCPL and HSW.

23. City directories, 1889–1890, 1900.

24. *Baist's Real Estate Atlas of Surveys of Washington, District of Columbia: Complete in Four Volumes, Prepared from Official Records, Private Plans, and Actual Surveys* (Philadelphia: G. Wm. Baist's Sons, 1907), plate 19.

25. U.S. Census, 1910.

26. "In Memoriam — Louis Peirce Shoemaker," *Records of the Columbia Historical Society* 20 (1917): 296–98; *In Memoriam: Louis Shoemaker* (Washington: Brightwood Citizens' Association, 1917).

27. Obituary, "Harry Wardman, Hotel Builder, 65," *New York Times*, Mar. 19, 1938.

28. George Kennedy, "Thriving Brightwood Section Can Recall Rich Historical Past," *Evening Star*, Sept. 4, 1950; Sally Berk, interview with the author, August 1987; obituary, "Harry Wardman"; Sally Lichtenstein Berk, "The Richest Crop: The Row Houses of Harry Wardman (1872–1938), Washington, D.C. Developer," MA thesis, George Washington University, 1989.

29. *Baist's Real Estate Atlas*, 1945.

30. U.S. Census, 1930, 1950, 1970.

31. Paul Wice, "Safe Haven: A Memoir of Playground Basketball and Desegregation," *Washington History* 9, no. 2 (Fall–Winter 1997–98): 55–71; U.S. Census, 1970.

32. See www.neighborhoodinfodc.org/censustract/census.html. Current census tract 18.04 is bounded by Missouri Ave. and Aspen St. south to north and Georgia Ave. and 14th St. east to west and is not comparable to tracts cited earlier.

CHAPTER 8. PALISADES

1. Stephen R. Potter, National Archeologist, National Park Service, interview with author, June 28, 2007; Robert L. Humphrey and Mary Beth Chambers, *Ancient Washington Indian Culture of the Potomac Valley*, G.W. Washington Studies, no. 6, 2nd ed. (Washington: George Washington University, 1985), ii, 4, 11, 23, 37–39.

2. Donald Beekman Myer, *Bridges and the City of Washington* (Washington: U.S. Commission of Fine Arts, 1983), 3; Albert Boschke, *Topographical Map of the District of Columbia, Surveyed in the Years 1856, '57, '58 & '59* (Washington: D. McClelland, Blanchard & Mohun, 1861).

3. Mary E. Lazenby, "'Footing It' on the Maddox Branch," *District of Columbia American Motorist* (June 1930): 58.

4. Augusta Weaver, "White Haven," manuscript, Kiplinger Library, HSW, 2–3; Benjamin Franklin Cooling, "Defending Washington during the Civil War," *Records of the Columbia Historical Society* 1971–72 (1973): 320; National Park Service, "The Civil War Defenses of Washington, D.C.," www.nps.gov/cwdw; "Death of Last Male Descendants of One of the Colonial Patriots," *Evening Star*, July 24, 1886, 1; Judith Beck Helm, *Tenleytown, D.C.: Country Village into City Neighborhood*, 2nd ed. (Washington: Tennally Press, 2000), 38, 82–83, 131, 133, 144–45.

5. Helm, *Tenleytown*, 39, 49; Charles E. Davis Jr., "Forgotten Era Lives in Titles to Land Here," *Times Herald* (Washington), Dec. 3, 1952, 28.

6. "Chain Bridge School," nomination form, D.C. Inventory of Historic Sites (Feb. 2002), 27–28, available at the D.C. Historic Preservation Office.

7. Mary Mitchell, *Divided Town* (Barre, MA: Barre Publishers, 1968), 43.

8. Dr. Edward S. Smith, "When We Were Young," *Leaves of Wesley Heights* 29–11 (Nov. 1955): 9; "Refrigerated Trucks and Railway Cars," *World of Invention* (Thomson Gale, 2005–6) at www.bookrags.com/research/refrigerated-trucks-and-railway-car-woi/.

9. Harold Gray, "A Community History," *Golden Anniversary Celebration 1916–1966* (Washington: Palisades Citizens Association, 1966), 10; *Dickson's National Capital Directory for 1888* (Washington: William Dickson, 1888), lxxxvi–lxxxvii.

10. Madison Davis, "The Old Cannon Foundry above Georgetown, D.C. and Its First Owner, Henry Foxall," *Records of the Columbia Historical Society* 11 (1908): 50, 53, 57; Mitchell, *Divided Town*, 152.

11. Frances Trollope, *Domestic Manners of the Americans*, ed. Pamela Neville-Sington (London: Penguin Books, 1997), 183; Mike High, *The C&O Canal Companion* (Baltimore: Johns Hopkins University Press, 1997), 126.

12. *Keim's Illustrated Hand-Book Washington and Its Environs: A Descriptive and Historical Hand-Book to the Capital of the United States of America*, 4th ed. (published by the author, Washington, 1874), 217; Compiled under the general editorship of Freemont Rider by Frederic Taber Cooper, *Rider's Washington: A Guide Book for Travelers* (New York: The Macmillan Co., 1924), 484.

13. Axel Silversparre, *Guide to Washington, D.C. and Environs within a Radius of Twenty Miles from the Capitol* (Washington: R. E. Whitman, 1887), 31.

14. *Stranger's Guide for Washington City* (Washington: William H. Morrison, 1884) 51; Joseph Fletcher, interview with author and Michael Dolan, Apr. 12, 2005; Ray Fletcher, telephone interview with author, Apr. 28, 1997.

15. Federal Writers' Project, *Washington, City and Capital* (Washington: Government Printing Office [GPO], 1937), 804, 812, 816; Gail Redmann, Historical Society of Washington, D.C., interview with author, Apr. 1997; Elizabeth Green, *War Workers' Handbook*, Information Department, Committee on Women's Defense Work, U.S. Council of National Defense (Washington: GPO, 1918), 19–20.

16. John Clagett Proctor, "The Bicycle Craze Days," *Evening Star*, Mar. 27, 1938; records of the Capital Bicycle Club, Washingtoniana Division, DCPL; "The Capital and the Capital Club," *The Wheelman* 3–2 (1883): 90–91; Proctor, "Bicycle Days Produced Youthful Traffic Experts," *Evening Star*, Aug. 25, 1929; *Baist's Real Estate Atlas*, 1903.

17. Records of D.C. Surveyor's Office, bound volume of survey maps titled "Governor Shepherd," 37, 127; G. M. Hopkins, *A Complete Set of Surveys and Plats of Properties in the City of Washington, District of Columbia, Compiled and Drawn from Official Records and Actual Surveys* (Philadelphia: G. M. Hopkins, 1887). Harlem had subsequent name changes, which

most likely resulted from infusions of capital from additional investors. On plat maps in 1892, it appears as Jones Harlem, as W. A. Gordon's Harlem in 1893, and as Crowns in 1894.

18. Roderick S. French, "Chevy Chase in the Context of the National Suburban Movement," *Records of the Columbia Historical Society* 1973–74 (1976): 301n3, 311.

19. LeRoy O. King Jr., *100 Years of Capital Traction: The Story of Streetcars in the Nation's Capital* (College Park, MD: Taylor Publishing, 1972), 48–49.

20. James M. Goode, *Capital Losses: A Cultural History of Washington's Destroyed Buildings* (Washington: Smithsonian Institution Press, 1979), 278, 344–46, 452; Stilson Hutchins and Joseph West Moore, *The National Capital, Past and Present* (Washington: Post Publishing Co., 1885), 299–300.

21. "Palisades of the Potomac," promotional broadside, Palisades Public Library archives; Donald E. Gerrety, "Palisades: An Early Suburb of Washington," unpublished paper, University of Maryland, 1979, 1–20, Kiplinger Library, HSW; Judith H. Lanius, "Massachusetts Avenue Heights 1911–1941: Ideal and Reality," paper presented at a conference of the Latrobe Chapter of the Society of Architectural Historians, Dec. 3, 1994.

22. "Map of Potomac Heights Washington D.C." (Potomac Heights Land Company), Palisades file, Washingtoniana Division, DCPL.

23. G. M. Hopkins, *Atlas of Fifteen Miles around Washington Including the County of Prince Georges Maryland* (Philadelphia: G. M. Hopkins, 1878).

24. Gray, "A Community History," 16; "New Library for the Community," *Leaves of Wesley Heights* 39, no. 1 (Jan. 1965): 14; Traceries, "Chain Bridge Road School," 2; Mathilda D. Williams, "A Happy Restoration," *Leaves* 40, no. 8 (Aug. 1966): 25–27.

25. Luis Aguilar Jr., "Not Just a Business," *Washington Post*, Oct. 25, 1984; city directories, 1900–1954; Robert K. Headley, *Motion Picture Exhibition in Washington, D.C.* (Jefferson, NC: McFarland Co., 1999), 290.

26. Federal Writers' Project, *Washington*, 807; Harry C. Ways, "The Washington Aqueduct 1852–1992," unpublished manuscript, 1996, 101–5; John Clagett Proctor, "Old Conduit Road," *Star*, June 20, 1937; "City to Move Road Off Conduit,"

Evening Star, July 10, 1932; "Conduit Road Residents Seek Relief," *Evening Star*, Jan. 28, 1934.

27. Gray, "A Community History," 15; D.C. Surveyor's Office, *Subdivision Book 109*, 73.

28. Harold Gray, "A Brief History of the Potomac Palisades," 5, Palisades vertical files, Washingtoniana Division, DCPL.

29. Anita Holmes, "Modern Makes the Grade in Tour Conscious D.C.," *Washington Post*, Apr. 13, 1952; Robert J. Lewis, "Ten Homes Included in 'Modern House Tour' Set for April 20," *Evening Star*, Apr. 12, 1952; "1,000 Expected for Modern Homes Tour Tomorrow," *Evening Star*, Apr. 19, 1952; "Modern House Tour," Apr. 20, 1952, published by Sidwell Friends School; a detailed architectural survey of Chain Bridge Road, University Terrace, Arizona Avenue, Garfield Street, and Loughboro Road was conducted by Judith H. Lanius with the assistance of Marion K. Schlefer; "Statement of Judith H. Lanius before the Zoning Commission of the District of Columbia in Support of the Chain Bridge Road / University Terrace Area Tree and Slope Protection Overlay."

30. Betty Nowell, "Harriman Home Shows Owners' Original Ideas," undated newspaper article in Reservoir Road vertical file, Washingtoniana Division, DCPL; "An Old House Renews Its Youth," *The Washingtonian* 6, no. 5 (Aug. 1930): 14–18; "1800 Foxhall Road," vertical file, Washingtoniana Division, DCPL; Wolf Von Eckardt, "German Chancery Suits Style to Terrain," *Washington Post*, Apr. 19, 1964; *Baist's Real Estate Atlas of Surveys*, 1887 and 1931.

CHAPTER 9. BARRY FARM / HILLSDALE

1. Louise D. Hutchinson, *The Anacostia Story: 1608–1930* (Washington, DC: Smithsonian Institution Press, 1977), xix, 19, 27; Anatole Senkevitch Jr., ed., *Old Anacostia, Washington, D.C.: A Study of Community Preservation Resources* (Washington: University of Maryland School of Architecture and Metropolitan Washington Planning & Housing Association, 1975), 4.

2. Allen Chapel African Methodist Episcopal Church archives; Hutchinson, *Anacostia Story*, 47.

3. Donald Beekman Myer, *Bridges and the City of Washington* (Washington: U.S. Commission of

Fine Arts, 1974), 45; Senkevitch, *Old Anacostia*, 5–10.

4. Senkevitch, *Old Anacostia*, 9; Hutchinson, *Anacostia Story*, 53–54.

5. Senkevitch, *Old Anacostia*, 29–48.

6. "Saint Elizabeths Hospital," nomination form, National Register of Historic Places (rev. Aug. 1986), available at the D.C. Historic Preservation Office.

7. *Centennial Papers, St. Elizabeths Hospital 1855–1955* (Washington: Centennial Commission of St. Elizabeths Hospital, 1956), 8–10.

8. Wilhelmus Bogart Bryan, *A History of the National Capital, 1815–1878* (New York: Macmillan Co., 1916), 2:556–57.

9. John Henry Dale Jr., personal communication with author, 1967; Hutchinson, *Anacostia Story*, 81–83; Bryan, *A History of the National Capital*, 2:556–57.

10. Erma K. Simon, interview with author, 1986.

11. Rev. William J. Simmons, *Men of Mark* (Cleveland, OH: George M. Rewell & Co., 1887), 304–5; population figures from 1885 D.C. police census, in Philip Ogilvie, "Vinegar Hill Area 1715 to 1964," 29–30, a manuscript chronology available at the Kiplinger Library, HSW.

12. Joan Chase et al., *Congress Heights: Its Historic Context, 1608–1953*, prepared for the Congress Heights Community Association and Its Comprehensive Historic Preservation Survey, 1987–88; LeRoy O. King Jr., *100 Years of Capital Traction: The Story of Streetcars in the Nation's Capital* (College Park, MD: Taylor Publishing Co., 1972), 13, 14; Dianne Dale, *Mark the Place: Historic Hillsdale: Voices of an Invisible Community* (Bethesda, MD: Ibex Publishers, forthcoming).

13. Dale, *Mark the Place*.

14. "Nichols Avenue Elementary School / Old Birney School Site," African American Heritage Trail Database, www.culturaltourismdc.org.

15. Paul Dixon and Thomas B. Allen, *The Bonus Army: An American Epic* (New York: Walker & Co., 2004), 95–96, 115, 118–20, 137, 178–80.

16. Frederick Douglass Patterson, *Chronicles of Faith* (Tuscaloosa: University of Alabama Press, 1991), 79–80, 121, 175; Dale, *Mark the Place*.

17. Adrienne Jennings, member of Campbell Church who was present that day and became a plaintiff in *Bolling v. Sharpe*, conversation with author, 2007; "D.C. Group Opened Case in Fall of 47," *Washington Afro American*, May 18, 1954, 8; *Bolling v. Sharpe*, 347 U.S. 497 (1954).

18. James G. Banks and Peter S. Banks, *The Unintended Consequences: Family and Community, the Victims of Isolated Poverty* (New York: University Press of America, 2004), 25.

19. Banks, *Unintended Consequences*, 34–35, 61–62; Office of Assistant to the Mayor for Housing Programs, *Washington's Far Southeast 70* (Washington: District of Columbia Community Renewal Program, 1970), 23–28.

20. Thomas Cantwell, "Anacostia: Strength in Adversity," *Records of the Columbia Historical Society* 49 (1973–74): 348.

CHAPTER 10. DUPONT CIRCLE

1. James M. Goode, *The Outdoor Sculpture of Washington, D.C.* (Washington: Smithsonian Institution Press, 1974), 291.

2. William M. Maury, *Alexander "Boss" Shepherd and the Board of Public Works,* G.W. Washington Studies, no. 3 (Washington: George Washington University, 1975), 24; Tanya Edwards Beauchamp, *Dupont Circle Historic District* (repr. Washington: D.C. Historic Preservation Office, 2003), 4. Boundary Street was renamed Florida Avenue in January 1890 at the request of nearby residents who claimed that the name was causing property values to fall. See "Boundary Street No Longer," *Washington Post,* Jan. 15, 1890, 8.

3. Beauchamp, *Dupont Circle Historic District,* 3.

4. James M. Goode, *Capital Losses: A Cultural History of Washington's Destroyed Buildings* (Washington: Smithsonian Institution Press, 2003), 96–97, 138–39; Frank G. Carpenter, *Carp's Washington* (New York: McGraw-Hill, 1960), 72.

5. Goode, *Capital Losses,* 264–65.

6. Walter S. Albano, "History of the Dupont Circle Neighborhood, Washington, D.C., 1880–1900," MA thesis, University of Maryland, 1982.

7. Goode, *Outdoor Sculpture,* 291.

8. Harriet S. Blaine Beale, ed., *Letters of Mrs. James G. Blaine*, vol. 1 (New York: Duffield, 1908), 204–5.

9. Judith J. Lanius and Sharon C. Park, "Martha Wadsworth's Mansion," *Washington History* 7, no. 1 (Spring–Summer 1995).

10. "Dupont Circle Historic District," nomination form, National Register of Historic Places, 1976, available at the D.C. Historic Preservation Office.

11. Beauchamp, *Dupont Circle Historic District,* 12–13.

12. Albano, "History of the Dupont Circle Neighborhood," 46.

13. "Strivers' Section Historic District," nomination form, National Register of Historic Places, 1983, available at the D.C. Historic Preservation Office; William Henry Jones, *The Housing of Negroes in Washington* (Washington: Howard University Press, 1929), 107; Mara Cherkasky, "Slices of the Pie: Black and White Dupont Circle from the 1920s to the 1950s," MA thesis, George Washington University, 1985, ix, 7, 49, 126, 129; "Dupont Circle Historic District Expansion," nomination form, National Register of Historic Places, 2005, available at the D.C. Historic Preservation Office; real estate advertisement in the *Washington Bee,* July 15, 1911.

14. Dupont Circle National Register of Historic Places expansion application.

15. "Chauffeurs Used to Line Up," *Evening Star*, Sept. 24, 1969.

16. Dupont Circle NRHP expansion application, 8–9; information on the Edson Bradley home supplied by Caroline Mesrobian Hickman, Washington, D.C.

17. Benjamin Forgey, *Washington Post*, Nov. 15, 1987.

18. Goode, *Capital Losses,* 138–41.

19. Donnie Radcliffe, "Curtain Comes Down on the Dancing Class," *Evening Star*, Dec. 10, 1967.

20. Ibid.

21. American Appraisal Company, Appraisal Report for Thomas Leiter Residential Property, Nov. 30, 1943, on file at the Kiplinger Library, HSW.

22. William Clapton, "Bell Tolls for Dupont Circle Underpass," *Washington Post*, undated, vertical files, Kiplinger Library, HSW.

23. *Washington Post*, Aug. 16, 1966.

24. Ina Russell, ed., *Jeb and Dash; A Diary of Gay Life, 1918–1934* (Boston: Faber and Faber, 1993), 213; L. Page "Deacon" Maccubbin, interview with author, June 19, 2007; Michael Dolan, "A Short History of a Very Round Place," *Washington Post Magazine*, Sept. 2, 1990, 38.

25. Tanya Edwards Beauchamp, *Massachusetts Avenue Historic District* (Washington: D.C. Historic Preservation Office, 2000); Kimberly Prothro Williams, *Strivers' Section Historic District* (Washington: D.C. Historic Preservation Office, 1999).

CHAPTER 11. GREATER SHAW

1. See Marcia M. Greenlee, "Shaw: Heart of Black Washington," in *Washington at Home: An Illustrated History of Neighborhoods in the Nation's Capital*, ed. Kathryn Schneider Smith (Northridge, CA: Windsor Publications, 1988); Sandra Fitzpatrick and Maria R. Goodwin, *The Guide to Black Washington: Places and Events of Historical and Cultural Significance in the Nation's Capital*, rev. ed. (New York: Hippocrene Books, 1999); and Kimberly Prothro Williams / EHT Traceries, *Greater U Street Historic District* (Washington: D.C. Historic Preservation Office, 2003).

2. Greenlee, "Shaw," 119; S. Fitzpatrick and Goodwin, *Guide to Black Washington*, 126; *Midcity at the Crossroads: Shaw Heritage Trail* (Washington: Cultural Tourism DC, 2006).

3. Allison K. Hoagland, "7th Street Downtown," in Smith, *Washington at Home*, 47; James Borchert, *Alley Life in Washington: Family, Community, Religion, and Folklife in the City, 1850–1970* (Urbana: University of Illinois Press, 1980).

4. Williams, *Greater U Street*, 3.

5. Constance McLaughlin Green, *Washington: A History of the Capital, 1800–1950* (Princeton: Princeton University Press, 1976), 1:21; Keith Melder, *City of Magnificent Intentions: A History of Washington, District of Columbia*, 2nd ed. (Washington: Intac, 2001), 211–25; Greenlee, "Shaw," 120.

6. Greenlee, "Shaw," 121–22.

7. Sterling A. Brown, "The Negro in Washington," in Federal Writers' Project, *Washington, City and Capital* (Washington: Government Printing Office, 1937), 74; Green, *Washington*, 277.

8. Brown, "The Negro in Washington," 72; Letitia Woods Brown, *Free Negroes in the District of Columbia, 1790–1846* (New York: Oxford University Press, 1972).

9. Willard B. Gatewood, *Aristocrats of Color: The Black Elite, 1880–1920* (Bloomington: Indiana University Press, 1990), 39.

10. Fitzpatrick and Goodwin, *Guide to Black*

Washington, 120, 129–30; *Midcity at the Crossroads,* Sign 3.

11. Brown, "The Negro in Washington," 78.

12. EHT Traceries maps created for Williams, *Greater U Street.*

13. "Fifteenth Street Presbyterian Church," African American Heritage Trail Database, www.cultural tourismdc.org; Fitzpatrick and Goodwin, *Guide to Black Washington,* 156–57.

14. "St. Luke's Episcopal Church / Alexander Crummell," Trail Database; Fitzpatrick and Goodwin, *Guide to Black Washington,* 153.

15. Fitzpatrick and Goodwin, *Guide to Black Washington,* 131.

16. Ibid., 131, 133.

17. Michael Andrew Fitzpatrick, "A Great Agitation for Business: Black Economic Development in Shaw," *Washington History* 2, no. 2 (Fall–Winter 1991): 48–73; Fitzpatrick and Goodwin, *Guide to Black Washington,* 132; "Andrew Hilyer Residence," Trail Database.

18. Fitzpatrick, "A Great Agitation," 59.

19. Ibid., 64; Fitzpatrick and Goodwin, *Guide to Black Washington,* 168–69.

20. Fitzpatrick, "A Great Agitation," 64.

21. Fitzpatrick and Goodwin, *Guide to Black Washington,* 131–32

22. Ibid., 119; James A. Miller, "Literary Washington and the New Negro Renaissance," in *What's the Story?,* Conference Proceedings, Dec. 7–8, 2004 (Washington: Cultural Tourism DC, 2005), 17–20.

23. "Howard Theatre," Trail Database; Fitzpatrick, "A Great Agitation," 67.

24. "Lincoln Theatre and the Lincoln Colonnade," Trail Database; Fitzpatrick and Goodwin, *Guide to Black Washington,* 122–24; William Henry Jones, *Recreation and Amusement Among Negroes in Washington, D.C.: A Sociological Analysis of the Negro in an Urban Environment* (1927; repr., Westport, CT: Negro Universities Press, 1970), 168.

25. Fitzpatrick and Goodwin, *Guide to Black Washington,* 191–92.

26. "Restoring Honor to an Icon's Home," *Washington Post,* Jan. 28, 2006.

27. Ronald M. Johnson, "Those Who Stayed: Washington's Black Writers of the 1920s," *Records of the Columbia Historical Society* 50 (1980): 484–99.

28. Barbara Foley, "Jean Toomer's Washington and the Politics of Class: From 'Blue Veins' to Seventh-Street Rebels," *Modern Fiction Studies* 42, no. 2 (Summer 1996): 289–321.

29. Fitzpatrick, "A Great Agitation," 73.

30. Brown, "The Negro in Washington," 82; Borchert, *Alley Life in Washington,* xi.

31. Spencer R. Crew, "Melding the Old and the New: The Modern African American Community, 1930–1960," in *Urban Odyssey: A Multicultural History of Washington, D.C.,* ed. Francine Curro Cary (Washington: Smithsonian Press, 1996), 208–27; Brown, "The Negro in Washington," 89.

32. Melder, *City of Magnificent Intentions,* 447–51; Spencer Crew, "Melding the Old and the New," 221–23.

33. See www.neighborhoodinfodc.org/censustract/census.html for more information compiled by the Urban Institute and the Washington DC Local Initiatives Support Corporation.

CHAPTER 12. MOUNT PLEASANT

Mara Cherkasky thanks Gail Redmann McCormick and Ryan Shepard, formerly of the Kiplinger Library of the Historical Society of Washington, D.C., and Ellen Kardy, formerly with the Mount Pleasant Branch of the DC Public Library, for their assistance with her research for the Mount Pleasant Heritage Trail and the Images of America booklet, *Mount Pleasant.*

1. D.C. Building Permits Database, DCPL; Thomas Heiss deeds, D.C. Recorder of Deeds; Thomas Heiss papers, Tennessee State Library and Archives, Microfilm: Part 08, MF, 700–799; auction notice by J. C. McGuire, *Evening Star,* Dec. 5, 1854.

2. Glenwood Cemetery, Book C, 244; Virtual American Biographies, www.famousamericans.net/hiramwalbridge; "The Wedding," *Evening Star,* Sept. 2, 1857, 2; George B. Corkhill in "Celebrities at Home," *The Republic,* Jan. 28, 1882, Mount Pleasant files at Mount Pleasant Branch Library; "'Ingleside' Sold at Auction," *Washington Post,* Apr. 10, 1889, 6.

3. "Real Estate Transfers," *Washington Post,* June 11, 1896, 9; "Ingleside," nomination form, National Register of Historic Places (Sept. 1986), available at the D.C. Historic Preservation Office; "Stoddard Baptist Home Founded 84 Years Ago," *Washington*

Afro-American, Apr. 25, 1964; "Stoddard Baptist Home Honors Its Past Presidents," *Washington Afro-American*, Jan. 20–26, 2001; "New Site May Be Sought for Presbyterian Home," *Washington Star*, Feb. 12, 1958.

4. Auction notice by J. C. McGuire, auctioneer, *Evening Star*, Dec. 5, 1854, 3; information on French pieced together from *The Intelligencer*, U.S. Census, property deeds, conversations with Tripp Jones of the Church of the Epiphany, correspondence with West Point Archives, and "Reminiscences of Epiphany, A Discourse Preached by Request in the Church of the Epiphany, Washington, D.C., by Rev. C. H. Hall, D.D.," in Church of the Epiphany vertical file, Washingtoniana Division, DCPL.

5. *Washington Post*: Apr. 24, 1885; Jan. 12, 1890; May 17, 1891; June 1, 1892.

6. Resolution of appointment for William Selden in Charles Glover papers, MS 525, Kiplinger Library, Historical Society of Washington, D.C.; *Evening Star*: Feb. 28, 1861, 1, and Mar. 9, 1861, 2.; H. C. Harmon, B. P. Davis, J. B. Bloss, S. G. Arnold, W. C. Lipscomb, Jr., and A. L. Sturtevant, *Annals of Mount Pleasant* (Washington: O. H. Reed, 1876), 14.

7. "Samuel P. Brown Dead," *Washington Post*, Feb. 20, 1898, 7; "The Metropolitan City Railway," *Evening Star*, July 13, 1865, 2.

8. Harmon et al., *Annals of Mount Pleasant*, 14.

9. Constance McLaughlin Green, *Washington: A History of the Capital, 1800–1950* (Princeton: Princeton University Press, 1976), 1:339–62.

10. "Affairs of Mount Pleasant," *Evening Star*, Sept. 27, 1879; Harmon et al., *Annals of Mount Pleasant*, 29.

11. Edith Spears, "The Flowery 80s Were Gay in Mount Pleasant," *Washington Post*, Mar. 31, 1935.

12. Ibid.; *D.C. Commissioners' Report* (1885–86), 329; Anneli Moucka Levy, "Washington, D.C., and the Growth of Its Early Suburbs: 1860–1920," MA thesis, University of Maryland, 1980.

13. "New Line to Mount Pleasant," *Washington Post*, Jan. 13, 1903, 2.

14. D.C. Building Permit 699, Oct. 14, 1902, NA; "Bid in Their Homes," *Washington Post*, Oct. 11, 1902, 10; Michael R. Harrison, "The 'Evil of the Misfit Subdivisions': Creating the Permanent System of Highways of the District of Columbia," *Washington History* 14, no. 1 (Spring–Summer 2002): 43.

15. U.S. Census, 1900; D.C. building permits, NA; William B. Bushong, "Glenn Brown and the Planning of the Rock Creek Valley," *Washington History* 14, no. 1 (Spring–Summer 2002): 58.

16. Washington city directories; "1800 Block of Park Road," nomination for Historic Landmark Designation, available at the D.C. Historic Preservation Office; D.C. Building Permits Database.

17. Deeds dated Aug. 2, 1906, and Jan. 13, 1910, D.C. Archives; map of Block A, Ingleside, E. of 2613, Liber Count 7, folio 37, dated Feb. 18, 1911, D.C. Surveyor's Office; "Citizens Buy a Park," *Washington Post*, Nov. 5, 1909, 2; minutes, Mount Pleasant Citizens Association collection, D.C. Community Archives, Washingtoniana Division, D.C. Public Library (Community Archives).

18. Mount Pleasant Citizens Association minutes; "$200,000 Library Branch Is Opened at Mount Pleasant," *Washington Post*, May 17, 1925, 9; Washington Water Color Club flyer, 40, District of Columbia Public Library, Community Archives.

19. Clara Najarian Andonian, conversation with Mara Cherkasky, Aug. 31, 2006.

20. Mount Pleasant Citizens Association minutes and Executive Committee minutes, July 19, 1948, Mount Pleasant, Community Archives.

21. *Kimball et al. v. Curry et al.*, U.S. District Court for the District of Columbia, No. 2305-50 Civil Action, 1950; interviews by Mara Cherkasky with Louise Townsend Smith, Oct. 23, 2003; with Kai Butler, Mar. 13, 2004; with Richard Hardy, May 26, 2004; and with Eddie Hicks, Oct. 26, 2003.

22. U.S. Census, 1950, 1960, 1970.

23. Mount Pleasant Neighbors Association and Historic Mt. Pleasant collection, Community Archives.

24. Ibid., correspondence, July 17, 1961; letter to the editor, Vida Ord Alexander, "Mount Pleasant Residents Resent Slum Slur," *Evening Star*, Nov. 10, 1961; "Visitors Cut Short Citizens Meeting," *Evening Star*, Nov. 15, 1961, D21; "City May Close Facilities to Segregated Groups," *Washington Post*, Nov. 17, 1961; letter to the editor, Eugene M. Baker, "Prods City Heads," *Evening Star*, Feb. 27, 1962; Sam Eastman, "D.C. Buildings to Let Segregated Units Meet," *Evening Star*, Mar. 13, 1962, A1.

25. Flyers, Mt. Pleasant Neighbors Civic Association

and Historic Mount Pleasant Records, Community Archives; Jeff and Marshall Logan, interview with Mara Cherkasky, Nov. 6, 2004.

26. All Souls Unitarian Church's Web site, www.all .souls.org.

27. Elinor Hart, conversation with Mara Cherkasky, Sept. 2005; Galey Modan interview with Bob Aguirre, May 2005; Anne Chase, "Low-Income Tenants Buy Mt. Pleasant Building," *Washington Post,* Oct. 11, 1984; Christopher Dickey, "This Must be a Dream Come True; Kenesaw Tenants Purchase Apartment," *Washington Post,* June 9, 1978; Dickey, "90 Tenants Pay $25,000 on Building," *Washington Post,* Nov. 14, 1978; Dickey, "The Kenesaw Is Saved for Its Tenants," *Washington Post,* Dec. 16, 1978; Rental Housing Conversion and Sale Act of 1980, Section IV, "Tenant Opportunity to Purchase."

28. Blair Gately, "Stoddard Officials, Neighbors Oppose Landmark Designation," *Washington Post,* Apr. 26, 1979.

29. Dennis E. Gale, *Inner City Revitalization and Minority Suburbanization* (Philadelphia: Temple University Press, 1987).

30. Carmen Marrero, interview with Mara Cherkasky, Jan. 24, 2004.

31. "15 Years after Violent Clashes, Fragile Accord Being Redrawn," *Washington Post,* May 7, 2006, C6; *Washington Times,* Feb. 5, 1993, and Oct. 27, 1992; Claudia Lujan, conversation with Mara Cherkasky, July 2006.

CHAPTER 13. LEDROIT PARK

1. Prerna Rao, "LeDroit Park: A D.C. Oasis," *The GW Hatchet Online: An Independent Student Newspaper* (www.gwhatchet.com), Feb. 21, 2006.

2. "How LeDroit Park Came to Be Added to the City," newspaper clipping, May 31, 1903, Suburban Districts vertical file, Washingtoniana Division, DCPL; Rayford W. Logan, *Howard University: The First Hundred Years, 1867–1967* (New York: New York University Press, 1969), 60, 78, 81. Also see Ronald M. Johnson, "From Romantic Suburb to Racial Enclave: LeDroit Park, Washington, D.C., 1880–1920," *Phylon* 45, no. 4 (Dec. 1984): 264–70; Lilian Thomas Burwell, "Reflections on LeDroit Park: Hilda Wilkinson Brown and Her Neighborhood," *Washington History* 3, no. 2 (Fall–Winter 1991–92):

46–61; Tanya Edwards Beauchamp, *LeDroit Park Historic District* (Washington: Georgetown Heritage Trust and the D.C. Historic Preservation Office, 1996).

3. Beauchamp, *LeDroit Park Historic District.*

4. Ibid.

5. Charles A. Hamilton, "Washington's First Residential Suburb," *The Nation's Capital Magazine* 1 (Dec. 1930): 29; "How LeDroit Park Came to Be."

6. "How LeDroit Park Came to Be"; "Howardtown is Happy," *Washington Post,* Aug. 1, 1888; "The Fence will Go Up," *Washington Post,* Aug. 2, 1888; "He Would Fight First Rather Than See The Fence Come Down," *Washington Post,* Oct. 10, 1890.

7. Woody West and Earl Byrd, "Place of Dreams and Nightmares," *Washington Post,* Feb. 28, 1974. For more about the Williams house, see Sandra Fitzpatrick and Maria R. Goodwin, *The Guide to Black Washington* (New York: Hippocrene Books, 1990).

8. Mary Church Terrell, *A Colored Woman in a White World* (New York: Arno Press, 1980), 113–14.

9. For a discussion of the rapid concentration of black population and institutions in the Northwest quadrant of Washington, see Constance McLaughlin Green, *The Secret City: A History of Race Relations in the Nation's Capital* (Princeton: Princeton University Press, 1967), 201–14.

10. Virginia Cunningham, *Paul Laurence Dunbar and His Song* (New York: Dodd, Mead, 1947), 169.

11. "Unpublished Letters of Paul Laurence Dunbar to a Friend," *Crisis* 20 (June 1920): 73; Benjamin Brawley, *Paul Laurence Dunbar, Poet of His People* (Chapel Hill: University of North Carolina Press, 1936), 87.

12. Terrell, *A Colored Woman,* 111; Paul Laurence Dunbar, *Lyrics of the Hearthside* (New York: Dodd, Mead, 1899), 132–34.

13. Paul Laurence Dunbar, "Negro Society in Washington," *The Saturday Evening Post* 174 (Dec. 14, 1901): 9.

14. Hamilton, "Washington's First Residential Suburb," 29.

15. Langston Hughes, *The Big Sea: An Autobiography* (New York: Alfred A. Knopf, 1940), 206–7. Unhappy in Washington for most of his two years in the city, Hughes was especially displeased with the racial segregation of the city and the limitations this

practice imposed on blacks living in the nation's capital.

16. Burwell, "Reflections on LeDroit Park," 47–48.

17. George Kennedy, "LeDroit Park Abounds with Examples of Reconstruction Architecture," *Evening Star*, May 14, 1951; LaBarbara Bowman, "LeDroit Park's Two Faces," *Washington Post*, Feb. 4, 1971.

18. Cynthia Gorney, "Battle for LeDroit Park," *Washington Post*, Jan. 2, 1977.

19. Rudolph A. Pyatt Jr., "In LeDroit Park, Howard Is Teaching by Example," *Washington Post*, Dec. 28, 1998; Beauchamp, *LeDroit Park Historic District*.

20. Lauretta Jackson has long chronicled the history of LeDroit Park. See her "Oral History Presentation on LeDroit Park," presented at the Columbia Historical Society on Oct. 15, 1974, at Kiplinger Library, HSW.

CHAPTER 14. COLUMBIA HEIGHTS

1. Herbert Stockton, "Historical Sketch of George Washington University," *Records of the Columbia Historical Society* 19 (1916): 99–139.

2. *National Intelligencer*, Sept. 4, 1829; Beulah Melchor, "A History of the Title to the Campus of Howard University, 1651–1885," MA thesis, Howard University, 1943; the *Washington Herald*, Oct. 23, 1921, includes a section of a neighborhood history by Judge Charles S. Bundy; James M. Goode, *Capital Losses: A Cultural History of Washington's Destroyed Buildings* (Washington: Smithsonian Institution Press, 1979), 36.

3. Goode, *Capital Losses*, 37.

4. D.C. Land Records, Liber 957, Folio 465, D.C. Recorder of Deeds; Matthew B. Gilmore and Michael Harrington, "A Catalog of Suburban Subdivisions of the District of Columbia, 1854–1902," *Washington History* 14, no. 2 (Fall–Winter 2002): 27.

5. Theodore E. Burton, *John Sherman* (Boston: Houghton, Mifflin, 1906), 18.

6. Mary S. Logan, *Reminiscences of a Soldier's Wife* (New York: Charles Scribner's Sons, 1913), 424–30.

7. D.C. Land Records, Liber 1058, Folio 123, D.C. Recorder of Deeds.

8. Amzi Barber file, Moorland-Spingarn Research Center, Howard University Archives; Washington city directories, 1884–1909.

9. Ruth Ann Overbeck et al., "Upper Cardozo / Columbia Heights Comprehensive Survey," 1988–89, available at D.C. Historic Preservation Office.

10. Columbia Heights Citizens Association, "A Statement of Some of the Advantages of Beautiful Columbia Heights" (1904), 31, at Washingtoniana Division, DCPL.

11. Ibid., 3; *Washington Herald*, Oct. 23, 1921.

12. D.C. Land Records, Liber 1058, Folio 123, D.C. Recorder of Deeds.

13. LeRoy O. King Jr., *100 Years of Capital Traction: The Story of Streetcars in the Nation's Capital* (College Park, MD: Taylor Publishing, 1972), 82.

14. Overbeck, Upper Cardozo / Columbia Heights survey; *Evening Star*, Apr. 26, 1913, and June 4, 1913; James M. Goode, *Best Addresses: A Century of Washington's Distinguished Apartment Houses* (Washington: Smithsonian Institution Press, 1988), 284; *Evening Star*, Mar. 17, 1914; D.C. Building Permits Database. On front porch row houses, see Sally Lichtenstein Berk, "The Richest Crop: The Row Houses of Harry Wardman (1872–1938), Washington D.C. Developer," MA thesis, George Washington University, 1989.

15. King, *Capital Traction*, 75; Cleland C. McDevitt, *The Book of Washington* (Washington: Washington Board of Trade, 1927), 343.

16. "Tivoli Theater," nomination form, National Register of Historic Places, 1985, available at D.C. Historic Preservation Office.

17. Obituary, Alice Marriott, *Washington Post*, Apr. 19, 2000; see also www.marriott.com.

18. *Hundley et ux. v. Gorewitz et al.*, 77 U.S. APP. D.C. Reports 132 F.2d 23, 48.

19. A. H. Lawrence, *Duke Ellington and His World* (New York: Routledge, 2001); Mark Tucker, *Ellington: The Early Years* (Urbana: University of Illinois Press, 1991).

20. *Washington Star*, Dec. 1, 1974.

21. "Cardozo High School," nomination form, National Register of Historic Places, 1993, available at the D.C. Historic Preservation Office.

22. Courtland Milloy, "Washington: Ten Years After," *Washington Post*, Apr. 3, 1978; "River of Darkness," *Washington Post*, Nov. 23, 1980.

23. Lawrence C. Staples, *Washington Unitarianism* (Washington: Metcalf Printing & Publishing, 1970), 146–47.

24. "Cardozo Area Renewal Plan Moves Ahead," *Washington Post*, Sept. 9, 1969.

25. National Capital Planning Commission and the D.C. Redevelopment Land Agency, "Civil Disturbances in Washington, D.C., April 4–8, 1968, A Preliminary Damage Report," May 1968; Howard Gillette Jr., *Between Justice and Beauty: Race, Planning, and the Failure of Urban Policy in Washington, D.C.* (Baltimore: Johns Hopkins University Press, 1995), 169.

26. D.C. Land Records, Liber 13075, Folio 588, D.C. Recorder of Deeds; Goode, *Capital Losses*, 415; "Riggs-Tompkins Building," nomination form, National Register of Historic Places, 1986, available at the D.C. Historic Preservation Office.

27. See www.neighborhoodinfodc.org/censustract/census.html for extensive census information compiled by the Urban Institute and the Washington DC Local Initiatives Support Corporation.

CHAPTER 15. DEANWOOD

1. Ruth Ann Overbeck, the author of the essay on Deanwood in the 1988 edition of *Washington at Home*, passed away in 2000, and her text has been updated by Kia Chatmon. For the original text see *Washington at Home: An Illustrated History of Neighborhoods in the Nation's Capital*, ed. Kathryn Schneider Smith (Northridge, CA: Windsor Publishing, 1988), 149–57; additional research can be found in Ruth Ann Overbeck et al., "Deanwood Comprehensive Survey," conducted for the D.C. Historic Preservation Division, 1987–88; see also the Ruth Ann Overbeck papers in Special Collections, Gelman Library, GWU (Overbeck papers), for oral histories conducted with Deanwood residents.

2. D.C. Recorder of Deeds; U.S. Census. Other sources used extensively for this study by Ms. Overbeck include D.C. real estate plat maps, D.C. tax records, Washington city directories, and D.C. building permits, as well as extensive oral interviews, some of which are included in the Overbeck papers; see also Donald Beekman Myer, *Bridges and the City of Washington* (Washington: U.S. Commission of Fine Arts, 1974), 50.

3. Randolph W. Lowrie manuscript collection, privately held.

4. Ibid.; D.C. emancipation records at the National Archives corroborate Lowrie's reminiscences and describe Harriet Watkins as five feet, eight inches, tall and a fine cook.

5. D.C. Recorder of Deeds; Lowrie manuscript collection.

6. Afro-American Bicentennial Corp., *A Study of Historic Sites in the District of Columbia of Special Significance to Afro-Americans*, part 2 (Washington: Afro-American Bicentennial Corp., 1974), 109.

7. Plat maps, Records of the D.C. Surveyor's Office, D.C. Recorder of Deeds.

8. D.C. Recorder of Deeds; Washington city directories.

9. The Deanwood History Committee, *Washington, D.C.'s Deanwood* (Charleston: Arcadia Publishing Co., 2008), 63–80, 81–92; Deanwood History Project Committee, *Deanwood: A Model of Self-Sufficiency in Far Northeast Washington, D.C. (1880–1950)* (Washington: Deanwood History Project, 2005).

10. Lowrie manuscript collection.

11. Deanwood History Project, *A Model*, 2.

12. Antoinette J. Lee, "Public School Buildings of the District of Columbia, 1804–1930" (1989), available at the D.C. Historic Preservation Office.

13. Keith Melder, *City of Magnificent Intentions: A History of Washington, District of Columbia,* 2nd ed. (Washington: Intac, 1998), 323; Deanwood History Project, *A Model*, 8.

14. Richard Harrigan, *Pastimes in Washington: Leisure Activities in the Capital Area, 1800–1995* (Westminster, MD: Heritage Books, 2002), 80–81; Obituary of Maxwell Smart, *New York Amsterdam Star-News*, Feb. 22, 1941.

15. www.library.drexel.edu/archives/digital/early photosarchitecture.html; Harrison M. Etheridge, "The Black Architects of Washington, D.C., 1900–Present," D.A. thesis, Catholic University of America, 1979; Overbeck analysis of D.C. building permits as found in Overbeck et al., "Deanwood Comprehensive Survey."

16. Patsy Fletcher, "Architecture of Deanwood," Historical Resources Survey, available at D.C. Office of Historic Preservation.

17. Overbeck analysis of D.C. building permits; Dr. John Ross, "The Role of Black Craftsmen in Neighborhood

Development," unpublished manuscript, 1987, in the Overbeck papers.

18. Deanwood History Project, *A Model*, 5; D.C. Building Permits Database, DCPL; H. D. Woodson vertical file, Washingtoniana Division, DCPL; Dreck Spurlock Wilson, ed., *African-American Architects: A Biographical Dictionary, 1865–1945* (New York: Routledge, 2004), 459–61.

19. Plat filed in D.C. Surveyor's Office; undated advertisement in author's possession; Overbeck oral history interviews, Overbeck papers.

20. Smithsonian Anacostia Museum and Center for African American History and Culture, *The Black Washingtonians: The Anacostia Museum Illustrated Chronology* (Hoboken, NJ: Wiley & Sons, 2005), 124.

21. Marya Annette McQuirter, "Claiming the City: African Americans, Urbanization and Leisure in Washington, D.C., 1902–1954," PhD diss., University of Michigan, 2000, 135–36.

22. Elaine Bowman, interview with Kia Chatmon, Oct. 2006.

23. Ibid.

24. Deanwood History Project, *A Model*, 16; "Funeral Directors Conduct Last Rites for A. L. Rollins," *Washington Post*, Feb. 8, 1947.

25. Dennis Chestnut, interview with Kia Chatmon, Oct. 2006; Patricia Sullivan, "Getting Its Groove Back: A Park under Restoration Will Be Renamed Today for Marvin Gaye," *Washington Post*, Apr. 2, 2006; Deanwood History Committee, *Washington D.C.'s Deanwood*, 100–101.

26. Reginald Parker and Elaine Bowman, interviews with Kia Chatmon, Oct. 2006.

CHAPTER 16. KALORAMA
The author thanks Andrea Forbes Schoenfeld of EHT Traceries, Inc., for her research assistance.

1. Michael Harrison, "Above the Boundary: The Development of Kalorama and Washington Heights, 1872–1900," *Washington History* 14, no. 2 (Fall–Winter 2002): 57–58; Mary Mitchell identifies the site as "precisely between the houses now numbered 2300 and 2301," in "Kalorama: Country Estate to Washington Mayfair," *Records of the Columbia Historical Society* 1971–72 (1973): 166; G. M. Hopkins, *A Complete Set of Surveys and Plats of Properties in the City of Washington, District of Columbia, Compiled and Drawn from Official Records and Actual Surveys* (Philadelphia: G. M. Hopkins, 1887), plate 40.

2. Mitchell, "Kalorama: Country Estate," 164–67; James Goode, *Capital Losses: A Cultural History of Washington's Destroyed Buildings* (Washington: Smithsonian Institution, 1979), 29–31.

3. Junior League of Washington, *The City of Washington: An Illustrated History* (New York: Alfred A. Knopf, 1977), 102-03; Mitchell, "Kalorama: Country Estate," 167–74.

4. Mitchell, "Kalorama: Country Estate," 175; the forty acres sold to Freedman's Bank became the Belair Heights Subdivision.

5. "Suburban Residences," *National Republican*, June 17, 1882, 8.

6. Harrison, "Above the Boundary," 59; Thos. J. Fisher & Co. map of Kalorama Heights; 1887 Hopkins Atlas.

7. "Connecticut Avenue Extension," *Washington Post*, Jan. 12, 1889; "Argued for Straight Extension," *Washington Post*, Feb. 21, 1897.

8. Harrison, "Above the Boundary," 65–67.

9. Ibid., 62–63; "The Biggest Deal Yet," *Evening Star*, Feb. 11, 1890; Mitchell, "Kalorama: Country Estate," 177–79; A. Hodges, ed., *Washington on Foot: A City Planner's Guide to the Nation's Capital* (Washington: National Capital Area Chapter, American Institute of Planners, 1976), 118–31.

10. Hodges, *Washington on Foot*, 119; Mitchell, "Kalorama: Country Estate," 182.

11. Donald Beekman Myer, *Bridges and the City of Washington* (Washington: Commission of Fine Arts, 1974), 68.

12. "Kalorama Triangle Historic District," nomination form, National Register of Historic Places, 1986, available at the D.C. Historic Preservation Office; D.C. Preservation League / Traceries, "D.C. Apartment Buildings Survey, 1985–87," available at the D.C. Historic Preservation Office; LeRoy O. King Jr., *100 Years of Capital Traction: The Story of Streetcars in the Nation's Capital* (College Park, MD: Taylor Publishing, 1972), 28.

13. James M. Goode, *Best Addresses: A Century of Washington's Distinguished Apartment Houses* (Washington: Smithsonian Institution, 1988), 43–46.

14. "Apartment Buildings Survey"; "Sheridan-Kalorama

Neighborhood Study, 1987–88," available at the D.C. Historic Preservation Office.

15. Mitchell, "Kalorama: Country Estate," 188–89.

16. Miriam H. (Mrs. George Maurice) Morris, conversation with the author, ca. 1975; "Hundreds Meet Archduke Otto at Reception of George Morrises," *Washington Post*, Jan. 21, 1941.

17. EHT Traceries, Inc., *Sheridan-Kalorama Historic District* (Washington: D.C. Historic Preservation Office, 2000), 11.

18. Ed Hatcher, "Washington's Nineteenth Century Citizens Associations and the Senate Park Commission Plan," *Washington History* 14, no. 2 (Fall–Winter 2002).

CHAPTER 17. CHEVY CHASE

The author thanks the Chevy Chase Historical Society for the use of its archival collection and Eleanor Ford for her gracious editing assistance.

1. *Chevy Chase, Maryland: A Streetcar to Home* (videotape; Chevy Chase, MD: Chevy Chase Historical Society, 2006); Elizabeth Jo Lampl and Kimberly Williams, *Chevy Chase: A Home Suburb for the Nation's Capital* (Crownsville, MD: Montgomery County Historic Preservation Commission, Maryland-National Capital Park and Planning Commission, and Maryland Historical Trust Press, 1998), xiv; Roderick French, "Chevy Chase Village in the Context of the National Suburban Movement, 1870–1900," *Records of the Columbia Historical Society* 1973–74 (1976): 312–13; Albert W. Atwood, "The Romance of Senator Francis G. Newlands and Chevy Chase," *Records of the Columbia Historical Society* (1966–68): 301.

2. *Manufacturers' Record*, June 21, 1890, 41; French, "Chevy Chase Village," 318.

3. Ibid., 318–19.

4. James M. Goode, *Capital Losses: A Cultural History of Washington's Destroyed Buildings*, 2nd ed. (Washington: Smithsonian Institution Press, 1979), 96–97.

5. Edith Claude Jarvis, "Old Chevy Chase Village," *The Montgomery County Story* 12–1, quarterly publication of the Montgomery County Historical Society (Nov. 1969): 2; French, "Chevy Chase Village," 320.

6. Lampl and Williams, *Chevy Chase*, 24–25; French, "Chevy Chase Village," 320–21.

7. French, "Chevy Chase Village," 324. The date of the land grant varies according to the source consulted. Albert W. Atwood, in *Francis G. Newlands: Builder of the Nation* (Washington: Chevy Chase Land Company, 1969), gives 1720 as the date, and Jarvis, in "Old Chevy Chase Village," gives 1751.

8. Thos. J. Fisher & Co., brochure, "Chevy Chase for Homes," 1916, 9.

9. French, "Chevy Chase Village," 316–17.

10. Kenneth T. Jackson, *Crabgrass Frontier: The Suburbanization of the United States* (Oxford: Oxford University Press, 1985), 123; Atwood, *Builder of the Nation*, 31; Gavin Farr, interview with Judith H. Robinson, Aug. 25, 1987.

11. Atwood, "Romance of Senator Francis G. Newlands," 299. Atwood is quoting the memoirs of Edward L. Hillyer, former vice president and trust officer of the Union Trust Company and former president of the Land Company.

12. Jarvis, "Old Chevy Chase Village," 4.

13. Fisher & Co., map, "Chevy Chase, Section 2," 1899.

14. French, "Chevy Chase Village," 324; *Philadelphia Real Estate Record and Builders' Guide,* 1891 and 1892, 416–17.

15. Atwood, *Builder of the Nation*, 35.

16. Samuel J. Henry, *The Old Days of Horse and Hound: Being the Story of the Chevy Chase Hunt, 1892–1916* (published by author, Chevy Chase, MD, 1960), 7.

17. "Chevy Chase: Premier among Washington Suburbs," *Washington Times*, May 31, 1903.

18. Fisher & Co., "Chevy Chase for Homes," 25.

19. Lampl and Williams, *Chevy Chase*, 122–24.

20. Ibid., 125–26.

21. *F. H. M. Klingé Property Atlas of Montgomery County* (Lansdale, PA: Frank H. M. Klinge, 1931), vol. 1, plate 1, is one example of a map indicating Section 1, Chevy Chase Historical Society; Lampl and Williams, *Chevy Chase: A Home Suburb,* 112.

22. Atwood, *Builder of the Nation*, 38. Atwood references a letter of Feb. 6, 1897, from the secretary of the Chevy Chase Land Company to stockholders; French, "Chevy Chase Village," 323, 326.

23. Atwood, *Builder of the Nation*, 39; Fisher & Co., "Chevy Chase for Homes," 28.

24. Edward Hillyer, "Manuscript History of the Chevy Chase Land Company" (Chevy Chase, MD: Chevy

Chase Historical Society, ca. 1946), 61; Lampl and Williams, *Chevy Chase*, 128–29.

25. Lampl and Williams, *Chevy Chase*, 128–29.

26. Peggy Fleming and Joanne Zich, *Small Town in the Big City* (Washington: Three Sisters Press, 2005), 10.

27. Fisher & Co., "Chevy Chase for Homes," 11.

28. Lampl and Williams, *Chevy Chase*, 127.

29. Fleming and Zich, *Small Town*, 10–13.

30. Atwood, "Romance of Senator Francis G. Newlands," 304.

31. Susan Reimer, "The Money That Made Chevy Chase," *Real Estate Washington*; advertisement, *Washington Post Magazine*, June 19, 1983.

CHAPTER 18. CLEVELAND PARK

1. The land grant research that provided material for this paragraph was done by Priscilla McNeil, using land documents in the Hall of Records, Annapolis, Maryland, on file at the Kiplinger Library, HSW.

2. Frances Trollope, *Domestic Manners of the Americans* (1836; New York: Howard Wilford Bell, 1904), 198.

3. Grace Dunlop Peter and Joyce D. Southwick, *Cleveland Park: An Early Residential Neighborhood of the Nation's Capital* (Washington: Cleveland Park Library Committee, 1958), 35.

4. "Research Details National Importance of Tregaron Grounds," *Cleveland Park Voices* 13, no. 1 (Spring 1999), newsletter of the Cleveland Park Historical Society.

5. Kathleen Sinclair Wood, introduction, "Cleveland Park" (1904 real estate brochure reprinted in Washington by the Columbia Historical Society, 1982), 4, 8.

6. Wood, "Cleveland Park," 6, 10, 14.

7. Fulton R. Gordon, *Connecticut Avenue Highlands* (Washington: published by the author, 1903).

8. City directory, 1918.

9. Ibid., 1895–1925; T. W. Tirana, "Cleveland Park Contemporary," *Washington Star Sunday Magazine*, Jan. 20, 1983.

10. Rives Carroll, ed., *Cleveland Park Voices* (Washington: Cleveland Park Neighborhood History Project, 1984), 15.

11. Ibid., 21, 39.

12. Zachary M. Schrag, *The Great Society Subway* (Baltimore: Johns Hopkins University Press, 2006), 41–45, 125, 134–36; *D.C. Federation of Civic Associations v. Thomas F. Airis*, D.C. Court of Appeals, 391 F.2d 478, 1968; *D.C. Federation of Civic Associations v. John A. Volpe*, D.C. Court of Appeals, 434 F.2d 436, 1970.

13. Carroll, "Cleveland Park Voices," 11.

14. Donald Beekman Myer, *Bridges and the City of Washington* (Washington: U.S. Commission of Fine Arts, 1974), 68.

CHAPTER 19. CONGRESS HEIGHTS

Material in this chapter before 1950 is based on a historic resources survey, "Congress Heights Comprehensive Survey, 1987–88," by Joan Chase, Nate Howard, the National Preservation Institute, Ruth Ann Overbeck, and Maxine Smith for the Congress Heights Community Association, under a grant from the Historic Preservation Office of the D.C. Office of Planning, financed with federal funds from the U.S. Department of the Interior, National Park Service. Available at the D.C. Historic Preservation Office. The author is grateful for this research and also thanks Sharon Reinckens, Portia James, Anthony A. Gualtieri, all colleagues at the Anacostia Community Museum.

1. Plats filed at the Maryland Hall of Records, Annapolis, MD; Guy Castle, "Gisborough as a Land Grant, Manor and Residence of the Dents, Addisons, Shaaffs and Youngs," *Records of the Columbia Historical Society* 53–58 (1959): 282–85; James M. Goode, *Capital Losses: A Cultural History of Washington's Destroyed Buildings* (Washington: Smithsonian Institution Press, 1979), 4–6.

2. Guy Castle, "Blue Plains and Bellevue: Two Early Plantations of the Washington Area," *Records of the Columbia Historical Society* 1963–1965 (1966): 22.

3. Bettie Stirling Carothers, compiler, *1776 Census of Maryland* (Lutherville, MD: published by the author, 1970), in the Hall of Records, Annapolis, MD; D.C. Emancipation Records, NA; Louise Daniel Hutchinson, *The Anacostia Story: 1608–1930* (Washington: Smithsonian Institution Press, 1977), 70–73.

4. Henson Family Papers, Anacostia Community Museum Archives, Smithsonian Institution.

5. LeRoy O. King Jr., *100 Years of Capital Traction: The Story of Streetcars in the Nation's Capital* (College Park, MD: Taylor Publishing, 1972), 13, 37; *East of the River: Continuity and Change*, exhibition brochure,

Smithsonian Anacostia Community Museum (Washington: Smithsonian Anacostia Community Museum, 2007), 8; General Assessment Records of the District of Columbia, 1893–94, NA.

6. Alan B. Slauson, ed., *A History of the City of Washington: Its Men and Institutions* (Washington: Washington Post Co., 1905), 234; United States Realty Company of Washington, D.C., *Randle Highlands in Greater Washington* (Washington: [1910?]), 26.

7. Building permits contain marginal notes about the lack of civic improvements and indicate uses such as stables and chicken houses; Maxine Smith interview with Albert A. Liff, 1988, in "Congress Heights Comprehensive Survey," at the D.C. Historic Preservation Office; *Evening Star*, Apr. 5, 1907, 21.

8. *Baist's Real Estate Atlas of Surveys of Washington, District of Columbia: Complete in Four Volumes, Prepared from Official Records, Private Plans, and Actual Surveys* (Philadelphia: G. Wm. Baist's Sons, 1907), plate 23; School Building Survey File, Charles Sumner School Museum and Archives; Washington Perspectives, Inc., "Firehouses of the District of Columbia," 1986, available at the D.C. Historic Preservation Office; building permit 1397, Nov. 11, 1905, and Post Office records, NA.

9. U.S. Census, 1910; Overbeck, oral history interview with Eva M. Trusheim, ca. 1980.

10. William M. Haussmann, Acting Chief, Division of Design and Construction, to Chief, Bureau of Yards and Docks, U.S. Navy, June 13, 1960, RG79, NA.

11. Laura Cohen Apelbaum and Wendy Turman, eds., *Jewish Washington: Scrapbook of an American Community* (Washington: Jewish Historical Society of Greater Washington, 2007), 13, 49; Washington Highlands Jewish Center 4th Anniversary Dance booklet, 1950, 19; "Through the Lens: Jeremy Goldberg's Washington," *The Record* [Jewish Historical Society of Greater Washington] 27 (2005–6): 29–30; "Congregational History," Congregation Shaare Tikvah, www.uscj.org/seabd/templest/history.html; Sheila Gallun Cogan interview for *East of the River* exhibition, Anacostia Community Museum, 2007.

12. International Jewish Cemetery Project, Washington, D.C., www.jewishgen.org/cemetery/northamerica/washdc.html; *The Record* 27 (2005–6): 43–45.

13. Ruth Ann Overbeck interview with Louise Shelton, 1988, in "Congress Heights Comprehensive Survey," at the D.C. Historic Preservation Office; Doralis Cloer to Maxine Smith, May 13, 1988.

14. Trusheim interview; Thomas J. Cantwell, "Anacostia: Strength in Adversity," *Records of the Columbia Historical Society* 1973–1974 (1976): 349–52.

15. Cogan interview; David A. Nichols, "'The Showpiece of Our Nation': Dwight D. Eisenhower and the Desegregation of the District of Columbia," *Washington History* 16, no. 2 (Fall–Winter 2004–5): 44–65.

16. See District of Columbia, Community Renewal Program, *Washington's Far Southeast 70: A Report to the Honorable Mayor Walter E. Washington, District of Columbia* (Washington: Office of the Assistant to the Mayor for Housing Programs, 1970).

17. Irene R. Kaplan, "Overview of the 2003 Greater Washington Jewish Community Study," *The Record* 27 (2005–6): 46; Claudia Levy, "104-Year-Old Negro Parish Buys SE Church," *Washington Post*, May 2, 1969, C4.

18. Community Renewal Program, *Washington's Far Southeast 70*, 23–28.

19. LaBarbara Bowman, "Coates Unopposed on Ballot," *Washington Post*, Nov. 1, 1974, C1–5; see, e.g., Richard Severo, "This Is Anacostia," *Washington Post*, May 8, 1966, E1–5 and Paul W. Valentine, "'Like Living on a Rock Pile,'" *Washington Post*, July 23, 1969, C1–4.

20. www.neighborhoodinfodc.org.

21. Herbert H. Denton, "Anacostia's Schools Bulging," *Washington Post*, Feb. 17, 1969.

22. Darrell Watson, interviews for *Banding Together* exhibition, Anacostia Community Museum, 2006.

23. Percy Battle, interview for *East of the River* exhibition, 2007.

24. See articles in the *Washington Post*, the *Evening Star*, and the *Washington Afro-American*, especially "Young Adults Pelt Stores with Rocks," *Washington Post*, Aug. 16, 1966; "Pause for Thought," *Washington Post*, Aug. 17, 1966; "Probe Is Set on Violence in Anacostia," *Washington Post*, Aug. 17, 1966; and Thomas W. Lippman, "The Weekend: 'Operation Checkmate' Helped Keep It Quiet," *Washington Post*, Aug. 22, 1966; Larry A. Still, "11th Precinct Gets Negro Captain," *Evening Star*, Aug. 22, 1966.

25. www.thearcdc.org; Ingrid Drake, "REC Center

Profile: Southeast Tennis and Learning Center," *East of the River*, Aug. 2006, www.capitalcommunitynews .com/publications/eotr/2006-AUGUST/HTML/ REC_Center_Profile.cfm.

26. Washington DC Economic Partnership, "Congress Heights," 2008 Neighborhood Profiles, www.wdcep .com.

27. "News & Events," Asheford Court, www.asheford court.com/news.html.

28. www.assumptionchurch-dc.org; "Churches and More Churches," *One Page at a Time Newsletter* 4, no. 2 (Apr. 1998), www.dcwatch.com/sandra/ss9804.htm; www.covenantbaptistdc.org; Peter Perl, "Hustling for Souls," *Washington Post*, Aug. 26, 2001.

CHAPTER 20. KENILWORTH

The author thanks the Humanities Council of Washington, DC, and Jane Levey of Cultural Tourism DC for supporting and encouraging the publication of his booklet, *Kenilworth: A D.C. Neighborhood on the Anacostia River* (Washington: Humanities Council of Washington, DC, 2006).

1. The name Fife appears in the area that is now the Mayfair-Parkside neighborhood in G. M. Hopkins, *A Complete Set of Surveys and Plats in the City of Washington, District of Columbia* (Philadelphia: G. M. Hopkins, 1894); "Old Landmark Preserved," *Washington Times*, Dec. 12, 1930, mentions a Beall land marking stone placed in marsh in the same area; letter from Helen Shaw Fowler to the *Washington Times*, Dec. 17, 1930 (in the collection of Ruth Shaw Watts), references an original parchment deed in the possession of Mrs. Clement W. Sheriff that records the 1764 transfer to Joshua Beall.

2. Donald Beekman Myer, *Bridges and the City of Washington* (Washington: U.S. Commission of Fine Arts, 1974), 50.

3. Keith Melder, *City of Magnificent Intentions: A History of Washington, District of Columbia,* 2nd ed. (Washington: Intac, Inc., 1998), 481; Jim Haskins and N. R. Mitgang, *Mr. Bojangles: The Biography of Bill Robinson* (New York: William Morrow, 1988), 41; Albert Cassell, in Marya Annette McQuirter, *African American Heritage Trail* (Washington: Cultural Tourism DC, 2003), 36, also at www. culturaltourismdc.org/info-url3948/info-url_show .htm?doc_id=205000.

4. Original deed, Lucianna Miller to Walter B. Shaw, in the collection of Ruth Shaw Watts.

5. Information about Helen Fowler's husband and child is scanty, retained only orally through Shaw family descendants Ruth Shaw Watts and Ethan Brent.

6. Ethan Brent, conversation with author, July 20, 2005.

7. George Kennedy, "Famous Lily Ponds Give Kenilworth Its Deserved Reputation," *Evening Star*, Apr. 30, 1951.

8. Matthew B. Gilmore and Michael R. Harrison, "A Catalog of Suburban Subdivisions of the District of Columbia," *Washington History* 14, no. 2 (Fall–Winter 2002–3): 26–55.

9. Ruth Shaw Watts, interview with author, July 21, 2004. This and all other interviews cited below can be found in the Joe Lapp "Out of Kenilworth" oral history collection, Washingtoniana Division, DCPL.

10. The John Colvin controversy is documented by a series of articles in the *Washington Post*, from "Color Line in Suburb; Kenilworth Citizens Incensed at Board of Education," Nov. 8 through Nov. 22, 1904.

11. Jeanne Rogers, "Kenilworth Transfer to Negro Use Set for Feb. 1," *Washington Post*, Jan. 15, 1954.

12. John Haizlip Sr., interview with author, Nov. 19, 2004.

13. Carolivia Herron, daughter of Georgia Johnson Herron, interview with author, Aug. 19, 2004.

14. Frank Matthews, interview with author, Feb. 10, 2004.

15. Naomi Wilson, interview with author, Nov. 20, 2003.

16. Hamil Harris, "Bishop James Peebles, Sr., Dies; Founded Jericho Baptist Church," *Washington Post*, Sept. 27, 1996; Ruben Castaneda and Hamil Harris, "More Room for More Souls; 8,000-Member Church Gets New Home," *Washington Post*, Dec. 29, 1997.

17. Martin Well, "Dump Fires Are Covered Up," *Washington Post*, Feb. 18, 1968.

18. Adele Bernstein, "460 Homes Vacant Here as 3000 Families Hunt Quarters," *Washington Post*, Sept. 7, 1943.

19. S. L. Fishbein, "Segregation Dropped for 3 Home Units," *Washington Post*, July 12, 1952.

20. Walter McDowney, interview with author, Aug. 1, 2004.

21. Lashawn Moore Reynolds, interview with author, May 28, 2005; "Mayor Looks into Past for Community Advice," *Washington Post*, Nov. 20, 1971;

the decline of Kenilworth Courts is well illustrated by Bart Barnes, " 'This Place Is Like a Reservation': Black Youths Hope to Quit Kenilworth," *Washington Post*, Sept. 27, 1971.

22. Ellen Hoffman, "Mayor Spurs Action to Mend 400 Broken School Windows," *Washington Post*, Jan. 5, 1968; Owen Davis, interview with author, Feb. 12, 2004.

23. Lewis Simons, "Unique Group Gets Youths into College," *Washington Post*, Aug. 6, 1978, outlines the early successes of the College Here We Come program, part of the series "Voices of the Projects" in the *Post*, Mar. 31, Apr. 18, May 5, and June 25, 1978, about challenges in public housing around the city, often with a focus on Kenilworth Courts.

24. The successes of tenant management in Kenilworth Courts are well documented in *Washington Post* articles throughout the 1980s; Gil Klein, "For the Poor — Hope, Schooling, Independence," *Christian Science Monitor*, Sept. 17, 1985, is a good summary.

25. Ann Mariano, "Tenants of D.C. Project Move toward Ownership; Event Clouded by Political Controversy," *Washington Post*, Oct. 25, 1988; Matt Neufeld, "Residents Finally Get Housing Complex," *Washington Times*, Oct. 1, 1990; Louie Estrada, "Public Housing Advocate Kimi Gray Dies," *Washington Post*, Mar. 4, 2000, and other coverage in the *Post* and the *Washington Times*.

CHAPTER 21. TAKOMA PARK

1. Sam Bass Warner, *Streetcar Suburbs: The Process of Growth in Boston, 1870–1900* (New York: Atheneum, 1968), 169; Harlan Paul Douglas, *The Suburban Trend* (New York: Arno Press and New York Times, 1970), 35.

2. Margaret Gilbert Jamison, "Benjamin Franklin Gilbert: Founder of Takoma Park," in *Supplement to Official Program and Early History of Semi-Centennial Celebration of the Founding of Takoma Park, MD-DC* (Takoma Park, DC: Pioneer Press, 1933), 44; *Fifty Years of Progress in Takoma Park,* program of the Fiftieth Anniversary Celebration of the Founding of Takoma Park, MD-DC (Takoma Park, DC: Pioneer Press, 1933), 9.

3. B. F. Gilbert Real Estate, *The Villa Lots of Takoma Park: A Suburb of Washington City* (Washington: A.G. Gedney, 1886), 2.

4. Robert M. Bachman, "Takoma Park, Maryland, 1883–1992: A Case Study of an Early Railroad Suburb," MA thesis, George Washington University, 1975, 52.

5. Ibid., 44–47; Gilbert Real Estate, "Villa Lots," 9.

6. Frank E. Skinner, "Benjamin Franklin Gilbert 1874–1907: Personal Recollections of Him and the Early Days of Takoma Park," *The Takoma Enterprise* 12, no. 2 (Dec. 1939): 1–19.

7. Takoma Park City Council, *Takoma Park: A Photo History of Its People by Its People* (Takoma Park, MD: City of Takoma Park, 1956), 12–22.

8. *Fifty Years of Progress*, 16–22.

9. Vincent Scully, *American Houses, Thomas Jefferson to Frank Lloyd Wright: The Rise of American Architecture* (New York: Praeger, 1970), 176; Charles N. Glaab and Theodore N. Brown, *A History of Urban America* (New York: Macmillan, 1967), 214; Marcus Whiffen, *American Architecture Since 1780: A Guide to the Styles* (Cambridge, MA: MIT Press, 1969), 217.

10. Bachman, "Takoma Park," 26–27.

11. Takoma Park City Council, *Takoma Park,* 8; LeRoy O. King Jr., *100 Years of Capital Traction: The Story of Streetcars in the Nation's Capital* (College Park, MD: Taylor Publishing, 1972), 98, 101; Ellen R. Marsh and Mary Anne O'Boyle, *Takoma Park: Portrait of a Victorian Suburb* (Takoma Park, MD: Historic Takoma, Inc., 1984), 18.

12. Bachman, "Takoma Park," 87–88.

13. Ibid., 102–6.

14. Richard Longstreth, "Takoma, DC and Takoma Park, MD: Historical Portrait," unpublished study by students in AMST/HIST 278 , George Washington University, 2002, 81, 84, Kiplinger Library, HSW; Marlette Conde, *The Lamp and the Caduceus: The Story of the Army School of Nursing* (Washington: Army School of Nursing Association, 1975), chap. 4.

15. Whiffen, *American Architecture*, 217; Longstreth, "Takoma, DC and Takoma Park, MD," 51.

16. Marsh and O'Boyle, *Takoma Park,* 65–66; Walter Irey, "The Takoma Park Citizens Association, Maryland and the District of Columbia*,*" *The Takoma Enterprise* 8, no. 2 (Dec. 1935): 8–9.

17. Frank E. Skinner, "The Public Schools of Takoma Park: A Brief History," *The Takoma Enterprise* 2, no. 5 (Dec. 1929): 2; Tanya Edwards Beauchamp, *Takoma*

Park Historic District (Washington: D.C. Historic Preservation Office, 2005), 10.

18. *The Takoma Park Booster* (Takoma Park: Takoma Park, MD-DC Chamber of Commerce, 1939), 11.

19. Ibid., 17–19.

20. Marsh and O'Boyle, *Takoma Park*, 50.

21. Marvin Caplan, "Shepherd Park: Creating an Integrated Community," *Washington at Home: An Illustrated History of Neighborhoods in the Nation's Capital,* ed. Kathryn Schneider Smith (Northridge, CA: Windsor Publications, 1988), 265–67; Longstreth, "Takoma, DC and Takoma Park, MD," 93.

22. Caplan, "Shepherd Park," 168–69.

23. Ibid.

24. "Mayor Abbott," *The Montgomery Journal,* May 29, 1985.

25. "Regrets? It Doesn't Bother Me At All That I Don't Have a Suburban Decorum," *Takoma Park Newsletter,* Jan.–Feb. 1991.

26. U.S. Census Bureau, 2000 Census of Populations and Housing, "Summary of Population and Housing Statistics," PHC-1-10, District of Columbia, Washington, DC 2002, 55.

27. Smith Group, Inc., Gorove/Slade Associates, Economic Research Associates, EHT Traceries, Inc., and D.C. Office of Planning Staff, "Takoma Central District Plan," 2002, 10–16.

CHAPTER 22. BROOKLAND

1. John Facchina and Thea Reachmack, interviews by Merrill Lavine, Sarah Lightner, and George McDaniel, Nov. 1979. This essay is based on a study conducted in 1979 by graduate students in historic preservation at George Washington University in a course taught by John N. Pearce and George W. McDaniel. The results were first published as George W. McDaniel, ed., *Images of Brookland: The History and Architecture of a Washington Suburb,* George Washington University Graduate Program in Historic Preservation, Historical and Cultural Resources Studies, no. 1 (Washington: Center for Washington Area Studies, George Washington University, 1979). Subsequently this work was revised and enlarged and published as George W. McDaniel and John N. Pearce, eds., *Images of Brookland: The History and Architecture of a Washington Suburb,*

rev. and enl. by Martin Aurand, George Washington University Studies Series, no. 10 (Washington: George Washington University, 1982). Original student papers, by Elizabeth Baylies, Howard Berger, N. Gail Byers, Barbara Fallin, Merrill Lavine, Sarah Lightner, Susan Minogue, and Kent Newell, and related documents are in the Brookland Neighborhood Collection, Gelman Library, GWU. A list of those who gave extensive assistance, including conducting interviews, is found in McDaniel, *Images,* ii, and a summary of primary sources is found in McDaniel, Pearce, and Aurand, *Images,* 6.

2. McDaniel, Pearce, and Aurand, *Images,* 8; "Brooks Mansion," nomination form, National Register of Historic Places, available at the D.C. Historic Preservation Office; Brooks Family Papers, Archives of Catholic University of America, Washington, D.C.

3. McDaniel, Pearce, and Aurand, *Images,* 7.

4. Ibid., 8–13.

5. McDaniel, *Images,* 23; McDaniel, Pearce, and Aurand, *Images,* 13–14; LeRoy O. King Jr., *100 years of Capital Traction: The Story of Streetcars in the Nation's Capital* (College Park, MD: Taylor Publishing Co., 1972), 17.

6. Subdivision information from Washington County books, District of Columbia Surveyor's Office; real estate map, "Brookland and Additions — Lots for sale by McLachlen & Batchelder" (1892); G. M. Hopkins, *A Complete Set of Surveys and Plats of Properties in the City of Washington, District of Columbia* (Philadelphia: G. M. Hopkins, 1894); *Baist's Real Estate Atlas of Surveys of Washington, District of Columbia* (Philadelphia: G. Wm. Baist's Sons, 1903) ; King, *100 Years of Capital Traction,* 17, 26; John W. Boettjer, "Street Railways in the District of Columbia," MA thesis, George Washington University, 1963, 65, 104; Street Railway file, Washingtoniana Division, DCPL; McDaniel, *Images,* 12–19; McDaniel, Pearce, and Aurand, *Images,* 11; "University Station," *Evening Star,* July 13, 1940; Baltimore and Ohio Railroad Co. file, Washingtoniana Division, DCPL; U.S. House of Representatives, 61st Cong., 2nd sess., "City and Suburban Railway Extensions" (Report No. 961), Apr. 6, 1910, 1.

7. McDaniel, *Images*, 49–50.

8. McDaniel, Pearce, and Aurand, *Images*, 14, 40; for discussions of architectural styles in Brookland, see also 34–78.

9. McDaniel, Pearce, and Aurand, *Images*, 15–16, 18; John Clagett Proctor, "Rambler Travels for Details of History of Brookland Section," *Evening Star*, Nov. 8, 1925; Proctor, "Brookland's Development," *Evening Star*, Apr. 20, 1947.

10. McDaniel, *Images*, 26.

11. Ibid., 27; McDaniel, Pearce, and Aurand, *Images*, 18; 26–29, 44–45; Pamela Scott and Antoinette J. Lee, *Buildings of the District of Columbia* (Oxford: Oxford University Press, 1993), 285; Marya Annette McQuirter, *African American Heritage Trail* (Washington: Cultural Tourism DC, 2003), 39–40.

12. McDaniel, *Images*, 32–43; McDaniel, Pearce, and Aurand, *Images*, 20–24; John M. Rosson, "Brookland Association Points to Rosy Past and Bright Future," *Evening Star*, Jan. 11, 1955; Brookland file and Brookland Citizens' Association file, Washingtoniana Division, DCPL.

13. McDaniel, *Images*; McDaniel, Pearce, and Aurand, *Images*; Map Room, Bureau of Street Construction, Department of Transportation, D.C. Government; D.C. Building Permits, NA.

14. John Tracy Ellis, *The Formative Years of the Catholic University of America* (Washington: American Catholic Historical Association, 1946).

15. McDaniel, Pearce, and Aurand, *Images*, 78.

16. McDaniel, *Images*, 43–48; McDaniel, Pearce, and Aurand, *Images*, 20–22; D.C. Building Permits, NA; Harry R. Tansill, Letter to the Editor, *Evening Star*, Mar. 27, 1979; "Flames Destroy Baptist Church," *Evening Star*, Nov. 29, 1926; unidentified newspaper clippings, Brookland file, and Brookland Citizens' Association file, Washingtoniana Division, DCPL; Rosson, "Brookland Association."

17. McDaniel, Pearce, and Aurand, *Images*, 26.

18. McDaniel, *Images*, 52–60; McDaniel, Pearce, and Aurand, *Images,* 25–29; *First Annual Brookland Tour* (Washington, 1965); Sterling A. Brown, "Blacks in Brookland: A Gentle Lecture to a Stripling," *Washington Star*, Apr. 18, 1979; Rev. Joseph A. Miles and files, Brookland Union Baptist Church, Washington, D.C.; George Kennedy, "Brookland Continues Amazing Growth Beginning with Real Estate Deal in 1880's," *Evening Star*, Sept. 18, 1950.

19. McDaniel, *Images*, 62–83; McDaniel, Pearce, and Aurand, *Images*, 30–33; Paul Peachey and students, Brookland Studies, Department of Sociology, Catholic University of America, Washington, D.C.; Brookland files, Washingtoniana Division, DCPL; *Washington Post*, Dec. 13, 1970, D1; Apr. 16, 1973; Jan. 1, 1974; May 31, 1976, A1; July 28, 1977; Aug. 6, 1977; Dec. 4, 1977, 8; Apr. 31, 1978; Nov. 20, 1978; June 28, 1979.

CHAPTER 23. EAST WASHINGTON HEIGHTS

1. "Washington's Great Future: Col. Arthur E. Randle Predicts Wonderful Growth," *Evening Star*, Sept. 2, 1909.

2. Constance McLaughlin Green, *Washington: Village and Capital, 1800–1878* (Princeton: Princeton University Press, 1962), 16; Frederick Gutheim and Antoinette J. Lee, *Worthy of the Nation: Washington, DC, from L'Enfant to the National Capital Planning Commission*, 2nd ed. (Baltimore: Johns Hopkins University Press, 2006), 25, 32, 38.

3. Donald Beekman Myer, *Bridges and the City of Washington* (Washington: U.S. Commission of Fine Arts, 1974), 47.

4. Ibid.; LeRoy O. King Jr., *100 Years of Capital Traction: The Story of Streetcars in the Nation's Capital* (College Park, MD: Taylor Publishing, 1972), 37; *East of the River: Continuity and Change* (Washington: Smithsonian Anacostia Community Museum, 2007), 6; "Randle's Great Work: Washingtonian's Efforts Result in Big Improvements," *Washington Post*, May 2, 1906.

5. James Bradley, "New York Food Museum: Sugar," www.nyfoodmuseum.org/sugar.htm.

6. Dr. George C. Havener, "Randall Highlands" [*sic*], Oct. 19, 1924, Residential Section vertical file, Washingtoniana Division, DCPL; "Randle's Great Work," *Washington Post*, May 2, 1906; Hillcrest Citizens Association, *Hillcrest Bulletin* (June 1928): 6.

7. "At the Overlook Inn," *Washington Post*, Aug. 6, 1894, 5; "Coaching to the Overlook Inn," *Washington Post*, June 14, 1895, 7.

8. "Money for Overlook Inn Road," *Washington Post*,

July 7, 1896, 10; "Minority Oppose Another Charter," *Washington Post*, Feb. 21, 1897, 12.

9. *Hillcrest Bulletin*, 6; "Col. Bliss is Convalescent," *Washington Post*, Mar. 13, 1898, 7; "Lightning Struck Flagpole: Two Persons Slightly Shocked at Overlook Inn, Anacostia," *Washington Post*, Aug. 11, 1904, 2; "Bad Dogs Are Doomed," *Washington Post*, Sept. 23, 1900, 20.

10. "Randle's Great Work"; "Havemeyer Property Sold," *Washington Post*, Aug. 1, 1915; "Washington's Great Future," *Evening Star*, Sept. 2, 1909.

11. "Approve Forts for Playgrounds," *Washington Post*, Jan. 21, 1912; "Twining City Sale," *Washington Post*, June 8, 1888.

12. King, *Capital Traction*, 106.

13. United States Realty Company of Washington, D.C., *Randle Highlands in Greater Washington* (published by the author, Washington, ca. 1910), 26, in the Smithsonian Institution library at the National Museum of American History.

14. "Many at Randle Highlands," *Washington Post*, Apr. 17, 1906, 5; "New Suburb Opens," *Washington Post*, Oct. 25, 1906; *Randle Highlands in Greater Washington*, sales brochure of the United States Realty Company, Smithsonian Institution Anacostia Community Museum.

15. "Marshalls Dine at Home of Col. and Mrs. Randle," *Washington Post*, July 24, 1914; "To Open Subdivision: Randle Highlands Will Celebrate with Barbecue (Fire Station Soon to be Erected)," *Washington Post*, Sept. 5, 1909.

16. "Southeast Adds to Its Neighborhood Theaters," *Washington Post*, Apr. 2, 1940.

17. Christine Sadler, "Our Town: Closely Knit Community of Anacostia Knows How to Fight for What It Wants," *Washington Post*, Nov. 22, 1939; *Hillcrest Bulletin*, 6.

18. "Col. Randle Kills Self in California," *Washington Post*, July 5, 1929.

19. "All Gas Home Joins Quality with Design," *Washington Post*, Oct. 1, 1933; "Many Observe Model Home's Real Efficiency: G.E. Electric Equipment Put In House by U. S. Randle," *Washington Post*, Oct. 8, 1933.

20. King, *Capital Traction*, 106.

21. Louise Daniel Hutchinson, *The Anacostia Story: 1608–1930* (Washington: Smithsonian Institution Press, 1977), 61; Katherine Cole Stevenson and H. Ward Jandl, *Houses by Mail, A Guide to Houses from Sears, Roebuck and Company* (New York: Preservation Press, 1986).

22. Vernon C. Thompson, "Barry Moves to Hillcrest, Southeast's Gold Coast," *Washington Post*, Dec. 20, 1979; "Building Gains Ground in Vast Southeast DC," *Washington Post*, Feb. 14, 1937; "Paul P. Stone, Arthur S. Lord, Edward E. Caldwell, Avon Shockey — Are Proud to Announce the Removal of the Headquarters of Their Developments: Crestwood, Hawthorne, Hillcrest," advertisement, *Washington Post*, June 22, 1941.

23. *Hillcrest Bulletin*, 6; Christine Sadler, "Our Town: Summit Park Asks Only That It Be Let Keep Elbow Room," *Washington Post*, Sept. 21, 1939.

24. Duncan Spencer, "Randle Highlands — Middle America: It's Not Like Reston or Those Places," *Evening Star*, Apr. 9, 1971; "City Will Get Its Initial Multi-Level Shop Center," *Washington Post*, Mar. 14, 1965.

25. Christine Sadler, "Our Town: Randle Highlands Growing Rapidly," *Washington Post*, Sept. 20, 1939.

26. "Summer at Edgemore," *Washington Post*, July 29, 1894.

27. "9-Hole Fort Dupont Public Golf Course Opens This Morning," *Washington Post*, July 10, 1948.

28. Joseph D. Whitaker, "Elegance, Majesty, Poverty," *Washington Post*, Dec, 28. 1980; *Hillcrest Bulletin*, 6.

29. "Need of New Anacostia School Intensified by Defense Influx: Construction of Thousands of Home Units in Area to Find Education Facilities Scanty," 1941 newspaper article, Anacostia 1800–1939 residential section vertical file, Washingtoniana Division, DCPL; Thomas Cantwell, "Anacostia: Strength in Adversity," *Records of the Columbia Historical Society* 49 (1973–74): 348; Pearl Cross interview, June 14, 2003.

30. Cleve Mesidor, "The Cranes are Coming to Ward 7," *East of the River* (Jan. 2008); Pastor Franklin Senger, conversation with author, Dec. 19, 2007.

31. Abbott Combes, "Fort Dupont Park to Close Golf Links," *Washington Post*, Nov. 26, 1971; Paul Williams, "Think Rink," *Washington Post*, Feb. 3, 2006.

CHAPTER 24. WESLEY HEIGHTS AND
SPRING VALLEY

1. "Wesley Heights," *Evening Star*, June 7, 1930; "Spring Valley," *Evening Star*, May 20, 1933.

2. Marc A. Weiss, *The Rise of the Community Builders: The American Real Estate Industry and Urban Land Planning* (New York: Columbia University Press, 1987); Kenneth T. Jackson, *Crabgrass Frontier: The Suburbanization of the United States* (New York: Oxford University Press, 1987); Jeffrey M. Hornstein, *A Nation of Realtors: A Cultural History of the Twentieth-Century American Middle Class* (Durham: Duke University Press, 2005); Diane Shaw Wasch, "Models of Beauty and Predictability: The Creation of Wesley Heights and Spring Valley," *Washington History* 1, no. 2 (Fall 1989): 58–76; "Persistency in Consistency," *Leaves of Wesley Heights* (Feb. 1929): 27.

3. "Real Estate Boards Advance Code of Ethics," *The American City* 31 (Sept. 1924): 271; "A Subdivision: But No Lots for Sale," *National Real Estate Journal* 29 (July 9, 1928): 52, 54.

4. National Capital Park and Planning Commission, *Annual Report* (1928), 5–7, and *Annual Report* (1931), 10; "A Subdivision: But No Lots for Sale," 54.

5. "The Ideals of Home Are Realized in Wesley Heights," advertisement, *Leaves* (Dec. 1928): 27.

6. Helen C. Monchow, *The Use of Deed Restrictions in Subdivision Development* (Chicago: Institute for Research in Land Economics and Public Utilities, 1928), 28–31; B. R. Hastings, "Report of Committee on 'Advantages in Building by the Subdivider,'" *Annals of Real Estate Practice* (1924), pt. 3, 62–64; Judith Robinson, "Chevy Chase: A Bold Idea, A Comprehensive Plan," in *Washington at Home: An Illustrated History of Neighborhoods in the Nation's Capital*, ed. Kathryn Schneider Smith (Northridge, CA: Windsor Publishing, 1988), 194; Frederick Gutheim and Antoinette J. Lee, *Worthy of the Nation: Washington, DC, from L'Enfant to the National Capital Planning Commission*, 2nd ed. (Baltimore: Johns Hopkins University Press, 2006), 160–61.

7. "A Subdivision: But No Lots for Sale," 54; obituary of Gordon E. MacNeil, *Leaves* (Apr. 1945): 5; W. C. Miller, "Modern Trends in Subdividing," *Annals of Real Estate Practice* (1930): 298.

8. Norma Knight Jones, "Gardens and Morals," *The American Home* 15 (Apr. 1936): 11; *Leaves* (May 27, 1929): 12.

9. *Leaves* (Feb. 1927): 2.

10. B. L. Jenks, "Restrictions for a High-Grade Subdivision," *Annals of Real Estate Practice* (1925), pt. 3, 140; Bruce H. Wark, "Subsidizing Transportation by the Subdivider," *Annals of Real Estate Practice* (1928): 637–43; notice in *Leaves* (Oct. 1941); *Leaves* (Aug. 1929); "Our Town," *Washington Post*, Nov. 10, 1939.

11. *Leaves* (May 1929): 7; Miller, "Modern Trends in Subdividing," 300; "Restrictions in Subdivisions Urged to Protect Owners: Modern Principles of Successful Development Explained by W. C. Miller," *Evening Star* (Feb. 12, 1927); Anatole Senevitch, ed., *Old Anacostia Washington, D.C.: A Study of Community Preservation Resources* (Washington: School of Architecture, University of Maryland Metropolitan Washington Planning and Housing Association, 1975), 7; George W. McDaniel and John N. Pearce, eds., *Images of Brookland: The History and Architecture of a Washington Suburb*, rev. and enl. by Martin Aurand, George Washington University Studies Series, no. 10 (Washington: George Washington University, 1982), 18, 27; Marvin Caplan, "Shepherd Park: Creating an Integrated Community," in Smith, *Washington At Home*, 262; Constance McLaughlin Green, *Washington, A History of the Capital, 1800–1950* (Princeton: Princeton University Press, 1976), 2:330.

12. Miller, "Modern Trends in Subdividing," 300; Monchow, *Deed Restrictions*, 47–50; Robert M. Fogelson, *Bourgeois Nightmares: Suburbia, 1870–1930* (New Haven: Yale University Press, 2005); Delores Hayden, *Building Suburbia: Green Fields and Urban Growth, 1820–2000* (New York: Pantheon Books, 2003), 65–70.

13. "Wesley Heights Offers Community Features," advertisement, *Leaves* (Jan. 1929): 27; Gwendolyn Wright, *Building the Dream: A Social History of Housing in America* (New York: Pantheon Books, 1981), 201, 208, 212; Jackson, *Crabgrass Frontier,* 208.

14. "Our Town."

15. "The Club's First President," *Leaves*, 16.

16. Miller, "Modern Trends in Subdividing," 301.

17. Mrs. John D. Hemenway, "The First Public School in Wesley Heights," *Leaves* (June 1970): 10.

18. "We Welcome Julius Garfinckel to The Spring Valley Store," *Leaves* (Aug. 1942): 15.

19. Cover, *Leaves* (May–June 1999); cover, *Leaves* (July–Aug. 1995); advertisement, *Leaves* (Jan.–Feb. 1995).

20. Jonathan B. Tucker, "Chemical Weapons: Buried in the Backyard," *Bulletin of the Atomic Scientists* 57, no. 5 (Sept/Oct.): 51–57.

21. Zoning Commission for the District of Columbia, Final Rulemaking published at 39 DCR 6827, 6829 (Sept. 11, 1992); as amended by Final Rulemaking published at 47 DCR 9741-43 (Dec. 8, 2000).

22. Jennifer Caspar, "Neighbors Size up Zoning Issue on Home Additions," *Washington Post*, Dec. 22, 1990; J. C. Nichols, "Control of Subdivision Development Advocated," *The American City* (Apr. 1927): 493.

CHAPTER 25. ADAMS MORGAN

The author thanks Marsha McAdoo Greenlee for sharing her research on Adams Morgan prior to 1935, Audrey Singer with the Brookings Institution for her demographic research, and Laura Croghan Kamoie and Cultural Tourism DC for the research for the Adams Morgan Neighborhood Heritage Trail, which has enriched this essay.

1. Mart Malakoff, "Adams Morgan ... The Millionth Go-Round," in *Cityscape* 2, no. 2 (Washington: Western High School for the Arts, Oct. 1975): 47.

2. Kim T. Conley and Douglas G. Bushell, "Diversity of People Helps Give Adams Morgan Its Character," *Washington Post*, May 21, 1984.

3. Jane Freundel Levey, *Roads to Diversity: Adams Morgan Heritage Trail* (Washington: Cultural Tourism DC, 2005); Sue A. Kohler and Jeffrey R. Carson, *Sixteenth Street Architecture* (Washington: U.S. Commission of Fine Arts, 1978), 1:337–49.

4. D.C. Building Permits Database, DCPL; Reed-Cooke, like Adams Morgan, was named for two schools — the Marie H. Reed Community Learning Center and the H. D. Cooke Elementary School — a name coined by Advisory Neighborhood Commissioner Edward G. Jackson in 1981.

5. Paul Kelsey Williams, "Lanier Heights Early History Surprises," *Intowner*, March 2007.

6. Jeffrey Henig, *Gentrification in Adams Morgan: Political and Commercial Consequences of Neighborhood Change*, GW Washington Studies, no. 9 (Washington: Center for Washington Area Studies, George Washington University, 1982), 13–14.

7. Ibid., 15, 22.

8. Ibid., 15–16.

9. Audrey Singer, *Exploring New Settlement Areas among Latinos in the District of Columbia* (Washington: Brookings Institution, 2006), 2.

10. Joseph C. Goulden, "¡Inmigración!" *Washingtonian* (Sept. 1978), 171.

11. Henig, *Gentrification*, 16.

12. Lucy M. Cohen, *Culture, Disease and Stress among Latino Immigrants* (Washington: Smithsonian Institution, 1979); Casilda Luna, interview with the author, 1981.

13. Gerald Suttles, *The Social Order of the Slum* (Chicago: University of Chicago Press, 1968), 24.

14. Carlos Rosario, interview with the author, 1981.

15. Ibid.

16. Ibid.

17. Olivia Cadaval, *Creating a Latino Identity in the Nation's Capital: The Latino Festival* (New York: Garland Press, 1998); Casilda Luna, interview with the author, 1981.

18. Arturo Griffiths, interview with the author, 1981.

19. Carlos Salazar, taped interview for "Perspectivas: Washington's Hispanics in the 1980s," a radio program funded by the D.C. Community Humanities Council, 1980.

20. Sol & Soul: Artists for Social Change Press Release, Aug. 28, 2005.

21. Krishna Roy, "Sociodemographic Profile," in *The State of Latinos in the District of Columbia: Trends, Consequences, and Recommendations* (Washington: Council of Latino Agencies, 2002), 5. (www.consejo.org/sol/CLA.Ch.1-Sociodemographic%20Profile.pdf.)

22. Larry Van Dyne, "Who We Are: Where Immigrants Are Living," *Washingtonian* (Oct. 2006): 93; Audrey Singer, Samantha Friedman, Ivan Cheung, and Marie Price, *The World in a Zip Code: Greater Washington, D.C. as a New Region of Immigration* (Washington: Center on Urban & Metropolitan Policy, Brookings Greater Washington Research Program, 2001).

CHAPTER 26. SHEPHERD PARK

1. Diane Flanagan-Montgomery, interview with Marvin Caplan, June 3, 1987. Marvin Caplan, the author of the essay on Shepherd Park in the 1988

edition of *Washington at Home*, passed away in 2000, and his text has been updated by Ralph Blessing. For the original text see *Washington at Home: An Illustrated History of Neighborhoods in the Nation's Capital*, ed. Kathryn Schneider Smith (Northridge, CA: Windsor Publishing, 1988), 261–69.

2. "The Silver King of Batopilas," *The California Native Copper Canyon Companion* (Spring 1999), available at www.calnative.com; typed memo by Grace Shepherd Merchant, Shepherd's daughter, Alexander Robey Shepherd Papers, Manuscript Division, Library of Congress.

3. J. Harry Shannon, "The Rambler," *Sunday Star*, May 7, 1916; file no. 45,997, Columbia Insurance Co. documents the sale of the property at 7714 13th Street, NW (today Parcel 91/142), to Darius Clagett by the heirs of Basil Loveless on Mar. 8, 1847 (Liber W.B. 134 folio 226); *National Intelligencer*, Nov. 3, 1837.

4. Mary L. Standee, "Borden's Dream" (1952), in typescript, provides an early history of Walter Reed Hospital; available at the Medical Library of the Walter Reed Army Medical Center.

5. "Principal Local Events," *Records of the Columbia Historical Society* 15 (1912): 360; Shannon, "The Rambler," *Sunday Star*, May 7, 1916.

6. Quotation from title to the home of the late author, Marvin Caplan, 1210 Geranium Street, NW; Henry P. Gilbert, who lived in a Shepherd Park home built by his parents in 1926–27, interview with Marvin Caplan, May 11, 1987; June Confer, correspondence with Ralph Blessing, Dec. 18, 2006.

7. LeRoy O. King Jr., *100 Years of Capital Traction: The Story of Streetcars in the Nation's Capital* (College Park, MD: Taylor Publishing, 1972), 129.

8. Mrs. J. F. Rose, "History of the Shepherd School," Archives of the D.C. Public Schools at Sumner School; "A History of Northminster," Northminster Presbyterian Church.

9. Rev. Nancy Clark, pastor of Northminster Presbyterian Church, interview with Marvin Caplan, June 3, 1987; undated 1940 *Washington Post* article in the Shepherd Park file, Kiplinger Library, HSW.

10. David Fraser Webster, nephew of Marjorie Webster, interview with Marvin Caplan, May 12, 1987; Webster "Register for 1929–30"; "The Last Word," *Washington Post*, Dec. 16, 1967.

11. Jacqueline Clemens, Alice Dove, Anita Henderson, and Norma Kelly, "A History of Shepherd Park," Shepherd Park file, Kiplinger Library, HSW.

12. "The Colonial Village," *National Real Estate Journal*, Mar. 30, 1931; Merle Bollard, Colonial Village historian, interview with Marvin Caplan, June 5, 1987; Merle Bolland, "History of the Colonial Village," unpublished manuscript May 1988, Kiplinger Library, HSW; Caplan interviews with Virgil Carter, president of the Civic League of North Portal Estates, June 15, 1987; with Esta Benson, North Portal resident since 1950, July 6, 1987; and with Harry Friedman, builder in the area in 1948, July 28, 1987.

13. Sources on the Jewish migration include Hillel Marans, *Jews in Greater Washington: A Panoramic History of Washington Jewry, 1795–1960* (Washington: Hillel Marans, 1961); "Life in the Old Southwest," a taped panel discussion, Mar. 5, 1968, in Jewish Historical Society of Greater Washington, *Records* 2 (Nov. 1968): 3–35; Joseph Waksbert and Gary A. Tobin, *A Demographic Study of the Jewish Community of Greater Washington, 1983* (Bethesda, MD: United Jewish Appeal Federation of Greater Washington, Inc., 1984); Rev. Roland W. Anderson, "Sitting in Peanut Heaven," *The Christian Ministry* (July 1974).

14. Hillel Marans, *Jews in Greater Washington: A Panoramic History of Washington Jewry for the Years 1795–1960* (Washington: Hillel Marans, 1960), 70–71.

15. Information based on Marvin Caplan's personal experience as president of Neighbors, Inc. For a detailed account of classified housing ad policy of the *Washington Post*, the *Evening Star*, and the *Daily News*, see a speech by Sen. Wayne Morse in the *Congressional Record*, June 3, 1960, 86th Cong., 2d sess., 10947. Senate Bill 3346 introduced by Sen. Hubert Humphrey, Apr. 7, 1960, proposed fines and jail terms on District media that mentioned race, color, religion, ancestry, or national origin in real estate ads.

16. Marvin Caplan was instrumental in founding Neighbors, Inc., and leading its anti-blockbusting efforts; a small park on Alaska Avenue is today dedicated to his memory.

17. Carol Valoris, executive director of Ohev Sholom, correspondence with Ralph Blessing, Nov. and Dec. 2006.

18. Marvin Caplan interviews with Joseph and Anna Hairston, June 24, 1987 (Mr. Hairston was one of the first black residents to join the Citizens Association); Fannie Bigio, fifty-year resident of Shepherd Park and former president of the Citizens Association, interview with Caplan, May 27, 1987; Constance Feeley, "NW Welcomes New Diplomatic Set," *Evening Star*, May 15, 1961.

19. *Fifth Annual Report*, Neighbors, Inc., 1963, inside cover, in the Neighbors, Inc., collection, D.C. Community Archives, Washingtoniana Division, DCPL.

20. Anderson, "Sitting in Peanut Heaven."

21. Virgil Carter, president, Civic League of North Portal Estates, interview with Marvin Caplan; "Portal Estates: Urban Setting and Suburban Atmosphere," *Washington Post*, Aug. 30, 1986; Juan Williams, "Uptown: North Portal Estates — The Hallmark of Neighborhood for Washington's Blacks," *Washington Post Sunday Magazine*, Oct. 21, 1982.

22. Marvin Caplan interviews with Rev. Nancy Clark, pastor of Northminster Presbyterian Church, June 3, 1987, and Pastor David Shreeves, Shepherd Park Christian Church, June 10, 1987; Ralph Blessing interviews with Carolyn Fon, Northminster

Presbyterian Church, Dec. 28, 2006, and Pastor Marcus Leathers, Shepherd Park Christian Church, Dec. 20, 2006.

23. Marvin Caplan interviews with Rabbi A. Nathan Abramowitz, May 28, 1987; Howard and Barbara White, May 19, 1987; and Julian and Mollie Berch, May 25, 1987; David Zinner, executive director, Tifereth Israel Congregation, correspondence with Ralph Blessing, Nov. 17, 2006.

24. William Greider and Richard Harwood, "Hanafi Muslim Bands Seize Hostages at 3 Sites," *Washington Post*, Jan. 19, 1973.

25. Alfred E. Lewis and Timothy S. Robinson, "Seven Executed in District's Biggest Mass Murder," *Washington Post*, Mar. 10, 1977; Marvin Caplan interviews with Jack Spiro, executive director, Ohev Sholom, May 6, 1987; Rabbi A. Abramowitz, May 28, 1987; and Marshall Abrams, father of the injured girl, June 1, 1987.

26. Elissa Silverman, "U.S. Plans To Retain Site of Hospital: D.C. Hoped to Get Walter Reed Land," *Washington Post*, May 11, 2006.

27. "Shepherd Park: Past and Present," video directed by Walter J. Gottlieb, Silver Spring Media Arts, 2006, at www.silverspringmedia.org/spvideo.

About the Contributors

The second edition of *Washington at Home* is dedicated to the memory of two of the authors of the first edition, Marvin Caplan and Ruth Ann Overbeck, who both passed away in the year 2000. Their excellent work remains in this book, updated by others as devoted as they were to the city of Washington. Both are sorely missed.

MARVIN CAPLAN was a writer and journalist, a leader in the labor movement, and a strong believer in justice for all that led him to take key roles in the civil rights movement, including the directorship of the Leadership Conference on Civil Rights. In Shepherd Park, he was a founding member and first president of Neighbors, Inc., an organization that worked to build an integrated community in the face of rapid demographic change, and an active member of Tifereth Israel Congregation. He authored *Farther Along: A Civil Rights Memoir*, published in 1999. His articles appeared in the *Washington Post, Atlantic Monthly, New Republic,* and *Washington Jewish Week*, among many other publications. In 2003 a park was named in his honor at Alaska Avenue and Holly Street in Shepherd Park. His chapter has been updated by fellow Shepherd Park resident and friend Ralph Blessing.

RUTH ANN OVERBECK, an American social historian, was one of the first in the nation to found her own public history firm, Washington Perspectives, through which she conducted meticulous research on the architecture and social history of neighborhoods and buildings in Washington and elsewhere. The chapters on Deanwood and Congress Heights rest heavily on surveys she conducted for the D.C. Office of Historic Preservation. Among other publications she authored *Houses and Homes: Exploring Their History*. For decades she pursued research topics related to her home neighborhood of Capitol Hill. Neighbors, friends, and colleagues have organized to honor and continue her work through the Ruth Ann Overbeck Oral History Project and the Ruth Ann Overbeck Lecture Series. Ruth Ann's extensive research papers are available in Special Collections at the Gelman Library of George Washington University. Her chapter on Capitol Hill has been updated by fellow Capitol Hill resident Nancy Metzger; her chapter on Deanwood by

Kia Chatmon, a new resident who follows in Ruth Ann's footsteps as an avid neighborhood historian.

BLANCHE WYSOR ANDERSON is a librarian with three decades of experience as a professional in pubic libraries in Virginia, including positions in reference, branch management, and library administration. She holds an MSLS degree from the University of North Carolina at Chapel Hill. Her interest in her Northern Virginia community, where she lives with her husband and co-author G. David Anderson, leads her to leadership roles in local service and religious organizations.

G. DAVID ANDERSON is steeped in the history of George Washington University and its Foggy Bottom neighborhood, having served as archivist for the university from 1987 to 2009 and for the past four years as historian and archivist. He led the effort to create the online *GW and Foggy Bottom Historical Encyclopedia* (http://encyclopedia.gwu.edu). Previous to his appointment at GW, David was the head of special collections at Colgate University and archivist at Columbus State University. He earned his BS and MA degrees in urban history at Georgia College and State University and an MS in library science at Florida State University.

ROBERT MCQUAIL BACHMAN, president of the American Foundation for Pharmaceutical Education, lived on Takoma Avenue in Silver Spring, Maryland, and made Takoma Park, Maryland, the subject of his thesis while earning his MA degree in American studies from George Washington University. He now resides in Poolesville, Maryland, but he continues his interest in Takoma Park and vicinity as a member of Historic Takoma, Inc., and has over the years participated in many other local organizations, including the North Takoma Citizens Association, Neighborhoods Together, Inc., and the Silver Spring Citizens Advisory Board.

RALPH BLESSING, who works with the Fulbright Scholar Program at the U.S. Department of State, has been a resident of Shepherd Park since 1987 and has served the community as president of the Shepherd Park Citizens Association. His interest in other cultures has led him to serve as a Peace Corps volunteer in Panama and Ecuador

and to travel widely throughout Latin America. He has a BS degree in anthropology from Loyola University in Chicago.

JIM BYERS serves as marketing director for Arlington Cultural Affairs in Arlington, Virginia. He became interested in the history of neighborhoods east of the Anacostia River after living in Washington's Ward 7 for more than a decade. Drawing on his studies of communications at American University and a deep love of music, he has been a freelance music critic for the *Washington Post* and now hosts *Latin Flavor*, a radio program on WPFW-FM.

OLIVIA CADAVAL is a folklorist and chair of Cultural Research and Education at the Smithsonian Center for Folklife and Cultural Heritage. She has written extensively on the Latino communities of Washington, D.C., and helped establish the Latino Community Heritage Center at the Latin American Youth Center where she trained youth in fieldwork and exhibition development. She holds a PhD in American studies and folklife from George Washington University.

KIA CHATMON holds a BA degree in anthropology from Stanford University. In 2001 she purchased a home in Deanwood, where her grandmother grew up in the 1930s, and became active with the Deanwood Citizens Association and its efforts to preserve the community's history. She is the chair of the Deanwood History Committee, which published *Washington DC's Deanwood* in 2008, and worked with community members on the Deanwood Neighborhood Heritage Trail, sponsored by Cultural Tourism DC, the first such trail east of the Anacostia River.

MARA CHERKASKY served as community historian for *Village in the City*, the Mount Pleasant Neighborhood Heritage Trail sponsored by Cultural Tourism DC. She is also the author of a pictorial history of Mount Pleasant in Arcadia Publishing's Images of America series, published in 2007, and frequently gives walking tours of the neighborhood. After a career in journalism, she is now a historian with Cultural Tourism DC developing Heritage Trails in neighborhoods throughout the city and managing its African American Heritage Trail. She holds an MA in American studies from George Washington University.

DIANNE DALE is a community historian whose family has lived in Hillsdale Anacostia for four generations since 1892. She is president of the Anacostia Historical Society and past president of the Anacostia Garden Club. She is a graduate of Howard University with a BS in recreation and allied sciences, an MS in child development, and an MPA in public administration. She provides lectures on the history of black Anacostia in conjunction with her forthcoming book, *Mark the Place: Historic Hillsdale, Voices of an Invisible Community.*

EMILY HOTALING EIG is an architectural historian and preservation specialist with EHT Traceries, a Washington-based consulting firm. Her firm has surveyed and/or documented more than seventy-five neighborhoods in the District, Maryland, and Virginia, leading to many local and National Register historic districts, among them Sheridan-Kalorama and Kalorama Triangle, about which she writes in this volume. A graduate of Brandeis University, she received her MA in teaching and museum education with a focus on architecture and historic museum properties.

KATHERINE GRANDINE chose Brightwood as her thesis topic for her MA degree in American studies with an emphasis on historic preservation from George Washington University. In her professional career in historic preservation she has conducted architectural surveys, written local landmark and historic district nominations and National Landmark applications, prepared cultural resources planning documents, and conducted other research related to the history of American localities throughout the country. She is currently senior project manager and historian at R. Christopher Goodwin & Associates, Inc.

JUDITH BECK HELM, a third-generation Washingtonian, wrote the first full-scale history of a Washington community, *Tenleytown, DC: Country Village to City Neighborhood*, published in 1981 while she lived in the neighborhood. It was republished in 2000. She was instrumental in reviving the community's historic name. She holds a Master of Divinity degree from the Lutheran Seminary in Gettysburg, Pennsylvania, and served as pastor of three successive Lutheran churches in Pennsylvania before retiring to Cary, North Carolina.

ALISON K. HOAGLAND is professor of history and historic preservation at Michigan Technological University. Before moving to Michigan, she lived in Washington and coordinated the volunteer survey of historic buildings in Washington's old downtown for the preservation

group Don't Tear It Down (now the D.C. Preservation League). Aside from Washington history, she has written books and articles on Alaskan buildings, fort architecture, and workers' housing. She has an MA degree from George Washington University in American studies.

RONALD M. JOHNSON, professor emeritus on the history faculty at Georgetown University, is a specialist in American cultural and social history who has published frequently in the fields of race relations and urban affairs. He co-authored *Propaganda and Aesthetics*, a study of African-American literary politics in the twentieth century. He holds a PhD from the University of Illinois.

BRIAN KRAFT, with a degree in computer science from Pennyslvania State University, began to research Washington history as an avocation in 1997. He has led tours of Washington neighborhoods for the Historical Society of Washington, D.C., the Smithsonian Institution, and others, and is the historian for the Columbia Heights Neighborhood Trail sponsored by Cultural Tourism DC. He is the creator and editor of the D.C. Building Permits Database, an electronic collection of information regarding the development of Washington.

JUDITH LANIUS, an independent architectural historian and historic preservationist, lives close to her subject on historic Chain Bridge Road in the Palisades, across the street from the Civil War–era Battery Kemble. She has been the first chief curator at both the U.S. Treasury Building and the National Building Museum, has written and lectured on turn-of-the-nineteenth-century architecture and interiors, and has been responsible for several award-winning restorations. She holds an MA in art history from Boston University.

JOE LAPP grew up in two communities—the rural, Amish-Mennonite community in Lancaster County, Pennsylvania, and urban, African American Kenilworth, where his parents established a mission church, Fellowship Haven. With a BA degree in English from Calvin College in Michigan, he began his writing career by delving into the history of the community of his youth. Based on extensive oral histories, in 2006 he published the booklet *Kenilworth: A DC Neighborhood by the Anacostia River*, on which his essay is based. He developed his chapter while living and writing in Pakistan.

LINDA LOW has been a history teacher and a preservation consultant and has been involved in a variety of history and preservation projects, including Mount Pleasant's successful historic district application and the landmark designation of the houses and carriage houses on the north side of the 1800 block of Park Road. A Mount Pleasant resident since 1970, she is presently a Realtor in the Washington area. She holds BA in history from the University of Tennessee.

GAIL SYLVIA LOWE is a historian with the Smithsonian Anacostia Community Museum. She is head of the museum's Research, Documentation, and Publications Department and specializes in African American religious and spiritual traditions. The curator of many museum exhibitions, including *Speak to My Heart: Communities of Faith and Contemporary African American Life*, she holds a BA from Harvard/Radcliffe College and an MA from Yale, both in U.S. history, and a PhD in American studies from George Washington University.

KEITH MELDER is retired from the Smithsonian Institution's National Museum of American History, where he served for more than twenty years as curator of American political history. With a PhD in American studies from Yale University, he has specialized in political and women's history, and has published many articles and books, including *City of Magnificent Intentions: A History of Washington, District of Columbia*. He is a resident of Southwest Washington, where he continues to watch its history unfold.

NANCY METZGER specializes in historic preservation. She has lived on Capitol Hill since 1974 and published *Brick Walks and Iron Fences* on Capitol Hill's history and architecture in 1977. She has been chair of the Historic Preservation Committee of the Capitol Hill Restoration Society for more than a decade, regularly convenes a coalition of the historic districts in the District of Columbia, and has been active in the Barracks Row Neighborhood Heritage Trail and the Ruth Ann Overbeck Oral History Project. She graduated from Ohio University with a BS in journalism and studied landscape architecture at North Carolina State University.

JAMES A. MILLER is professor of English and American studies and chair of the American Studies Department at George Washington University. He has a strong interest in black history and culture in Washington, D.C., particularly its relationship to twentieth-century national movements, such as the New Negro Movement of the 1920s and the Black Arts Movement of the 1960s and 1970s. His article "Black Washington and the New Ne-

gro Renaissance" appeared in *Composing Urban History and the Constitution of Urban Identities*. He holds a PhD from the State University of New York at Buffalo.

JOHN N. PEARCE is director of the James Monroe Museum and Memorial Library at the University of Mary Washington in Fredericksburg, Virginia. He involved his students in extensive study of the Brookland neighborhood while a professor at George Washington University. He has been director of historic properties at the National Trust for Historic Preservation and associate curator of cultural history at the Smithsonian Institution, among other positions related to American history and historic preservation. He received his BA in American studies from Yale and his MA in early American culture from the University of Delaware.

KATHRYN COLLISON RAY steeped herself in the literature of Washington history while serving as assistant chief of the Washingtoniana Division of the DC Public Library and later as manager of the Tenley-Friendship Branch of the library in Tenleytown. She is past president of the D.C. Library Association. She holds an MS in library science from Catholic University and studied Washington history with Letitia Woods Brown at George Washington University where she received an MA in American studies. She is currently a reference librarian at American University.

JUDITH HELM ROBINSON is a professional architectural historian, preservation advisor, and publications specialist. She is past president and advisor to the Board of Directors of the Chevy Chase Historical Society and has documented the history of Chevy Chase for many years. She is principal of Robinson & Associates, a historic preservation firm specializing in architectural and landscape history, which has won nationwide recognition. Her BA degree in English and art and architectural history is from Randolph-Macon Woman's College.

DIANE SHAW studied Wesley Heights and Spring Valley while earning her MA in American studies at George Washington University. She went on to obtain a PhD in architectural history from the University of California at Berkeley and is currently an architectural and urban historian in the School of Architecture at Carnegie Mellon University. The author of *City Building on the Eastern Frontier: Sorting the New 19th-Century City*, her research focuses on the ordinary instead of the extraordinary, illuminating overlooked aspects of our architectural heritage.

KATHRYN SCHNEIDER SMITH is a community-based public historian who has focused on raising public awareness and understanding of the history of the city of Washington for residents and visitors. She is past president of the Historical Society of Washington, D.C., and the founding editor of its journal, *Washington History*. She is the author of a number of books on Washington and the founding director of Cultural Tourism DC. She holds a BS in journalism from the University of Wisconsin and an MA in American studies from George Washington University.

LINDA WHEELER lived in Dupont Circle for twenty-five years while she covered the neighborhoods of Washington, preservation issues, African American history, and the National Mall and its monuments for the *Washington Post*, as well as a beat called "the changing city," created for her because of her intense interest in urban communities. She began a column, "A House Divided," that dealt with the Civil War and all its aspects in Washington, Virginia, and Maryland, which she continues to write under contract with the *Post*. She holds a degree in journalism from Ohio State University.

KATHLEEN SINCLAIR WOOD, an architectural historian, is recently retired after a lifetime of researching, writing, and lecturing on the subject of American architecture. A longtime resident of Cleveland Park, she was a founder and the first executive director of the Cleveland Park Historical Society and wrote the successful application for the listing of the neighborhood on the National Register of Historic Places. She holds an MA in art history from the University of Michigan and pursued further graduate studies in architectural history toward a PhD at the University of Delaware.

Index

cemeteries *(cont.)*
 Lincoln Memorial, 397; Oak Hill, 19, 23, 277; Ohev Shalom-Talmud Torah, 335; Washington Hebrew, 335; Washington National, 397
Center Market, 8, 55, 56, 62, 63, 64, 196, gal.
Central Americans, 226
Chase, Calvin, 203
Chesapeake and Ohio Canal: commerce and trade through, 18; and Foggy Bottom, 73–74, 75, 77, 85; and Georgetown, 23, 24, 25, 26, 28, 30, 32, 35; and the Palisades, 139, 141, 144, 145, 146–47, 148, 151, 152
Chevy Chase (D.C. and Maryland), 3, 7, 295–311, 319, 420; and Brightwood, 132; and Cleveland Park, 318; and Dupont Circle, 188; and Hillcrest, 408; and Kalorama, 282, 287; lake, 283, 301, 311, 366; and streetcars, 275; and Takoma Park, 364, 367, 370; and Tenleytown, 109, 115–16, 117
Children's National Medical Center, 343
Chinese, 8, 64–65. *See also* Asians / Asian Americans
circles: Anna J. Cooper, 8, 228, 234, 236; Chevy Chase, 280, 293, 304, 305, 307; Dupont, 12, 180, 183, 184, 189, 190–91, 192, 298; Logan, 198; Sheridan, 281, 282, 289, 292; Washington, 73, 76, 81
citizen and civic associations: American University Park, 117; Brightwood, 127, 133, 134, 453; Brookland, 389; Brookland Neighborhood, 389; Chevy Chase, 295; Brightwood Avenue, 133; and Columbia Heights, 244, 245; Deanwood, 257, 267; Devonshire Downs (North Cleveland Park), 117; and Downtown preservation, 68; Dupont Circle, 179, 186, 191, 192, 193, 195; East Washington, 399; Federation of Citizens Associations, 222; Friendship, 116–17; Georgetown, 34; Hillsdale, 163, 168; Kalorama Citizens, 292–93, 294; Kenilworth, 352; LeDroit Park, 231, 237, 239; MacArthur Boulevard, 152; Midway, 186; Mount Pleasant, 218, 220, 221; Northeast Boundary, 267; Northwest Suburban, 116; Palisades, 139, 152; Pleasant Plains, 249; Shepherd Park, 449, 455, 458; Sixteenth Street Heights, 455; Southwest, 95, 104; Takoma, D.C., 370; Takoma Park, 364, 370

City Beautiful movement, 5, 219
City Hall, 55
civic activism, 5, 12–13, 178; and Adams Morgan, 433, 439, 443, 444–46, 447, 448; and Barry Farm / Hillsdale, 169; and Brightwood, 133, 137; and Brookland, 389, 390; and Capitol Hill, 36, 48, 51; and Chevy Chase, 311; and Cleveland Park, 322–23, 324–27; and Columbia Heights, 251; and Congress Heights, 341–42, 344; and Deanwood, 267, 270; and Downtown, 66, 67; and Dupont Circle, 187, 192; and East Washington Heights, 399, 413–14; and Foggy Bottom, 85–86; and Georgetown, 29, 34; and Greater Shaw, 203, 209–10; and Kalorama, 292–94; and Kenilworth, 5, 356–59; and LeDroit Park, 237; and Mount Pleasant, 217–18, 220, 222–24; and the Palisades, 150; and Shepherd Park, 449, 452–53, 457, 458, 459, 461, 462; and Southwest, 95, 102, 104; and Takoma Park, 369–70, 371, 372, 373, 374, 376–77; and Tenleytown, 116–17, 121
civil rights: and Consolidated Parent Group (CPG), 169; and Greater Shaw, 67, 137, 201, 209, 210; and Hamburger Grill, 209; and LeDroit Park, 232; and Meridian Hill Park, 437; and Mount Pleasant, 227; and New Negro Alliance, 11, 209, 210; Reconstruction era, 9; and Shepherd Park, 458; and Sousa Junior High School, 166, 169. *See also* segregation/ desegregation; voting rights
Civil Service Reform Act, 44, 273
Civil War, xiii, 2, 4, 7, 9, 12, 15, 42, 105, 107, 141, 175, 334, 410, gal.; and Adams Morgan, 436; and Barry Farm / Hillsdale, 158; and Brightwood, 123, 129–30, 132, 138; and Congress Heights, 330, 331; and Deanwood, 261, 262; and Downtown, 56, 57, 59; and Foggy Bottom, 75, 76, 78; and Fort Stevens, 125; and Georgetown, 24; and Greater Shaw, 198, 199, 201; and Kalorama, 278–79; and Mount Pleasant, 213; and Mount Pleasant Hospital, 217; and Palisades, 141, 142, 143; Pennsylvania Regiment, 114; and Shepherd Park, 449; and Southwest, 90, 91; and St. Elizabeths Hospital, 161; and Tenleytown, 113
Civil War forts/installations: Battery

Kemble, 9, 107, 142, 143, 153; Camp Barker, 9, 198; Camp Fry, 75, 76; Camp Stoneman, 331; Camp Tennelly, 114; Fort Carroll, 9, 331; Fort Davis, 410; Fort Duquesne, 110; Fort Greble, 331; Fort Mahan, 261; Fort Massachusetts, 129, gal.; Fort Pennsylvania, 113, 114; Fort Reno, 9, 113, 114, 117; Fort Stanton, 9, 161, 171; Fort Stevens, 113, 123, 125, 129–30, 131, 136, 137, 449, gal.; Giesboro Calvary Depot, 161, 162, 331, 334; Martin Scott Battery, 143; Vermont Battery, 143; Wisewell Barracks, 198, 202. *See also* military/ military installations
Clagett, Darius, 451
Claggett, D. Thomas, Jr., 189
Clarke, David A., 223, 225
class and income, 4, 48, 51, 78, 79, 95, 173, 393; and Adams Morgan, 433, 441; and automobiles, xiv; and Brightwood, 136; and Brookland, 382, 383–84; and Capitol Hill, 44; and Cleveland Park, 320, 321, 327; and Columbia Heights, 254, 255; and Congress Heights, 335, 336, 343, 344; and Deanwood, 269, 271; and Downtown, 56, 67, 70; and Dupont Circle, 182; and Foggy Bottom, 71, 75, 85; and Georgetown, 19, 24, 28, 29–30; and Greater Shaw, 198, 200, 210, 211; and Hillcrest, 406, 407; and Hillcrest and Penn Branch, 414; and Kalorama, 277, 284, 285, 294; and Kenilworth, 347, 351; and LeDroit Park, 232, 237, 239; and Mount Pleasant, 213, 223, 225, 227; and Palisades, 147, 149, 155; and poverty, 44; and Reno, 117; and Shepherd Park, 449, 453, 456, 463; and Southwest, 90, 91, 95, 96, 97, 99, 104; and Summit Park, 408; and Takoma Park, 363, 368, 369; and Tenleytown, 116, 121
Cleveland Heights, 317
Cleveland Park, 3, 4, 7, 12, 61, 115, 275, 312–27, 417, gal.
Cloud, Abner, 141
Coates, James E., 339–40
Cobb, Montague, 249
Colonial Village, 449, 455, 459, 462
Columbia Heights, 4, 127, 240–56, 439; African Americans in, 9; development of, 7; Latinos in, 8, 442, 443, 445, 448; and Metrorail, 3; migration through,